MAYA SCULPTURE OF COPÁN

Maya Sculpture of Copán

The Iconography

By Claude-François Baudez

UNIVERSITY OF OKLAHOMA PRESS : NORMAN AND LONDON

Library of Congress Cataloging-in-Publication Data

Baudez, Claude F.
 Maya sculpture of Copán : the iconography / by Claude-François Baudez.
 p. cm.
 Includes bibliographical references and index.
 ISBN 0-8061-2594-2 (alk. paper)
 1. Copán Site (Honduras) 2. Maya sculpture—Honduras—Copán Site. 3. Mayas—Religion and mythology. 4. Mayas—Politics and government. I. Title.
F1435.1.C7B38 1994 93-43681
730'.97283'84—dc20 CIP

Book designed by Bill Cason

Unless otherwise noted, all illustrations appear by permission of the Instituto Hondureño de Antropología e Historia.

The paper in this book meets the guidelines for permanence and durability of the Committee on Production Guidelines for Book Longevity of the Council on Library Resources, Inc. ∞

Copyright © 1994 by the University of Oklahoma Press, Norman, Publishing Division of the University. All rights reserved. Manufactured in the U.S.A.

1 2 3 4 5 6 7 8 9 10

Contents

List of Illustrations	vii
Acknowledgments	xi
Introduction	3
Previous Research at Copán	5
The History of Copán: A Summary	8
The Copán Sculpture: Previous Iconographic Studies	11
The Proyecto Arqueológico Copán Sculpture Program: Conservation and Recording	12
Methodology	13
Organization of the Present Study	14

PART I. ANALYSIS

CHAPTER 1. Freestanding Monuments — 19

CPN 1	*Stela A*	19
CPN 3	*Stela B*	23
CPN 4	*Stela C*	28
CPN 5	*West Altar of Stela C (La Tortuga)*	36
CPN 7	*Stela D*	38
CPN 8	*Altar of Stela D*	43
CPN 9	*Stela E*	46
CPN 11	*Stela F*	48
CPN 12	*Altar of Stela F*	53
CPN 13, 14 and 15		55
CPN 13	*Altar G1*	55
CPN 14	*Altar G2*	58
CPN 15	*Altar G3*	58
CPN 16	*Stela H*	59
CPN 17	*Altar of Stela H*	64
CPN 18	*Stela I*	66
CPN 19	*Altar of Stela I*	69
CPN 20	*Stela J*	69
CPN 21	*Altar of Stela J*	70
CPN 23	*Altar L*	72
CPN 24	*Stela M*	74
CPN 25	*Altar of Stela M*	76
CPN 26	*Stela N*	80
CPN 27	*Altar of Stela N*	87
CPN 28	*Altar O*	90
CPN 29	*Stela P*	92
CPN 30	*Altar Q*	95
CPN 33	*Altar T*	97
CPN 34	*Altar U*	104
CPN 37	*Altar Z*	107
CPN 38	*Stela 1*	107
CPN 40	*Stela 2*	109
CPN 41	*Stela 3*	112
CPN 42A	*Prismatic Sculpture*	118
CPN 42B	*Prismatic Sculpture*	118
CPN 43	*Stela 4*	118
CPN 44 and 48		122
CPN 44	*Altar Y*	122
CPN 48	*Altar X*	125
CPN 45	*Globular Altar of Stela 4*	125
CPN 46	*Archaic Sculpture*	127
CPN 47	*Stela 5*	127
CPN 51	*Archaic Sculpture*	132
CPN 52	*Stela 6*	133
CPN 54	*Stela 7*	137
CPN 55	*Stela 8*	139
CPN 62A	*Cribbing Frame of Stela 13*	139
CPN 64	*Altar 14*	140
CPN 82	*Altar D' (Oblong Altar, Altar 41)*	141
CPN 98	*Altar T'*	144
CPN 99	*Altar U'*	147
CPN 101	*Altar W'*	147
CPN 109, 110, and 111		147
CPN 131	*Four-lobed Disk*	151
CPN 155	*Tunkul*	151
CPN 188	*Stela 35*	155
CPN 634	*Carved Slab*	156

CHAPTER 2. Architectural Sculpture — 158

Structures 9 and 10 *Ball Court A*	158
Ball Court A-I	158
Ball Court A-IIa	158
Ball Court A-IIb	162
Ball Court A-III	164

Structure 11	166	Accessories and Symbolic Objects	247
Architecture	166	Animated Beings	247
Sculpture	168	Summary	248
Structure 12 *"The Reviewing Stand"*	177	Finer Divisions	248
Structure 16	184	CHAPTER 4. Religion and Politics at Copán	255
Structure 18	189	Beliefs	255
Exterior Decoration	189	Cosmology	255
Interior Decoration	194	Supernatural Beings	266
Associated Monuments	197	Bipolar Thought	267
Structure 22	200	Ritual	268
Structure 24 *The Jaguars' Stairway*	211	Sacrifice	268
Structure 26 *The Hieroglyphic Stairway*	217	Perambulations	277
Seated Statues	221	The Ancestor Cult	277
Prone Figures	230	Kingship	278
The Decorated Benches	232	The King on Stelae	278
Structure 9M-146	232	Other Portraits of the Ruler	279
CPN 489: Bench Support	232	Ancestors	280
CPN 999: Sculptured Bench	235	Conclusion	281
PART II. SYNTHESIS		APPENDIXES	
CHAPTER 3. The History of Monumental Art at Copán	239	1. Dedicatory Dates of Monuments Analyzed in This Study	283
Major Periods	239	2. Glyphic Elements in Copán Iconography	284
Formal Properties	239	References	289
Costume	247	Index	297

Illustrations

FIGURES

1. Map of the Main Group at Copán — 7
2. The Main Plaza looking south — 20
3. CPN 1: southeast — 21
4. CPN 1: (a) east; (b) northeast — 22
5. CPN 3: (a) east side; (b) west side — 24
6. CPN 3: (a) south side; (b) north side — 25
7. CPN 4: (a) oblique view of east side; (b) east side — 29
8. CPN 4: west side — 30
9. CPN 4: (a) north side; (b) south side — 31
10. CPN 5: (a) north side; (b) south side — 37
11. CPN 7: (a) south side; (b) north side — 39
12. CPN 7: west side — 40
13. CPN 7: east side — 41
14. CPN 8: east side — 44
15. CPN 8: (a) north side; (b) south side — 45
16. CPN 9: east side — 47
17. CPN 11: west side — 49
18. CPN 11: (a) north side; (b) south side — 50
19. CPN 11: east side — 51
20. CPN 12: (a) west side (b) south side — 54
21. CPN 13: (a) north side; (b) south side — 56
22. CPN 14: (a) east side; (b) west side; CPN 15: (c) west side — 57
23. CPN 16: (a) north side; (b) west side — 60
24. CPN 16: east side — 61
25. CPN 17: (a) north side; (b) south side — 65
26. CPN 18: west side — 67
27. CPN 20: west side — 70
28. CPN 21: (a) west side; (b) east side — 71
29. CPN 23: (a, a') south side; (b, b') north side — 73
30. CPN 24: (a) north side; (b) west side; (c) south side — 75
31. CPN 25: top — 77
32. CPN 25: west side — 78
33. CPN 25: (a) south side; (b) north side — 79
34. CPN 26: north side — 81
35. CPN 26: (a) west side; (b) east side — 82
36. CPN 27: (a) east side; (b) south side — 88
37. CPN 27: (a) west side; (b) north side — 89
38. CPN 28: (a) south side; (b) north side — 91
39. CPN 29: west side — 93
40. CPN 30: roll-out of periphery — 96
41. CPN 30: (a) west side; (b) south side; (c) east side; (d) north side — 98
42. CPN 33: front — 100
43. CPN 33: left-profile group of figures — 102
44. CPN 33: right-profile group of figures — 102
45. CPN 33: back — 103
46. CPN 34: front — 105
47. CPN 34: (a) left side; (b) right side — 106
48. CPN 38: front — 108
49. CPN 40: south side — 110
50. CPN 41: south side — 113
51. CPN 41: north side — 113
52. CPN 41: east side — 114
53. CPN 41: west side — 114
54. CPN 43: southeast side — 119
55. CPN 43: (a) east side; (b) northeast side — 120
56. CPN 44: one broad side — 123
57. CPN 44: the opposite broad side — 123
58. CPN 48: one broad side — 124
59. CPN 48: the opposite broad side — 124
60. CPN 45: (a) side view; (b) top view showing liquid flowing down — 126
61. CPN 47: west side — 128
62. CPN 47: east side — 129
63. CPN 52: southeast side — 134
64. CPN 52: west side — 135
65. CPN 54: front — 138
66. CPN 64 — 140
67. CPN 82: (a) east side; (b) north side — 142
68. CPN 101: front — 143
69. CPN 109: (a, b, c, d) four vertical sides — 144
70. CPN 110: (a, b, c, d) four vertical sides — 146
71. CPN 110: (a, b, c, d) four vertical sides — 148
72. CPN 131 — 150
73. CPN 155: (a) north side; (b) south side; (c) east side — 152

74. CPN 188: (a, a'; b, b') two broad sides 154
75. Ball Court A-III: view from north stairs of Structure 11 159
76. Ball Court A-IIa: central marker 159
77. Ball Court A-IIb: (a) north marker; (b) central marker; (c) south marker 160
78. Ball Court A-IIIb: (a) north marker; (b) central marker; (c) south marker 161
79. Main stairway of Structure 11 from Structure 26 166
80. Plan of Structure 11 167
81. (a, b, c) Carved steps from main stairway of Structure 11; (d) fallen block from stairway 169
82. Toad(?) figures on southern wall of Structure 11 171
83. *Bacab* and reptilian head from façade decoration of Structure 11 172
84. Structure 11: (a) north door and (b) south door of central chamber 173
85. (a) *Tzolkin* from Codex Madrid; (b) earth monster from the Panel of the Foliated Cross at Palenque 174
86. (a) Graffiti (a) from Structure 1-Sub, Dzibilchaltún and (b) incised on floor in Tunnel 2, Structure 26, Copán; (c) reading sequence of Structure 11 hieroglyphic panels 175
87. Carved step from northern entrance to central chamber of Structure 11: (a) right-profile figures 7–10; (b) left-profile figures 7–10 178
88. Structure 12 and West Court 179
89. West Court: (a) west slab; (b) middle slab 181
90. Structure 12: upper steps and inscription 182
91. Detail of painted scene on Early Classic wooden bowl from Burial 160, Tikal 183
92. Elevation of Structure 16 185
93. Structure 16: (a, b) rear of west room during excavation by Maudslay; (c) skulls and *kan* signs 186
94. Façade of Structure 18 looking south 190
95. Temple 18: (a) northwest jamb; (b) northeast jamb 191
96. Temple 18: (a) southwest jamb; (b) southeast jamb 192
97. Temple 18: detail of decoration on riser of step-bench 193
98. CPN 60 199
99. Structures 22A, 22, and 21A: plan and section 201
100. *Cauac* masks from Structure 22: (a) corner mask; (b, c) masks at entrance 203
101. Structure 22: statue impersonating maize from façade 204
102. Structure 22: inner door, western section 206
103. Structure 22: inner door, eastern section 207
104. East Court with Structure 24 212
105. Structure 24: (a) representation of the setting sun; (b) standing jaguar 214
106. Structure 24: (a, b) death heads at both ends of step; (c) East Court, south carved slab 216
107. Structure 26: the Hieroglyphic Stairway 218
108. Structure 26: (a) statue 1; (b) statue 3 222
109. Structure 26: (a) statue 4; (b) statue 5 224
110. Structure 26: (a) statue 6; (b) "King-Grasping-Fish" 228
111. Structure 9N-82: carved bench 233
112. (a) Carved bench from Structure 9M-146; (b) carved bench from group 10K (CPN 999) 234
113. Emblematic and glyphic forms of the earth: (a) crocodile from CPN 33; (b) up-ended frog from CPN 33; (c) *cauac* from CPN 33; (d) *caban* infixed within a water lily blossom from CPN 1; (e) earth monster with T616b and *caban* markings from Toniná, Monument 69 259
114. Cruciform medallions and Ts as conventional representations of the earth: (a) Copán Temple 18, southeast jamb; (b) Machaquilá Stela 10; (c) Machaquilá Stela 4; (d) Copán Temple 18, northeast jamb; (e) Copán Temple 18, southwest jamb; (f) Quiriguá, Monument 2 (Altar of Zoomorph P); (g) Toniná, Monument 135 261
115. 7-Head and 9-Head as emblematic representations of the earth: (a) Structure 18, façade; (b) CPN 98; (c) CPN 7, west and east; (d) Ball Court A-IIb, north marker; (e) Ball Court A-IIb, south marker; (f) CPN 33 263
116. Iconography of sacrifice. The double-scroll lancet form: (a) CPN 16, east; (b) CPN 47, east; (c) Yaxchilán, Lintel 25. The head-lancet form: (d) Huehuetenango vase; (e) CPN 11, south; (f) CPN 7, west; (g) Temple 18, southeast jamb; (h, i) CPN 7, south; (j) CPN 3; (k) CPN 7 269

Illustrations

FIGURES

1. Map of the Main Group at Copán — 7
2. The Main Plaza looking south — 20
3. CPN 1: southeast — 21
4. CPN 1: (a) east; (b) northeast — 22
5. CPN 3: (a) east side; (b) west side — 24
6. CPN 3: (a) south side; (b) north side — 25
7. CPN 4: (a) oblique view of east side; (b) east side — 29
8. CPN 4: west side — 30
9. CPN 4: (a) north side; (b) south side — 31
10. CPN 5: (a) north side; (b) south side — 37
11. CPN 7: (a) south side; (b) north side — 39
12. CPN 7: west side — 40
13. CPN 7: east side — 41
14. CPN 8: east side — 44
15. CPN 8: (a) north side; (b) south side — 45
16. CPN 9: east side — 47
17. CPN 11: west side — 49
18. CPN 11: (a) north side; (b) south side — 50
19. CPN 11: east side — 51
20. CPN 12: (a) west side (b) south side — 54
21. CPN 13: (a) north side; (b) south side — 56
22. CPN 14: (a) east side; (b) west side; CPN 15: (c) west side — 57
23. CPN 16: (a) north side; (b) west side — 60
24. CPN 16: east side — 61
25. CPN 17: (a) north side; (b) south side — 65
26. CPN 18: west side — 67
27. CPN 20: west side — 70
28. CPN 21: (a) west side; (b) east side — 71
29. CPN 23: (a, a') south side; (b, b') north side — 73
30. CPN 24: (a) north side; (b) west side; (c) south side — 75
31. CPN 25: top — 77
32. CPN 25: west side — 78
33. CPN 25: (a) south side; (b) north side — 79
34. CPN 26: north side — 81
35. CPN 26: (a) west side; (b) east side — 82
36. CPN 27: (a) east side; (b) south side — 88
37. CPN 27: (a) west side; (b) north side — 89
38. CPN 28: (a) south side; (b) north side — 91
39. CPN 29: west side — 93
40. CPN 30: roll-out of periphery — 96
41. CPN 30: (a) west side; (b) south side; (c) east side; (d) north side — 98
42. CPN 33: front — 100
43. CPN 33: left-profile group of figures — 102
44. CPN 33: right-profile group of figures — 102
45. CPN 33: back — 103
46. CPN 34: front — 105
47. CPN 34: (a) left side; (b) right side — 106
48. CPN 38: front — 108
49. CPN 40: south side — 110
50. CPN 41: south side — 113
51. CPN 41: north side — 113
52. CPN 41: east side — 114
53. CPN 41: west side — 114
54. CPN 43: southeast side — 119
55. CPN 43: (a) east side; (b) northeast side — 120
56. CPN 44: one broad side — 123
57. CPN 44: the opposite broad side — 123
58. CPN 48: one broad side — 124
59. CPN 48: the opposite broad side — 124
60. CPN 45: (a) side view; (b) top view showing liquid flowing down — 126
61. CPN 47: west side — 128
62. CPN 47: east side — 129
63. CPN 52: southeast side — 134
64. CPN 52: west side — 135
65. CPN 54: front — 138
66. CPN 64 — 140
67. CPN 82: (a) east side; (b) north side — 142
68. CPN 101: front — 143
69. CPN 109: (a, b, c, d) four vertical sides — 144
70. CPN 110: (a, b, c, d) four vertical sides — 146
71. CPN 110: (a, b, c, d) four vertical sides — 148
72. CPN 131 — 150
73. CPN 155: (a) north side; (b) south side; (c) east side — 152

74. CPN 188: (a, a'; b, b') two broad sides 154
75. Ball Court A-III: view from north stairs of Structure 11 159
76. Ball Court A-IIa: central marker 159
77. Ball Court A-IIb: (a) north marker; (b) central marker; (c) south marker 160
78. Ball Court A-IIb: (a) north marker; (b) central marker; (c) south marker 161
79. Main stairway of Structure 11 from Structure 26 166
80. Plan of Structure 11 167
81. (a, b, c) Carved steps from main stairway of Structure 11; (d) fallen block from stairway 169
82. Toad(?) figures on southern wall of Structure 11 171
83. *Bacab* and reptilian head from façade decoration of Structure 11 172
84. Structure 11: (a) north door and (b) south door of central chamber 173
85. (a) *Tzolkin* from Codex Madrid; (b) earth monster from the Panel of the Foliated Cross at Palenque 174
86. (a) Graffiti (a) from Structure 1-Sub, Dzibilchaltún and (b) incised on floor in Tunnel 2, Structure 26, Copán; (c) reading sequence of Structure 11 hieroglyphic panels 175
87. Carved step from northern entrance to central chamber of Structure 11: (a) right-profile figures 7–10; (b) left-profile figures 7–10 178
88. Structure 12 and West Court 179
89. West Court: (a) west slab; (b) middle slab 181
90. Structure 12: upper steps and inscription 182
91. Detail of painted scene on Early Classic wooden bowl from Burial 160, Tikal 183
92. Elevation of Structure 16 185
93. Structure 16: (a, b) rear of west room during excavation by Maudslay; (c) skulls and *kan* signs 186
94. Façade of Structure 18 looking south 190
95. Temple 18: (a) northwest jamb; (b) northeast jamb 191
96. Temple 18: (a) southwest jamb; (b) southeast jamb 192
97. Temple 18: detail of decoration on riser of step-bench 193
98. CPN 60 199
99. Structures 22A, 22, and 21A: plan and section 201
100. *Cauac* masks from Structure 22: (a) corner mask; (b, c) masks at entrance 203
101. Structure 22: statue impersonating maize from façade 204
102. Structure 22: inner door, western section 206
103. Structure 22: inner door, eastern section 207
104. East Court with Structure 24 212
105. Structure 24: (a) representation of the setting sun; (b) standing jaguar 214
106. Structure 24: (a, b) death heads at both ends of step; (c) East Court, south carved slab 216
107. Structure 26: the Hieroglyphic Stairway 218
108. Structure 26: (a) statue 1; (b) statue 3 222
109. Structure 26: (a) statue 4; (b) statue 5 224
110. Structure 26: (a) statue 6; (b) "King-Grasping-Fish" 228
111. Structure 9N-82: carved bench 233
112. (a) Carved bench from Structure 9M-146; (b) carved bench from group 10K (CPN 999) 234
113. Emblematic and glyphic forms of the earth: (a) crocodile from CPN 33; (b) up-ended frog from CPN 33; (c) *cauac* from CPN 33; (d) *caban* infixed within a water lily blossom from CPN 1; (e) earth monster with T616b and *caban* markings from Toniná, Monument 69 259
114. Cruciform medallions and Ts as conventional representations of the earth: (a) Copán Temple 18, southeast jamb; (b) Machaquilá Stela 10; (c) Machaquilá Stela 4; (d) Copán Temple 18, northeast jamb; (e) Copán Temple 18, southwest jamb; (f) Quiriguá, Monument 2 (Altar of Zoomorph P); (g) Toniná, Monument 135 261
115. 7-Head and 9-Head as emblematic representations of the earth: (a) Structure 18, façade; (b) CPN 98; (c) CPN 7, west and east; (d) Ball Court A-IIb, north marker; (e) Ball Court A-IIb, south marker; (f) CPN 33 263
116. Iconography of sacrifice. The double-scroll lancet form: (a) CPN 16, east; (b) CPN 47, east; (c) Yaxchilán, Lintel 25. The head-lancet form: (d) Huehuetenango vase; (e) CPN 11, south; (f) CPN 7, west; (g) Temple 18, southeast jamb; (h, i) CPN 7, south; (j) CPN 3; (k) CPN 7 269

117. Iconography of sacrifice: (a, b) personified knife (CPN 1 and CPN 24); (c) knife-tongue (alabaster sherd from tomb-fill of Structure 18); (d) whis-tongue (CPN 3); (e) composite staff (CPN 1) 271

118. Iconography of sacrifice. The knotted serpent: (a) CPN 43. The loop serpent: (b) CPN 41; (c) CPN 9. Pseudo-Tlaloc: (d, e) CPN 52. The jaguar, patron of pax: (f) CPN 18; (g) CPN 4, west. The jaguar, patron of Uo: (h) CPN 18; (i) CPN 4, west 274

CHARTS

1. The Copán Dynastic Sequence 9
2. Distribution of selected time-sensitive iconographic elements on monuments and architectural sculpture 240

Acknowledgments

This study is largely the outcome of the sculpture program of the Copán Archaeological Project inaugurated and administered by the Honduran Ministry of Culture through its Institute of Anthropology and History, then directed by Dr. Adán Cueva and later by Lic. Ricardo Agurcia Fasquelle. Funds were provided by the Banco Centroamericano de Integración Económica and the World Bank. Matching and supplementary funds for the sculpture program were provided by the Centre National de la Recherche Scientifique (France), and the Commission des Fouilles et Missions Archéologiques of the French Ministry of Foreign Relations. I would like to express my deep gratitude to these organizations and their representatives.

My warmest thanks go to my former coauthor, Berthold Riese, with whom I have had many stimulating exchanges and fruitful discussions for several years. His deep knowledge of Maya epigraphy and civilization was invaluable to me.

I am most grateful to Sydney Picasso, who very generously and competently translated my manuscript, originally written in French, into English.

In the Sculpture Program of the PAC, illustrators and photographers were crucial. Warmest thanks go to photographer Jean-Pierre Courau, who has spent many seasons with the project and has devoted most of his time to the sculpture program. His cooperation continued into the final months of preparation of this study. He has been a cheerful and helpful companion, loyal and reliable in difficult situations during both phases of the project. Among our artists Barbara W. Fash, Anne S. Dowd, and Anke Blanck have to be singled out for executing the most demanding and difficult illustrations in the field. Special thanks go to Anke Blanck for her patience and willingness to continue work on the illustrations through 1988.

Dr. Hasso Hohmann and Dr. Annegrete Vogrin have been very helpful with their comments on several matters. They and their publisher, Akademisches Druck- u. Verlagsanstalt, are deeply thanked for having kindly authorized the reproduction in this book of some of the illustrations from their *Die Architektur von Copán*.

CLAUDE-FRANÇOIS BAUDEZ

MAYA SCULPTURE OF COPÁN

Introduction

In the collective mind, Maya cities seem to be the product of feverish imaginations. Long after they had been abandoned (apparently suddenly and for unknown reasons), they were discovered immersed in luxuriant tropical vegetation where it is sometimes difficult to distinguish ruins from trees. The technological limitations of this civilization (no true architectural vault, no wheels, no metals) are surprising and contrast with its intellectual achievements: astronomical calculations, sometimes more precise than those of the most advanced cultures of the Old World at the same period, and writing that, even at first glance, reveals a high level of sophistication. Through the work of archaeologists, art historians, ethnohistorians, and scholars of many other disciplines (beginning a little more than a century ago), the Maya are becoming increasingly less "mysterious" and more real; they now appear not as aliens from another world but as human beings of flesh and blood who eat, dream, make war as well as love, create things and ideas. It is mostly through their art that we become acquainted with them, as we breathlessly climb their pyramids, enter their dark and humid buildings in trepidation, stare at their carved stelae and panels trying to make out what they represent, and look at the strange scenes painted on their pottery. Scared by the ghastly expression of their monsters, moved by the subtlety of a hand gesture delicately incised on a bone, puzzled by the meaning and function of an obsidian "eccentric" knife, or charmed by the quality of an emerald jade figurine, we never react to Maya art with indifference. The first exposure to it generally baffles us with the strangeness of the motifs, the complexity of the composition, and the difficulty of singling out its elements. Every Mayanist with teaching experience knows how difficult it is to make the audience recognize or identify the stylized serpent head or the jaguar mask that he or she delineates on the classroom's screen.

Herbert Joseph Spinden, in his *Study of Maya Art* (1913), was the first to analyze such motifs and decompose them into its constituents. He reviewed the representations and their manifestations in the different arts but showed more concern for style and stylistic evolution than for meaning. In Tatiana Proskouriakoff's *Study of Classic Maya Sculpture* (1950: 2) her "primary purpose ... [was] to examine variations in the Classic monumental style which would furnish clues to the relative dates of the execution of individual monuments." She soon realized that "criteria based on the occurrence of certain designs or motifs could be used only to define the Classic Maya style as a whole or, at best, its two major periods. The more comprehensive and more sensitive changes were found to lie not in the selection of definable forms or motifs, but in the artist's approach to his subject." In other words, it is not the motifs that are prone to change but rather the way they are treated. Proskouriakoff did not address the question of meaning in her study; and, following her example, Mayanists have for long been reluctant to tackle the problem of content. Even modern studies such as *The Monuments and Inscriptions of Tikal: The Carved Monuments* (Jones and Satterthwaite 1982) and *The Monuments and Inscriptions of Caracol, Belize* (Beetz and Satterthwaite 1981) do not include an iconographic study together with the epigraphic analysis. There have been many iconographic analyses dealing with specific ques-

tions or themes such as deities (Schellhas 1903), animal figures (Tozzer and Allen 1910), autosacrifice (Thompson 1961; Joralemon 1974), the triadic sign (Kubler 1969; Greene Robertson 1974), the *cauac* monster (Taylor 1978), and the water complex (Rands 1955). In spite of their respective merits, too often thematic studies are not systematic in that only examples that support the proposed hypotheses are selected. Another shortcoming is that such studies use data from different regions and from different periods of Maya history; as Kubler many times voiced it, the relationship between significant and signified may change through space and time ("disjunction").

Dealing with the sculpture of a single site with a majority of dated monuments avoids these pitfalls by controlling the time and space variables. No site is better suited than Copán for such a global study. On the southern fringe of the Maya area, it is the Classic Maya site that has been the most extensively studied and therefore is the best documented in such matters as settlement patterns and occupation through time, political and dynastic history, architecture, and ceramics and artifacts. The corpus of the monumental sculpture is large, homogeneous, and relatively well preserved and documented. Its many monuments offer a variety of representations as well as texts. Here, in most cases, the ruler identified by his costume and attributes is surrounded by human, grotesque, or symbolic representations. We may thus expect that the message transmitted by the iconography will refer to the person of the king and to his relations with the cosmos. No living human except the king seems to be represented in the Copán sculpture. The Copanecs used sculpture in association with architecture not to adorn their buildings but to define their meaning and their function. Most of the excavated structures from the Main Group appear to be gigantic three-dimensional cosmograms, a conclusion not foreseen at the beginning of this study.

One of the purposes of this work is to help the nonspecialist identify the motifs that compose an image. I would also like to demonstrate that, at Copán at least, the representations themselves, and not only their stylistic treatment, may have experienced change over the years. My major concern, however, is to understand the messages expressed in the images carved on the stone monuments, since my ultimate goal is to gain information on Maya society and thought. From the beginning, we must be aware of the characteristics of monumental art, which define its domain and its scope. Monumental stone carving not only expresses a "concern for permanence" as Proskouriakoff put it (1971: 141); it is an official and propaganda medium, generally executed for public display. Thus, we may expect to define images related to dynastic history and to official religion and cosmology; even more importantly, we may learn from these images the relationships between these two realms. Representations of mythological episodes, everyday life, or mundane matters are less likely to be found in monumental sculpture.

I share Proskouriakoff's view (1965: 470) that iconography is a language and must be dealt with as such. The only major difference between Maya epigraphy and iconography is that the former is linear, one-dimensional, while the latter is two- or sometimes even three-dimensional. If iconography is a language, we must first identify and understand the units that compose this language. Then we must analyze the syntax that rules the combination of these elements.

The structuralist approach, so successfully applied to linguistics, is a very appreciable tool in dealing with iconography. It has been observed very often that a particular motif acquires meaning not only through symbolization, but because it forms pairs of oppositions with other terms. Many of these pairs are singled out in the present study (contrasted heads of cosmic monsters, vertical cosmograms, juxtaposed elements, the right versus the left side of monuments, etc.). The scrupulous respect for symmetry in Maya art helps the analyst in discovering oppositions: two dissimilar motifs in a symmetrical position may have the same or a different meaning; in order to find out if they are variants or contrasting terms, other examples in other contexts are required for comparison. Thus, when two terms *A* and *B* appear to be interchangeable in their opposition to *C*, proximity—but not equivalence—is then postu-

Introduction

In the collective mind, Maya cities seem to be the product of feverish imaginations. Long after they had been abandoned (apparently suddenly and for unknown reasons), they were discovered immersed in luxuriant tropical vegetation where it is sometimes difficult to distinguish ruins from trees. The technological limitations of this civilization (no true architectural vault, no wheels, no metals) are surprising and contrast with its intellectual achievements: astronomical calculations, sometimes more precise than those of the most advanced cultures of the Old World at the same period, and writing that, even at first glance, reveals a high level of sophistication. Through the work of archaeologists, art historians, ethnohistorians, and scholars of many other disciplines (beginning a little more than a century ago), the Maya are becoming increasingly less "mysterious" and more real; they now appear not as aliens from another world but as human beings of flesh and blood who eat, dream, make war as well as love, create things and ideas. It is mostly through their art that we become acquainted with them, as we breathlessly climb their pyramids, enter their dark and humid buildings in trepidation, stare at their carved stelae and panels trying to make out what they represent, and look at the strange scenes painted on their pottery. Scared by the ghastly expression of their monsters, moved by the subtlety of a hand gesture delicately incised on a bone, puzzled by the meaning and function of an obsidian "eccentric" knife, or charmed by the quality of an emerald jade figurine, we never react to Maya art with indifference. The first exposure to it generally baffles us with the strangeness of the motifs, the complexity of the composition, and the difficulty of singling out its elements. Every Mayanist with teaching experience knows how difficult it is to make the audience recognize or identify the stylized serpent head or the jaguar mask that he or she delineates on the classroom's screen.

Herbert Joseph Spinden, in his *Study of Maya Art* (1913), was the first to analyze such motifs and decompose them into its constituents. He reviewed the representations and their manifestations in the different arts but showed more concern for style and stylistic evolution than for meaning. In Tatiana Proskouriakoff's *Study of Classic Maya Sculpture* (1950: 2) her "primary purpose . . . [was] to examine variations in the Classic monumental style which would furnish clues to the relative dates of the execution of individual monuments." She soon realized that "criteria based on the occurrence of certain designs or motifs could be used only to define the Classic Maya style as a whole or, at best, its two major periods. The more comprehensive and more sensitive changes were found to lie not in the selection of definable forms or motifs, but in the artist's approach to his subject." In other words, it is not the motifs that are prone to change but rather the way they are treated. Proskouriakoff did not address the question of meaning in her study; and, following her example, Mayanists have for long been reluctant to tackle the problem of content. Even modern studies such as *The Monuments and Inscriptions of Tikal: The Carved Monuments* (Jones and Satterthwaite 1982) and *The Monuments and Inscriptions of Caracol, Belize* (Beetz and Satterthwaite 1981) do not include an iconographic study together with the epigraphic analysis. There have been many iconographic analyses dealing with specific ques-

tions or themes such as deities (Schellhas 1903), animal figures (Tozzer and Allen 1910), autosacrifice (Thompson 1961; Joralemon 1974), the triadic sign (Kubler 1969; Greene Robertson 1974), the *cauac* monster (Taylor 1978), and the water complex (Rands 1955). In spite of their respective merits, too often thematic studies are not systematic in that only examples that support the proposed hypotheses are selected. Another shortcoming is that such studies use data from different regions and from different periods of Maya history; as Kubler many times voiced it, the relationship between significant and signified may change through space and time ("disjunction").

Dealing with the sculpture of a single site with a majority of dated monuments avoids these pitfalls by controlling the time and space variables. No site is better suited than Copán for such a global study. On the southern fringe of the Maya area, it is the Classic Maya site that has been the most extensively studied and therefore is the best documented in such matters as settlement patterns and occupation through time, political and dynastic history, architecture, and ceramics and artifacts. The corpus of the monumental sculpture is large, homogeneous, and relatively well preserved and documented. Its many monuments offer a variety of representations as well as texts. Here, in most cases, the ruler identified by his costume and attributes is surrounded by human, grotesque, or symbolic representations. We may thus expect that the message transmitted by the iconography will refer to the person of the king and to his relations with the cosmos. No living human except the king seems to be represented in the Copán sculpture. The Copanecs used sculpture in association with architecture not to adorn their buildings but to define their meaning and their function. Most of the excavated structures from the Main Group appear to be gigantic three-dimensional cosmograms, a conclusion not foreseen at the beginning of this study.

One of the purposes of this work is to help the nonspecialist identify the motifs that compose an image. I would also like to demonstrate that, at Copán at least, the representations themselves, and not only their stylistic treatment, may have experienced change over the years. My major concern, however, is to understand the messages expressed in the images carved on the stone monuments, since my ultimate goal is to gain information on Maya society and thought. From the beginning, we must be aware of the characteristics of monumental art, which define its domain and its scope. Monumental stone carving not only expresses a "concern for permanence" as Proskouriakoff put it (1971: 141); it is an official and propaganda medium, generally executed for public display. Thus, we may expect to define images related to dynastic history and to official religion and cosmology; even more importantly, we may learn from these images the relationships between these two realms. Representations of mythological episodes, everyday life, or mundane matters are less likely to be found in monumental sculpture.

I share Proskouriakoff's view (1965: 470) that iconography is a language and must be dealt with as such. The only major difference between Maya epigraphy and iconography is that the former is linear, one-dimensional, while the latter is two- or sometimes even three-dimensional. If iconography is a language, we must first identify and understand the units that compose this language. Then we must analyze the syntax that rules the combination of these elements.

The structuralist approach, so successfully applied to linguistics, is a very appreciable tool in dealing with iconography. It has been observed very often that a particular motif acquires meaning not only through symbolization, but because it forms pairs of oppositions with other terms. Many of these pairs are singled out in the present study (contrasted heads of cosmic monsters, vertical cosmograms, juxtaposed elements, the right versus the left side of monuments, etc.). The scrupulous respect for symmetry in Maya art helps the analyst in discovering oppositions: two dissimilar motifs in a symmetrical position may have the same or a different meaning; in order to find out if they are variants or contrasting terms, other examples in other contexts are required for comparison. Thus, when two terms *A* and *B* appear to be interchangeable in their opposition to *C*, proximity—but not equivalence—is then postu-

lated. Structural analysis is the best way to single out elements and to recognize their value within a semiotic system. Contrasting terms and variants can then be defined, and entire systems reconstructed.

PREVIOUS RESEARCH AT COPÁN

The first known description of the ruins is contained in a letter dated 1576 addressed to the Spanish king Philip II by Diego García de Palacio (1920). The stelae and other carved monuments immediately impressed this early visitor, reminding him of images of monks and bishops. In 1699 Francisco Antonio de Fuentes y Guzmán (1933), a Guatemalan historian, described the ruins. However, his description (probably based on hearsay) is vague and verbose and does not convey much additional information. In 1834 Juan Galindo (1920) inspected the site on the first official mission for the Central American government. His report is also the first illustrated description of Copán, containing a rough map, cross-sections and plans of buildings, and drawings of sculptures. He also made excavations at the site, digging a tomb chamber in the East Court of the Acropolis. In 1839 John Stephens and Frederick Catherwood spent several weeks in Copán, clearing the site, sketching a map and recording the monuments. The chapter on Copán in Stephens's two-volume travel book (1841: vol. 1, chapters 5–7) includes a map of the Main Group, a general description of the ruins, and Catherwood's superb illustrations of numerous monuments. Catherwood himself later published some views of Copán in colored lithographs (1844).

In 1885 and again in 1894 (under the aegis of the Peabody Museum), Alfred Maudslay spent several months at Copán; besides taking casts and photographs of the sculptures, he excavated Structures 4, 11, 16, 20, and 22, the last four being the most important constructions of the Main Group. His work was published as part of the *Biologia Centrali-Americana* (1889–1902). The photos are excellent; the drawings by several artists, particularly those by Anne Hunter, were executed from the casts and photos brought back to England by Maudslay. Considering the time at which they were made, their quality is outstanding; for a century they have been used as working documents by epigraphers and art historians alike. Some drawings are nearly perfect; for instance, there are almost no changes—only very minor ones—to make to the iconographic record of Stela H (CPN 16). Others, which were executed only from photos, leave more to be desired; there are errors of interpretation and doubtful reconstructions of eroded parts, such as on Stela N (CPN 26). From 1891 to 1895 the other Peabody Museum expeditions discovered nine new stelae and excavated the Hieroglyphic Stairway and several tombs south of the Acropolis.

Under the auspices of the Carnegie Institution, in 1920 Morley published *The Inscriptions at Copan*, a monumental work that includes a complete inventory of the sculptures known at the time; each epigraphic analysis is preceded by documentary data on the monument. Morley was mainly interested in the chronological information given by the texts and did not pay much attention to the noncalendrical parts of the inscription. Furthermore, the description of the images is nonexistent or reduced to a few general sentences. The poorly executed drawings are by Morley himself. The second part of the book is devoted to a chronology of the site, divided into three periods: Early (before 9.10.0.0.0 or A.D. 633), Middle (from 9.10.0.0.0 to 9.15.0.0.0 or A.D. 731), and Great (after 9.15.0.0.0). Every period is represented by some architectural activity and by a certain number of monuments characterized by their inaugural date, their morphology, and the text/image ratio.

From 1935 to 1946 (except for a two-year interruption due to the war) the Carnegie Institution carried out intensive investigation and restoration. Eighteen broken monuments were repaired and reerected in 1934, Ball Court A was thoroughly explored and restored, and the Hieroglyphic Stairway was reconstructed on the western slope of Structure 26. The Carnegie staff also excavated and in part reconstructed Structures 11 and 12 and the temple of Structure 22, previously excavated by Maudslay but not consolidated. Several reports resulting from these activities were published: Aubrey S. Trik's (1939) on Temple 22, Gustav Strömsvik's on the ball courts

(1952) and on the stela operations (1941), and John Longyear's (1952) on the ceramics are the most important ones. Others, however, were not published, such as the reports on excavation and repair of Structures 26, 11, and 12.

After cessation of the Carnegie activities at Copán, the Instituto Hondureño de Antropología e Historia (IHAH) took charge of the ruins and under its director Jesús Núñez Chinchilla undertook several salvage operations. These are poorly or not published, and his papers and fieldnotes were not accessible to scholars until recently. At the northern end of the actual airstrip Núñez Chinchilla excavated several structures near the former entrance to the Archaeological Park, which include the superbly carved bench CPN 999; he also excavated a cave deposit on the road to the hamlet of La Laguna in the southern foothills.

In 1970 two architectural students from Graz, Hasso Hohmann and Annegrete Vogrin, started a project of architectural documentation and analysis of the Main Group at Copán for their doctoral dissertations, which developed into a major architectural study of the site. It has been continued intermittently to the present (1977, 1985, 1987). They have published the results of their study of the Main Group in *Die Architektur von Copán* (1982) and several short articles. Making ample use of unpublished fieldnotes, maps, and photographs of previous expeditions, Hohmann and Vogrin supply the first description, architectural history, and functional analysis of many important structures and complexes in the Acropolis (fig. 1).

From 1975 to 1977 Gordon R. Willey directed a multi-disciplinary project in the Copán valley. While several natural scientists were reconstructing the ancient environment of the region, the archaeologists were studying the settlement patterns through site survey, mapping, and excavation.

Succeeding the Harvard University project, the Proyecto Arqueológico Copán (PAC), part of a larger project of tourist development of the Copán area, was created by the IHAH and financed by the Banco Centroamericano de Integración Económica (BCIE). I was appointed director of its first phase. Field operations began late in 1977. Fieldwork was carried out in the valley as well as in the center of the city. In the former the main objective was a settlement pattern study, utilizing three different strategies. In the Main Group we studied the archaeological history of the Great Plaza (visible and hidden structures); we excavated and restored Structures 4 and 2, as well as Ball Court B. Furthermore, we explored and consolidated the east side of the Acropolis (cut by the Copán River) and excavated and restored Structure 18, the first royal funerary temple ever found at the site. The PAC's first phase lasted until 1980 and was reported in a three volume publication (Baudez 1983).

Immediately following the first phase, a second phase, directed by William T. Sanders, was inaugurated, lasting from 1980 to 1985. Nominally it retained some of the staff from the first phase, including René Viel in the Ceramic Laboratory, William Fash and Charles Cheek as field archaeologists, Berthold Riese as epigrapher, and myself for the iconography of the sculpture. Several structures in the 9N grid unit (a zone known as Las Sepulturas, 600 m east of the Main Group) were excavated. Among them the very important Structure 9N-82 with its splendidly carved hieroglyphic bench (Webster 1989). The valley survey was extended east and northeast (covering an area of 135 sq km) and many students pursued their own small-scale projects for their doctoral dissertations.

In 1985 the Copán Mosaic Project was established, directed by William Fash. In his own words (1991: 62), the goals of the project were "to conserve, document, re-articulate, analyze, reconstruct, and interpret the tens of thousands of fragments of tenoned mosaic façade sculptures which originally adorned dozens of Late Classic masonry structures in the Copán valley." To date, work has been completed or is in progress on Structures 10L-9, 10, 11, 16, 21A, 22, and 26. Another objective of this project was to continue the study of Copán inscriptions by Linda Schele, David Stuart, and Nikolai Grube, to name only the principal epigraphers. The Mosaic Project has recently been incorporated in the Honduras government-sponsored Copán Acropolis Archaeological Project, headed by W. Fash.

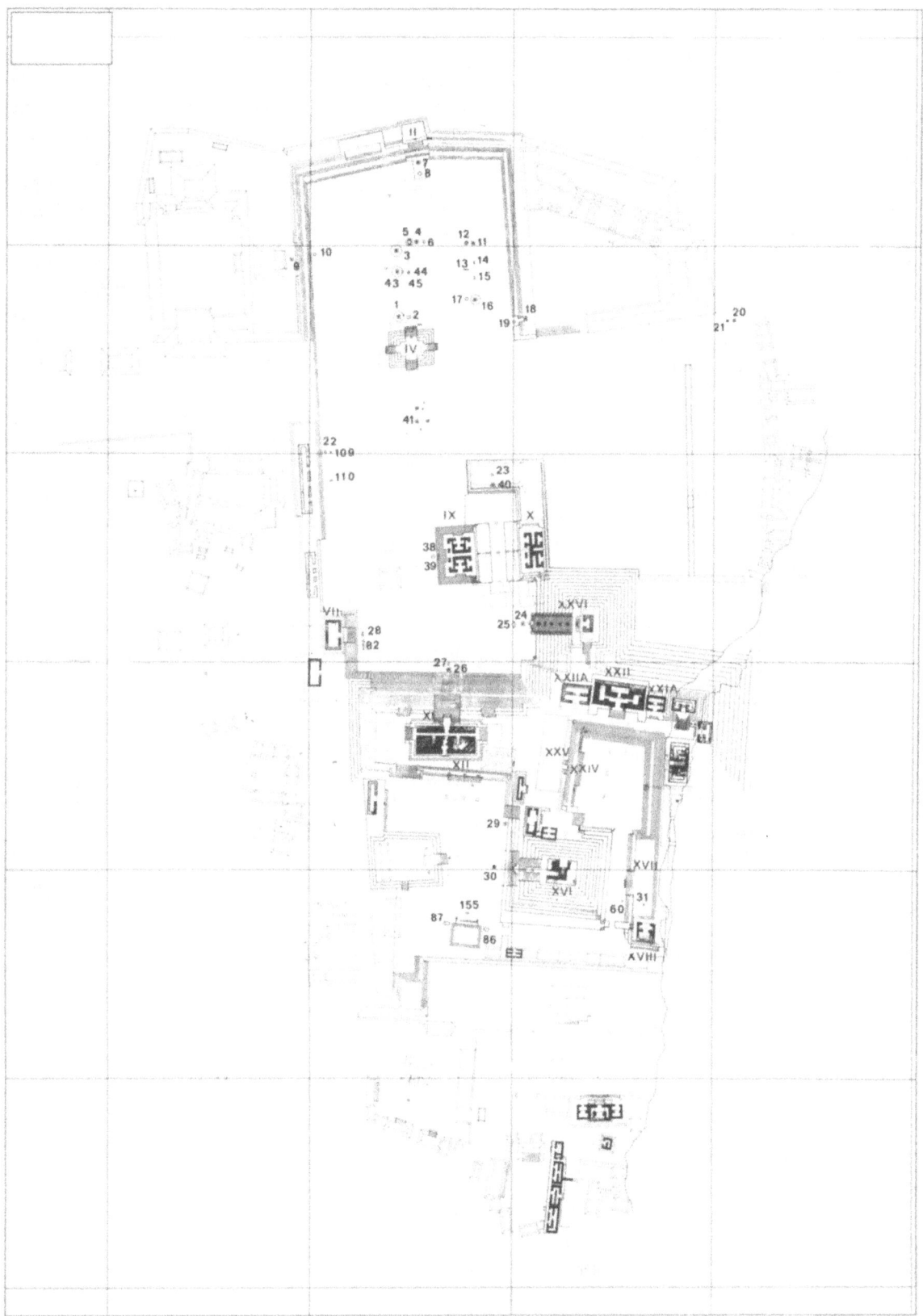

FIG. 1. Map of the Main Group at Copán. Freestanding sculptures are indicated with Arabic numbers, structures mentioned in the text with Roman numbers. After H. Hohmann and A. Vogrin, from *Die Architektur von Copán (Honduras)*. Copyright © 1982 by Akademische Druck- und Verlagsanstalt.

THE HISTORY OF COPÁN: A SUMMARY

The earliest settlement in the Copán valley is represented by a house floor excavated in the PN-8 Group and dated to the Rayo Phase (1300–900 B.C.). In the same area several Middle Preclassic platforms (Uir, 900–400 B.C.) with subfloor burials were investigated. The pottery (belonging to the Gordon funerary sub-complex) is similar to the vases found by Gordon (1898) in caves in the Sesesmil valley, a few kilometers from the Main Group. The incised ceramics and the jade offerings are Olmec in style.

Very little evidence of Late Preclassic occupation has been found in the Copán valley; this situation is accounted for either by a regional demographic reduction or by a more nucleated settlement that is yet to be found or has been swept by the changing courses of the river. In Early Classic times (Bijac Phase, beginning ca. A.D. 100), there was a resumption of human activity in the valley, evidenced through burials in the 9N-8 Group containing tetrapod bowls decorated with the Usulután technique and others with incipient polychrome painting. Several buildings (including a ball court) dated to the fourth century or before were erected in the Main Group. The "archaic" sculptures (CPN 46 and 51) coeval with this architectural activity reveal strong influences from the Guatemalan Highlands and Pacific Coast. With the beginning of the Acbi Phase (A.D. 400–700, Middle Classic), the culture of this growing and expanding population (estimated between 8,000 and 12,000 at the end of this period by Fash 1991) was fully Mayan. It is precisely at this time that the Copán dynasty was founded.

Among the dynastic sequences proposed for Copán, the most recent have been presented independently by Riese (1988a) and Schele (1988). Both are summarized here (see chart 1), giving the dates of accession in the Long Count and in the Julian calendar. The reader will notice that, except for the rulers' designations, there are few major discrepancies between the two sequences. Concerning the founder, Riese has still some hesitations in accepting Yax K'uk' Mo'o, since there is an accession record of this name associated with a 9.13.10.0.0 date, before the reign of Eighteen-Rabbit. Riese seems to favor the hypothesis that Yax K'uk' Mo'o is a title rather than a name. In his sequence the founder would be Decorated Ahau, mentioned with early dates on the Peccary Skull and CPN 18; but Schele thinks that this character is a ruler associated with the date 8.6.0.0.0 who precedes Yax K'uk' Mo'o. There is also a difference of fifteen years between the two sequences for the accession date of Eighteen-Rabbit. The major discrepancy, however, concerns the end of the dynasty and the possible accession of a new ruler succeeding the sixteenth. Grube and Schele (1987) consider that he is the figure seated on a glyph block (which they read U-Cit-Tok) facing Rising Sun on Altar L (CPN 23); they interpret his accession date of 3 Chicchan 3 Uo as referring to 9.19.11.14.5 in the Long Count. Riese, while admitting this possibility, proposes as an alternative that the name of the figure refers to the second ruler (called Tok) of the dynasty, who, on CPN 30, is seated behind Yax K'uk' Mo'o; in this event, the Long Count date for the accession has to be placed back in the fifth century (between 8.16.9.8.5 and 8.18.10.0.5), and Rising Sun's death not long after A.D. 800, the dedication date of Structure 10L-18. In both sequences the first reigns of the dynasty are still poorly documented; we have very few reliable dates, names, or events for these early years. Recent epigraphic studies have demonstrated that the control of Quiriguá by Copán may have begun as early as the reign of the third ruler. We have more information on the sequence from the tenth reign on. Linda Schele (1987b) claims that CPN 9 (Stela E) with a dedicatory date of 9.5.0.0.0 is the first dated iconic stela at Copán and its protagonist would be the seventh ruler. Riese considers the earliest iconic and dated stela to be Stela 7 (CPN 54), representing the eleventh ruler and dedicated on 9.9.0.0.0. If this king built Structure Rosalila, recently discovered under Structure 10L-16, whose façade is decorated with what seems to me to be a large bird (fig. 52 in Fash 1991), I think that there was already at the time a temple dedicated to Yax K'uk' Mo'o, the founder of the dynasty.

			U-Cit-Tok	
				9.19.11.14.5(822)
9.18.10.0.0(800)				
	XVI	Rising-Sun	XVI Yax Pac	
9.16.12.5.17(763)	XV	Smoking-Squirrel	XV Smoke-Shell	9.16.12.5.17(763)
9.15.17.13.10(749)	XIV	Three-Death	XIV Smoke-Monkey	9.15.17.13.10(749)
9.15.6.16.5(738)				9.15.6.16.5(738)
	XIII	Eighteen-Rabbit	XIII Eighteen-Rabbit	
9.13.18.17.9(710)	?	Yax K'uk' Mo'o		
9.13.10.0.0(702)				9.13.3.6.8(695)
	XII	Smoke-Jaguar Imix-Monster	XII Smoke-Imix God K	
9.9.14.17.5(628)				9.9.14.17.5(628)
	XI	Smoking-Heavens	XI Butz' Chan	
9.7.5.0.8(578)	X	Cleft-Moon Leaf-Jaguar	X Moon-Jaguar	9.7.5.0.8(578)
9.5.19.3.0(553)				9.5.19.3.0(553)
	IX	?	IX ?	9.5.17.13.7(551)
	VIII	Head-on-Earth	VIII ?	
	VII	Jaguar Sun God	VII Water Lily Jaguar	
	VI	?	VI ?	
	V	?	V ?	
	IV	?	IV ?	
	III	?	III ?	
	II	Tok	II ?	
	I	Decorated Ahau or Yax K'uk' Mo'o	I Yax K'uk' Mo'o	bef. 8.19.10.0.0(426)

CHART 1 The Copán Dynastic Sequence According to Riese (in Baudez and Riese 1990) to the left and Schele (1988) to the right.

Many monuments are known dating from the reign of the twelfth king. His accession monument is CPN 47 (Stela 5), a double-figure stela illustrating his succession to the eleventh ruler. On 9.11.0.0.0 he erected in the valley six aniconic stelae to delimit the political or spiritual Copán estate. The same date is carved with his name on Quiriguá Altar L, possibly to assert his patronage of the Motagua valley site. According to their texts, CPN 38 and 52 (Stelae 1 and 6) are Smoke Imix monuments; however, they are so completely different in style and iconography from the other stelae of the same period that I proposed (Baudez 1986) that they both represented a usurper. Although no other arguments can be advocated to strengthen this hypothesis, I still believe these stelae to be

problematic. According to its iconography, CPN 18 (Stela I) shows a dead ruler and seems to be the last and possibly posthumous monument of Smoke Imix.

The thirteenth ruler, Eighteen-Rabbit, was one of the greatest kings of Copán and was considered such by his successors, according to the frequent references to his name found after his death. His accession date has not yet been firmly established and the climax of his reign appears to have been the celebration of the end of the 15th katun with the erection of CPN 1, 3, 16, and 43. On CPN 1 the Copán emblem glyph proudly appears with the emblem of the three other capitals that form the Maya realm: Tikal, Palenque, and El Perú(?). The stelae of his reign are carved in the high relief characteristic of the late Copán monuments, first used on CPN 38 and 52. Eighteen-Rabbit revived the dynastic cult, demonstrating respect for his predecessors by preserving their stelae, instead of breaking them into pieces and reusing them in building fills. He had CPN 47 reerected at the same time as his stela CPN 43 and he opened up a niche in the stairs flanking the northeastern side of the Great Plaza, to have CPN 18 and 19 standing in their original place; finally, he is probably the one responsible for the reerection of CPN 9, 40, and 29. The thirteenth king remodeled the Great Plaza with stairs on three sides and built the final state of Structures 10L-2 and 4 and Ball Court AII-b, whose central marker bears his name and effigy. Disputing Cheek's conclusions based on stratigraphic excavations (1983c), Schele, Stuart, and Grube (1989) place the dedication of Ball Court AIII during the reign of Eighteen-Rabbit. Stuart (1989) also credits the latter with the construction of Structure 22, whose text begins with a clause stating that on 5 Lamat a katun was completed; Stuart thinks it is the date 9.14.3.6.8 5 Lamat 1 Zip, which falls one katun after the day of the accession of Eighteen-Rabbit, 9.13.3.6.8 7 Lamat 1 Mol. Even in assuming that the latter really dates the king's accession (and this is not admitted by Riese, who prefers 9.13.18.17.9), Stuart's interpretation of the inscription is no more than a possibility that has to be reinforced by other data. The recent attribution of Structure 22 to Eighteen-Rabbit has led some authors to attribute to him buildings formerly dated to the reign of Rising-Sun: "It is also possible to conclude on the basis of style and depth of relief that he [Eighteen-Rabbit] also built Str. 20 and 21" (Fash 1991: 194). I do not think that "style and depth of relief" are sufficient criteria to bring about such changes in the architectural sequence. David Kelley (1962) demonstrated that the thirteenth ruler of Copán was captured, and presumably put to death, by Cauac-Sky of Quiriguá on 9.15.6.14.6. This event is frequently recorded at Quiriguá and at least once at Copán.

Stuart (quoted in Schele, Stuart, and Grube 1991) attributes the building of Structure 22A to the short reign of the fourteenth ruler because of the presence of a 9 Ahau glyph, found in the debris at the foot of the ruined structure. 9 Ahau is interpreted as a reference to a katun ending and the best "fit" of 9.15.15.0.0 9 Ahau 18 Xul is given. In my opinion, this is no more than mere supposition. I wonder why this same line of reasoning is not, for instance, applied to Structure 18, which displays at its corners a 6 Ahau glyph. CPN 26 (Stela N) is a double-figure stela that commemorates the accessions of the fourteenth and fifteenth rulers (Schele and Grube 1988).

The construction of the Hieroglyphic Stairway is firmly attributed to the fifteenth ruler, who is also depicted on CPN 24, the stela at the foot of the stairs. The longest-known Maya inscription carved on the steps covered at least two centuries of Copán history and recorded important events in the life of the successive rulers. Epigraphers are working hard to reconstruct the original order of the hieroglyphic blocks.

Rising Sun, the sixteenth and the last ruler of the dynasty, commemorated the succession of Eighteen-Rabbit to Smoke Imix with the erection of CPN 4 (Stela C), a double-figure stela carved in a flamboyant and very late style. New motifs and stylistic innovations (such as the Chenes-like *cauac* masks piled up at the corners of Structure 22 and the feathered serpent) reached the Copán region at this time, probably from the Northern Lowlands. Except for CPN 4, Rising-Sun did not erect stelae but conducted tremendous architectural activity on the Acropolis. He built Structure 11 as a cosmogram accompanied with a long continuous inscription carved on its four doors. Structure 12, for-

merly called "The Reviewing Stand," was added to the south of Structure 11 and was used as a stage for fertility rituals. I continue to think that Rising-Sun was the one who built Structure 22, whose inner door's frame reproduces the cosmic program of Structure 11 and its two annexes Structures 22A and 21. The last stage of Structure 16 was dedicated to the founder of the dynasty, and CPN 30 (Altar Q), at the foot of the stairway, displayed a summary of the dynastic sequence with Rising-Sun receiving the scepter from the founder, followed by the fourteen rulers who succeeded him. Rising-Sun ended his architectural program on the Acropolis with the construction of Structure 18, which included his future tomb. The funerary temple, inaugurated on 9.18.5.0.0, was materially and spiritually connected to the founder's pyramid by a raised passageway or viaduct. Dating from Rising-Sun's reign are monuments and buildings whose protagonists are high officials or relatives (half-brothers) of the king. These are found in the village zone (CPN 33 and 34), in the 9N-8 Group (Structures 9N-82 and 9M-146), and even in the Main Group (CPN 13).

After the death of Rising-Sun, illustrated and narrated on CPN 60 ("Stela" 11), a carved column fallen from the top of Structure 18, another ruler may have tried to found a new dynasty calling on the spirit of Rising-Sun (Grube and Schele 1987). In any event, his efforts were short-lived and his accession monument (CPN 23) remained unfinished. Even if the population lingered in the valley for a century or two, as some scholars claim, no more stone monuments were carved or temples built at Copán.

THE COPÁN SCULPTURE: PREVIOUS ICONOGRAPHIC STUDIES

It is not my purpose to cite the thematic studies that have utilized examples from the Copán corpus. The latter is so rich that almost all analyses on Maya art have borrowed from its images. In his pioneering work, Spinden (1913) presented the stylistic sequence of the sculpture at Copán. He noticed that through time the relief increased markedly; the ceremonial bar became abstract and rigid; the head of the main figure acquired greater importance relative to the body; the angle formed by the feet became smaller; the forearms, at first in a vertical position, became horizontal; the legs lengthened, the bust shortened and the face became more realistic; and so forth.

The periodization (Early Classic, Formative, Ornate, Dynamic) presented by Proskouriakoff in her 1950 study was remarkably well suited to the history of monumental art at Copán. Besides being a major contribution to Maya art as a whole, Proskouriakoff's book taught us much about the evolution of Copán sculpture. She was the first to predict the existence of monuments like CPN 188 (Stela 35) in these terms: "It seems likely however that stelae sculptured with human figures were erected in this region in the Early period and have since been destroyed. If so, they probably resembled the carving of the Leyden plaque and Tikal's Stelae 1 and 2, for the later Copán monuments show many traits in common with these figures, and one may guess that some variant of this style took root in the southeast and became the foundation of the Copán schools before the Early Cycle 9 group at Tikal was erected" (1950: 109). She rightly insisted on the radical change brought about in the stylistic evolution of Copán by CPN 38 (Stela 1). This monument is in fact the product of 'a different conception of spatial construction in which there are planes oblique to the front of the monument (formerly all planes were perpendicular to it). She also showed that Spinden's observations were not to be taken literally but rather expressed general trends; for instance, CPN 43 and CPN 11, which have the thickest relief, are not the latest monuments; they are coeval with or earlier than other stelae of lower relief. She also commented on a major characteristic of Copán sculpture: the blending of modernism and archaism: Early Classic Tikal Stela 1 has the same construction as a Copán stela from the Ornate Phase: the standing main figure, faces the observer; a serpent with one or two heads frames the main figure while small, grotesque figures clutch the serpent's body. Finally, Proskouriakoff has shown that during the Ornate Phase at Copán the iconographic message was more and more used to complement and sometimes replace the epigraphic message. This growing importance of

images is evident in the use of full-figure glyphs.

Proskouriakoff, studying both texts and images, later noted (1960) that on several series of Piedras Negras stelae the first monument showed a person seated in a niche accessed by a ladder. She came to the conclusion that the figure was a ruler who had acceded to power and that each series of stelae corresponded to the monuments of a separate reign. She was also able to identify the glyphs for accession and birth and interpreted those naming the ruler. She extended her method to the inscriptions at Yaxchilán (1963–64) and deciphered many events occurring in four reigns. Kelley (1962), using the same approach, was the first to recognize the names of rulers from Quiriguá and Copán and proposed hypotheses on the historical relationships of the two cities. It was then plainly demonstrated that the principal subject matter of the inscriptions on monumental sculpture and architecture was dynastic history and that the main figure on the monuments was that of the reigning king. In the past twenty years epigraphic studies have made considerable progress thanks to the participation of linguists in the decipherment process. It has become increasingly obvious that, following Y. Knorosov's (1952) hypothesis, many if not most of the Maya glyphs are phonograms. The dynastic history of major sites, such as Tikal, Palenque, Caracol, Bonampak, and Yaxchilán, has been unraveled; the syntax of Maya languages is now recognized in the hieroglyphic texts; readings have been proposed for names and titles, and parentage statements deciphered. At the same time, it was discovered that an image could sometimes throw light on the accompanying text: Proskouriakoff had shown the way when explaining the text of Yaxchilán Lintel 8 with the capture scene that illustrated it. In the 1970s and 1980s many valuable contributions to epigraphy and/or iconography were presented at the several Mesas Redondas de Palenque. Although few of them directly deal with Copán, many general interpretations of Maya motifs or scenes also concern the iconography of the site. I will refer to them in the course of this study. An attempt at a synthesis of the results obtained by the most active scholars in this field may be found in Schele and Miller (1986).

The Copán Notes, published jointly since June 1985 by the IHAH and the Copán Mosaic Project, are defined as "a running series of commentaries and small reports deriving from the multiplidiscinary research project designed to record and analyze the monolithic and architectural sculpture of Copán." Their most frequent authors are Linda Schele, Nikolai Grube, and David Stuart.

THE PROYECTO ARQUEÓLOGICO COPÁN SCULPTURE PROGRAM: CONSERVATION AND RECORDING

A first concern of the PAC was to preserve the monumental sculpture. The project entrusted Mason Hale, a Smithsonian Institution expert, to deal with the problem of the microflora that grew on the monuments; besides obscuring the designs, lichens and mosses are active in destroying the stones. The simple, efficient, and apparently harmless treatment tested and used by Hale at Quiriguá was successfully applied during the entire span of the first phase, but abandoned later, for reasons unknown. As a necessary follow-up program, consolidation and protection of the sculptures was envisioned. For this purpose Riese persuaded Josef Riederer of the Rathgen Laboratory of the Staatliche Museen Berlin to make a study and propose techniques of consolidating and protecting Copán sculptures. His proposals have been reported in several short articles.

A major aspect of the PAC was the documentation of sculpture. As a basic and first step, an inventory of the sculpture was started by Marie-France Fauvet-Berthelot in the 1977–78 season, and later continued by Riese, his wife Frauke Riese, other PAC staff members, and myself. The previous monument designations, developed by Maudslay, expanded by Morley, and using letters as well as numbers (the latter completed with prime and second coefficients), were difficult to handle; furthermore, new monuments had come to light after Morley's publication, and more were expected to be found. It was decided, therefore, that all sculptures catalogued would receive a current Arabic number from 1 forward, preceded by the abbreviation CPN for Copán, following Ian Graham's proposal for treating Maya sculpture in general (Graham

1975). All previously designated sculptures were included. Concordances are given here in the table of contents. I am aware that this new system, which some scholars continue to ignore, is disturbing old habits; but it avoids absurd and misleading designations such as Altar G2, Stela 1 and Stela I, East Altar of Stela 5, Altar W', and Stela (not a stela) 11.

The most important task of the visual documentation of Copán sculpture was a photographic record with Jean-Pierre Courau as the principal photographer. In 1978 we initiated the second part of the sculpture recording program, with exact line drawings. This seemed necessary since many monuments—such as CPN 4 and CPN 47—had never before been drawn and the drawings of others were not accurate. The following procedures for drafting were followed by all PAC artists. The sculptures were traced in pencil from photographs blown up to the scale of 1:5 to ensure maximum accuracy. Some extremely small pieces were drawn from 1:2 photographic prints and some very large sculptures from 1:10 prints. The artist then filled in the details at the original sculpture and at the same time checked his preliminary tracings. A third stage involved the epigrapher (Riese and assistants) or the iconographer (myself) checking and correcting these pencil drawings, comparing them once more to the original sculpture. The fourth stage consisted of inking the pencil drawings (with technical pens of standard line widths between 0.2 and 0.7 mm), incorporating all corrections proposed by the epigrapher and iconographer, as far as acceptable to the artist, who often cross-checked again with the original sculpture. A fifth step was sometimes added for sculptures that had deteriorated since their first photographic recording; in some instances, details from old photographs were added to the drawing. These, however, were stippled to indicate their less certain and reliable source. A final sixth stage consisted of ultimate corrections done on the finished inked drawings by the epigrapher and iconographer, when the drawings were revised for printing. These ultimate corrections were not checked using the original sculptures but based on field notes and the copious photographic record assembled over the years. Drawings were executed by staff artists Barbara W. Fash, Anne S. Dowd, Anke Blanck, Stanley Matta, Gustavo Valenzuela, and others, especially Riese and Elisabeth Wagner.

Early in the PAC first phase Riese and I decided to write a joint monograph on the sculpture of Copán; Riese was to take responsibility for the epigraphic study and I was in charge of the iconographic analysis. The purpose of studying texts and images together rested on the assumption that both media were closely related and that understanding the content of the inscriptions would throw light on the meaning of the images and vice versa. For several years we worked closely together, exchanging information, discussing interpretations, and selecting illustrations; most of our joint work was done through correspondence, but we also had several meetings in Berlin and in Paris in order to reconcile differences and create a homogeneous manuscript. When completed in 1988, it had become a monster of nearly 1,700 pages and no publisher wanted it as such. Riese found it difficult to suppress chapters or even paragraphs of his important contribution and decided to leave it as it was. The only solution then left to us was to publish our respective parts separately. At that point Riese generously allowed me to use his readings freely; I decided to borrow from my former coauthor only those data that concern the respective chronological position of the monuments and those that have a direct bearing on the meaning of the images. I have also taken into account the work of Grube, Schele, Stuart, and other epigraphers who have worked for the last ten years at Copán and published in the Copán Notes. When their dating of a monument is different from Riese's, both readings are given; as far as possible, however, I have avoided personally entering the debate and I refer readers to both sources, to decide for themselves which one they prefer.

METHODOLOGY

I began my analysis with descriptions of individual monuments: the first step was to identify motifs, the second to determine their meaning, the third to discover the meaning of complexes of motifs or of the whole monument. Progress was achieved through comparisons and feedback from individual de-

scriptions and interpretations. To understand a motif or a complex, a hypothesis was formulated then tested in the analysis of other monuments. When a high degree of consistency among the descriptions and interpretations had been reached, a lexicon could be built up. It included items of clothing, jewels, power attributes, cosmological images, grotesque figures, anthropomorphs, and so forth. A file was made for every variety in each category in which all the variety's occurrences were noted, indicating for each its context and associations. A tentative typology was then drawn up; after studying the files, changes were introduced: some varieties were broken down; others—which did not seem significant—were lumped together. The last step was to create larger semantic units that encompassed related varieties, such as sacrifice, earth, or ancestors. Once all the units and the relationships between units had been defined, it was possible to describe in large thematic sections what the Copán monuments were saying.

ORGANIZATION OF THE PRESENT STUDY

This book is divided into two major parts: analysis and synthesis. In the former I have treated the freestanding monuments separately from architectural sculpture. I have dealt only with sculptures presenting images, excluding most fragments, very deteriorated sculptures, and the entire corpus of incensarios.

In the table of contents, as well as in the text, the freestanding monuments are ordered according to their CPN number, but with their previous designations; thus, readers will have no problem in finding specific monuments. For additional help I have included the traditional nomenclature in parentheses following the CPN number in the heading of each sculpture monograph.

Architectural sculpture is presented together with the building or structure that supports it. Sculpture and architecture are indeed inseparable. In the Main Group the order of presentation follows the numbering of structures. I have adopted Hohmann and Vogrin's (1982) version of the traditional nomenclature for the Main Group and the PAC nomenclature for the Valley Groups, which identifies the quadrant in a grid covering the entire Copán valley. All structures of the Main Group are in grid unit 10L. When a building is located in that grid unit, the 10L designation is not expressed. For buildings in other units the proper grid identification is given. No effort has been made to use CPN numbers for architectural complexes and their sculptural elements. Architectural sculptures without provenience (such as CPN 13, 14, 15, and 28) are presented with the freestanding monuments. Conversely, CPN 489, a bench support, is presented together with other Copán benches at the end of the chapter on architectural sculpture.

In describing sculptures, I have tried to adhere to the same format and to follow the same conventions. All references to glyphs follow Thompson's *Catalog of Maya Hieroglyphs* (1962). Since all sculptures are manufactured from the local green tufa, this information is not repeated in the individual descriptions. When motifs are symmetrically distributed on both sides of a central figure, "left" and "right" refer respectively to the left and the right of the main figure, not of the reader or observer, unless explicitly stated otherwise.

The second part of the book contains chapters that sum up the results obtained through the analysis of the monuments. Iconographic analyses have been used with two different approaches: synchronic and diachronic. In the latter, units of the lexicon were plotted on the chronological scale (thanks to the reliable sequence of dated monuments) to study their distribution through time. I realized that many representations, and not only their stylistic attributes, had a limited distribution and could be used to define periods in the history of Copán monumental art. While it is true that Maya civilization as a whole used the same images and symbols from beginning to end, at the site level we observe differential use of icons through time that may reflect changes in the political or religious domains. Stylistic changes apparently corresponded to these semantic variations.

The synchronic approach used in my conclusions consists in presenting a picture of the rites and the beliefs related to kingship and cosmology. This picture is mostly based on eighth-century data, although there is no

reason to believe that Maya thought was much different in the preceding centuries. But it would be hazardous to extrapolate and treat the information from Copán as equally valid for the whole Maya area. Regional and local differences probably expressed meaningful variations in Maya politics and religion. Such a hypothesis will have to be tested through detailed analyses and comparisons of other Classic sites; then the relative place of Copán in Maya thought can be evaluated.

PART I ANALYSIS

CHAPTER I

Freestanding Monuments

CPN 1 (STELA A)
(figs. 3–4)

CPN 1 is carved from a prismatic four-sided shaft and its base is secured by a rectangular cribbing frame. The east side is sculpted in deep relief with a frontal human figure who also occupies half of the adjoining text-bearing sides. The back of the monument is entirely covered with glyphs.

DIMENSIONS
Height (maximum) 355 cm; depth (north-south) 87 cm; width (east-west) 78 cm; depth of relief on the east side 52 cm. The frame is 179 cm long (north-south), 172 cm wide, and 39 cm thick.

DISCOVERY, LOCATION, AND ASSOCIATIONS
In 1839 Stephens found CPN 1 standing in its original location, where it remains today, close to the north side of Structure 4 on the Main Plaza (fig. 2). However, it is the altar (CPN 2) rather than the stela itself that is placed on the central axis of this building. The erection of CPN 1 probably was coeval with the building of Structure 4–2nd (Cheek and Milla Villeda 1983). A circular platform, 3 m in diameter and approximately 30 cm high, was built to surround the stela. It destroyed the plaza floor, close to the edge of the basal platform, which extends from the base of Structure 4. The stela and its platform are directly related to the pyramid's last floor. Strömsvik excavated the cruciform masonry chamber beneath the stela. It contained a ceramic disk reworked in a Copador Polychrome sherd, another pottery fragment, and two stone flakes (Strömsvik 1941: fig. 10e). A much broken altar of cylindrical shape (CPN 2) is associated with CPN 1.

DEDICATORY DATE
9.15.0.3.0 12 Ahau 13 Mac (Baudez and Riese 1990).

COMPOSITION
The overall composition is symmetrical with respect to the vertical axis. The central figure is positioned frontally with feet pointing outward. A skull flanked by two serpents held by squatting figures is above the main figure's headdress. The remaining space is occupied by featherwork, which may have been attached to the headdress. The figure's legs are flanked by staffs with a serpent head at the end.

THE MAIN FIGURE
The youthful head of Eighteen-Rabbit wears a cylindrical headdress with three vertical braids connected by ribbons. A serpent head without lower jaw and with large skeletal terminal fangs is above and below the outer braids. Above the forehead the hair is brushed back, while on the sides it falls in long strands behind the ears. The figure wears large oval earflares of simple design, a collar of round beads, and a checkered pectoral or cape. He holds a serpent bar decorated with a mat pattern that ends in two flamboyant serpent heads with skeletal jaws and large terminal fangs.

The emerging creature to the right of the ruler has an elongated skull with a circular notch on the edge and a double wavy line with dots in the middle. The skull of the creature to the left ends in a hook (that may represent an antler) stamped with two concentric circles in a cartouche (T635). The wristlets and anklets incorporate the mask of the head form of the lancet used in self-sacrifice: a serpent head with three knotted bands as a headdress. This motif is inverted on the two ribbons hanging from the belt; they have

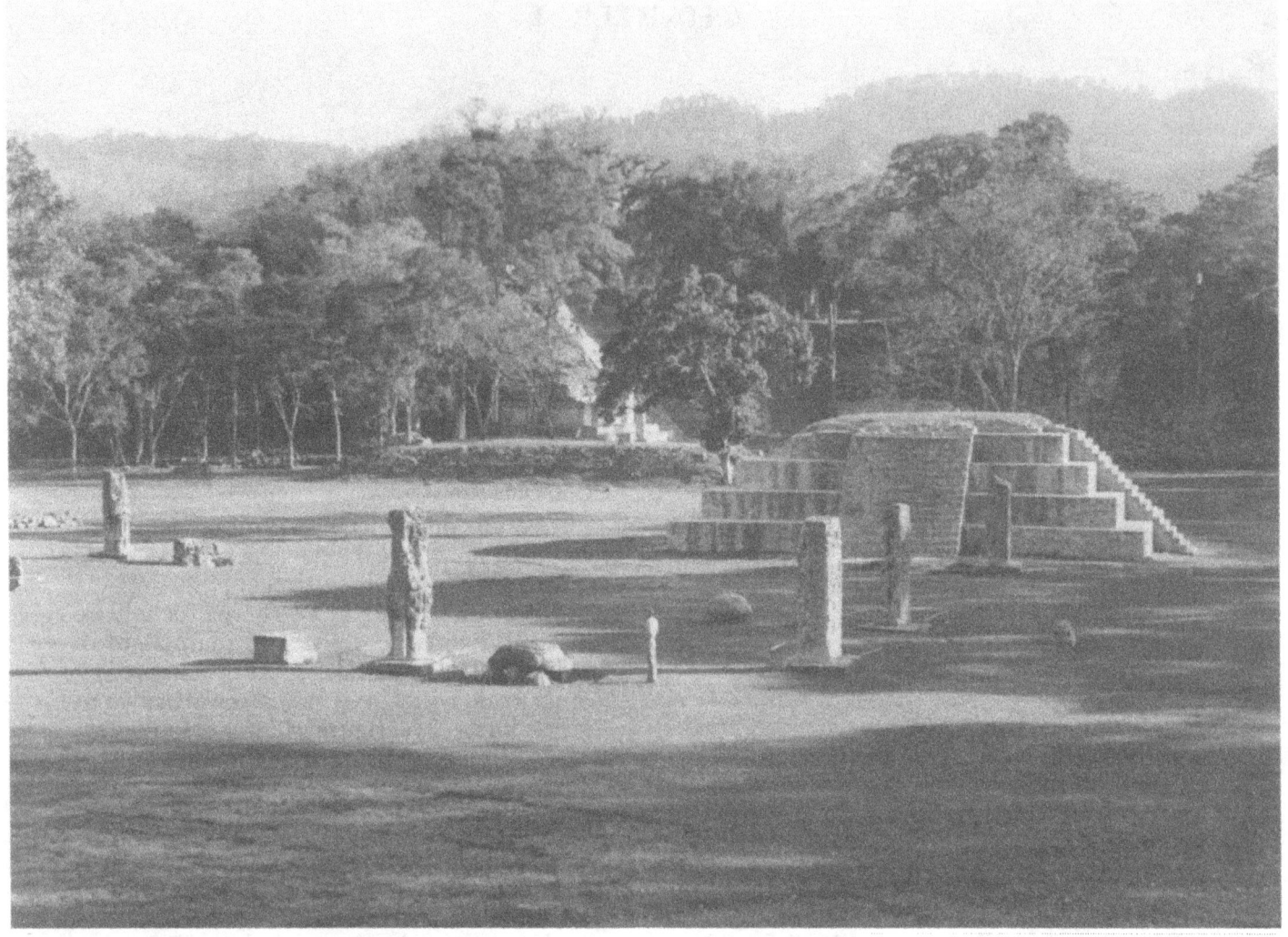

FIG. 2 The Main Plaza looking south; CPN 4 and CPN 3 in foreground. Photo by J.-P. Courau.

darkened, cross-hatched ends. The belt, a celestial band divided into panels, supports three masks of youthful heads. A knot (T60) crowns them, while a mat flanked by vegetal elements is under the chin. From the belt hang blackened *Oliva* shells, and from the masks hang three oval tinklers inscribed with T616b. The loincloth is carved on a prismatic column and is decorated with two rings flanked by lines; it ends with an elaborate form of T58. Two serpent upper jaws frame the loincloth, and ornate bird masks are tied with several rows of beads around the knees.

Surrounding the Main Figure: A human skull crowned with foliage tops the central figure. The skull has blackened eyes, earplugs, and U-shaped markings on the forehead that indicate bone. On both sides of the royal headdress an individual holds a skeletal serpent; because these figures have been beheaded by vandals, one must refer to Maudslay's illustrations (1889–1902: vol. 1, pl. 25,26), which show them. They had solar features: filed incisors, wrinkles around the mouth, squint eyes, and the *kin* sign on the forehead. The figure to the right of the ruler wore a headdress similar to the one near the king's right foot and a simple medallion on the chest. The figure to the left wears a hanklike pectoral like those worn by actors of underworld scenes (Robicsek and Hales 1981: vessel 27). Two staffs flank the central figure: they are composed of rhomboids separated by groups of three knotted bands. A round beaded shield bearing three circles (T524) partly covers the

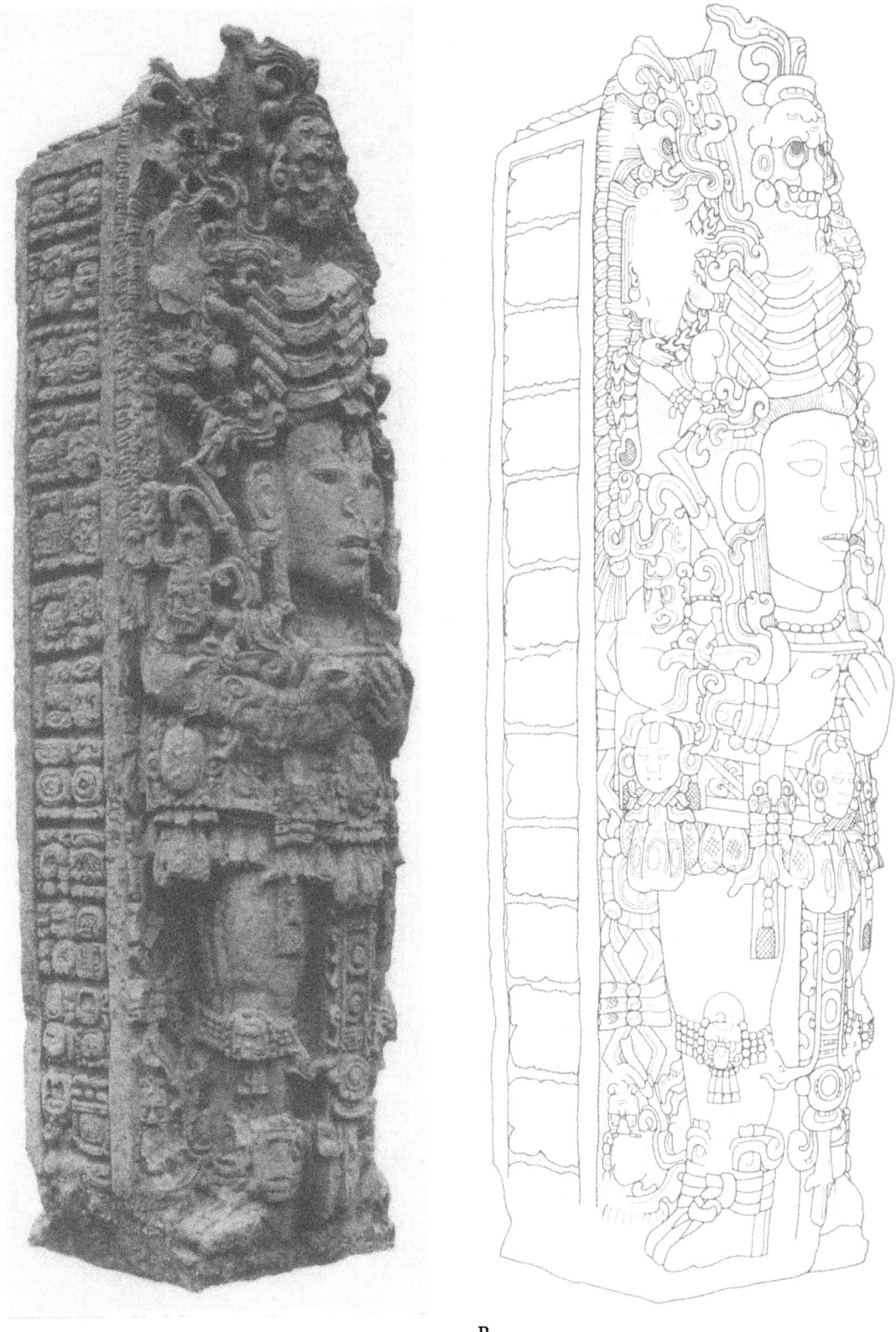

A B

FIG. 3 CPN 1: southeast. Photo by J.-P. Courau; drawing by A. Dowd.

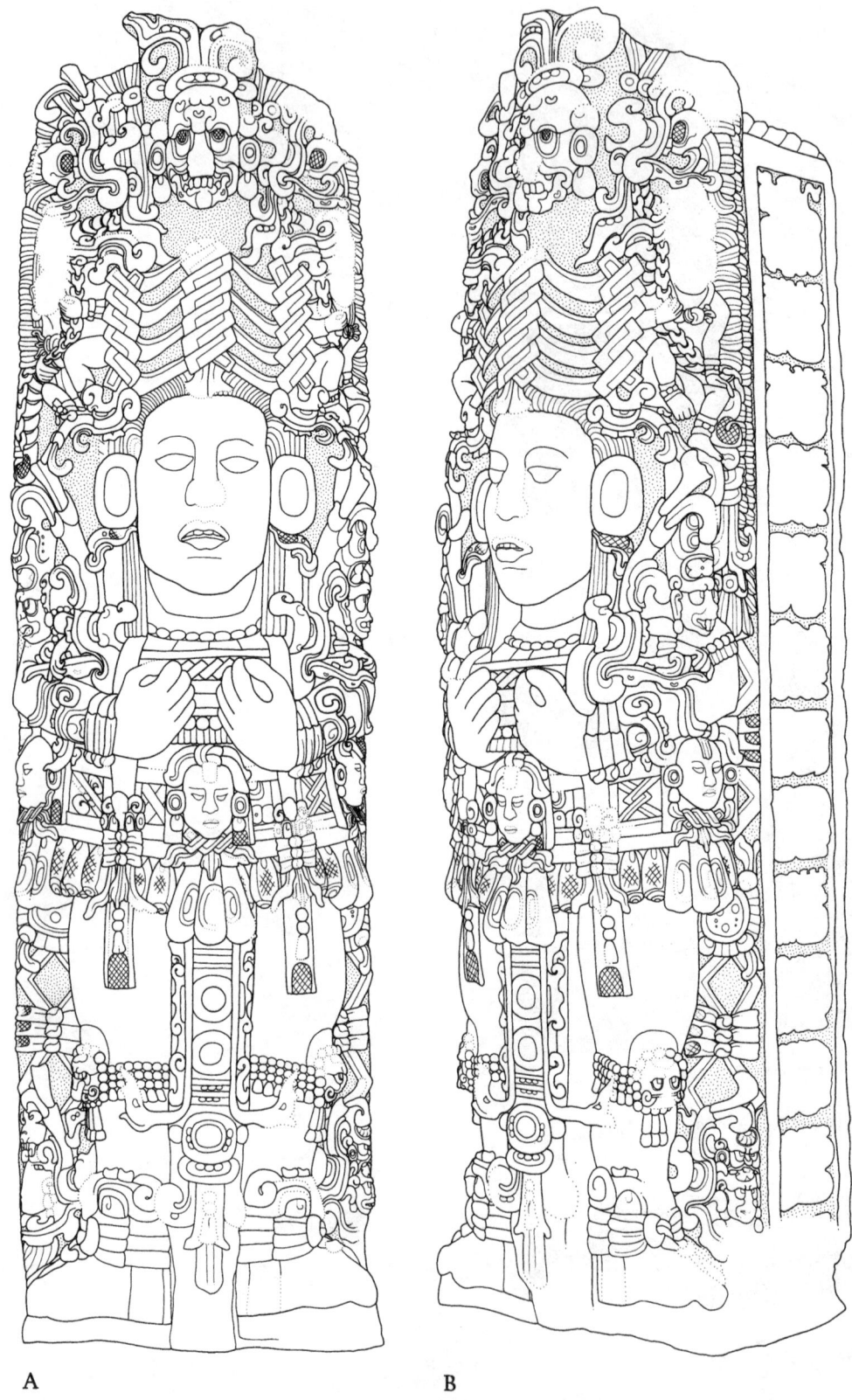

FIG. 4 CPN 1. (a) east; (b) northeast. Drawings by A. Dowd.

staff. A serpent with open mouth ends the staff at the foot of the central figure. The emerging head on the left wears a *kin* sign on the forehead and a helmet stamped with an *imix*. The right-hand creature wears a foliage-crowned skull as a helmet.

Interpretation: The headdress of the main figure expresses rulership on two accounts: first, because of the mat motif, a well-known symbol of rulership among the Maya; second, because the serpent heads at the ends of the braids make up serpent bars, another symbol of supreme rulership. A similar headdress is worn by ancestor figures on the east side of CPN 47. Note that the body of the serpent bar held by the king is also decorated with the mat pattern.

Two major themes are dominant in the iconography surrounding the ruler:

1. Association of the sun with sacrifice and death: The creatures emerging from the heads of the serpent bar are solar beings, because they have the *kin* sign on their forehead, T-shaped incisors, and squint eyes; at the same time, they are sacrificial implements: their elongated skull wears part of the *cauac* glyph (with the same meaning as *tun*, "stone") or part of the T635 glyph, with an equivalent meaning of stone. The squatting figures who clasp a skeletal serpent are also solar figures. Those who, emerging from the serpent heads at the staffs' end, take the place of the lance's point also have a solar nature, judging from the *kin* still visible on the left head.

The association of the sun with sacrifice and death is better understood if related to common Mesoamerican beliefs about the sun's course and sacrifice, according to which the set or dead sun needs human blood to rise again. The blood is obtained through the sacrifice of victims or through autosacrifice; the latter is indicated here by the lancets hanging from the belt, the blood-stained ribbons, and the wristlets and anklets, which are the lancet's head form.

2. Death and rebirth: Insofar as the death of human victims allows the sun to rise again, the cyclical theme of death followed by rebirth also refers to the earth. The skull-and-vegetation motif occupies a central place at the top of the monument. Close to it, the water lily blossom (T696) with the *caban* sign infixed, forming a symbol of the earth's fertility, is enclosed within the jaws of a skeletal serpent, whose head is graced with foliage. Serpent heads with a water lily blossom in the mouth compose the upper frieze of Structure 18 (Baudez and Dowd 1983: fig. M-23). A skeletal serpent with the *caban* glyph in the mouth is illustrated in a vessel by Robicsek and Hales (1981: 33, vessel 54). The solar beings who emerge from the ends of the staff, in lieu of lance points, have as a headdress a skull with leaves growing on it or a helmet with the *imix* glyph, equivalent to the water lily. The loincloth is flanked by serpent jaws adorned with vegetation.

The skull-and-vegetation motif may also be associated with royal accession (represented as a sunrise) as two published vases show (Robicsek and Hales 1981: 90, 91). On vessel 117 a young lord emerges from the split shell of a turtle, on which is drawn a skull crowned with leaves. On the other the lord directly rises from the split skull, out of which water lilies grow. The dual aspect of the earth is here clearly demonstrated.

CPN 3 (STELA B)
(figs. 5–6)

CPN 3 is carved from a prismatic four-sided shaft, and its surfaces are almost entirely covered with images. The text is reduced to a column of glyphs that takes up one-third of the north and south sides. The relief of the east side is much less accentuated than on other contemporaneous stelae (CPN 1 and CPN 11, for instance).

The stela is relatively well preserved. But, the figures to the left of the ruler's headdress and on the monument's top were already missing when Stephens saw the stela. Since then the figure on the top and to the right has disappeared, and the head of the ancestor to the right of the headdress has been severed.

DIMENSIONS

Maximum height 373 cm; length at base (north-south) 118 cm; width 100 cm.

DISCOVERY, LOCATION, AND ASSOCIATIONS

Stephens found this stela standing in the Main Plaza, probably at its original location. It rests on a drum-shaped pedestal, which also forms part of the roof of a cruciform masonry chamber that contained two vessels of "coarse red-brown, unslipped, unburnished ware" (Strömsvik 1941: 68). The square cribbing frame, 2 m on each side, is made up of several stones and stands in the middle of a circular platform.

DEDICATORY DATE

9.15.0.0.0 4 Ahau 13 Yax.

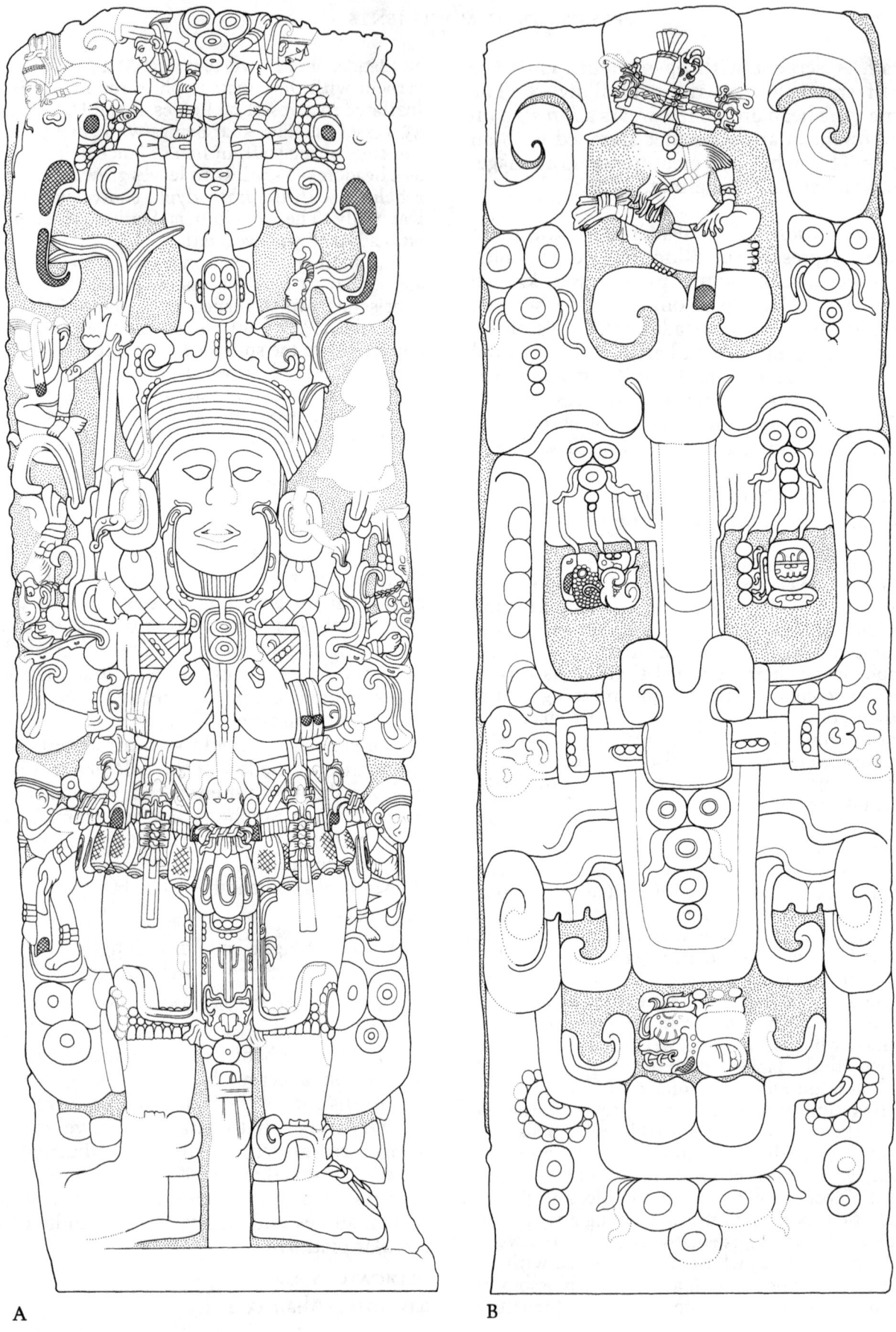

FIG. 5 CPN 3: (a) east side; (b) west side. Drawings by A. Dowd.

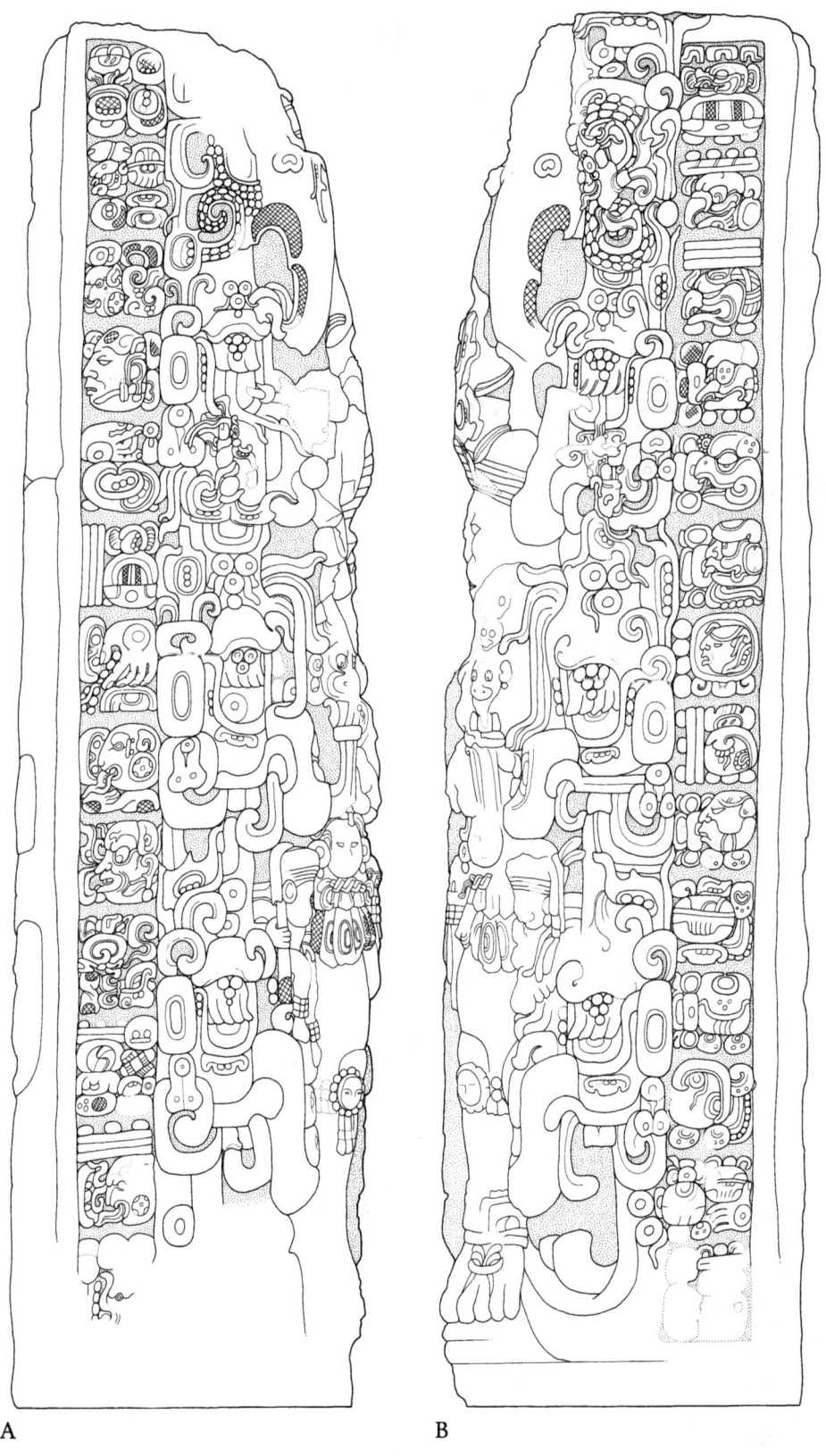

FIG. 6 CPN 3: (a) south side; (b) north side. Drawings by A. Dowd and B. Fash.

COMPOSITION

On the front the king Eighteen-Rabbit emerges from the mouth of the earth monster crowned with two macaw heads. The monster's body is indicated by superimposed profile masks carved on the north and south sides, while the rear head of the same monster occupies the whole west side of the monument.

THE EAST SIDE (FRONT)
(fig. 5a)

Above the ruler's headdress we can see—half hidden by ancestors—the upper part of the monster's head from which the king emerges. The two scrolls issuing from the mouth, the snout, the nose with two plugs, and the rim of the left eye socket can be discerned. The forehead and the snout are decorated with a group of three rings, an element of the *cauac* glyph that designates the earth monster. Its lower jaw is indicated behind the feet of the ruler by a row of teeth. These, however, are also part of the design of the lower *cauac* masks of the north and south sides.

The Main Figure: The main figure wears a turban, partly covered by the inverted image of the "whistongue," an autosacrificial symbol or instrument composed of the whiskers, the fangs, and the tongue of the jaguar (Baudez 1985a). The king also displays this object in front of his face and chest; its inverted replica in the headdress differs from it inasmuch as the fangs are shown as shells and there are three rings (T635) instead of two on the serrated tongue. Vegetal forms and the severed head of the personified maize are shown on top of the headdress. Two ribbons and uninterpreted motifs (a hand?) hang from the turban's top. The ruler's hair is invisible; a false beard is attached behind the chin.

The oval earflares have a serrated rectangular element in the center. A checkered cape or pectoral covers the shoulders and the upper part of the chest. The serpent bar held by the ruler has a short body decorated with sky-band elements; its extremities are serpent heads with a skeletal and bearded mandible and an upper jaw with large terminal fangs. From their open mouths emerge the head and shoulders of a grotesque being with long, knotted hair, like that worn by captives. On the left side his helmet is preserved: a death head with an elongated skull forming a knife's blade with the two characteristic notches on the rim. The grotesques are scroll-eyed and the ears are replaced by shells, a symbol of the underworld. A cord encircles the forehead, and the lower part of the face is covered by a whistongue.

The wristlets and anklets are composed of an upside-down serpent mask crowned with two knotted bands, an image of the lancet. The belt—decorated with sky-band elements, three youth masks, ribbons adorned with lancet effigies, blackened *Oliva* tinklers, and jade plaques—is in every respect similar to the one on CPN 1. The loincloth bears the mask of a solar creature (filed incisors, squint eyes) continued by a braid-and-tassel that includes a bell-shaped bead among its elements. Two serpent upper jaws adorned with vegetation flank the loincloth. The knee ornaments are small youth masks surrounded with beads; the sandals with a solid heel are of the usual type at Copán.

Surrounding the Main Figure: Two macaw heads and four pairs of anthropomorphic figures are symmetrically disposed on each side. Each of the central pair of figures at the top wears a flattened hat from which hang ribbons. The wristlets and anklets either are of the ribbon-on-band type or are made of three knotted bands. A rope encircles the neck of the man to the right side of the ruler.

Nothing remains of the figures that were located at the corners of the monument above the macaw heads. The one to the left was already missing at the time of Stephens's visit; the other one was broken after Maudslay's work. According to Annie Hunter's drawing, there was a man wearing a globular hat with a cord round it at mid-height, with hanging ribbons. A shell replaced the ear and the wristlet was a "ribbon-on-band." His right hand (Maudslay 1889–1902: vol. 1, pl. 37b) held the tongue of the serpent identified as the patron of Ceh.

The figures of pairs three and four stand with their back against the *cauac* heads at the headdress and thigh levels, respectively. They wear turbans (the exclusive headdress of the Copanecs), from which hang ribbons with blotched ends, the tangible results of self-sacrifice. Like the other ancestors on the mon-

ument, they have shells in lieu of ears, a rope round the neck, and the same anklets and wristlets.

THE NORTH AND SOUTH SIDES
(fig. 6)

At the top the macaw heads, already seen on the front side, have a long curved beak with black spots and a respiratory orifice and a circular eye surrounded with beads that reproduce the granular aspect of the bird's skin around the eye. Under it the cheek is indicated with a granular scroll. On the north side the macaw is provided with an ear topped with plant forms (maize); furthermore, its eye, which hangs out in front of the socket, has the form of an upside-down grotesque head. It is the head of the Thunderer (Baudez 1992)—or God K, as it is frequently called—pictured as shouting out, with a long lip, ax-and-smoke implanted in the forehead, and foliage sprouting at the top of the skull and out of the earflare.

Three *cauac* masks (those of the earth monster), seen in profile and facing east, take up the middle of the north and south sides. They call to mind an old crocodile with a flabby forehead, distorted with scrolls and wearing the three-ring element; the drooping eyelid is adorned with the bunch of grapes, another element from the *cauac* (T528) glyph. Under the eye we recognize affix T23, and on the long pendulous snout the three rings are drawn; large scrolls flank a molar. A maize plant and an inverted *ahau*/bone head are attached to the oval earflare. The whole ornament illustrates the death-and-rebirth theme. The middle mask—on both sides—differs from the others by the bunch of leaves(?) that sprouts out from its skull, while the upper mask is enucleated. On the south side a branched stem descends from under the eyelid; one of the branches carries the inverted head of a long-nosed creature with leaves on top of the skull. On the other side of the monument it is an inverted death head with vegetation that hangs from the socket.

Enucleation is a recurrent theme among the Maya, as evidenced by the death-eye collar of personages from underworld scenes, scratched out eyes presented in vessels by the same ghastly figures, the sometimes empty sockets of seemingly solar figures, and finally the images that show the eye hanging from the socket at the end of the optic nerve. We still do not know the precise meaning of this mutilation, which may be different according to what is concerned: the sun or the earth.

THE WEST SIDE
(fig. 5b)

The west side is completely taken up by the rear head of the earth monster seen in front. It is not skeletal and presents the same features as the front head or the body masks on the sides.

A man is seated cross-legged on the monster's forehead. In his right hand he offers a bundle of tied leaves, feathers, or ribbons. They are more probably sacrificial ribbons like those presented in bowls on the west side of CPN 4. The man wears a loincloth with blackened end, "ribbon-on-band" wristlets, a feather cape, a tubular bead as a pectoral, and a strip or rope around the neck. He has on his head the Copanec turban topped by a hemispherical hat surrounded by a wide band. A braid covered with serpent scales joins two solar heads wearing a serpent helmet. The whole motif may be seen as a serpent bar from which solar creatures emerge.

A cylindrical piece whose end is surrounded with cords and topped with feathers juts out of the band. Under it hangs a slightly bent point that is interpreted as the other end of the cylinder. This object, slipped between the hat and the band, looks like the object that some scholars interpret as a lancet in its sheath (Benson 1982; Robicsek and Hales 1981: vessels 86–89). Supporting this interpretation is the fact that the bent point hanging out from the hat is identical to the end of the huge lancet carved on the west side of CPN 7.

A jaguar paw topped with three knotted bands and feathers, is stuck to the headdress. We cannot help but see in this paw another form of lancet, since the more usual form of this instrument—the tongue and head of the serpent—is surrounded by knotted bands and feathers. The jaguar paw also appears as a scepter: the great-ancestor or the dynasty founder facing Rising-Sun on CPN 30 holds a similar object.

INTERPRETATION

CPN 3 represents the king Eighteen-Rabbit, rising out of the bicephalic earth monster.

On the front of the monument the king emerges from the mouth of the earth monster crowned with two macaw heads (symbolizing the diurnal sun k'inich k'ak' mo'o). The monster's body is indicated by superimposed masks carved in profile on the north and south sides, while the rear head of the same monster takes up the whole west side. This image likens the king to the rising sun, and it is no coincidence that it faces east.

The ruler carries implements, images, and patrons of autosacrifice. I have called the object held by the ruler in front of his face and chest a whistongue. It is composed of the whiskers, the fangs, and the tongue of the jaguar. The tongue is also the knife that makes up the active part of the lancet (compare with the loincloth of CPN 7). The grotesque creatures that emerge from the mouths of the serpent bar are replete with sacrificial symbols: knotted hair, death head helmet, knife-shaped skull, cord, and whistongue. In addition, the king wears images of the lancet for wristlets and anklets. Auto-sacrifice is closely linked to the sun and therefore to the king.

The king is also accompanied by ancestors who legitimize his power while insistently recalling the importance of bloodletting. These anthropomorphs are presumed to be ancestors because they have perfectly human features. However, they belong to the world beyond, as indicated by the shell (a death and underworld symbol) that replaces their ears. They wear bloodstained ribbons and a rope around the neck. One of the ancestors—today missing—held a head of the serpent that is the patron of Ceh. Thompson (1950: 112, 113) has shown that Ceh was the patron of the eastern (red) sky, a convenient patronage for an accession scene likened to a sunrise.

The north and south sides form the body of the bicephalic monster, not only because of their location between the monster's front and rear heads, but also because of the superimposed masks. In fact, cauac masks are often scattered on the body of earth monsters, as on CPN 25 or on Quiriguá Zoomorph P. The eyes of the upper cauac masks are enucleated: on the south side the hanging eye is a long-nosed, reptilian head, while to the north it is a death head. The opposition between the two heads may mean two different stages in the earth's fertility (expressed in both cases by foliage), which would parallel the opposition between 7-Head and 9-Head (see the interpretation of the markers of Ball Court A-IIb in chapter 2). The eye of the macaw head to the north is also scratched out and has the form of the Thunderer head with the ax-and-smoke implanted in the forehead and with foliage at the top of the skull. The opposition between the two macaw heads (one normal, the other one crippled) reminds one of the contrasted heads of the cosmic monster.

A great-ancestor is seated on the rear head of the earth monster, on the west side. His headdress displays both power symbols and autosacrificial implements, which are often confounded. It identifies its bearer as a great-ancestor, probably the founder of the lineage, if he is the same man with a jaguar paw who on CPN 30 transmits the supreme power to Rising-Sun. Its location on the forehead of the earth monster corresponds to the place taken by the late king on the altars of Quiriguá Zoomorphs O and P. It is then likely that, corresponding to the emergence of Eighteen-Rabbit to the east, his dead predecessor was pictured on the west side of the monument.

The glyph compound in the right eye of the *cauac* monster's rear head combines two logographs that sum up what the whole monument is about: the sun king (macaw) and the fertile earth (T529, which Stuart 1987 interprets as meaning *wits*, "hill" or "mountain"; see the discussion of *cauac* masks in chapter 4).

CPN 4 (STELA C)
(figs. 7–9)

CPN 4 is carved from a four-sided monolithic shaft. Two human figures are depicted on the broad east and west sides and extend to the north and south sides, leaving room for only two columns of glyph blocks there. The lower part of the stela is damaged. Many details in the upper part are also lost. Much of the red paint that originally covered the stela is preserved.

DIMENSIONS

Maximum height 386 cm; base measures 116 cm (north–south) by 85 cm; depth of relief (west) 52 cm; depth of relief (east) 40 cm.

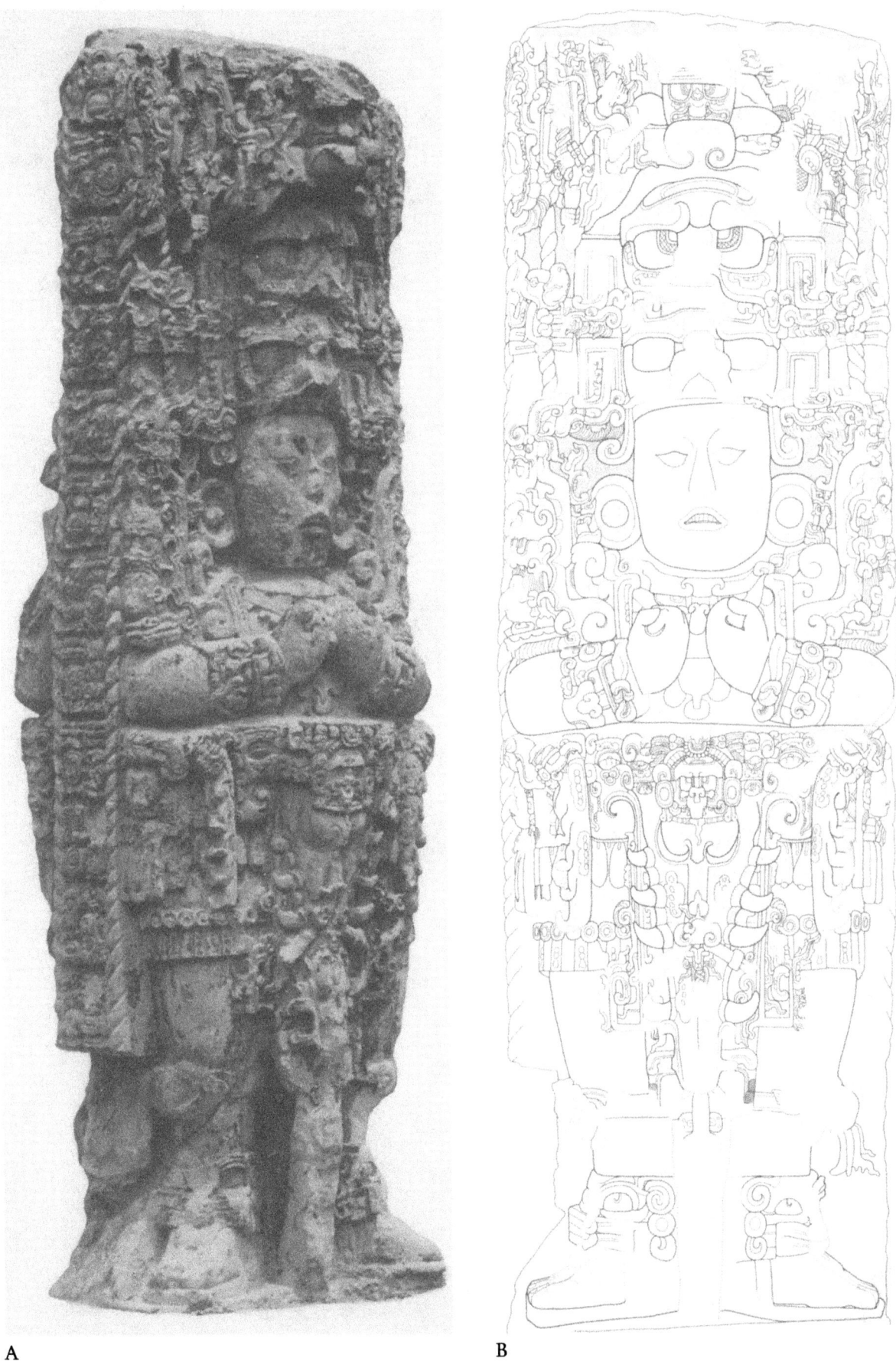

A B

FIG. 7 CPN 4: (a) oblique view of east side; (b) east side. Photo by J.-P. Courau; drawing by B. Fash.

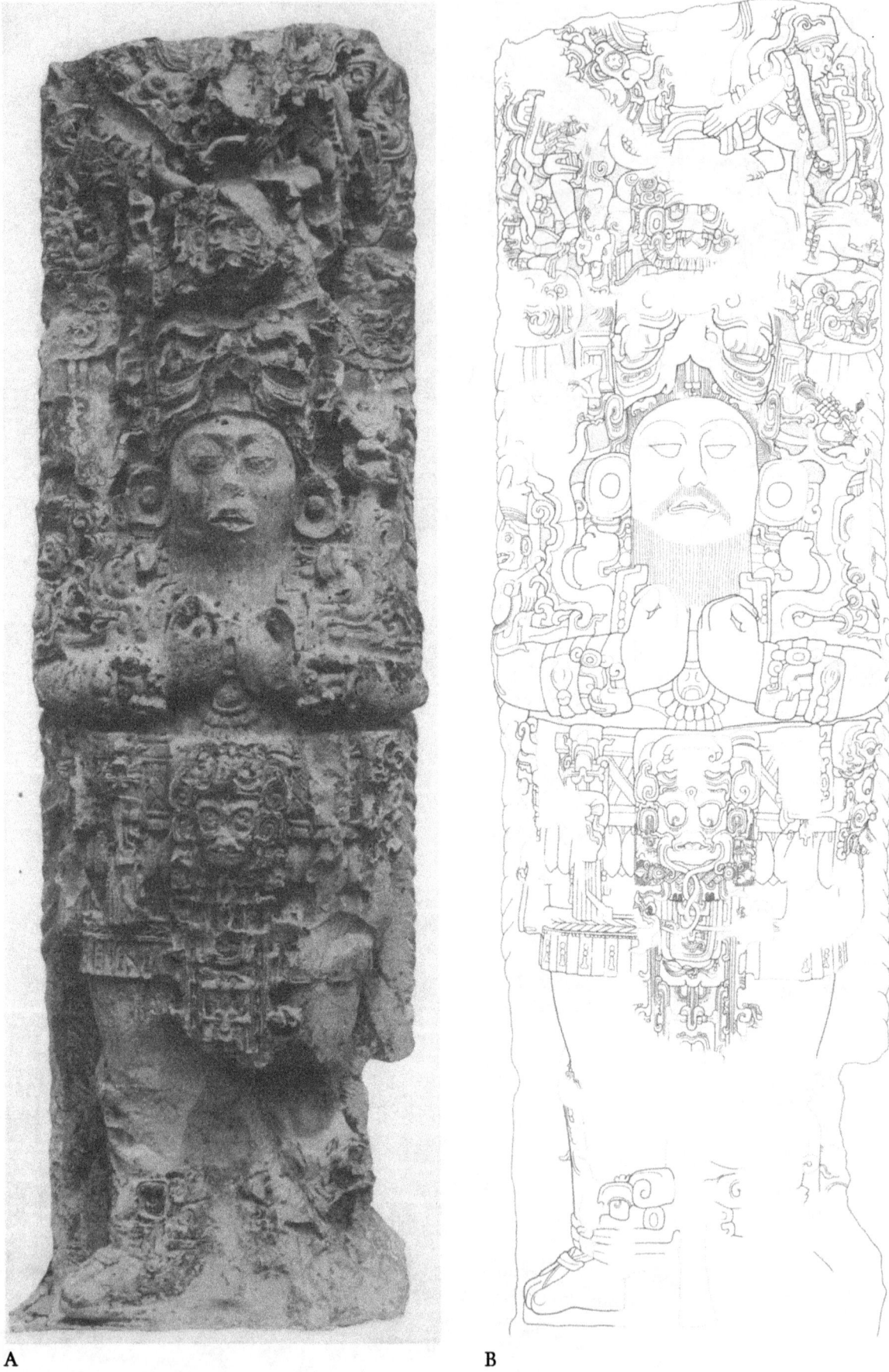

A B

FIG. 8 CPN 4: west side. Photo by J.-P. Courau; drawing by B. Fash.

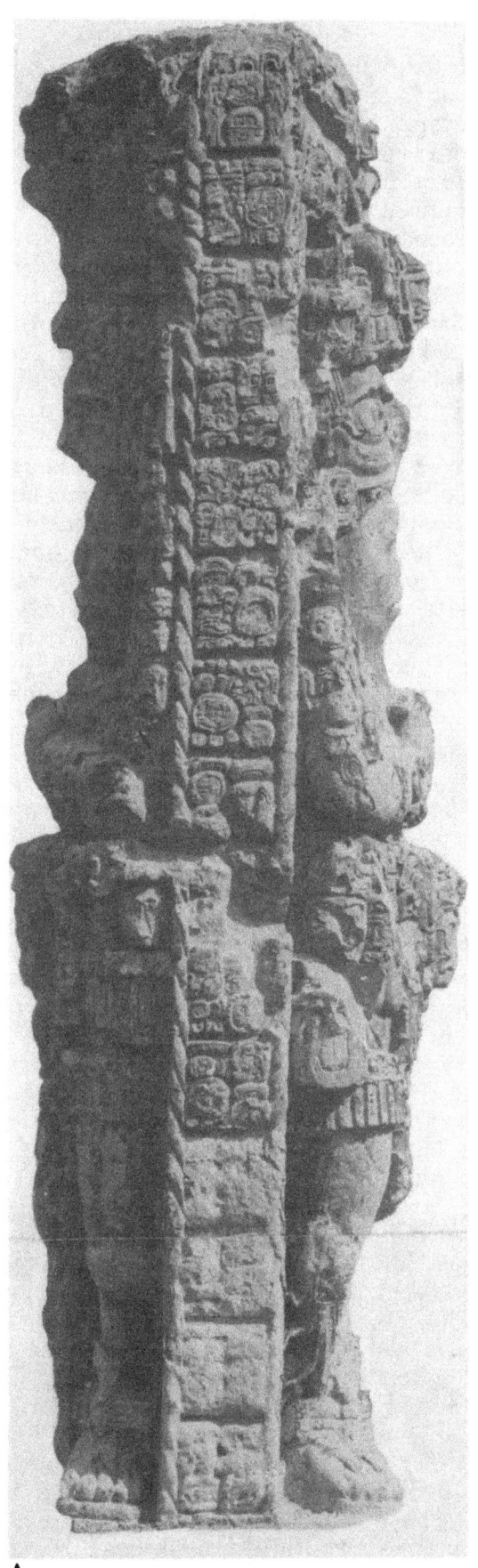 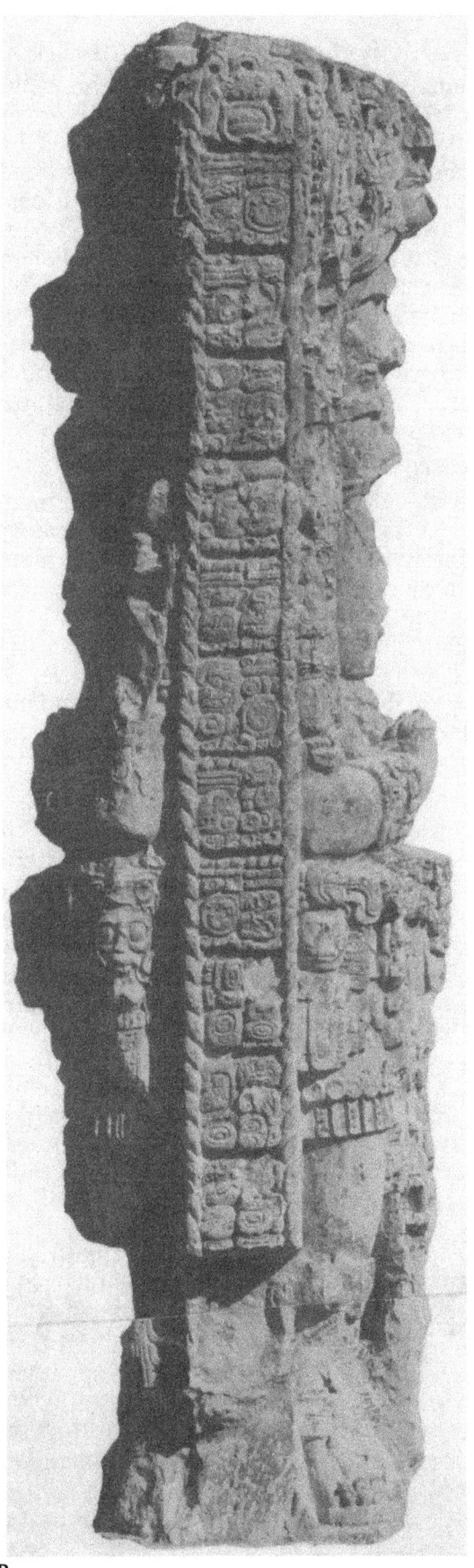

FIG. 9 CPN 4: (a) north side; (b) south side. Photos by J.-P. Courau.

DISCOVERY, LOCATION, AND ASSOCIATIONS

Stephens found CPN 4 broken on the Main Plaza, 15 m northwest of CPN 3: the lower third was still standing and surrounded by fragments. Carnegie archaeologists restored the stela and reerected it in its original location. Two altars are associated with CPN 4: to the east a plain prismatic block (CPN 6); to the west a composite altar in the form of a bicephalic turtle (CPN 5). A cruciform chamber built under the stela contained three coarse red-brown vessels, several stalactites, and a chalcedony pebble according to Gordon (1902, see also Strömsvik 1941).

DEDICATORY DATE

Of all the dates carved on this monument, I favor 9.17.12.0.0 4 Ahau 18 Muan as dedicatory date for stylistic reasons, as we will see later. Another possibility (with which I disagree for the same reasons), which is favored by L. Schele and others, is 9.14.19.5.0 4 Ahau 18 Muan. If this date were correct, the stela would have been erected by Eighteen-Rabbit and not by Rising-Sun as my chronological placement implies.

THE EAST SIDE
(fig. 7)

From one of the heads of the earth monster a young man emerges from the waist up; the monster's rear head, in crocodile form, covers his loincloth. The man is crowned by superimposed masks. At the monument's top supernaturals and ancestors carry the ceremonial bar, symbol of the power transmitted from one generation to the next.

The Earth Monster: The stela is divided into two parts by a sort of platform located just under the arms of the main figure: thus, the upper part appears to be slightly set back from the lower. The inverted head of the *cauac* monster that gives way to the man is just under this platform and in two parts located close to the long paws of the crocodile. Scanning from the platform down and from left to right, we see the teeth of the upper jaw, an inverted T23 sign, the droopy eyelid, the three-ringed element, the large scroll of the forehead, and the square earflare adorned with plants.

The rear head of the monster is indicated by a crocodile head, which covers the loincloth of the ruler. The multilobed element that is specific to the crocodile is repeated several times on the snout. A water lily blossom (T696) is above the plugged nose; below is a stylized mask with an emerging tongue(?) stamped with the crossed-bands element. The crocodile head wears a *cauac* helmet, which confirms its earthly nature; it is divided into two parts that flank the central bird mask. Part of the *cauac* sign is near the large forehead scroll. The *cauac* glyph also replaces the molars; with the meaning of "stone" it may, like the knife-tongue motif, convey the idea that the earth is bloodthirsty.

A bird mask is located in the middle of the monster's forehead, above the *cauac* helmet. Like the bird carved on the east side of CPN 16, it probably represents the day sun. The two dangling paws of the saurian, marked with multilobed elements, have wristlets made of a bird mask tied with visible straps; its forehead is decorated with crossed bands. This association bird/earth monster reminds one of the two macaws on top of the *cauac* head on CPN 3.

The Main Figure: He wears two superimposed helmets. Although the lower one is badly broken, a snout, possibly a feline's, and T616b on the forehead are visible. The molars, the squint eyes underlined with T23, and T616b on the forehead are preserved on the upper helmet, while the snout is missing. Both masks have the same rectangular earflares with a serpent head tied to their lower rim and are enclosed within the large mouth of a jaguar, identified through its upper lip, flattened muzzle, and part of an eye.

The youthful face of the central figure is flanked by two simple circular earflares. The pectoral is a mask with a long tongue that tapers into a point and partly hides three circles. The figure presses a serpent bar, of which only the ends are visible, against his chest. They are serpent heads with elongated upper jaws and a snout that terminates in a grotesque reptilian head with a smoking ax implanted in the forehead, with plant forms crowning its skull. A head with a long upturned nose (a bat?), a wide-open mouth, and a hooked skull adorned with plants replaces the nose of the bar's serpents. From their jaws emerges a youthful human head; he wears a

helmet in the form of a squint-eyed creature with a short, broad muzzle and a cartouche stamped on the forehead. A maize plant grows out of his head. The main figure's wristlets are made of a monster mask with wide snout, scrolls as eyeballs, and a knotted band round the head (the sacrificial lancet).

On the sides the belt decorated with crossed-bands supports a youthful mask with a knot (T60) on top of the head and a braid under the chin. On the right side the flanking ribbons are blackened. The earflares of the masks are circular and adorned with a serpent head above and below. Three oval plaques stamped with T616b hang under each mask; elsewhere plain *Oliva* tinklers hang from the belt.

The main figure wears a skirt whose edge is adorned with beads and ribbons, alternately plain and beaded. Entirely covered by the crocodile head that represents the rear head of the monster, the loincloth is flanked with upper serpent jaws; their ends are adorned with an open-mouthed jaguar head topped with plant forms. The knee ornaments are round medallions with leg straps. The anklets are inverted serpent masks with two knotted bands (once more the head form of the lancet) and the sandals are of the usual type, with high heels.

Surrounding the Main Figure: The top of the east face of the stela is arranged around a central squint-eyed mask that crowns the large jaguar head described above. An anthropomorphic figure was seated to the right of it, but the only part that remains is a much damaged head. Its lower jaw is replaced by a hand (T713) that signifies completion or death. It probably was an underworld figure. Nearby is a serpent head whose upper jaw terminates in a bird head with a bent beak and a bifurcated tongue. An ancestor wearing a cylindrical turban with a ribbon hanging down to thigh level emerges from the serpent jaws. He has two knotted bands around the wrist and three others around the ankle. He carries a ceremonial bar from which hangs a braid-and-tassel (a mat motif plus T58). At the bar's end the serpent jaws hold a large knot that continues with a rope going all the way down to and framing one side of the inscription. Another rope, with three knotted bands and a bat head, is tied to it. This rope hangs down to the level of the main figure's feet.

The sculptures are terribly damaged on the left side of the mask. Whatever remains shows that the composition did not duplicate that of the right side. A bare-footed anthropomorphic seated figure leans against the central mask; its head is broken except for a bat ear. The creature therefore seems to be from the underworld and not an ancestor like the figure who faces it, of which only a leg remains. He is an ancestor because he wears a sandal with a fringed ankle-guard, a garment never worn by supernaturals. A hand located above the leg may belong to the same individual. Three wrist bands, a leg, and a sandal belong to a third figure whose location corresponds to that of the bar-carrying ancestor on the right side. Here too the bar is adorned with a braid-and-tassel. The serpent jaws hold a large triangular eccentric knife with notches and a pendant rope framing the inscription. An open-mouthed bat head and three knotted bands on another rope are fastened to the bar's end.

THE WEST SIDE
(fig. 8)

Since this face of the stela is placed behind the altar, the main figure appears to sink into the bicephalic turtle, an image of the earth. He wears a simple helmet crowned with a headband on which three masks are fastened. Above it a central figure holds a serpent whose two mouths give way to a bar-carrying ancestor. The ropes hanging down from the bar's ends bear creatures or images associated with sacrifice that frame the central figure.

The Main Figure: The helmet of the main figure has upturned eyes half covered by drooping lids connected to the forehead by a vertical strip, with the T23 sign underlining them. The now broken snout was upturned. The rectangular earflares have a serpent head attached to their lower rim. Large scrolls come out of the mouth's corners. The helmet may represent a crocodile or serpent, but not a jaguar. It is topped by a headband with three masks. The central one is the mask of the patron of Pax, an aspect of the night sun with close ties to sacrifice; it has no lower jaw, but the tongue is stamped with the crossed-bands

motif and flanked with bent fangs and large scrolls. The nose is broken, the eyes squint (the eyeball reproduces T42), and the ears wear an oval flare adorned with plants. The right-hand mask has a lower jaw and a beard(?). The squint eyes (T42) and the tapered skull reproduce the sacrificial implement that makes up the central element of the tripartite emblem. A scroll and a bone head are extensions of the oval earflares. The left-hand mask is much destroyed; however, squinting eyes, a lower jaw, a flabby narrow nose, and a drooping lip are apparent. These masks seem to be closely tied to death and sacrifice by virtue of their decoration.

The beard covers the lower part of the main figure's face. It is quite different from the usual false beards (as on CPN 3 and CPN 7) and here indicates old age in contrast to the youth of the figure on the stela's east side. A serpent head hangs from the round earflares. The serpent bar's ends have a very elongated upper jaw, like the one on the east side, but here no grotesque heads replace the reptile's snout. Only the right-hand portion is well preserved. A turbaned monkey with small round eyes, a short muzzle, and a half-open mouth holds a severed head. It has no lower jaw, but round eyes with a circular pupil, a broken nose, and a skull surrounded by a crown of hair from which a maize plant grows; it therefore seems to be the head of personified maize. The monkey, rarely shown at Copán, is probably a solar symbol, since it sometimes takes the place of *kin* in the full-figure glyphs (CPN 7; Yaxchilán Lintel 48). Since the figure wears the turban, a royal headdress, it is an image of the sun-king, who oversees fertility, as indicated by the severed maize head he holds.

The wristlets are made of a monster head with a branch knotted on the forehead. The pectoral is an ornate *ahau*. Two inverted lancets on ribbons hang from the X-decorated belt: the tongue is wide and short; a bone perforates the nose; the eyes are large ovals. A knotted band is around the skull, to which plants and ribbons are fastened. The three belt masks are different. The central one wears a helmet with oval eyes, a now-broken upturned snout, and scrolls on the forehead. It is destroyed beyond identification, but it is certainly not a jaguar. It is tied to the mask below by a strap visible from behind. The mask itself has large round scroll-eyes edged by double lines that are twisted on the nose to form the cruller ornament. The upper lip is curled up over filed incisors. The whiskers progressively turn into serpents that cross each other three times under the chin. The oval earflares are surrounded by blackened ribbons and topped with a jaguar ear; a serpent(?) head hangs from the earflare. Like the other two, the central mask is underlined with a mat with beads (T58) at the ends; it is the solar creature with jaguar features, patron of the month Uo and of the numeral seven.

The left mask carries a bat helmet, with large serrated ears, an upturned, elongated snout, and round eyes. The mask displays the features characteristic of the patron of the month Pax: absence of lower jaw, serrated scrolls at the corners of the mouth, and a knife-tongue (two rings probably indicating that it is made of stone). It has large, rounded scroll-eyes and wears oval earflares.

Although the right mask is too eroded for a precise identification, it does wear a serpent helmet. It has squint eyes and earflares with a scroll above and a serpent head below them. It probably represents another aspect of the jaguar/night sun, and completed a trilogy with the patron of Uo and the patron of Pax.

Plain shell tinklers hang from the figure's belt. Oval plaques stamped with T24 and T561 (sky) are below the masks. The skirt's edge is a braid decorated with a herringbone pattern and hanging ribbons, either plain or beaded. The loincloth is flanked by stylized serpent heads and has two superimposed jaguar masks; the smaller upper one has a cartouche on the forehead, squint eyes, nose plugs, and scrolls at the corner of the mouth. Beside these, the lower has a foliated branch knotted on the forehead. The knee ornaments have almost disappeared, but they seem to have had a tongue stamped with the crossed-bands and surrounded with plant motifs. The common lancet image, an inverted mask topped with two knotted bands, makes up the anklet.

Surrounding the Main Figure: A man holding a bicephalic serpent is seated on the top middle part of the stela. His hands can be seen below a large mask, which probably was

his pectoral. The serpent mouths hold two bar-carrying ancestors. The ophidian head to the right has the *kan* sign stamped on the supraorbital plate and the lower jaw has plants including a maize cob fastened to it. The serpent to the left has neither a *kan* sign nor a mandible. It displays a wide tongue marked with three rings and prolonged by the braid-and-tassel composed of a mat, a round bead, another bell-shaped one, and tubes.

The figures coming out of the monster's mouths wear a turban topped by a cylindrical hat. They wear round earflares and triple-knotted wristlets. They have sandals with high-heeled backs or three bands knotted around the ankle. Both hands hold the serpent bar, which is relatively large and decorated with the braid-and-tassel. Ropes hang from the bar's end, and one of them reaches the base of the monument and frames the inscription. From the corners of the mouth two twisted ropes hang down. Attached elements include:

1. Two small figures, seated cross-legged and leaning forward, presenting knotted bands in a shallow bowl. The right-hand one has a solar head (T-shaped incisors, squint eyes, *kin* sign on the forehead). The one to the left wears a loincloth whose back forms a loop tied with three bands; the missing head wore a helmet with a long-nosed face crowned with a bunch of feathers and topped by a monkey head wearing three knotted bands.
2. Two circular medallions depict the same mask in profile that combines features of the bat with those of the patron of Pax, including a large serrated tongue, a scroll at the corner of the mouth, and no lower jaw. The elongated snout turns upward with a tuft of hair between eye and snout; the scroll-eye is flattened under a low forehead. No ears are visible, but behind the head are scrolls and ribbons.
3. Two small figures are seated with one leg tucked up under the body, the other one hanging down. The personified lancet is carried on their shoulder. The better-preserved figure, to the left, has long knotted hair and an earflare with an *ahau*/bone pendant.

All elements emerging from the open jaws of the bar serpent held by the great-ancestors refer to sacrifice and autosacrifice. The rope that links several elements is a sacrificial symbol *par excellence*. Supernaturals with solar attributes displaying knotted bands and bloodstained ribbons are attached to it. Medallions that depict the bat with Pax jaguar features strengthen the link to sacrifice, as do the lancet-bearers.

INTERPRETATION

On the east side the young king, like the rising sun, comes out of the jaws of the bicephalic earth monster. Through the bird-upon-earth motif (the bird mask on the crocodile head), he introduces himself as the day sun ready to triumph over the earth and darkness. His headdress, with several jaguar images, symbol of the night sun, shows that he has just come from the underworld. Above him infernal creatures mingle with royal ancestors carrying ceremonial bars. The serpents at the ends spew forth sacrificial symbols: the knot, the eccentric knife, the rope, the bat, the three-knotted bands. The message from beyond reminds us of the necessity of bloodletting. There is also a clear allusion to accession at the top right: a bar-carrying ancestor emerges from the jaws of an (earth) serpent.

To the west the late king is pictured. He seems to sink into the bicephalic turtle, an image of the earth. His headdress and his belt masks display several infernal creatures that borrow their features from the sun, the jaguar, and the realm of sacrifice. The beings emerging from the bar's ends represent the king as the sun (the monkey as *kin*) holding the severed head of maize.

This is another example of the need for sacrifice and death to obtain life and growth. The sacrifice theme is profusely illustrated around the ruler's headdress and seems to be directly associated with royal power.

CPN 4 is a monument that commemorates the succession of Eighteen-Rabbit to Smoke-Jaguar. Like the rising sun, the young king appears to the east coming out of the jaws of the earth monster, directly carved on the monument. To the west the old ruler sinks into the earth. The major differences or oppositions between the two sides are in the masks from the headdress and the belt. On the west side emphasis is given to the infernal creatures that the ruler is ready to join and to sacrifice. Three pairs of motifs illustrate this theme on the sides and on the upper part, while to the east only the bats and the knotted bands represent it. The young ruler is sur-

rounded only by symbols of sacrifice; but with the old king these same symbols are represented by infernal creatures.

In spite of these differences, we do not find on this monument a clear-cut life/death opposition, as on CPN 47. The ancestor figures on the top seem to emerge from the serpent jaws to the west as well as to the east. On both sides an accession image illustrates the continuity of the dynastic cycle.

COMPARISONS

CPN 4 should be compared with other double-figure stelae from Copan. It repeats, 130 years later, the composition of CPN 41. Both monuments display at the top of both sides ancestors emerging from the waist up from serpent mouths that represent the earth; these figures carry the ceremonial bar, from whose ends fall ropes to which sacrificial symbols are fastened. On CPN 47 there is also an accession scene on the east side. On CPN 26 succession is indicated on the lower part of the two narrow sides by the double image of rulers emerging from the earth jaws, while others sink into it. CPN 3 also shows the king coming out of the bicephalic earth monster; there the movement is horizontal, while on CPN 4's east side it is vertical. It has already been observed that the bird-upon-the-earth theme is shared by the two monuments. On CPN 18, a funerary monument, the deceased king wears the contrasted masks of the Uo jaguar and Pax jaguar on his belt; this same opposition is expressed on CPN 4.

STYLISTIC DATING

I think that CPN 4 was erected by Rising-Sun to commemorate the succession of Eighteen-Rabbit. Date G, 9.17.12.0.0 4 Ahau 18 Muan, is proposed as the dedicatory date. It does not celebrate a calendrical anniversary, but rather commemorates a historic event, which occurred on 9.14.19.5.0 4 Ahau 18 Muan, a date shared by CPN 1 and CPN 16. This, however, is not the accession date of Eighteen-Rabbit. Among several possible dates, the latest is preferred for stylistic reasons. The style is very flamboyant, as on the late Copán monuments (CPN 26, CPN 13, 14, and 15, for instance) and on the east side grotesque masks are found at the end of upper jaws or take the place of serpent noses. Proskouriakoff (1950: 38, 40) considers this a late trait (II K1-K2), post 9.16.0.0.0. At Copán it is only present on late sculpture (CPN 13, 28, 33). The location of CPN 4 among Eighteen-Rabbit's monuments and especially close to CPN 3, which celebrates the king's accession, supports the hypothesis that this stela commemorates the accession of Eighteen-Rabbit.

CPN 5 (WEST ALTAR OF STELA C—
LA TORTUGA)
(fig. 10)

CPN 5 is a composite altar representing a bicephalic turtle. One head appears to be dead, while the other is "alive." The turtleshell, oriented north-south, rests on six carved stones with tenons forming the two heads and the four legs of the animal. The carapace has pecking marks from erosion, and its edge is chipped in several places, especially on the east side. The living head, whose tenon is missing, and the southwestern leg are both chipped.

DIMENSIONS

Carapace 200 cm by 200 cm by 100 cm; death head 50 cm high, 30 cm wide, and 40 cm deep; length of tenon 60 cm. Legs on south side 35 cm high, 28 cm wide, and 48 cm deep; length of tenon 42 cm.

DISCOVERY, LOCATION, AND ASSOCIATIONS

The carapace, which we assume not to have been moved after discovery, is approximately 150 cm to the west of CPN 4. Stephens found one of the turtle heads 2 m from CPN 3 among the fragments of CPN 4; it can be seen on Catherwood's drawings of the rear and the north sides of CPN 3. Maudslay (1889–1902: vol. 1, p. 45) believed it may have belonged to the turtle-shaped altar near CPN 3. His photograph shows the altar with the turtle carapace resting on its legs on the north side (ibid: pl. 40).

According to Gordon (1896), the dead head faced west, while the remains of another head were oriented eastward, toward the stela. Clearly, Gordon believed that the former was in its proper place; his reconstruction with the legs oriented east-west while the heads were on a north-south axis is impossible. Undoubtedly, the Carnegie Institution returned the heads to their proper places between the legs. Today the death head is to the north,

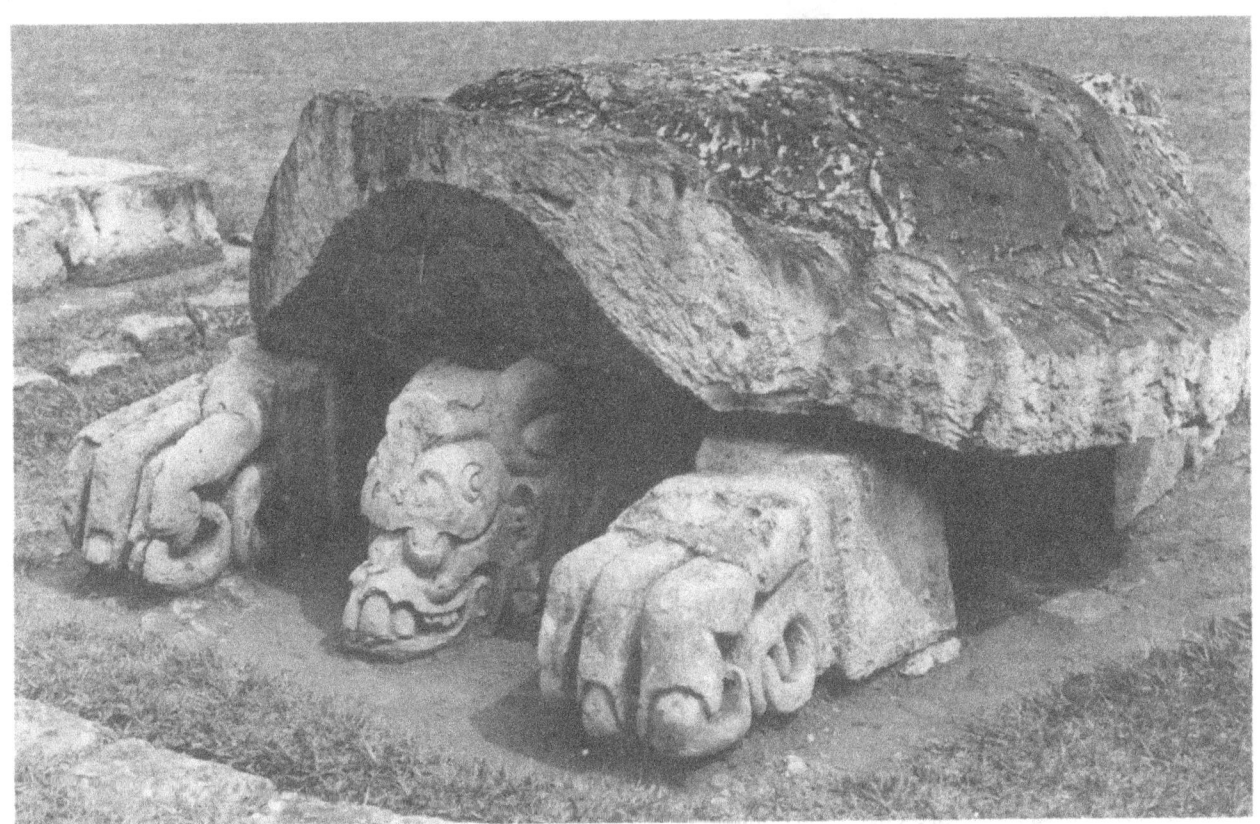

A

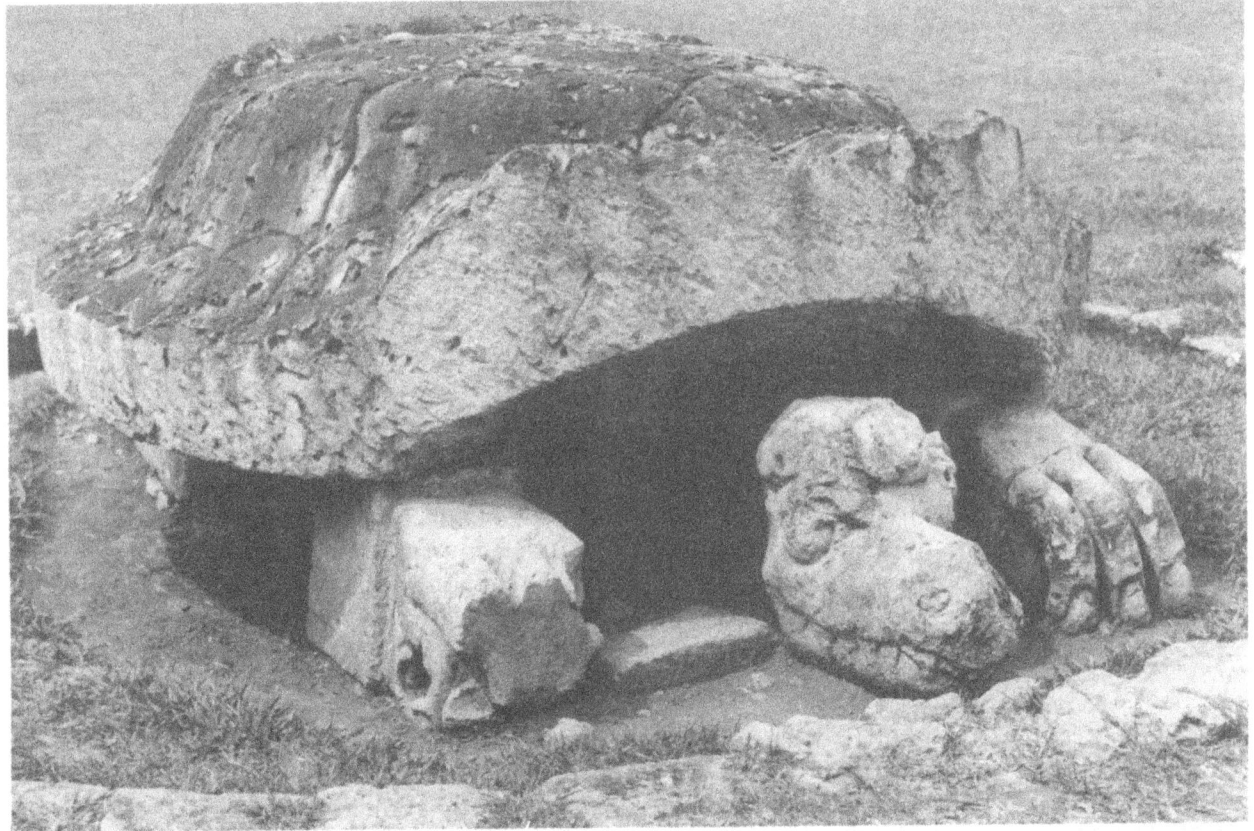

B

FIG. 10 CPN 5: (a) north side; (b) south side. Photos by J.-P. Courau.

although its original location is not known. CPN 5 rests in the middle of a circular basin, 365 cm in diameter. It sinks 15 cm into the Plaza floor and is encircled by a row of little stones whose tops are at Plaza floor level. It is also associated with CPN 4, facing its west side (see discussion under CPN 4).

DESCRIPTION

The carapace is dome-shaped with a wide border that tapers up at the front and rear and down on the sides. It is decorated with oblique lines that crisscross and form lozenges to represent the shell. The legs and feet are identical on both sides with five clawed digits: three in front and two in back. Catherwood observed that the living head to the south resembles a crocodile more than a turtle, especially because of the round elongated nose and the jagged teeth. A headband or knotted plant circles its forehead. The other head to the north is a skull with two unidentified protuberances behind and on top. An upside-down *ahau* hang from the ears. Crescents indicating bone are scattered on the forehead and temples. The pupils are placed slightly upward. The skeletal jaws are implanted with huge teeth.

INTERPRETATION

This altar represents the double-headed earth monster. While the heads look crocodilian, the body is a turtle shell. This animal, judging from polychrome vases that show a bicephalic turtle with personages emerging from the cleft carapace, is an image of the earth (Robicsek and Hales 1981: figs. 57–59). This altar rests in the center of a small circular basin that might represent the swamp in which the earth in its habitual crocodile form might float. The turtle forms an iconographic unit with the west side of CPN 4. Seen from behind the altar, the old king depicted on the stela seems to sink into the earth, represented by the altar.

CPN 7 (STELA D)
(figs. 11–13)

CPN 7 is a prismatic stone shaft with a maximum height of 353 cm, with a width and thickness of 95 cm. The broad side to the south is occupied by a standing human in frontal view. Interlaced serpents frame the figure and overlap onto the narrow sides. The opposite broad side (north) is carved with a full figure inscription. A cribbing frame composed of several stones encases the stela.

DISCOVERY, LOCATION, AND ASSOCIATIONS

Stephens found this monument where it is today, at the foot of Structure 2 and facing toward the Plaza. It stands on a cruciform masonry chamber, which contained loose dark earth and two weathered potsherds only when opened by Strömsvik. The stela is associated with an altar (CPN 8); both are on a T-shaped low platform whose base borders Structure 2, with which the ensemble is clearly associated (Cheek and Embree 1983).

DEDICATORY DATE

9.15.5.0.0 10 Ahau 8 Ch'en.

The Main Figure (fig. 11a): A personified lancet is perched atop the main figure's head. It has squint eyes, a lolling tongue, no lower jaw, and is crowned by two knotted bands and vegetation. A checkered cape is draped over the figure's shoulders and chest. Upturned hands press the serpent bar against the chest. The bar is decorated with mat patterns. The figures of the Thunderer or "God K" emerging from the serpent heads at the ends have a double crown of hair, large scroll-eyes, a scroll atop each ear, the ax-and-smoke element implanted in the forehead, and a bead necklace. The elongated upper jaw has an upturned end, and wrinkles frame the open mouth.

The main figure wears bracelets and anklets with the mask of the personified lancet, which includes an inverted serpent head topped by two knotted bands. The wide belt bears the mat motif and the beard-and-scroll design from the celestial band. The side masks are youth heads with a ribbon tied on the top (T60) and a braid under the chin, from which hang three oval tinklers marked with T616b. In contrast, the belt tinklers are blackened *Oliva* shells. The front panel of the loincloth bears an inverted lancet mask with foliage and three knotted bands. It has crossed eyes, two fangs flanking the muzzle, and a tapered tongue marked with T617a. Panaches, a rosette, and beads cover the loincloth, which is framed by stained ribbons. The knee ornaments are mutilated masks with large eyes and wrinkles around the mouth; attached by a

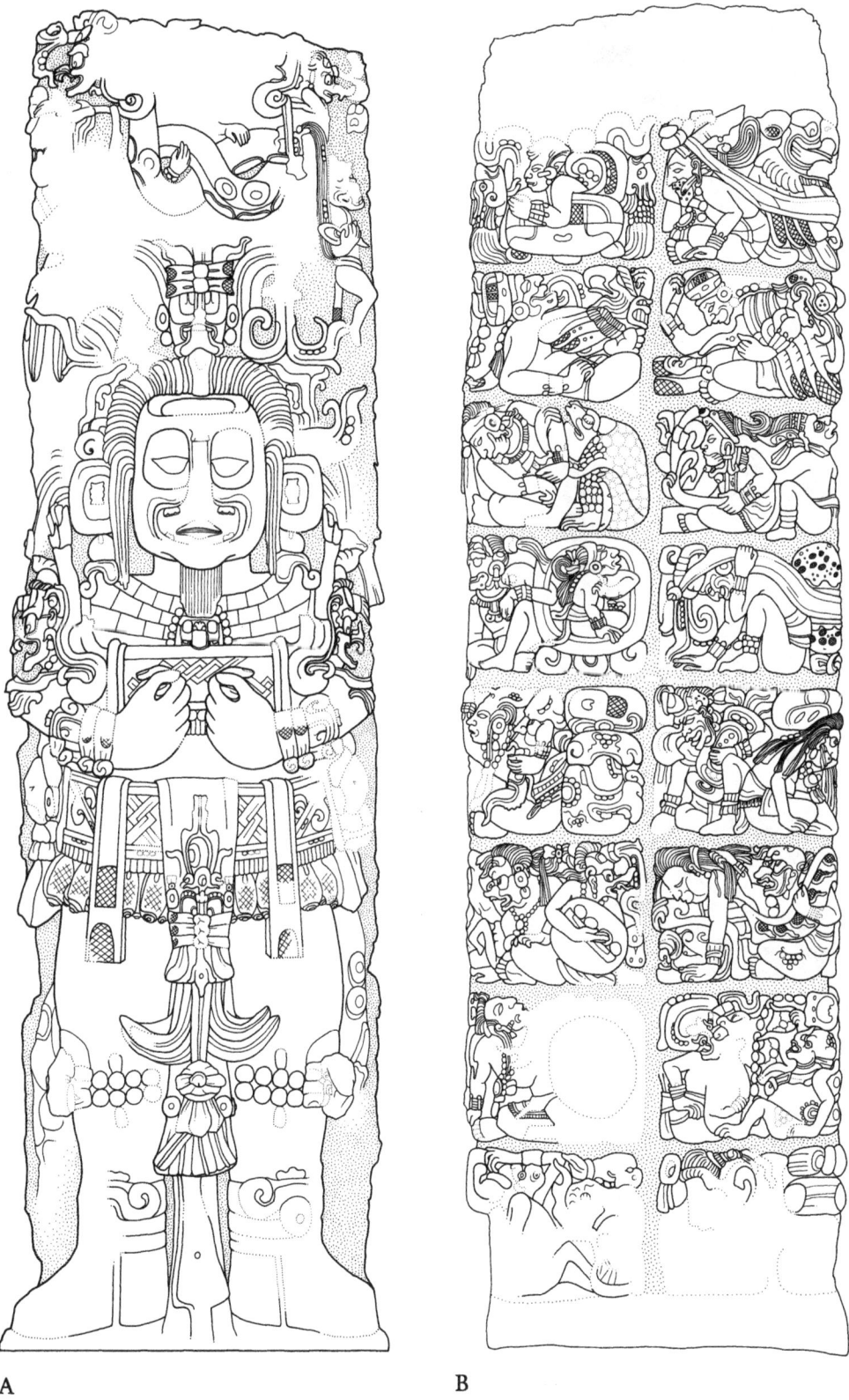

FIG. 11 CPN 7: (a) south side; (b) north side. Drawings by A. Dowd.

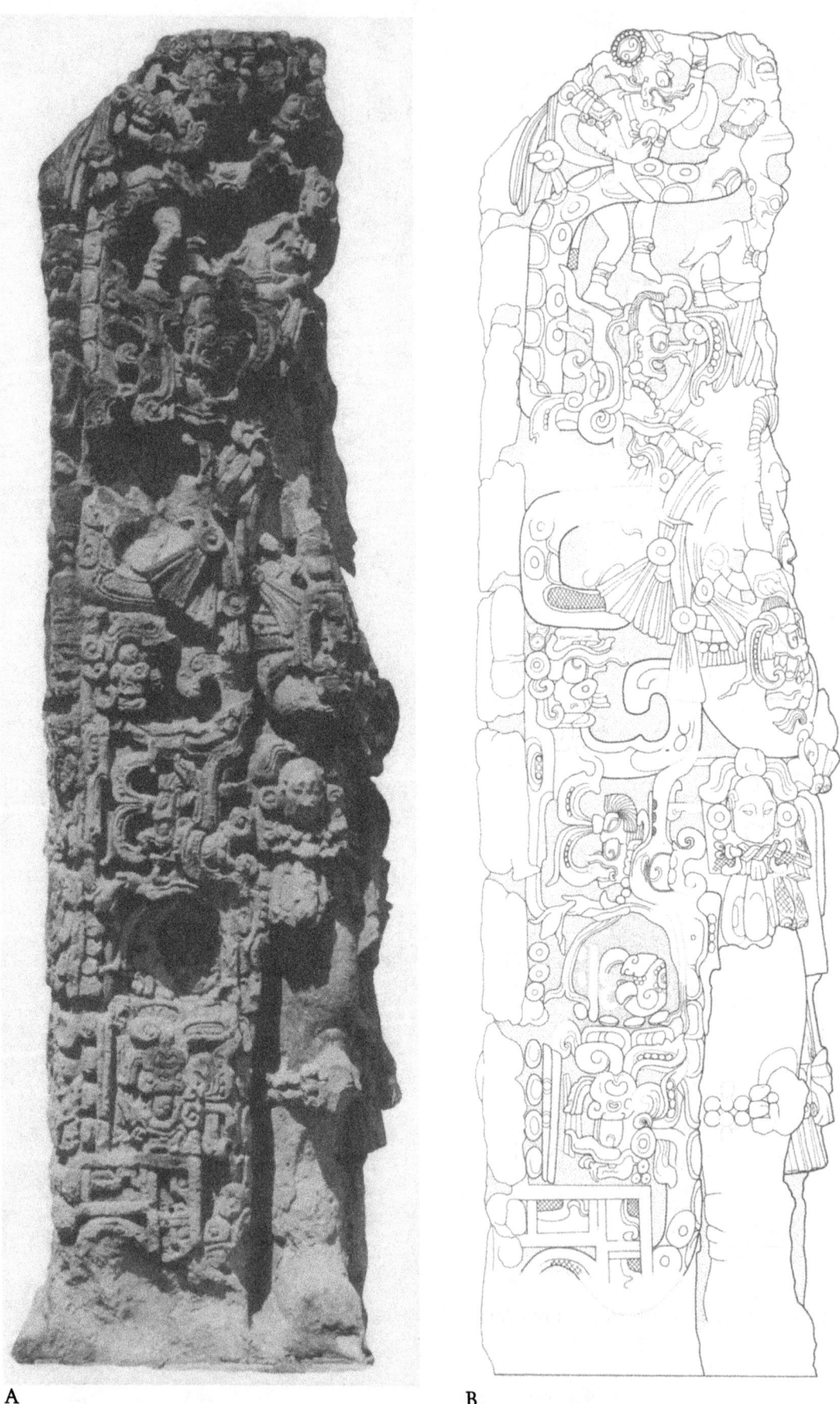

A
B

FIG. 12 CPN 7: west side. Photo by J.-P. Courau; drawing by A. Dowd.

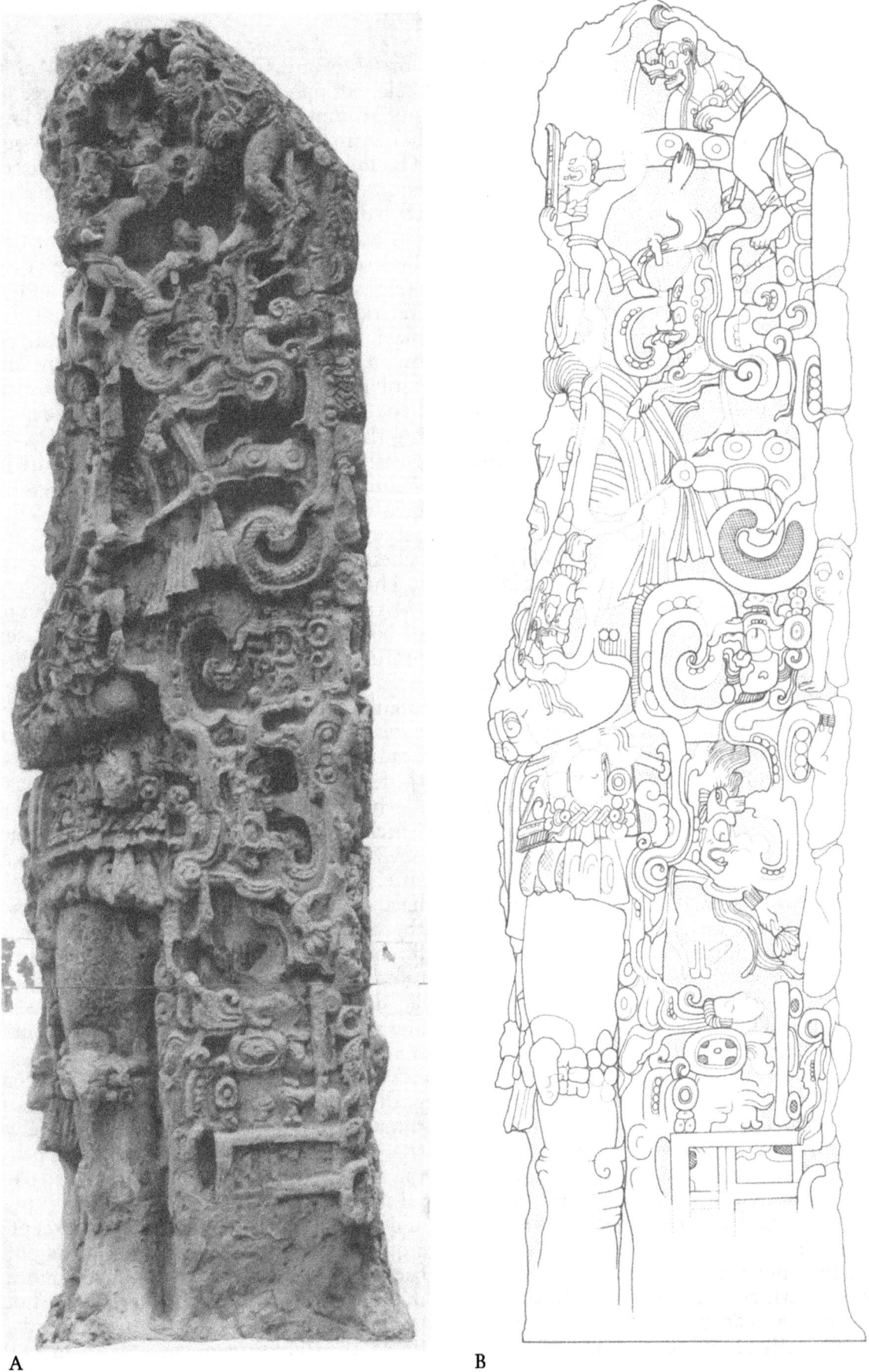

A B

FIG. 13 CPN 7: east side. Photo by J.-P. Courau; drawing by A. Dowd.

double row of beads, they partially cover three knotted bands. The figure's hair is pulled back at the top, while long strands fall along the sides. The figure's eyes peer through the large cutout ovals of his mask, whose forehead is marked with T616b. The mask's mouth displays two molars, and a false beard hangs from the chin. The oval ear ornaments, with a serrated rectangle in the center, are crowned by a serpent jaw and bear a dangling bead.

The main figure wears symbols of death, sacrifice, and royalty. The mask is barely individualized, except for the T616b sign on the forehead. Having sacrificial connotations, this sign is found on the forehead of solar creatures, whether nocturnal (jaguar masks from the bench of Structure 18) or diurnal (the bird on the back of CPN 16). The figure wears the mask of the nocturnal sun, as on the figure on CPN 18, because he is dead. The relative position of the stela and its altar (CPN 8) supports this view. An observer looking at both monuments witnesses the main figure on the stela half hidden by the altar; he or she then gets the impression that the figure is sinking into the death head of the bicephalic earth monster. Further, the T-shaped platform on which the monuments stand has the same form as the forehead of the earth monster into which, on Quiriguá Monuments 23 and 24, the masked dead ruler disappears (Baudez 1988).

Surrounding the Main Figure: A small figure was sitting at the top of the stela; only his hands, which hold two interlaced bicephalic serpents, remain. Each serpent has one of its heads in the front of the monument, while the other is visible on the narrow face on the opposite side. Thus, the head corresponding to the one to the left (east) of the sitting figure can be seen on the stela's west face. All the serpent heads, as well as the creatures in their jaws, are nearly identical to the ends of the serpent bar. The creatures, however, present different objects; the one at the top right (west) of the stela holds a severed head, whereas the figure emerging from the opposite serpent head on the east side presents a plant. The cosmic serpents implicitly demonstrate the duality of sacrifice/growth and death/rebirth.

Each narrow side of the stela further depicts a vertically placed serpent. Its head faces north, toward the hieroglyphic back of the stela. An ophidian creature with the ax-and-smoke motif in the forehead and holding a bud or flower is inside each serpent's mouth. The tail of the serpent does not terminate in another head but sinks "below ground"; although the tail area is eroded, there is in fact not enough room for a second serpent head. Two serpent tails occupy the middle of each stela side between the bicephalic and the monocephalic serpents. An inverted skeletal mask seems to be attached to either tail, adding a negative connotation to both. It is equivalent to the rear death head of bicephalic monsters with the function of expressing the negative pole of a basic duality. The positive pole is manifest by the creature (the Thunderer) who bears vegetation above and below. Thus, the ruler is framed by cosmic serpents who, according to Thompson's (1970) scheme, constitute heaven and earth.

This duality is also expressed by the heads with numerical coefficients on the lower part of both narrow stela sides. In both cases a profile skeletal ophidian head faces north, toward the hieroglyphic back of the stela, on an angular strip which represents the earth (the *caban* sign is infixed). On the west side the head is marked by T629 on the forehead and coiffed with leaves and T24 signs. Other leaves are hidden by the ear ornament. This head, which evokes the skull-and-vegetation motif of CPN 1, is preceded with the number 9 and surely designates a terrestrial image. The head on the stela's east side is marked with the number 7 and T281 (*kan* cross) on the forehead topped with the severed head of the maize figure. Again, the heads express the basic duality with the death head/leaves pair and with the image of the severed head of the maize plant.

Two pairs of grotesque figures associated with the bicephalic serpents preside over the ruler on both narrow stela sides. On the west side the larger grotesque is perched behind the serpent (fig. 12). It has an elongated skeletal upper jaw, round eyes with a scroll pupil, and vegetal motifs behind the ear. Except for a quiff above the forehead, the hair is pulled back and fastened with T632. Ribbon-on-bands make up the bracelets and anklets. Although the large oval behind the left arm is unidentifiable, the right arm grasps a giant lancet that

is topped by an ophidian head with three bands that terminate in vegetation. Both this and the corresponding grotesque on the stela's east side wear a T511 (*muluc*) pectoral flanked by two tripartite elements and the same anklets. Although their faces are similar, the east figure has only a quiff as a hairstyle. A long ribbon hangs from the ear of this empty-handed figure.

The remaining grotesque on each narrow stela side is just above the ruler's head. On the east side a bat-headed figure hangs from the serpent with the left hand and holds a lancet in the right (fig. 13). The large handle is marked with T617a, while the blade tapers to a sharp point. The corresponding figure on the west side is seated. The face is eroded except for an eye with a large ring. He wears the same pectoral, wristlets and anklets as the other grotesques. All these figures seem to be supernatural patrons of sacrifice as evidenced by the lancets they bear, the bat-faced figure (vampire), the ribbon through the ear, and the ringed eye (see CPN 47 and CPN 52).

In sum, the ruler's cosmic frame repeats and reinforces the symbolism of his costume. The serpents express duality in at least two ways. The creatures in their maws hold either a severed head or a life/rebirth symbol, whereas living heads and inverted death heads are attached to the serpent tails.

The heads with numerical coefficients on the narrow sides also express duality: maize or other vegetation emanates from death images. The grotesques holding lancets symbolize sacrifice, as do the personified lancet headdress and its mirror image on the loincloth. This is reminiscent of CPN 3, where the whistongue on the ruler's face is inverted on his headdress (Baudez 1985a).

From the inscription carved in full-figure glyphs on the north side, we know (Baudez and Riese 1990) that the stela is ascribed to Eighteen-Rabbit. Its date is the latest one attested for this ruler. One year later he was already dead at the hands of the lord of Quiriguá. This may be reflected in the iconography of the associated altar, which stresses death and which might have been completed only after the stela was finished and Eighteen-Rabbit had been captured and killed by the people of Quiriguá.

CPN 8 (ALTAR OF STELA D)
(figs. 14–15)

CPN 8 is a nearly square monolith with a bicephalic monster carved in deep relief on the vertical sides. Although the upper surface is smoothly dressed, it is much pitted from erosion. The many traces of red paint indicate that the entire monument was originally painted red.

DIMENSIONS

Height (average) 110 cm; width east-west (at top) 215 cm; width on each side (average) 150 cm.

DISCOVERY, LOCATION, AND ASSOCIATIONS

CPN 8, first mentioned by Stephens, is located approximately 2 m south of CPN 7 and rests on the same low T-shaped platform. Both are similarly oriented toward the south, and their association is unquestionable.

COMPOSITION

The monster carved on the altar is shown both living and dead. The living head occupies the northeast and northwest sides, while the dead head occupies the southeast and southwest sides. A condensed form of the body occupies the east and west corners, with two paws joined to one common leg. Thus, each head is framed by two front legs.

The Northern Head (see fig. 15a): The eyebrows of the living crocodilian head are raised at the ends below a protruding forehead. T23 is below each of the round eyes. The semicircular block under the snout has two notches on each side that might represent filed incisors or the tongue. Curved fangs and two molars jut out from the upper lip. No lower jaw is depicted. The sides of the nose form scrolls accompanied by a semicircle bordered with dots. Two elements of T528 (*cauac*) are apparent on the face. Concentric semicircles edged with dots mark each eye. Three or more rings arranged to form a triangle are distributed over the face: three times on the forehead, above and below the nose, on the cheeks, and on the temples, where they are joined by a U-shaped element. The two forelimbs rest vertically behind the head, where the upper portions also meet the south head. The limbs are skeletal, as the end of the tibia is marked with crescents to indicate bone. The anklet is a band marked with T504 (*akbal*), whose top

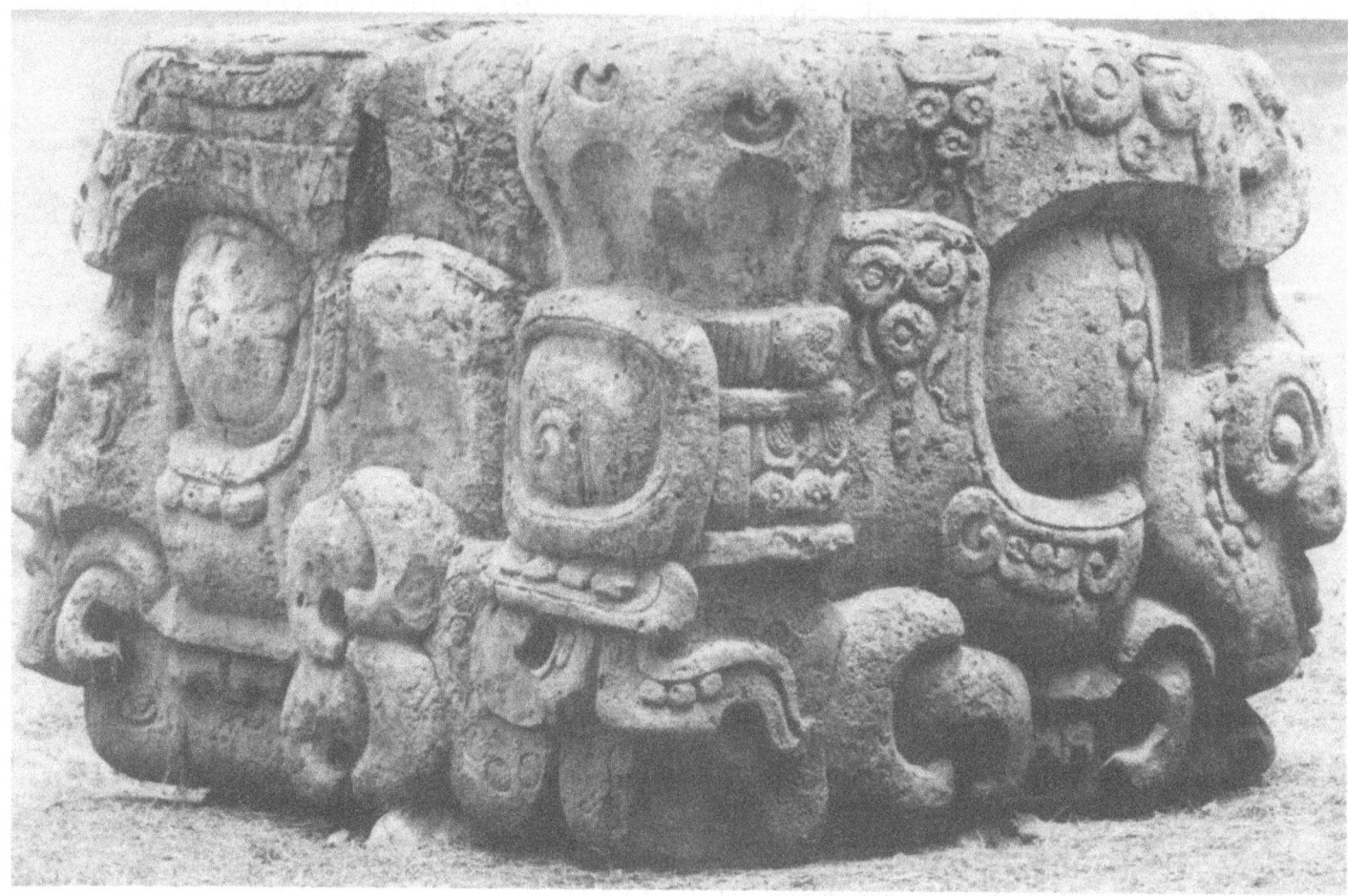

FIG. 14 CPN 8: east side. Photo by J.-P. Courau.

is a sort of collar with bloodstained ribbon. The paw is that of a jaguar, marked with black spots and small circles. A curled claw emerges from a skeletal crescent-shaped digit.

The Southern Head (see fig. 15b): A black spot separates two convex rectangles that contain a blackened arch on the bulging forehead. Two black hoops adorn the temples. The eyebrows turn up into scrolls above round eyes that bear the *kin* sign (T544) and are underlined by three beads. The upper jaw reveals two large incisors flanked by curling fangs and two molars. The mandible is divided into four segments. Undulating lines and crescents denote the jaw and snout as skeletal. The body is reduced to the forelimbs and paws that flank each head. Each leg is common to two paws. It is skeletal: its upper end is a bone marked with crescents. On the live side the anklet is a band marked with T504 (*akbal*) crowned with trimmed feathers and a black-spotted element. On the dead head side the anklet is made of a circular cartouche containing a vertical scroll with a double line and two curved lines at the ends. A beaded band that terminates in a double scroll is below the cartouche. The paws are that of a jaguar, marked with black spots and small circles. Curled claws (one on the live side, two on the dead side) emerge from crescent-shaped digits. These images might convey a double meaning. The ear ornament bears a bone end on top and a jaguar paw on the bottom. This is the inversion of a form of earrings worn by the jaguar, patron of Pax (see an example on CPN 18). In addition, the inversion itself is appropriate for a death head.

INTERPRETATION

CPN 8 represents a monster whose contrasting heads express universal duality (or

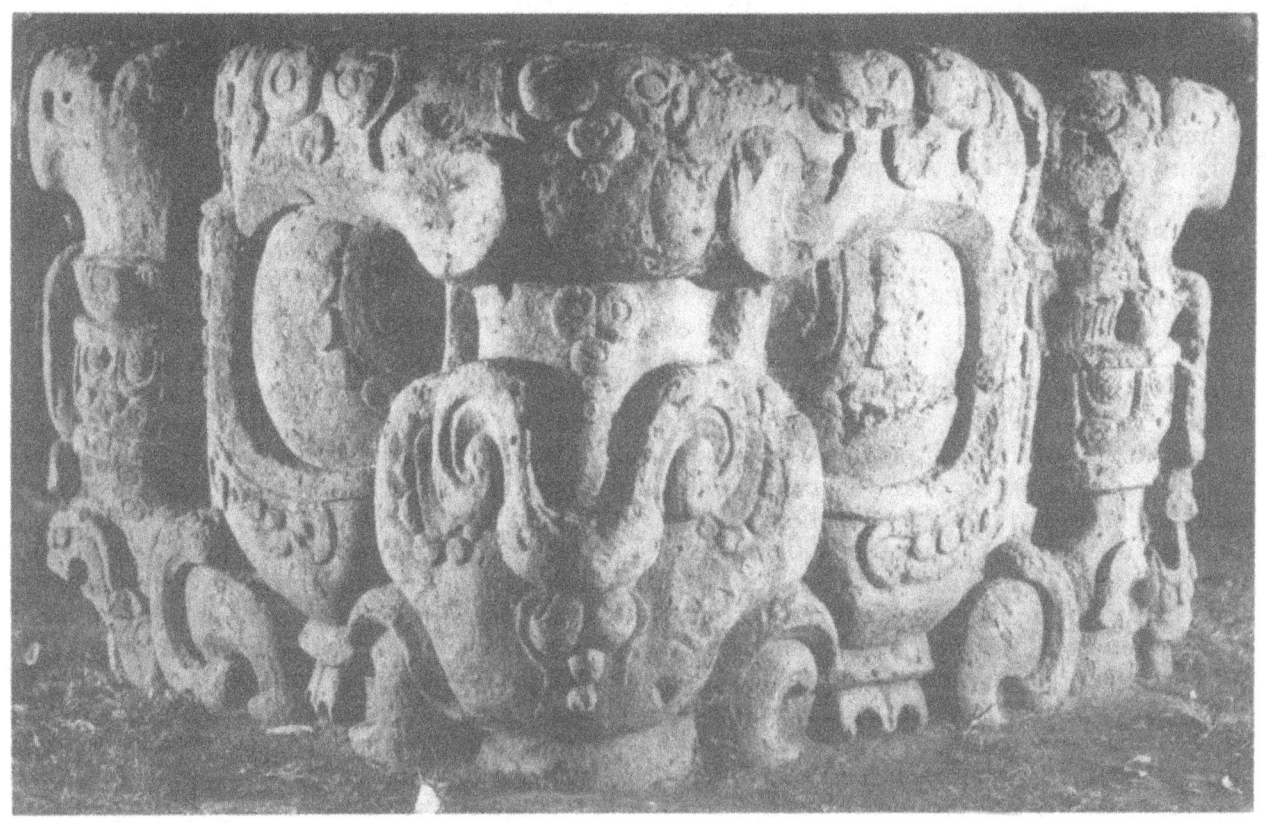

A

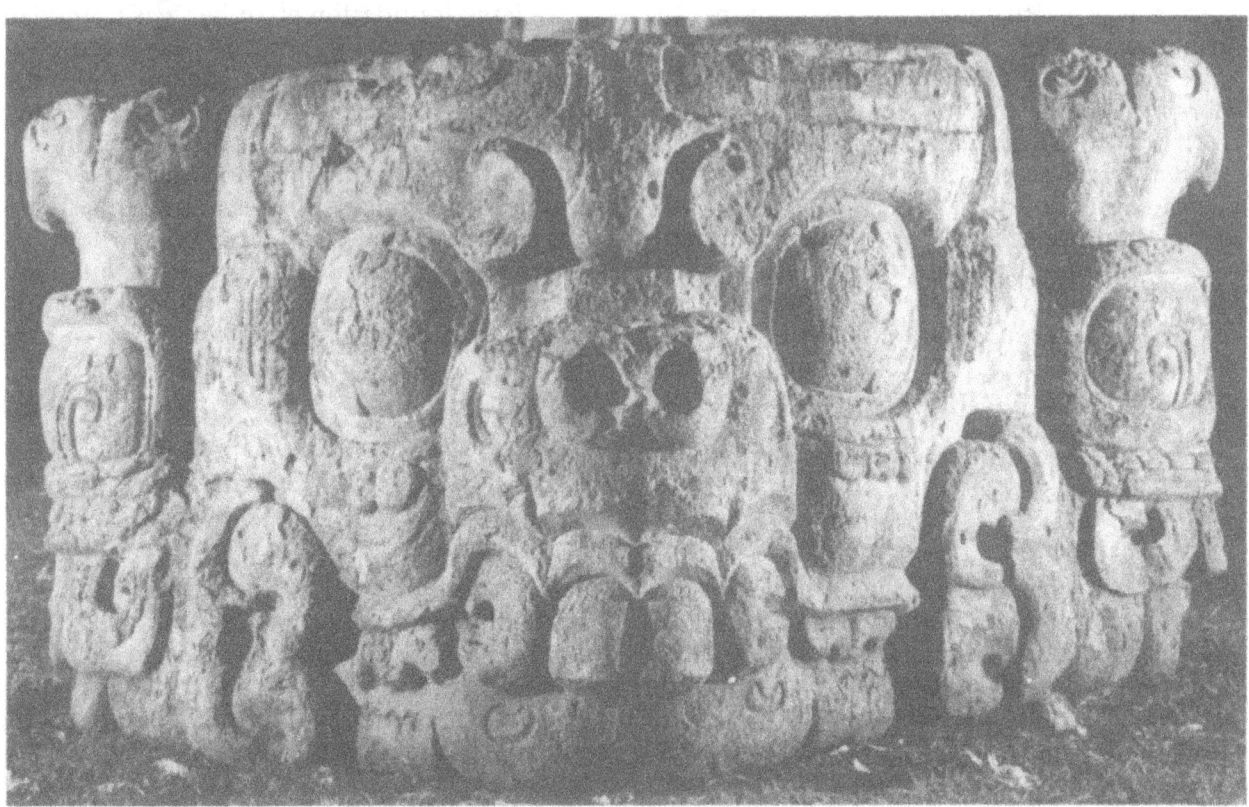

B

FIG. 15 CPN 8: (a) north side; (b) south side. Photos by J.-P. Courau.

ambivalence), the cornerstone of Maya thought. A living crocodilian head is represented on the north. The skull of the nocturnal sun occupies the south side of the altar.

The monster's body favors the south side in its symbolism of death. The legs and claws are skeletal; the jaguar paws of the nocturnal sun bear the *akbal* band signifying darkness on one side and the ear ornament associated with the Pax jaguar or death on the other. The jaguar/sun/death aspect is further accentuated by the orientation of the altar. Since the south side of the altar is visible in front of the stela, the south or death head metaphorically becomes the front head of the monster. The limbs flanking the head look like ear ornaments when seen frontally. Further, they reproduce the inverted image of the ear ornament sometimes worn by jaguar/sun heads: a flare between a jaguar paw and a bone.

On the death side the anklet's central part or the earflare is incised with a vertical hook-shaped scroll, an element used as the pupil of reptilian earthly creatures. On the live head the pupils are *cauac* elements, but placed in such a way as to make the eyes squint. In both cases it is as if eyes of the opposed sign have been added to each head. This may be interpreted as a reminder that life contains in itself a promise of death and vice versa.

That more importance was given to the morbid aspect of this duality supports my hypothesis. In essence CPN 7 is a funerary monument that represents the deceased king, who, behind this altar, appears to sink into the realm of the dead like the old ruler on the west side of CPN 4. The iconography of this altar reiterates the fundamental duality expressed on its stela.

CPN 9 (STELA E)
(fig. 16)

CPN 9 is a prismatic shaft with the east side carved with a standing frontal human and the other three with hieroglyphic inscriptions. The top and base of the stela are severely eroded. The monument is set into the usual cribbing frame of four large rectangular blocks. According to Strömsvik (1941: 70), the "front stone bears defaced carving perhaps similar to knot figure on cribbing of Stela 13. Surface of cribbing decorated with crossed lines probably representing lashings." These decorative patterns are found on the two largest blocks, which might therefore be recut altars.

DIMENSIONS

Maximum height 344 cm; depth (east-west) at base 62 cm; width (north-south) 44 cm; maximum depth of relief (figural side) 25 cm.

DISCOVERY, LOCATION, AND ASSOCIATIONS

Maudslay reported this stela lying on the terrace to the east of Structure 1, while on the Peabody map the stela is located north of the structure. Excavation by the Carnegie archaeologists exposed a well-cut square stone slab (100 cm to the side and 30 cm thick) in an old excavation in front (east) of Structure 1. This slab was thought to be the stela's foundation stone. The monument was set up there after its restoration, where it remains today. This location probably corresponds to its placement when the site was abandoned. But the hieroglyphic text and the style of the stela indicate a much earlier date than has been assigned to the stairs leading to the platform on which it stands. This and the fact that no associated foundation chamber was found led Morley (1920: 107) to assume that the monument was reerected here in ancient times and that its original location was not there, but at an unknown place. A cylindrical altar (CPN 10) was found broken on the Plaza floor close to where the stela itself was found. It is therefore assumed that both were originally associated in a typical stela-altar ensemble. Neither the stela nor the altar has a foundation chamber in its actual location.

DEDICATORY DATE

9.11.13.5.0 13 Ahau 18 Zec (Baudez and Riese 1990). 9.5.0.0.0 11 Ahau 18 Zec (Schele 1987a).

COMPOSITION

CPN 9 is rigorously symmetrical. The main figure is standing with his arms folded very high on the chest, holding a bicephalic serpent. The headdress top is surrounded with a small mask and two ancestor figures. Ropes followed by the knotted serpent motif, then by a large serpent head, frame the main figure from the waist down.

The Main Figure: The defaced head, outlined with beads, wears a headdress made of two eroded masks. The earflares of the king

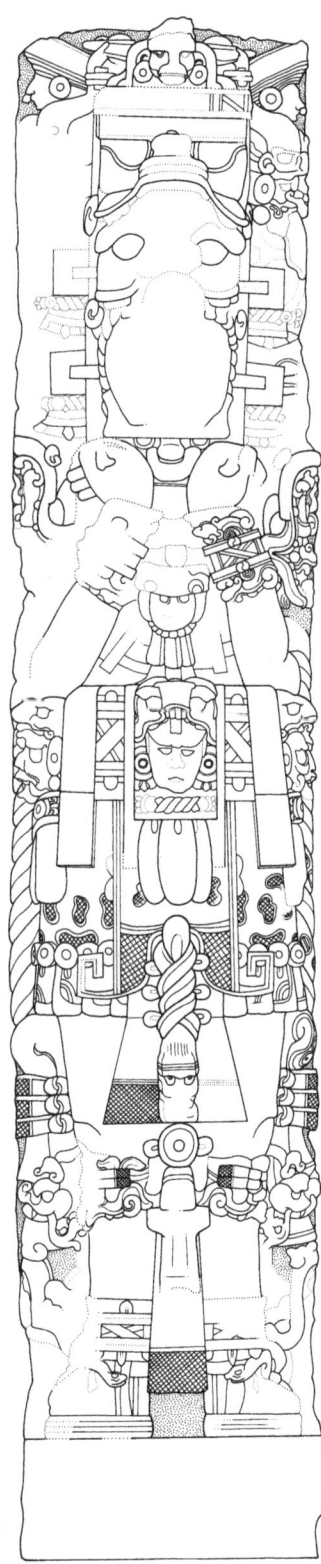

FIG. 16 CPN 9: east side. Drawing by A. Dowd.

(Water Lily–Jaguar for Schele or Smoke-Jaguar Imix-Monster for Riese) as well as those of the lower mask are square with a central hole through which passes a strap, as if to hold them. They are framed above and below by the braid and tassel (T58), below which three radiating elements (T255) show. A mask (of a jaguar?) is beneath the chin. The eroded pectoral consisted of a mask and headdress, with a row of hanging tubular beads. An oval depression, possibly for an inlay, is above the pectoral. The wristlets are made of a cartouche with crossed bands (T552) between two serpent heads with a knotted band above the forehead.

The bicephalic and apparently segmented serpent's body is hardly visible behind the pectoral. The left head—the only complete one—has jaws wide open on the head of a blind jaguar (T1013) with the ax-and-smoke sign sprouting from the forehead, itself decorated with a *cauac* element (T528). The ax-and-smoke is the only recognizable motif on the right side.

The belt is decorated with crossed-bands in panels and three masks. The central mask is that of a young man wearing a realistic jaguar helmet. The same helmet crowns the side masks, which represent a jaguar with goggles on the eyes, serpents at the corners of the mouth, oval earplugs with scroll and bead, a flattened muzzle, a curled upper lip, and a pointed tongue turned to the side. It has no lower jaw, but has squinting eyes and a semicircular cartouche with horizontal lines on the cheeks (T24) and possibly knotted bands above the forehead. This creature is clearly the Pax jaguar. The braid-and-tassel motif underlines each mask. Two pairs of superimposed ribbons hang from the belt. There are three oval tinklers below the central mask and two below the side masks. There they are adorned with parallel lines in an oval cartouche (T24).

The loincloth has the spots of a jaguar and ends as a blackened fishtail. It is framed by two stylized serpent's jaws. The jaguar skirt is lined with a row of beads and tinklers with stone markings (T528). A long hanging apron partly covers the lower tail of the loincloth and hangs down to the feet: it includes a mat, a small eroded mask, several beads, and a tassel. The garters consist of a serpent mask topped by two knotted bands and sprouting

leaves. The anklets are made of the crossed-band motif in a rectangular frame, between two groups of radiating elements (T255). A serpent binds the high-heeled sandals.

Surrounding the Main Figure: A small mask of a prognathous creature with rounded earplugs topped with a scroll crowns the headdress. Water lily(?) stems emanate from the mask. This is another manifestation of the skull-and-vegetation motif, as on CPN 40 and CPN 29. On both sides of the ruler's upper helmet a turbaned figure with circular earflares brandishes an ax. The lower part of the figure is covered by a grotesque agnathic (without a lower jaw) head with a long lolling tongue. It wears an animal helmet and an ear ornament made of a circular piece with a scroll above and a bead below.

On both sides of the main figure a rope hangs down from the elbows; it disappears beyond the skirt's lower rim and continues down to the serpent head, of which it may be the body. The knotted serpent motif flanks the thighs: the body forms a loop tied with three knotted bands. A small serpent emerges from the mouth of the serpent's head, and another one ties the sandal (Proskouriakoff's Type A2).

INTERPRETATION

The iconography of this early stela is much less complex than that of later monuments. The ruler places himself under the patronage of the jaguar. Two jaguar masks make up his headdress, two "blind jaguars" come out of the serpent bar, and two Pax jaguar masks are tied to the sides of the belt. Other sacrificial symbols include lancet heads as knee ornaments and the knotted serpents that flank the legs of the ruler. On the upper part of the stela two turbaned ancestors are threatening invisible victims with their axe. The skull-and-vegetation motif that crowns the whole composition expresses the life cycle.

CPN 11 (STELA F)
(figs. 17–19)

On this prismatic shaft the main figure faces west, but also occupies at least half of the sides of the monument. The back bears an inscription divided by rope loops into five groups of four glyph blocks each. This monument has the deepest relief of any other Copán stela. Although still standing, it has suffered from erosion, especially on the top and the north side. A cribbing frame holds the stela in place.

DIMENSIONS

Maximum height 340 cm; base 85 cm by 85 cm. Cribbing frame 184 cm (north-south) by 171 cm.

DISCOVERY, LOCATION, AND ASSOCIATIONS

In 1839 Stephens found CPN 11 standing 10 m north of CPN 16 and facing CPN 3 across the Plaza. Since it stands upright in its cribbing frame, this is undoubtedly its original location. CPN 11 is associated with CPN 12, a figurative altar. Unlike other contemporaneous stelae in the Main Plaza, CPN 11 does not stand on a circular platform and is not provided with a foundation chamber.

DEDICATORY DATE

9.14.10.0.0 5 Ahau 3 Mac.

THE WEST SIDE

The main figure, standing and holding the serpent bar, is flanked by two bicephalic serpents that edge the entire monument. Six grotesque figures arranged symmetrically in pairs grip the ropes that are the bodies of the two serpents. Three individuals were seated above the main figure's headdress: one in front view, the other two in profile.

The Main Figure: The king is frontally posed with his legs slightly apart and his feet open at a right angle. Just above the belt the upturned hands support the serpent bar. The face looks expressive compared to other Copán monuments. Stephens (1854: 93) describes it in these terms: "The expression is grand, the mouth partly open, and the eyeballs seem starting from the sockets; the intention of the sculptor seems to have been to excite terror." If the haggard look evoked by the bulging eyes and the open mouth is indeed intentional with the purpose of expressing fear or pain, it would be one rare instance of facial expression in the sculpture of Copán. The hair is pulled back on top of the head and falls in long strands along the sides to the shoulders. The headdress is a helmet, doubtless a serpent, because of its resemblance to the serpent head on the upper left.

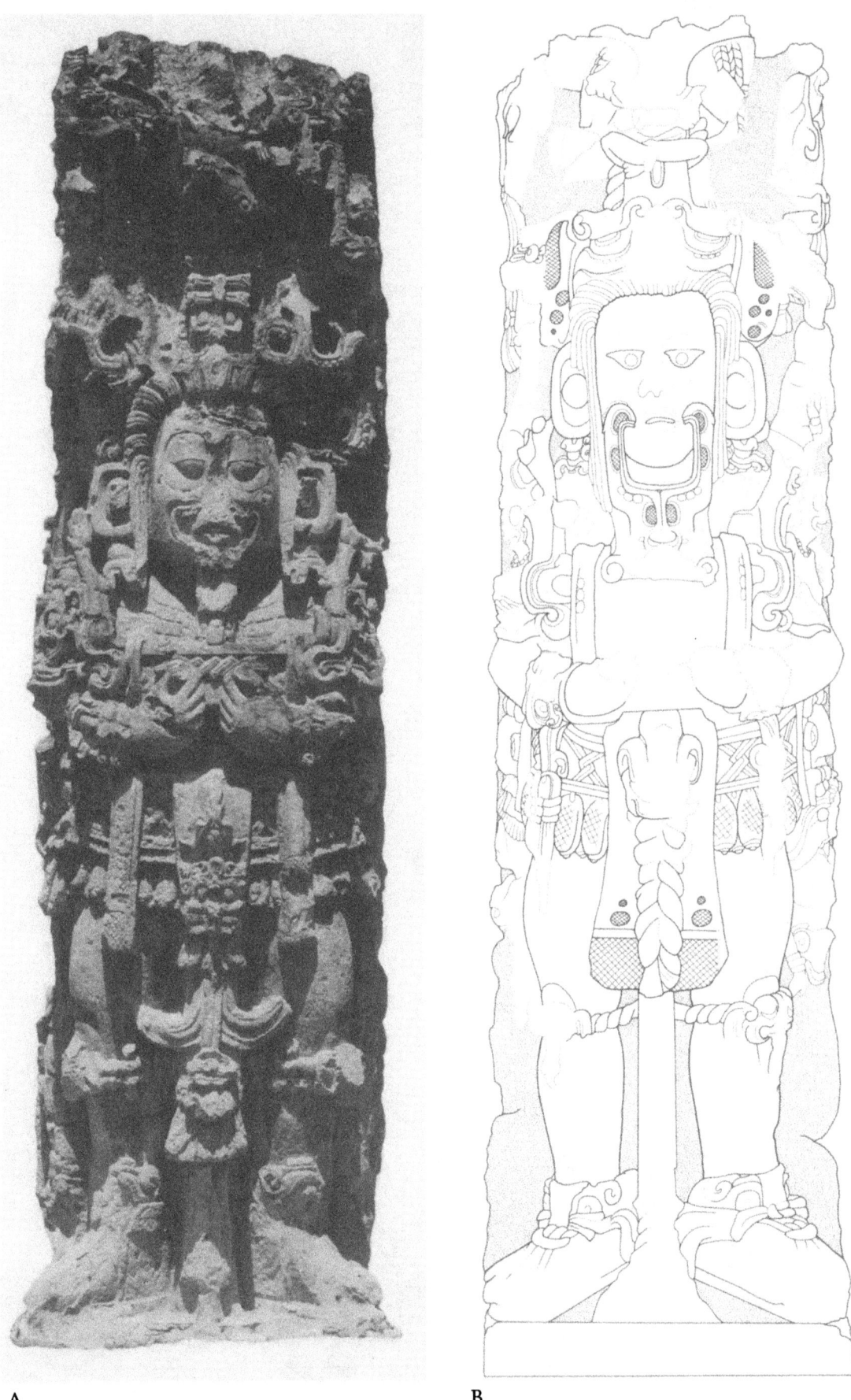

A B

FIG. 17 CPN 11: west side. Photo by J.-P. Courau; drawing by A. Dowd.

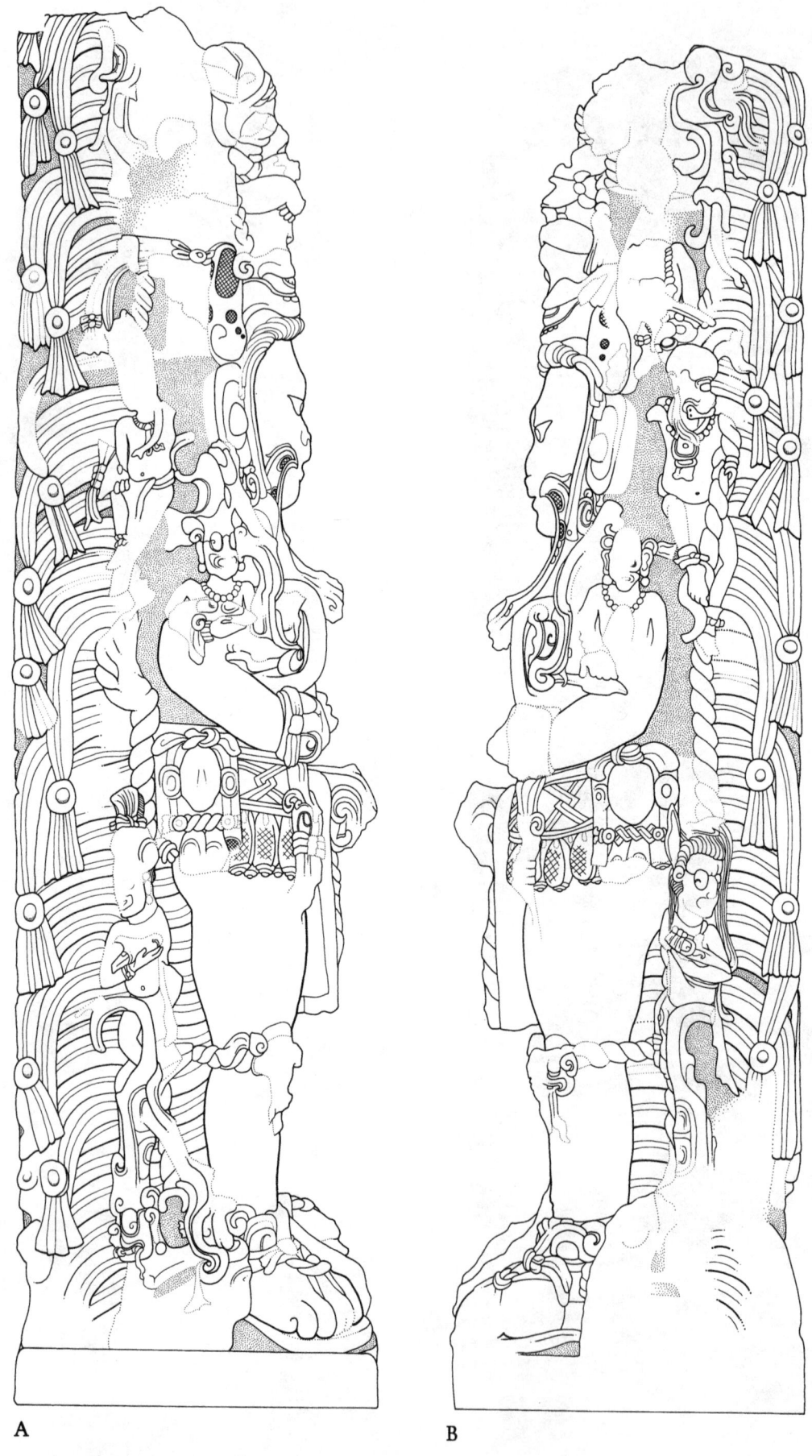

FIG. 18 CPN 11: (a) north side; (b) south side. Drawings by A. Dowd.

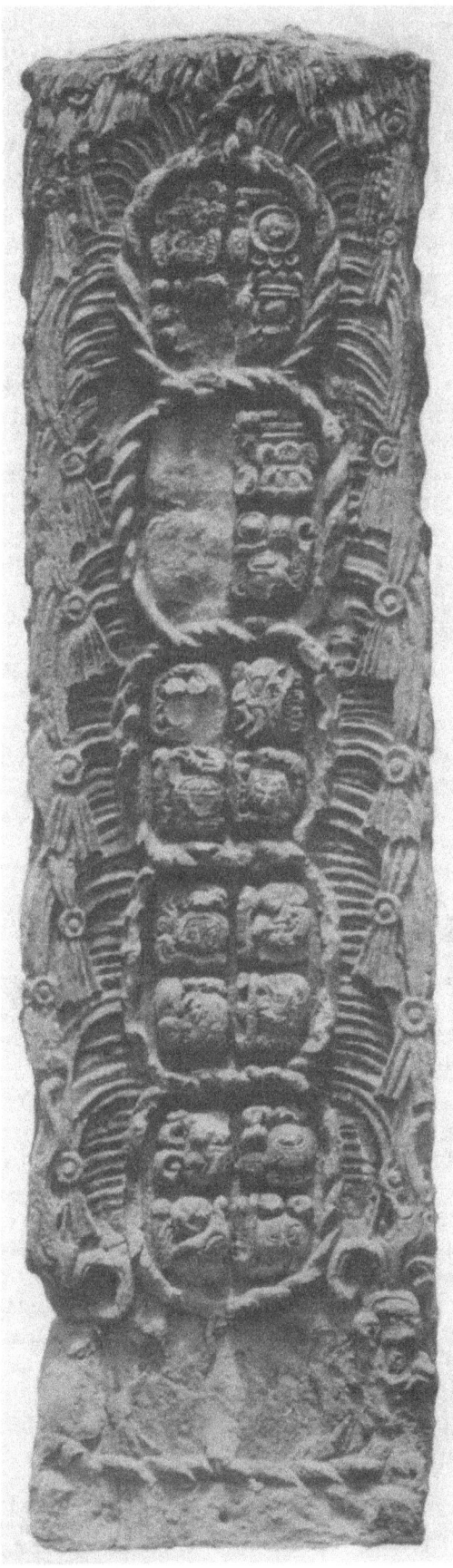

FIG. 19 CPN 11: east side. Photo by J.-P. Courau.

The large oval ear ornaments have serpent's heads at the bottom and jaguar ears above (compare with those on the solar creature from the central block of Structure 24). The lower part of the face is covered by the whistongue, which leans upon the serpent bar. The knife-tongue that is the active component of the lancet (Baudez 1985a) is broken here. The scrolls that indicate the fangs are near the crack. The serpent bar is high and short, with a body limited by two beaded bands.

The damaged serpent jaws on either end hold the bust of a grotesque figure with a skull in the form of an eccentric knife, big scroll eyes, and wrinkles accentuating his mouth. The better-preserved figure is on the main figure's right. It wears a necklace with round beads and holds a personified lancet made of a serpentine head coiffed with knotted bands. The left figure might have resembled this one. The personified lancet is also featured on the wristlets and anklets: the serpent heads are right-side-up on the wrists but inverted on the anklets. The belt is decorated with the oft-repeated twisted-band motif. The lateral masks are youth heads with a knot at the top of the skull and a braid below the chin. The personified lancet is featured inverted on the two ribbons that hang from the belt. Blackened *Oliva* shells used as tinklers also hang from the belt. The large apron of the loincloth has a flared end with black spots of different sizes that are reminiscent of those on the false ears of the main figure or the feathers of the *muan* bird. A damaged mask is in the center of the belt, over the loincloth. It is a personified and inverted lancet (compare with the lancet on the ribbon at close hand). A rope, another image of sacrifice and mortification, emerges from below this mask and occupies the center of the loincloth. At knee level a rope binds two, presently quite damaged, small masks; their wavy eyelids, short pointed ears, and unwieldy triple-forked tongues are still visible. This could associate these creatures with the bloodthirsty beings who are part of the sacrificial imagery. The main figure wears sandals with only the ankle straps remaining.

Surrounding the Main Figure: Only remnants of the three figures at the top of the stela are preserved. The central figure, presented in

frontal view, still has traces of the crossed legs, the end of the loincloth, and part of a rope. The two profile figures who frame him lean sharply outward; traces of their rope belts coiled several times around their waists still remain. This could identify them as captives, if their dominating positions were not incompatible with the status of prisoners. They are rather ancestors shown as "penitents."

A cord with grotesque figures attached runs along either side of the principal figure. Each cord is a bicephalic serpent with asymmetrical heads; the living head, near the main figure's feet, faces outward. Its jaws open onto a grotesque creature of eccentric shape, with a very elongated skull ending in a hook bearing a cartouche enclosing two superimposed circles. The rear head of the serpent is agnathic and skeletal and inverted in two ways: inward (toward the main figure) and also downward (toward the rear head).

Three grotesque creatures were placed along this cord at the main figure's sides. The upper figures, of whom only a few traces remain, were at the level of the helmet. To the south part of a torso, a bit of rope, a left arm, and a foot with two knotted bands that encircle the ankle are visible. This individual bore an object on a tray. All that remains of the symmetrical figure is a foot covered with knotted bands and a pectoral in the form of a knot.

The middle figures frame the head of the ruler. The left one, almost standing, holds himself with his remaining hand by the cord that passes between his feet. The head is skeletal; ribbons hang from the ears; a necklace of round beads encircles the neck; and glyph T511 is presented as a pectoral. The anklets are of the ribbon-on-band type. The figure on the other side, now headless, holds an anvil-shaped object with ribbons attached by three knotted bands. These probably are bloodstained strips, an autosacrificial offering. The pectoral resembles the ear ornament worn frequently by death heads (T122); the trace of a ribbon hanging from the ear is a distinctive sign denoting sacrificial victims.

The last creatures, which accompany the ruler at thigh level, grasp a serpent-head lancet in their bent arms. The figure to the right of the ruler, the better preserved of the two, has large scroll-eyes and long ears without visible markings. The other figure, also with apparently nonhuman ears, has his hair pulled up in a tuft at the top of the head and attached with knotted bands; this headdress is the same as that of captives and autosacrificial victims.

THE EAST SIDE

The inscription that rises in high relief from a background of feathers is framed by rope loops. The rope is certainly more than an ornament here, judging by its role on the front of the monument. It places the inscription under the auspices of sacrifice. The sculpture is quite deteriorated below the text, but a profile skeletal head with foliage is visible. There is room for another head toward the south, since it is possible that, as on the west face, the rope that encircles the inscription is in fact presented as the body of a bicephalic serpent whose heads (or at least one of them) illustrate the theme of death and rebirth.

INTERPRETATION

The western face of CPN 11 depicts the Copán ruler Eighteen-Rabbit framed by two celestial bicephalic serpents. Another two-headed monster probably frames the inscription on the back of the monument. In both cases, the rope associates the ruler depicted or mentioned in the hieroglyphic text with the theme of sacrifice. On the west side the front heads of the monsters contain a creature whose skull is an eccentric. The costume and attributes of the king underscore his role as a victim: his loincloth represents a feather from the *muan* bird; his ears show his place in the underworld; the rope entwining his knees, which most likely continues onto his loincloth, signifies his role as sacrificial victim, as do the lancet in the center of the belt and the pendant ribbons. At the same time the figures with eccentric skulls (heads) who emerge from the serpent bar also express sacrifice. The whistongue, finally, is ostentatious. The ruler is surrounded by ancestors, penitents, and patrons of sacrifice. The latter incite the king to autosacrifice, presenting lancets or bloodstained strips; their skeletal heads, jaguar ears, and sacrificial hair style designate them as dwellers of the underworld.

COMPARISONS

CPN 11—perhaps together with CPN 43—contrasts with other Copán monuments in

that its iconography exclusively treats sacrifice. The peculiar rope frame of the inscription is also found on the Templo Olvidado in Palenque, which dates to 9.10.14.5.10 3 Oc 3 Pop.

CPN 12 (ALTAR OF STELA F)
(fig. 20)

CPN 12 is a composite zoomorphic sculpture. Five individual stones form two jaguars standing upside down against a double jaguar mask. The north and south blocks that form part of the diving jaguars have disappeared since Maudslay's time.

DIMENSIONS
Central block 179 cm (north-south) by 110 cm by 117 cm high; west block (the only other complete piece) 46 cm (north-south) by 55 cm by 80 cm high. Original dimensions (estimated) 280 cm (north-south) by 220 cm.

DISCOVERY, LOCATION, AND ASSOCIATIONS
Stephens mentions only an altar in front of CPN 11. Maudslay first described it as if it were composed of a single block and thus had difficulties understanding it (1889–1902: vol. I, pl. 50–51). Later he discovered the blocks, permitting him to reconstruct the entire sculpture, which he photographed and illustrated. CPN 12 is located in the Main Plaza a few meters to the west of CPN 11, facing the front of the stela; this is undoubtedly its original location. Under it is a small rectangular masonry chamber with a circular floor and roof. The roof is at ground level and measures 60 cm in diameter and 20 cm thick. The chamber contained a "cache-bowl."

OVERALL FORM AND COMPOSITION
CPN 12 is composed of five blocks. The central and largest block has a rounded rectangular form; at each of its sides and in the center a smaller block was placed to complete the composition. Thus, the design is cruciform: on the east-west axis two great jaguar masks are placed back to back; on the north-south axis two whole jaguars lean against each other in a diving pose. Their forelimbs are at ground level and their rear limbs and tails are at the top of the central block.

The Jaguar Masks: On the main block their foreheads are wrapped with bands (single on the west, but double on the east) that are partially hidden by the back legs of the diving jaguars. These bands are ostensibly knotted to the north and south, under each jaguar's tail, and are covered at their middles by two knotted strips. On the west in unoccupied corners a double bow contains a hatched zone that reproduces glyph T617a. The big round eyes squint: the square unblackened pupil is encircled by double Ls. From the base of the nose a narrow band passes under the eye and ends in a scroll on the side of the mask, above the jaws. This band is bordered by triple beads. On either side of the muzzle the upper lip curls up over a large molar.

The lateral blocks on either side contain the nose, adorned with a tube; a rectangular muzzle with an upturned end; an upper lip above two curved fangs and a pointed tongue. The absence of the lower jaw, the short muzzle, the pointed tongue, the nose tube and the knotted bands, and the stone forehead lead us to identify these masks as those of the jaguar, more particularly the jaguar patron of Pax by the knife-tongue, the knotted bands, and the absence of a mandible.

The Diving Jaguars: The head and the forelimbs were carved on the blocks that were added to the north and south of the central block. The paws had three claws. A scarf was knotted under the chin, as on most of the jaguars from underworld scenes painted on ceramics (see, for example, Robicsek and Hales 1981: vessels 29, 30, 31, 33, 39, 40, 45, 46, 47, etc.). The jaguar wore a knotted band on his head (T60). In Maudslay's drawing the animal cheeks seem to have had hollows for obsidian inlays, as do the felines in the Jaguar Stairway of Structure 24. On the central block the rear limbs, with the legs turned upward, occupy the top and the sides. They are portrayed in great detail, with two claws at the front and a third behind. The tails are strongly emphasized; they are disposed horizontally on the upper part of the altar, adorned with black spots, and terminate in an ornament composed of a band, an inverted *ahau*, and a scroll, which should be interpreted as a variant of T535. This is the iconographic version of a title such as "Our Lord Jaguar."

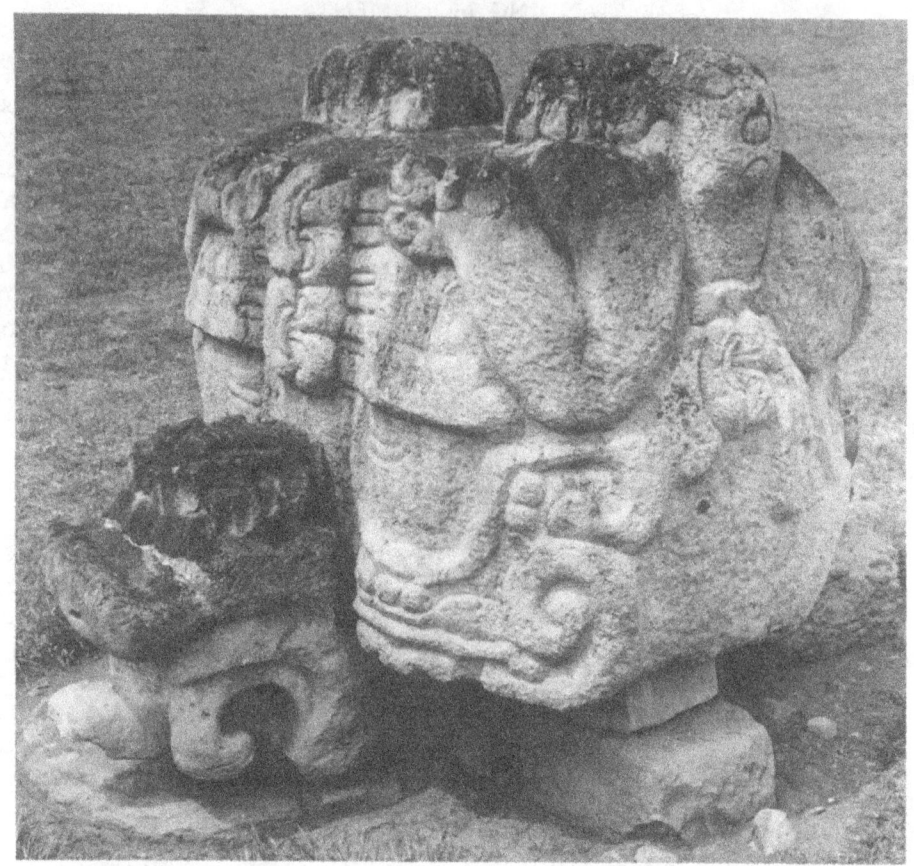

A

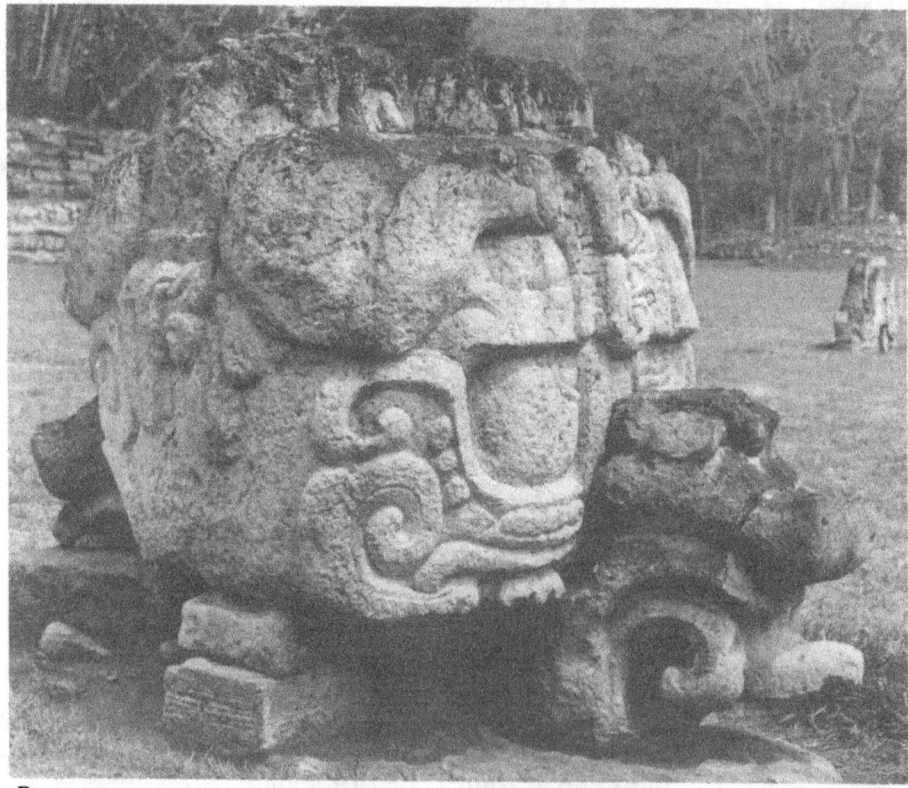

B

FIG. 20 CPN 12: (a) west side; (b) south side. Photos by J.-P. Courau.

INTERPRETATION

Four jaguars are arranged in cruciform plan on two axes. On the north-south axis the complete felines are presented realistically. Conversely, on the east-west axis two conventional masks are placed back to back. The cruciform construction may symbolize the jaguar in the four corners of the universe as the patron of the month Pax. There is no significant opposition between the masks and the diving jaguars. Both are patrons of sacrifice, as indicated by the scarves around their necks and by their diving postures; this could be a reminder that the jaguar symbolizes the setting sun or might be an expression of the inversion that applies to the underworld. Be that as it may, one finds this same position on a vase from the Popol Vuh Museum (Robicsek and Hales 1981: fig. 88), where the jaguar is portrayed among creatures who are all directly linked to sacrificial rites.

The altar's iconography perfectly accords with its associated stela. The portrait of the king in mortification corresponds to the sacrificial altar in the quadruple form of the Pax jaguar, the principal patron and beneficiary of blood rites.

CPN 13, 14, AND 15

Since CPN 13, 14, and 15 are silhouette sculptures distinct from other Copán monuments but similar to each other, they are presented together. CPN 14 and 15 are similar in form and in the composition of their inscriptions, but CPN 13 is somewhat different. Both faces of all three display a bicephalic feathered monster with a rectangular indentation in the middle of the body. A short hieroglyphic inscription is placed on both sides of the central indentation.

DISCOVERY AND LOCATION

Stephens (1854: 93) alluded to an altar (R on his plan) among "a mass of fallen sculpture" between CPN 11 and CPN 16. This could be one of the three altars discussed here. In 1885 Maudslay saw them close together on the Main Plaza between CPN 16 and CPN 11, where they remain today. Their location suggests that they were placed as a counterpart to CPN 43. They all face the west side of the Plaza and complete the eastern alignment of monuments CPN 16, 13, 14, 15, and 11, although, as we will see later, they probably were originally architectural sculptures. One may suspect them to have been parts of the decoration of Structure 3.

DEDICATORY DATE

Riese (in Baudez and Riese 1990) has shown that the three sculptures must be considered as a single text to be read sequentially, beginning with CPN 15 with a dedicatory date of 9.17.0.0.0 13 Ahau 18 Cumku, followed by CPN 14: 9.18.5.0.0 4 Ahau 13 Ceh, and ending with CPN 13: 9.18.10.0.0 10 Ahau 8 Zac. Schele and Freidel (1990: 322) give 9.16.15.0.0 as the dedicatory date of CPN 15. Schele (1987e) agrees with the date given by Riese for CPN 13.

CPN 13 (ALTAR G1)
(fig. 21)

Nearly identical bicephalic feathered serpents are carved on both faces of this silhouette sculpture. The lower rectilinear part must have rested on a plane surface (a platform, an edge, a step, etc.). The upper edge is very irregular but has three smooth planes arranged to carry tenons of sculptures or other salient architectural elements. The largest, which is in the form of a U, is above the vertical hieroglyphic panel; another is just behind the eyebrow of the living head; a third is above the water lily blossom that comes out of the dead head.

DIMENSIONS

255 cm long, 143 cm high, and 28 cm thick.

COMPOSITION

The monster has two heads facing opposite directions, and each has two front paws. Thus, there is no front/rear opposition as on CPN 25, for example, where the four feet are oriented in the same direction. The central part of the monument, where the monster's body should be, is filled by a bicolumnar inscription on a feathered background.

The Dead Half of the Monster: Its maw contains the bust of a figure with an elongated head; a T-shaped cartouche with T617a infixed in the lower corners is stamped on the forehead. The oval scroll-eyes are ringed. The mouth is accentuated with wrinkles. The rectangular ear ornaments have a top scroll. The hair is pulled back into a single lock. This solar creature wears a necklace with several

FIG. 21 CPN 13: (a) north side; (b) south side. Drawings by A. Blanck.

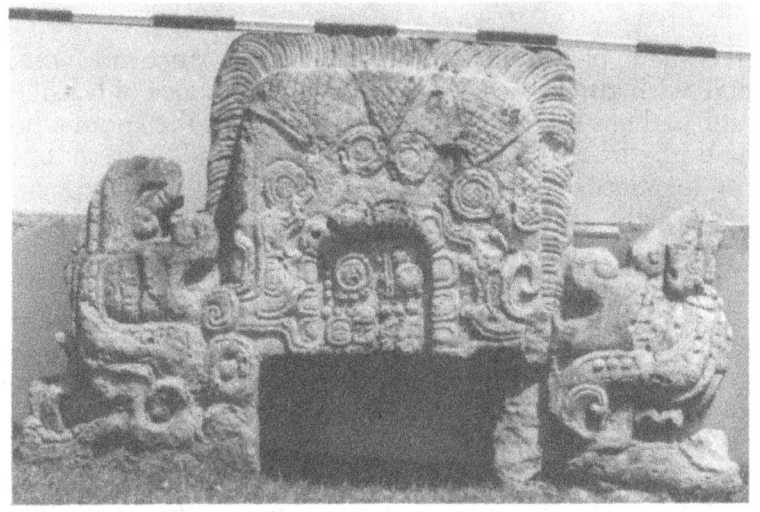

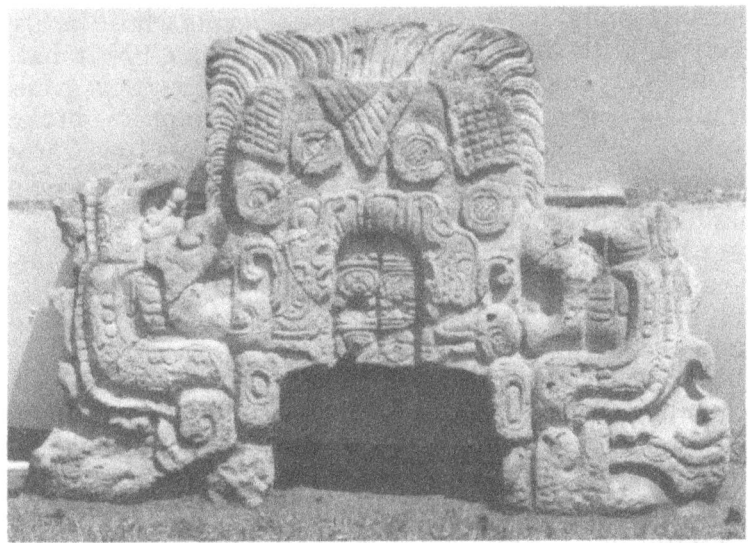

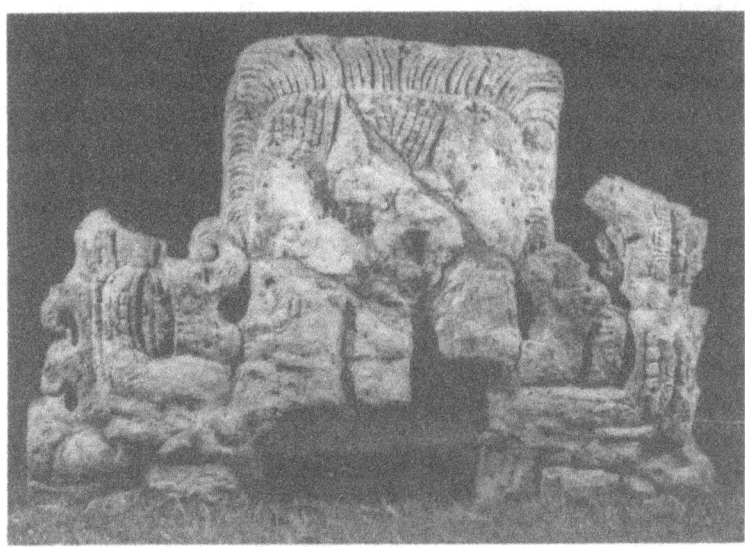

FIG. 22 CPN 14: (a) east side; (b) west side; CPN 15: (c) west side. Photos by J.-P. Courau.

rows of beads and wristlets made of tubular beads. The foot is skeletal with three toes, two in front and one behind, perhaps like that of a deer. The bones of the limbs are realistic, but bear a wavy line. The necklace is composed of radiating elements with regularly spaced death eyes. The eyebrows are U-shaped with scrolls at the ends. On the left profile (to the south) a stylized water lily blossom emerges from the lower scroll. It is replaced on the right profile by an ear ornament terminating in a grotesque head with a whistongue and an eccentric knife skull stamped with T616b. The eye is rectangular, with a blackened eyelid(?). The nose is without tubes. The upper jaw is plain and skeletal, with large hooked fangs and very large terminal fangs. The mandible is also skeletal, with molars and fangs, and decorated with wavy lines and little circles. There is no tongue.

The Living Half of the Monster: The figure contained in the maws has his forehead decorated with a knotted water lily. The almond eyes are encircled. He has high cheekbones and a prognathian mouth framed by whiskers. His circular ear ornaments contain three small circles. This *bacab* wears a necklace of round beads, with another large bead as a clasp. The wristlets are tubular beads. The foot is the same as that of the dead half, but with flesh. There is no necklace. The eyebrows are U-shaped with a scroll above, while below a shell terminates in a band with a curled end and two big black spots; this has the same shape as the upper jaw. It is bordered by the stylized linear jaw of a serpent. There is a water lily pad with an indented edge between the eyebrow and the end of the snout. The eye is rectangular, with a circular black pupil, and half covered by the eyelid, bearing the *ek* sign. The nose has tubes. A grotesque decorative jaguar head is attached to the upturned end of the upper jaw. It has semicircular black spots and is provided with molars and fangs. The mandible has semicircular black spots, with molars and fangs. The tongue is formed as a stylized serpent jaw.

INTERPRETATION

The bicephalic monster embodies two facets as expressed by the living and dead heads. It is possible that it symbolizes the heavens and not the earth, since no *cauac* elements are found. The presence of feathers and the decorative masks on the snout—both characteristic of later periods—are noteworthy.

CPN 14 (Altar G2)
(fig. 22a,b)

The same bicephalic serpent is carved on both faces. The stone forms an arch with a rectangular opening into which a piece of sculpture of an architectural element was inset. CPN 14 and CPN 15 could have framed the head of a statue in the manner of the first figure seated on the Hieroglyphic Stairway of Structure 26; his helmet is framed by two interlacing serpents whose heads are at the same level as his own. CPN 14 has on each side a centrally placed vertical panel of four glyph blocks. The sculpture, broken into several pieces, was restored by Carnegie archaeologists.

DIMENSIONS

170 cm long, 115 cm high, and 33 cm thick; the arch opening is 52 cm wide and 33 cm high.

DESCRIPTION

A bicephalic serpent, similar on both sides of the monument, has two identical living heads. The wide-open jaws show the palate striped on both sides of a middle line. Semicircular blackened spots decorate the jaws; the nose is pierced by tubes; the eyebrow is U-shaped with a scroll at either end; the eye with the hook-pupil is half covered by a striped drooping eyelid. A large water lily blossom emerges from behind the ear ornament. Framing the inscription, the serpent's body is bordered by featherwork marked with circular and triangular black spots that indicate the scales.

CPN 15 (Altar G3)
(fig. 22c)

CPN 15 is similar to CPN 14, but smaller and carved with less care. Each side carries a centrally placed vertical panel of four glyph blocks. One side is almost completely eroded.

DIMENSIONS

187 cm long, 110 cm high, and 38 cm thick; the arch opening is 36 cm high and 59 cm wide.

CPN 16 (STELA H)
(figs. 23, 24; Maudslay 1889–1902: vol. 1, pl. 54–61)

The broad west side depicts a frontal standing person, whose costume extends onto the adjoining narrow sides. The broad east side is carved with a cosmological composition above a small panel of glyph blocks. Traces of red paint remain in many places. The stela is secured in place by a cribbing frame composed of several rectangular blocks of stone.

DIMENSIONS
Maximum height 356 cm; length and width at base 100 and 95 cm. The cribbing frame measures 212 cm (east-west) by 180 cm and is 29 cm high.

DISCOVERY, LOCATION, AND ASSOCIATIONS
CPN 16 was discovered by Stephens standing upright in its present location on the Main Plaza. It is approximately 40 m east of CPN 1 and 25 m south of CPN 11, in the center of a low circular platform on top of a cruciform masonry chamber. The latter contained a cache of 33 whole beads of hard stone (18 jade), 105 fragments of stone beads (13 jade), fragments of plaques, two shells, and two legs of a *tumbaga* figurine (51% gold, 44% copper, and 5% silver) of Panamanian origin. CPN 16 is associated with an altar (CPN 17). The setting of CPN 16 facing CPN 1 across the Plaza may be significant, as suggested by their respective iconography and epigraphy.

DEDICATORY DATE
9.14.19.5.0 4 Ahau 18 Muan.

COMPOSITION
The main figure and its costume occupy the entire west front and half of the north and south sides, the other half being decorated with interlaced serpents and anthropomorphs. The back of the monument presents a cosmological composition. Featherwork fills the otherwise free spaces on the entire stela.

THE WEST SIDE

The Main Figure: The figure seems to be of a youth. Although the hair is pulled back at the top, long strands frame the face. A row of tubular beads crowns the forehead, topped by a large helmet whose nose portion is broken; it probably represents a bird, since it is flanked by wings in which a serpent head constitutes the wing's framework (Spinden's "wing panel"). It has large square eyes with scroll pupils and its forehead is decorated with T616b. Its oval ear ornaments are framed by a vegetal motif above and a serpent head below. The upper jaw has two molars and two scroll fangs.

The main figure wears nearly circular ear ornaments with a serrated rectangle in the center and one bead at the bottom. A large cape of jade plaques covers the shoulder and chest. Hanging from the neck is a long tubular bead with three smaller radiating beads at each end. Both arms are pressed against the chest, with the upturned hands holding the serpent bar, partially hidden by the bead. The bar itself is decorated with the mat pattern. The serpent heads at the ends have a skeletal, bearded jaw. Their maws enclose a grotesque figure whose skull is in the shape of a stone eccentric. The sign consisting of a wavy line bordered with dots confirms this interpretation. The creature has the ax-and-smoke implanted in the forehead. He has large oval eyes with circular pupils at the top and ears adorned with a top scroll and a lower bead.

The main figure wears wristlets made of several rows of round beads with a feather border. A small grotesque mask hangs from the serpent bar and is visible between the figure's hands. It is framed by beads and has large eyes and wrinkles around the mouth. From the belt hang ribbons with blackened ends; they are partly covered with a braid adorned with round and bell-shaped beads. The belt supports two small side masks with T616b on the forehead, squinting eyes, mouth wrinkles, and ear ornaments with scroll and bead; they are underlined with the mat motif and T255. The large mask at the center of the belt probably represents a *xoc* fish; it has round scroll eyes, triangular teeth, and tufts of hair on the temples, cheeks, and on both sides of the now-broken muzzle. A *Spondylus* shell (a death symbol) replaces the mask's jaw and indicates that the jaw is skeletal. The same image appears on Quiriguá Zoomorph P, where a *Spondylus* shell substitutes for the jaw of the rear skeletal head of the monster. The central mask continues as a braid-and-tassel. The figure wears a long skirt of jaguar skin covered with a netted beadwork that forms a diamond pattern. Sandals with thick soles and fringed heels cover the feet.

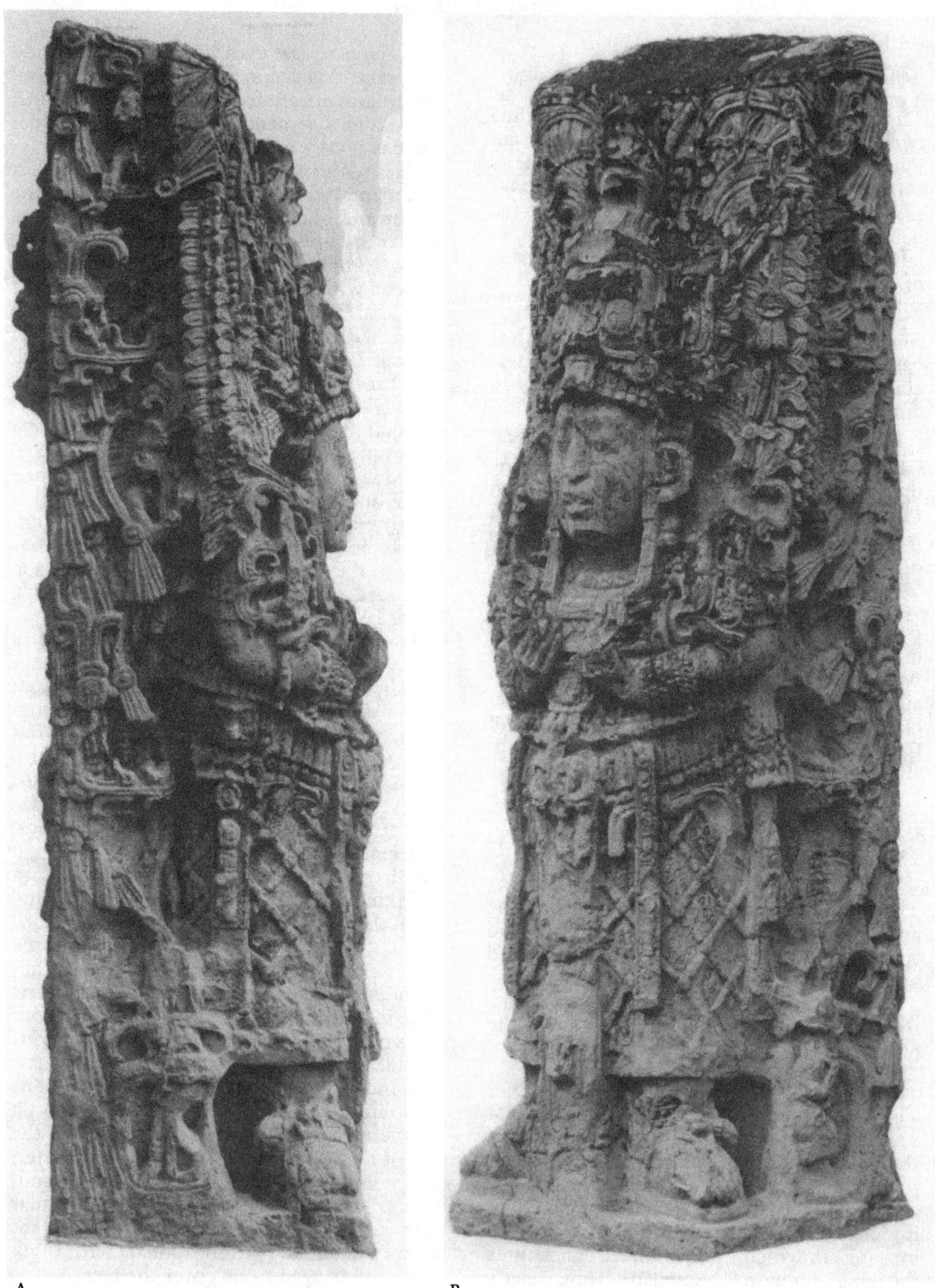

A B

FIG. 23 CPN 16: (a) north side; (b) west side. Photos by J.-P. Courau.

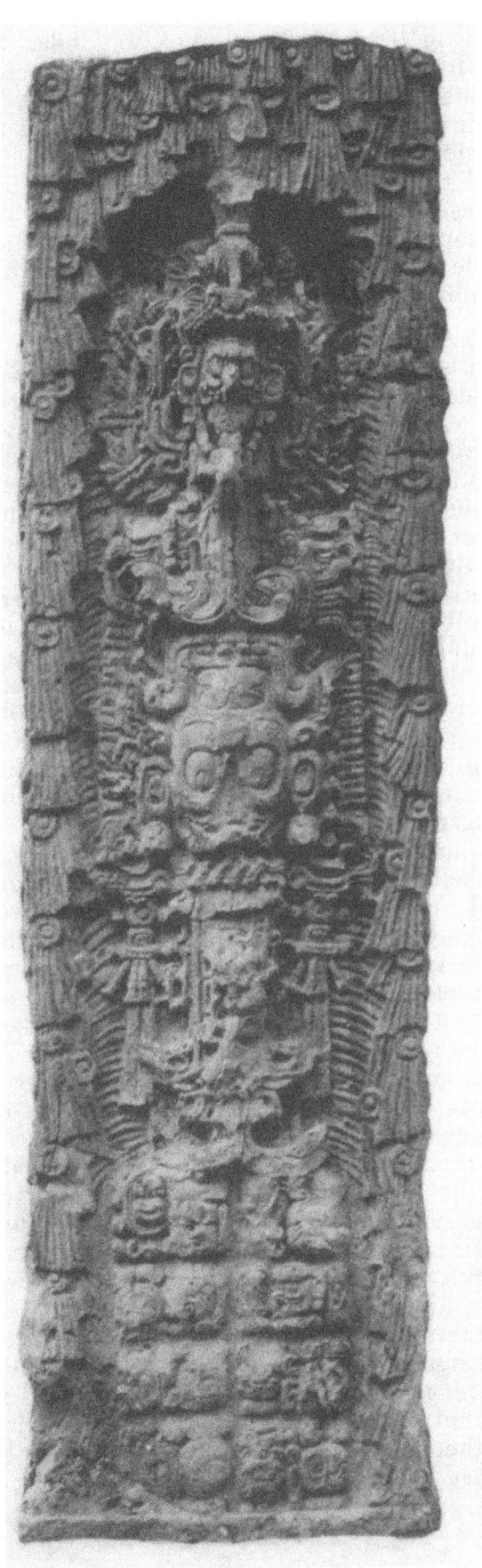

FIG. 24 CPN 16: east side. Photo by J.-P. Courau.

Above the Main Figure: Directly above the helmet is a vertical motif composed of a maize cob between two husks, one long and one short. Two bones protrude from behind the maize and stand against a black-spotted trapezoidal background. The upper corner of the wings flanking the helmet overlaps a stylized serpent head with a pendant band decorated with two bows that are knotted and adorned with feathers. A cross embellished with two twisted strips straddles the middle of the band. This motif, which appears on multiple occasions on the scepters ("torch staffs") at Yaxchilán (Lintels 9, 33, 50, and Stela 11) is interpreted by Benson (1978: 94) as a "tabbed opening," similar to those depicted on the Palenque banners or the clothes worn by captives at Toniná. I rather think that it is an artifice in which the sculptor attempted to portray in its entirety a motif that could otherwise only be seen partially.

A bow-and-serpent is also above the main figure's head. A similar motif forms a scepter held by both figures, one female and the other male, depicted on the Cleveland Stela and the Kimbell Art Museum Stela, which form a pair. Jeffrey Miller (1974: figs. 2, 6) published these two monuments and noted that the "bow and serpent object" is also handled on Calakmul Stela 9 and is part of the headdress of the main figures on Piedras Negras Stela 4, Machaquilá Stela 2, Dos Pilas Stela 1, and Lintel 3 of Tikal Temple 1.

Interpretation: Two major themes are apparent on the stela's west side: sacrifice and fertility. The former theme is symbolized by the grotesque heads emerging from the serpent bar, while the maize motif crowning the headdress indicates the latter. These two themes, in fact, are narrowly linked. The death/rebirth duality is also expressed by the bones behind the maize. This is the counterpart of the vegetation-crowned skull of CPN 1, the mate of CPN 16.

The gender of the main figure is not apparent. Long skirts are not a clear guideline for identifying females. As Thompson and Proskouriakoff have shown, males perform certain rituals adorned with long tunics (see the autosacrificial scenes in the Bonampak murals). In some instances, though, glyphs prefixed with female heads clarify this ambi-

guity. CPN 16's short text does not mention a clearly identifiable female, so the gender and identity of the main figure remain in doubt. Even if we assumed that the main figure is a woman, it would still be unclear whether the woman in question is the mother, wife, or daughter of the king. Comparison with other Maya representations may help determine the gender of the main figure.

Schele (1978: 46) interprets the costume of Chan Bahlum on the sculpted panel from the Temple of the Foliated Cross at Palenque as that of a woman due to the short net skirt. She asserts that the ruler appears in the guise of a woman because he plays the role of a mother who nourishes the gods in the autosacrifice he is about to perform. The net skirt as feminine attire is unconvincing on several counts. It is part of all the Toniná king's wardrobes, and their context does not imply femininity. If it holds true that women are often closely associated with autosacrifice (see the examples at Yaxchilán and Naranjo; see also Proskouriakoff 1961: 96), this does not exclude men from similar associations. CPN 16 is one of the rare examples at Copán where the main figure does not bear a lancet as part of the costume. It is surprising that a figure other than Eighteen-Rabbit bears the ceremonial bar, because this is part of the king's regalia. On the pair of stelae published by Jeffrey Miller (1974), however, the woman carries the same scepter and shield as her male counterpart.

I think that CPN 16 and CPN 1 form a pair and that the main figure of CPN 16 is either a woman, a historical figure distinct from Eighteen-Rabbit as represented on CPN 1 (i.e., his wife or mother), or a man disguised as a woman. In this hypothesis (which would explain why a loincloth covers the figure's skirt), the transvestite would impersonate the king's female alter ego required in the snake dance (see below).

CPN 16's text is a simple repetition with little variation of part of CPN 1's inscription. Moreover, both stelae bear the same divinatory date, which precedes the end of katun 15 by one tzolkin. They face each other on Copán's Main Plaza, as Stelae 24 and 22 do at Naranjo (9.13.0.0.0). At the latter site Proskouriakoff (1960: 464) distinguished the following stelae pairs by gender: Stelae 30 (male) and 29 (female) dated 9.14.3.0.0; Stelae 28 (male) and 31 (female) dated 9.14.10.0.0; Stelae 2 (male) and 3 (female) dated 9.14.1.3.19(?); in addition, there are Stelae 28 (female) and 29 (male) at Calakmul, and Stelae 33 (female) and 34 (male) at El Perú. According to the dates in the monuments, the woman on Naranjo Stelae 24 and 29 was older than her male counterpart and could have been his mother (Proskouriakoff 1961: 94–96).

THE NORTH AND SOUTH SIDES

The composition of the north and south faces is identical: a serpent body runs down from the top of the stela against a background of carved featherwork; halfway down the stela another serpent joins the first; they intertwine and run to the bottom of the monument while forming the T58 motif, which partly encloses a grotesque figure. On the south face this figure has a skeletal jaw, large scroll eyes, and a quiff on the forehead. The skull symbolizes death and sacrifice. It wears a collar that ends in a double-edged ornament reminiscent of those worn by captives at Toniná (Becquelin and Baudez 1979–82: figs. 104, 106). This collar also appears on the small figure on the stela's north side whose face is no longer visible.

The remainder of the stela's narrow sides is embellished with two maize impersonators and two profile agnathic serpent heads belonging to the serpents that run down the stela sides. Vegetal motifs are at ear level. The elongated and upturned muzzle bears a variant of T58 that includes a circle flanked by two smaller ones and marked with the *ik* sign and a half ring from which sprouts a maize motif. These are personifications of young maize identifiable by the same motifs on their skull, which grip the serpent body on the upper part of the stela. They all have their hair pulled back and wear wristlets and anklets made of tubular beads. All wear necklaces of round beads that extend down into a pectoral ornament; that of the figure at the top of the south face is T511. One of the figures on this side holds a personified lancet in the left hand; the serpent head is coiffed with three bands crowned with feathers (not visible on the drawing published by Maudslay).

Interpretation: The main figure is framed on both sides by cosmic serpents. Their head bears T58 crowned with maize and with *ik* infixes. This sign signifies wind and also, as Thompson has suggested, breath, life, and, by extension, abundance. T58, which we find again formed by serpent tails at the foot of the stela, is also a sign of abundance: the scrolls that crown it are clearly the husks and the ear, and the round element above this could represent the kernel. T58 would thus be sprouting maize. The presence of the impersonators of this same plant confirms this hymn to fertility and to abundance shown in the iconography of the narrow sides. The necessary and complementary theme is that of sacrifice: the maize figure showing the lancet reminds us that sacrifice is indispensable to life; the skeletal creatures, patrons of sacrifice shown in the very inside of the nourishing grain, are there to emphasize this same quality: death/rebirth, destruction/creation, and so forth.

THE EAST SIDE

Three sections of the stela back form discrete iconographic units. From top to bottom they are:

1. A bird in front view. The large head is crowned with hair pulled back and falling down the sides. The beaded headband has a ringed medallion in the center. Although the top of the headdress is presently broken, it joined the headband to a tuft of feathers at the top of the skull. The forehead bears T616b. The large eyes squint over the elongated beak. The oval earrings have a scroll and vegetation above and a bead at the bottom; the original center element is not visible today. Teeth and scroll-fangs frame the jaw. The wide tongue marked with three circles turns into a braid. The pectoral that hangs from the bead necklace is half hidden by the tongue. A profile serpent head forms the framework of the bird's wings. The claws embrace the upper part of the following motif.

2. A ceremonial bar with a bird head at each end. The body of the bar is an arch adorned with parallel bands plus celestial symbols. It is partially hidden by the central element and the tripartite emblem. The heads at the ends of the bar are those of a bird of prey. They are similar to the *katun* birds, with an open hooked beak surrounded with wrinkles, a protruding forehead, and an oval ear ornament with scroll and bead. A braid hangs from each of these heads; it is attached to a serpent head that has a pendant chain made of a round bead, a bell-shaped bead, tubular beads (one horizontal, the others radiating), and two ribbons with blackened ends.

3. A solar mask crowned with the tripartite element. The large tripartite emblem rests above the mask; it includes a shell, spine, and crossed-bands. The mask top is crowned by an arch whose curling ends could represent the jaw of a jaguar. The mask's bumpy forehead also is reminiscent of a jaguar. It is stamped with the *kin* sign (T544); the large ringed eyes have scroll pupils. A skeletal jaw is below the broken muzzle. The oval ear ornaments are crowned by scrolls and maize, while a bead hangs from the bottom. A braid with the leaf-and-fringe motif is below the mask, joining the two serpent heads described above. Below we imagine the solar jaguar mask flanked by two serpent upper jaws, which on stelae compose the upper part of the loincloth's front panel. Here it is partly hidden by a small anthropomorph seated cross-legged with the torso leaning forward. Although the face is eroded, a collar and pectoral are visible; both are similar to those on the skeletal creatures at the bottom of the stela's narrow sides. The braid and the leaf-and-fringe motif are at the feet and bottom of the loincloth.

Interpretation: The back (east face) of CPN 16 depicts the back rack worn by the main figure on the opposite side of the stela. It is a vertical representation of the cosmos, similar to the back rack worn by the right figure on Pier D of House D at Palenque and to the one visible on Quiriguá Stela I and on several polychrome vessels of the Holmul style (Coe 1978: 94; Reents-Budet 1991). The head represents the earth and the underworld, while the dead or nocturnal sun wears the tripartite emblem, as on the panel in the Temple of the Cross at Palenque (Schele 1974: 50). The celestial vault appears as a sort of ceremonial bar with bird heads at the ends, while the body is an arch marked with celestial signs. A bird representing the sun at zenith is perched there.

In Maya iconography the ruler may be integrated into a similar cosmological construction, standing or sitting on the masks that represent the earth monster and framed by the bicephalic celestial monster with a bird on top (e.g., Lintel 3 of Temple IV at Tikal; Stela I at Quiriguá; Stelae 6, 11, 14, and 25 at Piedras Negras). At Palenque the ruler Pacal is shown falling into the jaws of the earth monster while Chan Bahlum performs rituals accompanied by his ancestors. CPN 16 is

similar to this type of construction: the main figure (female) stands before the cosmos sculpted on his (her) back. This relationship, as depictions at Palenque, Quiriguá, and Piedras Negras demonstrate, endows the figure with a cosmic dimension.

CPN 16 and Stela I at Quiriguá present an analogy between the bottom part of the composition and the apron of the front loincloth. Similarly, the mask of the nocturnal sun can be compared to the central belt mask, the bicephalic bar to the serpent bar, and the bird to the crowned and feathered head. This interpretation seems to be confirmed by the braids hanging from the celestial vault, as well as from the serpent bars held by ancestors on CPN 47, CPN 41, and CPN 4. This signifies that the Maya conceived the human body, more precisely the ruler's body, as a microcosm.

I have indicated elsewhere (1992) that the couple formed by CPN 16 and CPN 1 is a structural analog to the pair on Pier D of Palenque House D. In both instances, the woman wears the *xoc* mask on her belt and a cosmogram on her back. The two figures seem to be getting ready to perform the snake dance or some other similar fertility rite.

CPN 17 (ALTAR OF STELA H)
(fig. 25)

This is a prismatic monolith, sculpted on all vertical sides. The composition is cruciform. Two masks stand back to back on the east-west axis and each occupies two sides of the altar; a figure depicted from the waist up is on the north and south angles. Since Stephens's visit, this monument has suffered from falling trees and milpa fire. When Maudslay saw it at the end of the nineteenth century, it was already quite damaged. It is now broken into two large blocks, one to the west, the other to the east. In addition, the lower two-thirds are indiscernible as a result of fragmentation.

DIMENSIONS
100–115 cm high, 235 cm long (north-south), and 220 cm wide.

DISCOVERY, LOCATION, AND ASSOCIATIONS
CPN 17 stands on the Main Plaza, approximately 2 m to the west of the front of CPN 16. This spatial association is thought to be original and intentional. No foundation chamber was built under the altar.

The Masks: The headband is composed of bands alternatively "white" (plain) and "black" (hatched). The white band on the bottom turns up into scrolls to become the eyebrows of the mask. The headband is divided by three groups of two wide transverse bands, one in the center, the others at the ends, facing a motif in three sections: an oval flanked by two scrolls. Apart from the bands, there is not much left of these masks; to the west on the left side is a molar and the body of a serpent emerging from the corner of the mouth. A bulbous mass is all that is presently discernible where the muzzle once was. On the east is a barely distinguishable molar on the right side.

The masks themselves are no longer identifiable; but the headband is associated at Copán with jaguar masks with solar traits (on CPN 34, as well as on CPN 27), so it is probable that they also were jaguars. On the Palace Tablet at Palenque the headband is used as a seat by the three protagonists; it is for this reason that this headband is sometimes referred to in the literature as a "throne."

The Torso Figures: Originally, they were probably identical: the least damaged of them is presently to the north. Its forearms rest on the ground and the hands are folded below the chin. The wristlets, barely visible, are of the ribbon-on-band variety. The long hair is arranged in a loop that falls forward. This same hairstyle is found on captives' heads as well as on the solar creatures associated with sacrifice. The oval earrings have a scroll above and a bead below. The large, squinting, rectangular eyes are bordered by groups of beads. The nose and the mouth (encircled by a wrinkle) are effaced. Judging by the hairstyle and the squinting eyes, they presumably are solar creatures.

INTERPRETATION
CPN 17 presents two pairs of representations distributed on a cruciform plan: two anthropomorphic creatures associated with sacrifice and the nocturnal sun are on the north-south axis; on the east-west axis are two jaguar masks standing back to back. The cruciform

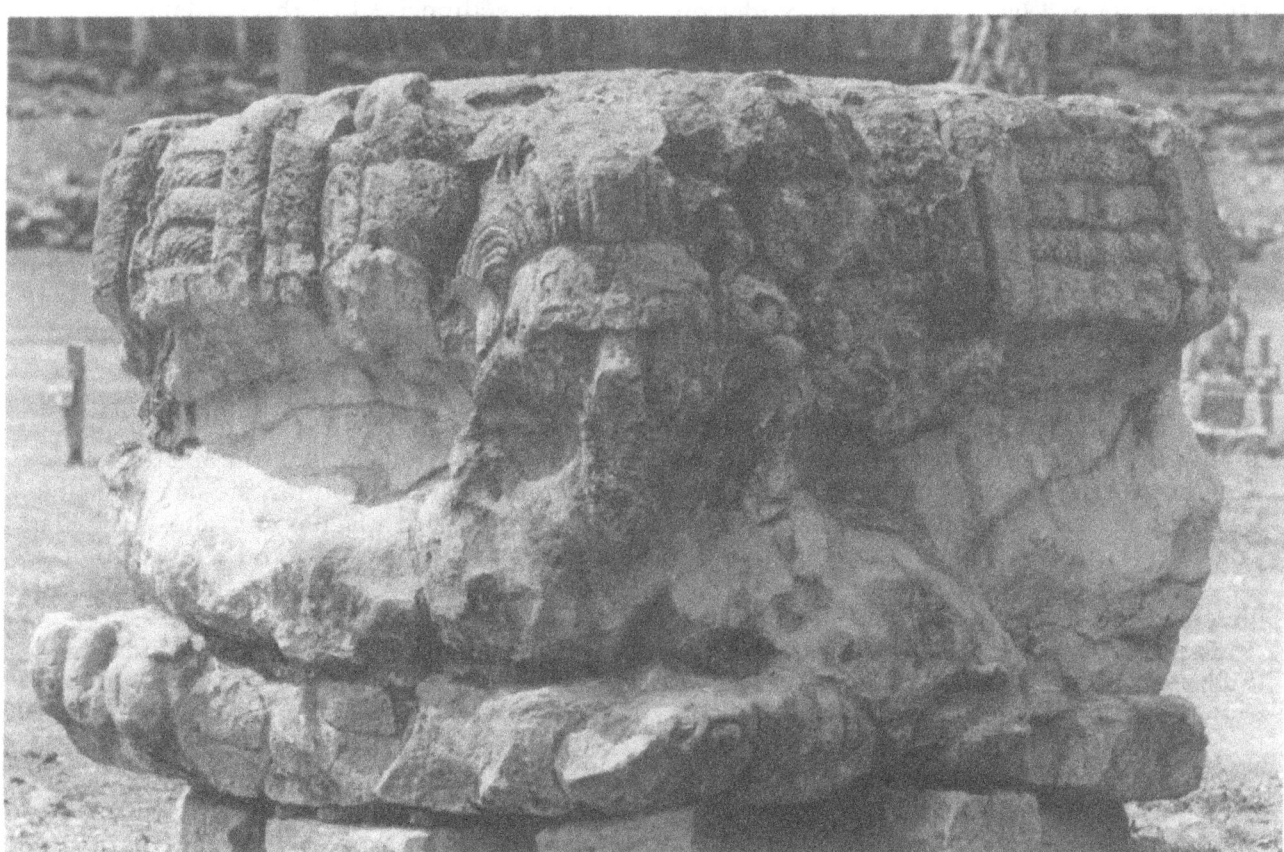

FIG. 25 CPN 17: (a) north side; (b) south side. Photos by J.-P. Courau.

composition corresponds to the jaguar and the solar beings, in their role of patrons of sacrifice. There is no opposition expressed between these masks and the torso figures, who bear similar meanings.

COMPARISONS

The composition closely resembles that of CPN 12, where two jaguar masks are on the east-west axis and two diving jaguars on the north-south line. The two monuments can be compared to CPN 27, also of cruciform composition, with two jaguar masks oriented north-south and a bat and a death head on the east-west axis. The representations on all of these altars emphasize their sacrificial function.

CPN 18 (STELA I)
(fig. 26)

CPN 18 is a prismatic monolithic shaft whose broad faces flare out from bottom to top. A standing frontal human occupies the entire west face and overlaps onto the adjoining sides, leaving room there for a column of glyph blocks. A text in two columns cover the east side of the stela. The glyphic inscriptions are framed by a plain raised border on all three sides. The stela is secured in a cribbing frame.

DIMENSIONS

Maximum height 264 cm; width (north-south) at base 70 cm; at top 89 cm; depth at base and top 49 cm. Maximum depth of relief (west side) 28 cm. The cribbing frame is 170 cm wide (north-south), 143 cm deep, and 17 cm high.

DISCOVERY, LOCATION, AND ASSOCIATIONS

The stela and its altar were discovered by Stephens and Catherwood in 1839. The stela stands in a niche close to the south end of the steps enclosing the northern part of the Main Plaza to the east, directly above a cruciform masonry chamber. This is thought to be its original location. The monument was re-erected there by Carnegie archaeologists after it was cleared of debris. At the same time, the niche was reset. The altar (CPN 19) was found lying a few meters to the west of the stela. In ancient or modern times it might have been displaced a short distance from its original placement, since its cruciform masonry chamber is slightly toward the west, closer to the stela.

The two monuments seem to be associated in an original ensemble. The cache under the stela contained stalactites, objects of marine origin, and four monochrome pots. The cache associated with the altar contained Copador polychrome vessels.

CPN 18 and 19 are aligned with Structures 3 and 4. This alignment was considered important enough to preclude displacement of the stela and altar even when the remodeling of the platform and its associated steps would have been a good reason for doing so.

DEDICATORY DATE

According to Berthold Riese (Baudez and Riese 1990), the stela and altar texts constitute a single inscription starting with the stela; the dedicatory date is on the altar: (9.13.0.0.0) 8 Ahau 8 Uo. Schele (1987c) has it five tuns earlier at 9.12.5.0.0 3 Ahau 3 Xul.

COMPOSITION

The main figure stands in a frontal pose with his feet pointing outward and his hands grasping the bicephalic serpent against his chest. With his costume and headdress, the figure occupies almost all of the available surface. Only a narrow band on the sides is available to accommodate at the top two serpents, to which cling two ancestors, and at the bottom two shields and two intertwined serpents.

The Main Figure: The face's grotesque features suggest that the figure wears a mask. Although it is quite damaged, great round eyes with horizontal scroll pupils and long hanging whiskers are visible. The eyebrows are made of large scrolls and shell sections replace the ears. This mask corresponds to glyph T1011 or to God GI of the Palenque Triad, one of the forms of the nocturnal sun. A row of beads surrounds the face and links the headdress to a jaguar chin-mask. The latter has a wide muzzle and eyes similar to those of the mask above with two scrolls placed high on the sides.

The helmet depicts a jaguar with a wide muzzle, a small nose, and eyes squinting upward; black spots and T103 are on the sides. A cartouche with a *kin* sign is on the forehead, and on the temples are two columns of spikes. The tripartite emblem with crossed bands, a

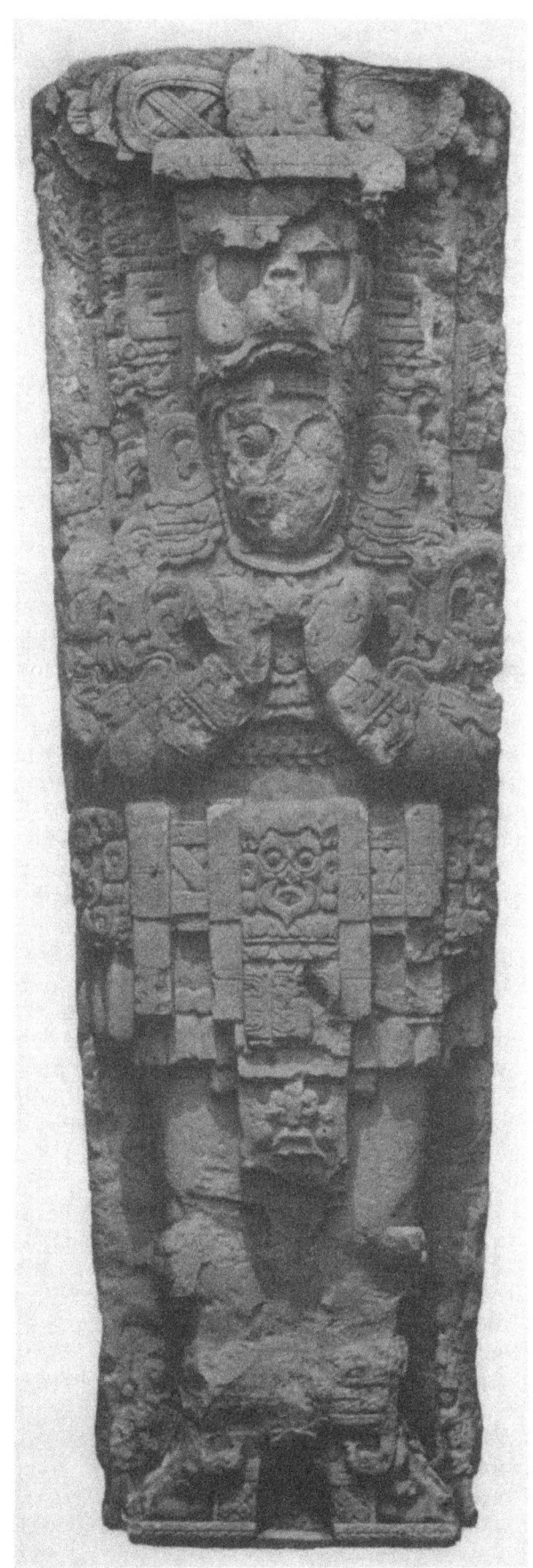 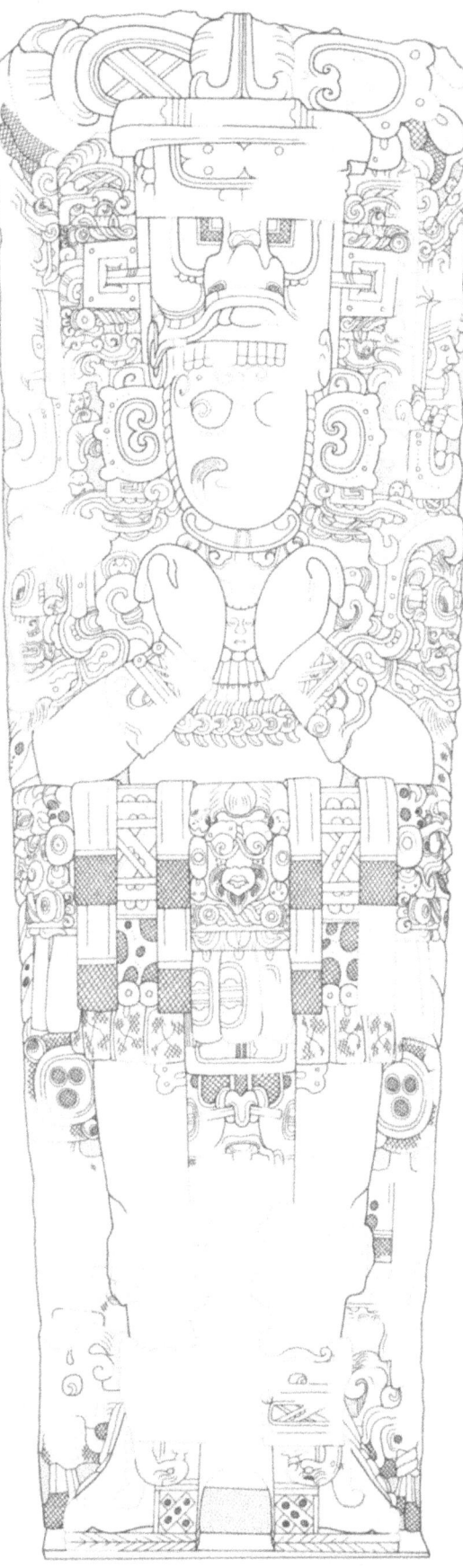

A B

FIG. 26 CPN 18: west side. Photo by J.-P. Courau; drawing by A. Dowd.

spine, and a shell stands above a wide headband with two T103s. The square ear ornaments have a circlet at each corner and a central hole; a band that comes out from behind the helmet passes through the hole to become, on the other side, a serpent's upper jaw. Each ornament is framed above and below by the braid-and-tassel (T58), the three radiating elements (T255), and a serpent's head. The upper one is upside-down and has the crossed-bands infixed in a cartouche (T552) in its mouth; the lower one is right-side-up with nothing in its mouth.

The shells that flank the mask of the main figure have an upper scroll and, below, a serpent head with crossed bands in its mouth. On the outside is a serpent snout adorned with *ahau* (indicating bone nose ornaments). The pectoral is a youth head with dangling beads. The bicephalic serpent held by the ruler is skeletal; the body is a mere spinal column and the heads are depicted as if dead, with wavy lines and little circles indicating bone, as well as eyebrows in shell form. Half-circles placed in the upper half of the eyes indicate death eyes, and the fangs are bared. In spite of this, each head has a beard and a forked tongue. The jaws open onto a feline head whose forehead is adorned by a cartouche with the stone symbol (T528) traversed by an ax-and-smoke motif. The head is crowned with a tuft of hair; the round eye has a scroll pupil and two serpentine objects frame the mouth. The muzzle is wide and the nose small. An oval ornament with a scroll hides the ear.

The wristlets are serpentine heads (inverted when the main figure lowers his arms) surmounted by a rectangular frame with beads at the four corners and containing crossed-bands. These also adorn the belt, which is covered with four pairs of ribbons with blackened ends. The belt's central mask represents the jaguar patron of the month Uo, one of the incarnations of the nocturnal sun. It is topped with a round form tapering into a point (a water lily blossom) surrounded by other vegetal elements. The arch of the eyebrows and the cheekbones are prominent and create the impression of goggles. The eyes are round with scroll pupils and circled with cords that intertwine on the bridge of the flaring nose. The upper lip bares open with two incisors carved in T-form; the mouth is surrounded by whiskers that join under the chin to create a sort of whistongue. The oval ear ornaments have a jaguar ear above them and an inverted *ahau* below.

The side masks represent another aspect of the jaguar as nocturnal sun and patron of the month Pax (called Pax jaguar), characterized by the absence of a lower jaw and a knife-tongue. Here the two masks also have the foreheads marked with a smoking-ax. They may refer to the name of the ruler Smoke-Jaguar. They have circular earrings with a jaguar paw above and an inverted *ahau* at the bottom, a Roman nose perforated by a bone (*ahau*), incisors carved as Ts, and wide scrolls at the corners of the mouth. The left mask squints, while the right one has scroll pupils. Both cheeks wear T24 in a cartouche. The three masks are bordered with the braid-and-tassel (T58) and by the three radiating elements (T255); under each are three tinklers stamped with T23 in a cartouche. The main figure wears a small beaded cape that is visible only on the stela's sides and a jaguar skin skirt edged with a row of round beads and tinklers stamped with a variant of the *edznab* sign. The top of the loincloth bears a jaguar mask whose forehead contains a framed T23, squinting and blackened eyes, a wide muzzle, and a nose provided with tubes. The upper lip curls up over T-incisors. The cheeks are prominent, stamped by T24, and have black spots. Two bone-ends are seen on either side of the loincloth. The knee ornaments include a mask (damaged) surmounted by two knotted bands with blackened ends. The anklets are identical to the bracelets. The sandals are attached by serpents, and the ankle straps are adorned with crossed-bands with round spots.

Surrounding the Main Figure: The helmet is framed by two profile serpent heads. The eyebrow is made of a shell. The round eye is divided into two parts, with vertical lines above and three dots below. The content of the jaw is presently unidentifiable. A turbaned ancestor figure is clinging to the serpent body; he wears an oval earring, a rectangular pectoral, and ribbon-on-band bracelets. The hooked serpent tail ends in T173 and a vegetal form.

Other serpents frame the lower body of the main figure; they appear intertwined at the

level of the serpent bar, adorned with black spots and dots. At the main figure's thigh level, each serpent is partly hidden by a circular shield surrounded by a black ring and four diagonal death eyes. Spotted ribbons hang from the shield with three black circles at the center. Profile serpent heads are at the feet of the main figure. A circle decorated with three black spots terminating in a braid-and-tassel emerges from their mouths.

INTERPRETATION

The figure on CPN 18 and the one on the west side of CPN 47 represent a dead ruler whose face is covered by the mask of the nocturnal sun with whom he is associated. The whiskers are jaguar and the shell ears allude to the underworld. The figure wears a helmet that represents the jaguar as symbol of the nocturnal sun: the *kin* glyph on the head is surmounted by the tripartite emblem, associated with the underworld. That the main figure belongs to the realm of the dead is confirmed several times by his costume and regalia. The bicephalic serpent pressed to the chest is a mere skeleton. The jaguars with an ax-and-smoke implanted in the forehead, who emerge from the serpent's heads, probably reproduce the name of the late ruler Smoke-Jaguar. The belt masks contrast two aspects of the nocturnal sun god: the patron of Uo in the center and the Pax jaguar on the sides. The shields have black spots (the three dots form: *ix*, "jaguar") and are adorned with death eyes. Aside from this, the ruler is placed in a cosmological context, being framed by two pairs of serpents, one above and the other below. The presence of ancestors assuring dynastic continuity is also noteworthy.

CPN 19 (ALTAR OF STELA I)

DIMENSIONS

134 cm in diameter and 49 cm in height; maximum depth of relief 2 cm.

DISCOVERY, LOCATION, AND ASSOCIATIONS
See CPN 18.

DESCRIPTION

The upper part, quite damaged, of this low cylinder is divided into quarters by two double bands that cross in the center and go down the sides of the block. The bands have fringes on one side, to the left as well as to the right. Three ribbons run along the block, knotted at four points, at the junction of the double bands they cover; in the middle the text is divided into four segments, three groups of two glyph-blocks each.

The vertically knotted package is doubtless an allusion to the accession "bundle"; the three knotted bands, in addition, recall the ritual of sacrifice and perhaps even the very function of the altar.

CPN 20 (STELA J)
(fig. 27)

CPN 20 is sculpted on one broad side (west) with a mask of the earth monster, on the other broad face with a mat pattern, and on the two narrow sides with two columns of glyphs. The base of the stela is secured by a square cribbing frame of rectangular blocks.

DIMENSIONS

Height 272 cm; width (north-south) at base 89 cm; depth 72 cm. The cribbing frame is 170 cm to the side.

DISCOVERY, LOCATION, AND ASSOCIATIONS

Maudslay seems to have been the first investigator to describe CPN 20, when it was standing upright in its original placement, a few meters to the east of the southeastern corner of Structure 3. CPN 20 stands on top of a cruciform foundation chamber that contained a large shell, five crude ceramic vessels, a ceramic jar with handles decorated by incision and painting, and white stones stained with red (Strömsvik 1941). Three meters west of CPN 20 stands the altar CPN 21.

DEDICATORY DATE

As stated by Riese: "CPN 20 is evidently the accession monument of a person called Yax K'uk Mo'o, and emphasizes his accession at 9.13.10.0.0. The text also mentions the accession of the preceding ruler of Copán, Smoke-Jaguar Imix-Monster, at 9.9.14.17.5" (Baudez and Riese 1990: vol. 2, p. 117).

DESCRIPTION

On the upper part of the mask, the glyphs surround a T-shaped space where an elaborate bunch-of-grapes motif from the *cauac* glyph hangs from a semicircular cartouche and terminates in an undulated point. The forehead occupies the same space as a glyph block: again, the semicircle and the grape bunch

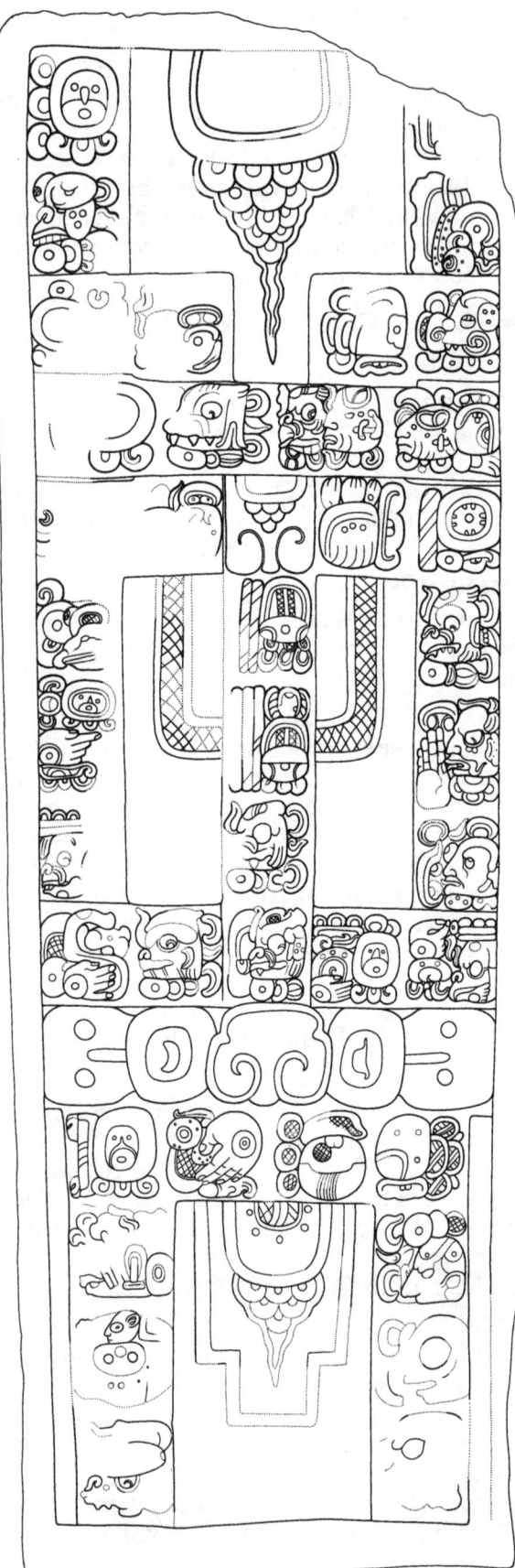

FIG. 27 CPN 20: west side. Drawing by A. Blanck.

appear above two scrolls. The squinting eyes are narrow rectangles separated by a column of three glyphs; each has a blackened band marking its upper inside corner. The nose is a double scroll terminating in two bones. Within a rectangular space framed by glyphs, is a T-shaped motif bearing a variant of T501 (the upper semicircle is hatched and the little lines along the inner border are missing) followed by the grape bunch. The same T-shaped motif, which above designates a cleft opening in the monster's skull, represents filed teeth below. No lower jaw is depicted.

INTERPRETATION

This mask combines earth and solar elements. It is very similar to jaguar representations that often adorn loincloths, as shown by the following traits: squinting eyes, nose pierced with bones, filed incisors, absence of a mandible. In contrast, the cleft at the top of the head, the presence of the *imix* glyph and *cauac* elements refer to the earth monster. This combination expresses the dual aspects of the earth.

It is tempting to compare CPN 20 to CPN 3 (see figs. 5–6, above). In both cases the mask of the earth monster is situated to the west. To the east, the mat, symbol of power on CPN 20, corresponds on CPN 3 to the image of the sun-king emerging from the earth. Because of this structural similarity, we interpret CPN 20 as a monument celebrating accession, or perhaps even succession: if the west face shows the sun setting on the horizon, the east face then presents the new power, symbolized by the mat. Hieroglyphic inscriptions arranged in a mat pattern are also found at Quiriguá (Stela H), Cancuén (Monument N.N.), and La Florida (Stela 10). None of these examples, however, is as complex and realistically executed as the mat design on CPN 20.

CPN 21 (ALTAR OF STELA J)
(fig. 28)

On this monolithic sculpture, a jaguar head is placed on top of a truncated pyramidal base with three large supports. A large flake has been detached from the south side of the jaguar head. Others are missing from the lower part of the sculpture, especially at the south and southeast. The surfaces are slightly eroded.

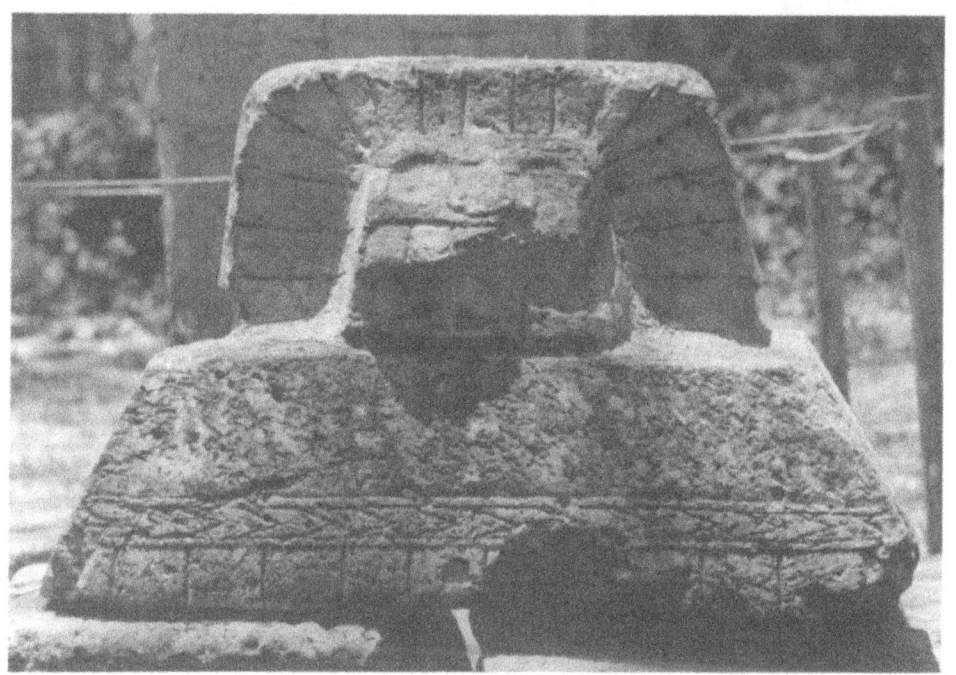

A

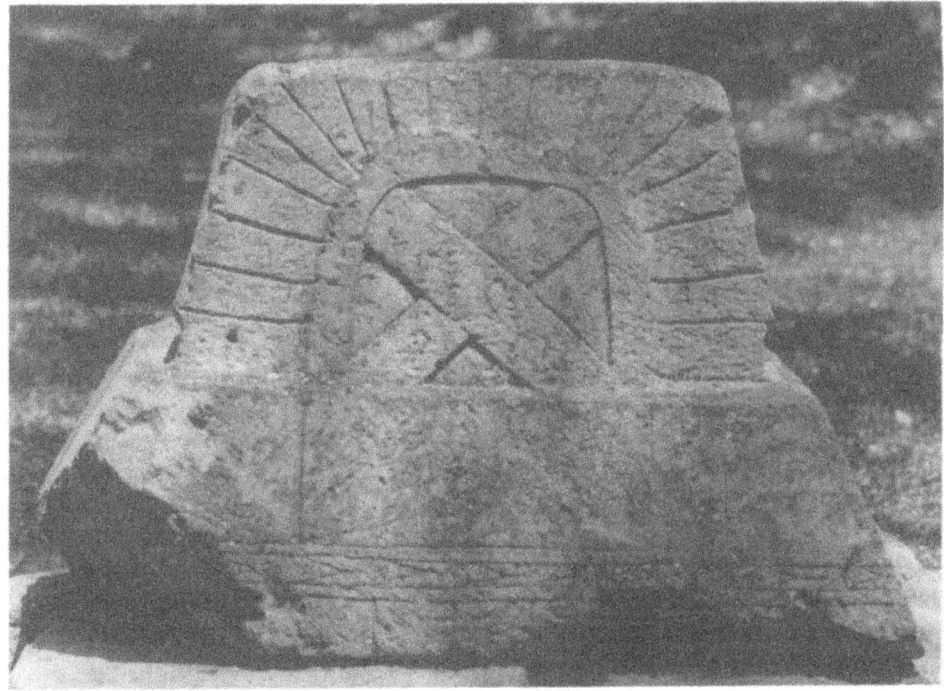

B

FIG. 28 CPN 21: (a) west side; (b) east side. Photos by J.-P. Courau.

DIMENSIONS

Height 69 cm; width at base 110 cm; width at top 60 cm.

DISCOVERY, LOCATION, AND ASSOCIATIONS

CPN 21 was first mentioned by Maudslay. It is approximately 150 cm west of CPN 20, which is thought to be its original position. A cruciform masonry cache below the altar contained an exceptionally rich offering, including twenty-one vases, among which were a Babilonia Polychrome, a Copador vessel, a rough jar, an incense burner with a chimney lid adorned with cacao pods in relief, and "flower pot" vessels. The altar is thought to be originally associated with CPN 20.

DESCRIPTION

The lower edge of the platform is adorned with a band of regularly spaced and fringed chevrons. The jaguar head, which faces west, is very schematic. It is a square block with two scrolls defining the forehead; two circular depressions, which perhaps held inlays, form the eyes on either side of the flaring nose. The upper jaw is indicated by a row of overhanging square teeth; another receding row is the mandible. The headdress is a large block of rounded rectangular shape framing the head. It is engraved in front and back with radiating lines. The crossed-bands sign is inscribed in a semicircular frame behind the skull and continues onto the platform in two vertical lines.

INTERPRETATION

This sculpture reinforces the iconography of the west face of the stela with which it is associated; the latter shows the mask of the earth monster as the home of the nocturnal sun. It appears in front as a jaguar head with a radial headdress (as the sun's rays?) and bearing crossed-bands, a sign of death and sacrifice. I have no interpretation to propose for the truncated pyramidal platform. The function of this sculpture is perhaps purely iconographic; it is not an altar, a sacrificial stone, or an offering platform.

CPN 23 (ALTAR L)
(fig. 29)

The top and two opposite sides of this prismatic altar are dressed smooth but uncarved. The other two sides are sculpted with scenes and hieroglyphs; the northern face, however, seems to have never been completed.

DIMENSIONS

114 cm by 112 cm by 70 cm (high).

DISCOVERY AND LOCATION

CPN 23, first reported by Maudslay, is located on top of Structure 10A, which is a late addition to Ball Court A. In its present location, CPN 23 seems to be associated with CPN 40 in a stela-altar pair. However, there are strong indications that the stela was not originally placed there. Consequently, CPN 23 (Altar L) might have been moved there too, or might have been carved for the new setting of CPN 40. Its unfinished state rather suggests the latter possibility.

DEDICATORY DATE

Grube and Schele (1987) read the Calendar Round date as 3 Chicchan 3 Uo, a date that has two possible positions in the Long Count after Rising Sun's accession date: 9.16.19.1.5 and 9.19.11.14.5 (A.D. 822). The authors reject the earlier date as it is only seven years after the accession; they favor the later one as there are records of Rising-Sun ritual activity at Quiriguá on 9.19.0.0.0 and at Copán Structure 9N-82 on 9.19.3.2.0 11 Ahau 3 Yax.

Berthold Riese (Baudez and Riese 1990) observes that the *tzolkin* date is incomplete, being either 2 or 3, and proposes four possibilities:

$$\left. \begin{array}{l} (9.17.11.4.5) \\ (10.0.3.17.5) \end{array} \right\} 2 \text{ Chicchan 3 Uo}$$

$$\left. \begin{array}{l} (9.16.19.1.5) \\ (9.19.11.14.5) \end{array} \right\} 3 \text{ Chicchan 3 Uo}$$

South Side (fig. 29a, a'): Two figures, seated on glyphs, face each other on either side of a text in one column. The two individuals are practically identical, with one exception: the one to the observer's right has whiskers. The figures' heads are in profile, but the bodies are in front view. A hand rests on the thigh while the other holds an object at face level; it is a bundle of three or four pliable elements (branches, feathers, or ribbons) attached at the center. The headdress is a large turban composed of two truncated cones from which ribbons hang. From the turban juts out the ax-and-smoke motif. The jewels are one bead at the tip of the nose, a circular ear ornament

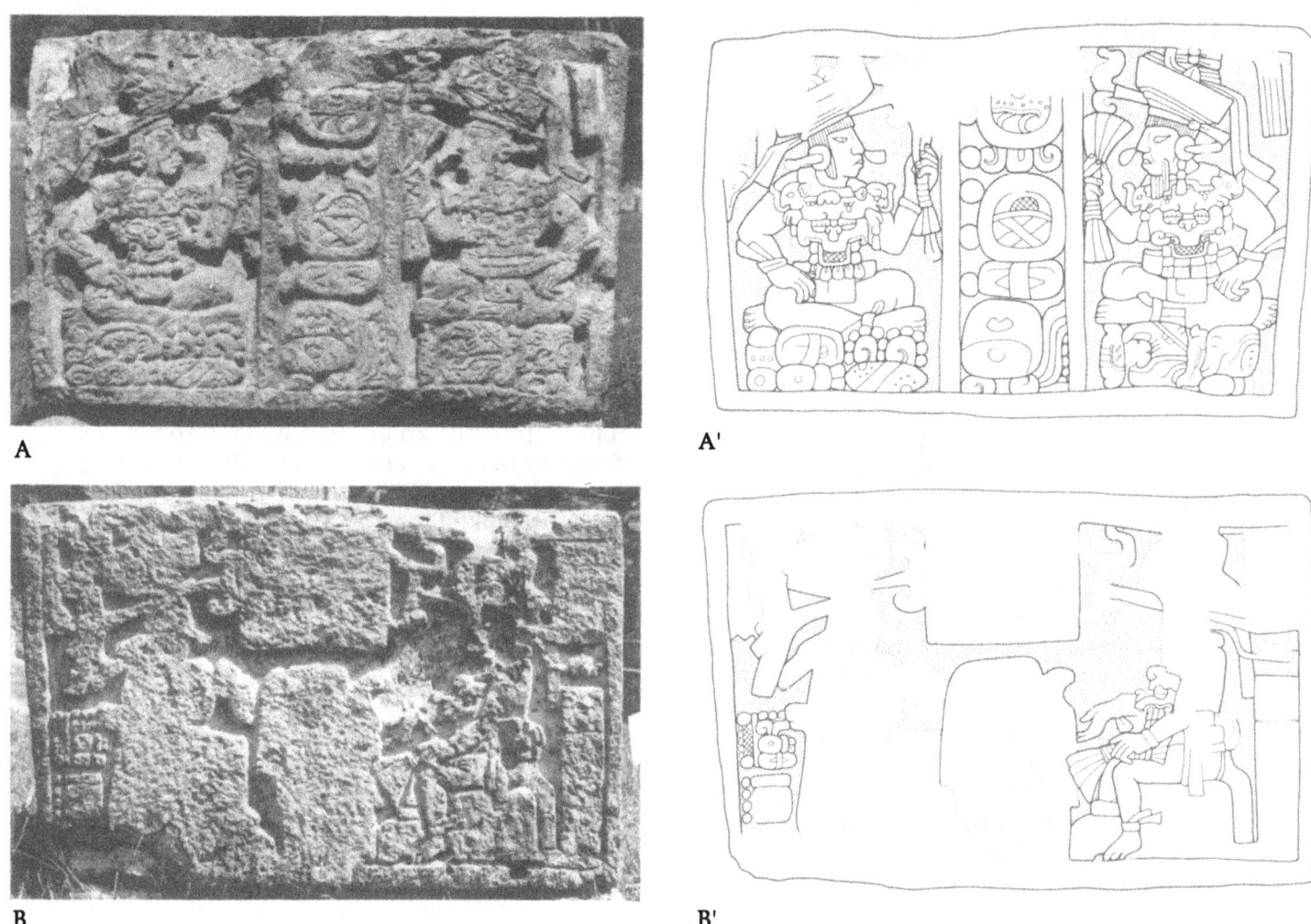

FIG. 29 CPN 23: (a, a') south side; (b, b') north side. Photos by J.-P. Courau; drawings by B. Fash.

with tube and beads, a pectoral of mask form with no lower jaw but a blackened tongue. At the upper edges of the mask one can distinguish two rabbit heads. The wristlets and anklets are a cord bound by a knot with one loop. The figures have a belt with tinklers and a loincloth.

North Side (fig. 29b, b'): Two figures face each other on either side of two glyph blocks. The figure on the observer's left is only a sketch; it must have been standing and presenting an object to the opposite figure. The latter is seated; its right hand is extended forward, the hand open. The left hand, which holds the same bundle as those shown on the south side, rests on the thigh. The pectoral is a serpent head in profile. The anklets resemble those of the south side. The right figure wears a loincloth, a belt adorned with ribbons, and a mask on the back. Behind each protagonist there is room for a short inscription: two glyphs associated with the left figure and at least three with the right one.

INTERPRETATION

The scene on the south side is very similar to the iconography of the west side of CPN 30 (see fig. 41a, below). The right figure, according to the glyphs on which he is seated, is the king Rising-Sun. His opposite looks identical and thus is supposed to be of the same rank; he is either one of Rising-Sun's predecessors or his successor. Could the rabbit heads be an allusion to Eighteen-Rabbit's dynasty? The ax-and smoke would indicate that both figures are dead, as this motif is found only on supernaturals and dead humans. On the un-

finished north side a scene of homage was apparently planned, in which the ruler seated on a throne received an object from the hands of a lower ranking personage.

According to Riese, CPN 23 "shows either the accession to the throne of Copán of a successor to Rising-Sun or refers back to an early ruler of the official Copán dynasty, perhaps the second shown on CPN 30 (Altar Q)" (Baudez and Riese 1990: vol. 2, p. 128).

CPN 24 (STELA M)
(fig. 30)

CPN 24 is carved from a four-sided stone shaft. A human figure in very deep relief is carved on the broad west side, while the featherwork and other accessories are carved on the narrow, north and south sides. The east face is sculpted with two columns of glyphs, which are framed by the overlapping featherwork of the figure. CPN 24 was found broken and missing many details—mainly of the main figure's costume—either through erosion or breakage. Only a few traces of the seven small figures surrounding the ruler remain. One of them, almost entirely preserved, is presently in the Royal Museum of Art and History in Brussels.

DIMENSIONS
Height 336 cm; length (north-south) 110 cm; width at base 81 cm. The cribbing frame measures 210 cm (east-west) by 192 cm (north-south) by 46 cm (high).

DISCOVERY, LOCATION, AND ASSOCIATIONS
Maudslay found this stela broken into two or three large pieces, face down, a few meters west from the altar at the base of the Hieroglyphic Stairway. Gordon excavated the cruciform foundation chamber nearby; it contained thirty ceramic vessels, some of the Copador Polychrome type; a small jar filled with mercury and covered with a *Spondylus* shell; several small fragments of jadeite; and stalactites. Strömsvik had the stela restored and reerected in its original position, where it remains today. A bicephalic monster altar (CPN 25) stands nearby and with CPN 24 is thought to form an original stela-altar pair. Both are associated with Structure 26 by their position and date stated in the text of CPN 24.

DEDICATORY DATE
9.16.5.0.0 8 Ahau 8 Zodz. Riese writes: "Since CPN 24 has a central location in front of the Hieroglyphic Stairway, and because of its dedicatory date which falls at the end of the chronology of said stairway, a close association of these two monuments is deduced. I therefore surmise that Smoking-Squirrel is represented on the stela, and that he is also the ruler responsible for the erection of the stairway" (Baudez and Riese 1990: vol. 2, p. 134).

COMPOSITION
The fifteenth ruler (Smoking-Squirrel or Smoke-Shell) is posed frontally with feet pointed outward. He carries the serpent bar in his hands. Three small figures are seated on his helmet, and two others on either side of his legs. There probably was another pair on either side of the headdress. Traces of carved serpents remain along the sides of the main figure.

The Main Figure: The helmet portrays a crocodile head with an elongated snout and wide nostrils, as may be been on early photographs (Gordon 1902: pl. XVI: 1, 3). The snout has disappeared, but two molars remain, as do two shells that represent fangs. Two other shells replace the ears, which continue downward into a blackened U-shaped element. Although the ruler's face is obliterated, we can see that his hair is pulled back above the forehead and falls to the sides in long strands. Two groups of three beads may be barrettes. Oval ear ornaments terminate in a bead. The figure wears a beaded cape and a pectoral, which partly covers the serpent bar. An effaced mask fills the center of a rectangle prolonged at both ends by radiating tubes. The serpent bar has two living heads at the ends containing the head of the Thunderer (or God K) with an open ophidian mouth, an oval eye with a scroll pupil, and a forehead adorned with T528 in a cartouche in which the ax-and-smoke motif is implanted.

The belt is divided into panels that contain the crossed-bands motif. The three youth masks are coiffed by one knotted band. Under the chin is a braid with three hanging tinklers stamped with the stone sign (T528). Blackened shells hang from the belt, partly

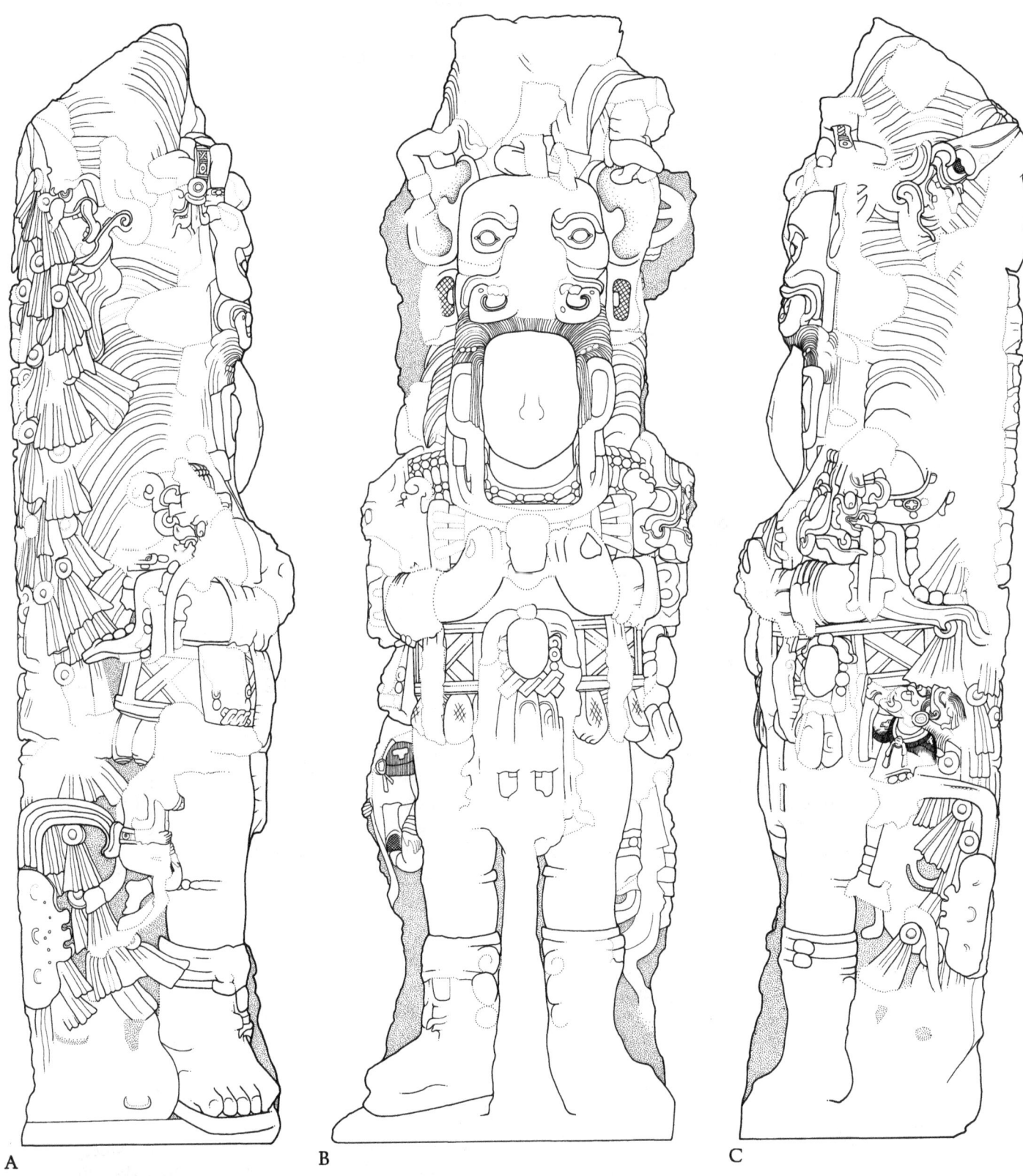

FIG. 30 CPN 24: (a) north side; (b) west side; (c) south side. Drawings by A. Dowd.

covering two ribbons bearing the mask personifying the lancet. There are only vestiges of the loincloth mask, which undoubtedly represented the solar jaguar, with rectangular squinting eyes and flanked by two stylized serpent heads. The wristlets and anklets are ophidian heads, not inverted, topped with three knotted bands. The knee ornaments are effaced, and the sandals are unidentifiable.

Surrounding the Main Figure: A serpent bar passes behind the helmet and overlaps on the adjoining sides of the monument. The two ends, now damaged, are gaping heads that contain two death heads with open jaws and with a long pointed skull in the shape of a knife blade. The blade-skulls have notches and cavities intended for inlays. Three figures, almost entirely destroyed today, occupy the top of the stela. The central figure wears a loincloth and is seated on the helmet, with one leg hanging down and the other tucked under the body. The side figures strike the same pose, with their backs turned to the central one; each wears a loincloth that continues into a braid-and-tassel. The anklet is made of two knotted bands. The left figure is still visible in Gordon's photo (pl. XVI: 3). The figure's grotesque face resembles that of the creature found next to the main figure's left leg (fragment preserved in Brussels). Raising his head, he squints and has wrinkles around the mouth. His helmet has not yet been identified. A rope encircles his neck and his shoulders are covered with a featherwork cape with T-shaped signs. A ribbon on a band decorates his ankle.

To the north, a corresponding figure (undoubtedly another grotesque) is headless. He has a cape with T-shaped signs and a loincloth with blackened ends. His pectoral, which was carved in high relief, has almost entirely disappeared, but the strands of a knot are still visible. The wristlet is made of two ties that join a band.

The north and south sides of the stela have preserved serpent elements on a featherwork background studded with rosettes. At ankle level a stylized skeletal mandible like those of CPN 26 remains. Next to the left side of the serpent bar there is a looped serpent tail with a *kan* cross. Another, bordered with beads, has damaged relief that suggests a lower jawbone. These motifs are too fragmentary to reconstruct the original composition. Besides this, there is a large, flat, and poorly understood element (shell?) between the left leg of the main figure and the stylized serpent mandible.

CPN 25 (ALTAR OF STELA M)
(figs. 31–33)

CPN 25 is a composite sculpture, formed by three individual blocks. A rectangular central block forms the monster's body; two blocks, one to the south and the other to the north, represent its two heads. They are tenoned into a semicircular cavity in the central block. The latter is practically intact, but the north and south blocks are chipped in places.

DIMENSIONS
Length 255 cm; width 160 cm; height 101 cm.

DISCOVERY, LOCATION, ASSOCIATIONS
In 1839, Stephens noticed the south block of this monument (*bacab* inside serpent fauces) among the scattered fragments of sculpture and had Catherwood sketch it. Maudslay described a grotesque animal with four feet but no head (this was the center block) immediately to the west of CPN 24; he noted the existence of a large cavity in front and behind in which heads might have been placed to form the double-headed dragon. Nearby he found the tenoned block portraying the death head and correctly placed it to the *north*. Then Gordon wrote that he concurred with Maudslay's placement of the death head to the *south* (though Maudslay had said *north*). Who then could have moved it? Gordon found the living head, which he placed to the north of the central block.

In 1977 the heads were located in the same positions, as described by Gordon, which I think are incorrect for the following reasons:

1. According to the orientation of the feet, the monster faces south; meanwhile, the living head of bicephalic monsters is always the front head and thus should be located on the south side.
2. The death head is so narrow that, although it fits into the north cavity, it does not fit into the south cavity.
3. If the living head is placed to the north, its width covers some of the reliefs of the monster's body (*cauac* elements).

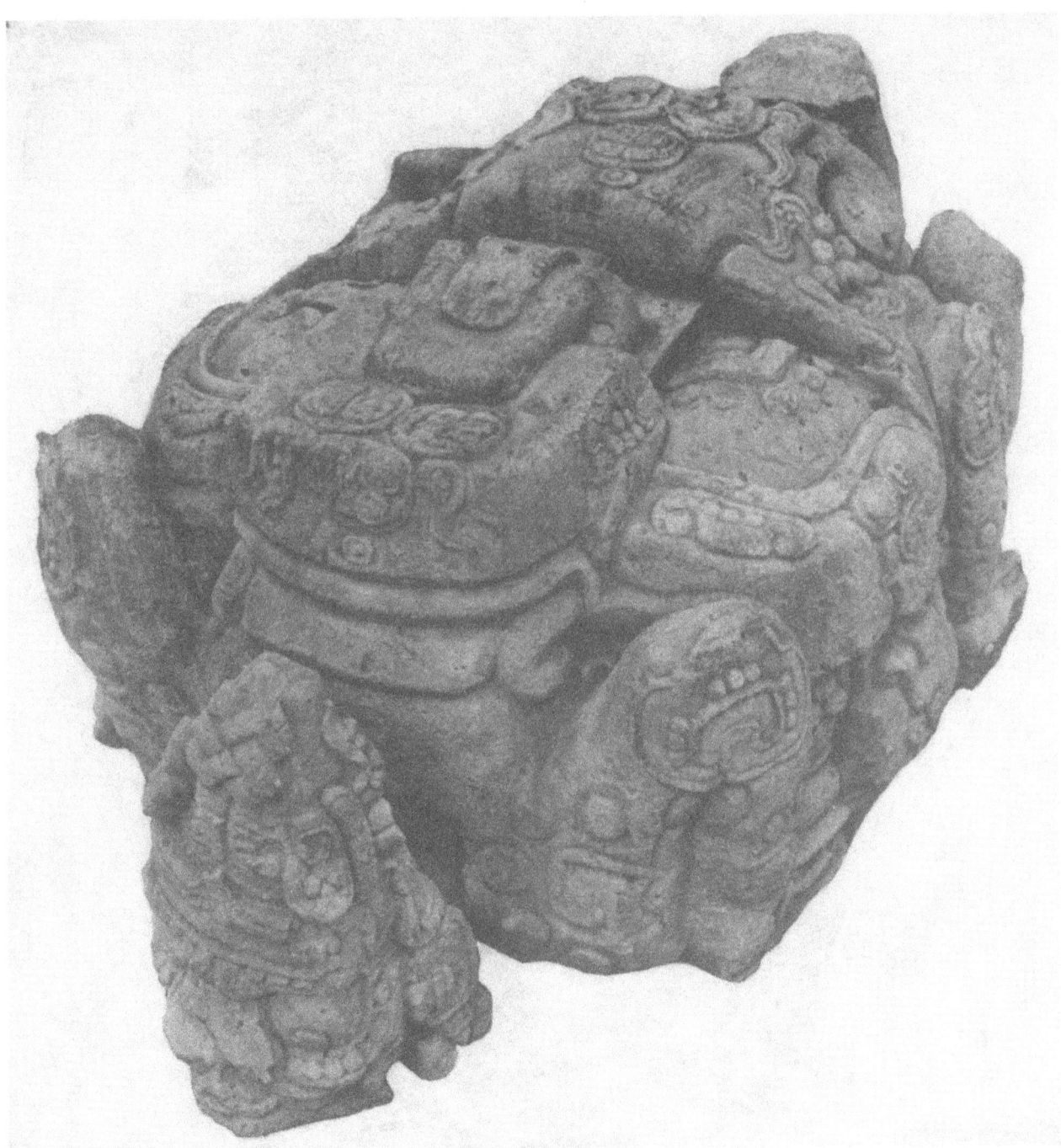

FIG. 31 CPN 25: top. Photo by J.-P. Courau.

4. The sign interpreted as a star or Venus when associated with the bicephalic monster is always on the living side. However, here we have two star or Venus signs on the south side of the center block.

In accordance with the above, we had the heads inverted when the PAC project began in 1977.

CPN 25 is spatially associated with CPN 24. This is thought to be its intended original association. No foundation chamber was found beneath this altar.

COMPOSITION

Aside from the four feet of the monster that face south, the center block has three large *cauac* masks carved on top and on the east and west sides (figs. 31–32). The south side (fig. 33a) is the front living head, whose jaws

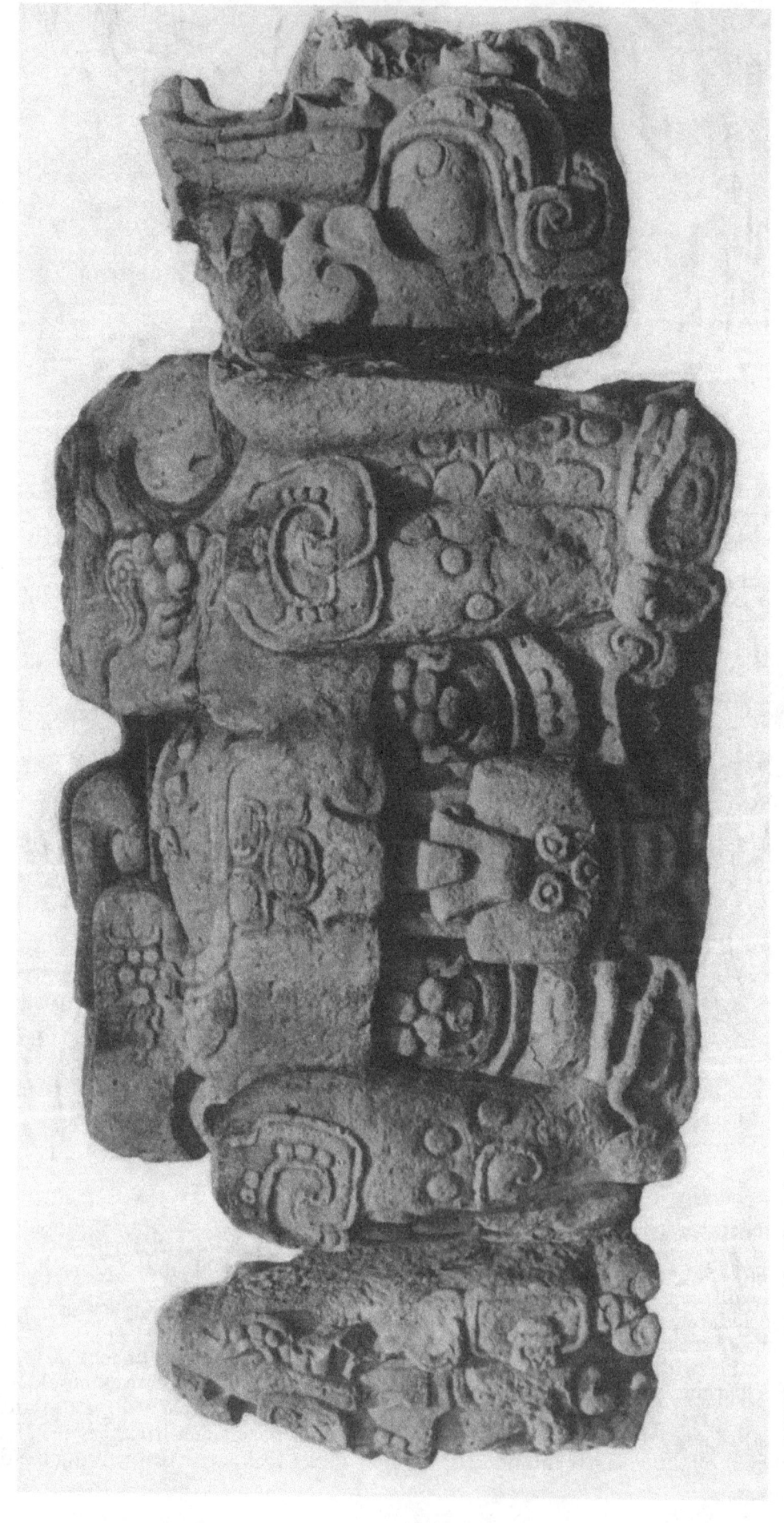

FIG. 32 CPN 25: west side. Photo by J.-P. Courau.

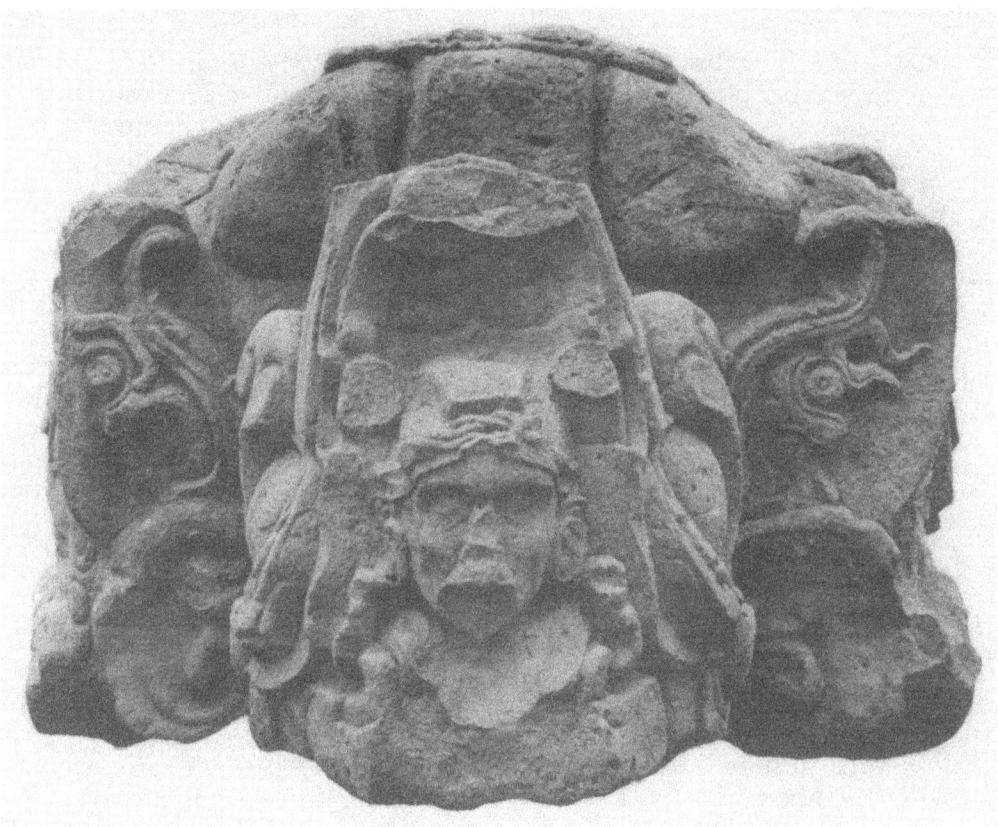

A

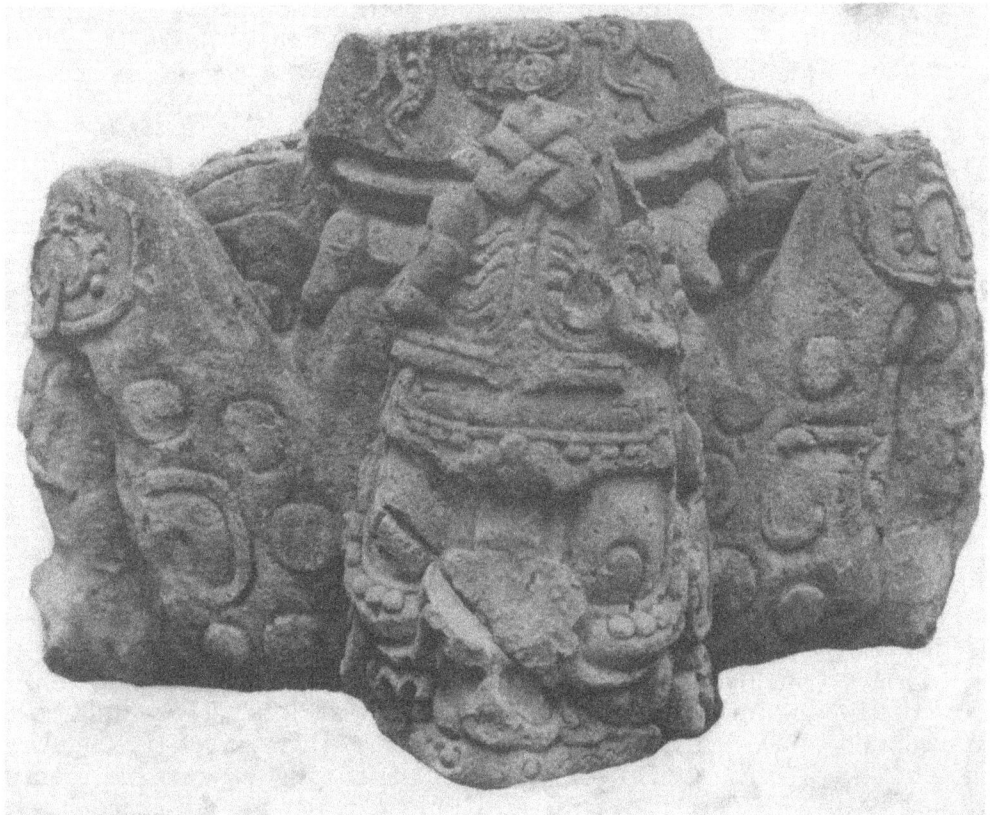

B

FIG. 33 CPN 25: (a) south side; (b) north side. Photos by J.-P. Courau.

enclose a *bacab*'s head. The back skeletal head is carved on the smaller north block (fig. 33b).

DESCRIPTION

The front head (fig. 33a) is that of a serpent with oval eyes and scroll pupils underlined with T23, a nose with tubes, scrolls at the corners of the mouth, and an alveolate palate. On the center block, in place of the ears, are two shells crowned with a wing like element bearing a carved stylized serpent jaw and the sign for a star or Venus (T2). The *bacab* head in the jaws is that of an old man with a wrinkled face. He wears a long bonnet completely covered with hatching (to represent black rather than netting) and whose end is turned up onto the top of the head and toward the front. A knotted cord or stem is above the forehead. The *bacab* wears characteristic earrings—disks adorned with three small circles.

The four feet on the four sides of the central block are all very similar: a sort of trilobed shell marks the knee, and the foot is actually a deer hoof (fig. 32). Both sides and the top of the body are covered by three large masks. The top one is oriented to the north (fig. 31); its protruding forehead has a large scroll on either side. The squinting oval eyes have L-shaped pupils edged with beads with the sign T23 below. The nose on two levels is placed in the middle of the square snout. Below the upper lip two fangs surround a wide, short, rectangular tongue. Elements of the *cauac* glyph (three circles surrounded by streamers, grape bunches, scrolls or half-circles edged by dots) are scattered on the forehead and snout and near the eyes. Each of the circles contains a now-eroded glyph.

The side masks (fig. 32) are identical and differ from the preceding top mask in the following ways: eyes are covered with the grape bunch; three beads replace T23; scrolls are at the ends of the mouth; the upper jaws contain teeth, both molars and fangs. Besides the masks, *cauac* elements occupy the blank spaces and adorn the limbs.

The rear head (fig. 33b) wears a sort of bonnet, pointed at the top and crowned with a braid with the elements that form the tripartite emblem. The *kin* sign in a rectangular cartouche is on a headband. The head, with skeletal jaws, has eyes with scroll pupils edged with beads; the nose is broken. The ear ornament is rectangular, Proskouriakoff's type VI-C (1950: 60): "Flare or tau-element shown *en face*," and with a scroll above and an *ahau* below.

INTERPRETATION

CPN 25 represents the bicephalic earth monster with a living, ophidian front head from which a *bacab* emerges. The rear skeletal head is marked with the tripartite emblem (of the infernal world). If CPN 24 and its altar CPN 25 form a meaningful ensemble—as CPN 4 and CPN 7 with their respective altars do—then CPN 24 and CPN 25 likewise depict the movement of the ruler in reference to the earth monster, either upward (emergence or accession) or downward (into the earth).

COMPARISONS

The iconography of CPN 25 is reproduced later on the bench of Structure 9N-82 with the image of the *bacab* as a positive terrestrial supernatural, emerging from the living side of the monster, as the toad or the maize god. The form and composition of CPN 25 is similar to Altars M and N at Quiriguá, as well as the zoomorphs from the same site. The use of *cauac* masks on the monster's body, which we have already seen on CPN 3, is the norm at Quiriguá.

CPN 26 (STELA N)
(figs. 34–35)

CPN 26 is a monolithic shaft. Two figures stand back-to-back on its south and north sides. They and their regalia spread onto the west and east sides, leaving room for only one column of glyph blocks on each side. The relief is quite accentuated and almost carved in the round, especially around the heads of the two principal figures. Traces of red paint are preserved. The stela is in rather good condition although numerous small details are broken or effaced. Generally, the most salient elements have suffered the most: muzzles on helmets, ancestor figures at the top, ends of the serpent bar. By comparing modern photographs with Maudslay's and with Catherwood's drawings, we can see that deterioration over the last eighty years has been minimal. CPN 26 is secured in place by a cribbing frame (CPN 26A) made of several stones that

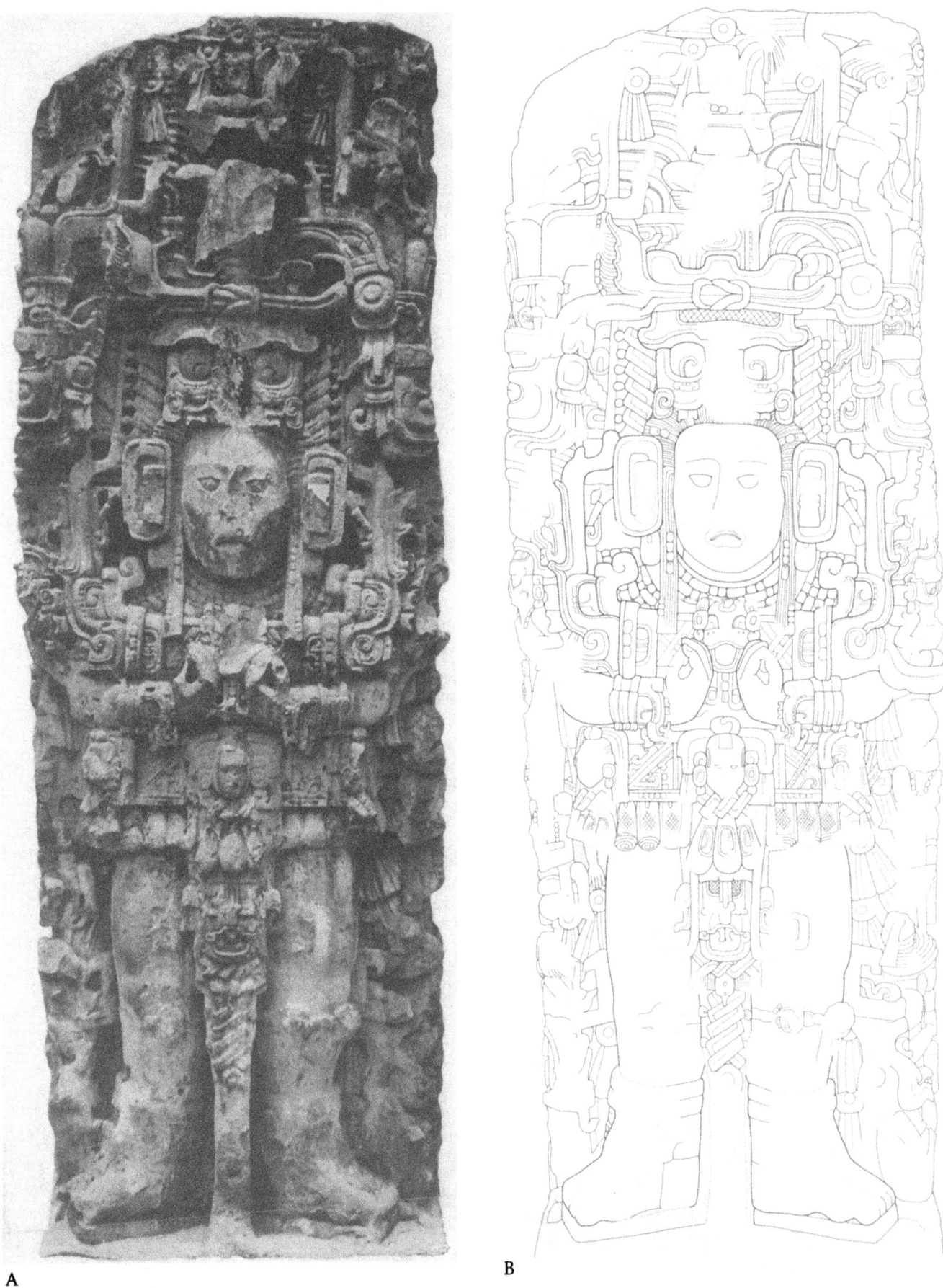

FIG. 34 CPN 26: north side. Photo by J.-P. Courau; drawing by B. Fash.

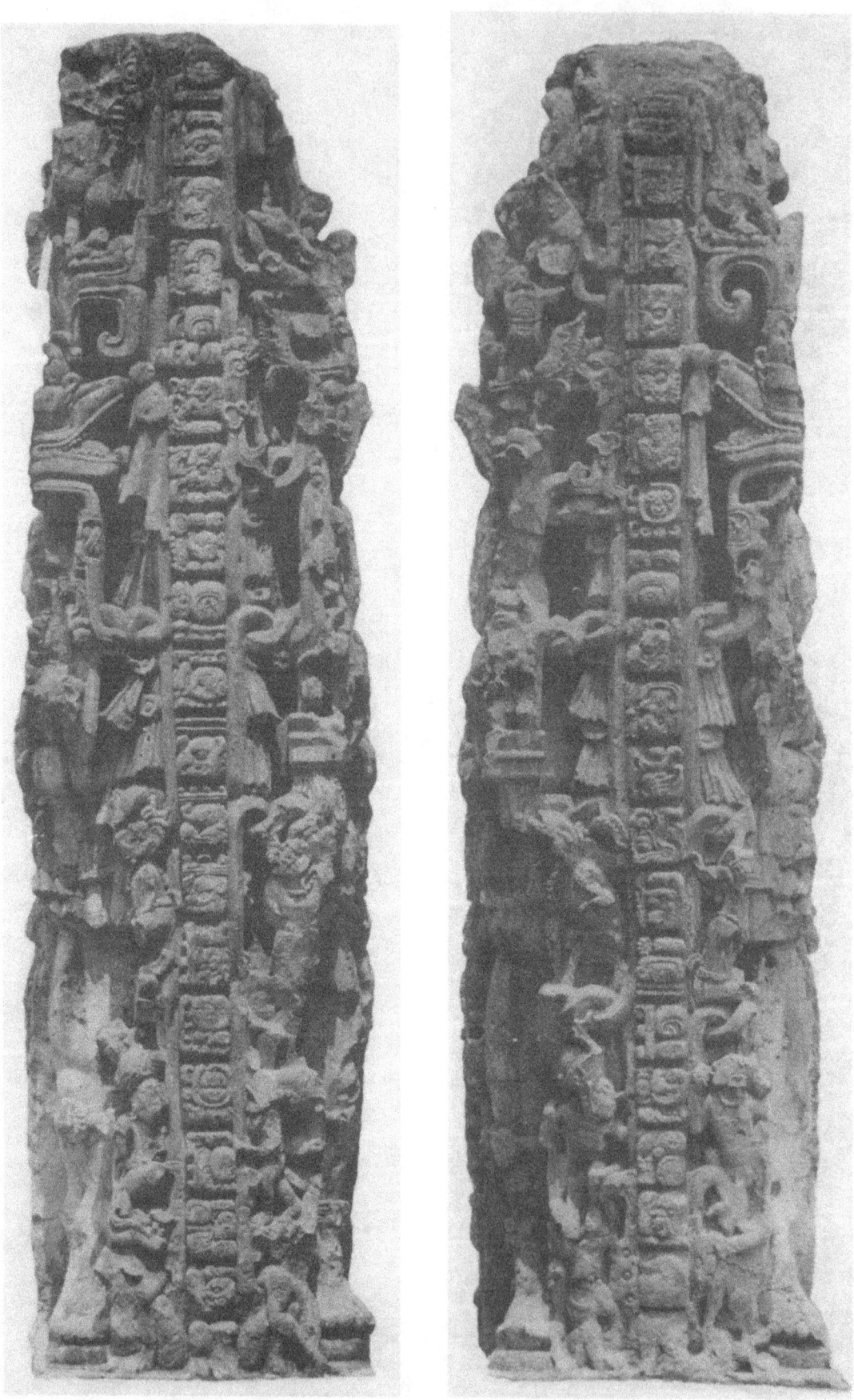

FIG. 35 CPN 26: (a) west side; (b) east side. Photos by J.-P. Courau.

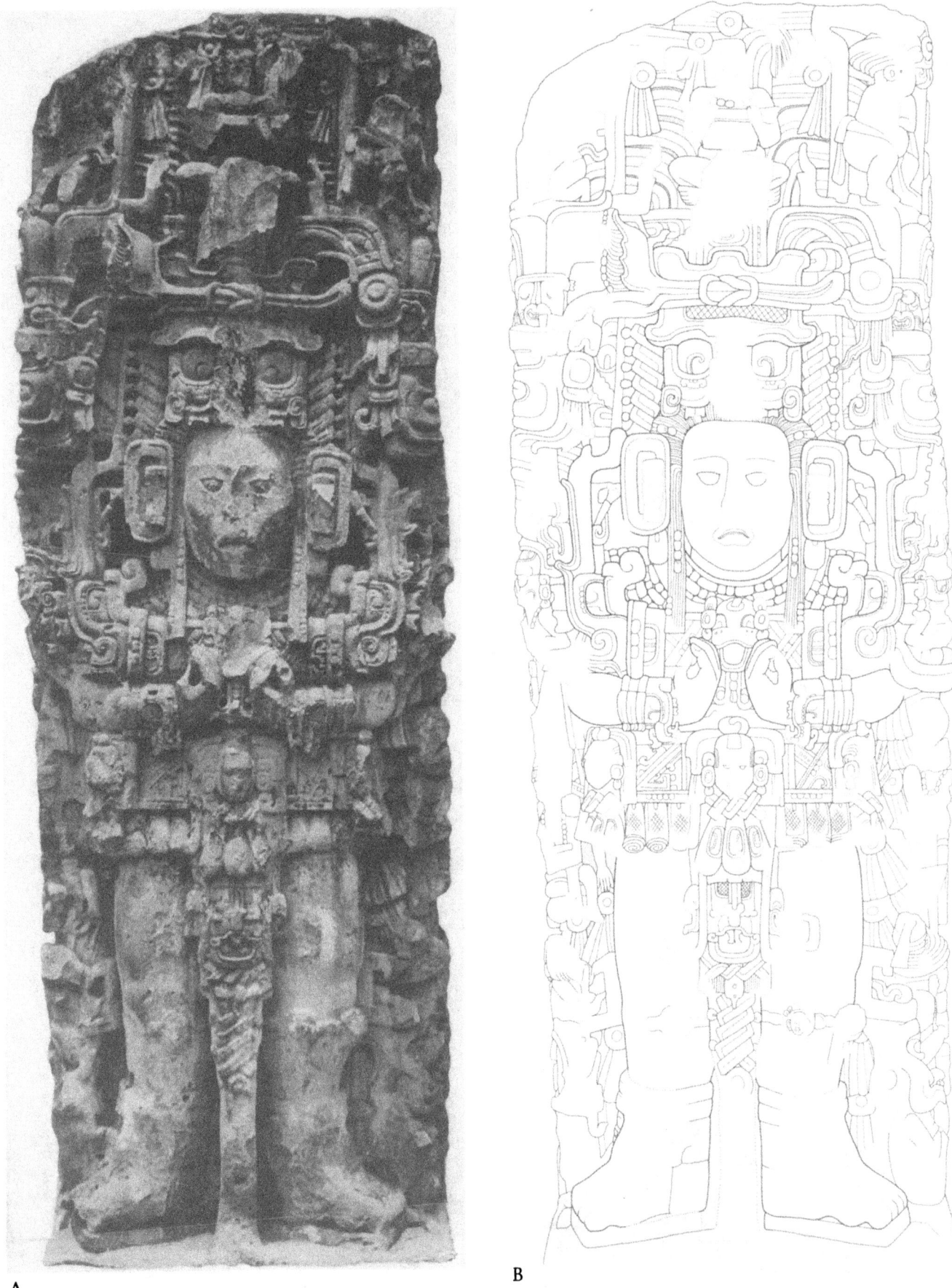

A B

FIG. 34 CPN 26: north side. Photo by J.-P. Courau; drawing by B. Fash.

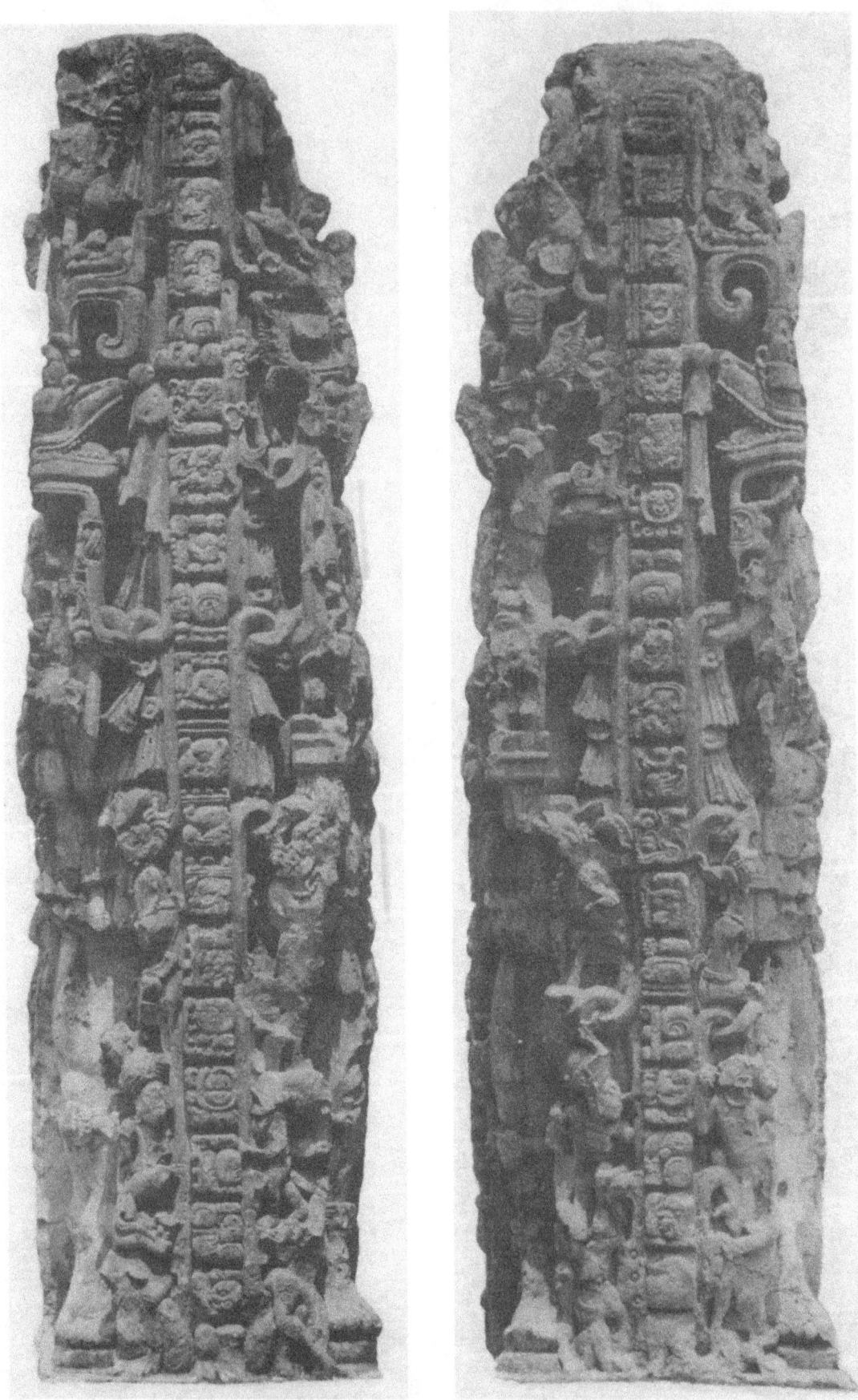

FIG. 35 CPN 26: (a) west side; (b) east side. Photos by J.-P. Courau.

bear an inscription forming a rectangular frame around the stela.

DIMENSIONS

Maximum height 356 cm; length (east-west) 123 cm; width 94 cm. The relief on the north side is 40 cm deep, 45 cm on the south side. The cribbing frame is 213 cm long (north-south), 197 cm wide, and 38 cm high.

DISCOVERY, LOCATION, AND ASSOCIATIONS

Stephens found CPN 26 *in situ* and standing at the foot of the stair leading from the court of the Hieroglyphic Stairway to Temple 11, where it remains today. The stela stands on top of a cruciform masonry chamber that contained "five shallow bowls, eight 'flower pots,' one lid, all of coarse gray-brown ware, two 'flower pots' broken before being deposited, and several stalactites" (Strömsvik 1941: 76). The associated altar (CPN 27) stands in front of the stela's north side in the court of the Hieroglyphic Stairway.

DEDICATORY DATE

9.16.10.0.0 1 Ahau 3 Zip.

NORTH FACE

Composition: Three small human figures are seated above the main figure. The center one holds a serpent body that continues to the left and right sides. It splits near the side figures: one of the branches goes down the side, while the other passes behind an ornate *ahau* at the northeast and northwest corners of the stela and joins the former on the side. There the two branches go down and intertwine at regular intervals. One terminates in an upper serpent jaw, the other by a skeletal mandible. Clinging to the celestial serpents, on either side, is a pair of anthropomorphic figures with grotesque heads. Underneath, two rulers are represented—one emerging from, the other one entering, the jaws of an earth monster.

The Main Figure: The creature that is represented on the helmet cannot be identified, as its snout is damaged. The round eyes with scroll pupils, are bordered with T23. The upper jaw has molars and scrolls at the corners. A braid edged with beads is vertically placed on each side; it either replaces or conceals the ear ornaments. Another motif, difficult to identify, is close to it: an oblique, indented band with what seems to be a large bead above and below in a rectangular frame. The helmet bears on its forehead a large rectangular plaque with an indented edge and a hatched center. It is a water lily pad, attached with the stem of the same plant, folded over and apparently knotted in the center. On the right it ends with a flower, which we would expect—according to Maudslay's drawing—to be nibbled by a fish. However, Maudslay's photographs show that such a fish was not there at the time. Discreet traces of removal suggest that at this place there was a relief that was eliminated, when and why we do not know.

The headdress is crowned by a large bar in high relief, adorned with circles and crossed bands, whose end reproduces another flower form. This group is interpreted as a stylized version of the stem and water lily blossom. The braid-and-tassel motif, perhaps a royal or sacred symbol, emerges from under the indented plaque or water lily pad. The main figure has a youthful face; his hair is pulled back above his forehead and falls into long strands on the sides. The ear ornaments are rectangular, with a central element of the same form, and end in an oval bead. A beaded cape covers the shoulders and chest. The pectoral mask, at present almost entirely effaced, was better preserved in Maudslay's time. It is an upside-down death head—the skull made from a shell, the eyes rolled upward, and the tongue hanging out.

The serpent bar, held horizontally by the forearms, is adorned with crossed bands. The ends are stylized ophidian heads, quite elongated. The eye has a double-scroll pupil (T122). The creatures emerging from the jaws are very damaged. Their graphic restitution is dubious. Instead of bird's heads we identify them as creatures similar, if not identical, to the Thunderer (abusively referred to as God K in the literature). Its remains include a semicircle in a cartouche on the forehead, a rectangular earflare with scroll and bead, a large rectangular eye with scroll pupil, and a necklace of round beads.

The wristlets are composed of a serpent head with T122 as a pupil and coiffed with three knotted bands. The belt is divided into panels containing elements of the celestial band, including a *zip* monster and a bearded sky monster on a diagonal. The belt has three

youth masks with a band knotted on the head (T60) and a braid below, including three tinklers stamped with T616b. Blackened shells hang from the belt. The loincloth is adorned with a jaguar mask (blackened squinting eyes, wide nose with tubes, arched lip over T-shaped incisors, mandible in a half-circle form) flanked by stylized serpent jaws. The loincloth continues into a braid-and-tassel of which only the braid and bead element remain. The knee ornaments are two small youth masks surrounded by beads and having tubular beads continuing down toward the feet. An ophidian head crowned with two knotted bands adorns the ankle.

Above the Main Figure: Against a background of feathers, rosettes, and ribbons, the three now-headless figures at the top of the stela undoubtedly represent ancestors. During Maudslay's time the left figure still had its head coiffed with the turban, part of the regalia of Copán rulers. The middle figure sits tailor-fashion with arms folded high on his chest holding a serpent body in the manner of a serpent bar. He wears a loincloth and a beaded necklace. The lateral, potbellied figures wear only the loincloth; the one on the right is kneeling on one leg while the one on the left sits below the arched braid-and-tassel.

On either side at helmet level a crocodile head is shown in profile: the gaping jaws open outward and toward the back, a cascade of ribbons hangs at the end of the snout, the teeth are triangular, the tongue is short and round, and the eye has a scroll pupil. The circular ear ornament has a jaguar ear (in the form of an ace of spades) above and a tripartite element below. The crocodile has a cruller—generally reserved for the solar creatures—on the bridge of his nose. On the cheeks is the whistongue in the form of a fine band that extends down into an indented half-circle that represents the tongue, with crossed bands in a cartouche. This mask combines the terrestrial nature of the crocodile with traits of solar origin (jaguar ear, cruller, whistongue). One may question the association of the decorated *ahau* with the crocodile head or with one of the serpents coming from the top of the monument; in fact T535 is often seen on serpent tails. The very relationship of the crocodile head with the rest of the decoration is unclear; is it isolated or is it linked to the serpent body on the sides?

Surrounding the Main Figure: Two serpents intertwining at regular intervals frame the main figure on the east and west sides. One ends on the front of a stylized serpent jaw in the shape of an angular scroll with a schematic indication of the supraorbital plate and the nose; the other ends on the back in the form of a stylized skeletal mandible with little circles and Us indicating bone. This conventionalization, either of two serpents or a bicephalic serpent whose body runs along the stela's sides, was already intimated on the sides of CPN 24.

At the level of the main figure's waist two grotesque figures sit on the last twist of the serpents. The one on the right (to the east) now has broken arms and an effaced face. It is marked with a cartouche on the thigh indicating its supernatural origin, wears a loincloth, and has a now-damaged pectoral ornament at the end of a long bead necklace that continues at the back. The oval ear ornament terminates upward in an undulating element marked with the *ek* sign, which evokes the motif worn by the *bacab* scribe of Structure 9N-82-2nd. The headdress is composed of a band of tubular beads ending in a water lily stem and blossom similar to the one that crowns the headdress of the main figure's helmet. In spite of its fragmentation this figure appears to be associated with the *bacab* and other creatures who watch over fertility. The left figure could be part of this same category as his eye, outlined with a sort of ring, is marked by a *cauac* element. His skull has a topknot. He still has a cartouche on his thigh and on his arm, a loincloth, an oval ear ornament, and a bead necklace, which falls down his back.

The earth monster is seated near the feet of the main figure. His anthropomorphic body faces forward (to the north) while his crocodilian head faces both backward and upward. To the right (east) a figure with bent legs sinks halfway into the jaws; he wears a loincloth and has a band or cord around his neck. His headdress seems royal: it is a large, truncated, cylindrical turban, surrounded by three knotted bands, with a pendant ribbon. The ear is replaced by a shell, emblem of the an-

cestors and the dead. The figure is posed like a prone cadaver, with raised head, half-open mouth, and hand half-closed in front of the face. This figure would be that of a dead ruler, sinking into the jaws of the earth monster parallel to the setting sun. To the left of the main figure and above the earth monster is a seated figure who wears the same headdress as the preceding character. However, this personage wears a jaguar pectoral ornament and his posture is that of a living man. In contrast to the preceding figure, I interpret this as a young king emerging from the earth's jaws, as the rising sun. Thus, we have here the dead ruler/new ruler parallel that affirms the continuity of the dynastic cycle, which may be implicitly compared to the solar cycle.

SOUTH FACE

Composition: The composition of the south face is identical to the north face, with the exception of the decorated *ahau*, which is absent on this side.

The Main Figure: The helmet is better preserved than and different from the one on the north face. The short, upturned pointed muzzle shows a row of even, triangular teeth. There is a large scroll at each corner of the mouth. The cheeks have black spots. The eye, with a blackened pupil, is half-hidden by a heavy eyelid. This probably depicts a crocodile, whereas the helmet on the north face is probably a serpent. The two masks may have a close semantic value because their headdresses are identical, consisting of a water lily flower attached to the forehead by a blossomed stem nibbled by the fish. The group is surmounted by a stylized variant of the stem blossom. The helmet is flanked by vertical braids bordered with beads. Further, the braid-and-tassel motif emerges from behind the water lily blossom.

The main figure has the same headdress as his counterpart on the north face, as well as the same ear ornaments, cape, and serpent bar held in the same position. Here the pupil of the ophidian eye is blackened rather than appearing as a scroll. The figures emerging from the jaws of the bar's serpents are better preserved and more recognizable as the Thunderer: the skulls of the emerging figures bear a double crown of hair, and their foreheads—stamped with a cartouche—are pierced by the ax-and-smoke; their upper jaws are elongated and the round eyes have a scroll pupil. These supernaturals emerge at the waist with hands placed in front of a rectangular pectoral suspended from a beaded necklace.

The pectoral of the main figure is a round mask with framing and pendant beads. The round scroll eye and the deep, wide mouth are the only distinguishable characteristics, but they are sufficient to identify the creature represented here. The wristlets are serpent heads coiffed with two knotted bands. The belt, loincloth, anklets, and knee ornaments are similar to those on the north face. Sandals with high heel-backs are attached to the feet by a strap that encircles the second and third toes and joins the anklet.

Above the Main Figure: The central figure above the main figure is similar to its counterpart on the opposite side. The right figure has a familiar posture, cross-legged and bound by the serpent, which passes onto his chest and is gripped with the left hand, while the right hand holds the head of the fish nibbling the water lily. The left figure, who also grips the serpent, is bent on one knee.

The crocodile head of the north face is replaced here by another mask, most likely a serpent: the upper jaw is elongated, the eye pupil is a scroll, and the nose has tubes. The ear ornament terminates in a tubular bead. But the animal also has characteristics of Pax jaguar: no lower jaw, large scrolls at the corners of the mouth, and a wide hanging tongue marked with crossed bands. A water lily stem is ostensibly knotted on the forehead, and the flower at the end is nibbled by a fish. Once again at the top of the head is the stylized variant of the stem blossom. Thus, this headdress essentially reiterates the helmet of the main figure.

Surrounding the Main Figure: The main figure is framed by intertwined serpents whose heads are indicated by either a stylized upper or lower jaw. The creature near the waist of the main figure to the right faces north. It has a grotesque head with ophidian features, an elongated jaw, and an open mouth with scrolls at the corners. The hair is pulled back in a single topknot and the forehead bears half-

circles in a cartouche. The eye is rectangular, with the pupil placed at the top. Cartouches on the arms and the thighs indicate that the creature is a supernatural. He also has a beaded necklace that hangs down the back. In sum, this could be the Thunderer without his smoking ax. The corresponding figure on the left has a human body and a deer head; it sits and looks south and upward. A water lily blossom comes out of its antlers. As do the others, the figure symbolizes the underworld and the nourishing earth.

On the main figure's right, at the feet, the earth monster sits on his heels. Its body is human but is stamped with three circles, a *cauac* element. Its crocodilian head (with one eye marked with crossed bands and the three-dotted eyelid) with gaping jaws is below a human figure. The later is turbaned, wears a loincloth, and has ribbon-on-band wristlets and anklets to indicate an ancestor. A simple thread is the necklace. The posture seems to be that of someone falling with head up, one arm in the air, and the other folded on the chest.

On the left side the earth monster sits with knees touching the chest. Large monster jaws appear in profile on its human body. This is another example of *cauac* masks on the body of the earth monster (as on CPN 3 and CPN 25). In addition, three circles are on his shoulder. The head is that of a toad with a round eye and black pupil half-hidden by a heavy eyelid and a scroll at the corner. Above the gaping jaws, a man slightly crouching and leaning forward faces north. He wears a large turban that is truncated and cylindrical and is adorned with the three knotted bands and the inverted whistongue; this is the same headdress worn by Rising-Sun on CPN 30. This figure has a bead in front of his nose and a T-shaped pectoral ornament under a tubular bead necklace. The jewels and posture contrast with his counterpart. Here an image emerges from the earth monster, in opposition to the preceding one, where the deceased ruler descends into the earth.

INTERPRETATION

Although not identical, the two stela faces are similar. The few differences can be considered variants rather than oppositions. The two main figures are young and unmasked. They are overseen and protected by ancestor figures and framed by serpents who represent one or all celestial serpents. One figure wears a serpent helmet(?), the other a crocodile one. But this is not a true opposition since the basic headdress is similar, including a water lily theme, symbol of earth fertility. The earth monster incorporates different aspects: whether crocodilian, ophidian, or batracian, two different aspects coexist in the same bicephalic monster (CPN 4). On the north face, on both sides of the helmet, a crocodile head is depicted with solar characteristics (jaguar ear, cruller, whistongue); on the south face a serpent head has attributes of the Pax jaguar (large knife-tongue with crossed-bands, no mandible). In both cases the creature represents a fusion of the terrestrial and the solar, the two leading principles of Maya cosmology, which are generally separated and often in opposition.

Is the absence of the decorated *ahau* on the south face meaningful? It is difficult to provide an answer, for we know neither what this motif signifies nor what its referent is. There is a possible opposition, difficult to demonstrate due to bad state of preservation, between the two pectoral masks. The other differences—for example, the serpent pupils on serpent bars—do not seem pertinent enough to contrast the two figures and their respective environments.

The grotesque figures on the sides of the main figures all come from the underworld and belong to the gods or spirits responsible for earthly fertility. One has a deer head topped with a water lily blossom; another has the stem and blossom of the same plant in its headdress; the third has a *cauac* element in its eye; the last one has only reptilian features, but is not specifically solar. Thus the two main figures are dressed as *bacab*s with all the water lily trappings and are accompanied by supernatural creatures belonging to the same domain. Is it the same individual represented twice in the same disguise? If so, this repetition would then signify that the king rules on the north as well as on the south but the design does not address the other world directions.

The hypothesis of two different individuals in the same disguise—that of a fertility patron—seems most probable. One of these

would be the future ruler Rising-Sun, and the other his predecessor, Smoking-Squirrel. That the figures are almost identical emphasizes the continuity of dynastic succession, illustrated on the sides by kings who sink into the jaws or, alternatively, emerge from the jaws of the earth monster. On these images the rulers appear anonymous, if one judges from a comparison with CPN 30; in fact, one of the new kings has the headdress of Rising-Sun but wears the jewels of his predecessor; the other has the same headdress as Eighteen-Rabbit and the pectoral worn by the fourteenth ruler. This does not mean that the rulers of Copán were anonymous—the inscriptions prove the contrary. The contrast between writing and iconography in this case stems from their respectively different roles. The former is linked to history (that of specific events) while the latter deals with the nature of royal power and the position of the ruler in the universe. The king is the king, whether named Rising-Sun or Smoking-Squirrel. If one king disappears, another immediately takes his place and the world order is not threatened.

SUMMARY OF THE ICONOGRAPHY AND
THE HIEROGLYPHIC TEXT
According to Riese:

The text of this stela with its cribbing frame mentions two successive rulers of Copán, namely Three-Death (XIV), Smoking-Squirrel (XV), and strangely, calls the stela by the name of their heir-apparent, Rising-Sun. The iconography partly fits into this pattern with two main figures who symbolize the power transfer from the current to the future ruler. Either, Smoking-Squirrel commemorates his predecessor, or he erected CPN 26 as an heir-designating monument to his successor-to-be, Rising-Sun. This latter interpretation accords better with the iconography of a double-face monument, where both sides portray the persons alive. (Baudez and Riese 1990: vol. 2, p. 150).

Schele and Grube (1988: 1) confirm that the base of the stela "commemorates the accessions of the 14th and 15th rulers of Copán . . . the accession of the 14th ruler, Smoke Monkey, on 9.15.6.16.5 6 Chicchan 3 Yaxkin . . . the accession of the 15th king, Smoke Shell, on 9.15.17.13.10 11 Oc 13 Pop." These authors further argue that on the stela base's inscription, Smoke Shell, as well as his father Smoke Monkey, are called God N-Ahau. God N is the same creature that I call *bacab*. On Stela N, both kings are represented under the disguise of a *bacab*, a disguise that corresponds to their title in the inscription.

CPN 27 (ALTAR OF STELA N)
(figs. 36–37)

The sides of this globular monolithic altar are carved with four grotesque heads; the legs are placed so as to belong simultaneously to two adjoining heads. The top and the upper part of the sculpture are in good condition, but the sides, especially the west and north sides, are badly broken.

DIMENSIONS
Maximum length (east-west) 155 cm; width 140 cm; height 98 cm.

DISCOVERY, LOCATION, AND ASSOCIATIONS
Maudslay was the first to describe this monument, which stands immediately north of CPN 26. Its relationship to CPN 26 is thought to be the originally intended association. No foundation chamber was found underneath the altar.

COMPOSITION
There is a cruciform design on the circular top of the altar. Maximum space has been given to the east side (fig. 36a), where protrudes a bat; the bat's forelegs flank its head. A simple mask is on the west side (fig. 37a). Two jaguar heads, each with a single leg, are on the north and south sides (fig. 36b, 37b).

DESCRIPTION
The motif on the top is a large trilobed shell with four radiating *ahau* signs. The east side of the monument is occupied by a frontal bat, portrayed from the waist up. Its partly broken, long snout is upturned beyond the forehead; the latter is modeled into two large scrolls that do not allow room for the ears. The round eyes with scroll pupils are underlined by eroded signs (T23?). The protruding cheekbones frame the partly broken, half-opened mouth; a molar and the base of the tongue are still visible at the mouth's corner, to the south. The face is covered with hair that reaches down to the legs. The *cauac* element, consisting of three circles framed by streamers, adorns the shoulders. Each paw has five digits with pointed claws.

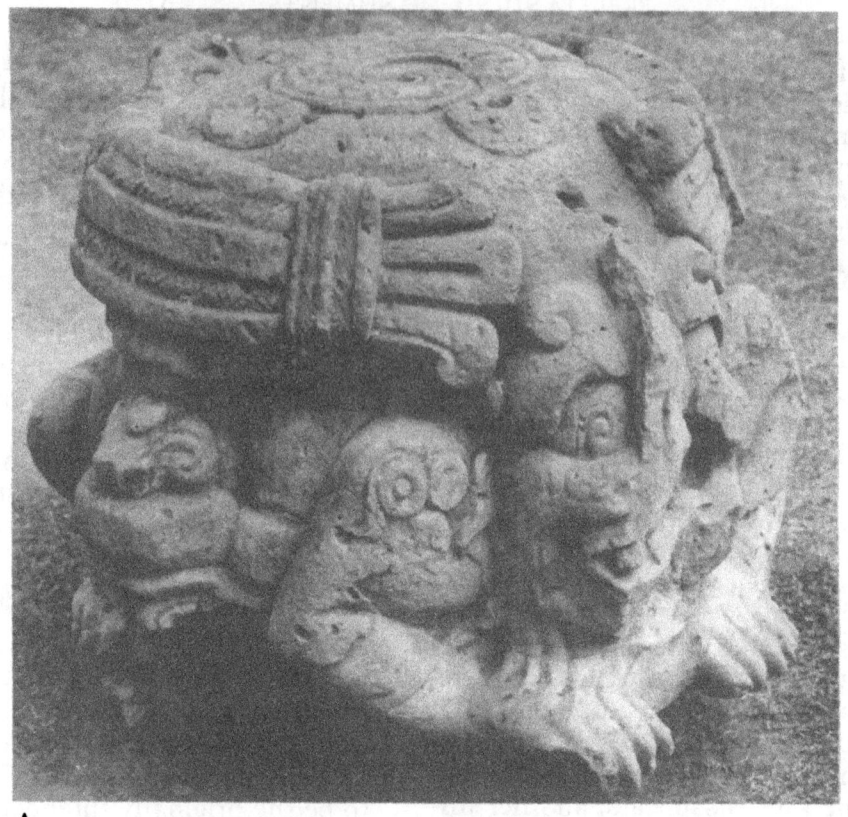

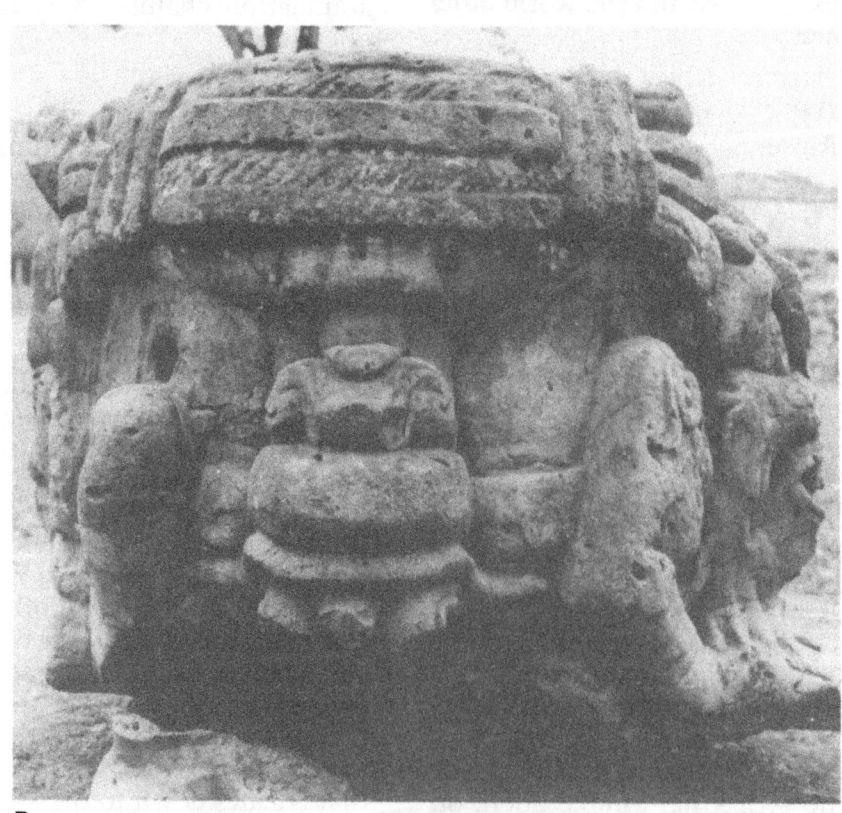

FIG. 36 CPN 27: (a) east side; (b) south side. Photos by J.-P. Courau.

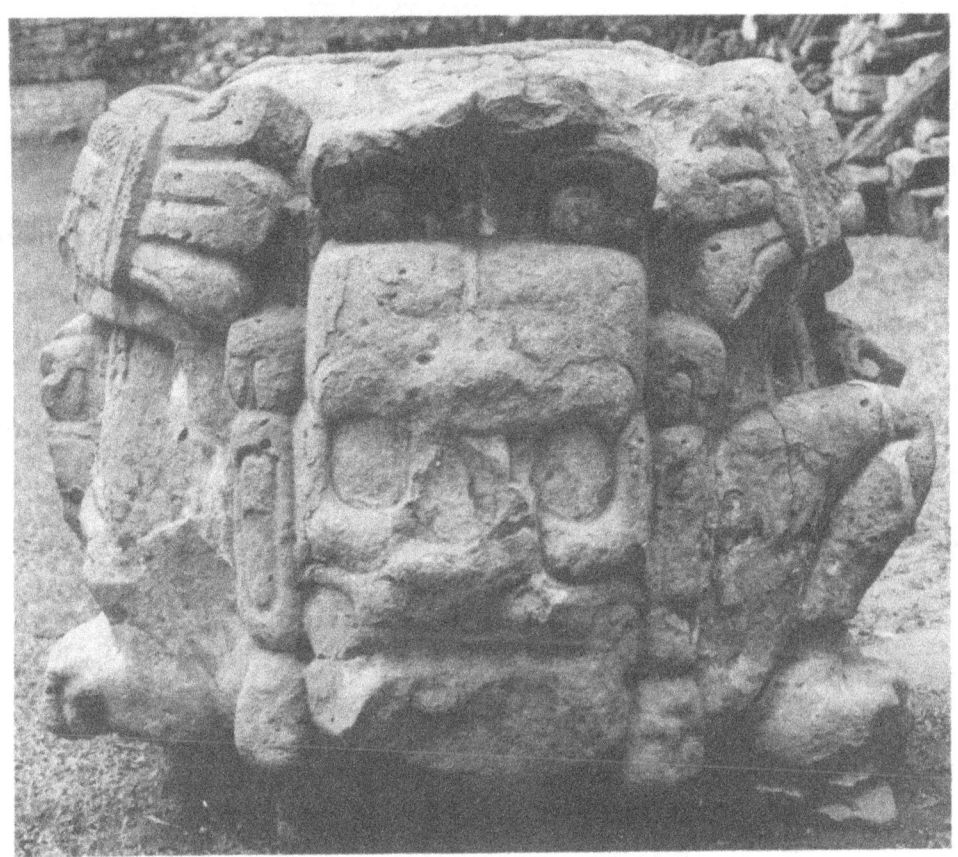

A

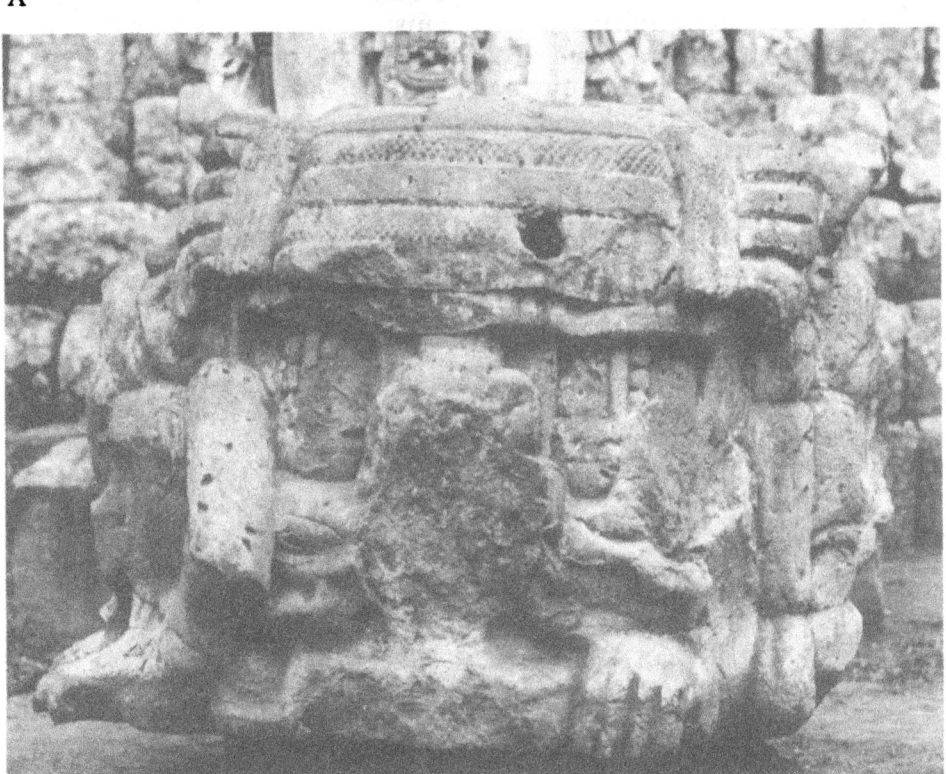

B

FIG. 37 CPN 27: (a) west side; (b) north side. Photos by J.-P. Courau.

A death mask crowned with foliage is on the west side. The face is very eroded: the round eyes are edged with beads. The broad nose is topped with a narrow motif that looks like the central element from the tripartite sign; the ear ornaments are of the scroll-and-bone/*ahau* type. The plant motif crowning the skull is made of two scrolls and two wavy leaves, as on the death head on top of CPN 1.

The north and south sides of the monument each have a conventional jaguar head, along with one lifelike leg. To the north the feline is shown with a single left leg placed to the side and set back from the head. The paw has four digits on the same line, and a fifth set back from the fourth. The headband is divided into horizontal white and black bands and has a tripartite element at both ends. The squinting eyes are shown as black rectangles framed by an L-shaped band edged with beads. The muzzle is broken, but the nose is a jaguar's. The mouth's features are gone. A scroll is still visible at the right corner of the mouth.

To the south the jaguar wears the same headband. The single leg, bent at a right angle, is placed against the right side of the head. The thigh bears the three circlets from the *cauac* sign. The paw has three digits in front and one to the rear. The eyes are squinting; the right one still shows traces of an L-shaped edge. The thin but very short muzzle tapers into a double-scrolled nose. The upper lip curls up, baring an incisor flanked by two partly broken fangs. There is no hint of a lower jaw. The tongue began close to where the leg was; apparently it was large and pointed at the end.

INTERPRETATION

This is not the bicephalic monster with masks on its body that Maudslay thought he was documenting. The legs and the two jaguars show that we are dealing with actual creatures and not with masks. Furthermore, the skull crowned with foliage cannot be considered the rear head of a bicephalic monster: it is an autonomous motif. Nor is this monument comparable to CPN 12 and CPN 17, which are made of two couples arranged in a cross pattern.

The trilobed shell on the top is often seen on the knees of the earth monster. It may be a terrestrial symbol whose sacred nature is underlined by the attached four *ahau*. The bat, to which more importance has been given, is an underworld creature especially associated with sacrifice. It is also the main sign of the Copán emblem glyph.

The death head upon which plants grow is a familiar image that illustrates the vegetative cycle, in which life and fertility have death as their origin. In this monument it confers an essential role to death and the underworld.

We do not know how distinctive the jaguars originally were; but one tongue identifies a Pax Jaguar, and this creature displays a very unusual *cauac*. The altar displays three creatures from the underworld, two of whom wear *cauac* signs; this is comparable to CPN 26, where terrestrial and solar attributes are blended in the same creature (crocodile with cruller; jaguar ear and whistongue; serpent Pax). This blending of opposite concepts corresponds exactly to the fourth icon, showing plants growing out of a skull. All these infernal representations might have the same function: to emphasize the close relation between life and death, sacrifice and growth. It is also a justification of the sacrifices that were probably performed on this stone.

We do not yet undertand the possible relationship between the four figures and the cardinal directions. For instance, it is not known why the bat would pertain more to the east than to the north. However, even if there is no concordance between a representation and a given direction, the four figures express universality, or every possible direction on earth.

CPN 28 (ALTAR O)
(fig. 38)

CPN 28 is a pyramidal monolith. The transverse section is triangular and has a U-shaped indentation in the middle. This characterizes it as a silhouette sculpture, which was probably intended for some architectural function. All four inclined sides are sculpted.

DIMENSIONS

Maximum length at base 217 cm; maximum width at base 70 cm; height 106 cm.

DISCOVERY AND LOCATION

CPN 28 was first described by Maudslay as standing at the western end of the court of

A　　　　　　　　　　　　　　　　　B

FIG. 38 CPN 28: (a) south side; (b) north side. Photos by J.-P. Courau.

the Hieroglyphic Stairway, just east of Structure 7. However, as it is probably an architectural sculpture, this might not be its original location. Structures 7 or 11 are the closest buildings to which CPN 28 might have originally belonged.

COMPOSITION

A feathered serpent is on the west side, and two interlaced serpents are on the east. A toad and a head-first fish that fit together are on the north, and on the south are two male humans with another fish.

West Side: The scaly body of the profile live serpent on the west side wears the characteristic back (ringed black dots) and belly (plain half-circles) markings. The edge of the back and the whole tail are feathered. A small serpent, head-first with open jaws, is carved on the stone's corner, where the monster's body turns up; a water lily blossom is behind the ear, and a scroll or a bead is at the tail's end.

A double scroll (T122) is within the mouth of the large, bearded serpent. A stylized jaguar head is carved on the tip of its upturned snout. The serpent has a hook in its oval eye, and tubes just out of its nose; the eyebrow is U-shaped, and a large water lily blossom is behind the head. The tongue is beneath a stylized serpent head whose eyebrow is made of the usual scroll at the mouth's corner.

East Side: The intertwined serpents surround a central motif made of a braid, a tripartite element (T255 or T125), and a panache of feathers. The two serpents are similar, although the one to the right is larger. They display both kinds of body markings, and the ornate *ahau* (T535) is attached to their tails. The two monsters wear bracelets made of tubular beads; their paws have three claws in front and one to the rear. The heads are similar to the one on the west side; however, the water lily is replaced here by simpler plant forms.

North and South Sides (fig. 38): On the north side a toad and a head-first fish fit together. Two standing frontal individuals are on the south side; their legs are parted and they wear a loincloth. The tallest has his hands resting on his thighs; he has circular earflares and a tall but poorly defined headdress with an enlarged top. The head of the other figure hardly reaches his companion's shoulder. He has one hand on his chest and another close to his left shoulder. A head-first fish in profile is above him.

INTERPRETATION

The three similar, living, large serpents depicted on this monument make no opposition between left and right on the east side, nor between the east and west sides. The lack of *cauac* elements would indicate that they are sky rather than earth monsters. The figures carved on the north and south sides must be seen within or emerging from the jaws of the serpent carved on the east side. To the north we see a toad, an animal associated with earth, rain, and fertility, and a fish, an aquatic symbol *par excellence*. Their head-first position may mean rainfall. The south side, with the downward fish, does not seem to contrast with the north side. Costume and attitude do not really individualize the two humans. They are carved in an unusual style, with frontal faces, but have nothing in common with the human figures on the dynastic monuments. The main characteristic, the difference in size, may express a father/son relationship and thus be a fertility image. In this respect, the fertility of the human would be associated with the agrarian fertility brought by the rains (image of the fish).

COMPARISONS

CPN 28 is the closest parallel to CPN 13. Both function as architectural decoration, and both depict sky serpents. They share, in addition, late traits such as decorative grotesque heads on the serpent's snout, the tongue in the form of a serpent, and the feathered serpent. To account for the stylistic differences observed on this monument, it is very possible that the motifs on the north and south sides were carved at a later date than those to the east and west.

CPN 29 (STELA P)
(fig. 39)

This is a prismatic shaft with the two broad sides flaring out toward the top. The west side is sculpted with a standing human in frontal view, and the other three sides are carved with glyphic inscriptions. The overall condition is rather good, except for the lower west wide, which has suffered from erosion since Maudslay's time. The feet of the human figure once present are completely effaced today. The stela is encased in a cribbing frame.

DIMENSIONS

Height 321 cm; width (west side) at base 65 cm and at top 87 cm; depth (south side) 53 cm. Cribbing frame is 146 cm (north-south) by 143 cm (east-west) by 30 cm (height).

DISCOVERY, LOCATION, AND ASSOCIATIONS

When first reported by Stephens in 1839 it was standing where it is now, on the west side of the extreme northern end of Structure 16, facing the West Court.

Morley (1920) argued that CPN 29 had been taken from an unknown original location and reerected there, late in Copán's history. His major arguments are the lack of an associated altar and the late date of the content of the stela cache. Disagreeing with Morley, Strömsvik (1941) assumes that CPN 29 is presently at its original location. He argues that the Acropolis had probably reached the level of CPN 29 at the time of the stela's erection, based on the observation that the level of the much earlier hieroglyphic step found in the tunnel dug into Structure 11 is the same as that of CPN 29. Even if Strömsvik is right in thinking that the actual level of the West Court had been reached already at the

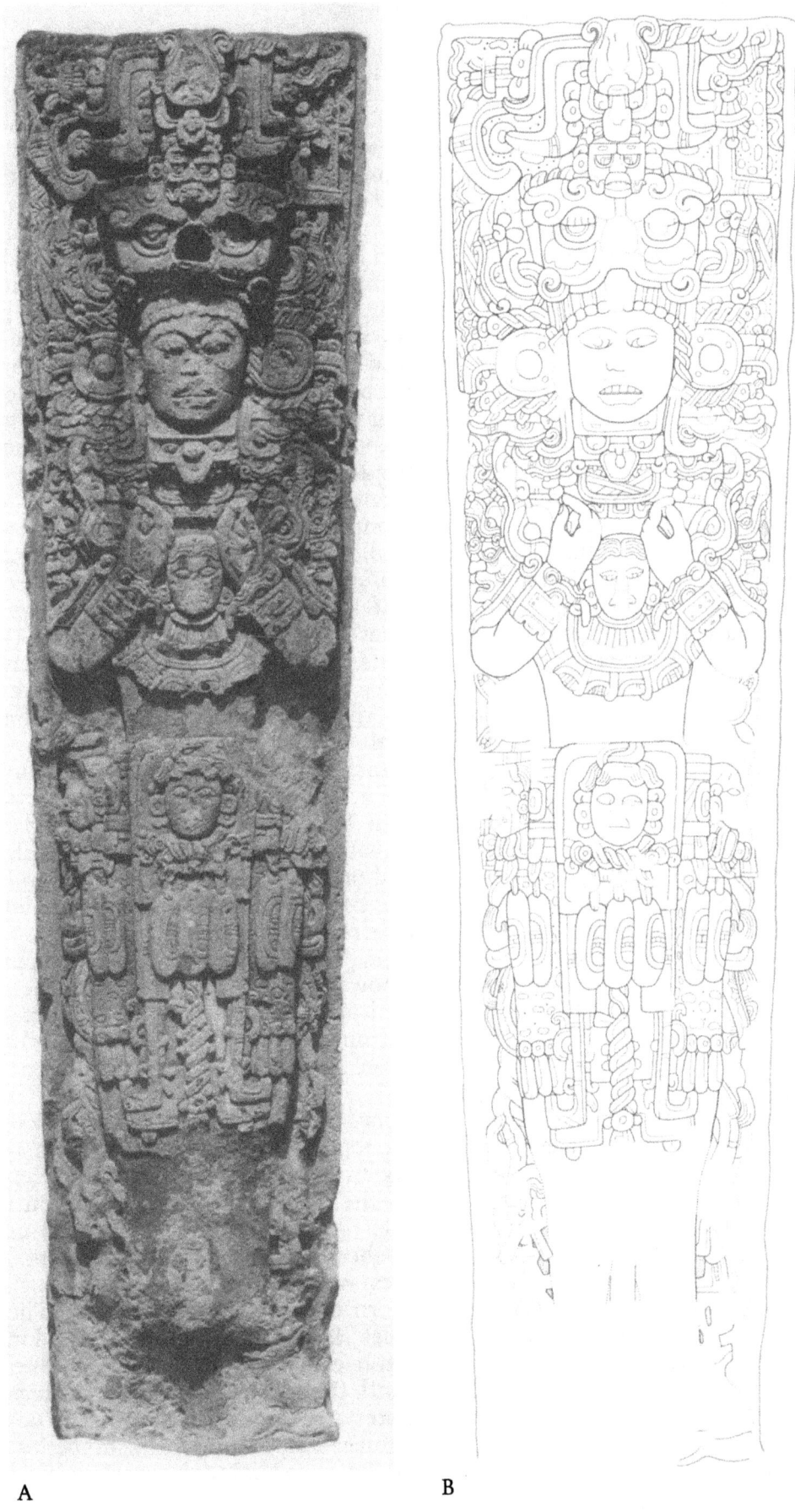

A B

FIG. 39 CPN 29: west side. Photo by J.-P. Courau; drawing by B. Fash.

time of the stela's erection, I contend that there had been so much building activity on the Acropolis from this date until A.D. 800 that it is indeed very likely that the monument had been displaced, and that Morley's arguments are still valid, too.

A cruciform masonry chamber below the stela contained lidded clay incensarios adorned with appliqué cacao pods, a dish, and three floreros, all judged "rather better finished than similar vessels under Stelae M and N" (Strömsvik 1941: 76).

DEDICATORY DATE

9.9.10.0.0 2 Ahau 13 Pop.

COMPOSITION

The design of the stela's west side follows a rigorous bilateral symmetry. The main figure, in frontal view, stands, holding the bicephalic serpent against his chest. Two masks are superimposed above his helmet: the upper mask is crowned with plants and partly hides a braid-and-tassel; the lower one is a serpent. The figure has two shields placed between his elbows and his belt, and his legs are flanked by two serpents. A jaguar skin is used as background.

The Main Figure: The eleventh ruler (Butz' Chan or Smoking-Heavens) wears a reptile helmet in serpent or crocodile form above a beaded headband. The helmet's forehead is made of several scrolls and crowned by a row of trimmed feathers. The rounded eyes are half-closed over circular pupils, with large T23 signs underlining the eyes. A Chac-like, upturned snout probably was tenoned into the deep socket between the eyes. Below this, the upper lip curls up and two scrolls emerge from the corners of the mouth. The figure wears a chin mask, which two forehead crescents denote as skeletal. It has scroll eyes, a broad muzzle under a small nose with attached bead, and scroll fangs. The lower jaw is replaced by an oval marked with crossed bands (T552) and by T124. The two bands that frame the face probably held together the helmet, the headband, and the chin mask. The bands look like serpent bars with an ophidian head at both ends of a braid. The upper head, at helmet level, has T552 in place of the lower jaw. The lower end of each band is turned up to form the forehead of another serpent head, horizontally placed on the figure's shoulders.

The main figure wears round earflares punctuated by four circlets. A hooklike element representing a downturned, stylized serpent jaw protrudes from behind the earflares. Two braid-and-tassel motifs frame the flare above and below. Another serpent head at chin level completes the decoration. The pectoral, a youth mask with well-combed hair parted in the middle, hangs from a collar made of one row of round beads; tubular beads form a collar below the mask. The bicephalic serpent that the king holds against his chest has a segmented body adorned with T24. The serpent head to the right holds in its jaws a jaguar-helmeted old solar figure with toothless mouth and roman nose adorned with the cruller. To the left is a human head with closed mouth, ringed eyes, and pierced nose. The human head wears an ophidian helmet. These two figures appear to be the "paddlers," a couple of supernaturals identified by Stuart (1988). The thick bracelets are made of a serpent head topped by a rectangular plaque with circles forming a quincunx and T23 (which is upside down when the king lowers his arms). The band and disk belt with pendant beads and tinklers is placed over the jaguar-skin skirt. Youth masks with a braid-and-tassel (T58) are on the front and sides of the belt. Two eroded circular shields with four radiating points adorned with three circlets (T824) are set between the main figure's elbows and belt. The tinklers of the latter are oval plaques incised with T24 signs. At the bottom center of the skirt is a braid-and-tassel flanked by serpent heads.

Above the Main Figure: Two masks sit above the reptilian helmet. The first has a protruding mouth flanked by serpentine elements (as on the mask worn by the king on the west side of CPN 47) and a flattened nose. The forehead is marked by two crescents, and the eyes squint downward. The earflares are adorned with scroll and bead. The second mask, larger than the first, has a long snout, scroll eyes, and no lower jaw. The pointed skull, flanked by two scrolls, is shaped like a water lily; wavy lines indicate bone. Curvilinear strips representing branches or stems jut out from behind the mask, which is thus a

variant of the skull-and-vegetation motif. They partly hide several motifs that are not clearly related: at the top, a braid; to the left a jawless serpent head and a hanging tassel. A jaguar skin covers the background.

On the Sides of the Main Figure: Two spiraling serpents frame the main figure's legs. Their segmented bodies are adorned with crosshatched triangles and regularly spaced tufts of hair or feathers; a similar tuft is attached to the tail. There are almost no traces of the heads, whose jaws opened onto a tassel. It is possible that this creature is an archaic form of the feathered serpent that is ubiquitous in Mesoamerican iconography.

INTERPRETATION

Through his helmet, the main figure places himself under the tutelage of the earth monster, who also controls fertility and abundance. The skull-and-vegetation crowning the headdress stresses this patronage. The skull, the small jaguar, the nocturnal sun mask, and the jaguar skin in the background represent the opposite, negative side of this basic duality. The bicephalic serpent held against the chest has in its jaws the "paddlers," probably two complementary mythological figures. The (feathered) serpents that frame the ruler's legs are cosmic monsters.

CPN 30 (ALTAR Q)
(figs. 40–41)

This prismatic monolith is slightly elevated from the court's floor and rests on four supporting stones. A framed hieroglyphic inscription covers the top, while the bottom is plain. The four vertical sides are sculpted with a total of sixteen human figures seated cross-legged on hieroglyphs. Two additional hieroglyphs are placed between the two persons who face each other on the west side.

DIMENSIONS

East-west 152 cm; north-south 147 cm; height 70–72 cm. Top 132 cm (east-west) by 126 cm.

DISCOVERY, LOCATION, AND ASSOCIATIONS

CPN 30 was first reported and illustrated by Juan Galindo. It seems never to have been moved from its location at the foot of the stairway that leads from the West Court to Temple 16. It is placed on the central axis of that stairway, in accordance with the Maya concept of symmetry. Neither a stela nor a cache is associated with this monument, ostensibly related to Structure 16.

DEDICATORY DATE

9.17.5.3.4 5 Kan 12 Uo.

DESCRIPTION

On each side of the altar there are four figures sitting cross-legged with one leg hanging down, on top of glyphs that name them. The whole set divides in two opposing groups of ten left-profile and six right-profile figures, seemingly lined up, which meet on the west face of the monument.

The opposing figures on the west face of the altar are especially noteworthy. The one to the left wears a turban adorned with a hybrid quetzal-macaw bird, a whistongue or a cutout shell with an infixed *kin*, and a crowning panache or lock of hair. His eye is circled with a ring, part of the war/sacrifice complex. An elongated object with a flared end, perhaps a bone or lancet, pierces the ear. A tubular bead hangs over the chest. He wears a feather cape and a loincloth. A small square shield, adorned with a serpent head, partly covers the right forearm. The figure seems to offer a jaguar-paw scepter to the individual facing him. Together they flank the Calendar Round date carved near the top of the altar. The right-hand figure holds a bundle scepter in his right hand, while his left rests on his knee. He wears a round hat crowned by three knotted bands; ribbons also decorate the headdress. An upside-down whistongue with the crossed bands on the broad end adorns the hat. The jewelry includes a flare and tubular ear ornament, a bead collar, and a pendant of tubular beads with flared ends. Finally, a simple looped band adorns the wrists and ankles.

The remaining figures can be summarized briefly. With one exception, all other figures wear a biconical turban (which sometimes appears conical due to perspective) crowned by a knot and pendant ribbons. The fourth left-profile figure, however, wears a more impressive headdress. It includes a turban topped by a panache tied with three knotted bands. This figure also is the only one on the altar to wear a false beard. They all wear nose beads, and the ear ornaments include a circular flare and tube. One or more knotted bands or a

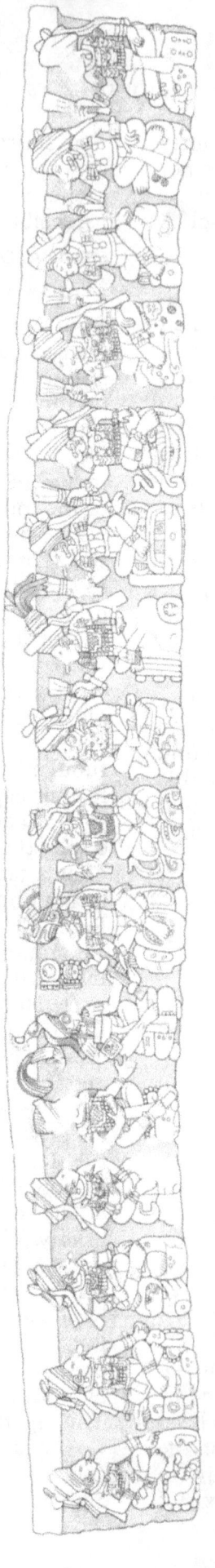

FIG. 40 CPN 30: roll-out of periphery. Drawing by A. Blanck.

ribbon-on-band make up the bracelets and anklets. With few exceptions, the left-profile figures hold the bundle scepter in front of their faces, while the right-profile ones hold it close to their bodies. Some wear a tubular bead over the chest. Others, however, may wear a pectoral in addition to, or instead of, the bead. Generally, the pectorals are of two types: a full-face mask with short nose and T-shaped mouths flanked by serpents and a nonfigurative beaded pectoral.

INTERPRETATION

The distribution of ornaments on the altar does not indicate any meaningful pattern, with the exception of the two central facing figures, and, to a lesser degree, the fourth person to the right, Eighteen-Rabbit, whose costume stresses his privileged status. Posture and presence or absence of tubular beads or of a certain pectoral type do not indicate any hierarchical order of right-versus left-profile group or position in the composition. Individual variations seem due only to the artistic concern to avoid monotony. With the exceptions cited above, all the figures are presented as equal and of the same rank. The very composition of the altar sides forms a close circle whose two ends, represented by the central figures on the west face, meet and face one another.

Most scholars now reject the so-called "Theory of Determinants" proposed by Spinden (1924: 140–141) and elaborated by Teeple (1930). This theory, still very popular in guides and magazines, interprets the gathering of the sixteen seated persons on CPN 30 as an astronomical meeting, whose main purpose would have been to determine the length of the tropical year. These astronomers would have come to Copán from all parts of the Maya area, their place of origin being given by the glyph on which they are seated. The Calendar Round date in the middle of the west side was interpreted as the date at which the astronomical adjustment was adopted. The major problem with this appealing theory is the absence of any date with astronomical importance in the texts carved on the altar; besides, the glyphs used as seats by the "astronomers" do not compare with any of the known emblem glyphs (Baudez and Riese 1990).

CPN 30 is now commonly interpreted as the dynastic succession of all officially recognized rulers of Copán at the time the monument was carved; the glyphs are assumed to denote names or titles of those rulers (see Davoust 1976, 1978, 1979). Four of them at least have been identified as the name glyphs of Copán rulers deciphered on other monuments. The date 6 Caban 10 Mol, ostensibly placed between the two main figures on the west side of the monument, is known to be the accession date of Rising-Sun: 9.16.12.5.17.

The person to the left of the central date is, according to this interpretation, the founder of the Copán dynasty. Because he holds the unusual jaguar-paw scepter in his left hand, I think he is the same person as the ancestor figure in the uppermost register of the west face of CPN 3. I also think that the Father Founder is also depicted on the major statue that stood in a niche in the north chamber of Temple 16, right above CPN 30 (see the discussion of Structure 16 in chapter 2). Ruler 2 seems to be the possible dynastic ancestor represented in a similar pictorial composition on CPN 23.

CPN 33 (ALTAR T)
(figs. 42–45)

The top of this prismatic monolith, which was already very eroded when first reported by Maudslay, is today almost completely effaced. It was carved with a crocodile spread out on its belly; the tip of the snout, the tail, and the hind limbs hang over the sides of the monument. Seated figures shown in profile take up the space between the animal's body and legs, on the vertical sides of the altar. There are two groups of six figures each, facing each other on the tail side. Each figure sits on a glyphlike sign. The two figures facing each other directly on the tail side are themselves part of the calendrical inscription: their heads and the "offerings" they are holding in their outstretched hands contain the hieroglyphic information. Along the middle of the crocodile's back a hieroglyphic inscription was originally carved. Only outlines of some glyphs remain. This inscription continues on the tail, which is carved on a vertical side and is much better preserved than the portion on the top. On the opposite

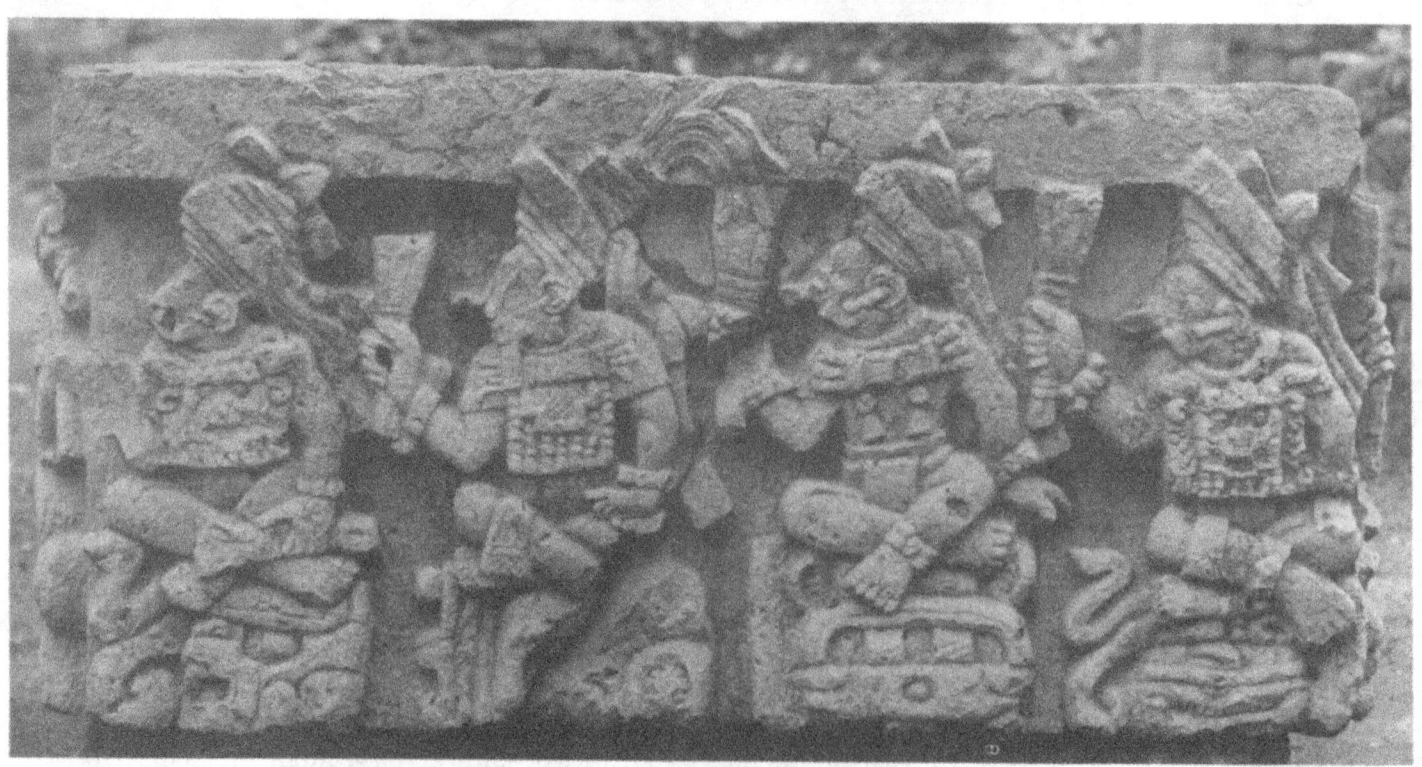

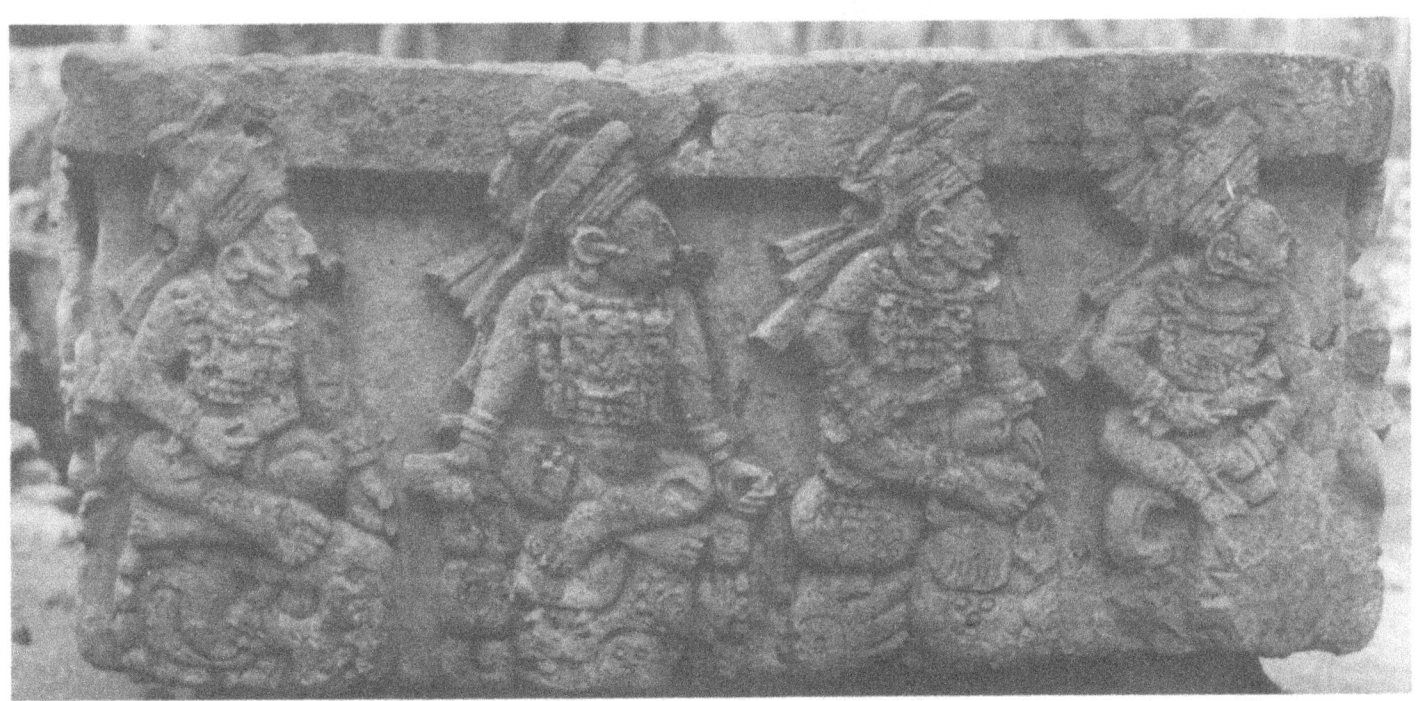

FIG. 41 CPN 30: (a) west side; (b) south side; (c) east side; (d) north side. Photos by J.-P. Courau.

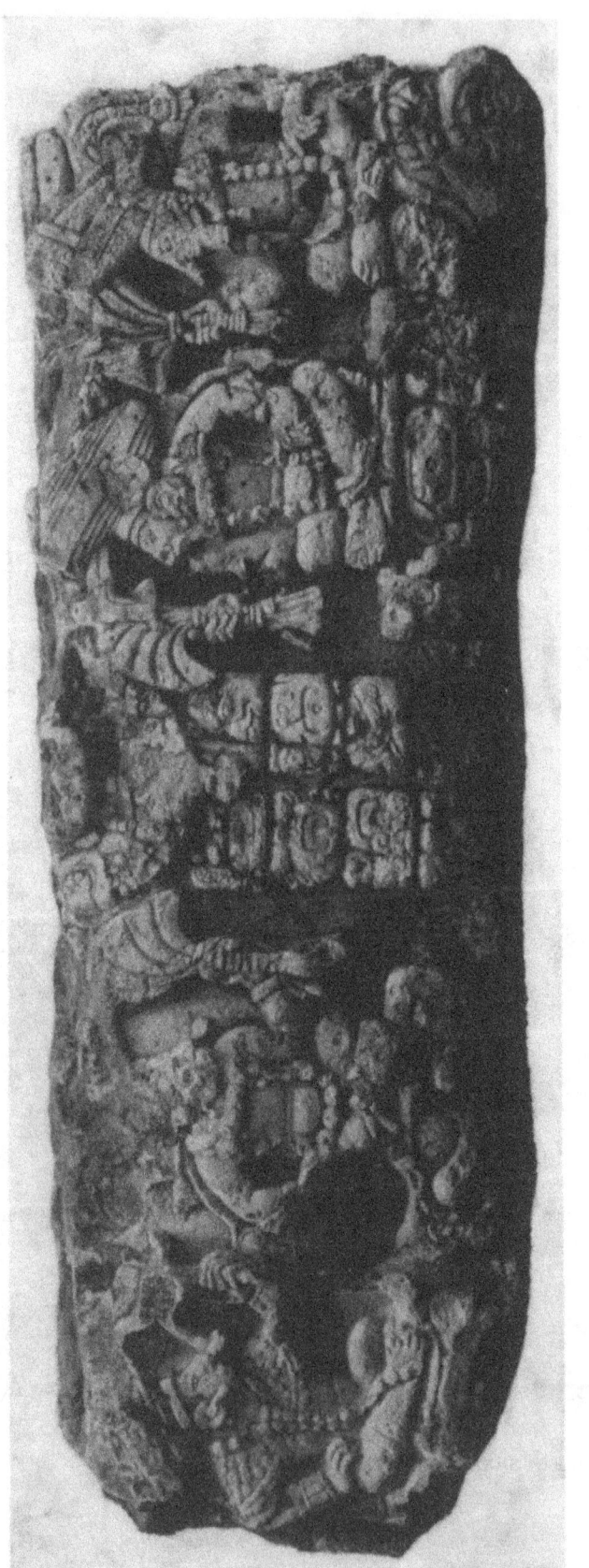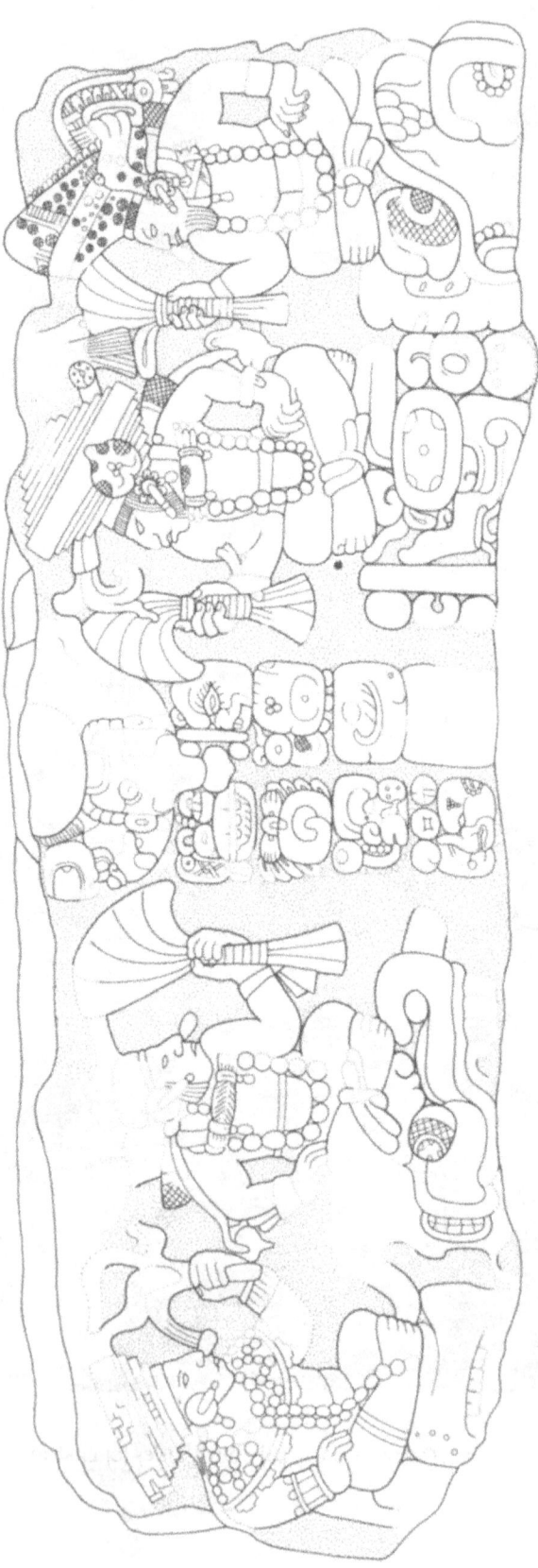

FIG. 42 CPN 33: front. Photo by J.-P. Courau; drawing by S. Matta.

vertical side, below the crocodile's snout, another hieroglyphic inscription is carved.

DIMENSIONS

Height 56 to 67 cm; length 195 cm; width 145 cm.

DISCOVERY, LOCATION, AND ASSOCIATIONS

Maudslay first saw this monument, together with CPN 34, on the village square of what is today Copán Ruinas. At an undetermined date CPN 33 was transferred to the nearby local museum, where it is on display in the courtyard. No monuments or structures originally associated with CPN 33 are known.

DEDICATORY DATE

9.17.12.5.17 4 Caban 10 Zip.

The Crocodile: It seems that the animal carved on top of CPN 33 is an impersonator wearing a crocodile skin according to the human proportions of the limbs, hands, and feet. The reptile skin is attached to the wrists and ankles by a water lily; a fish nibbling the blossom at the wrists reproduces the familiar nibbling fish image. Conversely, to the rear the fish is placed between the water lily and the headdress of the sixth figure in such a way that it belongs to both groups. We assume that the water lily/fish group is a rebus for *bacab—ba-ka* or *ba-ka-b(a)*—where the water lily/*imix* stands for *ba* and the fish for *ka*; thus, its presence at the four ends of the earth crocodile would recall the position of the four *bacab*s at the four corners of the earth (Deborah Tear, pers. comm., 1979). On the crocodile the scales are shown by pairs of ovals. Plants are attached to the round earflares. The cross-banded eyes are half closed. The snout is edged with pointed teeth, and its tip—on the monument's front—is made of three masks. The mask in left profile is well preserved and shows the jaguar/sun with *kin* on the forehead. A reptilian snout marked with a jaguar mask is a recurrent icon on the late Copán monuments (CPN 4, CPN 28, CPN 13, etc.).

The figures seated on both sides of the head (a single one) and of the body (two individuals) seem to be humans wearing serpent helmets and the usual jewels. Nothing indicates that they are from the underworld or come from the abode of the dead. Both hold a now-eroded glyph in their hands, but in two instances in the drawing published by Maudslay—a *kan* cross on the upper right and T122, "smoke" (from incense?) on the lower left—can be identified. They probably are dignitaries presenting offerings to the earth, whom they face. On the rear the two creatures on both sides of the tail are full-figure *caban* glyphs.

The Left-Profile Group of Figures: Figure 1 is a man with a frontal body and profile head (fig. 42). He is seated cross-legged on 7-Head, an image of the fertile earth (Baudez 1984). He holds a bundle scepter and wears a biconical turban adorned with ribbons; the smoking ax implanted in his forehead indicates that he belongs to the underworld (see CPN 60 and the prone figures on the Hieroglyphic Stairway). The water lily hangs from his head or headdress down his back. The earplug is tipped with a jaguar ear. The figure wears a long beaded collar, a tubular pectoral, and a strip tied in a single loop encircling his wrists and ankles.

Figure 2 is a man seated on a variant of the *cauac* glyph (composed of a dark and a light aspect?) prefixed by *yax* (fig. 42). It is another image of the earth (described as green, i.e., fertile?). The figure holds a bundle scepter and wears a (false?) beard. He has a biconical turban of jaguar skin; a blackened ribbon and a braid-and-tassel are also part of the headdress. The earflare is topped with a jaguar paw. The anklets, pectoral, and collar are similar to those of the preceding figure, and the bracelets are of the simple band type.

Figure 3 is depicted in profile seated on the ground (fig. 43). His body is human but his head is that of a bat. He was apparently wearing a helmet on top in the form of a reptile sticking out a forked tongue. His bracelets and his belt are made of tubular beads. A single strand necklace supports a youth mask.

Figure 4 is an anthropomorphic figure with an eroded face. Against his serpent helmet, another ophidian head faces backward (a bicephalic serpent helmet?). A jaguar tail is included in the headdress. The body has black markings. A serpent head replaces the left hand, and his right hand is replaced by another animal head. The jewels and the costume are the same as on the previous figure.

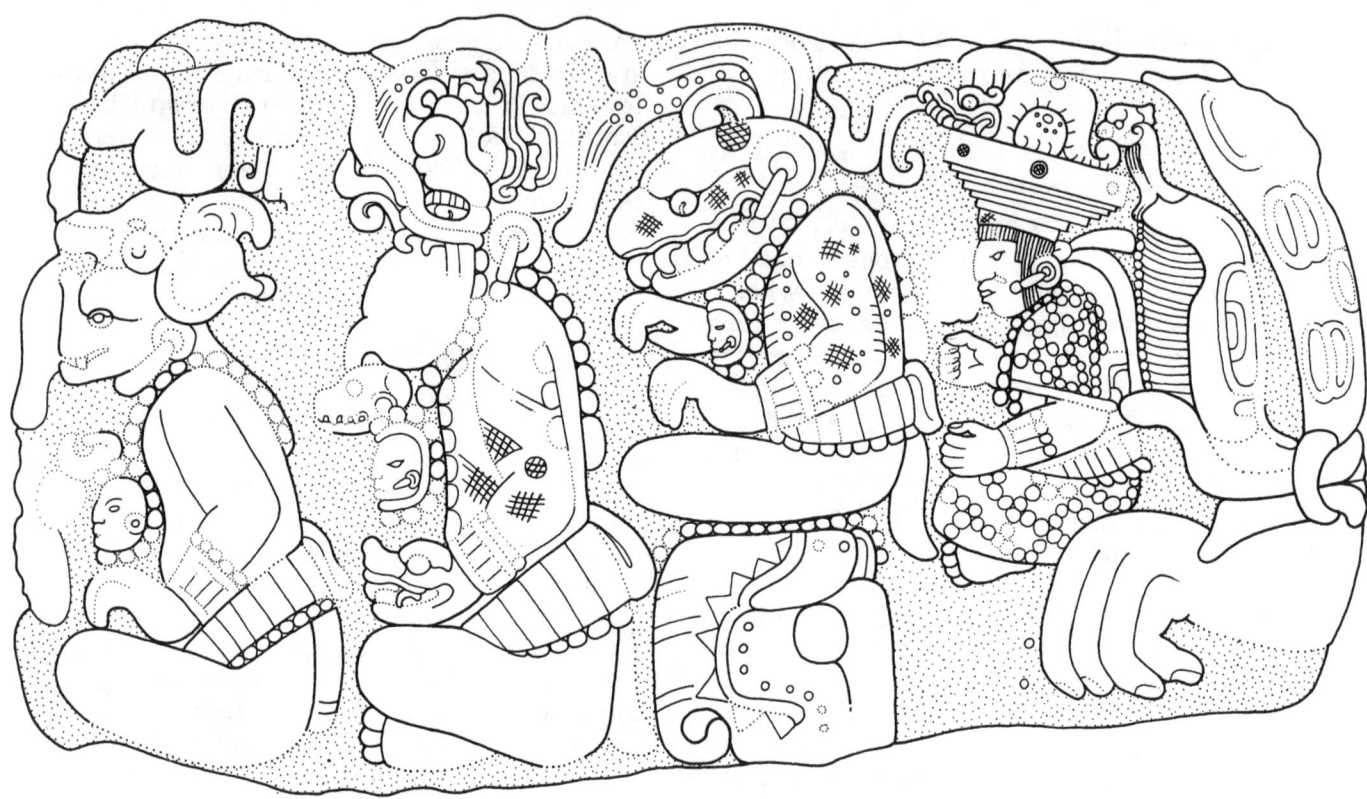

FIG. 43 CPN 33: left-profile group of figures. Drawing by S. Matta.

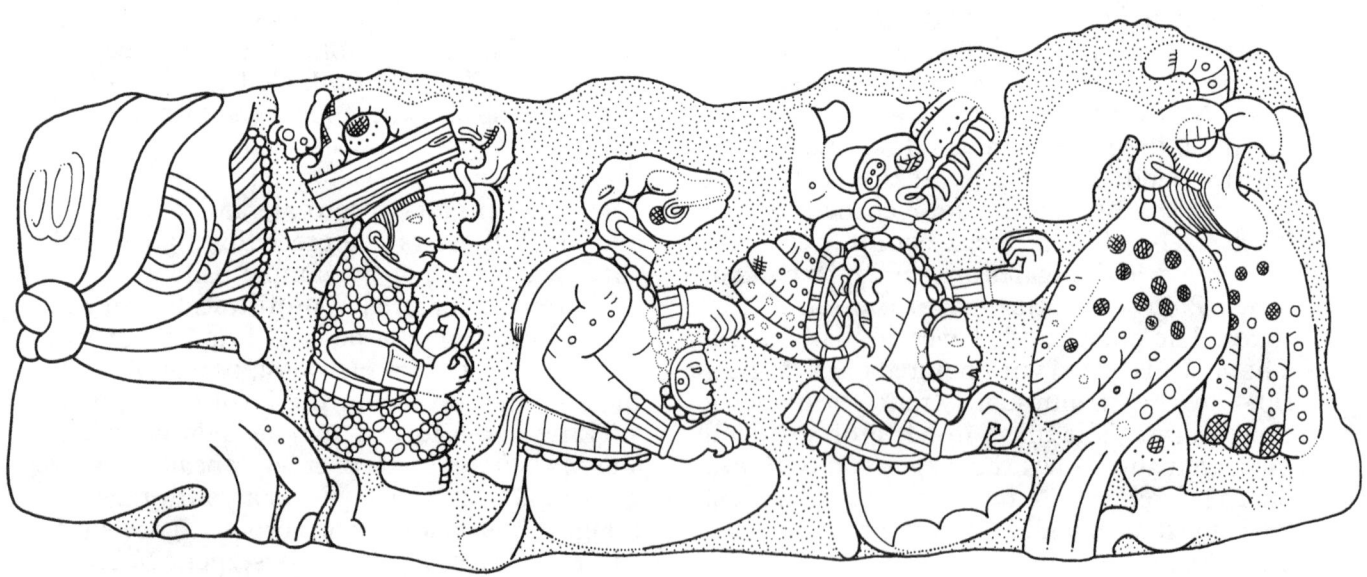

FIG. 44 CPN 33: right-profile group of figures. Drawing by S. Matta.

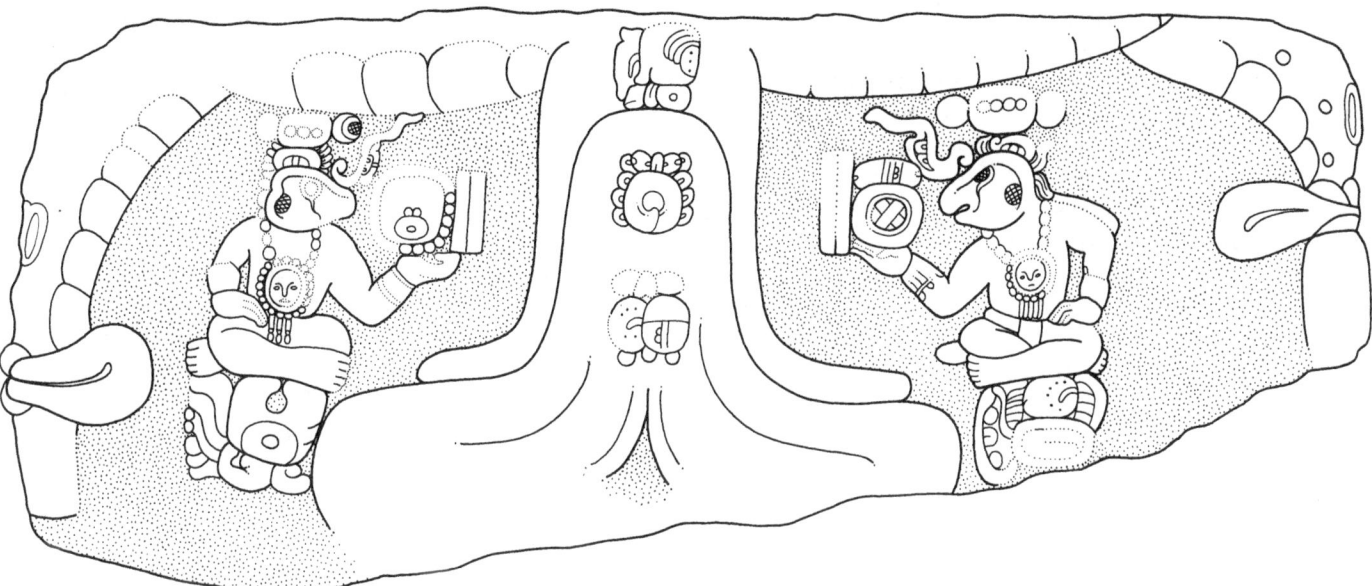

FIG. 45 CPN 33: back. Drawing by S. Matta.

with a jaguar head; black spots are scattered on both head and body. The teeth are formidable, the scroll-eye is round, and the ear ornament includes a tube. T19, a jaguar tail, and a ribbon are at the top of the head. The jewels and the costume are the same as on the two previous figures. This figure sits on a throne in the shape of a toad head facing upward (upended frog), another image of the earth.

Figure 6 is a human seated on an eroded throne, wearing a cape and a skirt covered by a jade net. It is unclear if the figure is a woman or a man. The hands are empty. A bead hangs from the nose. A serpent or crocodile with a forked tongue arches above T501 on the turban. The head of a small fish rests on the crocodile tail. Thus, the headdress might represent the *bacab* title and might refer to this figure.

The Right-Profile Group of Figures: Figure 1 is a man seated on a crocodile head with a *kin* sign infixed in the blackened eye and a water lily blossom in the back (fig. 42). Like his counterpart, he holds a bundle scepter and wears the same anklets, wristlets, ear ornaments, collar, and pectoral. Ribbons with blackened ends and a water lily were in the headdress, broken today. A bead is attached to his nose.

Figure 2 is a man on a throne, eroded except for a row of teeth and a *cauac* element, which may imply that this is the head of the earth monster. The individual holds a scepter different from the usual bundle: the short handle branches out into four wavy branches. He wears a conical turban adorned with regularly placed Ts. He also wears a long bead collar, wristlets made of tubular beads, a tubular earplug, and a nose bead.

Figure 3 is the only true animal on this monument (fig. 44). It is a bird with a hooked beak, a wrinkled, hairy face, and a half-closed eye. It may be identified as either the *katun* or the *muan* bird. The wings have black spots, circles, short straight lines, and black tips. A tubular earplug is the only jewel.

Figure 4 is an anthropomorph with a crocodile head, without a headdress, with long pointed teeth, a cross-banded eye, and plants behind the tubular earplug. The body is marked with rounded scales and on the back he wears a serpent wing with crossed bands. Tubular beads make up the wristlets and belt. A youth mask hangs on the chest from a row of round beads.

Figure 5 is an anthropomorph with an unidentified animal head; the elongated snout is reminiscent of an opossum or an iguana. Considering its resemblance to the full-figure *caban* glyph on the altar's back, this must be a terrestrial animal. Like the preceding figure, he has no headdress and wears the same ear ornaments, collar, pectoral, and

belt. Circlets and short lines are scattered on the arm.

Figure 6, similar to the sixth figure of the left-profile group, is seated on a now-eroded glyph, which was *imix* according to the drawing in Maudslay. It differs from its counterpart in the hand's position and the smoking ax implanted in the forehead, a motif exclusive to supernaturals and the deceased. The rebus form of *bacab* is atop the figure's turban: the reptile/*ba* flanked by a headfirst fish/*ka*, and arching above *imix*/*b(a)*.

INTERPRETATION

The monument's top is covered with the crocodile, which represents the earth, to which humans present offerings; the individuals carved on the sides, being under the earth, belong to the underworld. The figures are distributed into two homologous groups, including two humans, three animals, and one more human.

Men and animals are presented in distinct ways. Every human is seated on a glyphlike throne. It is not a name as on CPN 30, but rather a sign that recalls the earth or the earth monster: 7-Head, a crocodile head, the *cauac* monster, *imix*. As a rule, Maya iconography pictures the ruler standing or sitting on an image of the earth, even when he is in the netherworld. This image probably expresses the power of the ruler over the earth.

Except for the *muan* bird, who is standing, the animal figures are seated directly on the ground; the jaguar, however, who rests on an upended frog, is another earthly image. This probably likens the jaguar/night sun to the dead ruler.

The creatures we have been able to identify belong to the earth and the underworld: the bat, the jaguar, the *muan* bird, and the crocodile. The greatest importance is given to the four characters on the front of the monument. The body is in frontal view and not in profile as on the sides; they wear elaborate headdresses including the Copán turban, and hold the bundle scepter, a royal attribute according to CPN 23 and CPN 30. The sixth individual of each group is very different from the great-ancestors: he is smaller and shown entirely in profile. Although he has no right to the scepter, he wears an elaborate costume worthy of a queen or an important chief. The *bacab* title is expressed in rebus form in the headdress. This expression ends both groups, as *bacab* usually ends texts.

CPN 34 (ALTAR U)
(figs. 46–47)

One vertical side of this prismatic monolithic altar is sculpted with a jaguar mask flanked by two human figures seated in serpent mouths. Their heads and headdresses are broken off, and other details are also missing, particularly to the right of the jaguar mask. The back and the top of the monument are carved with glyphs.

DIMENSIONS

Height 93 cm; Length 170 cm; width 65 cm.

DISCOVERY AND LOCATION

CPN 34 was first described and illustrated by Maudslay, who found it together with CPN 33 in the village plaza of Copán Ruinas. At an undetermined date it was transferred to the local museum, where it remains today.

DEDICATORY DATE

9.18.5.0.0 4 Ahau 13 Ceh.

DESCRIPTION

The large jaguar mask wears a headband composed of horizontal black and white bands with a tripartite element and death eye at both ends. The muzzle is flat, and the upper lip curls up to expose incisors and fangs. There is no lower jaw, but two large scrolls emerge from the mouth's corners. The eyes are *kin* signs with inset *ahau* signs for pupils. Thus, one of the titles of the sun, *k'inich ahau* (Lord Sun-Eye or Sun-Face), is spelled out. An element of T528 (the dot-edged loop) on the cheeks refers to the vegetative earth. The mask expresses both aspects of the earth, summed up by the *kin* and *cauac* glyphs. David Stuart (1986a) also interprets the *kin* sign in the eye as meaning *k'inich*, but proposes that "sun-eyed [throne?] stone" is in fact the name of Altar U itself. I do not see why a name has to be given to this monument; I remind the reader that a *kin* sign is also infixed in the eyes of the rear head of the bicephalic monster depicted on CPN 8. In both cases, the *kin* sign has primarily a semantic value; on CPN 34 a phonetic reading

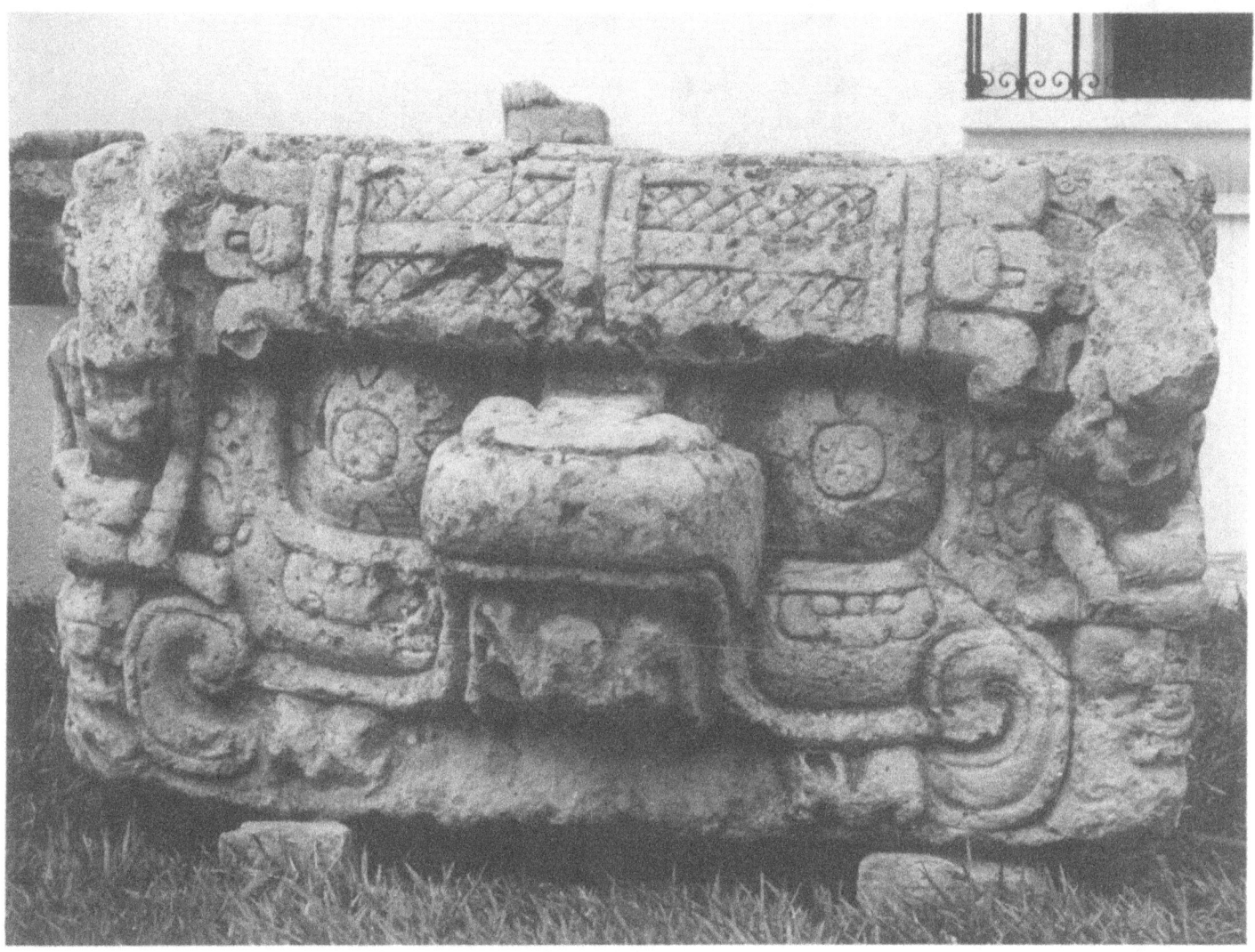

FIG. 46 CPN 34: front. Photo by J.-P. Courau.

is added with the presence of the *ahau* glyph, elegantly forming a *k'inich ahau* reading.

The two identical heads on both sides of the monument may be thought of as belonging to one monster, although its body is not indicated. The serpent skulls are extremely stylized—the eye has a black pupil and the lower jaw takes the form of the T628 sign. The upper jaw tapers into a downturned hook, while the fang follows the same form. Three circlets indicate bone. Starting from the scroll-shaped nostril, a supple band falls backward and ends with T58 with T503 (*ik*) infixed.

Two characters wearing a fringed cape, a belt, and a loincloth, each with a dangling leg, sit within the serpent jaws. To the left of the jaguar mask the belt is divided into squares, each containing a half-circle; to the right the semicircles are blackened to form death eyes or pairs of them form the *akbal* sign. This contrast may signify an opposition between the two individuals. One side of the loincloth is adorned with three crossed-bands and continues with T58, while the other falls into the monster's mouth. Single or double T616b signs are stamped on the thigh. The wristlets, anklets, jewels, faces, and most of the headdresses are eroded. The helmet of the figure to the left of the *k'inich ahau* still has an ear with circlets, an indented edge, and elongated elements that make up T824. The headdress of both figures also included a water lily blossom and its stem.

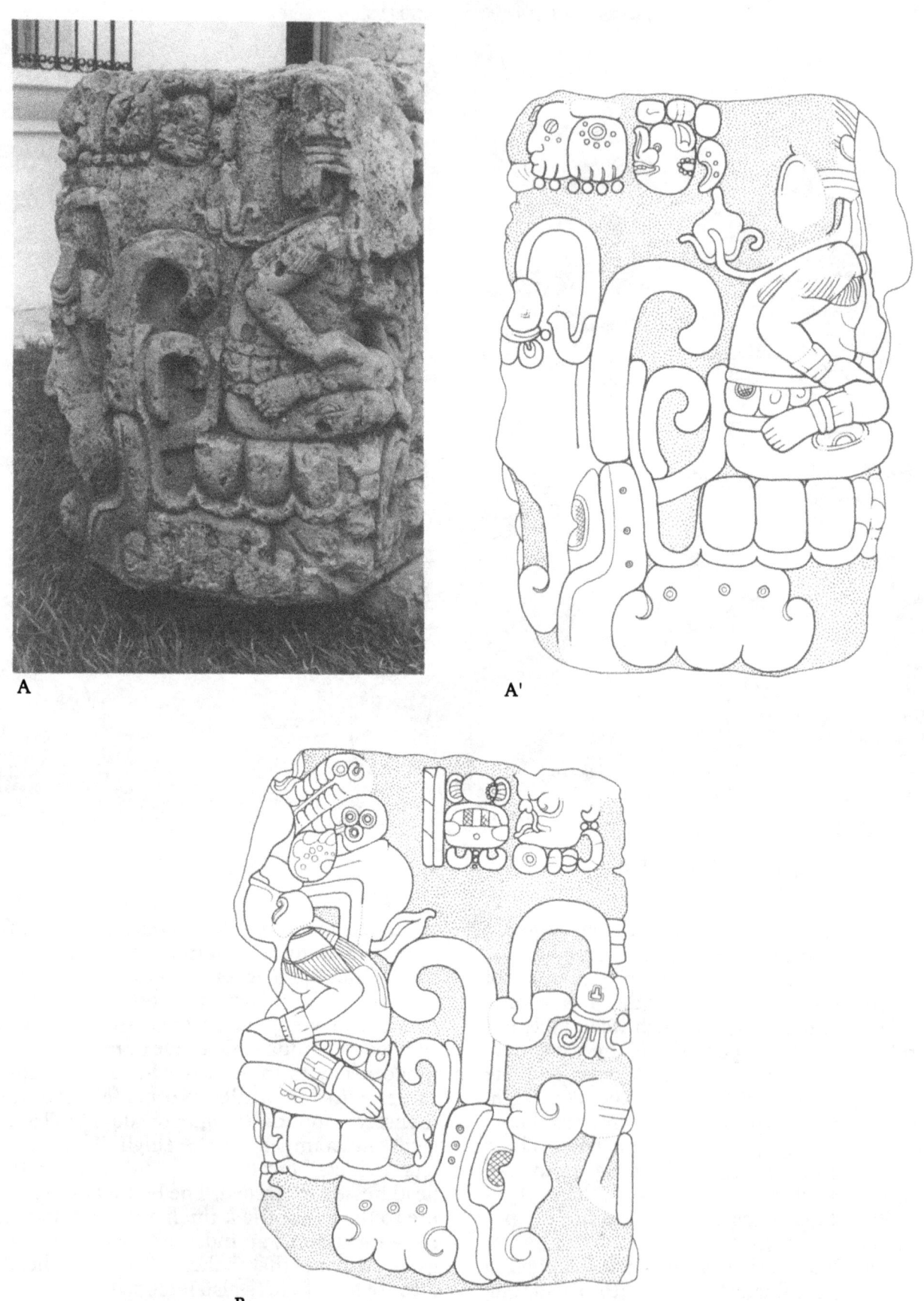

FIG. 47 CPN 34: (a, a') left side; (b) right side. Photo by C. F. Baudez; drawings by S. Matta.

INTERPRETATION

The poor state of preservation and lack of context and associations make the interpretation of this altar difficult. The sun and earth symbols, which are generally contrasted on the monsters' heads, are here together on the same mask, which probably represents the night sun within the earth. The skeletal serpent heads on the sides are those of a bicephalic sky or earth monster, or those of the serpent bar, a royal insignia. The figures in their maws are quite broken, and it is unclear whether they were identical or contrasting, grotesques or anthropomorphs.

CPN 37 (ALTAR Z)
(see Maudslay 1889–1902: vol. 1, pl. 112 and 113a)

One side of this prismatic monolith bears a mask; the other three are inscribed with hieroglyphs. The top and bottom are plain. The mask side has flaked off in many places. CPN 37 was found in 1893 by the Peabody Museum expedition on the uppermost terrace of Structure 11 close to the northeast corner of Temple 11A, where it remains today.

DIMENSIONS
71 cm by 53 cm by 65 cm.

DEDICATORY DATE
9.17.0.0.0 13 Ahau 18 Cumku.

DESCRIPTION
The full-face mask has squinting eyes and T501 on the forehead. The eroded muzzle seems to have been broad. Scrolls decorate the corners of the mouth above the lower jaw. The incisors are T-shaped. The oval ear flares have a scroll on top and a bone below. The upper half of a cruciform medallion adorned with *cauac* elements crowns the mask; water lily blossoms are carved on the upper corners of the altar.

This altar combines both aspects of the earth: its fertility and vegetative aspect with the cruciform medallion and the *cauac* and *imix* signs; its dark aspect with the jaguar/nocturnal sun. Compare CPN 37 with the earth representation below the standing ruler on the southeast jamb of Temple 18. On Toniná Monument 135 (fig. 114g, below), the ruler is seated on the upper part of a cruciform medallion, very similar to this one.

CPN 38 (STELA 1)
(fig. 48)

This monolithic shaft is sculpted with a human figure on one broad side. The opposite face and both narrow sides bear hieroglyphic inscriptions. The lower half of the stela is almost completely eroded. Minor cracks and flaked off portions are also observed. The preserved relief lacks sharpness, probably due to progressive erosion.

DIMENSIONS
Maximum height 291 cm; at base level, width (east-west) 74 cm and depth 46 cm. Maximum depth of relief 32 cm. Cribbing frame: 218 cm (north-south) by 110 cm by 58 cm (high).

DISCOVERY, LOCATION, AND ASSOCIATIONS
The Peabody Museum archaeologists found this monument fallen and broken close to Structure 9. Its unsculpted butt was still *in situ* on the second step of the stairs on the west side of that structure (Maudslay 1889–1902: vol. 5, 66; Gordon 1896). The stela is set into a single cribbing frame, embracing the butt that rests on a stone slab (100 by 90 cm) covering a cruciform masonry chamber; the latter contained five coarse vessels, stalactite fragments, *Spondylus* shells, one jade bead, and cinnabar (Gordon 1896).

When Gordon excavated and investigated its foundation, he destroyed the stratigraphic evidence of the stela's relationship with the construction phase of the associated structure. Strömsvik's (1952) assumption that CPN 38 dates to phase IIIa of the ball court has been questioned by Cheek (1983b): if phase IIb of this ball court was built by Eighteen-Rabbit, as suggested by the inscription on the central marker that predates his reign, the stela cannot be associated with a later construction phase. Two possibilities can be considered: either the monument was originally integrated into phase IIa of the ball court, which was then contemporaneous with its inscription, and was left untouched during subsequent remodelings of the ball court; or it was taken (together with its associated altar?) from an unknown original location and reerected in the ball court during its construction phase III. The presence of a standard foundation chamber does not contradict the assumption of secondary

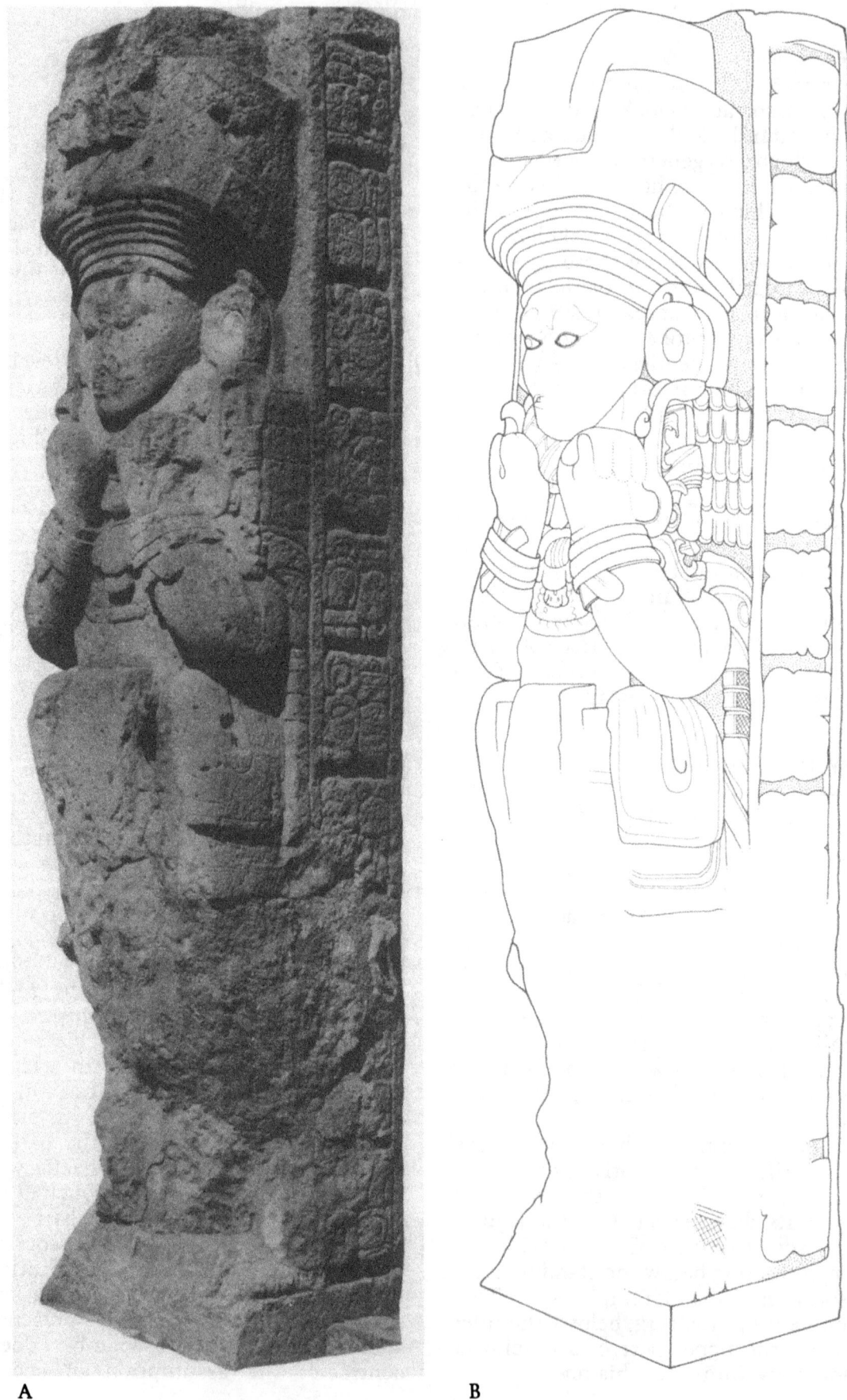

A B
FIG. 48 CPN 38: front. Photo by J.-P. Courau; drawing by A. Dowd.

reerection, as documented by CPN 40, which at the same time has a foundation chamber and predates the structure with which it is associated.

The Carnegie archaeologists reassembled, reinforced with steel dowels, and reerected CPN 38 in its original location, where it remains today. It is associated with CPN 39, a cylindrical altar (180 cm in diameter, 40 cm high) carved on its periphery with a band of hieroglyphs. Although Morley (1920) speculated that the association of these two monuments is not original, he had no supporting factual evidence.

DEDICATORY DATE
According to Riese (Baudez and Riese 1990: vol. 2, p. 204),

CPN 38 probably depicts the Copanec ruler Smoke Jaguar Imix Monster. The text of the stela continues on its altar. The dedication of these two monuments took place at 9.11.15.0.0 4 Ahau 13 Mol. The main reason for its erection was to commemorate the death of one of Smoke Jaguar's predecessors, either Leaf Jaguar or Jaguar Sun God, which makes one speculate if the sameness of the "Jaguar" part of the current ruler and the commemorated ruler might not be one reason for the commemoration.

DESCRIPTION
The main figure depicts a human with a youthful broad face with bulging eyes, protruding cheekbones, and an artificially flattened forehead. The headdress is a tall broad turban, with a cylinder crowning a truncated cone. The end of the cloth band falls forward over the front of the cylinder. The earflares are topped with a scroll. The figure wears a feather cape, which is visible only from the sides. A sort of ruff with oblique lines, a twisted piece of cloth, surrounds the neck. The pectoral is made of tubular beads with a trilobed pendant tapering to a bone. Against his chest the figure holds a bicephalic serpent, with beads adorning the body and very elongated heads. Their lower skeletal jaw is marked with a wavy line and circlets. A human head wearing the same circular earflares and the same turban as the main figure (probably an ancestor) appears between their jaws. A strip is wound several times around the wrist with protruding loops and ends. The front of the broad belt is covered by a loincloth, and its sides by a large cloth band arranged in a loop. A rope or a twisted serpent is visible behind the left arm. The blackened ends of three knotted bands at elbow level are reminiscent of the loop-serpent motif from other Copán sculptures.

CPN 38 and CPN 52 illustrate a fundamental change in the Copán stela tradition, not only in style but also in iconography. This change remains to be explained in a satisfactory manner.

CPN 40 (STELA 2)
(fig. 49)

This monolithic shaft has broad sides gently flaring out from bottom to top. The south side is sculpted with a standing human figure in front view, while the opposite face and both narrow sides bear hieroglyphic inscriptions. The figural side is very eroded, especially at the chest, waist, and feet. The stela is set into a cribbing frame composed of several large blocks.

DIMENSIONS
Height 294 cm; height of plain butt ca. 130 cm. Width of front at base 78 cm, at top 92 cm; depth of west side 54 cm. Depth of relief on figural side 11–14 cm. Cribbing frame 168 (east-west) by 139 by 35 cm.

DISCOVERY, LOCATION, AND ASSOCIATIONS
The Peabody Museum archaeologists found CPN 40 broken into two or three fragments on the Plaza floor at the south foot of the L-shaped extension of Structure 10 (Ball Court A). They reerected the monument there (Gordon 1896: pl. 2, "Plan of the Principal Structures"). However, while the Carnegie archaeologists did not find any further remains associated with the stela at that spot, they did discover part of its original cribbing frame on top of an untouched foundation chamber on Platform 10-A. This was therefore considered the original location of the stela at the time of abandonment of the Copán Main Group. Accordingly, CPN 40 was reerected there, where it remains today.

Since the dedicatory date of the stela is several katuns earlier than the platform on which it stands, this is certainly not its primary location, which remains unknown. CPN 40

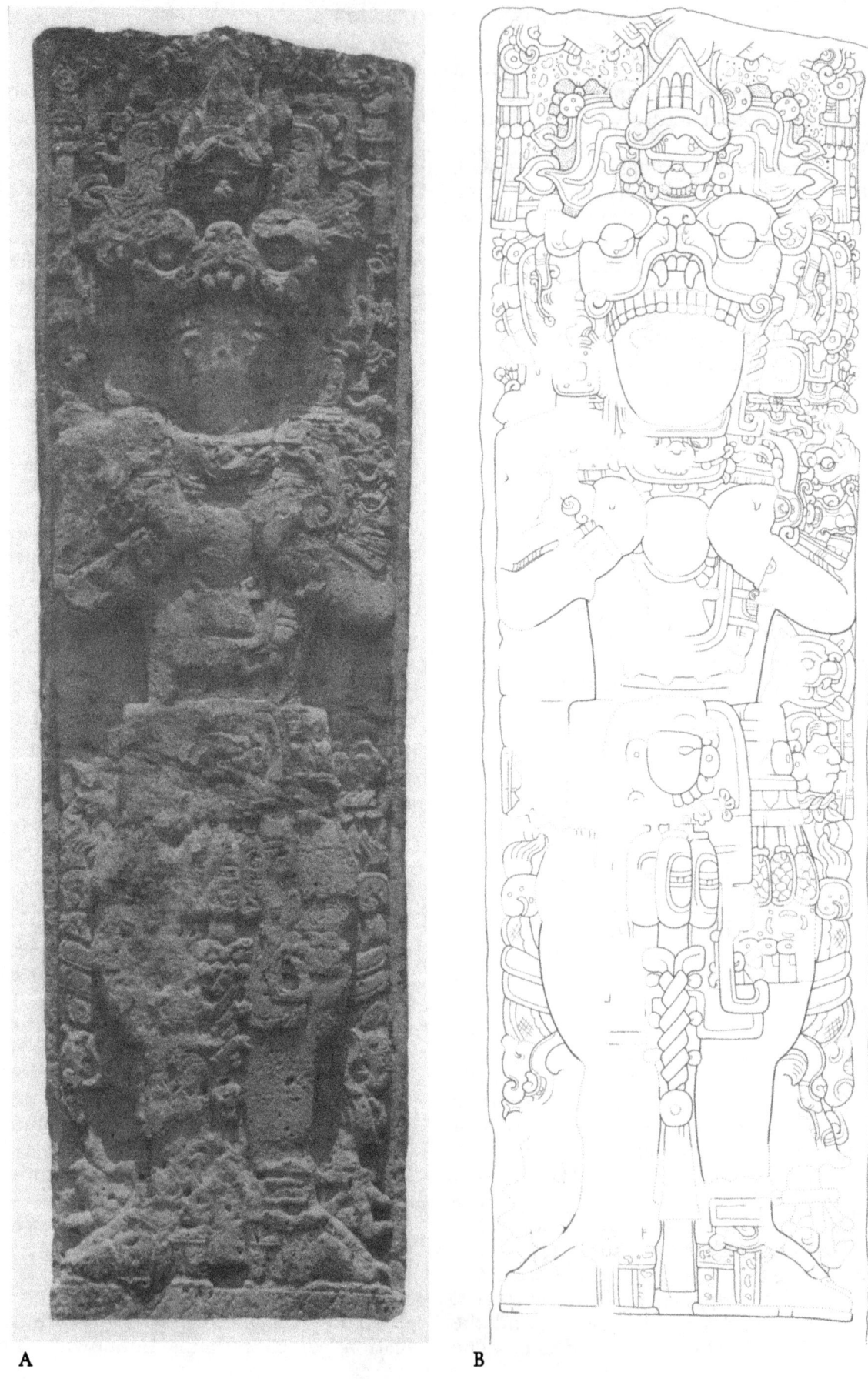

FIG. 49 CPN 40: south side. Photo by J.-P. Courau; drawing by B. Fash.

was erected in its secondary placement on top of Structure 10-A, above a cruciform masonry chamber that contained only a few stucco fragments when first opened. No altar is known to be originally associated with this stela. CPN 23, which today stands only a few meters north of it, is not thought to have any intentional association with this monument, especially considering the difference in date of manufacture of the two sculptures. It is, however, possible that when CPN 40 was transferred to its secondary emplacement on top of Platform 10-A CPN 23 was manufactured to be associated with it and to achieve a stela-altar pair. This would then constitute a secondary association for the stela and a primary association for the altar.

DEDICATORY DATE

9.11.0.0.0 12 Ahau 8 Ceh.

COMPOSITION

The figural composition is rigorously symmetrical relative to a vertical central axis. The formally posed frontal main figure holds the bicephalic serpent against his chest. Above the helmet a mask with a large headdress is flanked by plants. The stela's top is crowned by a horizontal serpent bar with a jaguar skin as background. The main figure has two shields between his elbows and belt, and two serpents flank his legs.

The Main Figure: The main figure wears a jaguar helmet above a beaded headband. The helmet ears are marked with half-circles edged with dots (part of T528, *cauac*). The chin mask also represents the jaguar with a broad muzzle, squint eyes, and an oval cartouche as a lower jaw. The two bands framing the face of the main figure probably connected the helmet, head band, and chin mask. They seem to connect ophidian heads. The upper one, at helmet level, has a band marked three times with T58 as a lower jaw. The lower end of the vertical bands is turned up to form the forehead of another serpent head that is placed horizontally. The square earflares have one circlet at each corner, which gives way outward to a stylized serpent jaw. A knotted band and T255 are placed above and below the flare. Another serpent head, at chin level, seems related to the ear ornaments. The eroded pectoral probably was a youth mask.

The bicephalic serpent held by the main figure has a segmented body adorned with T27. The head to the main figure's left—the only one preserved—is "alive" and its jaws enclose an old solar figure (probably the "Jaguar Paddler"), with a scroll-eye and Roman nose adorned with the cruller. His helmet is of a jaguar with a ringed eye and a water lily growing out of its skull. The wristlets are eroded but were probably similar to the anklets, which include a serpent head topped by a plaque with four circlets forming a square, and an eroded motif above.

Of the two round shields squeezed between the elbows and the belt, only the left one is preserved. It wears a (Pax?) jaguar head with a lolling tongue and no lower jaw. Four points radiate from the shield. The wide belt, made of strips and disks, is covered by a layered loincloth. A braid-and-tassel underlines each of the three youth masks. The three tinklers under the central mask are oval plaques with T24 engraved on them. The side ones seem to be made of turtle shell. A braid-and-tassel goes down in the middle of the loincloth and is flanked by two stylized serpent heads. The skirt is jaguar skin. The heels of the sandals are linked by two straps to the sole.

Surrounding the Main Figure: The centrally placed mask above the helmet has a narrow nose and a broad muzzle. The mouth is flanked by serpentine elements, and the round earplugs are topped with a scroll. The forehead is marked with the two elements that make up the *cauac* sign (T528). The headdress, whose base is an arch with a scroll at both ends, tapers to a point to form a leaf or a water lily blossom; a right hand is in front of this plant, under the tip of which is a similar but smaller form. Branches or stems that taper into a leaf are attached to the mask. A variant of T173 edges these plants, but the three radiating half-circles are not blackened. A serpent bar is horizontally laid at the stela's top; its body is a braid with two agnathic serpent heads on the ends, from which hang a tassel. The plant forms and the bar are set on a jaguar skin.

Two serpents frame the figure's legs. Their black-spotted bodies curve into a loop and are tied halfway up by two bands. The animal

tail bears a kind of tuft and a shell, and the jaws give way to an eroded tassel.

COMPARISONS

Structurally CPN 29 is very similar to CPN 40. The only appreciable difference is the presence of two masks on CPN 29 where CPN 40 has only one. There is not much variation in the motifs of the two monuments and in most instances the differences appear to be more variants than oppositions. The strongest contrast, which is certainly significant, concerns the helmet: earthly crocodile versus solar jaguar. In the Copán corpus of freestanding monuments, it is the only possible instance of paired stelae. It would therefore be surprising if CPN 29 and CPN 40 represent distinct rulers (respectively Butz' Chan and Smoke-Imix God K) as claimed by Schele (1988).

CPN 41 (STELA 3)
(figs. 50–53)

This monolithic shaft is carved with a standing human figure on each of the two broad sides; the design partly overlaps onto the adjoining narrow sides, where one row of hieroglyphs is also carved. When found, the stela was broken into several pieces. Traces (black spots) of severe damage from milpa burning are still present. The face and headdress of the main figure on both figural sides have almost entirely vanished. Secondary figures and the serpent bars are severely damaged. The stela was surrounded by a monolithic rectangular cribbing frame (CPN 41A), bearing sculpture. It is broken into many fragments and flakes are missing, so that the relief is somewhat eroded.

DIMENSIONS

Height (maximum) 357 cm; width (east-west) at base 92 cm; depth at base 55 cm. Depth of relief of south side 30 cm; of northern side 21 cm. Cribbing frame (CPN 41A): length 146 cm (outer), 103 cm (inner); width 104 cm (outer), 57 cm (inner). Actual height 26 cm (originally certainly higher).

DISCOVERY, LOCATION, AND ASSOCIATIONS

CPN 41 was found lying on the Plaza, circa 30 m south of Structure 4. Because of lack of architectural associations and affiliated altars, it seems doubtful that this was its original location. Maudslay was the first to mention this monument. At that time it was in such bad condition that he did not take casts or photographs of it. The first description is contained in the preliminary field report of the Peabody Museum expedition (Gordon 1896). The Carnegie Institution pieced the stela together and reerected it where it had been found. The associated cache is not cruciform as is the rule in Copán, but is approximately rectangular. It contained four jade irregular pendants, each carved with a human face. The stela was reerected and repaired by Carnegie archaeologists. They also replaced one glyph from the east face, which had been taken to the Peabody Museum by previous investigators. The cribbing frame was not reset around the stela base, since it was too damaged. It is now deposited on the plaza floor 5 m east of CPN 41.

DEDICATORY DATE

9.11.0.0.0 12 Ahau 8 Ceh.

THE SOUTH SIDE
(fig. 50)

The Main Figure: The main figure wears a helmet that is broken off, except for the rectangular earflares. They are pierced by a central hole linked by radiating lines to a circlet in each corner. A braid-and-tassel and a cartouche with T103 and T255 are above and below each flare. A profile serpent head is also attached below. The main figure wears similar earflares topped with the braid-and-tassel. A row of beads surrounds the face wearing a false beard. The chin mask is a jaguar with a T617a marking on the forehead, squinting eyes, broad muzzle, and serpentlike elements under the jaw.

Little remains of the serpent bar, which may have been rigid. The heads attached to the ends are skeletal with death eyes. The interior is badly eroded, but a portion of the lower right one is inscribed with black spots and dots, a trait common to both jaguars and death heads. The main figure wears bracelets in the form of serpent heads topped by a rectangular flare similar to the earflares. When the arms are lowered, the serpent heads become inverted. On the sides an armband is visible; it is similar to the wristlet, but lacks the serpent head.

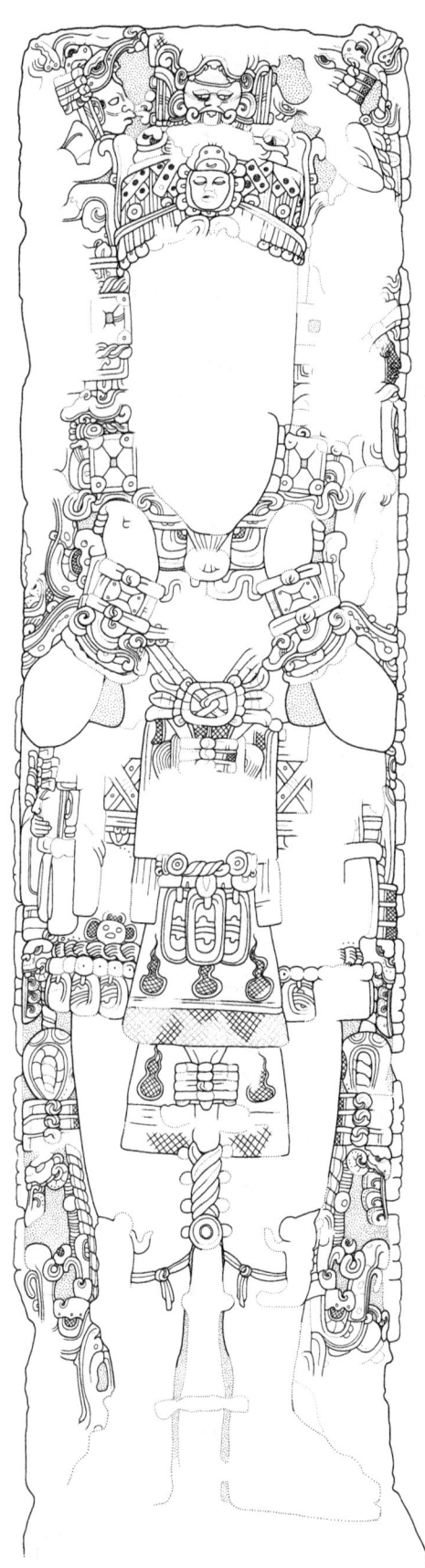

FIG. 50
CPN 41:
south side.
Drawing
by B. Fash.

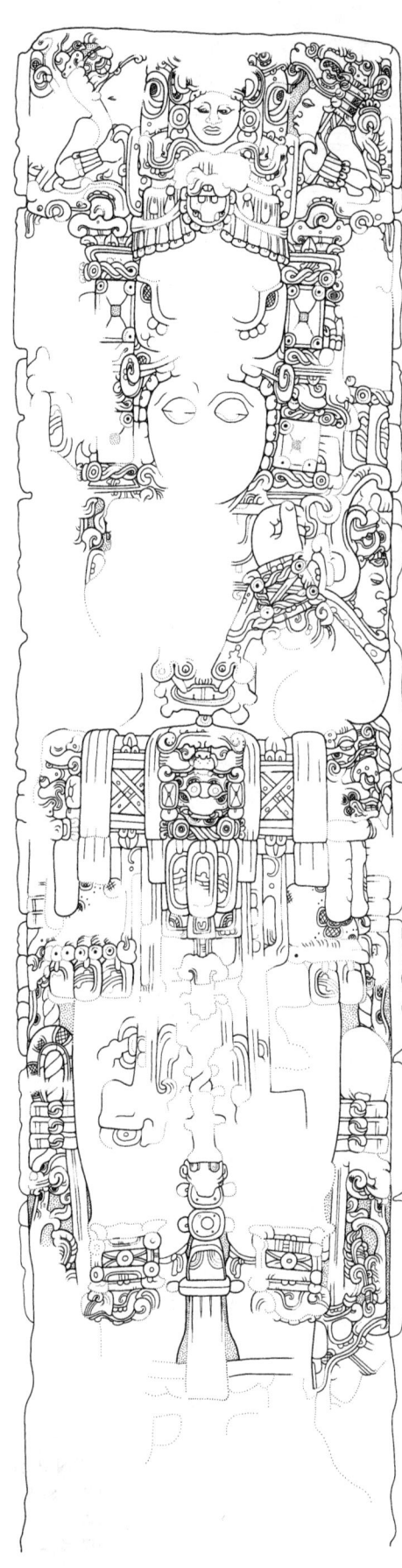

FIG. 51
CPN 41:
north side.
Drawing
by B. Fash.

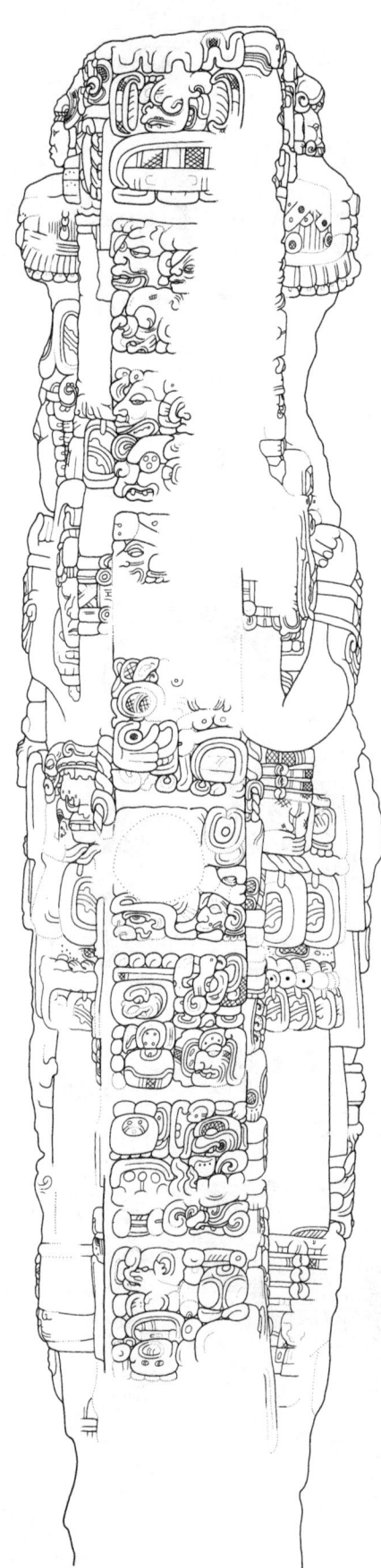

FIG. 52
CPN 41:
east side.
Drawing
by B. Fash.

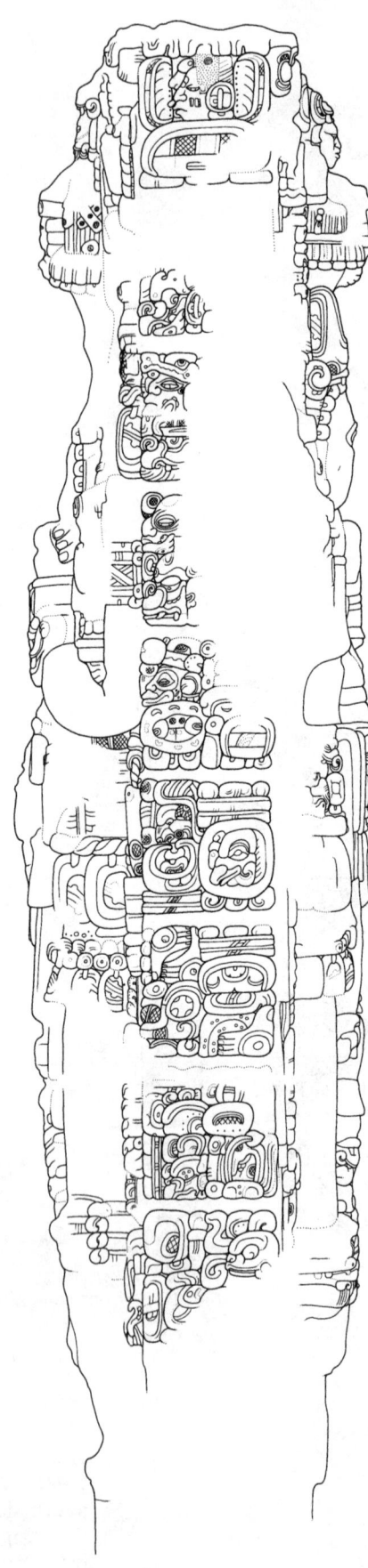

FIG. 53
CPN 41:
west side.
Drawing
by B. Fash.

Above the belt are three strips that support a medallion marked by T615. The belt itself is adorned by crossed-bands, which probably supported three identical masks. A spherical inclusion occupies the position of the central mask. Of the two side masks, only the left one is preserved (figs. 50 and 53). Like the right-hand mask, it is crowned by three knotted bands. It is a human face with a line that passes through the forehead, closed eye, and mouth. This type of facial painting is diagnostic of "God Q" (Thompson 1950: 131), equivalent of Xipe Totec from central Mexico and closely associated with blood sacrifices. The head is actually that of a corpse, as the closed eye and black spot indicate. The hand covering the mouth (T713a) signifies "completion," in this case "death". The ear ornament is adorned with T509 (*cimi* signifying "death") and T255. With its many signs, this belt mask expresses the concept of death and sacrifice. A braid-and-tassel (T58) and three oval plaques with incised T103 signs are below each mask. Ribbons, which are now eroded, partly cover the belt near the masks.

The main figure wears a jaguar skirt, indicated by round spots, concentric circles and dots. A variant of T173, also meaning "completion" or "death," is added to these markings. Wing-shaped elements and beads edge the skirt, with pendant tinklers in the form of bell-shaped plaques or shells marked with T103.

Both ends of the loincloth have black ends and a motif, repeated five times, consisting of a black circle with a wavy tail. A braid with an eroded mask topped by three knotted bands falls to the ground between the feet. The tassel at the end of the braid includes a round and a bell-shaped bead, as well as other (eroded) pendants.

Two finely knotted strings attach the knee ornament. Three knotted bands with T255 above and below are on the outer side of each leg, atop an eroded mask. The front of the knee ornament is broken, but traces of a climbing quadruped remain. The anklets and feet are completely eroded.

Surrounding the Main Figure: The helmet is crowned with a hat or a headband edged with beads and circlets and black-spotted crossed-bands on a striped background; the latter may represent the bloodstained ribbons of autosacrifice. A small human mask topped with *ahau* is in the middle of this headdress. Another mask above has no lower jaw, with a broad lolling tongue, T-shaped incisors, and scroll-shaped fangs. The face with bulging eyes and protruding cheekbones is adorned with two horizontal strips, one each above and below the eyes. Two scrolls with T255 below replace the ears. Only the fangs and teeth—among them filed incisors—remain from its helmet. The agnathic face, tongue, and filed incisors indicate that this mask is an anthropomorphized version of the Pax jaguar. Flanking bars and dots form the number 12; a comparison with the north side hints that these figures were probably contained within open serpent jaws.

On both sides of the top of the headdress a human figure emerges from the jaws of a skeletal serpent who has circlets (indicating bone) on the forehead, a large round scroll eye, and beadlike molars. The emerging individual wears an oval earflare with circlets forming a quincunx, a black spot on the temple, and, on the cheek, concentric circles edged with dots (a *cauac* element). Several beads stand in front of his nose. His helmet is a skeletal serpent head with a death eye, many circlets on the jaw, and bare incisors. On the shoulder he carries a bar adorned with oblique short lines that taper to a skeletal serpent head with an open mouth; the head is preceded by three knotted bands. We do not know whether the jaws contained anything—for instance, a knife-tongue. A rope hanging from the bar through a beaded ring vanishes, passes and reappears below the elbows, and then hangs down to the main figure's feet. The human figures seem to be ancestors wearing death insignia since their helmets as well as the ends of the bar are skeletal heads.

Only to the right of the main figure's helmet does anything remain of the framing elements. A profile human face wears a broken helmet with a pendant braid-and-tassel and two tinklers marked with T103. A line passes through the closed eye and runs down to the chin; on one side of the line the face is painted black. This depicts a "God Q" variant, already identified on the belt mask. This head was probably set within the jaws of a serpent, as on CPN 47.

The rope hanging from the monument's top emerges from the upper rim of the belt. After passing through a ring, it hangs down to the knees of the figure, where it is linked to an open-mouthed serpent. Covering the rope, twice on each side, a serpent forms a loop whose base is tied with three knotted bands from which juts out an animal head in profile. The serpent's body is black-spotted; on the right side it wears *imix* (T501), probably to indicate its terrestrial nature. The animal heads are skeletal and without a lower jaw: they are not identical, and we cannot be sure whether they represent the same animal. Their short muzzle would point to rodents or felines, and certainly not to reptiles. The teeth are bared, the upper lip is dotted, and the eye's pupil looks upward. From the mouth's corner a large scroll comes out and a very long tongue is adorned with curving lines edged with dots. It is the knife-tongue, marked with the stone sign (T528). The serpent at the stela's foot has a death eye and the supraorbital plate is skeletal (as shown by circlets). While the lower jaw looks skeletal too, the upper does not. The content of the jaws is eroded.

The south side of CPN 41 and the west side of CPN 47 share several motifs: the *ahau* mask crowned with a Pax Jaguar; the belt masks that represent death, whether death heads or images of God Q; the layered loincloth (compare also to CPN 4).

THE NORTH SIDE
(fig. 51)

The Main Figure: On the main figure's helmet only the beads under the eyes, two black spots at the corner of the eyes, large curved fangs crowned by T103, and earflares identical to those on the south side remain. The main figure's earplugs are like those of the helmet, but square. A serpent upper jaw juts out from their outer rim. The braid-and-tassel is above the flare; this element is found below together with T103 and T255. The face of the figure, surrounded with beads, is eroded except for the bulging eyes. The chin mask is broken.

The serpent bar is also broken with the exception of the left serpent head, which has a skeletal lower jaw and an upended upper jaw that looks alive. The jaws contain a realistic young human head. The bulging eye with a round pupil is half covered by a flaccid lid. The helmet has a broad and flat muzzle with black spots, ringed eyes, tongue, and square, black incisors. This creature reminds one of the pseudo-Tlaloc from the bar of CPN 52. The bracelets of the main figure consist of crossed-bands framed with four braid-and-tassel motifs, above the usual serpent head. The latter is lacking on the arm bands, visible on the west side. A shell rests on the belly just above the belt; it is supported by two bands that taper into two circles and may represent bones. From the belt, adorned with crossed-bands, hang two pairs of ribbons. The masks are death heads with round sockets, black spots on the forehead and the cheeks, rectangular earflares with central dot and diagonals, and a hanging bead. The central mask's helmet has scroll-like fangs, a flat muzzle, and scroll-eyes; its headdress has the sides turned up into two scrolls (an animal not yet identified, maybe a fish). The lateral masks have a different helmet, probably representing a toad (T741), with triangular teeth (except for the hooked incisors), black spots on the cheeks, and a circular plaque with three circlets in lieu of the ear; the snout has hooked nostrils, the eye is half closed, and a row of small ovals edges the upper lip. The braid-and-tassel underlines each mask, from which hang two or three oval plaques stamped with T103.

The skirt in jaguar skin wears T173 ("completion," i.e., "death"). It is edged with wing-like elements and beads from which dangle tinklers inscribed with T103. The loincloth mask, framed by stylized serpent jaws, is a jaguar: T617a and T517 (bone) on the forehead, large rectangular eyes, a flat nose, filed teeth; from the mouth with curled up lip falls a braid ending with an eroded mask whose lower jaw is replaced by a shell. Below is a round bead with five dots, a bell-shaped element with concentric lines, and a tubular bead. The knee ornaments are made of a serpent head topped with a rectangular plaque with circlets arranged in a quincunx. The lower part of the legs is completely destroyed.

Surrounding the Main Figure: At the top of the helmet is a beaded hat or a headband. Ribbons alternate with pairs of beads. A bird

mask is in the middle, surrounded by more beads and wearing a much eroded helmet; there are incisors or a tongue flanked by fangs, a nose, and a cleft on the skull from which jut out serpentlike forms. A youth (*ahau*?) mask is above it; it has a protruding mouth, a flat nose, and bulging eyes; of its helmet only the eye sockets' rim edged with beads and black spots and teeth remain. From its round earflares hangs a bead. Two serpent heads flank the mask; their jaws are wide open onto a knife with a notch marked with part of the *akbal* (T504) sign (designating an obsidian knife?).

On both sides of the headdress top a human figure emerges from the jaws of a skeletal serpent (the supraorbital plate and the upper jaw have circlets). The individual—preserved only to the left of the king—is youthful. His saurian or ophidian helmet has a black supraorbital plate, an oval-pupiled eye, and a drooping lid with "lashes" (as on some early monsters), a fang, a molar, and a scrolled nose. A water lily blossom (T696) with *caban* (T526) hangs from the helmet's upper jaw. The helmet worn by the ancestor to the right is more eroded and may have been different: the pupil is made of half-circles directed upward; the supraorbital plate is stamped with T617a; the lid is simple. Both ancestors wear a wristlet made of tubular beads edged with one row of round ones, and carry a bar on the shoulder; the body bears oblique lines and at their end are three knotted bands, T255, and an open-mouthed serpent head. It is not skeletal and has a scroll-eye and a curved fang at the mouth's corner. It is not clear whether the jaws enclosed anything. A cord comes out of the fang and links it to the tassel (T58) of a braid hanging down to the upper jaw of the serpent that encloses the human figure. The serpent heads that make up the helmet and the bar's end look alive.

At the level of the main figure's helmet, as on the south side, were two serpent heads whose mouths opened onto a mask, whose presence is today indicated only by the braids and the tinklers (marked with T103) that remain.

As on the south side, the lower body is framed by two ropes, each bearing the loop serpent motif twice. The heads seem to be of the same animal described on the monument's opposite side. But the scrolls at the corners of the mouth and the tongues are black-spotted, instead of being marked with *cauac* elements. At the level of the main figure's calves, a large serpent head was attached to the end of an apparently rigid staff, perhaps linked to the rope. The only preserved head looks alive and is adorned with jewels, particularly at nose level; the jaws contained a turbaned human head.

CPN 41A (CRIBBING FRAME OF STELA 3)
Each of the long sides shows the earth represented by two serpents with intertwined bodies that form knots. Their heads are identical and represented as alive. The eye is round with a hooklike pupil. Black spots are represented on its drooping muzzle. A cartouche with a *cauac* sign is carved on the middle of the serpents. Below this the space is divided by short vertical bands bordered below by a cross-hatched zone representing the color black. Framing the serpents, two twisted ropes with salient leaf-shaped elements (a cord with thorns?) are carved on two broad vertical zones. They are the continuation of the ropes that, on the stela, frame the legs of the main figure. In the middle of one of the narrow sides of the cribbing frame the rope-and-points are repeated between two eroded cartouches containing a glyph. On the last side, which is very eroded, two intertwined serpent bodies seem to be faintly visible.

INTERPRETATION
In order to know the meaning of this stela, a comparative analysis of the two main sides is required. Although the two sides look similar at first sight, we may wonder whether minute differences are intentional and relevant. For instance, on the south side the ancestors wear a skeletal helmet and serpent bar. Moreover, the signs on their faces may indicate death. On the opposite side the figures are instead shown alive, as are their helmets and their bars. Perhaps an opposition between ancestors sinking into the earth on one side and emerging from it on the other is intended, similar to CPN 26.

Other pairs of contrasting icons might make up oppositions; thus, to the anthropomorphized Pax-jaguar to the south corresponds a bird mask to the north. The belt masks on

the south side express death and sacrifice; on the opposite side the skulls topped with toad helmets illustrate the "death and rebirth" theme. I cannot decide whether these differences are mere variants or meaningful oppositions that would contrast the two figures. Be that as it may, I think that this double-figure stela, like the others in Copán, celebrates dynastic accession, whether present, past or future.

According to Riese (Baudez and Riese 1990), CPN 41 would have been erected on behalf of the current ruler Smoke Jaguar to announce the birth of his son and prospective successor. The iconographic program of this stela, with its two figural faces, also points strongly toward a genealogical interpretation.

COMPARISONS

On CPN 634 the intertwined serpents are also found beneath the ruler, where they are thought to represent the earth. The sculpted cribbing frame of a stela, while rare at Copán, is a common feature at Toniná, where the closest example to CPN 41A is Monument 22 (Becquelin and Baudez 1979–82: 753).

CPN 42A (PRISMATIC SCULPTURE)

This is a badly eroded prismatic stone sculpture with rounded edges. A plain plinth runs around the monument's base, interpreted as its top by Strömsvik (1941).

DIMENSIONS

125 cm high, 100 cm wide at base, and 60–70 cm deep.

DISCOVERY AND LOCATION

Specific information on the discovery and original context are lacking. Strömsvik (1941: 76) tells us that "during both Peabody Museum and Carnegie Institution excavations around base of this stela (CPN 41 or Stela 3), fragments of more ancient sculptures were found, apparently broken for reutilization in rubble fill." CPN 42A is now standing upright close to CPN 41.

DESCRIPTION

Although eroded, a face is visible on one of the monument's broad sides. A nose, two oval eyes with broad upturned pupils, and the lack of a lower jaw are apparent. Strömsvik identified the large quatrefoil on the forehead as a nose ornament. A series of trapezoids arranged in a column on the opposite side represents part of the headdress. A similar sculpture is CPN 42B.

CPN 42B (PRISMATIC SCULPTURE)

This is a badly eroded prismatic stone sculpture with rounded edges. A plinth surrounds its lower part.

DIMENSIONS

Now 105 cm high, 78 cm wide, and 66 cm deep.

DISCOVERY AND LOCATION

See CPN 42A.

DESCRIPTION

Traces of a face remain on one broad side. The large rounded eyes are reminiscent of a nocturnal bird. The two wide composite headdress bands frame the face and then turn up at right angles to run backward behind the ears. Two other vertical strips hanging down from the top of the head join the headband; they are linked by a central knot placed between two trapezoids. A comparable sculpture is CPN 42A.

CPN 43 (STELA 4)
(figs. 54–55)

On this high relief carving a standing human occupies one broad face and the adjoining narrow sides of the original prismatic shaft. On the opposite side carved featherwork frames a rather flat hieroglyphic inscription. A cribbing frame holds the stela in place.

DIMENSIONS

Maximum height 368 cm; length (north-south) 114 cm; and width 85 cm at base. Cribbing frame: 213 (north-south) by 185 by 23 cm.

DISCOVERY, LOCATION, AND ASSOCIATIONS

Stephens found this monument fallen and broken into several pieces on the Main Plaza, between CPN 1 and CPN 3. It was repaired and reerected by the Carnegie Institution in 1935. While excavating its cruciform masonry foundation chamber in 1894, E. P. Dieseldorff found CPN 44, a prismatic altar, and also CPN 46, an "archaic" anthropomorphic sculpture,

mask is in the middle, surrounded by more beads and wearing a much eroded helmet; there are incisors or a tongue flanked by fangs, a nose, and a cleft on the skull from which jut out serpentlike forms. A youth (*ahau*?) mask is above it; it has a protruding mouth, a flat nose, and bulging eyes; of its helmet only the eye sockets' rim edged with beads and black spots and teeth remain. From its round earflares hangs a bead. Two serpent heads flank the mask; their jaws are wide open onto a knife with a notch marked with part of the *akbal* (T504) sign (designating an obsidian knife?).

On both sides of the headdress top a human figure emerges from the jaws of a skeletal serpent (the supraorbital plate and the upper jaw have circlets). The individual—preserved only to the left of the king—is youthful. His saurian or ophidian helmet has a black supraorbital plate, an oval-pupiled eye, and a drooping lid with "lashes" (as on some early monsters), a fang, a molar, and a scrolled nose. A water lily blossom (T696) with *caban* (T526) hangs from the helmet's upper jaw. The helmet worn by the ancestor to the right is more eroded and may have been different: the pupil is made of half-circles directed upward; the supraorbital plate is stamped with T617a; the lid is simple. Both ancestors wear a wristlet made of tubular beads edged with one row of round ones, and carry a bar on the shoulder; the body bears oblique lines and at their end are three knotted bands, T255, and an open-mouthed serpent head. It is not skeletal and has a scroll-eye and a curved fang at the mouth's corner. It is not clear whether the jaws enclosed anything. A cord comes out of the fang and links it to the tassel (T58) of a braid hanging down to the upper jaw of the serpent that encloses the human figure. The serpent heads that make up the helmet and the bar's end look alive.

At the level of the main figure's helmet, as on the south side, were two serpent heads whose mouths opened onto a mask, whose presence is today indicated only by the braids and the tinklers (marked with T103) that remain.

As on the south side, the lower body is framed by two ropes, each bearing the loop serpent motif twice. The heads seem to be of the same animal described on the monument's opposite side. But the scrolls at the corners of the mouth and the tongues are black-spotted, instead of being marked with *cauac* elements. At the level of the main figure's calves, a large serpent head was attached to the end of an apparently rigid staff, perhaps linked to the rope. The only preserved head looks alive and is adorned with jewels, particularly at nose level; the jaws contained a turbaned human head.

CPN 41A (CRIBBING FRAME OF STELA 3)
Each of the long sides shows the earth represented by two serpents with intertwined bodies that form knots. Their heads are identical and represented as alive. The eye is round with a hooklike pupil. Black spots are represented on its drooping muzzle. A cartouche with a *cauac* sign is carved on the middle of the serpents. Below this the space is divided by short vertical bands bordered below by a cross-hatched zone representing the color black. Framing the serpents, two twisted ropes with salient leaf-shaped elements (a cord with thorns?) are carved on two broad vertical zones. They are the continuation of the ropes that, on the stela, frame the legs of the main figure. In the middle of one of the narrow sides of the cribbing frame the rope-and-points are repeated between two eroded cartouches containing a glyph. On the last side, which is very eroded, two intertwined serpent bodies seem to be faintly visible.

INTERPRETATION
In order to know the meaning of this stela, a comparative analysis of the two main sides is required. Although the two sides look similar at first sight, we may wonder whether minute differences are intentional and relevant. For instance, on the south side the ancestors wear a skeletal helmet and serpent bar. Moreover, the signs on their faces may indicate death. On the opposite side the figures are instead shown alive, as are their helmets and their bars. Perhaps an opposition between ancestors sinking into the earth on one side and emerging from it on the other is intended, similar to CPN 26.

Other pairs of contrasting icons might make up oppositions; thus, to the anthropomorphized Pax-jaguar to the south corresponds a bird mask to the north. The belt masks on

the south side express death and sacrifice; on the opposite side the skulls topped with toad helmets illustrate the "death and rebirth" theme. I cannot decide whether these differences are mere variants or meaningful oppositions that would contrast the two figures. Be that as it may, I think that this double-figure stela, like the others in Copán, celebrates dynastic accession, whether present, past or future.

According to Riese (Baudez and Riese 1990), CPN 41 would have been erected on behalf of the current ruler Smoke Jaguar to announce the birth of his son and prospective successor. The iconographic program of this stela, with its two figural faces, also points strongly toward a genealogical interpretation.

COMPARISONS

On CPN 634 the intertwined serpents are also found beneath the ruler, where they are thought to represent the earth. The sculpted cribbing frame of a stela, while rare at Copán, is a common feature at Toniná, where the closest example to CPN 41A is Monument 22 (Becquelin and Baudez 1979–82: 753).

CPN 42A (PRISMATIC SCULPTURE)

This is a badly eroded prismatic stone sculpture with rounded edges. A plain plinth runs around the monument's base, interpreted as its top by Strömsvik (1941).

DIMENSIONS

125 cm high, 100 cm wide at base, and 60–70 cm deep.

DISCOVERY AND LOCATION

Specific information on the discovery and original context are lacking. Strömsvik (1941: 76) tells us that "during both Peabody Museum and Carnegie Institution excavations around base of this stela (CPN 41 or Stela 3), fragments of more ancient sculptures were found, apparently broken for reutilization in rubble fill." CPN 42A is now standing upright close to CPN 41.

DESCRIPTION

Although eroded, a face is visible on one of the monument's broad sides. A nose, two oval eyes with broad upturned pupils, and the lack of a lower jaw are apparent. Strömsvik identified the large quatrefoil on the forehead as a nose ornament. A series of trapezoids arranged in a column on the opposite side represents part of the headdress. A similar sculpture is CPN 42B.

CPN 42B (PRISMATIC SCULPTURE)

This is a badly eroded prismatic stone sculpture with rounded edges. A plinth surrounds its lower part.

DIMENSIONS

Now 105 cm high, 78 cm wide, and 66 cm deep.

DISCOVERY AND LOCATION

See CPN 42A.

DESCRIPTION

Traces of a face remain on one broad side. The large rounded eyes are reminiscent of a nocturnal bird. The two wide composite headdress bands frame the face and then turn up at right angles to run backward behind the ears. Two other vertical strips hanging down from the top of the head join the headband; they are linked by a central knot placed between two trapezoids. A comparable sculpture is CPN 42A.

CPN 43 (STELA 4)
(figs. 54–55)

On this high relief carving a standing human occupies one broad face and the adjoining narrow sides of the original prismatic shaft. On the opposite side carved featherwork frames a rather flat hieroglyphic inscription. A cribbing frame holds the stela in place.

DIMENSIONS

Maximum height 368 cm; length (north-south) 114 cm; and width 85 cm at base. Cribbing frame: 213 (north-south) by 185 by 23 cm.

DISCOVERY, LOCATION, AND ASSOCIATIONS

Stephens found this monument fallen and broken into several pieces on the Main Plaza, between CPN 1 and CPN 3. It was repaired and reerected by the Carnegie Institution in 1935. While excavating its cruciform masonry foundation chamber in 1894, E. P. Dieseldorff found CPN 44, a prismatic altar, and also CPN 46, an "archaic" anthropomorphic sculpture,

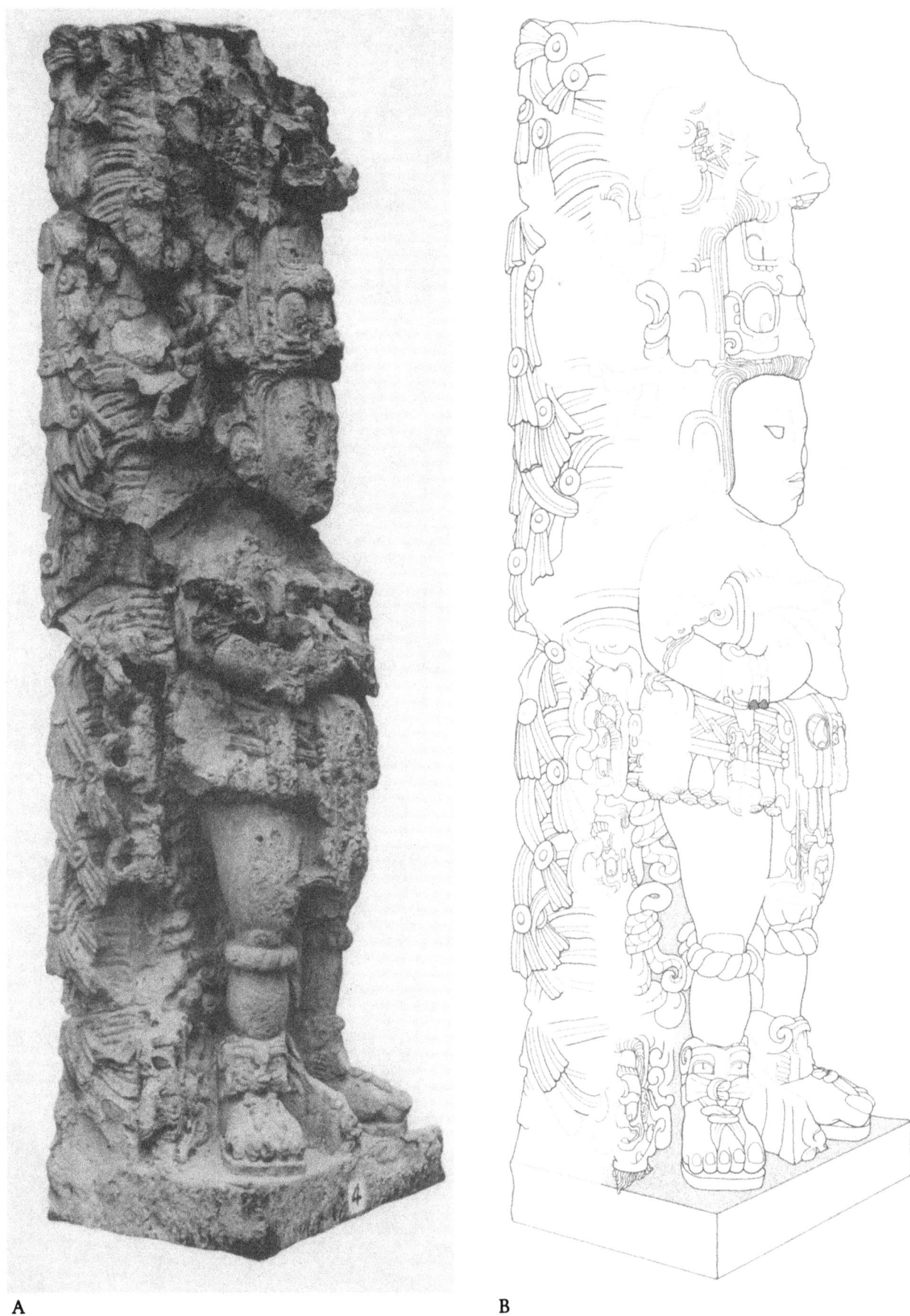

A B

FIG. 54 CPN 43: southeast side. Photo by J.-P. Courau; drawing by A. Dowd.

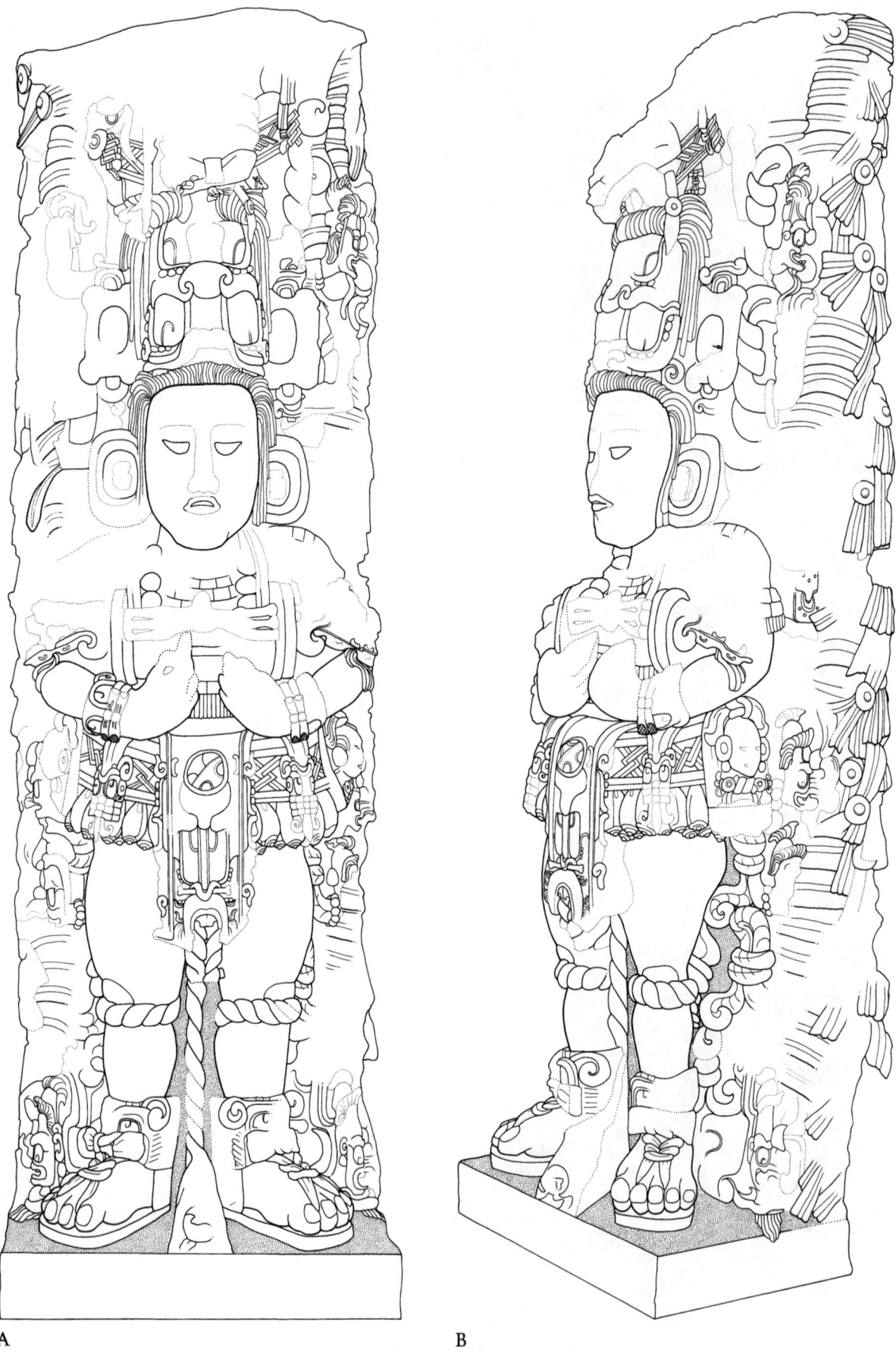

A B

FIG. 55 CPN 43: (a) east side; (b) northeast side. Drawings by A. Dowd.

in its rubble fill. Two similar monuments were found in the foundation of CPN 47. This seems to reflect a common erection pattern, and it is therefore assumed that both stelae were erected at the same time. For CPN 43 this was the original erection; for CPN 47, which is considerably older, it was probably a secondary reerection.

A spherical altar (CPN 45) stands a few meters to the east of the stela and is thought to be associated with it. Since CPN 1, CPN 43, and CPN 3 are aligned and are faced by a similar alignment formed by CPN 16 and CPN 11 across the northern part of the Great Plaza, these stelae are all thought to be associated in a pattern reminiscent of stelae alignments at Piedras Negras and elsewhere, but which is not a recurrent pattern at Copán.

DEDICATORY DATE

9.15.0.0.0 4 Ahau 13 Yax (Baudez and Riese 1990). For David Stuart (1986b), it is 9.14.15.0.0 11 Ahau 18 Zac.

COMPOSITION

Three human figures seated at the stela's top overlook the main figure. Originally, six creatures with grotesque heads and serpent bodies flanked the main figure on each side. A similar head in the jaws of a serpent is next to the feet of the main figure. Feathers occupy the remaining space.

The Main Figure: The youthful head wears a helmet with large scroll eyes and a broken muzzle; since the latter seems broad but not thick, it may have been a jaguar. Its earflares are rectangles whose outset and rounded angles are framed at top and bottom by a serpent head. The form recalls the water lily pad, so the whole helmet might represent the water lily jaguar. The helmet is crowned with a very eroded mask.

The hair of the main figure is pulled back and falls down the sides on the face. The oval earplugs have a central indented rectangular element. The figure wears a collar of round beads. Although much of it is eroded, traces suggest that originally a checkered cape was depicted. Arms held against the chest clutch a short, wide serpent bar; the ends are broken off, and only the bearded skeletal lower jaw remains. The eroded pectoral that partly covers the bar seemed to have been a horizontal tube with three radiating beads at each end. The wristlets are personified lancets, with an inverted serpent mask with two knotted bands on its top.

The wide belt is adorned with a twisted strip motif that is repeated several times and lacks a central mask. The ones on the sides are youth heads crowned by a knotted band (T60) and underlined with the braid-and-tassel. *Oliva* shells and two personified inverted lancets also hang from the belt. The lancets, which hang from ribbons, include a serpent head, knotted bands, and foliage.

A large jaguar mask with squint eyes, filed teeth, and nose tubes adorns the loincloth. A circular cartouche containing an eroded sign is on the jaguar's forehead; the sign is not *kin*, *kan*, or *chuen*, but probably T561e, "sky". Serpent heads flank the mask. Ropes surround the knees, and a cord falls from the lower edge of the loincloth to the feet. Finally, the anklets are made of an inverted serpent mask topped by a knotted band.

Surrounding the Main Figure: Three ancestral figures perched on the top of the helmet watch over the main figure. Only a bent knee and loincloth remain of the central figure, who was in frontal view in the foreground. All that remains of the side figures is a sandaled foot on the left. They held serpent bars marked with a mat symbol on the left and an X on the right; a braid hangs from each end.

Bordering both sides of the main figure is a motif that is repeated six times. It is a creature with a looped serpent body and a scrolled tail. The other end tapers into a Thunderer head with an elongated skull in the form of an eccentric knife; double-crowned hair; a forehead marked with T617a in a cartouche pierced by an ax-and-smoke; large oval scroll-eyes; an elongated upper lip; and a wide open mouth. The whole motif is a variant of the looped or knotted serpent, a symbol of sacrifice, as on CPN 41, CPN 47, and CPN 9 (fig. 118a below). If the Thunderer is a symbol of power (representing lightning in the form of the manikin scepter in the hands of the ruler), the motif may symbolize the sacrificed ruler or a sacrificed supernatural, patron of the royal dynasty. Similar Thunderer heads appear in jaws of the heads of sky serpents that frame the ruler on many monuments.

INTERPRETATION

Under his ancestor's protection, the king, who wears a jaguar helmet, appears as a "penitent," as the rope hanging from his loincloth, the ropes around his knees, the lancets tied to his belt, and his wristlets and anklets amply demonstrate. The symbol of the self-immolated king, a "god" with a knotted serpent body, is a leitmotif that emphasizes the king's ritual activity. Cosmic serpents whose heads contain the same Thunderer frame the whole picture.

From the analysis of the hieroglyphic text, Riese (in Baudez and Riese 1990) has inferred that allusion is made to mythical ancestors. The iconography bears this out in that auto-sacrificial symbols and attributes are shown to give legitimacy to the living descendants of the mythical forefathers of the Copán dynasty.

COMPARISONS

CPN 11 is five tuns earlier but directly comparable to CPN 43. Both stelae have the same composition (three ancestor figures at the top, cosmic serpents on the sides), are carved in the same style (high relief with the main figure taking up the three sides of the original block, the feet at right angle), and have similar representations: the ruler in his role of penitent, the ropes tied to the loincloth and the knees, the shape of the ceremonial bar, and so forth.

CPN 44 AND 48
(figs. 56–59)

CPN 44 is a rectangular monolith carved to resemble a bundle tied by six straps that cross each other on the stone's top and divide its surface into four squares. The wide sides are divided by three vertical scraps and a transverse strap; the narrow sides by only a vertical one. The side-straps are tied with a simple knot on the top of the altar. In the middle of the broad sides, the knot is more elaborate, with a loop and ends. Except for the straps, the top of the altar is plain; a hieroglyphic text covers the narrow sides with two panels of four blocks each, while the broad sides bear a two-figure scene. The relief in general is much eroded.

CPN 48 is a square monolithic block. It is carved with figural and geometrical designs and hieroglyphic inscriptions on all four vertical sides. Both horizontal sides are dressed, but left unsculpted.

DIMENSIONS

CPN 44: 118 cm by 89 cm by 34 cm. Depth of relief 0.5 cm. CPN 48: 130 by 98 by 31 cm.

DISCOVERY, LOCATION, AND ASSOCIATIONS

CPN 44 was found in 1894 by Erwin P. Dieseldorff when he explored the foundation of CPN 43. It was entirely buried and seems to have supported the stela (Gordon 1896: 42). If so, CPN 44 was reused for a different function. It is currently deposited 2 m east of CPN 43. CPN 46 was found in the same foundation.

During the following year Dieseldorff found CPN 48 reused as the pedestal stone of CPN 47. It has been deposited there, close to the stela. CPN 51 was found together with CPN 48.

DATE

Riese proposes the Long Count date 9.7.1.7.6 for the Calendar Round date 6 Cimi 19 Uo written on CPN 44. On CPN 48, 11 Edznab 1 Kankin would correspond to 9.8.12.7.18, the next round date being 9.9.0.0.0 3 Ahau 3 Zodz (Baudez and Riese 1990). Schele and Grube (1987) read the Calendar Round date of CPN 44 as 7 Cimi 19 Uo, occurring at 9.6.9.4.6, for the birth date of Butz'-Chan.

CPN 44 (ALTAR Y)
(figs. 56–57)

DESCRIPTION

Two grotesque figures face each other on either side of the central knot; their bodies are in part hidden behind the transverse band, which represents a "water frieze" (Coggins 1983). The band consists of two groups of horizontal lines on both sides of a row of circlets; several water elements such as T44, T23, and the trilobed shell frame the lines.

On the best-preserved and broad side (fig. 56) a quadruped with a long scaled body and a long skeletal head is below the frieze. A shell ends the tail. It is a crocodile, an image of the earth and an analogue to the skeletal long-nosed heads on the water friezes from CPN 109, 110, and 111. It seems that a similar creature was carved on the eroded opposite side (fig. 57).

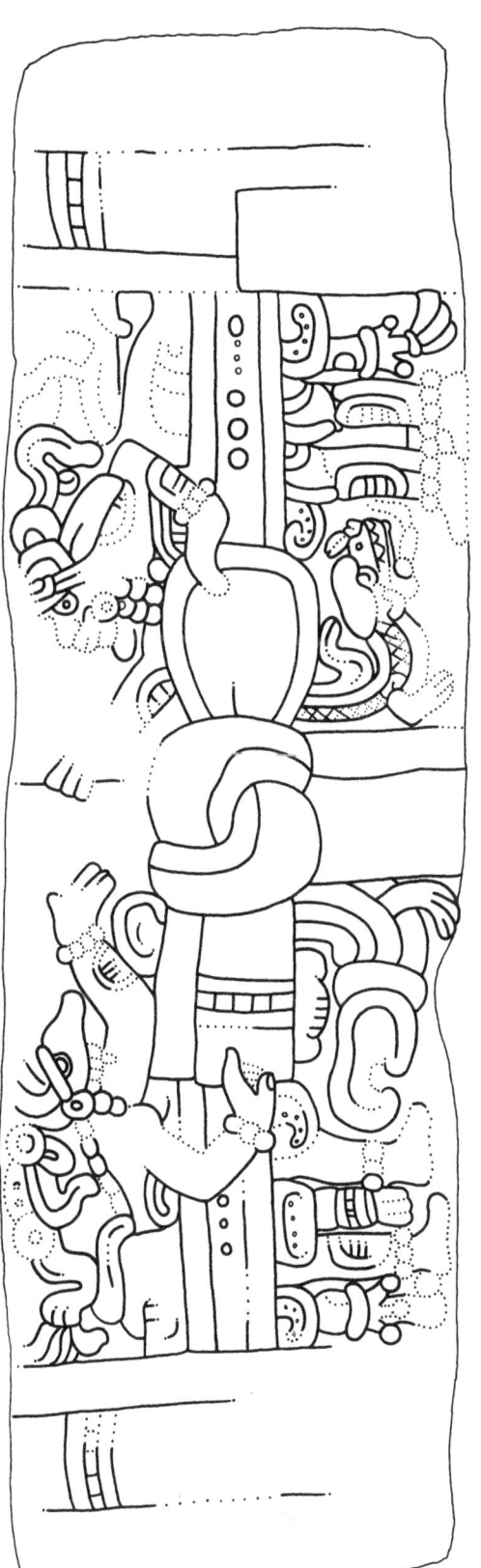

FIG. 56 CPN 44: one broad side. Drawing by G. Valenzuela.

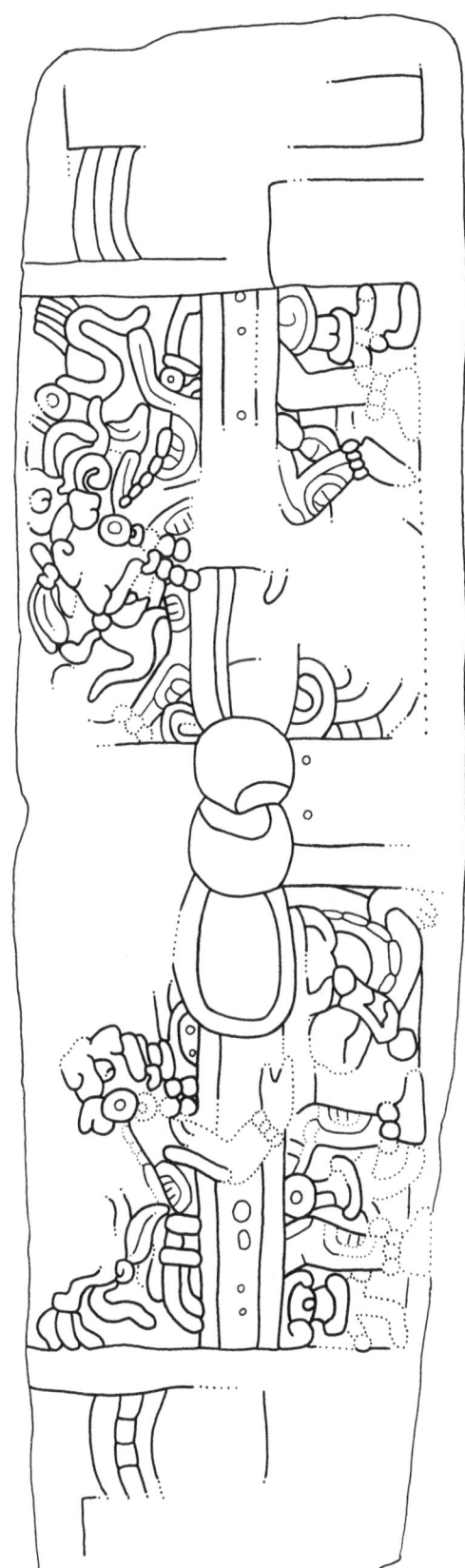

FIG. 57 CPN 44: the opposite broad side. Drawing by G. Valenzuela.

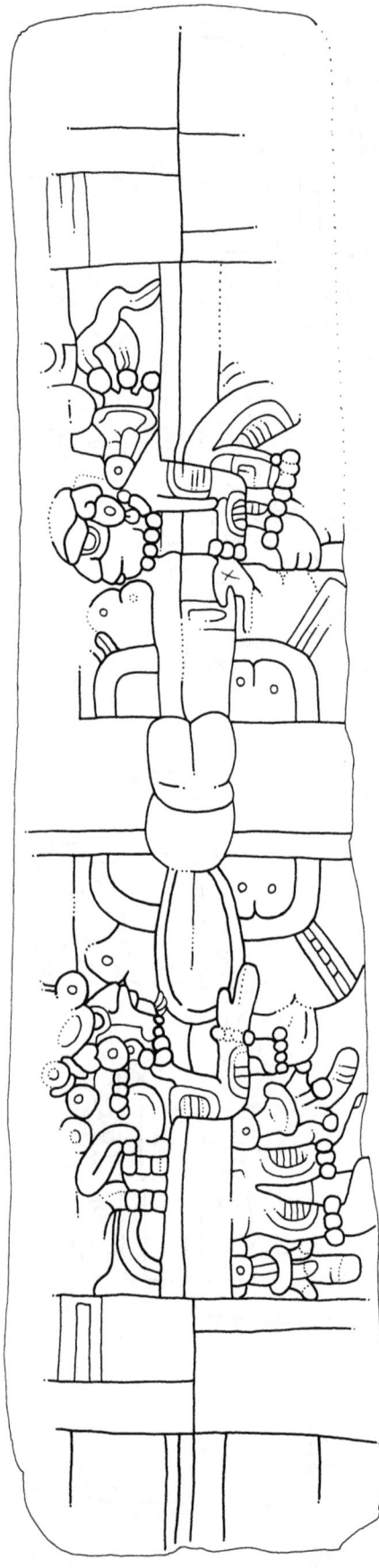

FIG. 58 CPN 48: one broad side. Drawing by G. Valenzuela.

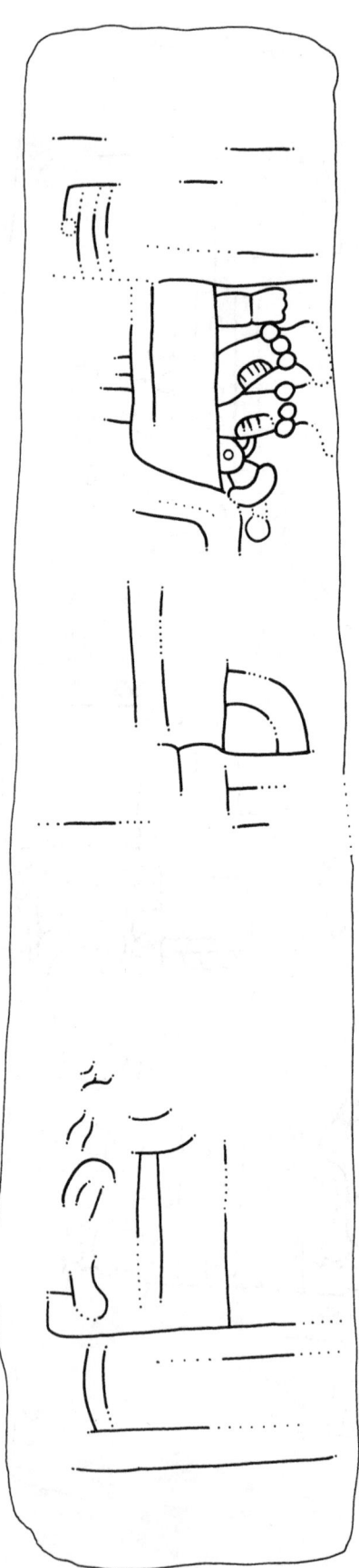

FIG. 59 CPN 48: the opposite broad side. Drawing by G. Valenzuela.

The grotesque figures stand with one arm facing the frieze and the other pointing to each other. In figure 56 one of them has a grotesque head with a pointed snout, while the other seems to be an old man. Their headdresses combine tassels and large beads; their collars, wristlets, and anklets are also made of a row of beads. The sign T24 is repeatedly stamped on their bodies. The front ends of their loincloths are fringed and braids occupy the back ends. On the side shown in figure 57 the grotesque heads have feline features and a jaguar ear tops their earplugs. Their headdresses are very eroded; their loincloths have tassels.

INTERPRETATION

Two themes coexist on this monument: the knot and the water frieze. The former is the most common symbol for sacrifice. The water frieze represents either the underworld waters or the pond where the earth crocodile floats, the source of all fertility. It is tempting to see a causal relation between the two themes: the grotesque figures would be supernaturals, spirits, or patrons of sacrifice that induce fertility.

CPN 48 (Altar X)
(figs. 58–59)

DESCRIPTION

The broad side shown in figure 58 is sculpted with a quatrefoil motif covered by a knot whose ends are held by profile figures. The quatrefoil with two circlets in each lower lobe may be regarded as a variant of the *kin* sign.

Beaded bands and bones radiate from its frame. The grotesque figure on each side is partially covered by the transverse bands of the knot, which it seems to hold. The braid-and-tassel adorns the headdress and is set between and behind the legs, while T24 markings are on the body. Since a jaguar ear tops the ear of each framing figure, they may be solar figures. Superimposed sacrificial and solar symbols framed by solar figures occupy the center of the altar's main face.

According to Riese (Baudez and Riese 1990), the event following Date A at A2-B2 is bloodletting with a flint knife.

It is very likely that CPN 44 and CPN 48 originally formed a pair dedicated to the sun/earth duality as seen elsewhere, for example, on the bench of Structure 18.

COMPARISONS

CPN 44 and CPN 48 belong to a group of similar "bundle altars," including the altar of CPN 52 and CPN 79 (or Altar A'). The aquatic frieze is also found on CPN 109, 110, and 111.

CPN 45 (GLOBULAR ALTAR OF STELA 4)
(fig. 60)

This globular monolith is horizontally surrounded by a rope carved in high relief about 30 cm above the ground. A shallow bowl with two grooves is carved on the upper half-globe. The grooves form a half-circle in opposite directions, ending at the rope.

DIMENSIONS

Height 90 to 100 cm; maximum diameter ca. 150 cm; thickness and height of rope 10 and 30 cm. Diameter of bowl 21 cm; depth of bowl 2 cm.

DISCOVERY, LOCATION, AND ASSOCIATIONS

CPN 45, first mentioned by Stephens, is 3 m east of CPN 43's front. No cache was found under CPN 45.

INTERPRETATION

The design of CPN 45 formed by the bowl and the two channels suggests a circular movement that could represent—like a swastika—the apparent movement of the sun. As the rope indicates, this altar certainly was a sacrificial monument. When liquid is poured into the bowl to the point of overflowing, it runs into the two channels and creates the illusion of the sphere spinning around. In other words, the bloodshed by sacrifice makes the sun "turn"; this interpretation suits my hypothesis on the finality of sacrifice that—I believe—was shared by the Maya and the Aztec alike. The sacrificial connotation of this altar fits the associated stela's iconography perfectly. Seen from above, the altar is reminiscent of the T538 glyph, which may express the same idea. Note that this glyph has been reported only from Copán and Quiriguá (Thompson 1962: 152).

A

B

FIG. 60 CPN 45: (a) side view; (b) top view showing liquid flowing down. Photos by J.-P. Courau.

CPN 46 (ARCHAIC SCULPTURE)
(Richardson 1940: fig. 37; Parsons 1986: fig. 89)

This is a pot-bellied seated anthropomorphic figure. The legs are bent around the base, the arms are crossed over the breast, and the hands repose on the sides. The hands and feet show only four fingers and thumbs are not shown; thus, the extremities look more animal than human. A segmented collar with a pendant pectoral is bound around the neck. This pectoral has the shape of a round medallion with a T-shaped appendage at the bottom. On the sides two double-rolled stripes or feathers rise above the belt. Feathers that emanate from the headdress cover the shoulders. On the back is a motif that seems to represent anklets and part of two legs.

CPN 46 is without a head, and the body is broken in two halves that have been reassembled by archaeologists. Minor portions flaked off along the fracture and are missing.

DIMENSIONS
Actual height 78 cm; width (average) 70 cm; thickness (maximal) 80 cm.

DISCOVERY, LOCATION, AND ASSOCIATIONS
CPN 46 was discovered by Erwin P. Dieseldorff, assistant to Alfred Maudslay, in the foundations of CPN 43. This, of course, was not its original archaeological context, but a secondary, nonfunctional reuse. It is not known where CPN 46 was originally located.

COMPARISONS
CPN 46 is very similar to CPN 51, found in the foundations of CPN 47. A third similar sculpture was found at La Florida de Copán by Samuel Lothrop in 1916 (Morley 1920: 421). According to Parsons (1981: 287), CPN 46 and CPN 51 " probably represent a Late Preclassic intrusion from the Pacific region." At Tikal a similar but smaller pot-bellied sculpture (Miscellaneous Stone Sculpture 82, Jones and Satterthwaite 1982: 91 and fig. 65 m–p) was found in a Cauac-phase fill. Parsons (ibid.) writes that he received a photo of a similar sculpture, also found at Tikal, but considerably larger (70 cm high), which has "a serrated medallion on its torso." No published record of this second Tikal pot-belly sculpture is available.

CPN 47 (STELA 5)
(figs. 61–62)

The two broad sides of this monolithic four-sided shaft are carved with standing human figures whose design overlaps the adjoining narrow sides, leaving only room for a single column of glyphs on each. The lower part of the monument is almost totally destroyed. Flakes are missing, especially in the headdress. In general, the west side is more eroded than the east. The stela was set into a cribbing frame whose stones, according to Strömsvik (1941: 76), apparently were used by the modern inhabitants of Copán to build foundations for a bridge over the Sesesmil River.

DIMENSIONS
Maximum height 300 cm; length at base (north-south) 114 cm and width 52 cm. Depth of relief on east side 15 cm; on west side 25 cm.

DISCOVERY, LOCATION, AND ASSOCIATIONS
CPN 47 was first reported by Gordon (1896: 38) at the location where it presently stands. It had fallen and broken into many pieces, but archaeologists from the Carnegie Institution pieced it together and reerected it. This location is probably a secondary, functional reerection, and its original placement is unknown. CPN 47 is associated with two cylindrical altars; CPN 49 is to the east, above a large cruciform foundation chamber; CPN 50 lies a few meters to the west. An archaic sculpture (CPN 51) and a bundle altar (CPN 48) were found in the foundation chamber of the stela.

DATE
According to Riese (Baudez and Riese 1990: vol. 2, p. 261),

The monuments may not all have been erected at the same time at their present location. CPN 47 and CPN 49 could have been erected first in some unknown location, since they constitute a traditional Stela-Altar ensemble. This would have been at the hotun date 9.11.15.0.0 4 Ahau 13 Mol. CPN 50 was added later, either at 9.12.0.0.0 or at 9.13.0.0.0, or it was added only after CPN 47 and CPN 49 had been re-erected at their present location. This is assumed to have happened at the same time as CPN 43 was placed in the Main

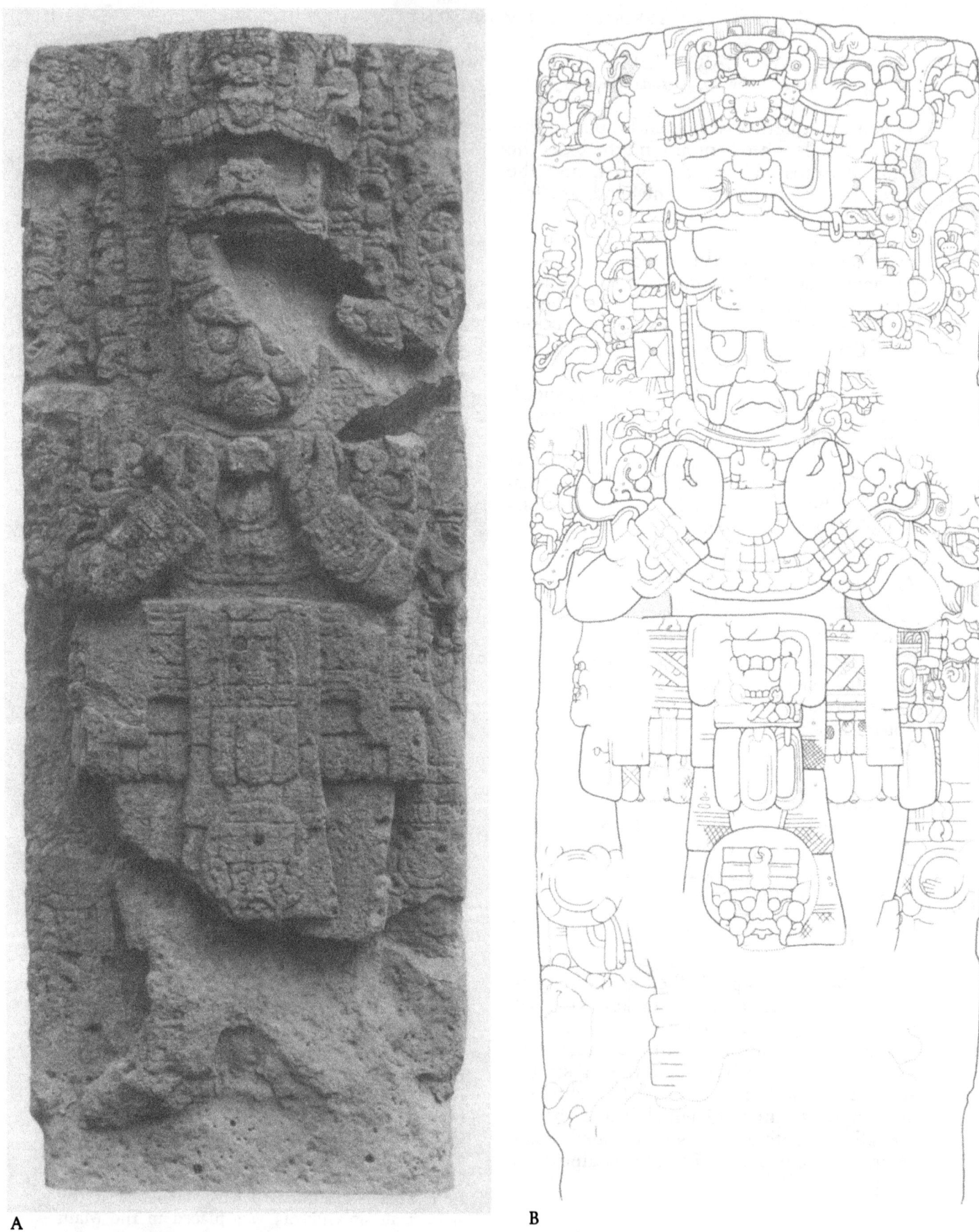

FIG. 61 CPN 47: west side. Photo by J.-P. Courau; drawing by B. Fash.

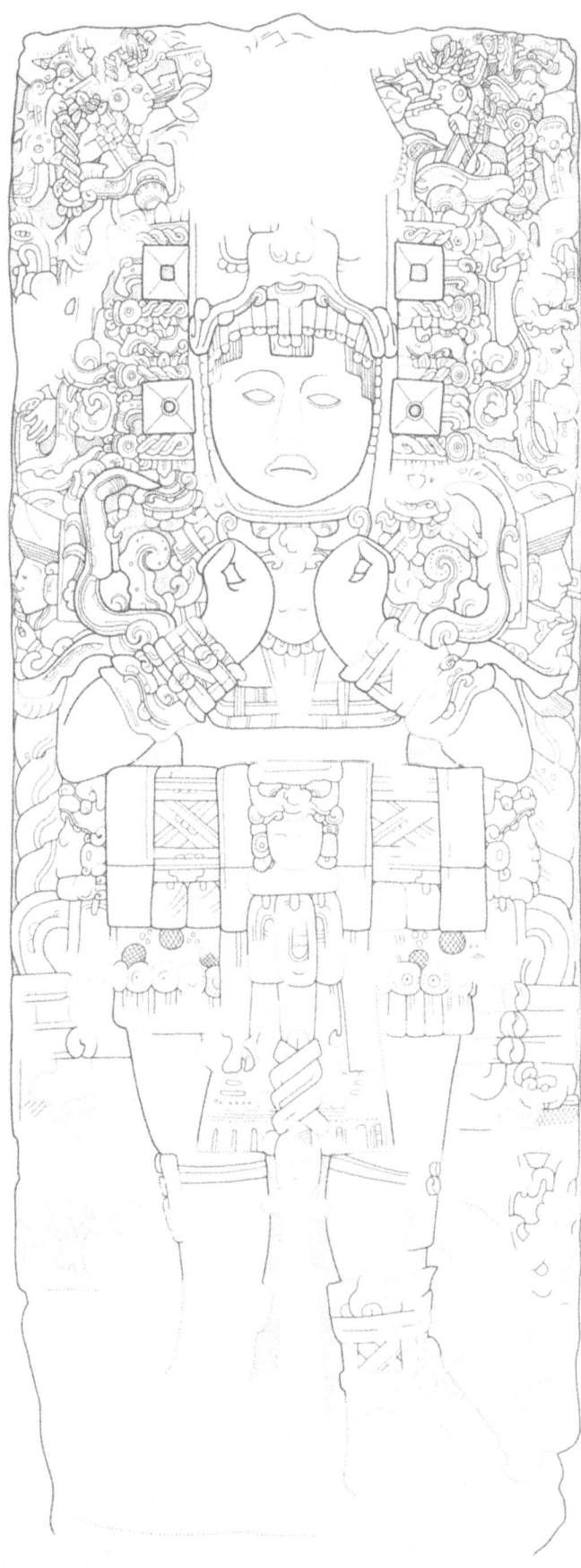

A B

FIG. 62 CPN 47: east side. Photo by J.-P. Courau; drawing by B. Fash.

Plaza, since the contents of the stela foundation caches below both stelae are very similar.

COMPOSITION

To the east as to the west the main figure is standing and holds a bicephalic serpent against his chest. The headdress is made of one or two superimposed helmets crowned with a hat wearing masks. Serpent jaws holding mythological or ancestor figures frame the king's head. The free space along the legs is taken up to the west by masks and shields, to the east by a rope and a knotted serpent. There were two wide-open serpent mouths on both sides of the main figures. The major difference between the two sides is at the top. On the west two serpent heads—like those flanking the main figure's head—are on both sides of the hat. On the east we find instead two ancestors who emerge from serpents, which—as on CPN 41—are stuck to the earplugs of the helmet.

THE WEST SIDE
(fig. 61)

The Main Figure: His lower helmet is destroyed, except for a bulging eye, a large scroll at the corner of the mouth, molars, and—on the mask's side—an oval cartouche with T103. The second helmet is better preserved: squint eyes, a flat nose on a muzzle inscribed with T528, and a wide rectangular tongue. It is probably a jaguar. The earplugs flanking the helmets are square with a central circlet and diagonals, with an outward element representing a serpent snout. From the earplugs hang the braid-and-tassel (T58) and T255. The uppermost headdress is a cap lined with beads with a small human mask in the middle. Its top is flanked with *ahau*/bones. Above is a jaguar mask wearing a flat cap whose two cutouts show T617a; the eyes squint, the muzzle and nose are broad, and there is no lower jaw. Two serpentlike elements flow from the corners of the mouth. There is a scroll above the earplug and a bead below. From this jaguar mask wave branches or stems tapering to a leaf. It is a variant of the water lily jaguar or of the skull-and-vegetation motif, such as on the top of CPN 1.

The face of the main figure (probably wearing a mask) is a sun jaguar. *Kin* in a cartouche is engraved on the forehead and the temples. The bulging eyes have a horizontal hook as a pupil. The broad nose is flanked by two protruding cheekbones from which hang two serpentlike elements that frame the muzzle. A row of beads encircle the head. The earplugs are identical to the helmet's, except for an additional serpent head below. The chin mask with a flat muzzle seems to be that of a jaguar; it overlooks a small round human mask, lined with beads, from which hang ornaments. Both masks form a pair like the one crowning the headdress. The bicephalic serpent that the main figure holds against his chest has skeletal body and heads. The indented lower jaw and the supraorbital plate bear wavy lines and circlets. The serpent heads, however, have beards and bifid tongues. The jaws contain a solar head with a Roman nose and filed teeth. There is a scroll above and a bead below the earflare. What remains of the helmet still bears T617a.

The wristlets consist of an inverted serpent head topped with three knotted bands. The belt, with crossed-bands on its body, has three death heads as masks. The straps that tie them to the belt are clearly visible from the sides. The central skull is topped with a knot (T60) framed with black-ended ribbons and underlined with the braid-and-tassel. The side masks have the three knotted bands as headdress; on their very eroded earplugs we can still see the *cimi* sign (T509). The three tinklers hanging from each mask are oval plaques wearing a now vanished sign. *Oliva* shells hang from the black-spotted (jaguar skin) skirt.

The loincloth's front is three-layered with enlarged and blackened ends bearing circlets and bars. The lower layer is mostly taken up by a circular shield with a pseudo-Tlaloc face, topped with the three knotted bands; it has ringed eyes, a flat nose, and round earplugs with a jaguar ear above and a bead below. The upper lip curls up, baring filed teeth framed by a hanging moustache. There is no lower jaw. The knee ornaments had the three knotted bands above an eroded motif. The anklets were, as usual, similar to the wristlets; only traces of knotted bands remain.

Surrounding the Main Figure: The headdress top is flanked by two serpent heads

opening wide mouths and leaning outward. They may be seen as the two ends of a serpent bar whose body is hidden by the cap. The upper jaw, upright at first, then curves above a head that is only preserved on the right. Deprived of the lower jaw, the head has a round eye, a pointed tongue, and a hooked nose; its earplug is graced with a jaguar ear. It wears a knotted band on the head and eroded motifs on the forehead. This is the jaguar as patron of the month Pax. Two more serpent heads located at the level of the main figure's head and lower helmet are similar to the ones above and, like them, look skeletal with an indented lower jaw and a protruding tongue. They hold a skull topped with a knotted band and other unclear motifs, a ringed eye, and an apparently skeletal jaw. The ringed eyes recall the pseudo-Tlalocs.

The same goggles are an attribute of the mask still present to the left of the belt. It has no lower jaw, but a long pointed tongue with two wavy lines and a large scroll at the corner. A knotted band tops the skull of this feline, reminding us of the heads with the same position on CPN 41. Below there are three knotted bands above a round shield with four salient balls and ribbons. There is almost nothing left of the serpent heads that flanked the feet of the main figure.

Interpretation: The west side of CPN 47 shows a figure wearing a jaguar mask whose solar nature is confirmed by several *kin* signs. He wears helmets depicting the same animal. The feline is again above an *ahau* mask at the top, as on the chest of the main figure. The three serpent bars of the monument's west side contain old solar figures with a Roman nose or a Pax jaguar or pseudo-Tlalocs, skeletal or without a lower jaw. Other pseudo-Tlalocs may be seen on the loincloth and near the belt, while the shield, a solar insignia associated with the jaguar, has a privileged location. The knotted bands that symbolize sacrifice and death crown the pseudo-Tlaloc on the loincloth, the shields, and the death heads on the belt. All the iconography of the west side deals with the themes of death and the jaguar, which represent the dead nocturnal sun, to which the later ruler, here depicted, is likened.

THE EAST SIDE
(fig. 62)

The Main Figure: The round eyes and the flat muzzle, generally indicating the jaguar, are still visible from the much eroded helmet. Cartouches containing a group of horizontal lines (T24) are engraved on the temples. The earflares are squares with a central circle and diagonals and an overhanging serpent head. Above and below these are successively the braid-and-tassel, T255, and a profile serpent head. As on the west side, the headdress was topped with a cap whose sides are preserved, showing branches or stems with leaves. Above the helmet's earplug is an inverted skeletal serpent head. The upper jaw is marked with a stone sign and *imix* (T501) is stamped in the eye. From the jaws issues a human figure carrying a bar, whose end is a serpent head preceded by a braid framed by T255. The gaping jaws contained a knife-tongue; the remaining part is marked with wavy broken lines lined with dots (T528). Just in front of the reptile's head a braid with the T58 tassel at both ends and T255 hang from the bar. A supple band with barbs juts out from behind the ophidian's ear. I identify it as a tongue, in comparison with other examples such as the central belt mask of CPN 4 west. In the middle of it is a variant of T628.

The figures coming out of the jaws of the two monsters look alive and youthful; in front of their nose, they have a turned up, *zip*-like serpent head, a round earflare, and a cylindrical headdress with two braids linked by chevrons. A braid and black-ended ribbons hang from their head. Their wristlets are of the ribbon-on-band type. The left figure raises in his right hand the remains of a triangular lancet, similar to the one shown below the individual emerging from the serpent bar. The right figure raises a vessel containing an offering, probably cacao pods, in comparison to the offering in the Madrid Codex (p. 95a).

The face of the main figure is youthful and plump. His earplugs are like those flanking the helmet; however, the central circlet is here replaced with a socket, which may have been intended to receive an inlay. The chin mask, perhaps of a jaguar, has scroll-eyes and very large fangs or emanations frame the head. It overhangs a small rounded human mask, surrounded with beads and adorned

with pendants. The body of the bicephalic serpent held by the young king is a supple rectangular band, a transitional form between the "naturalistic" serpent and the true "bar" that will replace it. Its extremities are live heads (see the serpent markings on the lower jaw to the right) with round scroll-eyes, a large convoluted supraorbital plate, and a sign for stone. Their jaws hold a youth wearing a turban with hanging ribbons. The *zip* monster is in front of his nose; its earplug is topped with a scroll. The left individual holds a lancet (or spine), triangular with a bifid upturned base. The right figure presents an offering in a bowl: two dotted ovals topped by a third one and apparently with the *po* sign; this could be copal.

The wristlets worn by the young king are made of an inverted serpent head crowned with the crossed-bands between two knotted bands and T255. The belt bears the same crossed-bands and three youth masks with jaguar helmets. Four pairs of ribbons partly cover the belt, from which hang plaques stamped with the same sign (T24) already seen on the king's helmet. The lower edge of the jaguar skin skirt is adorned with a row of beads and a fringe. As on the west side, bars and dots are very finely engraved there. The front end of the loincloth is fringed and a braid with eroded mask and pendants runs along its middle. The knee ornaments reproduce lancets: the triangular blade, broad first, then narrow, is topped with two knotted bands. The anklets are identical to the wristlets.

Surrounding the Main Figure: On both sides of the king's head two open mouths were perhaps destined to be the ends of a serpent bar with a hidden body. They are alive and have scroll-eyes, a long scalloped tongue, and a shell section as a fang. They contain a human figure, preserved on the left side only, who wears an *imix* monster helmet. These individuals hold an object or a glyph: to the right it is a scroll topped by T16 or T114 (the scroll could represent rubber; see Lounsbury 1973: 113); to the left, an unidentified motif surmounted by *yax*.

From the belt down the main figure is framed by two intertwined ropes covered in part by a serpent forming a loop tied by three knotted bands; the turned-up tail and the head of the animal overhang from it; the serpent head is very realistic, although its tongue is itself a small snake. Eroded reliefs demonstrate that at calf level serpent jaws contained a human head wearing a helmet.

Interpretation: The east side of the stela shows a young king who is standing under the protection of his ancestors and calls on their spirit. On the monument's top they emerge from the jaws of the earth monster, holding in one hand the serpent bar, a power insignia; in the other they hold the lancet for self-sacrifice or an offering, a reminder of the accession rituals.

The two back-to-back figures are contrasted. To the west, where the sun sets, the late king wearing the jaguar mask symbolizing the setting sun is pictured. He is surrounded by creatures, signs, and symbols related to death and the night sun. To the east, where the sun rises, the young king is not surrounded by infernal creatures but by his ancestors; the latter remind us of the rites celebrated at the time of accession. The monument illustrates the succession of Smoke-Jaguar Imix-Monster to Smoking Heavens (or Butz' Chan); Smoke-Jaguar's name is cited in the text, and the Initial Series date of the monument, according to Schele (1987), is the accession date of this ruler.

CPN 51 (ARCHAIC SCULPTURE)
(Parsons 1981: fig. 28; 1986: fig. 87)

This is a monolithic sculpture in two major fragments; the top section and large flakes are still missing from the front and back. The sculpture was repaired as far as possible by the Carnegie Institution.

DIMENSIONS

Height 93 cm; maximum width 80 cm; depth 82 cm.

DISCOVERY, LOCATION, AND ASSOCIATIONS

CPN 51 was discovered in the foundations of CPN 47 by E. Dieseldorff, when he was Maudslay's assistant. It had been deposited there in ancient times together with CPN 48. The original context is not known.

DESCRIPTION AND COMPARISONS

The sculpture represents a crouching jaguar with outstretched forelimbs, the paws resting

on the ground. Its head is lacking. It wears a collar with an eroded pectoral. Bracelets adorn the four paws; they are made of two straps: one plain, the other a grid pattern. The digits are crudely indicated by parallel lines. CPN 51 is similar to CPN 46, although more slender. Parsons (1981) compares it to a headless crouching jaguar from Ometepec in coastal Guerrero. Both sculptures belong to his Olmecoid Substyle Full-Round engaged relief.

CPN 52 (STELA 6)
(figs. 63–64)

One of the broad sides of this four-sided, slightly flaring shaft is carved with a standing human figure in front view. Due to the deep relief carving, the design overlaps on the adjoining narrow sides and leaves room for one column of text. The opposite broad side is carved with an inscription in two columns. When found, the stela was broken but essentially complete. It is set into a cribbing frame, which may have been sculpted, although this is not clear at present.

DIMENSIONS
Height 220 cm; width (east-west) at base 57, at top 60 cm; depth (base and top) 47 cm. Cribbing frame 137 (north-south) by 121 by 20 cm.

DISCOVERY, LOCATION, AND ASSOCIATIONS
Archaeologists of the Peabody Museum found CPN 52 lying on the ground, approximately 30 m west of CPN 47. It remains there today, having been repaired and reerected by Carnegie archaeologists. The stela is set on top of a cruciform masonry chamber, which contained sherds from an incised jar and from a reddish, crude *florero*. A rectangular bundle altar (CPN 53) was also found close by and is thought to have been originally associated with the stela.

DEDICATORY DATE
9.12.10.0.0 9 Ahau 18 Zodz.

DESCRIPTION
The main figure has a plump and youthful face crowned by a tall turban. A rectangular frame holds together the masks, feathers, and ribbons added to the turban. A pseudo-Tlaloc mask is shown upon a feathered background, on the front and the sides. It has no lower jaw; the upper jaw curls up above a row of teeth and a short and pointed tongue, flanked by two scrolls. The eyes are ringed and the earflares are adorned with a scroll above and a bead below. The headband is beaded. The headdress of the mask is made of a knotted band and another band engraved with a broken line, from which juts out the Mexican Year Sign. Two ribbons on which starlike designs are drawn hang down to the king's forehead on the sides. His earplugs have a scroll above and two bones below. The serpent he holds against his chest has a flaccid netted body. The same net design can be seen on the serpent heads with death eyes, a serrated tongue, and a bearded chin. A feather crest adorns their foreheads, and a small panache, their snout. From their mouths emerge fantastic heads with no lower jaw, but with ringed eyes and a long lolling tongue marked with the "stone" sign, between two scrolls. To the right of the figure the earplug is a plain circle, while it is a *kan* cross to the left. These heads wear a flat cap with a knotted band on the front; there is another knot with a feather or a leaf above it, and the snout of a live serpent to the right of the figure; on the opposite side it is a skeletal snout or an eccentric.

The wristlets of the main figure, either of cloth or of wickerwork, are flanked by two shells. In place of a belt, a rope turns four times around the waist. The skirt is made of blackened ribbons. Three upside-down scrolls with wavy tails are placed on the loincloth, whose end is painted black. These signs look like the diagnostic element of *caban*, which is also the facial marking of God R in the codices. Above is a design made of two motifs; the first is three-lobed and contains an eroded element, and the second has three parts: a pointed element and two upended strips framing it. An analogous design (but with black spots on the three-lobed motif) adorns the sandal heels. The knee ornaments include several concentric bands with geometric motifs (pyramids, chevrons, broken line), from which hang two superimposed trapezoids. On the sides of the monument, at waist level, are two elongated upended bands that probably represent the heads of cosmic serpents. Black-spotted feathers hang from them.

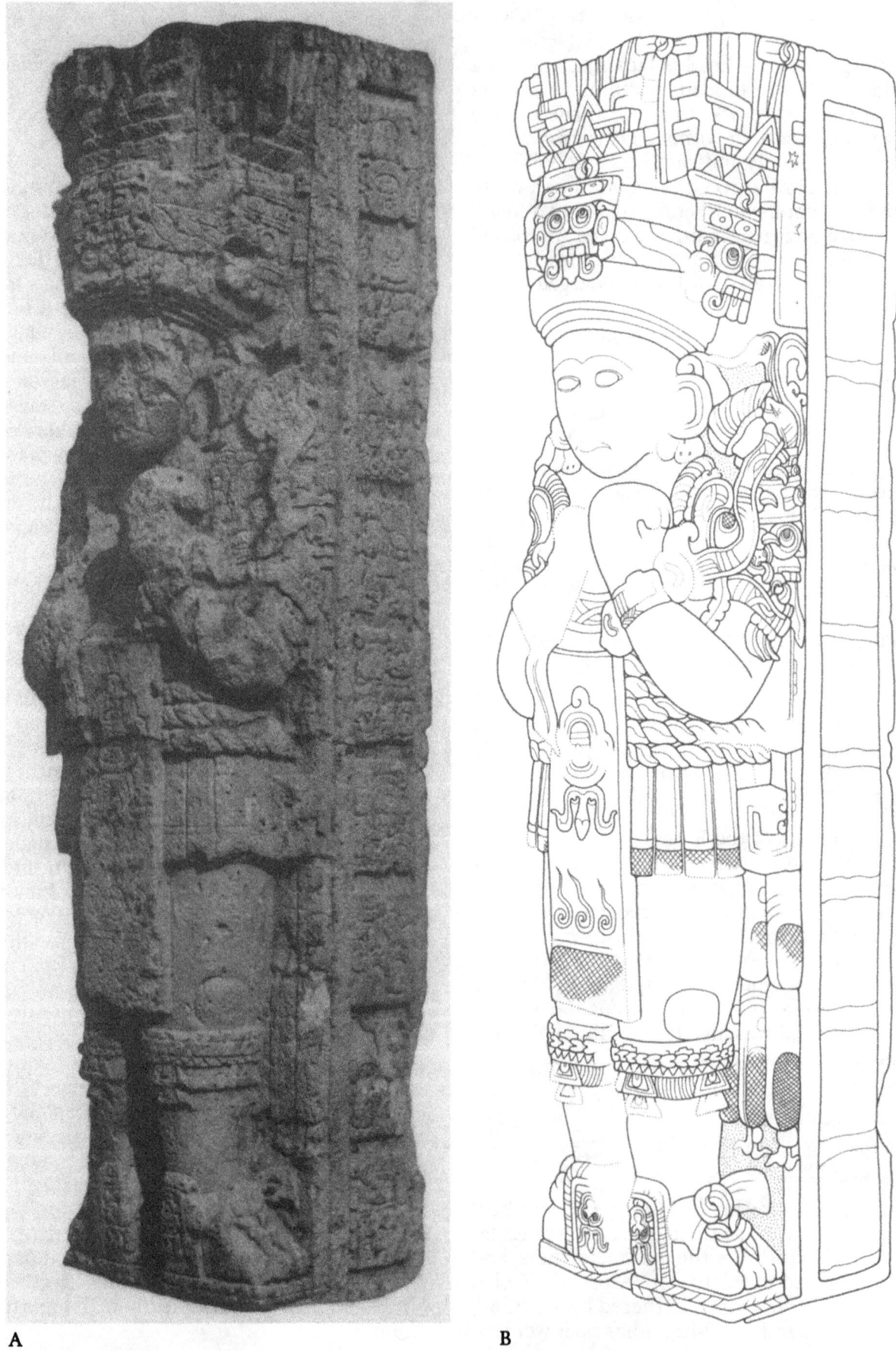

A B

FIG. 63 CPN 52: southeast side. Photo by J.-P. Courau; drawing by B. Fash.

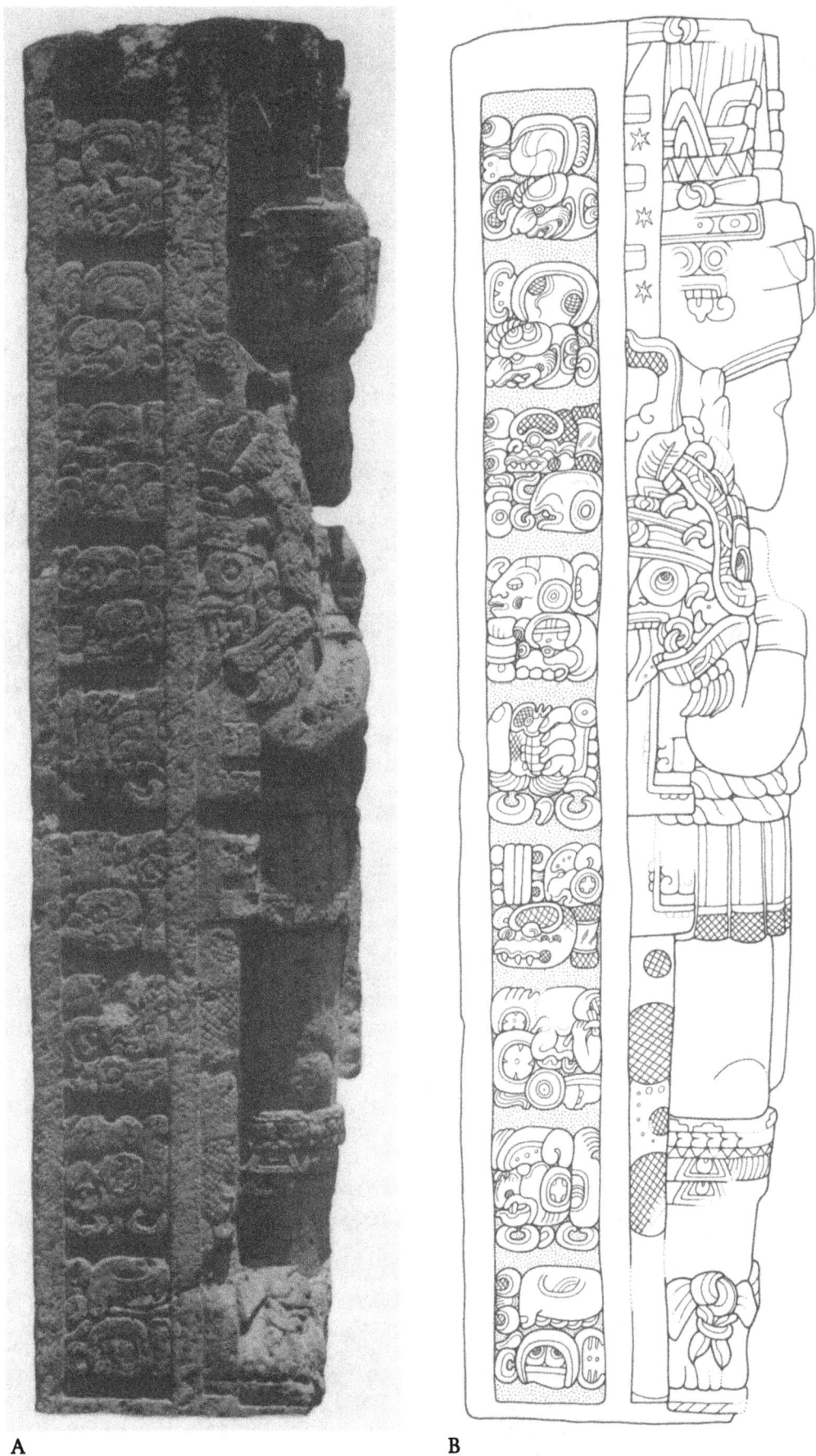

A B

FIG. 64 CPN 52: west side. Photo by J.-P. Courau; drawing by B. Fash.

INTERPRETATION

The main figure depicts a ruler. Schele (1984) has demonstrated that the pseudo-Tlaloc/Year Sign complex was associated with autosacrifice on Classic Maya monuments (Yaxchilán, Lintels 17, 24, 25) as well as with sacrifice of captives (Aguateca Stela 2 and Dos Pilas Stela 16). CPN 52 exhibits this complex and other sacrificial icons. The masks from the headdress and the creatures emerging from the heads of the bicephalic serpent are very similar. Although they recall the Mexican god Tlaloc because of their goggles, they have nothing else in common with a rain god; but they are very close to the Pax jaguar through their missing lower jaw and their long tongue stamped with "stone" and framed by large scrolls. Pasztory (1974) sees two aspects of Tlaloc at Teotihuacán: a jaguar Tlaloc associated with war and sacrifice, and a crocodile Tlaloc, which will become the Aztec rain god. It is certainly the first aspect that was exported to the Maya area during the Early Classic (Tikal Stela 31) according to its recurrent associations with war and sacrifice. At Copán the ringed eyes are found on images unrelated to a rain god (such as those found in company of the statues on the Hieroglyphic Stairway of Structure 26). The symbol of the knotted bands is associated with the pseudo-Tlalocs. Pasztory (1974: 19) observes that the "Jaguar-Tlaloc image is related to a group of net-jaguars associated both with weapons and war and with water and fertility." It is no coincidence that the bicephalic serpent on CPN 52 is netted.

The design on the loincloth and the sandals is comprised of a three-lobed cartouche and a tripartite element. In central Mexico this Teotihuacán-derived compound is common in epiclassic sites such as Xochicalco and Cacaxtla (Berlo 1989: 27). Interpreted as a human heart seen in cross-section with pendant blood drops, it is part of the Teotihuacán military costume (Stone 1989: 162–63). At Piedras Negras it is found on Stelae 7, 8, and 9. On the first of these it adorns the apron, the shields, the headdress, and the shoulders of the main figure. In addition, this monument displays the Year Sign and the blackened feathers of the *muan* bird. On Piedras Negras Stela 8 the "dripping fluid" element is in the jaws of a monster with jaguar ears and goggles, in the middle of the king's headdress. Although the stela has no Year Sign, it shows a pseudo-Tlaloc mask tied to a panache on the monument's top. This same motif may be seen on the spherical hat of Stela 9, without a pseudo-Tlaloc but with a Year Sign. Thus, the composite design is actually part of the Jaguar-Tlaloc/Year Sign complex as shown by the Piedras Negras Stelae 7, 8, and 9 by CPN 52.

Other sacrificial symbols on this stela are:

1. The shells flanking the wristlets, which often have a death connotation in Maya art; for instance, those associated with the three knotted-bands on the composite staffs on the Tikal stelae; the shell as a substitute of the skeletal jaw at Copán, Quiriguá, Naranjo; the shell as element of the tripartite emblem, and so forth.
2. The feathers of the *muan* bird, which are part of the paraphernalia of God L in ceramics and then associated with the underworld and sacrifice.
3. The rope that takes the place of the belt.

The iconography expresses sacrifice but does not specify whether it is autosacrifice or sacrifice of others. Did this question have any meaning to the Maya, who readily confused both forms of sacrifice? In fact, in the inscriptions, the T1:757.59:172 expression is associated with autosacrifice scenes (Yaxchilán Lintel 24) as well as bound captives (Columnar Altar 1 from Tikal; Schele 1984: 33, 34, and fig. 19). In iconography, the pseudo-Tlaloc/Year Sign may be found with either form of sacrifice. The rope around the waist may be a sign of penance. The rope that the warrior wears may be used to tie up his captives but also to liken himself to his victims (northeast jamb of Structure 18; Baudez 1983: vol. 2, p. 483). The text includes at least three references to autosacrificial rites (at C2, D6, and D8–D9; Baudez and Riese 1990).

COMPARISONS

CPN 38 and CPN 52 constitute a class of their own: they are the first high-relief monuments at the site: the main figure takes up more than half of the stela's sides, leaving a narrow space to the text. The relief is much lower on CPN 18, 20, and 47; it is only with CPN 11 that a comparable relief is found. CPN 52 is shorter than other Copán stelae. The setting around the main figure is re-

stricted to a narrow space on both sides of the legs. Besides the costume, there is nothing above or around the king's head and shoulders. Many of the motifs are exclusively found on this monument, such as the netted serpent, the design on the loincloth and the sandals, the wristlets, the skirt, and the knee ornament.

CPN 54 (STELA 7)
(fig. 65)

CPN 54 is a four-sided carved shaft slightly wider at the top than at the bottom. One broad side is sculpted in moderately high relief with the image of a frontal, upright human figure. The other three sides carry hieroglyphic inscriptions, which are enclosed by plain borders on the top and on two sides. The monument, broken into two pieces, has been restored. The carved surfaces are substantially eroded, and large portions of the principal figure and of the inscriptions are missing entirely. In spite of substantial erosion and damage, many traces of red paint remain, and it is therefore assumed that the entire monument was originally painted red. The stela was mounted on a cruciform masonry foundation chamber and was secured in place by means of a cribbing frame.

DIMENSIONS
Height 330 cm; width at base 75 cm; depth 50 cm; at top 82 and 48 cm, respectively.

DISCOVERY, LOCATION, AND ASSOCIATIONS
In 1874, according to local reports collected by Morley (1920: 103), Colonel Vicente Solís and his troops were passing through the village now known as Copán Ruinas when he found CPN 54. The monument was apparently lying on the ground. Solís had it moved a few meters toward the village plaza, with the intention of having it erected there. The stela, however, broke into two pieces and was left abandoned.

Maudslay rediscovered the stela in 1885 lying 50 m southeast of the Plaza. Later, Morley and Clementino López excavated a masonry foundation chamber close to the spot where Solís had abandoned the stela. Finally, Carnegie archaeologists repaired the stela and erected it in the courtyard of the local museum at Copán Ruinas, where it still stands.

For the description of the original site, installation, and associations of the monument, we must rely completely on the reports of early archaeologists, because the site has been stripped of its carved stones and has been built over in recent times. CPN 54 originally stood on a rectangular stone pedestal that concealed a cruciform masonry chamber. Resting on this same pedestal, to one side of the stela's butt, another stela fragment (CPN 76) and an undecorated cylindrical stone *incensario* were found. The chamber contained a shell, a perforated stone, two obsidian points, an obsidian knife, and a fragmentary hieroglyphic stone (Fragment V'14). Apparently CPN 54 had been erected on a low rectangular platform of about 459 square meters, which Morley referred to as a "mound." According to Morley, the platform bore evidence of several construction phases, all of which (with the possible exception of the last) predate CPN 54, as shown in his plan.

DEDICATORY DATE
9.9.0.0.0 3 Ahau 3 Zodz.

COMPOSITION
One broad side of the monument is dominated by the full-length portrait of the eleventh ruler (Butz' Chan or Smoking-Heavens) wearing an elaborate headdress. Above it a second tier of masks surrounded by plant motifs can be observed. Serpents frame the upper part of the figure, and the upper portion of two entwined serpents may be seen close to his right leg.

The Main Figure: His face is almost completely eroded except for the outlines of large, wide-rimmed oval eyes with hollow centers. Above a beaded headband is a mask conceived as a naturalistic jaguar head: a flat muzzle and nose, round eyes, and scroll-ears. Beneath the figure's chin is another jaguar mask, this one without a lower jaw, but with the same round eyes and broad, flat muzzle. Between the figure's forearms is a mask depicting a youth, which hangs from a row of round beads. On the figure's wristbands are depicted serpent heads, a rectangular plate with a circlet at each corner, and T23. The body of the bicephalic serpent that the ruler holds is no longer visible. Only the right head remains. It is animated by a scroll at the corner

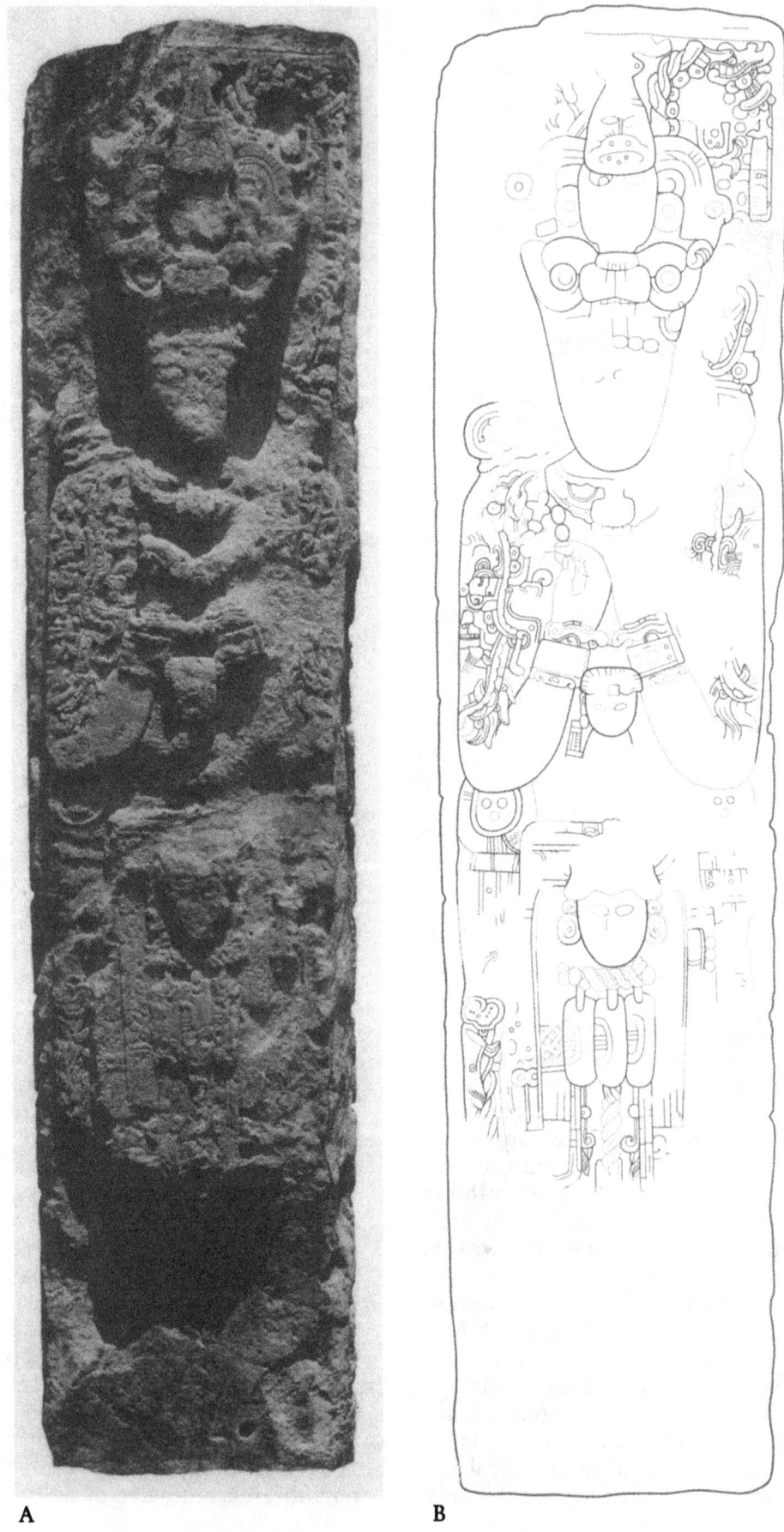

A　　　　　　　　　B

FIG. 65 CPN 54: front. Photo by J.-P. Courau; drawing by A. Blanck.

of the mouth and by its extended tongue. The creature's jaws are bordered by beads, a beard grows from the chin, and there is a tube extending from the nose. T173 appears between the molars and fangs. The head of an old solar creature emerges from the serpent's jaws. It has a skeletal, bearded lower jaw, scroll pupils in the eyes, and a cruller on the bridge of the nose. Serpentine forms frame the toothless mouth, with a bone and a scroll respectively below and above the earflare, as well as a bead hanging from the nose. This creature is very possibly the Jaguar Paddler (a form representing night) as Schele has suggested (1987b).

Surrounding the Main Figure: Above the helmet of the ruler, or perhaps forming a second tier, appears a mask now completely eroded with the exception of its earplugs. Above this is another head, a pointed skull shaped like a water lily blossom, while the mouth is drawn as an *ahau*/bone head. This seems to be a variant of the skull-and-vegetation theme. The two masks are surrounded by plant forms. The background is a jaguar skin. On both sides of the pointed skull mask appears a serpent bordered by beads. His head, without a lower jaw, is seen in profile and faces outward. A tassel hangs from it, composed of a round bead, a bell-shaped element, a transverse tube, and other round beads and streamers. The body of the serpent itself is represented by a braid. The whole design thus represents the braid-and-tassel motif. To the left of the ruler's helmet may be seen traces of an open-mouthed serpent. The head held in its jaws is not visible. Under the figure's right elbow appears a round shield. It has three circlets in the center and four equidistant medallions on its outer rim. It may be assumed that there was a corresponding shield on the left side. Flanking the right thigh are a pair of entwined serpents that terminate in a trilobed shell.

INTERPRETATION

The ruler appears to be under the patronage of the jaguar and the night sun, as demonstrated by the presence of the jaguar helmet, chin mask, and head emerging from the serpent bar. Death and rebirth themes are represented by skull-and-vegetation motifs appearing above the main figure. The entwined and looping serpents are symbols of sacrifice.

CPN 55 (STELA 8)
(Maudslay 1889–1902, vol. 1, pl. 109a and b, both sides)

The broad sides of this rectangular monolithic shaft are carved with hieroglyphic inscriptions and with a braid-and-tassel design. The two narrow sides are dressed but plain. When discovered, the stela was broken in two pieces, and large portions had completely scaled off.

DISCOVERY, LOCATION, AND ASSOCIATIONS

CPN 55 was found in 1893 by John G. Owens of the first Peabody expedition lying in the village cemetery (Group 10, according to Morley) of the modern Copán Ruinas. In 1912 the stela was broken up to serve as the foundations of a wall being built around the cemetery. It has never been recovered, and it is not known if the wall has been demolished in the meantime or if CPN 55 is still hidden in the actual wall. No architectural associations have been reported for this monument. CPN 56 was reused as one of its supporting slabs.

DEDICATORY DATE

9.17.12.6.2 9 Ik 15 Zip.

DESCRIPTION

Surrounded by glyphs, a central braid-and-tassel occupies more than the lower half of both sides. It is composed, from top to bottom, of a shell, a braid, a round bead, a bell-shaped element, a horizontal tubular bead, and radiating tubes.

The braid-and-tassel is a very common motif at Copán, where it seems to be part of the iconography of kingship. It probably is an emblem of royal power (the braid or mat being one of its major components). The motif has also a major importance in Structure 18, where it frames the niches of the east-west wall.

CPN 62A
(CRIBBING FRAME OF STELA 13)
(Strömsvik 1941: fig. 23c)

The cribbing frame (CPN 62A) around the base of CPN 62 (Stela 13, a monolithic shaft with inscriptions on all four sides) is composed of several individual slabs. It is carved

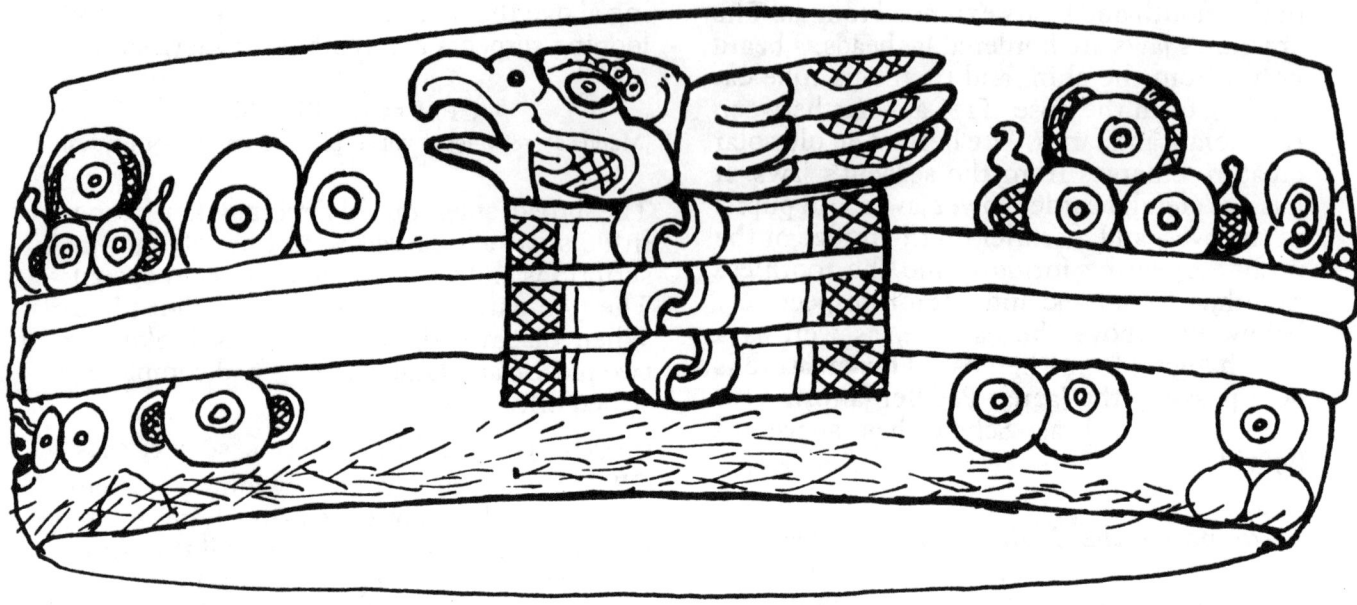

FIG. 66 CPN 64. After Dieseldorff 1930: fig. 11.

on the upper side and the outer vertical sides as a bundle with bands crossing each other and dividing the space into three panels. The two lengthwise straps are knotted in the middle. The central panel is taken up by the stela butt. Each of the other two slabs displays a serpent bent into a U, whose body is knotted. A medallion is tied to their forked tails.

This cribbing frame presents the interesting association of the bundle and the loop-serpent motif, both having sacrificial connotations.

DIMENSIONS
Length (north-south) 184 cm; width 132 cm; height 29 cm.

DISCOVERY, LOCATION, AND ASSOCIATIONS
CPN 62 is located on a steep bluff overhanging the north bank of the Copán River, 4 km northeast of the Main Group, in a region now called Petapilla. This is about halfway between the modern villages of Copán Ruinas and Santa Rita. CPN 62 was discovered by one of the Peabody expeditions at the end of the nineteenth century lying on the ground, broken into two fragments. It was relocated there by Morley in 1912 and first reported in print by him (1920). CPN 62 is associated with the cylindrical altar CPN 63. A small cist under the northwest side of pedestal among unshaped rocks contained three obsidian blades, shell fragments, and a piece of sandstone mirror back.

DEDICATORY DATE
9.11.0.0.0 12 Ahau 3 Ceh.

CPN 64 (ALTAR 14)
(fig. 66)

CPN 64 is a cylindrical altar with carving on the periphery. Its dimensions are unavailable.

DISCOVERY, LOCATION, AND ASSOCIATIONS
It is not known when and where this altar was discovered. It probably was found when Dieseldorff was Maudslay's assistant, since he is the first to mention this altar. Strömsvik (1947: 75) says it is located "on the road to Santa Rita." Its present location is unknown.

DESCRIPTION
According to Dieseldorff's drawing, two bands encircle this cylindrical altar; they are interrupted by three knots with a pendant upside-down bird with black markings on the face and the wings. The shape of the head and the hooked bill are reminiscent of the *katun* bird. Its inverted position (a negative connotation) concurs with the symbolism of the sacrificial knots. Pairs of concentric circles (jade symbols?) and groups of three circles from the *cauac* glyph are above and below the encir-

cling bands. They are flanked by black-spotted streamers, very much like the main element of *caban*. It is apparently an unusual, but meaningful, pairing of *cauac* and *caban*, two aspects of the earth. Possibly the knots and the bird were repeated on the other side of the altar. (See Dieseldorff 1930: fig. 11 on p. 44; Spinden 1913: fig. 214 on p. 161, after Dieseldorff; Strömsvik 1947: 75.)

CPN 82 (ALTAR D', OBLONG ALTAR, ALTAR 41)
(fig. 67)

CPN 82 is a rectangular prismatic monolith. A hieroglyphic text takes up the west and south sides (present orientation), and a bicephalic earth monster is depicted on the east side. A toad with a jaguar mask in the back occupies the north side and part of the altar's otherwise unsculpted top. CPN 82 has been referred to with various designations: "Ornament fallen from the stairway leading up to temple No. 11" (Maudslay 1889–1902; vol. 1, pl. IXb); "part of the face of a step from the hieroglyphic stairway" (Maudslay 1889–1902, vol. 5, p.16); "oblong altar" (Maudslay 1889–1902, vol. 1, pl. 114 a–g); Altar D' (Morley 1920 and most subsequent literature); and "Altar 41" (Núñez Chinchilla 1963).

DIMENSIONS
143 cm by 67 cm by 34 cm.

DISCOVERY, LOCATION, AND ASSOCIATIONS
Maudslay (1889–1902, vol. 5) found this monument on the eastern side of Structure 7, where it remains today. However, in his caption to the plate showing this monument he erroneously gives "fallen from the stairway leading up to Temple No. 11" as its provenience; although he corrects himself in the accompanying text volume (p. 68), some modern writers have repeated this incorrect statement. The altar was broken into three pieces when found. It was repaired and elevated on pedestal stones to insulate it from the ground by the Carnegie archaeologists. Not much of the relief has flaked off, but general erosion, especially on the top and the east side, is apparent.

DEDICATORY DATE
9.17.0.0.0 13 Ahau 18 Cumku.

The Bicephalic Monster (East Side): The monster's scale-covered belly and paws with reptilian claws occupy the lower edge of this face. Above the three rings flanked by streamers from the *cauac* sign (T528) identify the creature as the earth monster. Its live head and limbs face south, while its death head faces north. The live head has a double-scrolled eyebrow over the eye marked with crossed-bands and half-closed by a striated lid. A flower springs from the end of the upturned snout and plants jut out from behind the head. A youthful face with a tubular earplug and an eroded coiffure or headdress emerges from the monster's jaws. In Maudslay's drawing it is reminiscent of personified maize. It might be Rising-Sun, however, since this ruler is mentioned in the hieroglyphic text and the earplug is characteristic of real persons rather than supernaturals. In contrast, the death head wears a common type of earplug. The skull forehead is marked with the *kin* sign (T544) and crowned by the tripartite emblem.

The Toad/Jaguar Pair (North Side): The toad straddles the top and north side of the altar head downward, as if diving. The eyes are half closed. Three circlets adorn the round ear ornaments. A scroll hangs out of each corner of the wide mouth. A jaguar mask is set on the toad's back. It faces backward and has T616b on the forehead. The eyes are round, the muzzle flat. Fangs flank the filed teeth. The earplugs are of a common variety.

INTERPRETATION
The earth monster occupies the east side of the altar, and a live head is held in the maws of the live monster. This monument is probably, like CPN 3, an accession piece. The life/death duality of the earth monster is repeated by the jaguar/toad opposition. The diving toad on CPN 82 represents the earth in its wet and fertile aspect, as does the live monster with the emerging ruler. The monster's dead head with *kin* sign represents the night sun, corresponding to the jaguar head on the toad's back. That the toad head is aligned with the death head and the jaguar with the living one emphasizes the ambiguity in the expressed duality.

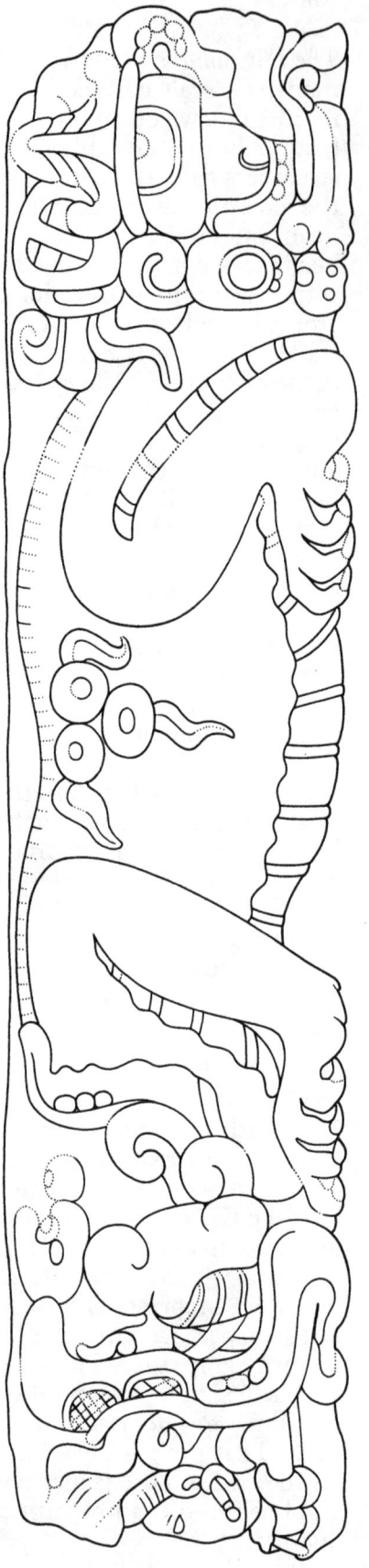
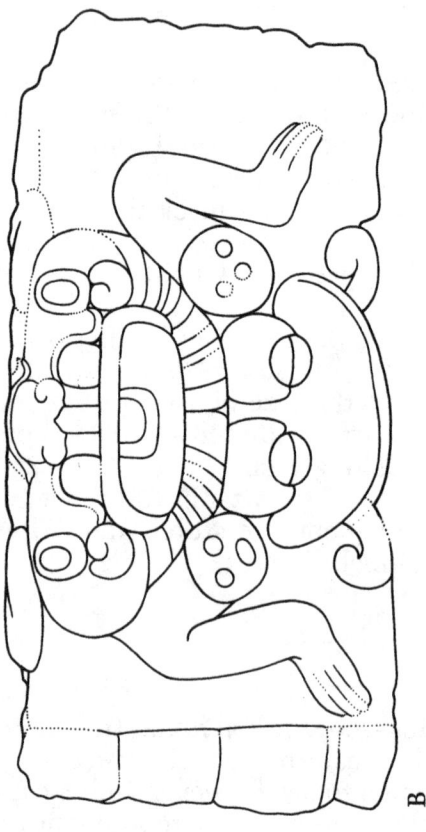

FIG. 67 CPN 82: (a) east side; (b) north side. Drawings by A. Blanck.

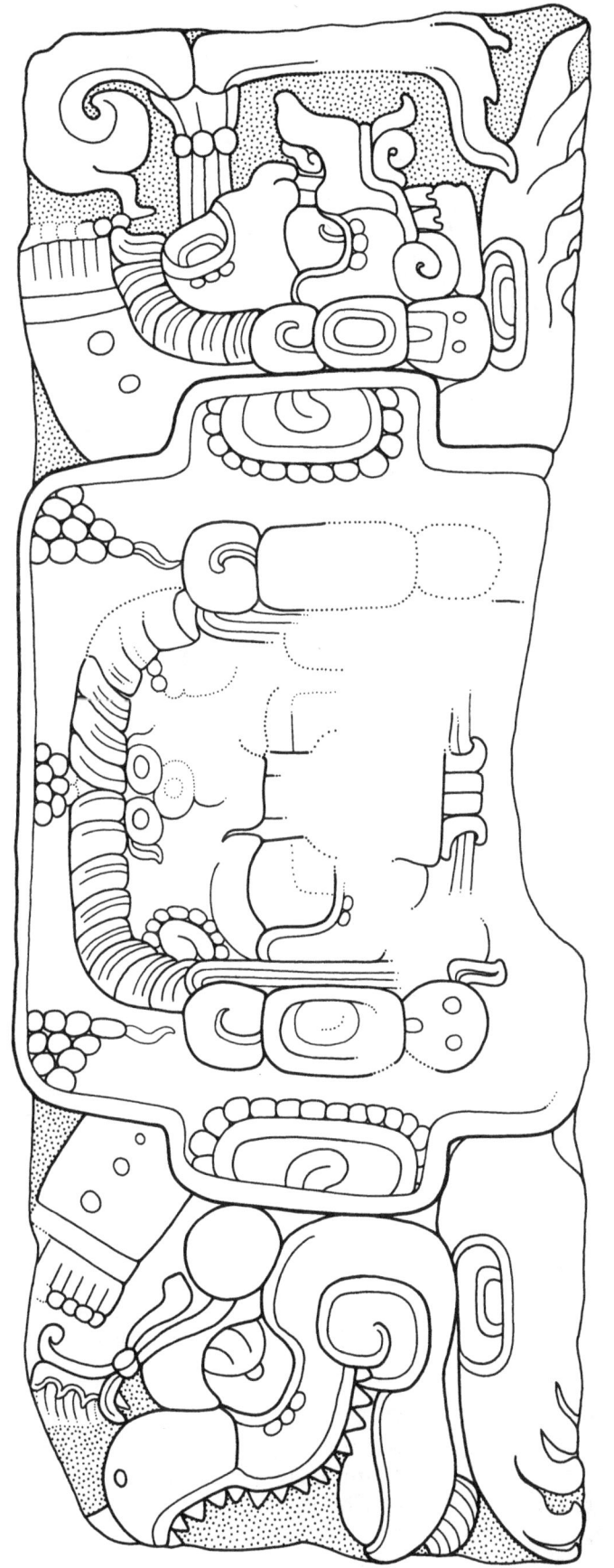

FIG. 68 CPN 101: front. Drawing by B. Fash.

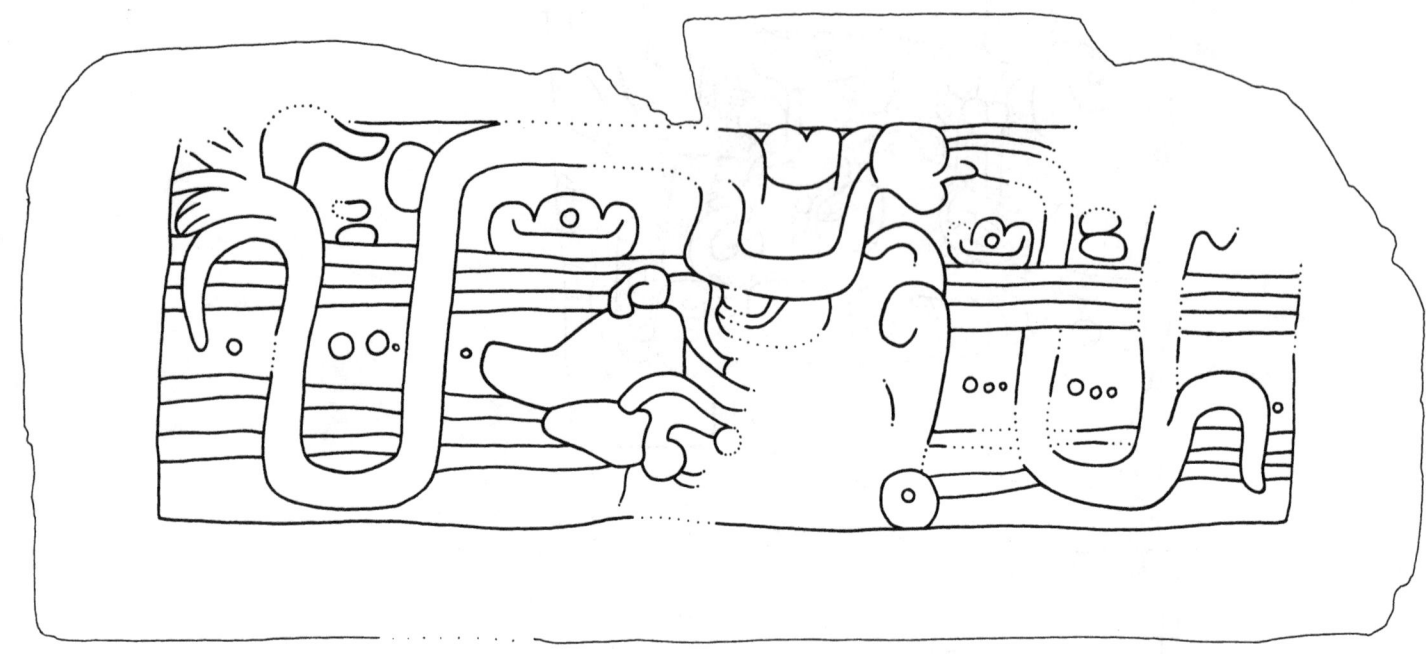

A

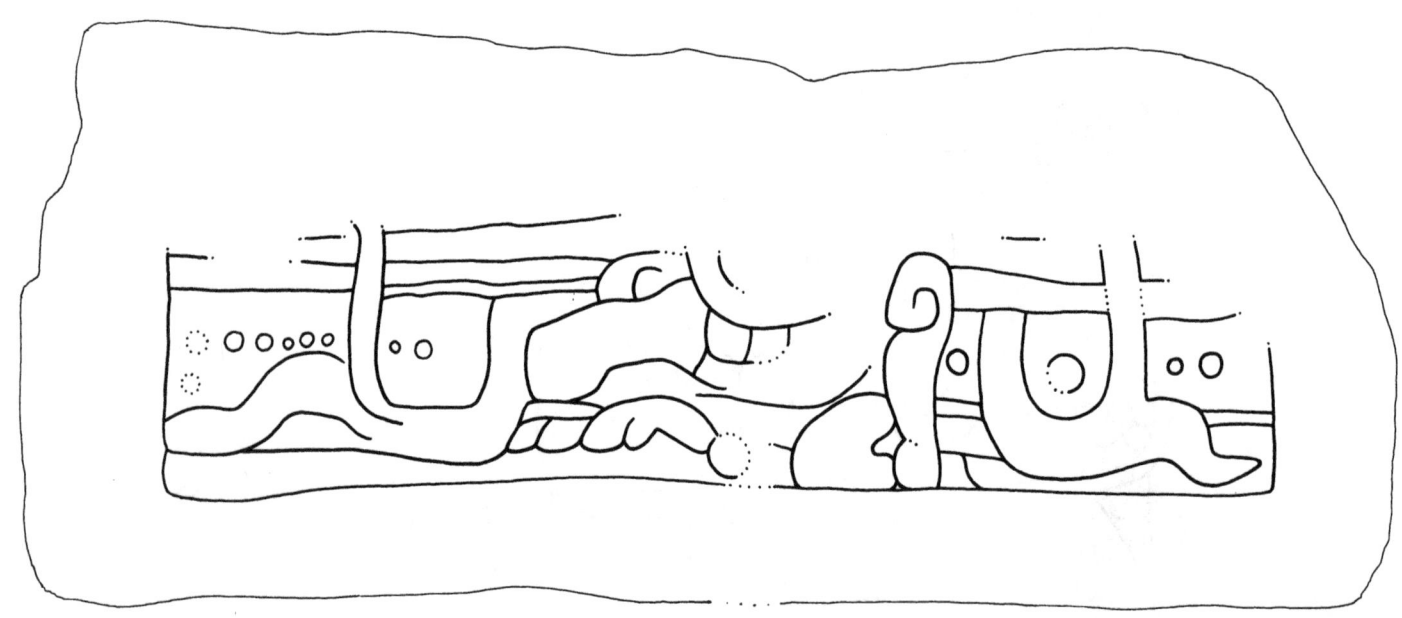

B

CPN 98 (ALTAR T')
(fig. 115b below)

CPN 98 is a cylindrical carved monolith. It is 30 cm high and measures 49 cm in diameter, according to Morley. When first described, "abundant traces of red paint" were still visible (Morley 1920). The 9-Head emblem is repeated four times, at equal intervals, on the periphery. It is an earth image (see discussion in chapter 4). Above these motifs is a plain raised border.

DISCOVERY AND LOCATION
According to Morley (1920: 375), CPN 98 was found in 1916, 0.5 km southwest of the village of Copán Ruinas, on the edge of the first terrace above the river floodplain. It is currently in storage at the local museum.

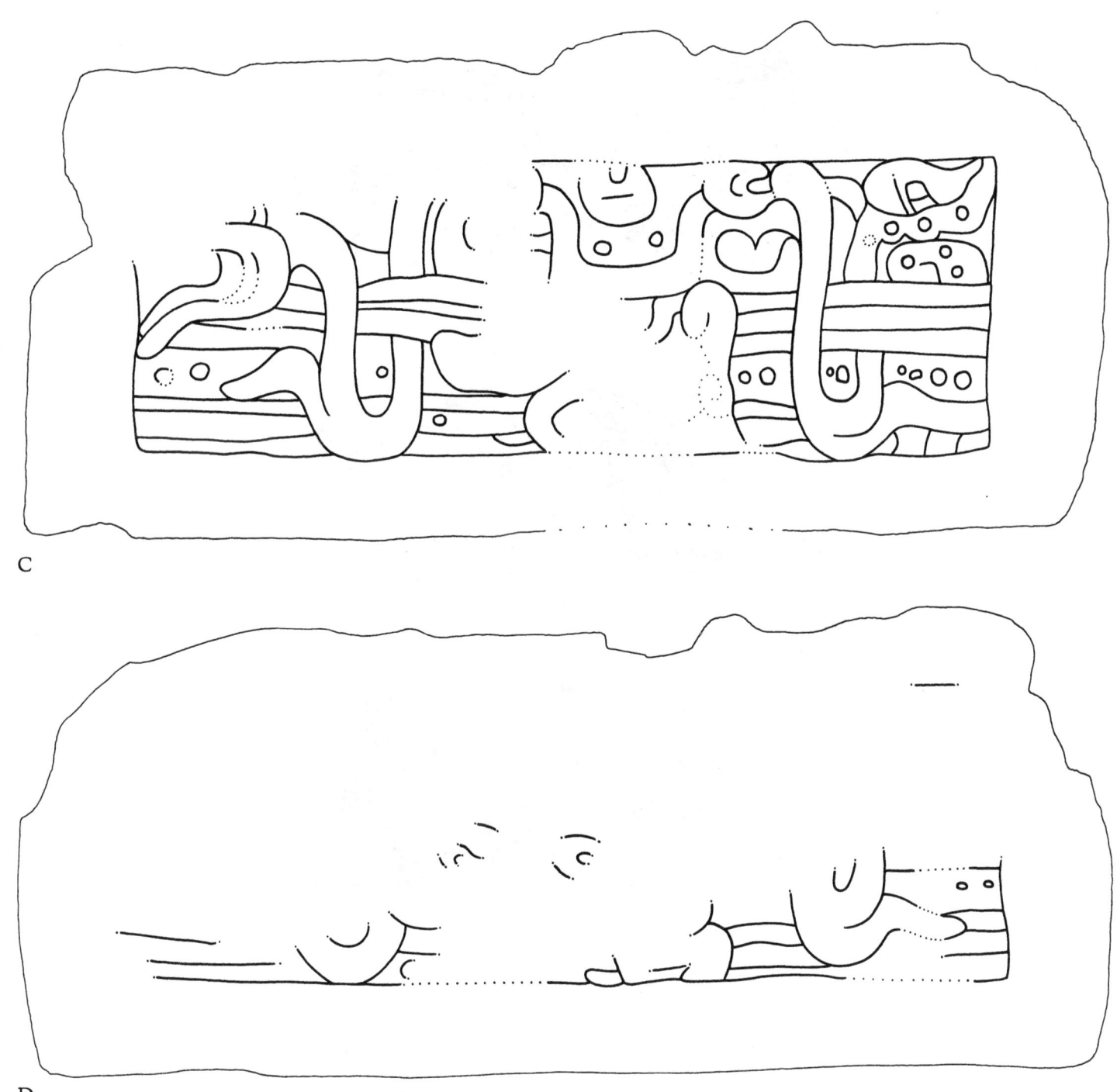

FIG. 69 CPN 109, four vertical sides: (a) west; (b) south; (c) north; (d) east. Drawings by G. Valenzuela.

A

B

C

D

FIG. 70 CPN 110, four vertical sides: (a) south; (b) west; (c) north; (d) east. Photos by J.-P. Courau.

CPN 99 (ALTAR U')

CPN 99 is a carved cylindrical altar, 29 cm high and 48 cm in diameter. According to Morley, the 9-Head emblem was carved three times on the periphery of this eroded sculpture. It is likely that a fourth identical emblem was present, judging from its similarity in shape and decoration to CPN 98.

DISCOVERY AND LOCATION

According to Morley (1920) CPN 99 was found in 1916 in the patio of a house at the southeast corner of the plaza of Copán Ruinas, near the base of the structure on which CPN 32 stood. It is now in storage at the local museum.

CPN 101 (ALTAR W')
(fig. 68)

CPN 101 is a prismatic block. The top is dressed plain. The four vertical sides are sculpted. One broad side is occupied by a bicephalic monster. The other three sides carry inscriptions.

DIMENSIONS

Length 94 cm; Width 43 cm; height 38 cm.

DISCOVERY, LOCATION, AND ASSOCIATIONS

This altar was originally found in 1891–92, according to Morley (1920: 330):

> Altar W' lies in a small court surrounded by the remains of stone buildings, one kilometer east of the Main Structure, on the west bank of the river.... The surrounding buildings were built of squared dressed blocks, and there are a number of sculptured fragments lying on the slopes of the substructures. It is evident from the latter that this group was of no small importance, and that it was handsomely embellished with sculptural mosaics, particularly the temple on the south side. The floor of the court has been silted to the depth of a third of a meter... and it was in this alluvial deposit that Altar W' was found by the first Peabody Museum expedition in 1891–92, buried in such a way that only its front surface was exposed. This was photographed, but no record of its provenance seems to have been kept or any mention made of its discovery.... The altar, as found in 1917, lay front up.

Today the altar is housed in the local museum in Copán Ruinas. From Morley's description of the original location, it is clear that this altar once was associated with a Plaza Group in the zone now called Las Sepulturas.

DEDICATORY DATE

9.17.5.9.4 8 Kan 12 Mol.

DESCRIPTION

The cruciform medallion makes up the body of the monster, on which is carved a large, full-face mask of the earth monster. There are *cauac* elements on the forehead; the hair is brushed back above it, and strands fall along the sides; an incisor is flanked by two fangs; the round earplugs are adorned with a scroll above and a bone below. More *cauac* elements surround the monster's mask.

To the left of the observer a toad represents the front of the monster. Its paw with four or five claws is marked with T616b. The tongue is thick and a row of small triangular teeth edges the upper jaw. There is a large scroll in the corner of its mouth. The round eye is half closed, the earplug is a disk, and a water lily is knotted around the head (as on the *bacabs*).

To the rear the leg, very eroded, has elongated digits. The reptilian head above it has an upturned snout; in the upper jaw are a molar, fangs, and the scroll at the corner. The lower jaw is short and skeletal. The scroll eye is round. A smoking bundle or torch is implanted in the forehead, marked with a cartouche. The hair is brushed backward. Above each head a rectangular band with circlets and a transverse fringed strip at the end juts out of the medallion's upper corner. It is a stylized form of a water lily blossom.

INTERPRETATION

CPN 101 is another depiction of the bicephalic earth monster with contrasting heads. The terrestrial nature of the monster is indicated by the cruciform medallion, *cauac* mask, and *cauac* signs. The live head is taken by a toad; the death side by the Thunderer: what is implanted in his forehead here is clearly a torch made of a bundle of sticks, and not the more usual ax (Baudez 1992).

CPN 109, 110, AND 111
(figs. 69–71)

These are prismatic monoliths of similar size, form, and design. Today they are all badly broken. Each vertical side bears a rectangular carved panel.

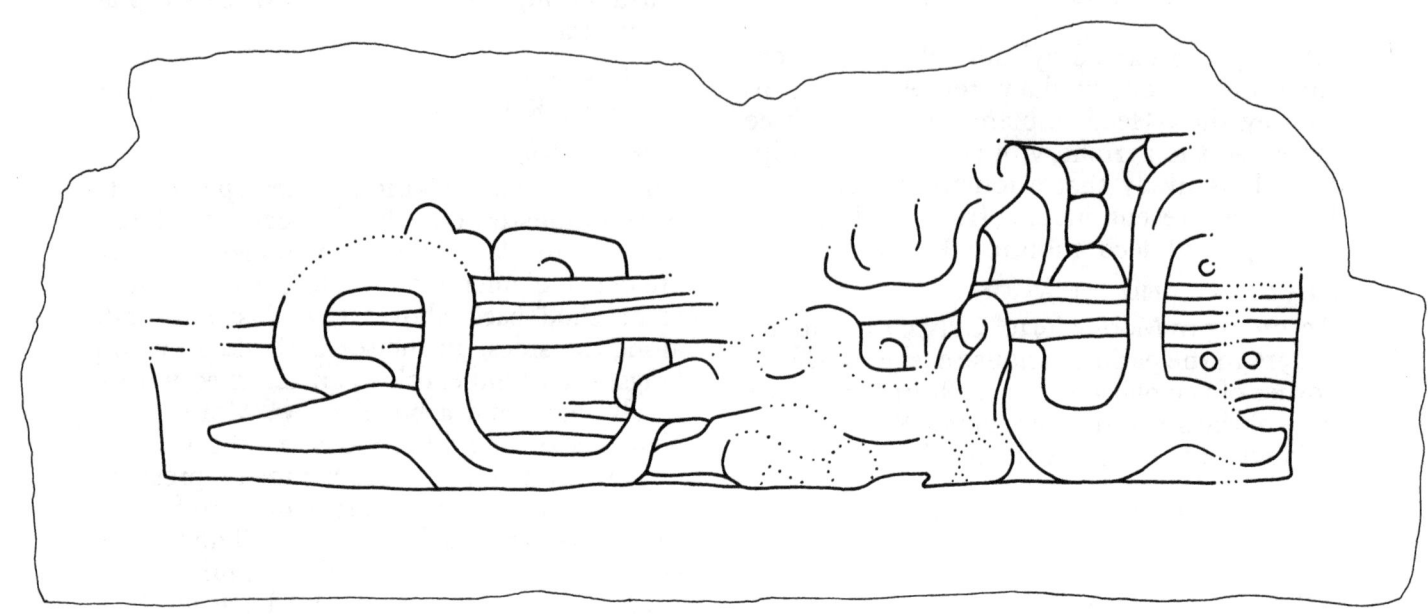

A

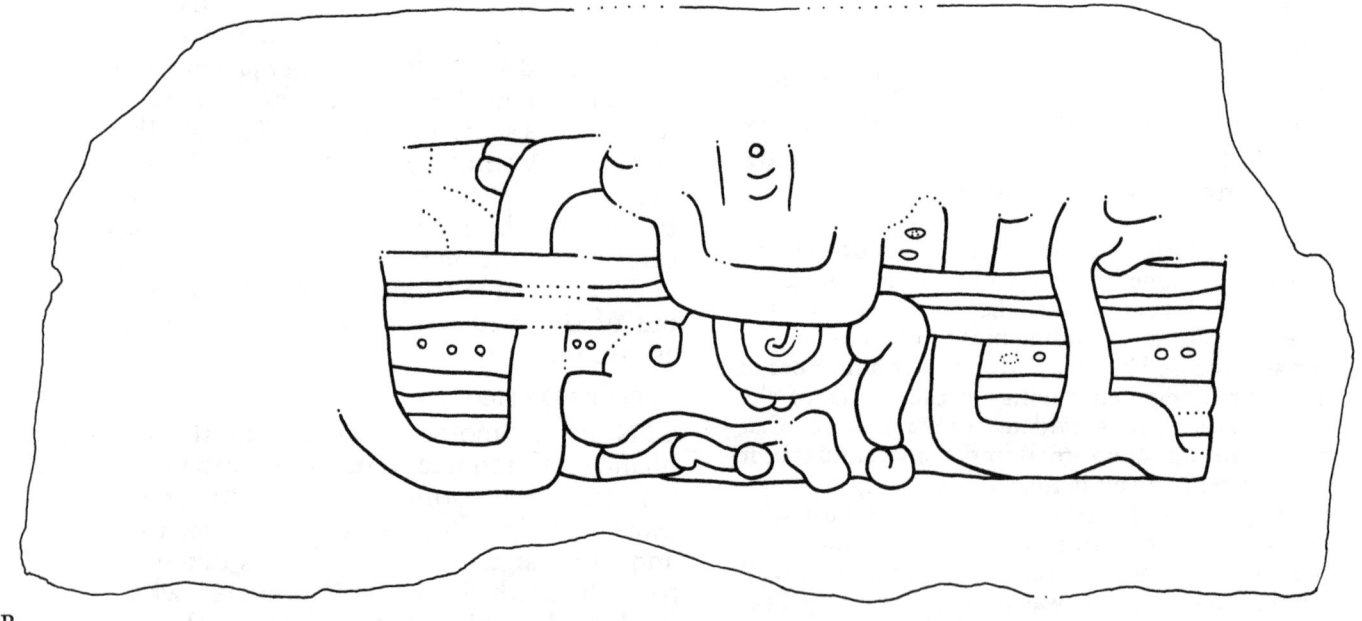

B

DIMENSIONS

CPN 110: 97 by 97 by 43 cm.

DISCOVERY, LOCATION, AND ASSOCIATIONS

Neither Gordon nor Maudslay mentions these three sculptures. However, a dot south of CPN 22 on the Peabody map (Gordon 1896) may indicate these monuments. Their original location is unknown. CPN 111 has been reused as a stair step on the east side of Structure 6. It remains unknown whether CPN 109 and 110, which are also probably earlier than the structure, have been reused in the same way; in fact they are now lying a few meters to the east of this platform and of CPN 111. The association of CPN 111 with the stairway of Structure 6 is secondary.

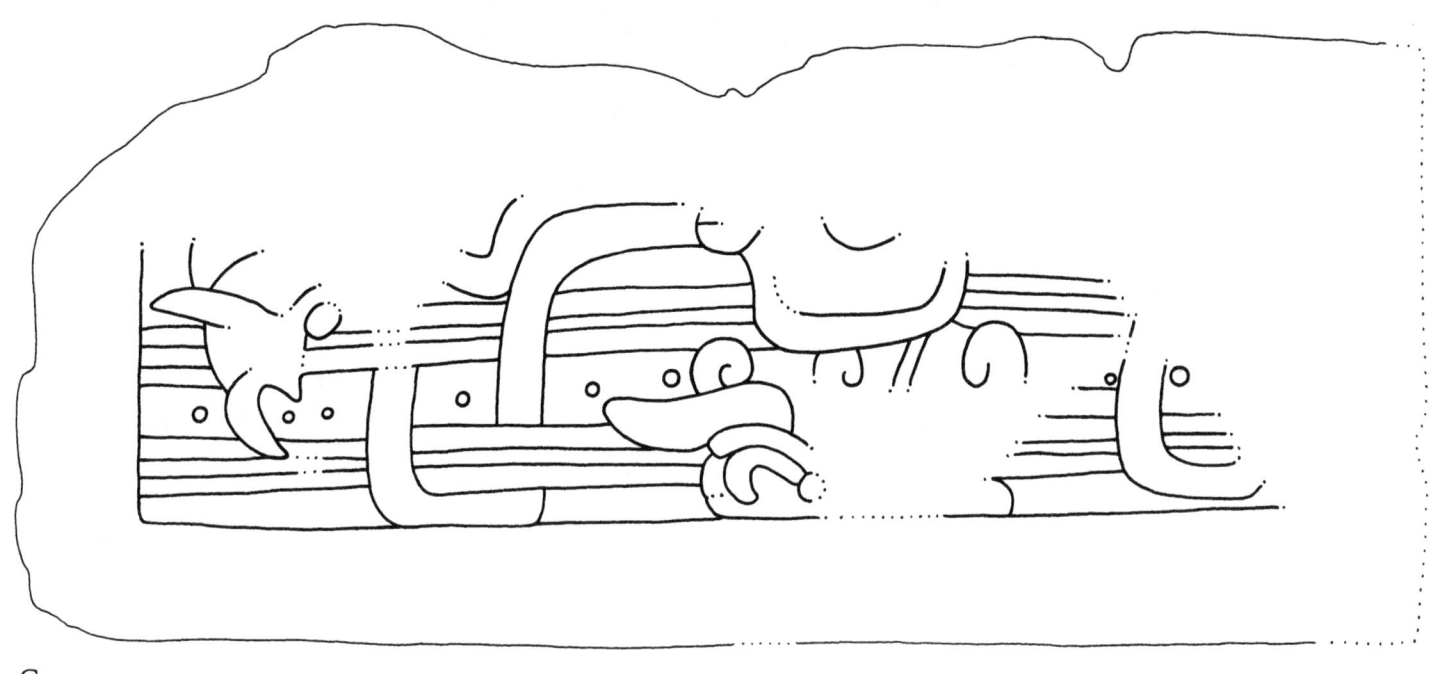

C

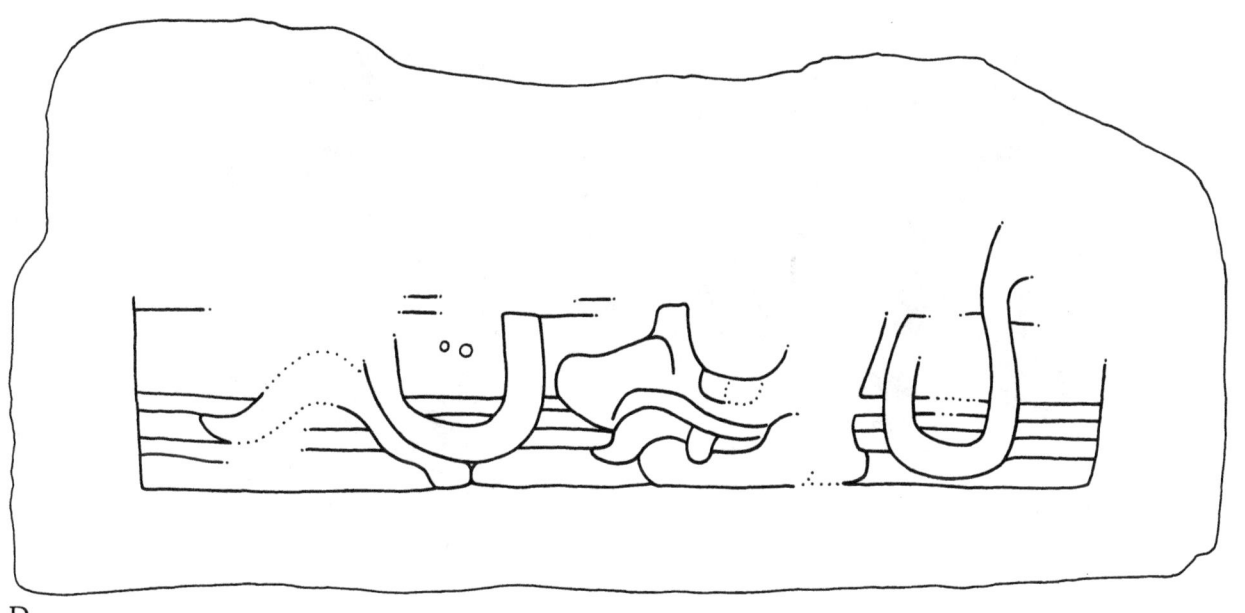

D

FIG. 71 CPN 110, four vertical sides: (a) south; (b) west; (c) north; (d) east. Drawings by G. Valenzuela.

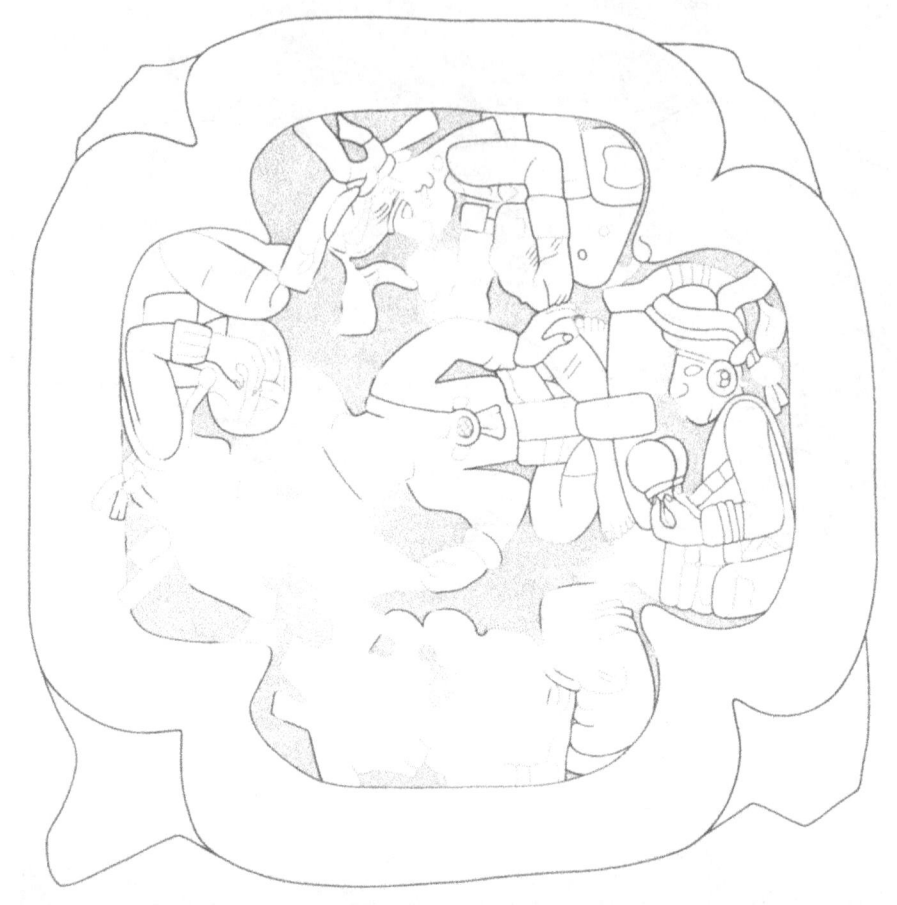
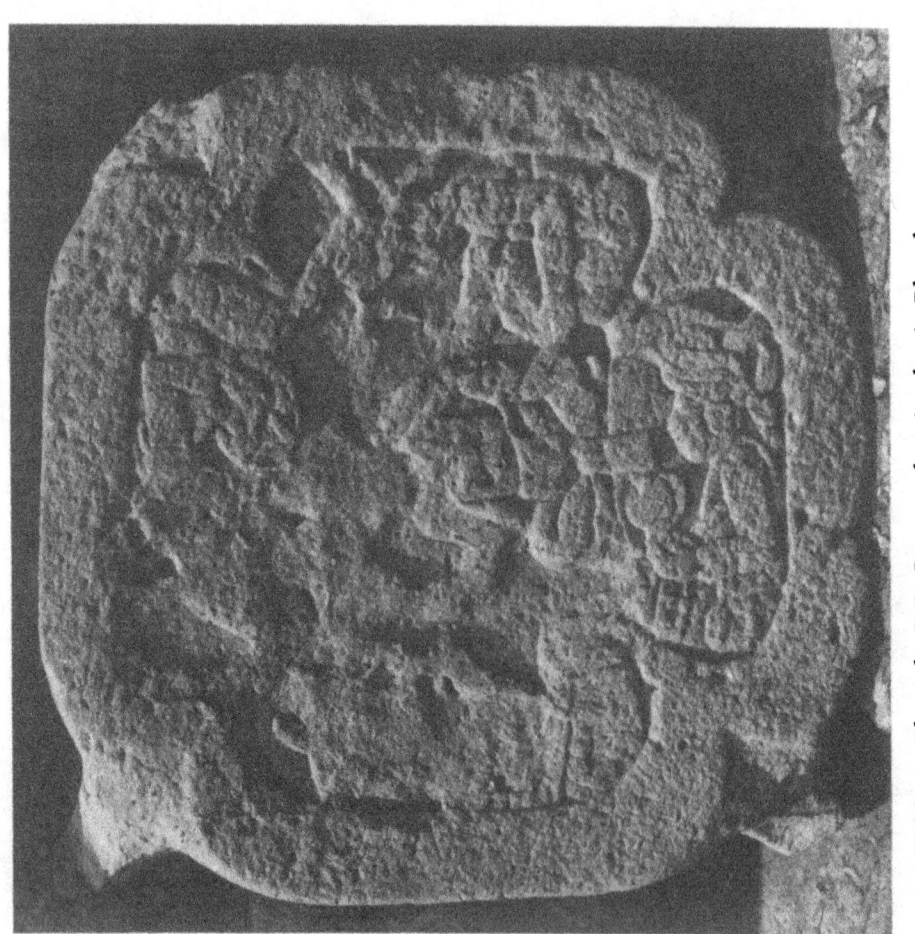

FIG. 72 CPN 131. Photo by J.-P. Courau; drawing by A. Blanck.

DESCRIPTION

Although they have minor variations, the design of all three stones is similar. The background is a wide band composed of two groups of four horizontal lines each. Circlets are irregularly scattered on the space between the two groups. A profile head with a long, pendulous snout and a rounded scroll-eye is slightly right of the center (as seen by the observer). A bead hangs from the human ear. The upper jaw shows teeth while, in most cases, the lower jaw is missing. The third major element of this composition is a plant; it is probably a water lily with two branches with leafy ends and a long undulating stem that intertwines with the two groups of straight lines. One of these undulations makes up the eyebrow of the central head in such a way that the two parts of the stem seem to emerge from it. Besides the circlets, there are several other motifs in this composition; note T188 (*le*; to be compared with the motif on the lower part of the tablet in Temple XIV at Palenque) on the west side of CPN 110 and T44(?) on the north side and T23 on the west side of CPN 109.

INTERPRETATION

These three stones are good examples of the motif that Coggins (1983) calls the "quadripartite water frieze," where the horizontal lines with circlets and dots represent the underworld waters (for a general iconographic analysis, see Hellmuth 1987); the long snouted head is an earth icon that gives birth to the aquatic plant, a fertility image. At Copán this symbolism is developed elsewhere, especially on Structure 24.

CPN 131 (FOUR-LOBED DISK)
(fig. 72).

This is a square stone disk with a triangular point at each of the four rounded corners. Only one point is complete, the others being broken. The monument is carved on one side only. The carving is heavily eroded, mostly in the upper zone to the viewer's left. Judging from its form and carving, this probably is a floor slab.

DIMENSIONS

100 cm in diameter and 21 cm thick. Length of the triangular point 15 cm.

DISCOVERY AND LOCATION

Gustav Strömsvik found CPN 131 on the surface in the area south of the Main Group, today called the Bosque. It was later deposited in the Court of the Hieroglyphic Stairway close to the markers of Ball Court A-IIa, where it remains today.

DESCRIPTION

The composition is similar to a four-leaf clover. The outline is enhanced by a broad plain border. A central figure is surrounded by four individuals who face him; each is seated in a lobe, as in a niche. The central figure sits cross-legged. His body is frontal, while his head is shown in left profile. The left hand rests on the knee, while the right arm is raised to present an object, which today is eroded. The figure wears a loincloth, pectoral, and wristlets. All details of the face and the headdress are eroded. The figure below is in left profile. His hands are clasped together above the knees holding two round objects (rattles?). The headdress looks like a helmet; the earflare is round. The figure seated above the central person is in left profile too. He holds a large round object (a ball?) on his knees. His face and headdress are eroded. The individuals seated to the right and left of the central figure are also in profile. The former, today very eroded, presents a long object; the left figure wears a round hat with locks(?) or ribbons. He holds an eroded rounded object in his arms.

INTERPRETATION

The four-lobed or cross-shaped composition seems to be an image of the earth; the points at the corners can be compared to the water lily blossoms placed between two lobes of similar representations (Structure 18 southeast jamb and CPN 101). It seems that the figures represent the four cardinal directions and the center. But their very bad condition prohibits their identification.

CPN 155 (*TUNKUL*)
(fig. 73)

This is a stone replica of a wooden slit drum. Its overall shape is that of a truncated pyramid. It is wider at the flat, rectangular top; the large sides are trapezoids; the small ones

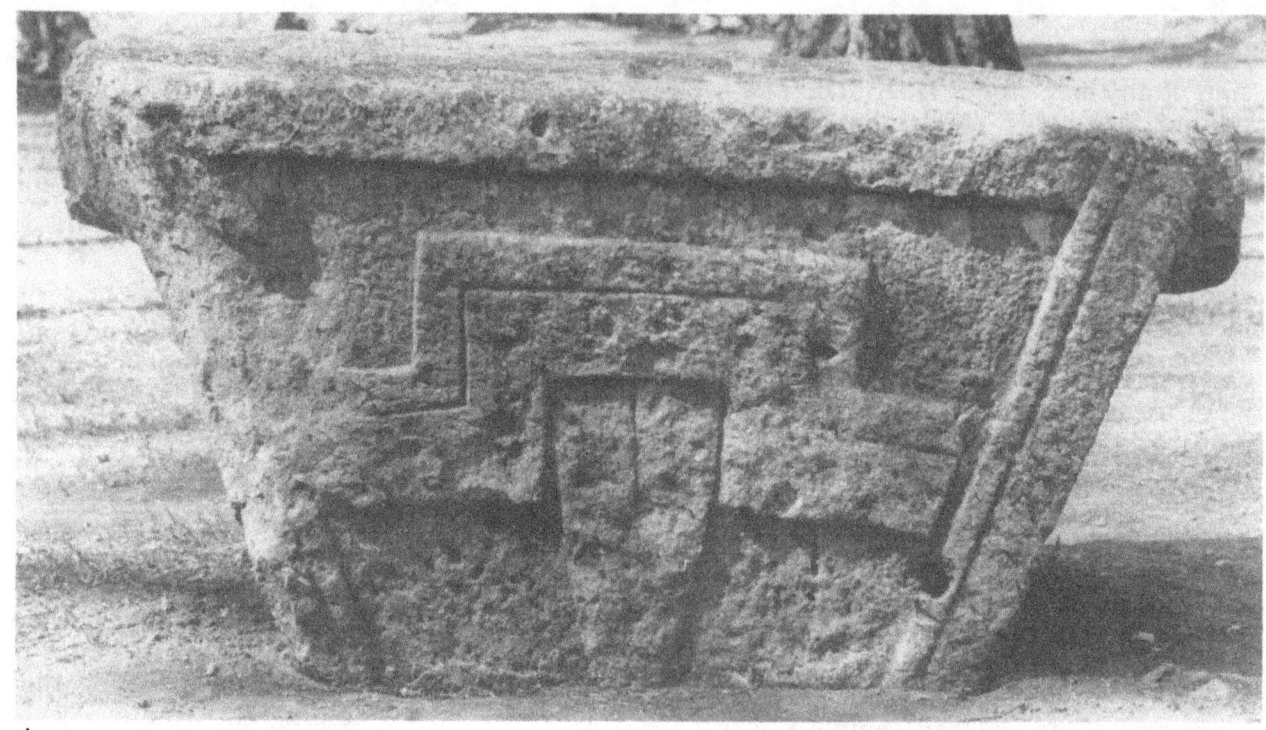

A

B

c

FIG. 73 CPN 155, three vertical sides: (a) north; (b) south; (c) east. Photos by J.-P. Courau and M. Gaida.

are rectangular with two knobs that might represent handles.

DIMENSIONS

Maximum length at top 137 cm; maximum length at base 78 cm; minimum height (from court level) 68 cm.

DISCOVERY, LOCATION, AND ASSOCIATIONS

Maudslay (1889–1902) was the first to report this sculpture located just north of Structure 14 on his plan, where it remains today. Its spatial association with Structure 14 seems to be original and intentional.

DESCRIPTION

The drum's top is surrounded by a carved double strap; the slits are rectangular. The shape of a jaguar's mouth with a curled lip above a hanging tongue is on the large side to the north and south. The *ek* sign is carved on both handles, while a *kin* variant, the "four-petal flower," is on the small sides.

INTERPRETATION

Uotan, apparently an equivalent of the jaguar god of darkness and lord of the day *akbal* among the Tzeltal was also known as "lord of the horizontal wooden drum" (Thompson 1970: 326). For Brinton (1882: 217) and Seler (1902–23: 458), both quoted by Thompson (1950: 73), Uotan means heart, and Seler (1904–9: 235) thinks that it is the equivalent of the Aztec Tepeyollotl (heart of the mountain), an underworld deity with jaguar features that personifies the echo. On CPN 155 we find the same relation of the drum (or echo) to the jaguar. But here the feline is associated with the sun, and we are then dealing with the jaguar as the night sun or the underworld sun. The word *pax* means drum as well as

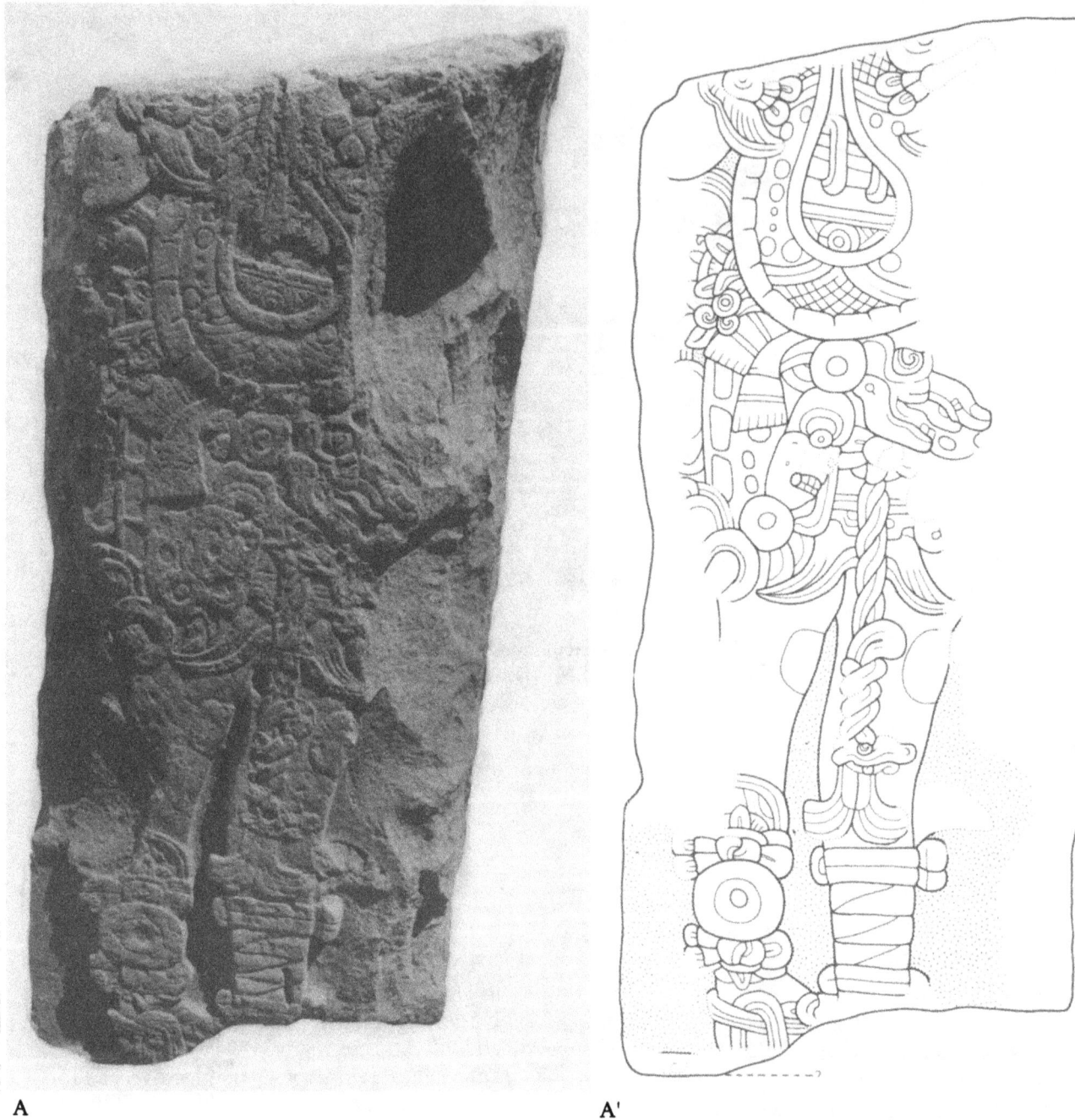

A A'

designating the sixteenth month of the *haab*. In fact, its glyph even depicts a slit drum. The patron of this month is a jaguar with special features that is closely related to sacrifice. On CPN 155 the jaguar is only represented by its mouth: this emphasis may mean that his knife-tongue is bloodthirsty, but also that the drum is his voice. The *ek* sign on the handles may indicate night if the sign is read "star" or "Venus," companion to the sun. The Maya were also certainly aware, in carving this monument, of the homonymy stone/drum as *tun* (Kelley 1976: 135; Justeson and Mathews 1983: 589); this is confirmed by T548, a very early glyph, which read as *tun* represents a *teponaztli* or *tunkul* (Brinton 1895: 92).

STYLISTIC DATING

This monument is probably early, judging from the style of the four-petal flower, *kin*.

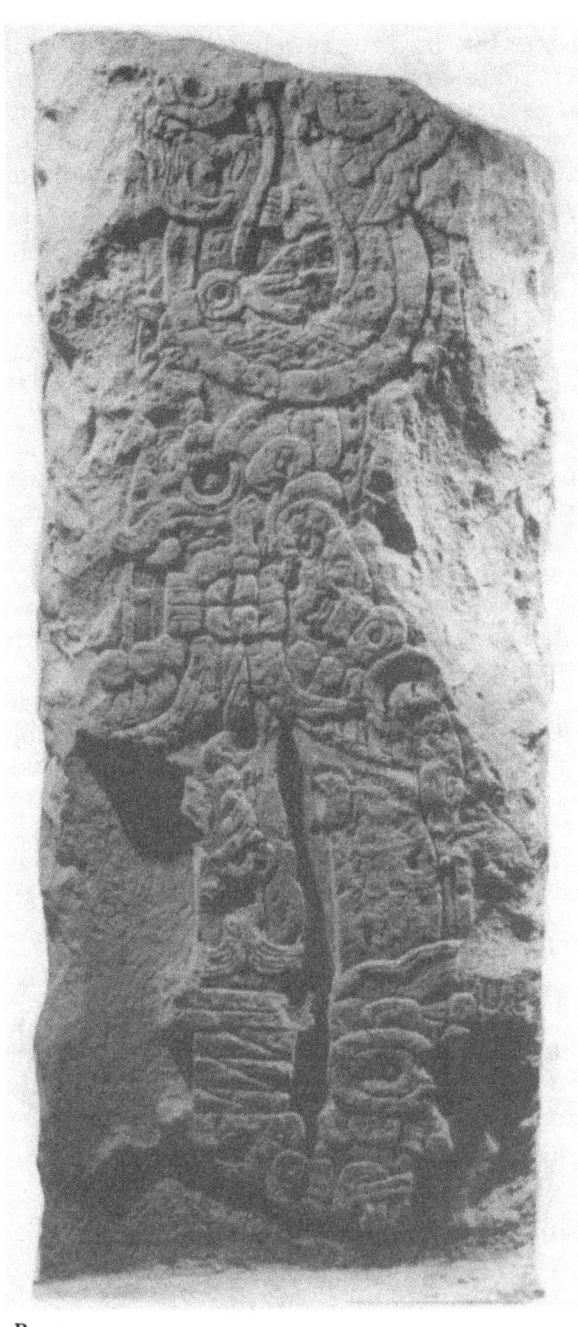 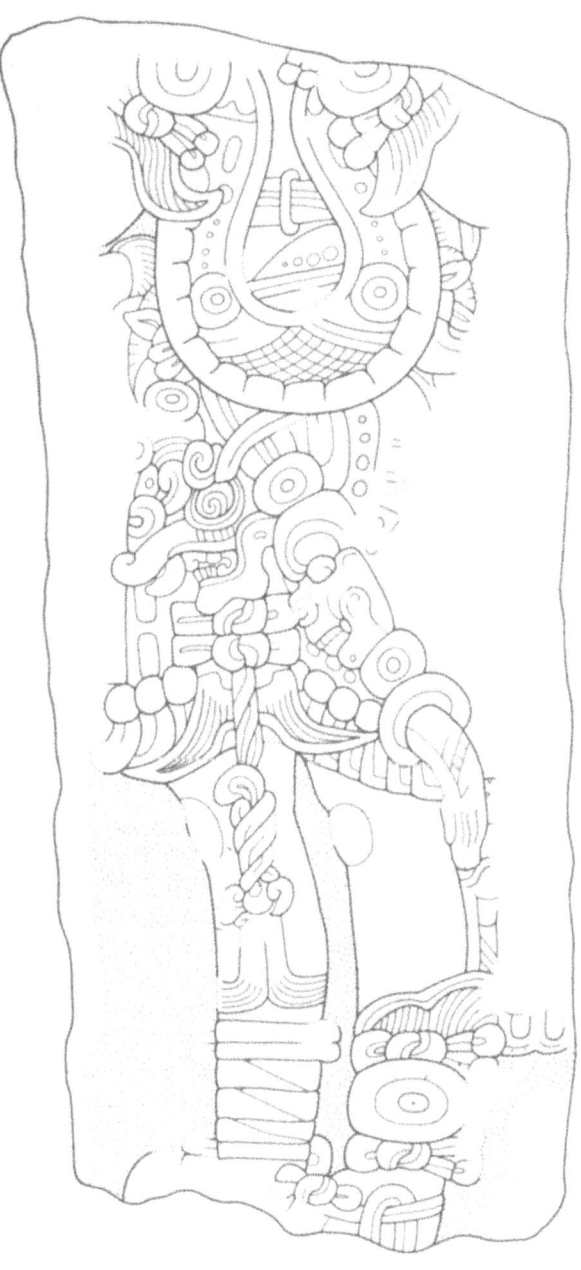

B B'

FIG. 74 CPN 188, two broad sides: (a, a') one side; (b, b') the opposite side. Photos by J.-P. Courau; drawings by B. Fash.

CPN 188 (STELA 35)
(fig. 74)

Two standing human figures are carved in low relief on the broad sides of this four-sided shaft. Their bodies are frontal, while their legs are profile and apart, the outer foot partly hiding the inner one. The narrow sides, which today are much damaged, were probably originally plain. The upper part of the monument is missing, since the two figures are only preserved from the arms down. Small portions of the unsculpted butt are still visible on one broad side.

DIMENSIONS

Height: 120 cm; maximum width 57 cm; maximum depth 32 cm. Depth of relief 2 cm.

DISCOVERY, LOCATION, AND ASSOCIATIONS

CPN 188 was found in March 1978 by the PAC, reused in the fill of the fourth terrace of the last construction phase of Structure 4. Its original location remains unknown. It was removed shortly after its discovery to allow further excavations and stored in the local museum in Copán Ruinas. CPN 188 is spatially associated with a cache found by Maudslay, 2 m below the top of Structure 4. This cache included an apparently Early Classic effigy vessel, containing two jade earplugs and a large jade bead, cinnabar, mercury (as a product of decomposed cinnabar), pearls, mother of pearl, and figurines cut out of shell (Maudslay 1889–1902: vol. 5, p. 20; vol. 1, pl. 21a and 9).

DESCRIPTION

The upper part of what remains of this monument shows forearms holding a bicephalic serpent against the chest. The wristlets are made of a large round bead between two knotted bands edged by a fringe of feathers(?) of irregular width. A pectoral made of several bands tied with transverse straps is within the loop formed by the serpent and above the belt. From the belt hang fringes, beads, scrolls, and a chain that falls obliquely backward. It includes a skull between two round beads (the upper one forming the earplug of the loincloth mask) and ends with a perforated disk from which emerges a jaguar tail. The jaguar skin skirt is edged with beads and tinklers. The fishtail loincloth has the mask of a long-nosed creature with a skeletal jaw. Under it are knotted bands and a rope on which the loop serpent may be seen; its tail is forked, like a loincloth. The legs are slightly bent; the knees are indicated by an oval. From the outside the anklets look like the wristlets; on the inner side a strap that encircles the leg is seen between the knotted bands. The sandals are tied by two straps knotted on the front of the foot; they support two other straps that hold the sole (Proskouriakoff 1950, Type A-1).

It is important to note the absence of any inscription on this monument, since the Early Classic stelae at Copán as a rule bear texts but no images. Here the narrow sides are plain, and there is no room for glyphs near the figures. It is unlikely that the monument's top bore a text. Perhaps the "silent" stela was accompanied by an inscribed altar.

COMPARISONS

CPN 188 cannot be compared to any other Copán monument, although it does possess some motifs common in the later sculpture; thus, the knotted bands, the looped serpent, and the fish-tail loincloth are carved on the monuments from the 9th to the 14th katun. The tradition of the double-figure stelae also begins with CPN 188. Could succession be represented? In any event, this sculpture is Early Classic (perhaps even earlier?), as indicated by the position and profile view of the feet. We also know that the stela was made in Copán, since it is carved from the local green tufa.

I have previously noted (Baudez 1983: 187, 188) that this monument mostly resembles the Leyden plaque. It also shares many traits with the Hauberg stela, with Uolantún Stela 1, Tikal Stelae 36, 28, and 1, and Yaxhá Stela 6. We may thus suggest that CPN 188 was carved at the end of baktun 8 or at the very beginning of the 9th baktun.

CPN 634 (CARVED SLAB)

On this slab the face and the right arm of the seated figure have been restored with plaster. A few chips are missing.

DIMENSIONS

Height 137 cm; width 111 cm; maximum thickness 25 cm.

DISCOVERY AND LOCATION

Maudslay found it at the eastern foot of Structure 13; it is now in the Copán Museum.

DESCRIPTION

A man, in front view, is seated cross-legged. The hair is tied on top of his deformed skull and falls in long strands on the sides. What looks like a (jaguar) paw passes through the ear lobes. The shoulders are tattooed and a collar made of claws encircles the neck. The man wears a loincloth and (now eroded) wristlets. In his left hand he holds what seems to be a bicephalic throne and in his right a bundle scepter or a maize cob. He is seated with

the two feet showing below the knees, on two intertwined serpents. They probably represent the earth; their live heads are similar, both having a kind of "flame brow" (Maudslay 1889–1902: vol. 5, p. 23), no lower jaw, and a long pointed fang. Two rectangular bands frame the seated figure; they are not plaited but seem to be twisted; at both ends they have a knot or rosette with radiating curves.

The bicephalic monster held by the figure seems to be a variant of the serpent bar. It is hard to decide upon the man's identity: ruler or maize impersonator? The base of CPN 41 is also carved with intertwined serpents, as an image of the earth on which the king stands. ·

CHAPTER 2

Architectural Sculpture

STRUCTURES 9 AND 10 (BALL COURT A)
(figs. 75–78)

Ball Court A, with its superimposed construction phases A-I, A-IIa, A-IIb, and A-III, is located at the northern margin of the Acropolis, abutting Structure 26.

BALL COURT A-I

Court A-I constitutes the earliest construction phase, dating back to the fourth century A.D. Its orientation is 351 degrees and its alley is 7 m wide and 27 m long. It is limited by two structures with sloping walls but without benches. The court includes a northern terminal zone closed by a platform. Where we would expect to find alley markers were large shallow depressions with evidence of fire. Strömsvik (1952) thinks these depressions contained stucco markers that have not survived.

BALL COURT A-IIA

Ball Court A-IIa was built during the Middle Classic (A.D. 400–600) 1 m above Court A-I, but with the same dimensions and orientation. Its sculptural decoration consisted of three alley markers, and perhaps parrot heads similar in design and position to those of Ball Court A-III.

ALLEY MARKERS

North Marker: This is a monolithic cylinder, slightly flaring toward the top. It is 46 cm high and has a maximal diameter of 54 to 57 cm. Its top is carved with a human figure in low relief. The figure shows his left profile and is enclosed within a four-lobed frame. He has one knee resting on the ground. His face is eroded. He wears a complex headdress, an earflare, a collar, and a round pectoral. The carving in front of him, which makes up one-third of the whole decoration, is completely eroded. The tip is flaked off and the sculpture very eroded.

Central Marker (fig. 76): A monolithic cylinder, slightly flaring toward the top, 60 cm high with a maximal diameter of 21 cm. Its top is carved with two human figures in low relief.

The scene is enclosed within a four-lobed medallion. The lower lobe is separated from the others by a horizontal band representing the ground. There is another band (a water frieze?) below. Above two human figures are kneeling on either side of an eroded image. The figure to the observer's left has his left padded knee on the ground. His right hand is spread on his belly while the other hand, with the wrist on the knee, reaches out. The man wears a large headdress composed of a reptilian helmet and a bunch of feathers. His face, whose features are eroded, is seen in profile; a round earplug is still visible. A double scroll is floating in front of the mouth. The man wears a bead collar and a wide belt. The costume also includes a skirt and possibly a loincloth shortened by a large knot.

Not much remains of the individual he is facing: a serpent helmet, a bead collar, a wide belt, and an ornament worn in the back that looks like a mask with headdress and ribbons. The image between the two figures is a narrow rectangle with knobs along the edges, forming T87 (*te*, "tree"). I suggest that the two kneeling men are paying homage to a tree.

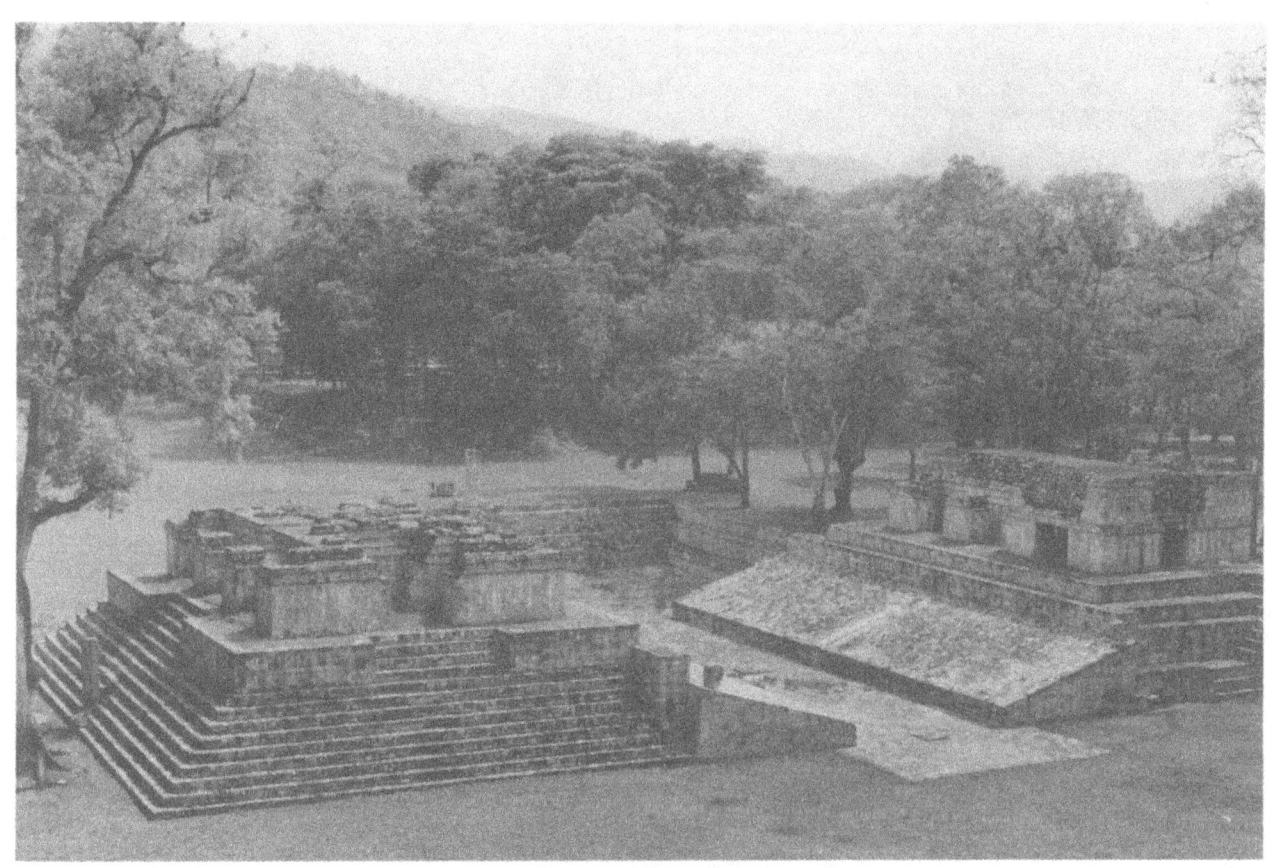

FIG. 75 Ball Court A-III: view from north stairs of Structure 11. Photo by J.-P. Courau.

FIG. 76 Ball Court A-IIa: central marker. Photo by J.-P. Courau.

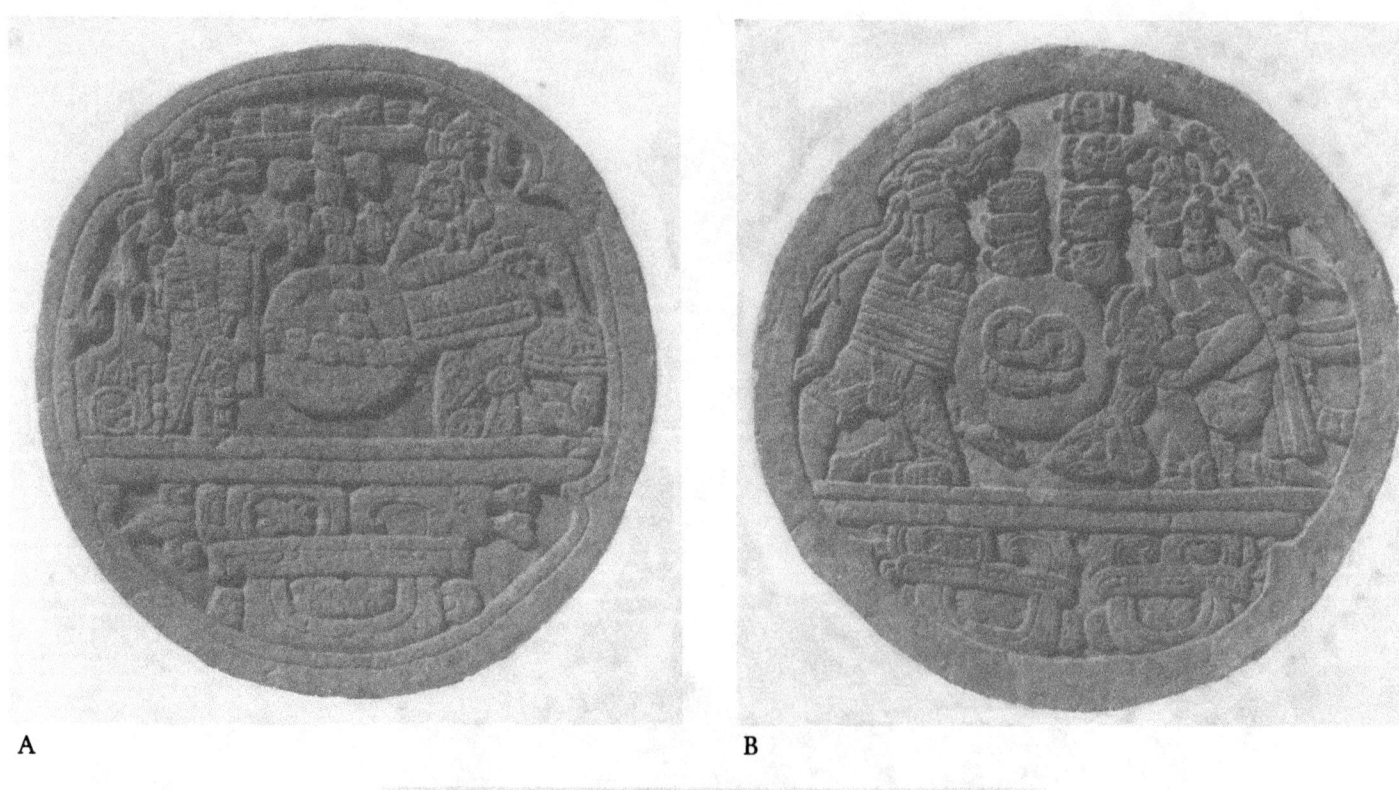

FIG. 77 Ball Court A-IIb: (a) north marker; (b) central marker; (c) south marker. Photos by J.-P. Courau.

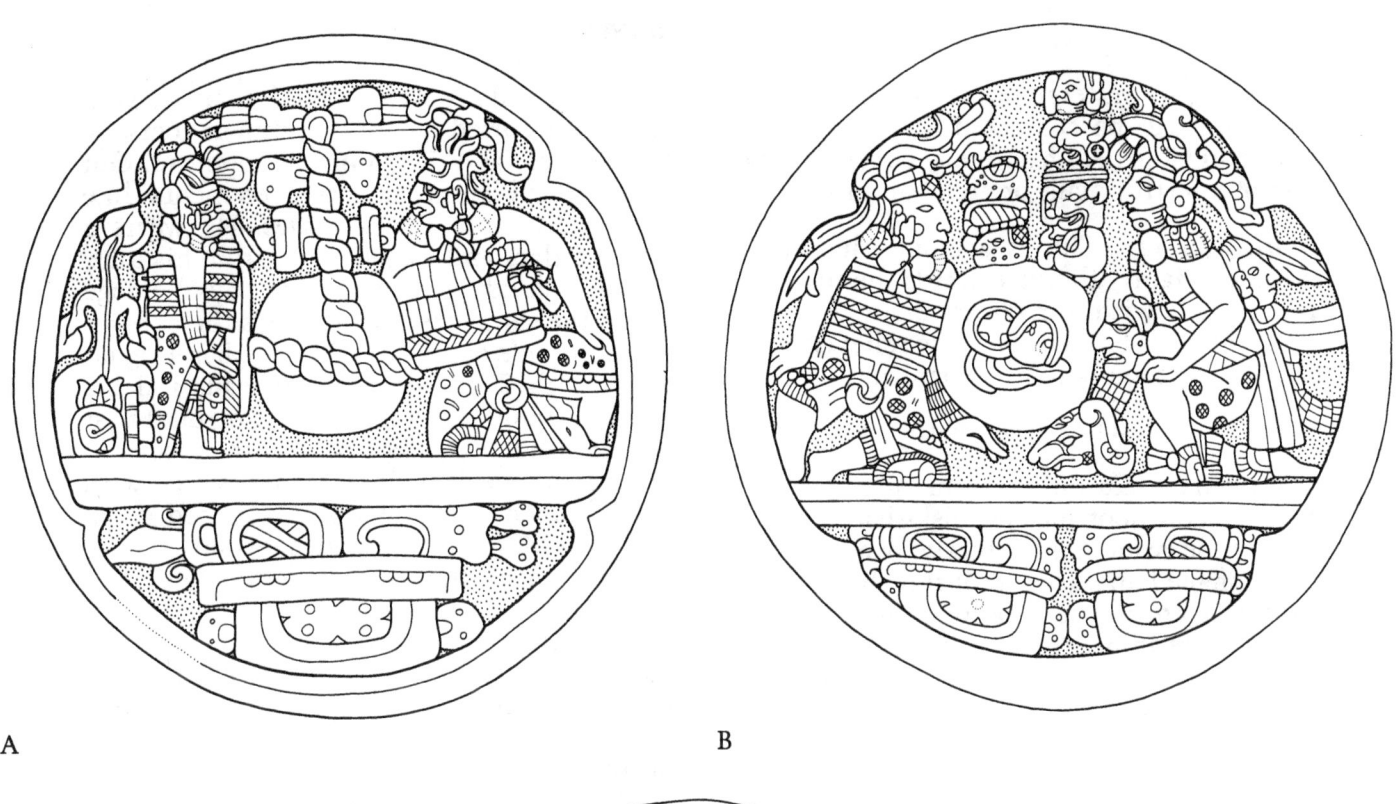
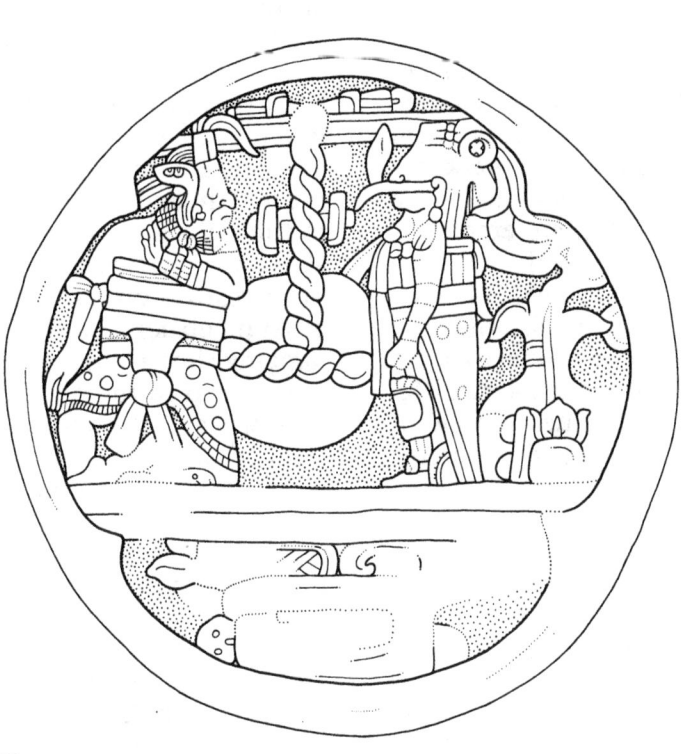
FIG. 78 Ball Court A-IIb: (a) north marker; (b) central marker; (c) south marker. Drawings by B. Fash.

Assuming my interpretation is correct, this sculpture can be compared to the markers from Ball Court A-IIb and may be an illustration of a fertility cult or an agrarian rite.

South Marker: This is a monolithic stone cylinder slightly flaring towards the top. It is 43 cm high with a maximal diameter of 55 cm. The tip is broken. The low relief carving on top is eroded beyond recognition.

Ball Court A-IIb

Ball Court A-IIb differs from A-IIa only in having a new floor and new disk-shaped markers. These were laid directly over the IIa drum-shaped markers. Probably Ball Court A-IIb was not in use for a long time since its markers are in pristine condition. Fash (1991: 114) assumes that Eighteen-Rabbit laid them just before building the new ballcourt A-III.

ALLEY MARKERS
(figs. 77–78)

North Marker (figs. 77a, 78a): This marker is a circular floor slab with a two-figure scene carved in low relief on one surface. It is 71 cm in diameter and 9–10 cm thick. The marker is fairly well preserved. A few details of the sculpture to the observer's left are eroded.

The whole design is enclosed within a four-lobed medallion. In the lower lobe the *kin* sign is topped by crossed-bands postfixed by T68 and a cut shell. The spine that we would expect to stand between these two elements is missing, probably due to lack of space. A horizontal double band separates this emblem from the scene above. Two figures stand on either side of a ball, which is tied by a rope to a horizontal double band at the level of the figures' headdresses. Bones, the *kin* sign, and the shell of the emblem flank the rope. The individual to the observer's right has his knee on the ground, and one arm bent against the chest, in a respectful attitude toward the figure he faces. He is dressed as a ballplayer: his chest is protected by armor, apparently made of wood and wickerwork; around his neck, he wears a composite collar made of several materials such as cotton, rubber, and leather, which looks more like a protective device than an ornament; his skirt is of jaguar skin and his loincloth is shortened by a large knot. His right arm and leg are padded. He has a jaguar face with curled-up lip, prominent incisors, squint eyes, and T617a on his forehead. Out of his head come radiating elements like flames or, more likely, leaves. He wears a large earflare and a bead hangs from his lobe.

The individual to whom he pays homage wears the same costume and has the pads on the same side of his body. He also has a jaguar head, with T617a on his forehead, and his hair is arranged in a loop that protrudes past his forehead. There is a bead with ribbons in front of his neck. Behind him is a tree with three branches and leaves. An eroded glyph topped with foliage and with a coefficient of 9 is in front of the tree.

Central Marker (figs. 77b, 78b): This is a circular floor slab 72 cm in diameter and 10 cm thick. A two-figure scene is carved on one surface. The sculpture is in excellent condition.

The whole design is enclosed within a four-lobed medallion. The lower lobe contains two three-part emblems, each with one *kin* topped with a shell and crossed-bands. The shell, always to the observer's right on the north and south markers, is here once to the right and once to the left. In the scene above we see two individuals, each with one knee resting on the ground; they face each other on either side of the ball. The ball is not hanging, but is struck by the chest and arm of the man to the observer's left, showing us that we are attending a game. The ball is marked with a *kan* cross, the T116 suffix, which reads *n(i)*, reinforcing the final consonant of the main glyph, and with *cauac* (T528), sign of the earth monster. Taken together, the two glyphs may be read as "precious earth" and express fertility.

The figure to the observer's left has a non-grotesque, plain human face; he wears a headband and a helmet in the form of a live serpent head to which a stem and flower are attached. He has the ballplayer outfit: collar, armor, pads on the left arm and leg, skirt in jaguar skin, loincloth shortened by a large knot. He faces his opponent, who is a creature from the realm of the dead: the hand replacing his jaw (T713a) means "completion" or "death"; the eye is half closed; the bare thigh (there is no skirt) is marked with black spots,

not those of the jaguar but those of a corpse. The serpent head of the helmet is skeletal. The hair is arranged in a loop that falls forward. The ear ornament is T58, *zac* ("white"). This individual wears the same neck protection as his opponent, but has a wide belt instead of the armor. He wears sandals, while his opponent is barefoot. The arm and leg pads are on the figure's right side, while the figure facing him wears them on the left: this indicates that the two figures are opponents in the game. The "dead" individual carries on his back a youth mask (a severed head?) together with ribbons and a padded device (a flexible shield?). A more realistic head is fixed on his belly: it is the head of an old man with a half-closed eye and mouth. The top of this head has the shape of a heron's head, indicating that the head is a skull, since in Yucatec *bak* means "heron," but also "bone." A third head can be seen at the end of the right arm of the dead individual: it is a rabbit head, as Schele and Miller (1983) have demonstrated.

South Marker (figs. 77c, 78c): A two-figure scene is carved on the top of this disk, 72 cm in diameter and 9–10 cm thick. It is less well preserved than the other two markers of Court A-IIb. The lower part and the area to the observer's right are eroded; the features of the standing figure are no longer visible.

The whole design is enclosed within a four-lobed medallion. The lower lobe contains a *kin* sign crowned by a shell and crossed-bands. Above it two figures stand on either side of a hanging ball, which is tied by a rope to a horizontal double band.

The figure to the observer's left has his knee on the ground and a hand resting on the opposite shoulder, in a respectful gesture. He wears the same outfit as the corresponding figure on the north marker. As on his opponent, pads protect his left side. He has a feline face and a rabbit ear. On the top of his skull a bunch of feathers or leaves juts out of a sort of sheath. The other individual has a youth's face. His hair, tied by three beads at the top of his head, falls on his back. This is not actually hair but probably maize foliage, as the *kan* cross would indicate. Dressed as a ballplayer, he wears a kind of mask over his mouth (today eroded), from which rises a feather or a leaf. A bead hangs from the earlobe. Behind this figure is the same tree as on the north marker; in front of it is an eroded glyph with the numeral 7.

Interpretation of the Markers as a Whole: In every example, the lower lobe of the disk contains the emblem of the nocturnal sun, which is dead during its journey in the underworld before its resurrection at dawn. The realm of the "dead" sun is the underworld and its emblem alludes to this region of the universe. I do not think that the scene depicted above actually takes place on earth. Inasmuch as the protagonists are supernaturals, the scene is located in the netherworld, and the emblem's position is dictated by a conventionalized perspective: it is to be seen in front of or behind the scene. The cruciform medallion that frames the scene confirms its location in the underworld.

The north and south markers follow the same pattern. A ballplayer, knee on the ground, pays homage to another player, standing near a tree, with a glyph and coefficient. The two people are separated by a ball hanging by a rope from the top. The *Popol Vuh* tells that when the ball is not in use, it hangs from the house top ("'We'll leave our rubber ball behind here,' they said, then they went to tie it up under the roof of the house": Tedlock 1985: 110); so we know that the scene carved on the north and south markers takes place not during a game, but before and/or after the game.

The 9-Glyph and 7-Glyph, drawn on the north and south markers respectively, are equivalents of the 9-Head and 7-Head emblems (Kubler 1977; Baudez 1984) made of a skeletal serpent head and the numeral 9 or 7. 9-Head seems identical to the skull-and-vegetation image of the water frieze; this is a representation of the earth, as indicated by a dead reptilian head, with promises of rebirth expressed by the plants growing on it. 7-Head, however, is much more than a simple promise; T629, a skull, is here replaced by *kan*, the color of the ripe maize. Thus, 7-Head is the realization of what 9-Head promised. These insignia represent two moments or aspects of the nourishing earth: 9-Head is death (and rebirth) while 7-Head is (death and) rebirth.

As far as a positive change may be observed from 9-Glyph to 7-Glyph, we may suppose that the north marker illustrates the situa-

tion before the game (hanging ball), while the south marker shows the result or what has happened after it. It is the game itself as illustrated on the central marker that makes this change possible.

On the north marker the figure associated with 9-Glyph to whom homage is paid has a feline head; the human close to 7-Glyph on the south marker has a youthful face with foliage and the *kan* cross in the headdress and is probably a maize impersonator. These images confirm the change that occurred from north to south, between two moments of the vegetative cycle: the first one with the man-jaguar represents the underworld and death (of the sun) as a promise of life; the latter, with anthropomorphized maize, represents the realization of this promise.

On the central marker the text carved above the ball includes the name of the king Eighteen-Rabbit, which probably designates the figure with the nongrotesque, human face. He would play ball in hell, and his opponent would be the "dead" lord. If he actually is Eighteen-Rabbit, he appears as an emulator of the *Popol Vuh* twins, who went down to hell to confront the lords of Xibalba in the ball game. This would be confirmed by a reading of *1 ahau (hun ahpu)* of A2, as proposed by Schele (1986b). The severed heads carried by the dead lord could be respectively those of the father and uncle of the king (the rabbit and the old man) that he comes to avenge. The rabbit head may in fact be an emblem of the king's lineage since it is found several times around one of the statues of the Hieroglyphic Stairway (Gordon 1902: pl. XIII:V) and on the protagonists of CPN 23.

It is not only a matter of revenge. The live king confronts the lord of the dead (referred to in the inscription at B1) in his realm, and the ball for which they fight bears a fertility emblem. It is a struggle against death whose stake is the ball, which symbolizes fertility but also, because of its round shape, the sun. The game played by Eighteen-Rabbit has the purpose of defeating the lord of the underworld in order that the sun may be born again to light and heat the earth and give life. We here recognize the end of the third creation according to the *Popol Vuh:* after having overcome the lords of Xibalba, the twins become the sun and the moon.

Thus, the markers illustrate three acts of a cosmic drama:

1. North marker: prologue. Before the game a creature from the underworld together with 9-Glyph (death) receives the homage of one of his team mates. Both players belong to the right (through their pads) team, whose "coach" is the "dead" lord of the central marker.
2. Central marker: action. During the game Eighteen-Rabbit overcomes the "dead" lord, avenges his ancestors, and allows the sun and the vital forces to win.
3. South marker: outcome. After the game a player from the underworld (or who still belongs to it) pays homage to the personified maize who precedes the 7-Glyph (fertility) emblem. Both belong to the winning team of the left, coached by Eighteen-Rabbit; the kneeling player wears a rabbit ear, to make clear to which side he belongs.

In other words, the three markers express the passage from death to life, from darkness to light, from sterility to fertility, made possible through the triumph of the life forces (incarnated by Eighteen-Rabbit) over those of death, which the dead lord represents. The king has a role of paramount importance; likened to the mythical twins and to the sun, he appears as the victor over death and the architect of fertility.

BALL COURT A-III
(fig. 75)

Ball Court A-III consists of two lateral parallel structures: Structure 9 on the west side and Structure 10 on the east side. These enclose the level playing alley, which is paved with large square blocks. Originally it was probably covered with a thick layer of stucco-cement, as can be inferred from the rough surface of the pavement and the fact that the alley markers protrude above the surface of the pavement. Three markers were set into the alley. Since they remained exposed they are badly weathered. A northern building (Structure 10A and its later angular addition 10B) was added, almost completely enclosing the northern end of the alley, leaving a passage only to the west. On the north-south axis of the alley three square monolithic markers are set into the pavement. Both lateral structures have inclined walls, each with a vertical band of hieroglyphs in its middle.

Above the incline, and corresponding with the alley markers below, are three sculpted macaw heads on each side. Whole macaws crowned the superstructures at the roof level (Fash 1991: pl. III).

The roofs of Structures 9 and 10 were flat, but probably slightly inclined to drain the rain water; according to Hohmann and Vogrin's (1982) reconstruction, each building had four waterspouts that projected from the roof. These water spouts were serpent heads. Several of these have been identified (one in the American Museum of Natural History, New York). Strömsvik (1952) assumed an elaborate carved panel above each doorway and serpent masks at each corner. These have not been reconstructed, however.

LOCATION AND RESTORATION

Relative to the previous ball courts, Ball Court A-III is displaced more than 10 m to the north. This displacement was probably necessary because the ever-growing Acropolis encroached upon the available space on that side, while to the north open space was available since earlier structures in that area had been demolished. Ball Court A-III with all its buildings was reconstructed by the Carnegie Institution. This reconstruction, however, is very conservative and does not include all decorative elements that belonged to the ensemble. Recently some further restoration has been undertaken by the Copán Mosaic Project.

Schele, Grube, and Stuart (1989) have proposed, according to their readings of the weathered inscriptions on the court's benches, a dedication date of 9.15.6.8.13 10 Ben 16 Kayab. This event falls during Eighteen-Rabbit's reign, contrary to Cheek's conclusions (1983b).

Compared to its predecessors, Ball Court A-IIII presents major innovations: a new location (more than 10 m to the north of Ball Court I and II), a new orientation (353 degrees 29 minutes), and square (instead of circular) alley markers.

THE ALLEY MARKERS

North Marker: A square floor slab, 113 cm long and wide and protruding 10 cm above the ground level, is carved in low relief on one surface, which is extremely eroded. The overall construction of the marker is similar to the construction of the north marker of the A-IIb court. In the middle is the ball, slightly shifted upward, hanging from a rope. To the observer's left a figure faces the ball, possibly with the right arm raised. It is hard to tell whether he is standing or kneeling. To the right an indistinct relief is all that remains of the corresponding figure. Under the ball is another raised area, round, with cross-hatching to the right; there is nothing here that resembles a three-part emblem.

Central Marker: This is a square floor slab. It was broken into two pieces when found, but has since been restored. It is carved on one side and the relief is even more eroded than on the north marker. The only recognizable relief is the ball, which takes up the center of the slab; it is possible that, as on the central marker of Ball Court A-IIb, it was shown in action and not hanging.

South Marker: This is an almost square floor slab, 109 by 113 cm, sculpted on one side. It is very eroded. It seems that the ball is slightly shifted upward and probably hanging, as on the north marker. To the observer's right there is perhaps a figure raising his left arm.

CONCLUSION:

BALL COURT A AS A COSMOGRAM:

According to the three markers of Ball Court A-IIb, each game reproduces a cosmic drama. The victory of the vital forces of the universe (which the king incarnates) over those of death enables the ball (symbol of the sun) to leave the underworld and light the heavens and enables the earth to bear fruit, especially maize. That the game is a reproduction of the solar course is strengthened by my interpretation of the court's architecture. On a vertical plane the alley represents the underworld, as indicated by the markers' iconography. The benches' top with the three macaws, images of the day sun, represents the celestial level; the sloping wall of Structures 9 and 10 establishes the transition (middle level) between underworld and sky. The ball, going up and down during the game, reproduces the solar cycle. This vertical interpretation—offered for Ball Court A-III—could be equally valid for Court II, assuming that the macaw heads found by Strömsvik at the foot of Structure 7 were set into the top of the lateral structures

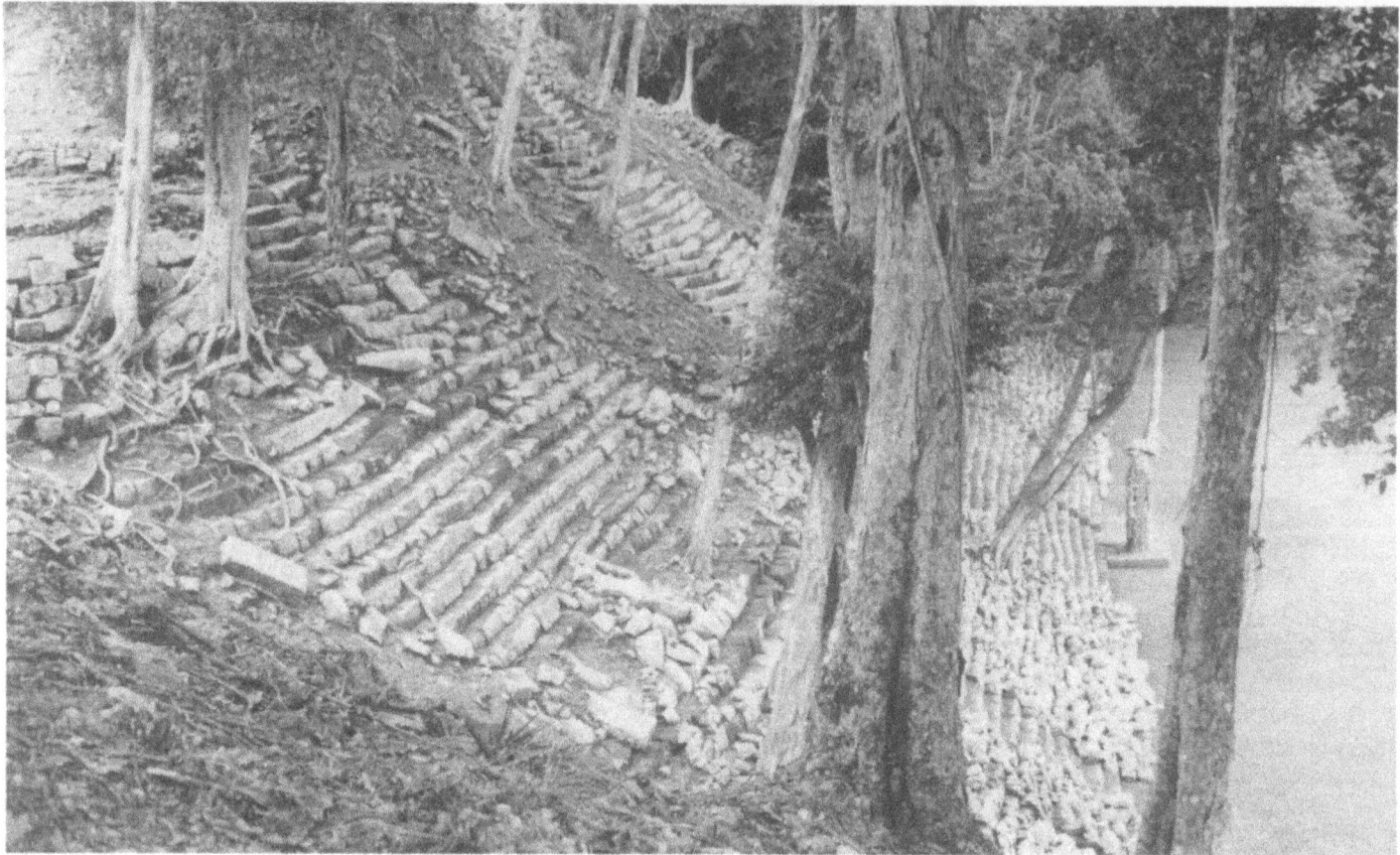

FIG. 79 Main stairway of Structure 11 from Structure 26. Photo by C. F. Baudez.

of Ball Court II. These vertical heads, carved in an earlier style than the heads on Court III, are on top of a plain tenon.

The tripartite vertical division of the iconographic program of Ball Court A-III is reproduced on the Hieroglyphic Stairway of Structure 26, which stands very close to the ball court. Here the underworld is represented by the skull altar at the base of the stairs; the temple on top of the structure is an image of the sky since its façade was also (according to Gordon 1902: 18, 19) decorated with macaws; the stairs themselves, in the form of a sloping giant reptile, make up the middle level between the two extremes.

STRUCTURE 11

ARCHITECTURE

THE SUBSTRUCTURE

Its northern flank, which is also the northern front of the Acropolis, is retained by a stairway divided into two flights by a narrow landing and then by two terraces (fig. 79). A central stair, 13 m wide, leads to the superstructure. The top of the block that divides the stair reaches the level of the temple's floor, at a height of 23 m above the Plaza. Three carved steps have remained below the block. From the central stairway one ascends the last terrace of the building platform via three steps along its side. The lowest of these was carved. The access is then very narrow, restricted to one person at once. Two partially hollowed out blocks flank the entrance: they could have been standard-bearers.

THE BUILDING PLATFORM AND ITS APPROACHES
(fig. 80)

One can reach its three terraces via the north stair, but also on the west (and presumably also on the east) via a small two-flight stair; their lower flight is wider and provided with ramps. These stairs are linked to the pyramid's great stairway by two series of narrow steps. Thus, from the Plaza one can take three independent paths: a central one to the

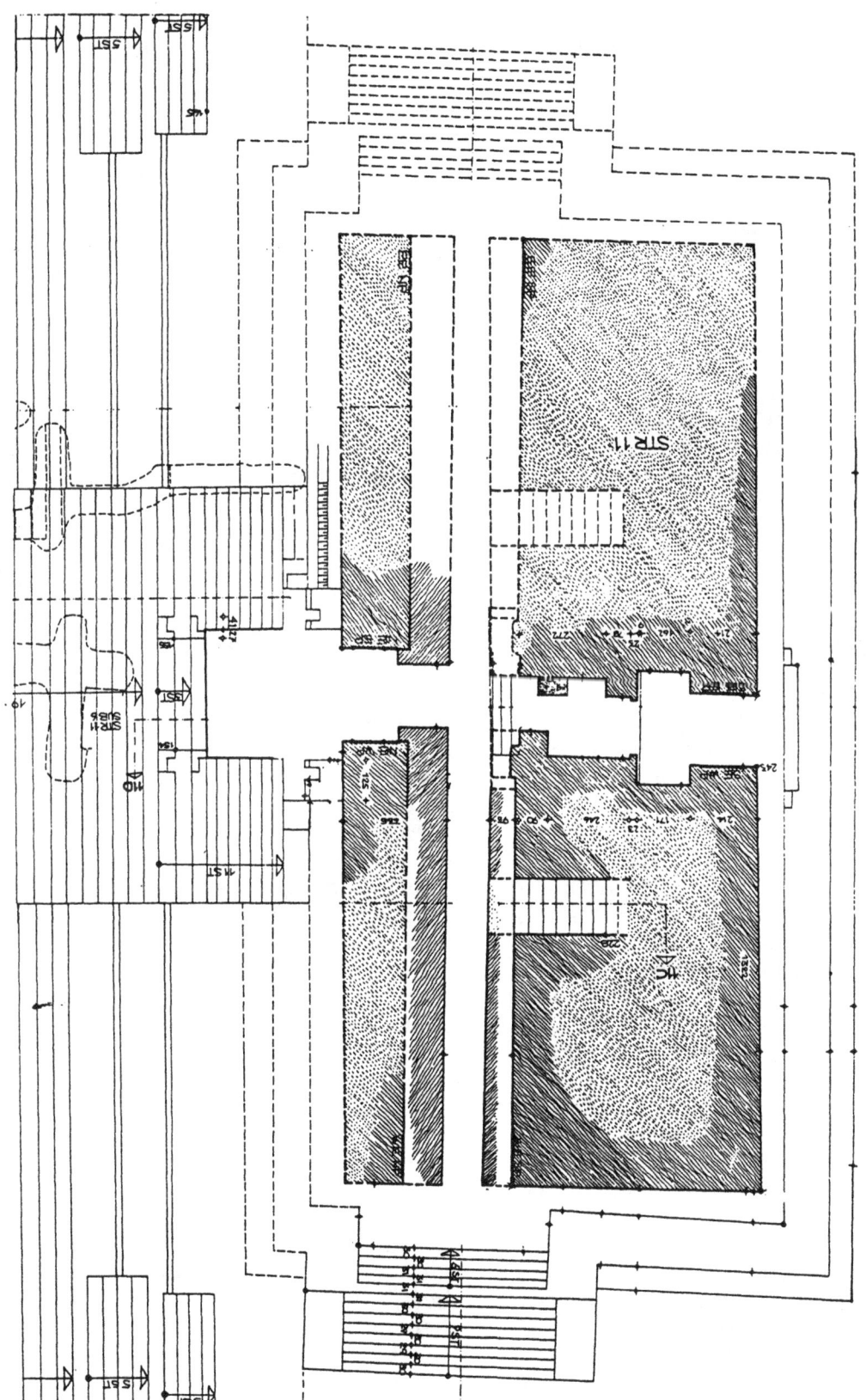

FIG. 80 Plan of Structure 11. After Hohmann and Vogrin 1982. From *Sixth Palenque Round Table, 1986*, edited by Merle Greene Robertson, p. 82. Copyright © 1991 by the University of Oklahoma Press.

north door of the building and two lateral ones on its west and east sides. Only to the south is there no independent access from the top of the pyramid to the temple's door.

THE SUPERSTRUCTURE
(fig. 80)

This is a nearly rectangular building divided into four parts by two long, narrow passages that intersect at right angles. While the east and west halves are of equal dimensions, the northern part is only a third as deep as the one to the south. From the east-west corridor two inset stairs led to an upper floor, presently missing. Originally the east-west corridor was 3.5 m wide with a north wall 2 m thick and a vault 4 m high. Probably because of these proportions, the vault collapsed. Afterward the north part of the building was reconstructed much wider, reducing the width of the corridor to less than 1.5 m. The new inner walls concealed the glyphic panels of the east and west entrances, leaving only those of the north and south in full view. But, access to the inner stairs was not obstructed.

A small chamber takes up the northern half of the southern arm of the north-south passage. On the south it is preceded by a T-shaped antechamber that duplicates the north entrance of the building and the east-west corridor. The room is of irregular plan with a salient to the southeast and another to the northwest, both 1 m wide. Averaging 4 m long and 2.5 m wide, the chamber is 1 m higher than the surrounding floor. From the north it is reached by three steps, while to the south one must step directly upon the platform. Both doors were framed by sculptures that made them appear to be skeletal serpent mouths. The reconstruction following the collapse of the vault concealed the sculptures of the chamber's north door. A step carved with a bicephalic monster and twenty human figures was laid astride the two upper steps leading to the chamber. The new door was decorated with sculptures, of which a few were recovered by Maudslay. A cache was built within the central chamber's fill. It partly recovers another and much deeper pit built during the construction of the building platform (Hohmann and Vogrin 1982: fig. 159). A deposit of shell and jade was found there (Longyear 1952: 19).

SCULPTURE

The sculpted decoration of Structure 11 was considerable, judging by the amount of fragments recovered on the north stair, in the West Court, and on the platform between the two courts (Gordon 1896: 22). Some of these stones have been used for building a dam on the river. While some of the temple's inner decoration has been preserved, no sculptures remain on its outer walls.

THE SUBSTRUCTURE
(fig. 81)

The decoration is limited to three steps carved below the central stairway's block. The lower step (fig. 81c) consists of a mutilated inscription in full-figure glyphs, which runs along the body of a bicephalic monster. Both heads are ophidian and skeletal, with black spots and "crescents" on the forehead, two squinting eyes with blackened pupils, an earplug with a scroll and bone, and so forth. From the observer's left to right, we successively notice between the two monster's heads the space for a missing figure; an eroded seated figure, facing left, with the right arm reaching out; a young man seated in an oval cartouche, facing left with the hand half-bent at face level, a headdress falling backward, and a bead in front of his nose (this glyph is probably *ahau*); an eroded, seated figure, facing right, holding an object(?) in his raised right hand; and three other effaced figures. "The design on the lower step may contain a Calendar Round date in which the coefficients and the day glyph are written with full-figure signs" (Baudez and Riese 1990: vol. 2, p. 418).

The middle step (fig. 81b) shows three anthropomorphs, much defaced but assumed to have been identical, separated by the diagnostic element of the *caban* glyph, repeated several times. The central figure and the one to the observer's right face left, while the left figure faces right. They wear a large headdress, which could represent maize husks; their hands hold out a sign consisting of a sketchy round face surrounded with beads and with vertical lines on both sides of the mouth. The figures wear as a pectoral a youth face, also surrounded with beads. Their belt and wristlets are made of tubular beads and

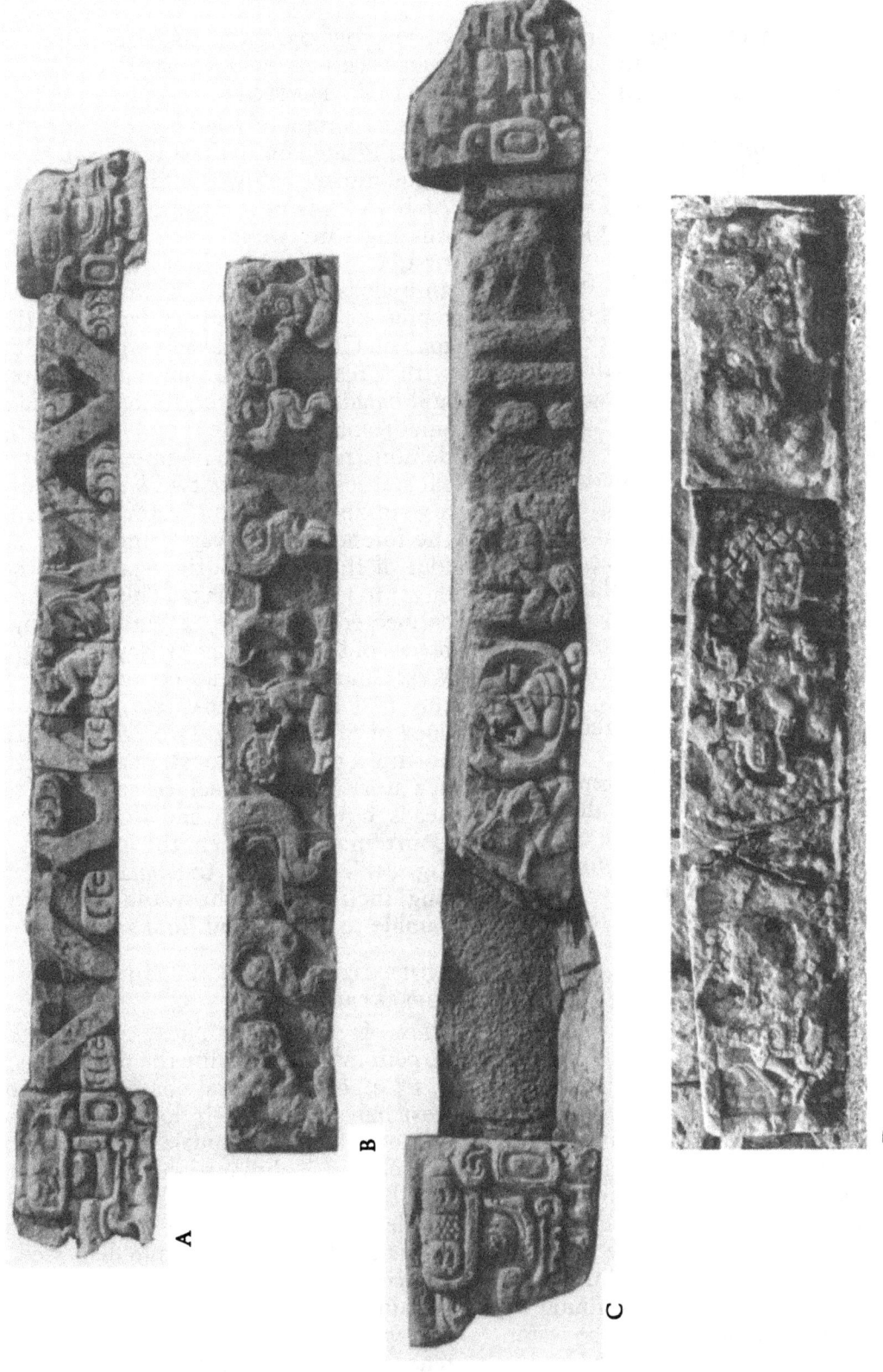

FIG. 81 Carved steps from main stairway of Structure 11: (a) upper step; (b) middle step; (c) lower step; (d) fallen block from stairway. Photos by J.-P. Courau.

the skirt(?) is tied on the thigh. I interpret this frieze as an image of a fertility cult in which impersonators of maize make offerings to the earth.

On the upper step (fig. 81a) is carved a serpent with two skeletal heads (because of the "crescents" on the forehead); they have a tongue and a scroll instead of a lower jaw; the body is reduced to a band zigzagging between T188 signs. In the middle of the frieze a seated figure, facing left, presents an offering in his outstretched hands. His very long headdress is comprised of a cartouche and a tuft of feathers. He has a bead at the end of his nose, an earplug with a tube, and a belt made of beads. Schele and Miller (1983: 73–74) have shown that T188 (whose phonetic value is *le*) means "leaf", and also "generation", especially when the topic is dynastic succession, and this is often confirmed by accession expressions. T188 repeated in the folds of the cosmic serpent either would convey a fertility message if we retain *le* as leaf or would express dynastic continuity in time and space.

Among the sculpted stones gathered at the north foot of the great stair is a long (202 cm) prismatic block that was part of a step of the stairway leading to the entrance of the temple (fig. 81d). During the earthquake of 1934, it fell down to the foot of the stairs, breaking into four fragments. On the riser are carved three figures on a background made of S-shaped serpent bodies. The central figure has a long nose and the smoking ax implanted in his forehead; he is seated on a water lily plant, whose blossom, marked with the numeral 7 and an eroded glyph, stands behind him. The same figure presents in his outstretched hand a block marked with the numeral 9. The two identical figures who flank him are humans; they hold a scepter, present an (eroded) offering, and wear *imix* on the chest. The whole scene might be another illustration of a fertility cult, where humans and an earthly supernatural (the Thunderer) join to present offerings on a background of rain or blood. The block with 7 and the water lily with 9 may be other forms of the 9 Head/7 Head pair (see discussion in chapter 4).

OUTER DECORATION OF THE SUPERSTRUCTURE AND ITS BUILDING PLATFORM

This is completely gone except for part of a frieze located on the last terrace of the building platform, below the temple's south door. At both ends of a sculpted band—presently missing—are two identical, four-legged, head-first beasts (fig. 82). Their likeness to any real animals is not obvious; however, I think they represent toads. They in fact look like the toad on CPN 101 and wear on the ear the disk with three circlets, a trait diagnostic of toads and *bacab*s. The latter, moreover, had a very important role in the temple's decoration, as demonstrated by the fragments of two colossal statues. These are two *bacab* heads, with a wrinkled face and a water lily knotted on the forehead. One was found at the eastern foot of the building (fig. 83a); the other fell down to the Great Plaza. They were probably connected to bodies, as indicated by large pieces of hands and feet today piled up in the West Court, which may come from the Structure II debris. I suggest that, as on the inner door of Structure 22, two *bacab*s were supporting a celestial monster carved on the upper story; the colossal crocodile or serpent heads now lying on the floor of the West Court may have been the monster's heads (fig. 83b); assuming the *bacab*s were squatting, their total height would have been comparable to the ground floor's height.

INNER DECORATION OF THE SUPERSTRUCTURE

Phase A: From this phase only the skeletal serpent mouths framing the narrow doors (1.2 to 1.5 m) of the central chamber remain. The west half of the north door was cleared and photographed by Maudslay (1889–1902: vol. I, pl. 7e), and Hohmann and Vogrin (1982: fig. 152) have presented a reconstruction of the whole door (fig. 84a). The sculpture has been dismantled and its elements dispersed. It included, about 60 cm from both sides of the opening, the two skeletal sides of the lower jaw, vertically disposed (because of the flattened perspective), with "crescent" signs, bared teeth, black spots, a blackened eye, and the beginning of a water lily blossom. They rested on a bone head and were not linked one to another.

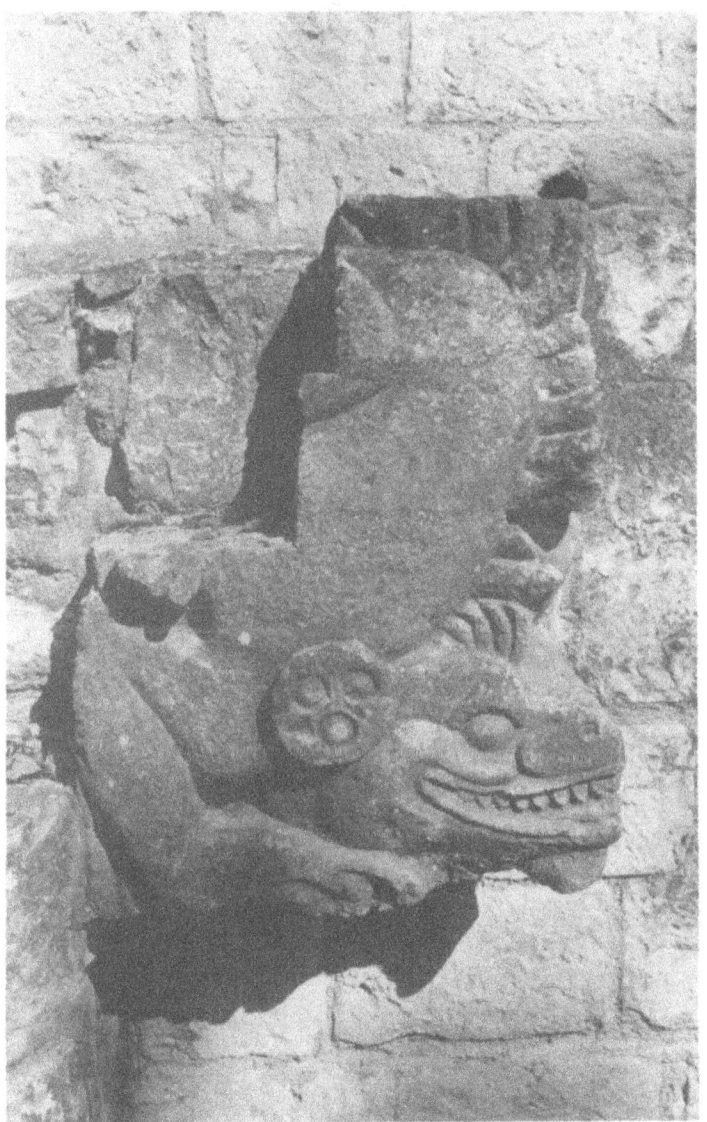 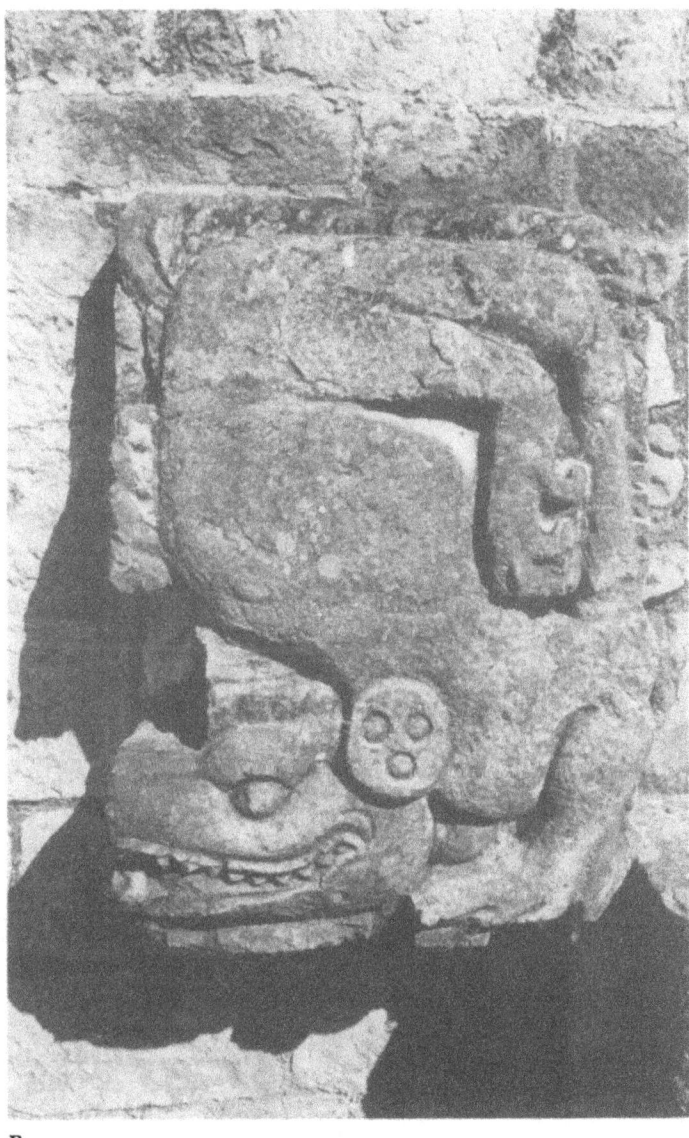

A B

FIG. 82 Toad(?) figures on southern wall of Structure 11. Photos by C. F. Baudez.

The sculpture from the south door is similar to the one from the north with the difference that here the two sides of the jaw are linked by the front teeth, upon which one steps when entering the door (fig. 84b). The difference between the two doors does not seem semantically meaningful; I interpret it as a difference of degree in stylization and abstraction. In any case, when one steps through the door, one comes into a serpent mouth. The central room then represents a bicephalic monster, oriented north-south. Its heads are skeletal because it represents the underworld, the realm of the dead. The *bacabs'* presence indicates the earthly nature of the whole ground floor, whose inner chamber constitutes a lower level. Furthermore, I suggest that the plan of the building, a cross roughly oriented to the cardinal directions (10 degrees east of north) and a central chamber, reproduces a Maya and Mesoamerican cosmogram, sometimes illustrated in the manuscripts. The tzolkin in the Madrid Codex has the form of a maltese cross with one loop, bordered by footprints, between every two arms (fig. 85a). The arms stand for the cardinal directions and enclose deities. The center of the cross is a large square framed by twenty

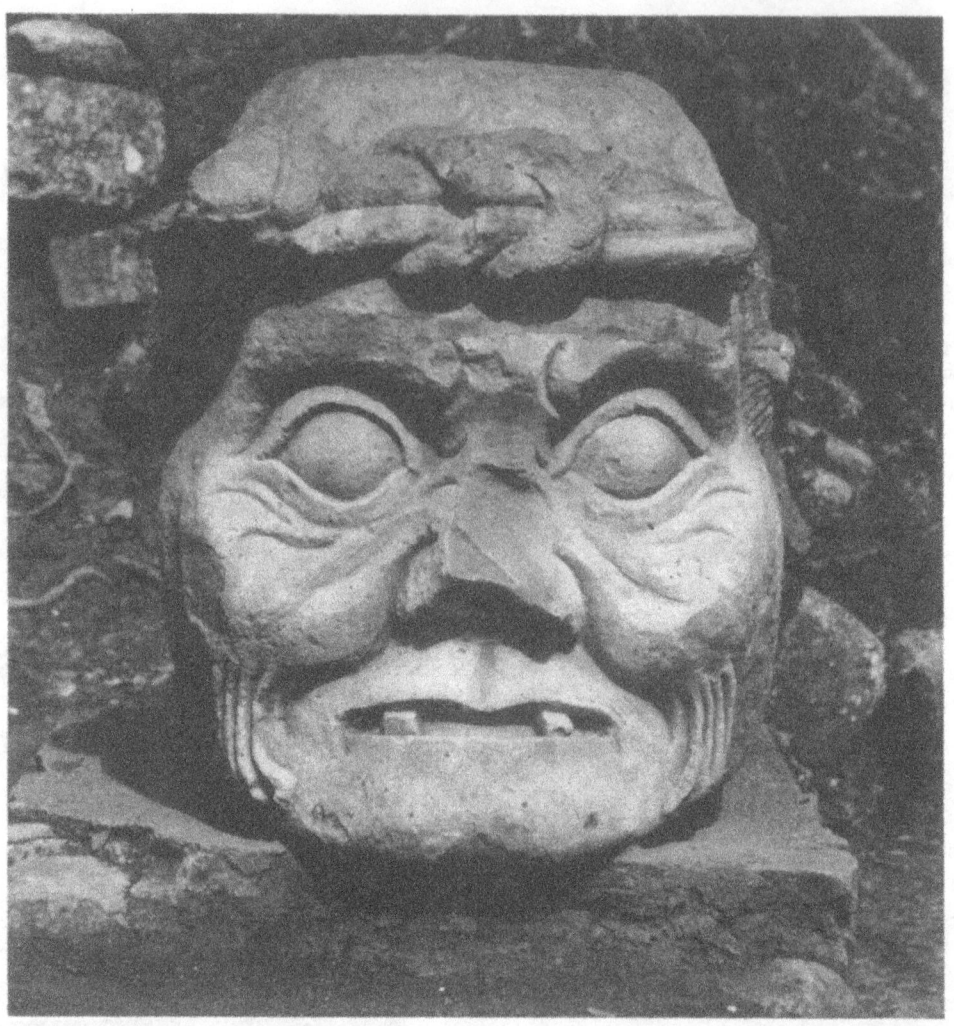

A

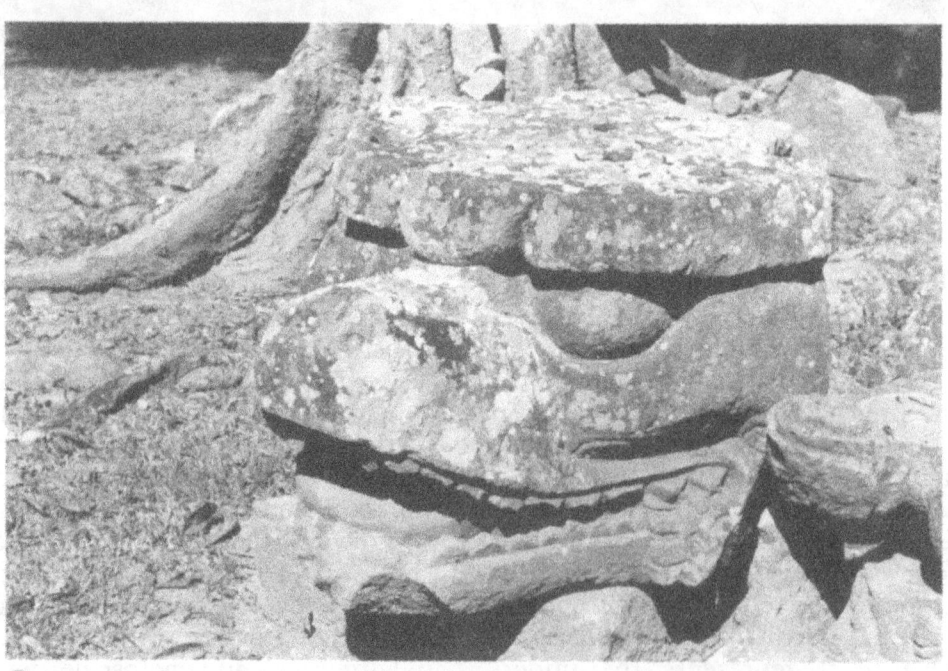

B

FIG. 83 (a) *Bacab* and (b) reptilian head from façade decoration of Structure 11. Photos by J.-P. Courau and C. F. Baudez.

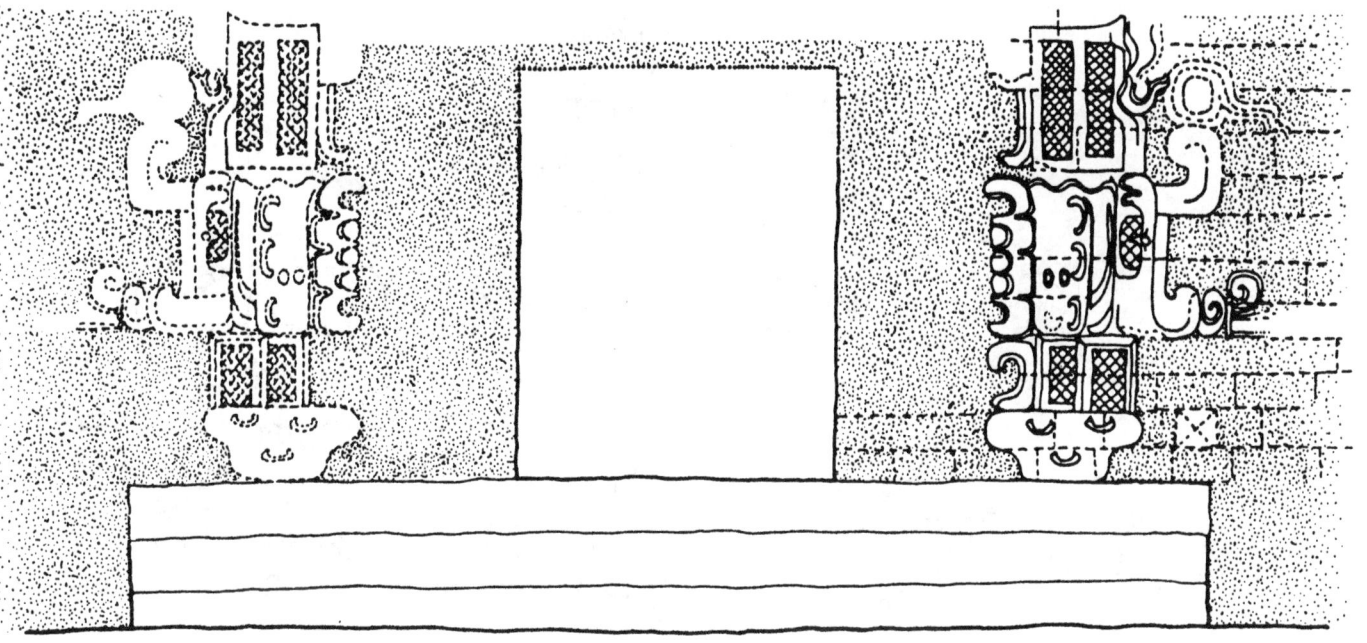
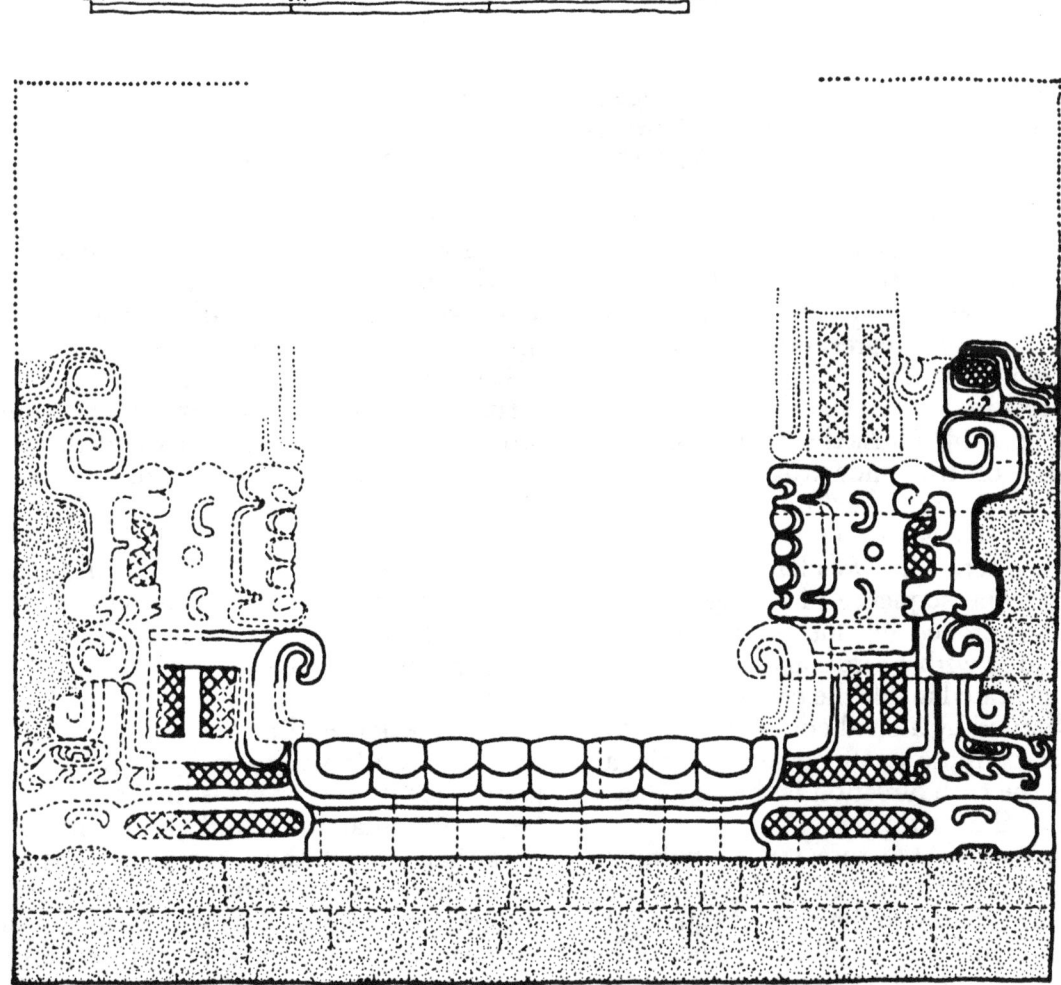

FIG. 84 Structure 11: (a) north door and (b) south door of central chamber. After Hohmann and Vogrin 1982. From *Sixth Palenque Round Table, 1986*, edited by Merle Greene Robertson, p. 83. Copyright © 1991 by the University of Oklahoma Press.

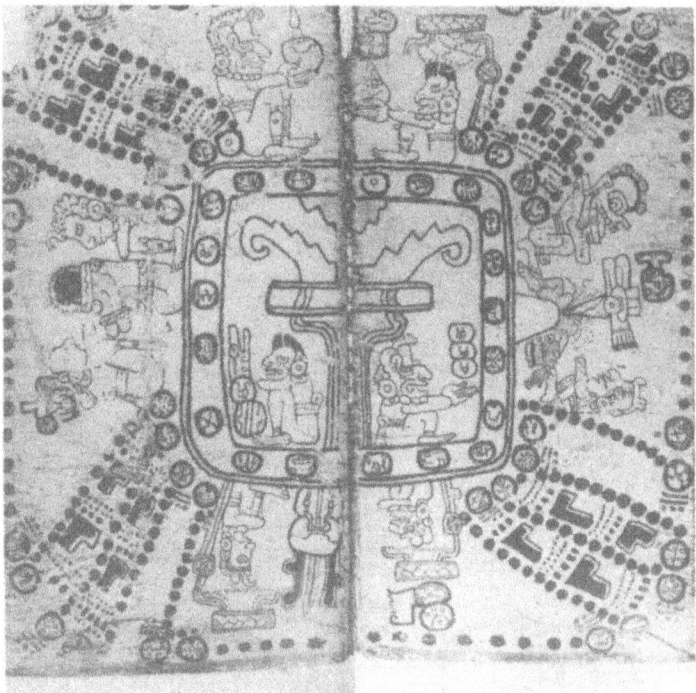
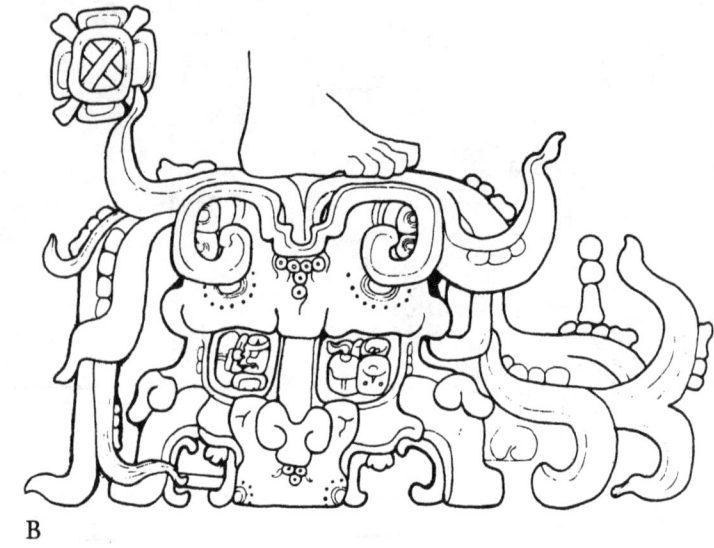

FIG. 85 (a) *Tzolkin* from Codex Madrid (pp. 75–77). After Villacorta and Villacorta 1977. (b) Earth monster from the Panel of the Foliated Cross at Palenque. Drawing by Linda Schele; from *Sixth Palenque Round Table, 1986*, edited by Merle Greene Robertson, p. 83. Copyright © 1991 by the University of Oklahoma Press.

day names; it contains two seated figures, each one in front of the entrance of a house or cave. The motif above them may be described as a stepped funnel between two scrolls. This is the cleft, probably representing a cave, often shown on the forehead of the earth monster that presumably gives access to the underworld (fig. 85b). Thus, the central square is an image of the underworld with one entrance from the top (the "funnel") and two others on the sides (where the deities are seated). Elsewhere, the Dresden Codex (29a, 30a) presents the sequence of five gods B or Chacs, each perched on one of the cosmic trees associated with a cardinal direction; the fifth Chac is seated inside the earth, shown as a hollow framed by a band containing *caban* signs. This example confirms that in Maya cosmology the fifth direction is the depths or the center of the earth.

The chamber of Structure 11, occupying a central position and having two side entrances, is a structural analog to the central square of the maltese cross in the Madrid Codex. It represents a bicephalic skeletal monster, an image of the earth as home of the dead (i.e., the underworld). We may find it paradoxical that a raised area actually represents an in-depth region; this, however, is compatible with Maya thought: a raised area is, first of all, a more sacred place than its surroundings.

If my reconstruction is correct, the whole structure is a cosmogram in which the upper story represents the heavens and the lower, the earth and the underworld. Access from the "earth" to the "sky" was possible through two small stairs inside the building. We do not know how the Copanecs used the upper story and the stairs, but since the space of the ground floor is more suitable for passage than for occupation, I suggest that it was intended for ritual perambulations performed at the time of period endings (katun or others). In this large building (29 m by 13 m in ground plan), the "living" space is limited to a chamber of irregular form and small dimensions (less than 10 m²); the remaining voids are no more than passageways whose ends open to the four directions. The access to the doors from the outside is easy, except to the south, where there are no stairs to enter the building platform. To enter the building from the south

FIG. 86 Graffiti (a) from Structure 1-Sub, Dzibilchaltún; (b) incised on floor in Tunnel 2, Structure 26, Copán. From *Sixth Palenque Round Table, 1986*, edited by Merle Greene Robertson, p. 85. Copyright © 1991 by the University of Oklahoma Press. (c) Reading sequence of Structure 11 hieroglyphic panels. From Baudez and Riese 1990.

you are forced to walk from one of the side stairs up to a narrow ledge along the outer walls.

The ritual paths certainly took into account the four directions indicated by the arms of the cross and the doors, plus a fifth materialized by the chamber. They might also have used the four corners of the building. Such a roundabout is indicated by footprints on the 260-day calendar of the Madrid Codex. Graffiti, whose design combines the cross with a square or circle, illustrate similar paths. They are found in many Maya sites: from Dzibilchaltún (fig. 86a; Andrews and Andrews 1980: fig. 106) to the Usumacinta (Maler 1901: fig. 26; 1903: figs. 34a, b; and 67) as well as at Toniná (Becquelin and Baudez 1979–82: 884–88; fig. 189) and Copán (fig. 86b). They are closed courses without beginning or end and imply a cyclic movement. It has been possible to reconstruct the path of the Dzibilchaltún graffito, whose cross has been traced with one stroke (Becquelin and Baudez 1979–82; 884–88). It alternatively links one point to its opposite and then to the closest point counterclockwise (such as N-S-E-W-S-N-W-E-N). The path on Monument 49 from Toniná conversely works clockwise (ibid.). The Copán drawing has nine loops instead of the usual four; I am unable to determine what the sequence of the linked points and the direction of the rotation would have been. Although this graffito and the plan of Structure 11 may be compared, the former gives no clue as to possible paths for the latter.

Do the glyphic panels at the doors offer any information on this problem? Insofar as the text has been deciphered, most of its content is dedicated to the celebration of Rising-Sun's accession and gives additional data in some way related to this major event. Since on the panels all texts are oriented outward, they do not indicate some doors as exits and others as entrances. If the respective length of the texts has any meaning, the north-south axis with twenty-four glyph blocks in both cases is favored, compared to the east-west direction with only fifteen or eighteen blocks. According to B. Riese (Baudez and Riese 1990), for anyone passing through a doorway the expected reading sequence would be first the left then the right panel. The sequence of doors is not demonstrated by any continuity from one panel to the other, as if we had a sentence interrupted on one panel and carried on on another. The reading sequence of the glyphic panels, according to Riese, is given in figure 86c.

According to Riese: "No explicit reference to the perambulatory function of Temple 11 has been detected in the text of the eight panels. It might be speculated that the 819 day cycle, mentioned in the text, was used as perambulation event. 9.17.0.0.0 is the most probable dedicatory date, since it is connected with a 'temple inauguration' phrase" (Baudez and Riese 1990: vol. 2, p. 453). Schele, Stuart, and Grube (1989) give 9.17.2.12.16 1 Cib 19 Ceh as the dedication date of Temple 11.

Phase B: The new construction hid from view the monster mouth framing the inner north door. A carved step-bench made of two large blocks was laid astride the two upper steps leading to the chamber. At both ends is a skeletal head in profile. The head on the left, partly broken, looks ophidian; it wears a skeletal serpent helmet and a water lily is tied around its forehead. The diagnostic element from the *caban* glyph is engraved on the monster's temple and confirms its earthly nature. The absence of *cauac* on the earth monsters from Structure 11 is noteworthy; it may be that *cauac* is not compatible with dead heads. The one to the right has a short, not ophidian, muzzle; however, it is skeletal and wears a water lily on the forehead. Here again we are dealing with a monster with two skeletal heads, which probably designates the underworld. The same theme was illustrated on the step at the foot of the stair block and on the chamber's doors. Between the two heads were carved two groups of ten human figures each, facing each other on both sides of a short text in two columns. The figures are seated on glyphs and hold as a scepter a bundle or a flowerlike object. The iconography and style are very close to those of CPN 30, particularly the headdresses and pectorals. The two figures facing each other on both sides of the inscription must be the same two who occupy the same location on CPN 30: Rising-Sun on the right, and the king assumed to be the founder of the dynasty on the left. In fact, the Founding Father here wears exactly the same headdress as on

CPN 30; on his turban he has a half-quetzal, half-macaw bird and a cutout shell. Unfortunately, Rising-Sun's head is defaced.

Although the glyphs below the figures constitute a sentence and do not individually name the kings, we have on this step as on CPN 30 (Altar Q) Rising-Sun with the fifteen kings who have preceded him on the throne. There are ten in front of him and five behind. All of them hold the bundle scepter and are coiffed with the turban completed with insignia, a headdress which, from the beginning of this study, I have assumed to be distinctive of the Copán rulers (fig. 87a). The four last figures behind Rising-Sun, although seated on glyphs and with the same posture as the other sixteen, do not wear the turban but a serpent Helmet, and hold not the bundle but a flower-like object (fig. 87b). Thus, they are probably not kings from Copán; they are either Copanec dignitaries or foreign rulers invited to the accession ceremony. It may be interesting to note that on CPN 30, as on the step, there are six kings on one side and ten on the other; on the altar the six are on the Founder's side, on the left, while on the step they are on the right. With the exception of the four last left-profile figures, the distribution of the several ornament types does not seem to indicate any meaningful structure that would reveal a hierarchical order. As on CPN 30, individual variations seem only due to the artist's wish to avoid monotony.

Thus, the comparison of the step from Structure 11 with CPN 30 has confirmed the number of sixteen rulers, Rising-Sun included, for the Copán dynasty; this number, let us recall, corresponds to the one given by the *hel* sequence. My analysis has also demonstrated that the bundle scepter and the turban are exclusively royal regalia. Finally, it has confirmed the association of the half-macaw half-quetzal bird (Yax K'uk'Mo'o?) with the founder of the dynasty.

Above the door were sculpted panels; two on the east were published by Maudslay (1889–1902; vol. 1, pl. 7b, c). On the first one a toad and a grotesque long-nosed creature with a smoking ax implanted in the forehead are facing each other. On the second panel a seated man (the king, according to the text close by) presents a severed head in a shallow bowl. It is a reptilian head with a smoking ax in the forehead. Riese thinks that "the text is the name phrase of Rising-Sun" (Baudez and Riese 1990: vol. 2, p. 459).

It is possible that the changes in the sculptured decoration caused by the new construction corresponded to a new function for the chamber; however, this is not mandatory. In fact, the south door has not been modified and we may imagine that the entrance to the underworld was indicated on the north as well as on the south; on one side by a skeletal cosmic head, on the other by a series of ancestors whose realm is the underworld.

SUMMARY AND CONCLUSIONS

The destruction of the architecture and the sculpture of this building does not permit us to be more explicit in our interpretations. It is certain that Structure 11 was a place of paramount importance, judging by the monumental quality of the north side of the Acropolis, dominated by this structure. It was not a dwelling but a temple built as an image of the universe. The ground floor represented the earth with openings to the four directions; a central chamber, in the form of a skeletal bicephalic monster, was a replica of the underworld. The upper floor was the sky, indicated on its façade as a cosmic serpent supported by two colossal *bacabs*. Ritual perambulations probably took place at period endings. The temple was also used to convey to posterity the glory of the ruling king: it is celebrated at the four entrances of the building—that is, the four directions of the universe—in long inscriptions: it is also illustrated by carved images showing the king celebrating his accession, surrounded by his predecessors.

STRUCTURE 12 ("THE REVIEWING STAND") (fig. 88)

This is a two-step platform, about 8 m high, which leans against the upper south side of Structure 11. Its orientation follows that of Structure 16 and not that of Structure 11, which is aligned with the Great Plaza. Both Structure 11 and 12 date from the reign of Rising-Sun and are approximately coeval. Structure 12 consists of a platform contained by a first vertical then sloping wall crowned with a molding. The six-step stair in the middle of the platform does not provide access to

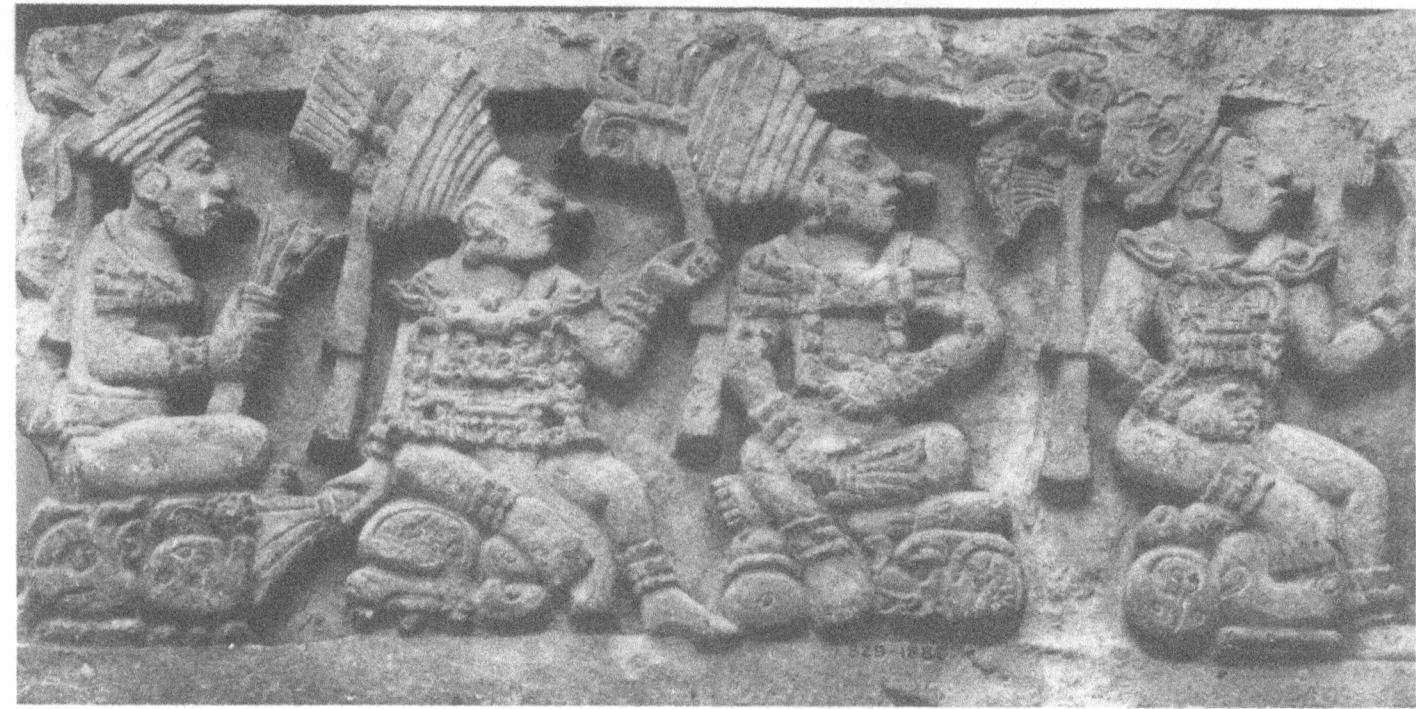

A

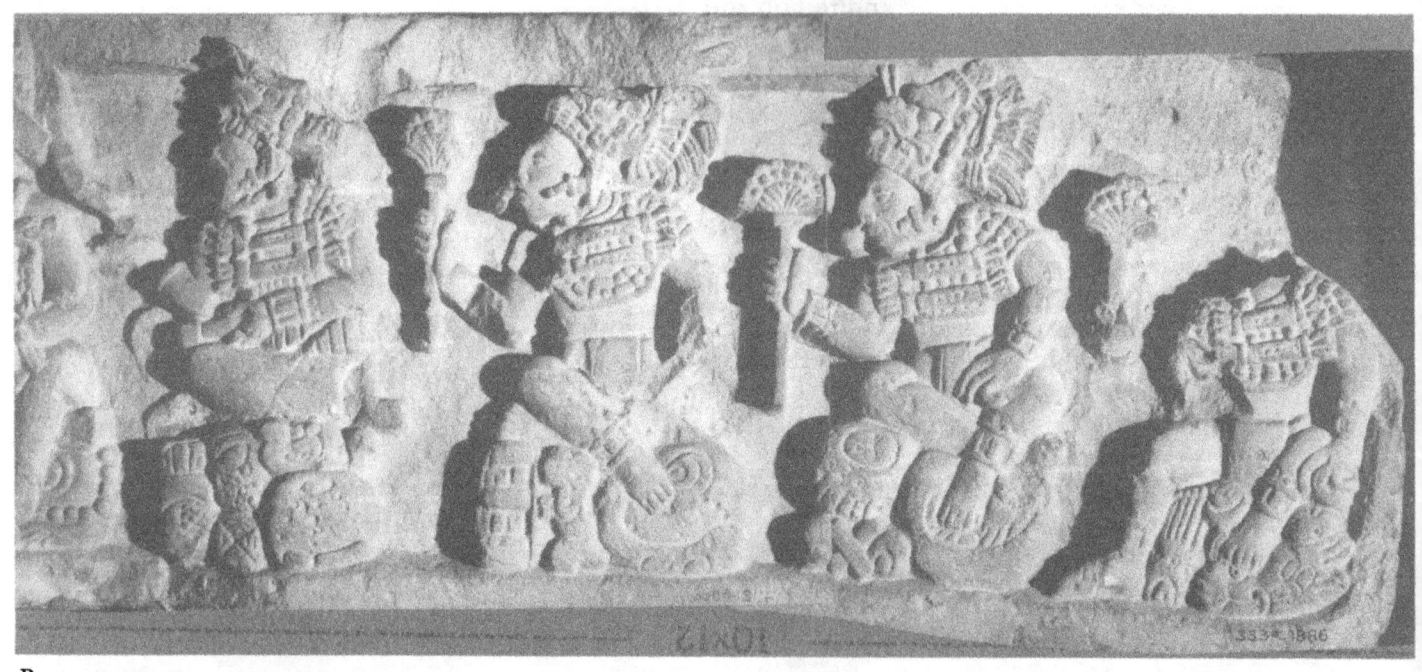

B

FIG. 87 Carved step from northern entrance to central chamber of Structure 11: (a) right-profile figures 7–10; (b) left-profile figures 7–10. Photos courtesy of the Museum of Mankind, by permission of the Trustees of the British Museum.

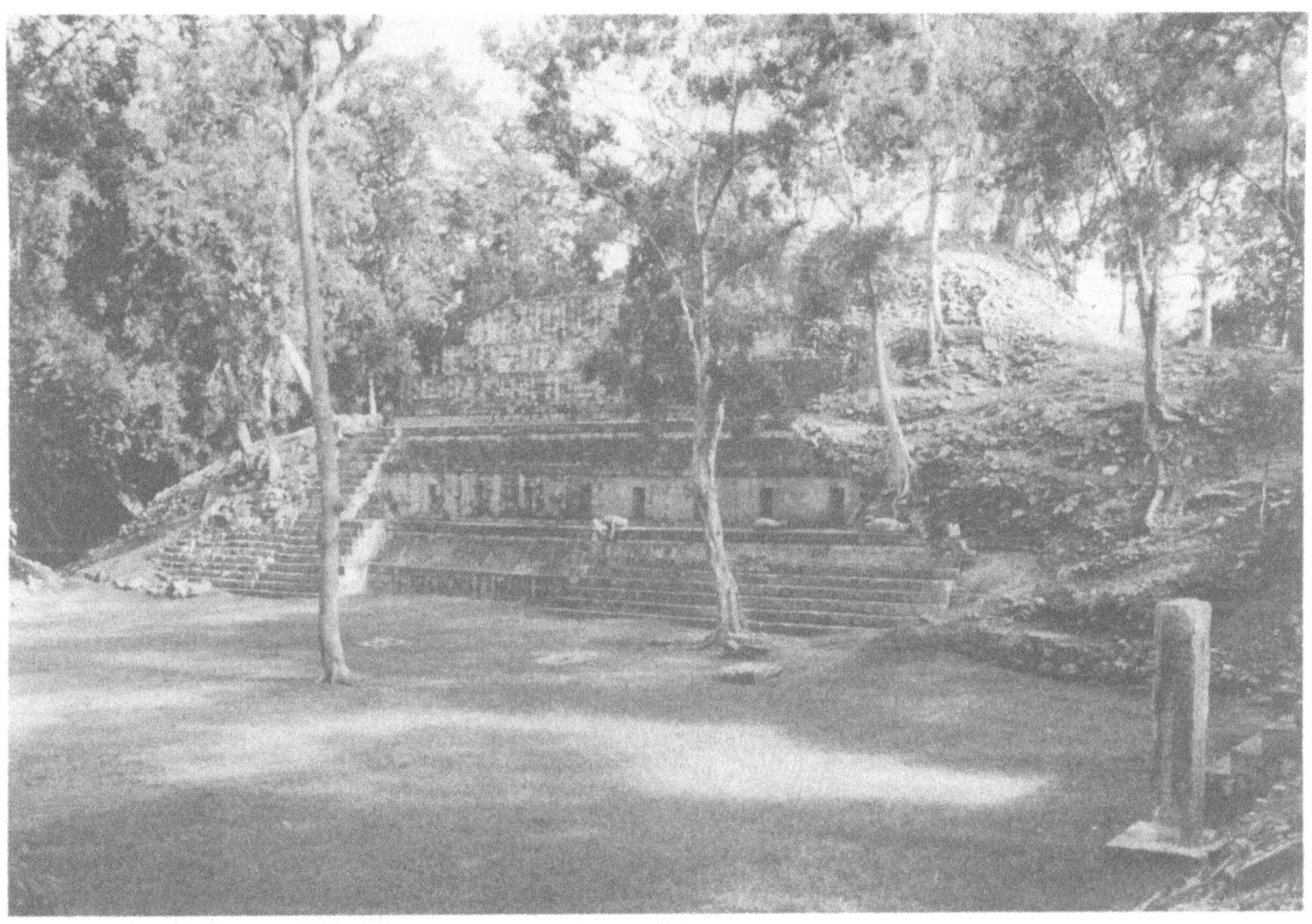

FIG. 88 Structure 12 and West Court. Photo by C. F. Baudez.

its top since the last step is actually 1 m below. A vertical wall in the upper part of the structure is hollowed out with four niches—two doors giving access to the same narrow and low room, and eight niches that lack a back room. I include the courtyard in front of Structure 12 with its three floor slabs in my presentation and analysis, since it is part of the architectural ensemble, as will be shown.

In Maudslay's time Structure 12 was concealed beneath rubble. However, the stair to the west that links the court with the top of Structure 11 was visible, as were the court's floor slabs and one of the conches. The Carnegie Institution investigated and restored Structure 12, but its work was cut short by World War II and the north-east corner remained unexcavated.

The Reviewing Stand and its associated architecture were lumped together with the adjoining Structure 11 by all later writers (Linda Schele 1987d included) until the original and architecturally necessary distinction was reestablished by Hohmann and Vogrin (1982). These authors extend the designation "Structure 12" to the entire building as described here; Maudslay used it for the stairway to the west, which leads from the West Court to the platform of Temple 11, since other parts were not cleared in his days. Part of the structure was nicknamed "Reviewing Stand" or "Tribuna de Espectadores," because it is not primarily a means of access to the terraces above, since its highest step does not reach the top of the lowest terrace. Also, its position overlooking the West Court suggested to many scholars "that it

might have served as a grand stand" (Proskouriakoff 1946: 47).

Sculpture associated with Structure 12 is distributed on three levels: the plaza floor with its three composite slabs carved in low relief; the stairs, which are partly carved with hieroglyphic inscriptions and have three high-relief sculptures on their upper part; and the platform on top of the stairs, which is decorated with three colossal conch shells.

The West Court Floor Slabs (fig. 89a, b): The three slabs cemented into the stucco floor of the West Court are carved on their upper horizontal surface. On the west slab (fig. 89a), the figure has no feet and his right knee is broken; the reliefs are very eroded, but less so than on the east slab, where the individual has lost his head, pectoral, and part of his loincloth. The middle slab (fig. 89b) is the best preserved, but the figure has lost one arm and many other details are no longer visible.

Dimensions: West slab, 146 cm by 125 cm; middle slab, 147 cm by 127 cm; east slab, 146 cm by 130 cm. Maximum thickness 36 cm.

The design is executed in three overlapping planes. On the foremost plane an anthropomorphic figure is seated cross-legged. The body is in frontal view and the profile head faces westward. The left hand rests on the thigh, while the right holds a bowl containing an eroded glyph (T683?). There is a notch in its left edge and a semicircular cartouche on its upper part. The head is reptilian, with an upturned snout and large double scrolls jutting out of the mouth. The lower jaw is skeletal, the eye round, and the earplug has a scroll above and a bone below it. The ear is adorned with plants. A glyph marks the forehead. A medallion with a youthful face surrounded with beads is worn on the chest. The wristlets and anklets are made of tubular beads with three spaced beads on the inner edge. There is a half-ring drawn on the arm. A braid-and-tassel terminates the loincloth. Behind the seated person four identical double scrolls are arranged in a cross pattern. The design on the third plane is the cruciform medallion, an emblem of the earth.

This is, in full-figure form, the long-nosed creature from the water frieze, apparently responsible for plant growth. It is the underground, vegetal aspect of the earth. The three figures face west, as if making offerings to the setting sun.

The Central Figure on the Stairs (fig. 90): The sculpture has its back against the sixth and last step, in the middle of the inscription carved on its riser. Originally the sculpture may have been made of one block. Today it is composed of three blocks cemented by the Carnegie staff. The central stone is a human head with an important hairstyle and a large collar. Each lateral block includes an arm and a shell standing on the shoulder. There is much chipping on the shells, and the face of the anthropomorphic figure is completely erased. The figure, reduced to the heads and arms, seems to emerge from the step on which it rests. The hair is arranged in a loop that falls forward. There are traces of an earplug adorned with a scroll and bone and of a collar. The hands are at the level of the collar, half closed with the palm upward. The wide wristlets include rectangular and square tubular beads. Two shells rest on the figure's shoulders.

The Two Lateral Figures on the Stairs (fig. 90): The two figures stand at the ends of the last step. Their back leans against the upper part of the platform that their heads rise above. The figure to the west is 136 cm high, the one to the east 147 cm, and their maximum width is 165 cm. They have one knee on the ground; the hand on the outer side is on the chest, while the other holds a rattle. The body and head are in front view and in high relief; the legs are in profile and less prominent. Stems ending with a flower or fruit are tied around the head. The skull of the figure on the observer's right is flanked by two shells whose lower edge rests on the ear. The headdress of the figure on the left is destroyed, but there was certainly enough room for two shells. The forehead is divided into three wrinkled masses. The cheekbones and mouth are protruding. The upper lip curls up, baring a row of teeth. A small realistic snake emerges from the corners of the wrinkled mouth. The ears are deformed by a large ornament passing through their lobes and decorated with three circlets. The eroded face of the right figure looks more human and less grimacing.

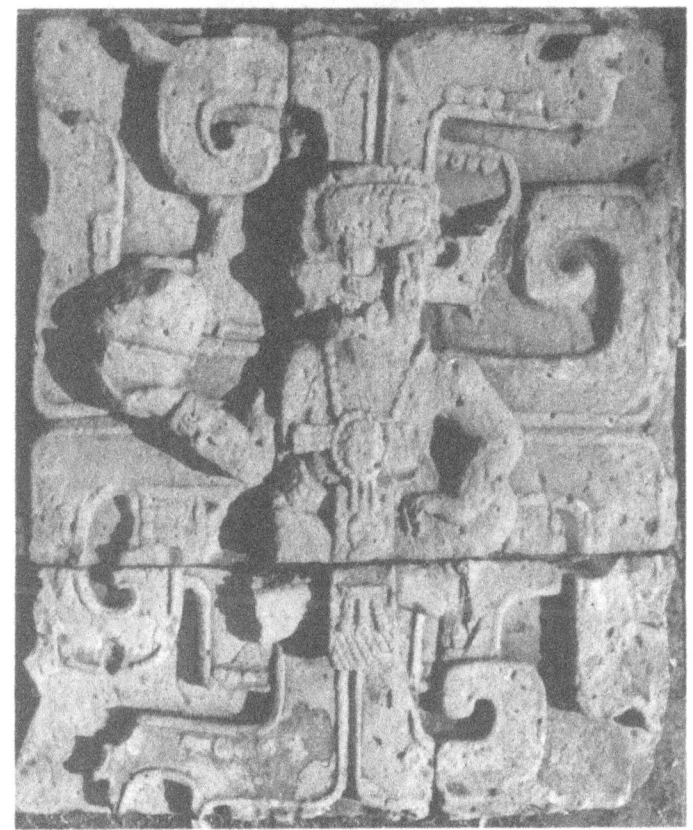 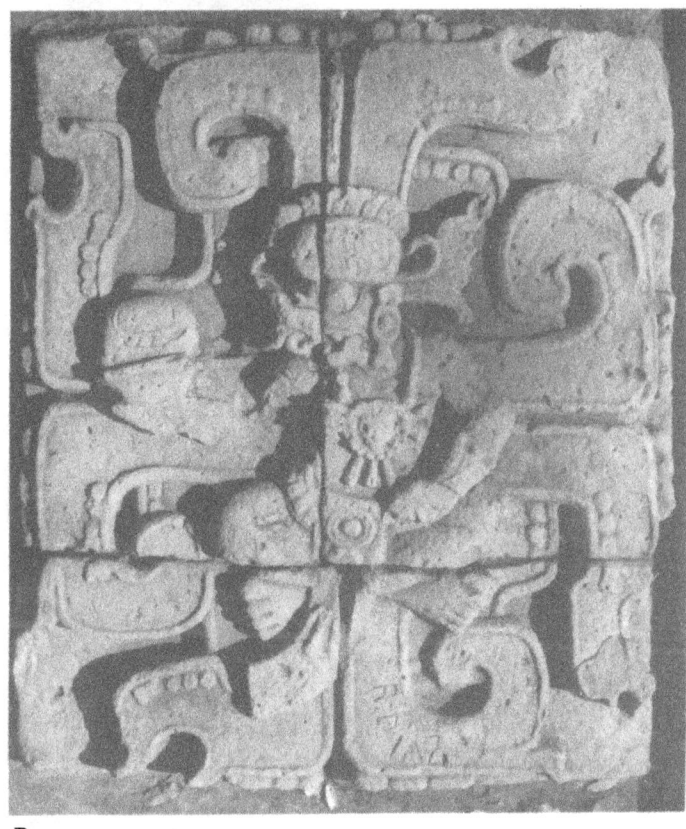

FIG. 89 West Court: (a) west slab; (b) middle slab. Photos by J.-P. Courau.

There is no trace of serpents emanating from his mouth. The collar is made of two intertwined stems: one of them tapers into a water lily blossom, the other into a bone. Cacao beans are tied to the collar. A serpent encircles the waist: its profile head is rather realistic, with a large tongue with a scrolled end; the tail may be seen under the neck and behind the tongue's scroll. The spherical rattle is marked with a deeply carved T (a cutout?) and crowned with feathers; its handle is grooved.

These monkeylike figures are close to the *bacabs* because of their kneeling posture, their wrinkles, and their plant headdress. The sign that hangs from their ears may be a variant of the disk with three circlets that *bacabs* and toads have on their ears. They wear fertility symbols: a water lily blossom, cacao beans, and a rattle marked with T503. The serpents around their waist and jutting out of the mouth emphasize their chthonian nature. The three figures are carrying shells, which—as we shall see later—indicate an aquatic environment.

The Three Conch Shells: Three conch shells lie on top of the platform. They have three or four spires, and their ends are cut off in order to be used as trumpets. They average 143 cm in length and 43 cm in width.

OVERALL INTERPRETATION

The key to the enigma is given by the stairs, which stop 1 m before the top. Carnegie archaeologists had proposed that the steps were used as seats by onlookers of rites performed in the court below. This interpretation seems unconvincing, since the stair is rather low and does not overlook the court; besides, people of high rank would have been reluctant to be seated in such a low position. Finally, this hypothesis does not take into account the iconography of the sculptures, which make up a coherent whole.

When one stands on the last step, one's head and torso stick out from the platform and one seems to emerge from the waist up, like the central figure who emerges from the

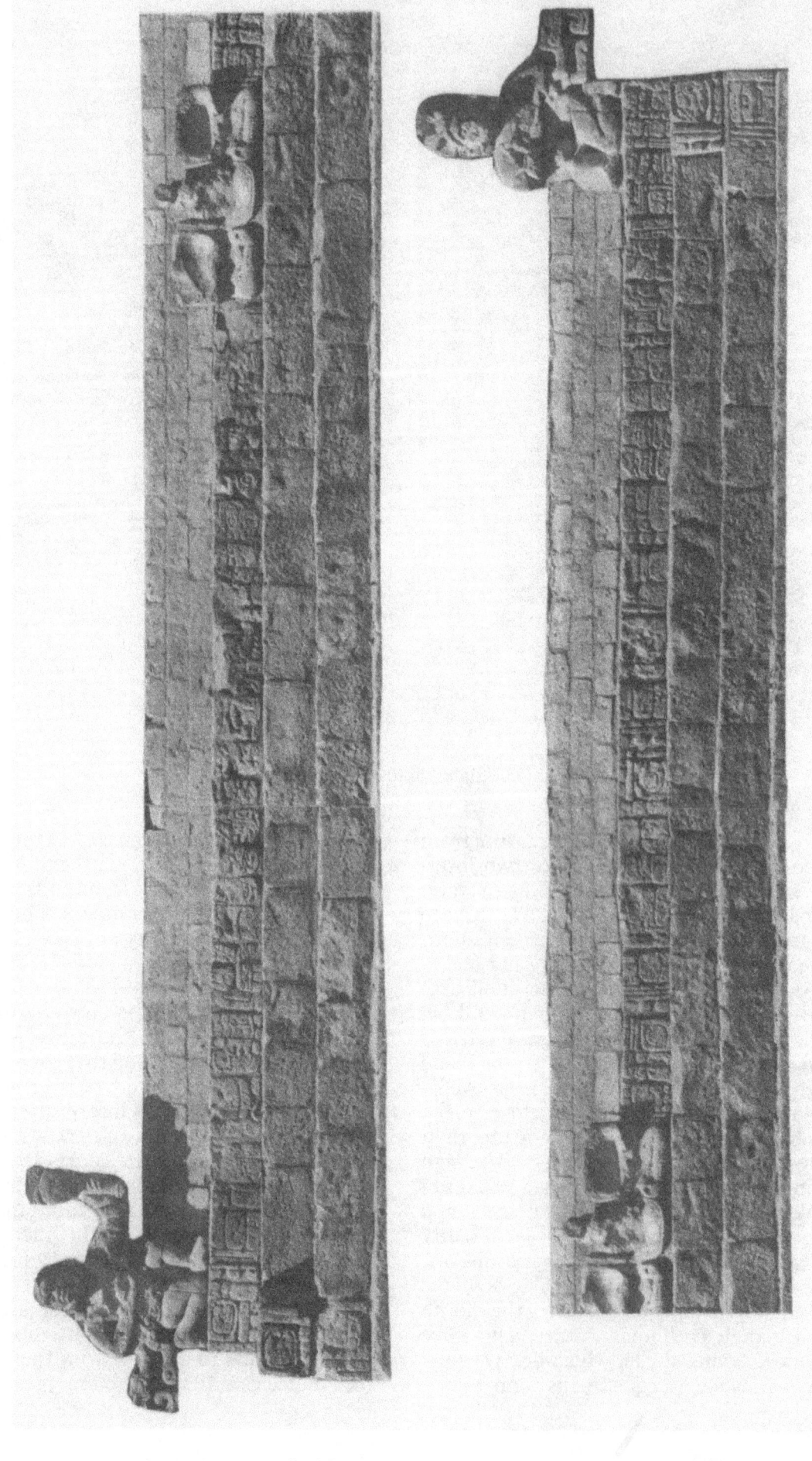

FIG. 90 Structure 12: upper steps and inscription. Photos by J.-P. Courau.

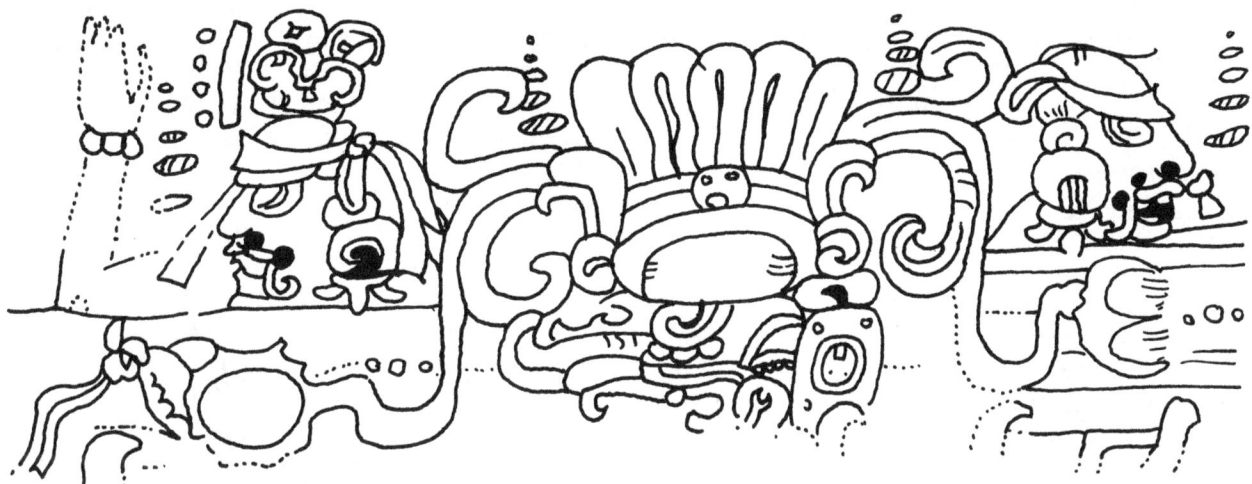

FIG. 91 Detail of painted scene on Early Classic wooden bowl from Burial 160, Tikal. After W. R. Coe.

sixth step. Assuming that the platform top with the conch shells represents the water surface, the persons who have ascended the steps seem to emerge from the water, like the protagonists of some water friezes. This theme discovered by Coggins (1983) is illustrated on a stuccoed bowl from Tikal Burial 160 (fig. 91 and Coggins 1983: 44, fig. 39). Four long-nosed heads grow water lilies and are placed in front of a horizontal band containing dots and circlets that represents water. Fish and stylized shells go with it, while six anthropomorphic figures emerge from it. The water frieze represents the underworld waters, source of fertility. The long-nosed monster in this context is the fertile aspect of earth, and the emerging creatures are from its retinue. The water frieze is widely distributed in the Maya area (see Hellmuth 1987). At Copán it is also illustrated on CPN 109, 110, and 111.

Structure 12 is a three-dimensional water frieze used as a stage for fertility rites. At the lower level are the long-nosed heads, here provided with a body and surrounded with vegetation radiating to the four directions; these creatures present offerings to the earth itself or to the setting sun, since they face west. The stair represents the underground water, whose surface is indicated by the three conch shells. From this fertile environment emerge creatures carrying shells and plants, with whom the performers of the rites identified themselves when they ascended the stairs. The two figures brandishing rattles look like guardians at the border between two worlds, comparable to the jaguars flanking the stairs of Structure 24. The performers of these rites might have looked like the dancers, accompanied with musicians, from Room 1, Structure 1, Bonampak. They impersonate creatures from the aquatic underworld (crocodile, crab, toad) and display water lilies (Miller 1986). It is possible that Structure 13 (on the west side of the court and facing Structure 16) played a role in the ritual acted on Structure 12, because of the presence on its top of freestanding sculptures related to water iconography: a pair of identical naturalistic crocodiles.

Schele and Miller (1986: 250) think that "captives were sacrificed on stairs fronted by three square markers that symbolize a ballcourt." Elsewhere, Schele (1987d) refers to the Reviewing Stand as a false ball court. This idea was first proposed by Mary Ellen Miller in a paper delivered at the Dumbarton Oaks Conference on the Southeast Maya Zone in 1984, but is not found in the published version of her work (1988). This interpretation rests on the comparison of the West Court, in front of Structure 12, and Ball Court A; since both have carved slabs cemented in the ground, Structure 12 and its court would represent a ball court with its three markers. I agree that the slabs in the West Court were probably markers in the sense that they may have played a role in the spatial organization of the ritual; but this has nothing to do with the ball game. On the inscription Schele (1987d)

reads the glyph at B' as a "ballcourt glyph"; even if this reading is right, it may refer to Ball Court A or even B and in no way "confirms the identification of the Reviewing Stand as a false ballcourt."

RELATION OF TEXT AND IMAGE

According to Riese: "Both non-calendrical parts speak of the contemporaneous king, Rising-Sun. In the first part he is linked to his predecessor Eighteen-Rabbit, in the second part to his immediate predecessor, Smoking Squirrel. The precise meaning of the whole text, however, is not clear" (Baudez and Riese 1990: vol. 2, p. 470).

The iconography and text focus on different themes: while iconography and architecture set the scene for agrarian rites, the text emphasizes dynastic matters. The architectural and iconographic symmetry is reflected in the symmetrical distribution of calendar dates in the text.

STRUCTURE 16
(figs. 92–93)

A two-flight stairway ascends Structure 16, the highest pyramid in Copán. The first flight, made of small blocks, consists of eighteen steps of a total width of about 17 m; a large T-shaped block stands in the center of the top steps. The upper flight, built with huge blocks, is narrower but higher (twenty-seven steps). Apparently it was divided in the middle by two stair blocks, one above the other (fig. 92).

Stephens was struck by the sight of the skulls aligned on the steps of this pyramid; in his report, however, he mistakenly had the skulls placed on the Hieroglyphic Stairway of Structure 26. Maudslay explored the superstructure and made a sketch plan of it; he discovered the north room with its stair leading to the first floor and the west room, which he completely cleared. He made a rapid description of the sculptures he found and took photographs, two of which have been published: one by himself (1889–1902: vol. 1, pl. 10a), the other by Hohmann and Vogrin (1982: pl. 86; see fig. 93a and b, respectively, of this volume).

The superstructure is of rectangular plan. Originally it included an upper floor, reached by a staircase starting from the back of the north room (4 by 3.5 m). The west room was 6 m long but only 2 m wide; when Maudslay cleared it of rubble, the walls were still standing to a height of 2 m. The remains of a frame in high relief were on the back wall and above a bench.

Sculpture of the Substructure: The central block of the first stair flight supported several rows of skulls in high relief, of which only a few remain today (fig. 93c). It was T-shaped with a projecting median part and two recessed sides. Hohmann and Vogrin (1982) reckoned that there were forty-two skulls without taking into account the spaces between them occupied by *kan* crosses. Thus, the number of skulls was certainly lower. The skulls are human and are arranged in a way reminiscent of the Aztec *tzompantli*. The T281 signs may have the meaning "precious" or "yellow," referring to ripe maize and fertility.

The Superstructure: Our data are limited to the content of the west room, known only through a short description and two photographs by Maudslay (fig. 93a, b). A high relief sculpture was set into the back wall, above the bench: a serpent lower jaw split into two vertical sides connected by the front part. This design, which reminds us of the doors of Temple 11 and 22, is stuck against the wall and only represents a mouth. It does not include eyes, brows, ears, and so forth. In Maudslay's photos the wall behind the sculpture has only remained to an extent of some 40 cm to the south, which leaves plenty of room for a central niche. In fact, this sculpture has meaning only if we imagine it framing a subject, which would appear—in agreement with the traditional composition in Maya art—within a serpent mouth.

The headless statue found by Maudslay in front of the bench probably came from the niche framed by the split serpent mouth. An arm fragment (fig. 93a) at a higher level than the statue placed by Maudslay on the bench would strengthen this hypothesis. The statue, seated cross-legged, wears a very wide braided collar that covers the shoulders and part of the chest. The pectoral supported by two straps is a rectangular block with black-stained ends and middle. A rope winds twice around the waist. The loincloth bears an

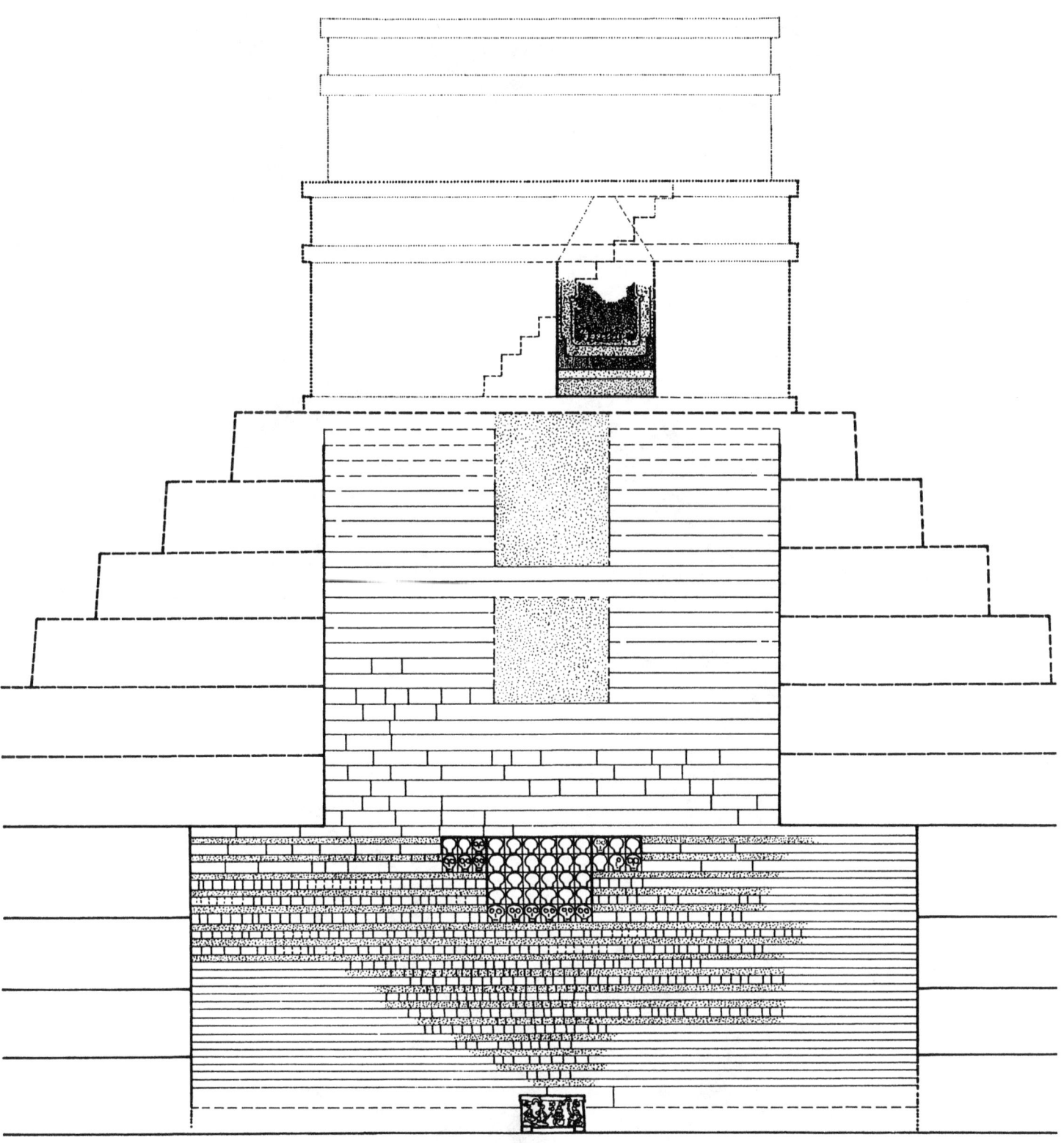

FIG. 92 Elevation of Structure 16. After H. Hohmann and A. Vogrin, from *Die Architektur von Copán (Honduras)*. Copyright © 1982 by Akademische Druck- und Verlagsanstalt.

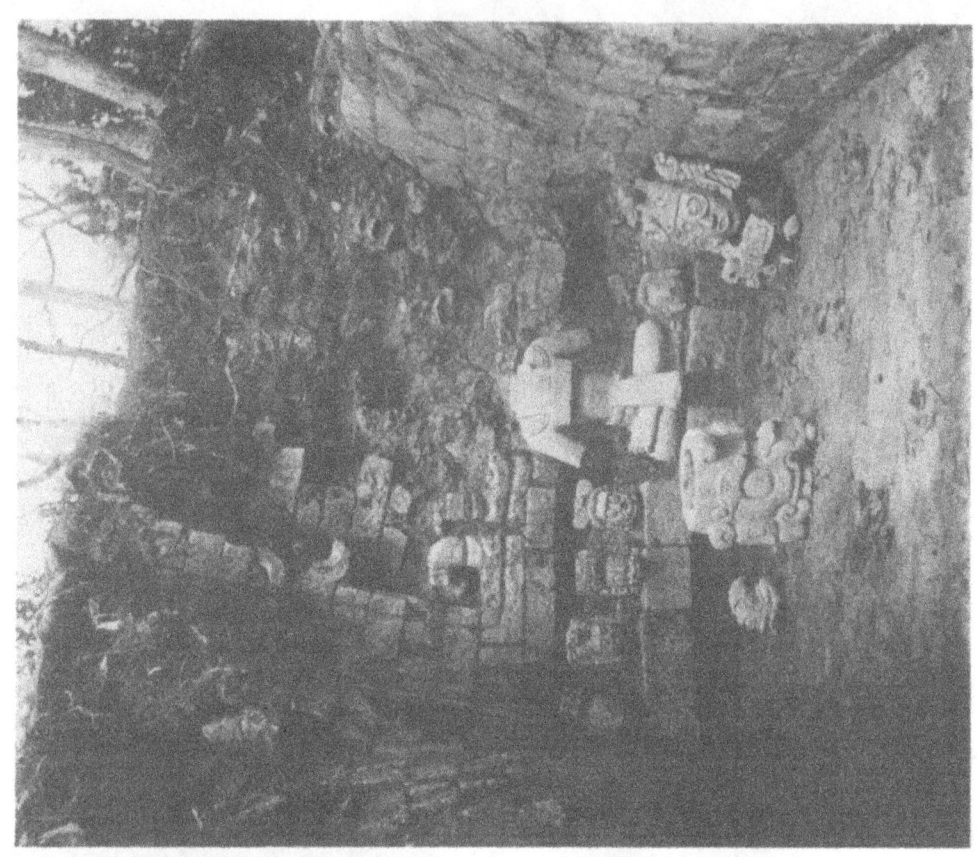

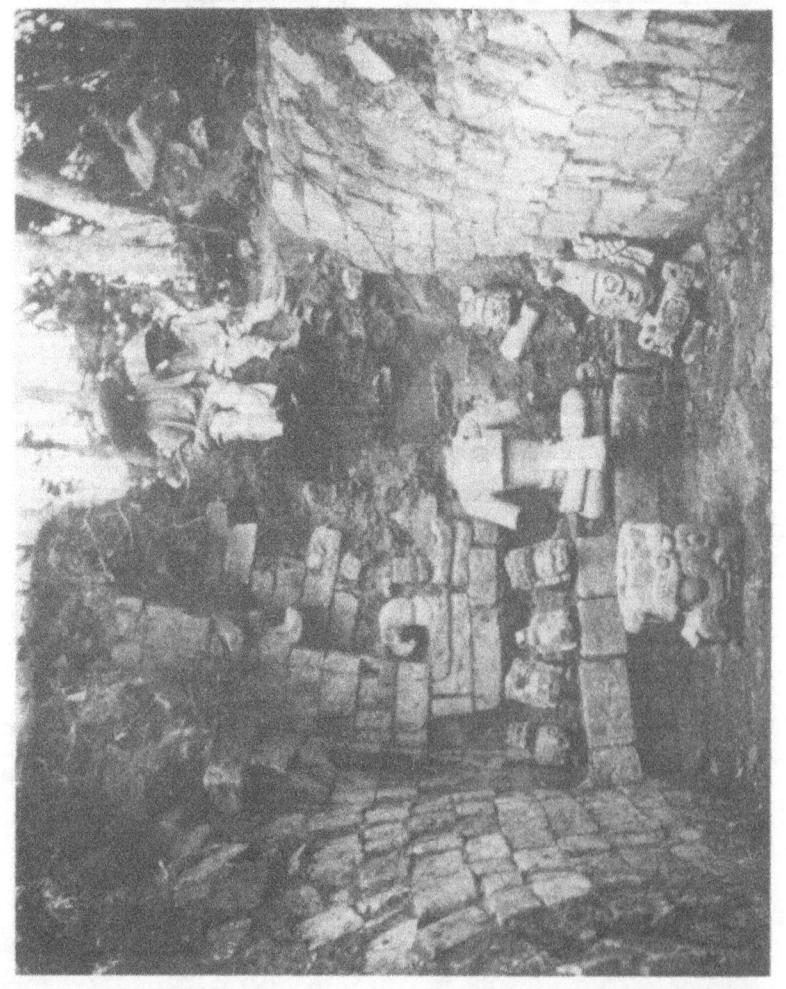

A

B

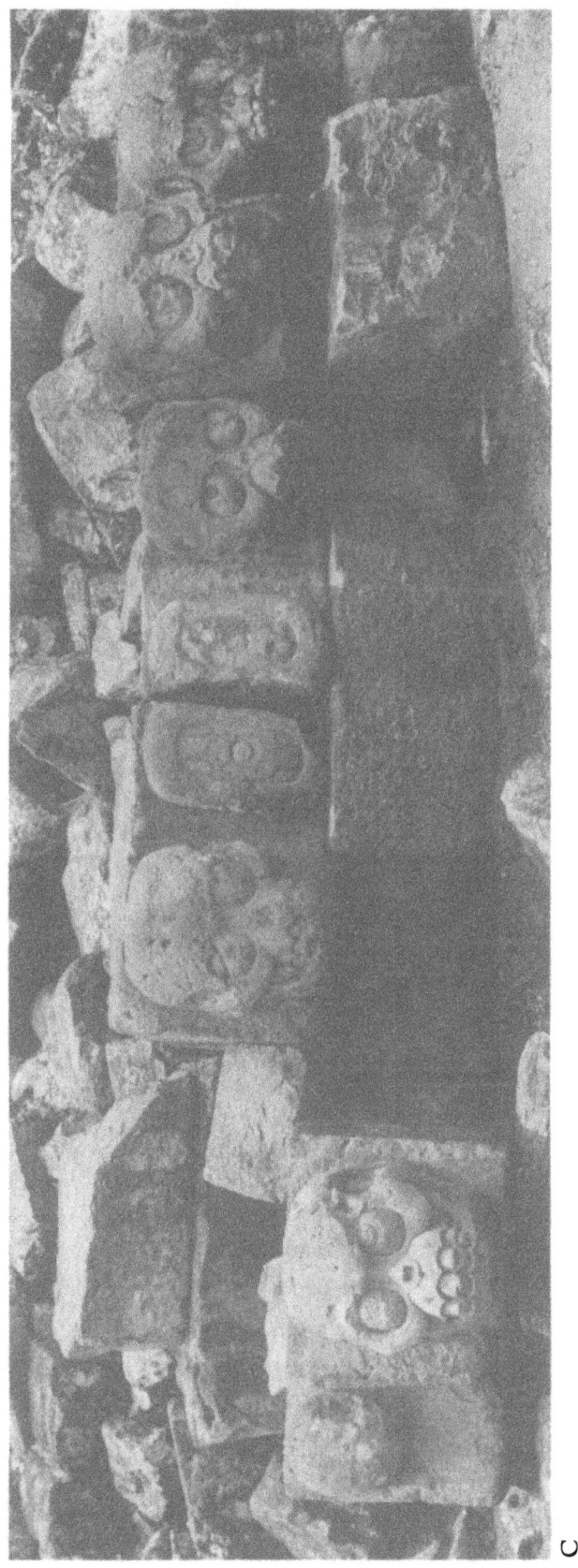

C

FIG. 93 Structure 16: (a, b) rear of west room during excavation by Maudslay. Photos courtesy of the Museum of Mankind, by permission of the Trustees of the British Museum. (c) Skulls and *kan* signs. Photo by C. F. Baudez.

unidentified design. The figure has leggings imitating bird legs and claws. Three fitted triangles are tied to a cord encircling the calf. Although headless, this statue appears by its costume to be a man, not a supernatural. The collar and the rectangular pectoral are worn by kings (CPN 30; Gordon 1902: pl. XV) the fitted triangles hang on the legs of the second statue of the Hieroglyphic Stairway, and the rope is used as a belt by the king on CPN 11 and CPN 52. The leggings in the form of animal legs are exceptional at Copán, but not so rare elsewhere, even as far away as Cacaxtla. On the Maudslay photo published by Hohmann and Vogrin (fig. 93b), one can see to the left of a stone censer a hand holding a severed grotesque head, just like the effigy on the censer from Tikal Burial 10; this hand probably belongs to the statue. To locate its head is harder. Maudslay writes, "a number of small human and grotesque heads formed the ornaments of a cornice round the wall about 7 feet above the cement floor" (1889–1902: vol. 5: 25) and six heads are shown on his photos. Five are of similar small size; two grotesque heads are pseudo-Tlalocs without lower jaw, with ringed eyes, and a headdress that combines the Year Sign and knotted ropes. The third one has solar features, such as filed incisors and whiskers. Of the two small human heads, one has a bird head in the headdress, while the other has no distinctive features besides the ringed eyes. Another head in the round is bigger than the five others. Two braids and ropes frame the ring-eyed face; ribbons pass through the ears; the hair is pulled backward and topped by a conical hat from which a quiff or a flame juts forward. This head could fit the statue if it were alone; but Maudslay apparently found with it the serpent bar pectoral: a braided body and two clawlike hooked ends.

Even if we cannot determine with certainty which one was the statue's head (assuming it is in Maudslay's photos) we may at least note that the iconography of the heads taken as a whole (pseudo-Tlaloc, solar creature, bird in the headdress, ringed eyes, ropes, braids, etc.) is similar to that of the statues on the Hieroglyphic Stairway. The latter, which like Temple 16 faces west, honors ancestors. This is probably also the function of Structure 16. The cult is first indicated by the presence near the bench of a stone censer in the shape of a *cauac* monster head and of two ceramic censers (Maudslay 1889–1902: vol. I, pl. 22a, b). These are shallow spiked bowls supported by a high cut-out pedestal base. The image in the serpent mouth carved in the wall was the object of worship. This was probably the headless statue found by Maudslay on the ground, which represents a ruler. There may have been only one statue, but there were also heads of supernaturals and ancestors. If the statue does not represent Rising-Sun, it may stand for one of his ancestors, preferably his predecessor Smoking-Squirrel or, even better, the founder of the dynasty; this person (identified as Yax K'uk' Mo'o by Linda Schele, 1986a) faces Rising-Sun on CPN 30 and on the carved step of Structure 11. The text on the top of CPN 30 states that Yax K'uk' Mo'o is the founder of the dynasty and that Rising-Sun has dedicated this monument called the Yax K'uk' Mo'o altar (on F1–F2; Schele 1989b).

The stairway expresses a close relationship between CPN 30 and the west room of Temple 16. On the former the most important person after Rising-Sun is the figure facing him, who is supposed to be the founder of the dynasty. Inasmuch as the iconography of the west room takes up attributes distinctive to this king, I am tempted to propose that the temple was dedicated to the cult of the Founding Father. Out of the sixteen kings on CPN 30, he is the only one with ringed eyes, a motif illustrated several times on the heads from the temple. The ornament that hangs on his chest is the same as the one worn by the headless statue. On CPN 30 the first king wears a cape made of two rows of feathers and a macaw-quetzal hybrid is part of his headdress, as on the step of Structure 11. In Temple 16 the statue has bird leggings and one of the heads has a bird in his headdress.

The king revered in the temple appears like the kings on the Hieroglyphic Stairway in the role of great sacrificer. He is not only surrounded with pseudo-Tlalocs, patrons of sacrifice, but he holds in his hand a severed head and his belt is made of ropes. Once more, the most celebrated of all royal functions is sacrifice.

The west room of Temple 16 recalls the scene from Yaxchilán Lintels 15 and 25, where an ancestor carrying his weapons and wear-

ing sacrificial symbols appears to the person who calls on him: it is the true apparition of a being who belongs to another world. Schele (1989b) identifies this figure as Yat Balam, whose name in the inscription is followed by a "founder" expression.

Recent excavations seem to confirm that Structure 16 is a temple-pyramid dedicated to the founder of the Copán dynasty. Linda Schele (1989b) writes that among the glyphs found in the debris from the temple was the name Yax K'uk' Mo'o and a fragment of the "crossed-batons" founder glyph. In 1989 William Fash found a headdress with a combined quetzal and macaw as its main head. The early version of Structure 16 known as the Rosalila Structure, which may date from the reign of Butz' Chan, probably had the same function. The façade of the two-story temple, uncovered intact by Ricardo Agurcia, displays a large bird modeled in stucco. The tall bird head at the center is flanked at a lower level by two inverted serpent heads that make up the bird's serpent wings. At the base of the temple are two birds with a human head in their beaks, another possible image of Yax K'uk' Mo'o (Fash 1991: fig. 52).

STRUCTURE 18
(figs. 94–97)

This structure was excavated and restored by the PAC in 1979–80 (see Baudez 1983). A stepped platform supports a two-room building facing north. Access to the north room is via a stair running along the entire width of the building; the south room is reached by stepping over a bench. This room is above a vaulted tomb, which was probably sealed after the burial; its original access was via an inner stairway that starts from the east part of the south room. There are no data available relative to the west part of the south room due to the complete collapse of this part of the building. Temple 18 was vaulted, but no parts of the vault are standing. A viaduct connected it with Structure 16, thus allowing a direct passage between the two buildings.

EXTERIOR DECORATION

The exterior decoration is divided into a lower, middle, and upper level and the roof. There remain additional decorative elements whose position is unknown.

The Façade: Lower Level (fig. 94): At the four corners of Structure 18 an outset carved block to the east and west represents 6 *ahau*. A similar one representing 7-Head is to the north and south. This 7-Head, a reptilian skeletal head with *imix* on the forehead, is an image of the earth. Two other blocks carved with the 7-Head motif are found on both sides of the door that the heads face. They are also outset (18 cm off the wall) and form the lower part of a niche, as the featherwork on the facade indicates. As an earth image, the 7-Head was probably used as a pedestal or as a seat for a statue. It is likely that the corner blocks were also used as pedestals for statues like the ones found in the excavation of the structure (Baudez and Dowd 1983: fig. M-26b). These are 130 to 140 cm high and are composed of three tenoned parts: head (although none was found), bust, and legs. The pedestals flanking the door were accompanied by two stylized water lily blossoms; this motif is identical to those hanging from the crocodile hands on CPN 33 and to the one that adorns the headdress of the main figure on the north side of CPN 26. Most of the time it emerges from the ear of a serpent, as on Structure 22's inner door, or on CPN 28, CPN 82, CPN 15, and so forth. It apparently has the same semantic value as *imix*.

While 7-Head is a familiar motif at Copán, its association with 6 Ahau is more problematic. They may be conceptually related because in the tzolkin the day 7 Imix follows the day 6 Ahau. Furthermore, 6 Ahau may be an allusion to the 6 Ahau that may begin the inscription on CPN 60 (see below), associated with Structure 18. 6 Ahau is also the name of the "Stingray Paddler," one of the creatures who propelled the late king on MT38 from Burial 116 of Tikal (Schele 1987b). Since Structure 18 is a funerary temple, the temple may have been placed under the patronage of this being.

The Façade: Upper Level: A frieze adorns the upper part of the façade. It is made of several pairs of agnathic serpent heads. The Janus-faced heads hold in their mouths, close to the fang, a water lily variant adorned with

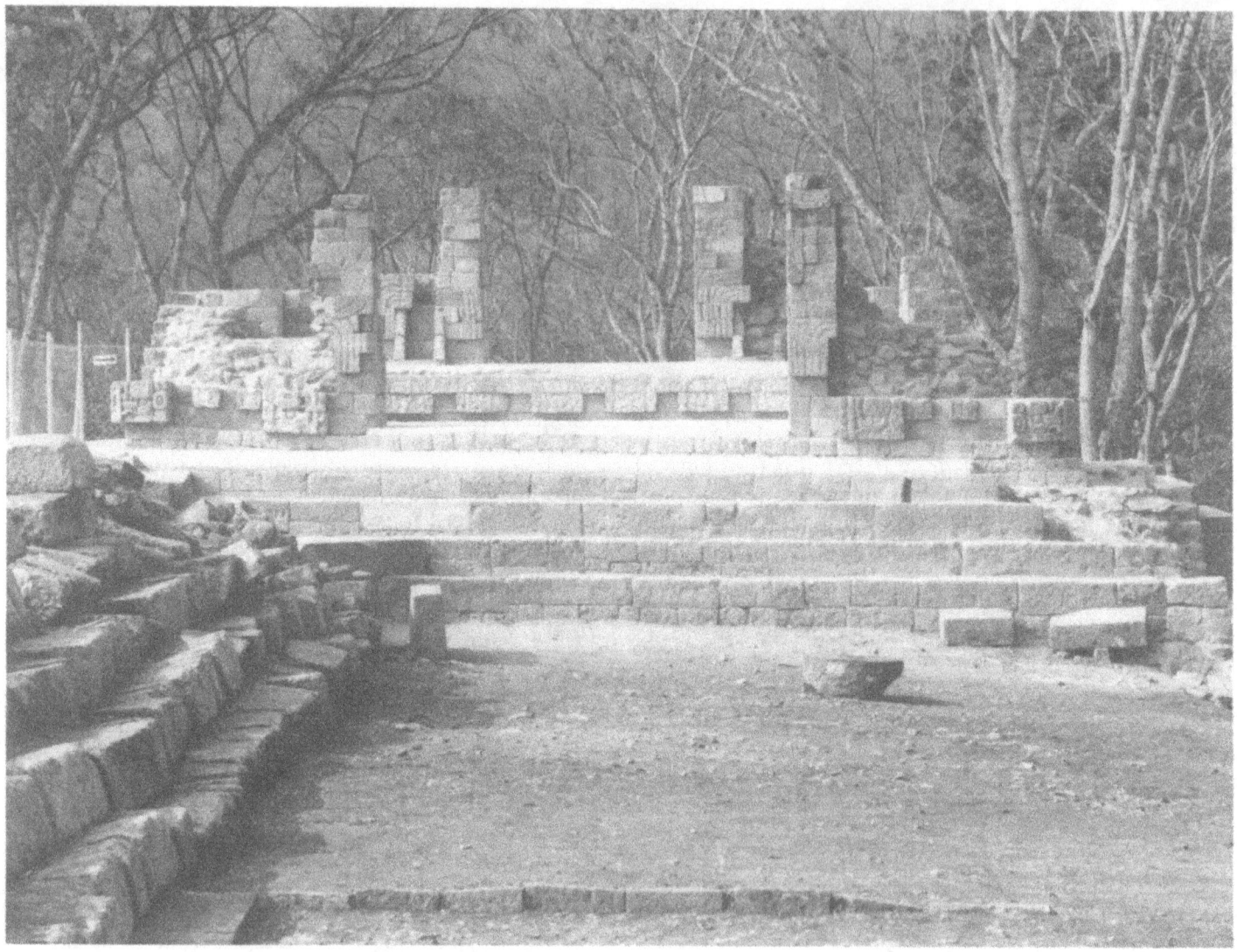

FIG. 94 Façade of Structure 18 looking south. Photo by J.-P. Courau.

feathers. This is reminiscent of CPN 1, where the two serpents that flank the king's headdress have in their mouth a water lily blossom (T696) stamped with the *caban* element.

The Façade: The Roof: The roof includes a frieze made of two rows of stones: vertical lines separated an upper horizontal braid from a lower series of squared Us. The whole is reminiscent of the thatch glyph (T614a). The frieze was interrupted at regular intervals by a rectangle with outset corners framing three tubular beads. In manuscripts and on painted vases this frieze is also seen on temple roofs.

The decoration also included at least twenty-six rather crude medallions in the form of round beads, surrounded by another row of beads. Three rows of two blocks each form a medallion on a square surface, measuring 55 cm on each side. Three main types are apparent: type A are youth heads, with a crown of raised hair, with or without a central lock; type B is composed of jaguar heads whose foreheads are stamped with T616b and with fangs and scrolls coming out of the mouth, muzzle, and nose; type C is the least clearly defined, encompassing grotesque heads with a grinning mouth, squint eyes, an animal nose, and either a beard or a protruding chin. The ears or ear ornaments are flabby. It is believed that type C medallions had flame eyebrows and crossed-bands on the forehead, since these features are never found on A or B medallions. The lower row of stones that

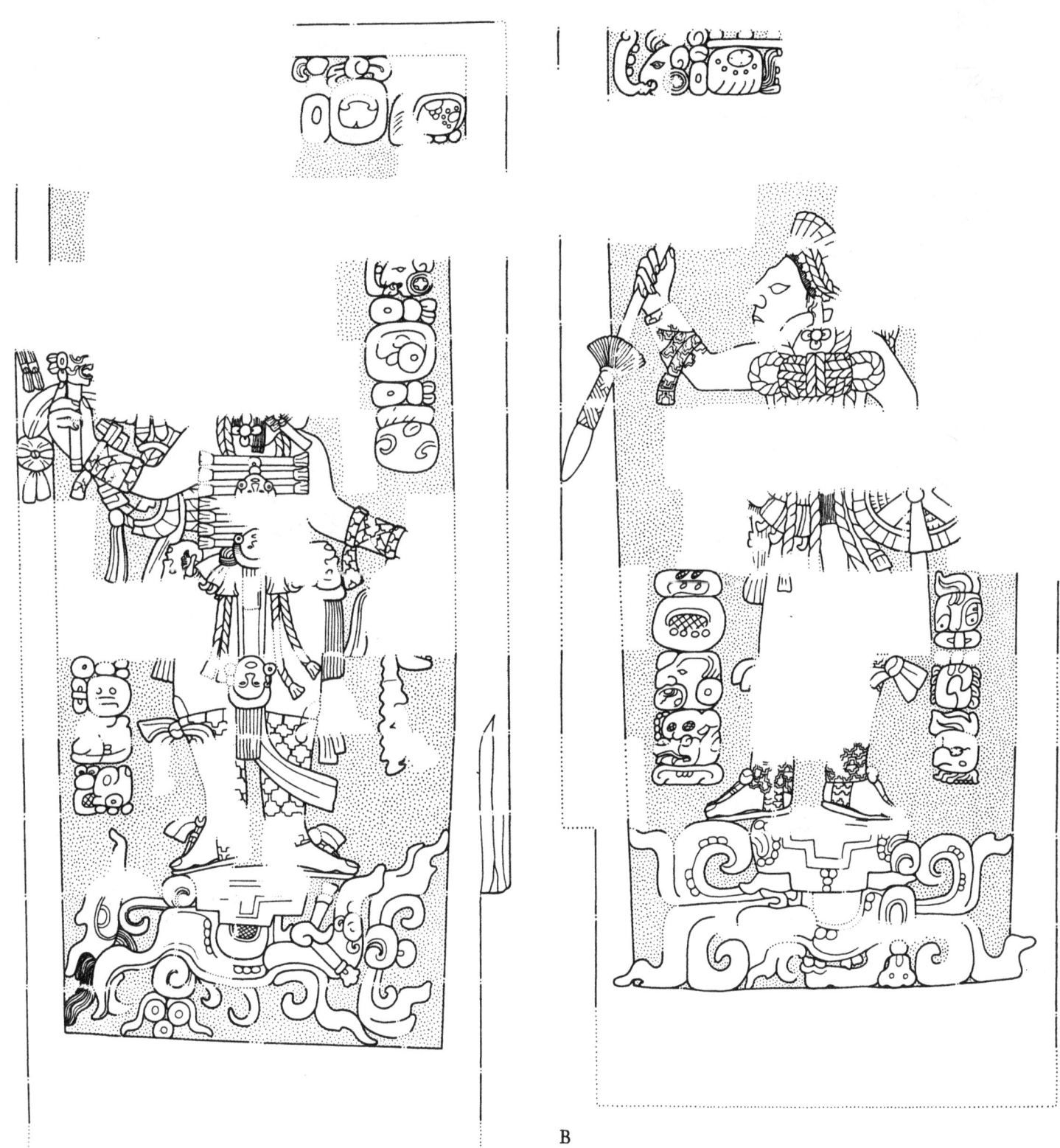

FIG. 95 Temple 18: (a) northwest jamb; (b) northeast jamb. Drawings by A. Dowd.

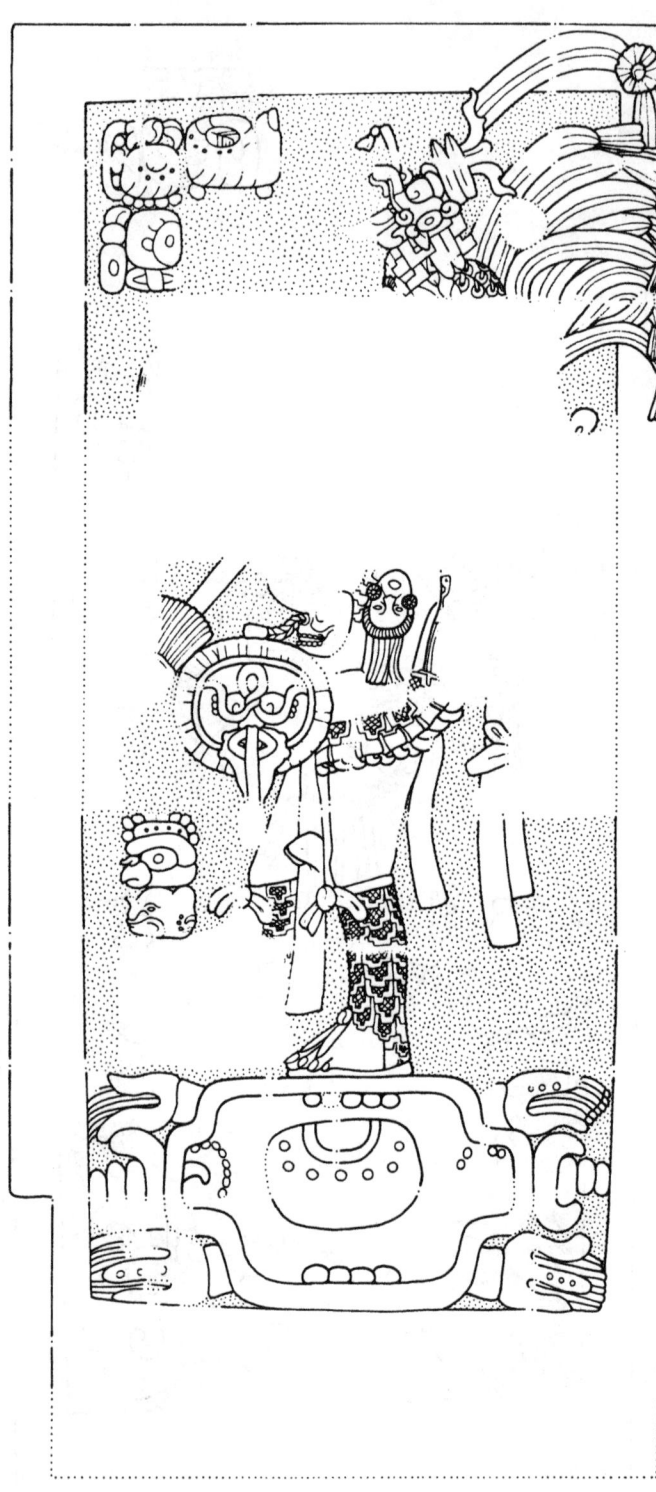

A
B

FIG. 96 Temple 18: (a) southwest jamb; (b) southeast jamb. Drawings by A. Dowd.

FIG. 97 Temple 18: detail of decoration on riser of step-bench. Drawing by A. Dowd.

make up the medallion is carved with round or tubular beads under the main motif. It is likely that the medallions were linked together in a beaded network, as on the pectoral worn by the tenoned statue found in the same structure (Baudez and Dowd 1983: fig. M-26b).

There were also at least five *cauac* masks, each one made of thirteen stones. Although very similar to those from Structure 22, they were spread on the same plane rather than placed at the building's corners. Surrounded with feathers, they were probably superimposed on the roof sides.

Serpent heads with a horizontal tenon looked like crude versions of the heads that formed the frieze on the upper walls. In both cases, a water lily blossom is attached to the serpent's fang. There were at least fourteen of these heads, 100 to 110 cm long, with the tenon measuring 50 cm. Blank medallions flanked by round and tubular beads made up another frieze on a single row of blocks. As their upper face is carefully worked, it is possible that they were at the roof's top (eight blocks and one corner were found). (See Baudez 1983: vol. 2, p. 484 and fig. M-23 [serpent frieze], fig. M-24a [thatch frieze]; fig. M-24b, c [medallions]; fig. M-25 [various].)

SUMMARY OF EXTERIOR DECORATION

The water lily blossom or its glyphic equivalent *imix* (T501) is the leitmotif of the outer wall decoration. It is one component of the 7-Head motif, an image of the earth that made up the pedestal of niched statues at the structure's corners (associated to 6 Ahau, a likely historical reference) and on both sides of the door. A serpent with a blossom in its mouth is another variety of the *imix* monster. Its repeated form makes up a frieze surrounding the building. Finally, pairs of blossoms are seen on each façade.

Thus, the main north façade contained four niches with statues standing on earth monster masks. The niches were surrounded with feathers and separated by water lily blossoms. Serpents with the same flower in their mouth decorated the upper portion of the walls. While the major motifs that make up the roof's decoration are known, their actual arrangement is only conjecture. Besides the frieze with T614a, a network of beads linked human and solar medallions flanked by superimposed *cauac* masks. Serpent heads tenoned into the masonry and a frieze repeating a stylized pectoral completed the embellishment of the façade.

INTERIOR DECORATION

The jambs of the inner and outer doors were carved. Large T-shaped niches edged with an inscription occupy the east and west walls of the first (north) room. The front of the step that separates the two rooms seems to be supported by eight carved masks. On both sides of the inner room two rectangular niches with a carved frame were surrounded with carved featherwork. All niches were empty when unearthed by the PAC.

THE FOUR DOOR JAMBS

The Northwest Jamb (fig. 95a): The low relief is directly carved on the wall. The motifs of the sculptured scene sometimes jut out of the frame that surrounds it. A man in front view stands on a reptilian mask in profile. An inscription is composed of one row of glyphs along the jamb's top and of two columns, one close to the figure's right leg, the other to the left of his head. The lower part of the jamb is nearly complete, but the upper third is almost totally missing; there are no traces of a headdress and part of the objects held by the figure is lacking.

The reptilian mask used as a pedestal lacks a lower jaw. It is flanked by a water lily and the three rings of the *cauac* glyph. The forehead is T-shaped, the eye blackened, and the snout upturned. The teeth that end in flamboyant scrolls are prominent elements.

The chin is the only part of the main figure's face that remains; the figure faces north and outward; the feet also point outward: the left one rests completely on the ground, while the right heel is raised (Proskouriakoff 1950: 28; fig. 9, I-51). The right hand holds up a scepter, while the left lowered one presents a trophy. The ribbons and tassel partly visible above and behind the right arm probably hung from the headdress; this is also true of the ropes dangling behind the head. Some locks of hair fall on the neck. The loincloth, which seems to be moving to the left, accentuates the dynamism of the main figure, which the raised foot already has suggested.

FIG. 97 Temple 18: detail of decoration on riser of step-bench. Drawing by A. Dowd.

make up the medallion is carved with round or tubular beads under the main motif. It is likely that the medallions were linked together in a beaded network, as on the pectoral worn by the tenoned statue found in the same structure (Baudez and Dowd 1983: fig. M-26b).

There were also at least five *cauac* masks, each one made of thirteen stones. Although very similar to those from Structure 22, they were spread on the same plane rather than placed at the building's corners. Surrounded with feathers, they were probably superimposed on the roof sides.

Serpent heads with a horizontal tenon looked like crude versions of the heads that formed the frieze on the upper walls. In both cases, a water lily blossom is attached to the serpent's fang. There were at least fourteen of these heads, 100 to 110 cm long, with the tenon measuring 50 cm. Blank medallions flanked by round and tubular beads made up another frieze on a single row of blocks. As their upper face is carefully worked, it is possible that they were at the roof's top (eight blocks and one corner were found). (See Baudez 1983: vol. 2, p. 484 and fig. M-23 [serpent frieze], fig. M-24a [thatch frieze]; fig. M-24b, c [medallions]; fig. M-25 [various].)

SUMMARY OF EXTERIOR DECORATION

The water lily blossom or its glyphic equivalent *imix* (T501) is the leitmotif of the outer wall decoration. It is one component of the 7-Head motif, an image of the earth that made up the pedestal of niched statues at the structure's corners (associated to 6 Ahau, a likely historical reference) and on both sides of the door. A serpent with a blossom in its mouth is another variety of the *imix* monster. Its repeated form makes up a frieze surrounding the building. Finally, pairs of blossoms are seen on each façade.

Thus, the main north façade contained four niches with statues standing on earth monster masks. The niches were surrounded with feathers and separated by water lily blossoms. Serpents with the same flower in their mouth decorated the upper portion of the walls. While the major motifs that make up the roof's decoration are known, their actual arrangement is only conjecture. Besides the frieze with T614a, a network of beads linked human and solar medallions flanked by superimposed *cauac* masks. Serpent heads tenoned into the masonry and a frieze repeating a stylized pectoral completed the embellishment of the façade.

INTERIOR DECORATION

The jambs of the inner and outer doors were carved. Large T-shaped niches edged with an inscription occupy the east and west walls of the first (north) room. The front of the step that separates the two rooms seems to be supported by eight carved masks. On both sides of the inner room two rectangular niches with a carved frame were surrounded with carved featherwork. All niches were empty when unearthed by the PAC.

THE FOUR DOOR JAMBS

The Northwest Jamb (fig. 95a): The low relief is directly carved on the wall. The motifs of the sculptured scene sometimes jut out of the frame that surrounds it. A man in front view stands on a reptilian mask in profile. An inscription is composed of one row of glyphs along the jamb's top and of two columns, one close to the figure's right leg, the other to the left of his head. The lower part of the jamb is nearly complete, but the upper third is almost totally missing; there are no traces of a headdress and part of the objects held by the figure is lacking.

The reptilian mask used as a pedestal lacks a lower jaw. It is flanked by a water lily and the three rings of the *cauac* glyph. The forehead is T-shaped, the eye blackened, and the snout upturned. The teeth that end in flamboyant scrolls are prominent elements.

The chin is the only part of the main figure's face that remains; the figure faces north and outward; the feet also point outward: the left one rests completely on the ground, while the right heel is raised (Proskouriakoff 1950: 28; fig. 9, I-51). The right hand holds up a scepter, while the left lowered one presents a trophy. The ribbons and tassel partly visible above and behind the right arm probably hung from the headdress; this is also true of the ropes dangling behind the head. Some locks of hair fall on the neck. The loincloth, which seems to be moving to the left, accentuates the dynamism of the main figure, which the raised foot already has suggested.

The sandals are topped with leggings that fasten with a large knot under the knee; the fabric is decorated with interlocking crosses. A band of the same fabric is rolled up around the wrist. At waist level hooked elements, probably jaguar claws, are visible below the tinklers.

A ribbon pierces the earlobe; this sacrificial emblem is emphasized by the attached knotted bands. Four beads forming a cross hang from the ear. Ropes that hang down from the headdress wrap around the neck and then reappear from under the belt. Others are also above and below the right arm. The pectoral is composed of seven horizontal tubes with a tassel at both ends. The man carries five small inverted severed heads. Three face the observer at chest, belt, and knee level; the two that are fastened to the belt are seen in profile. They are open-mouthed and have long falling hair and ears adorned with small round flares or, in one instance, with what looks like a paper flower. The left hand is missing, but it is obvious that there was no room for a spear or other weapon. Beneath the place that the hand occupied are incomplete motifs: a pair of ribbons, a skeletal lower jaw, and a tassel. I imagine that they formed a trophy, perhaps like those displayed on the southeast jamb (a human skull at the end of a cord). The right hand holds a scepter topped with an incomplete grotesque profile head, probably a jaguar. The feathers behind the scepter probably come from its top. Although a round shield is shown in profile, behind the figure's right arm, there is no evidence that it was fastened to him.

The Northeast Jamb (fig. 95b): 250 cm high and 115 cm wide, this also depicts a human figure standing on a mask. The inscription is composed of a row near the top and two columns on both sides of the legs. This jamb is the least complete of the four; after reconstruction forty percent of the carved blocks were still missing. There is almost no trace of the headdress, the stomach, and the thighs.

The pedestal is a reptilian head between two pairs of plant scrolls. The mandible looks skeletal. The T on the forehead is surrounded with *cauac* elements. The man's body is seen in frontal view, but the face is in profile and looks toward the right and outside. The feet are placed apart and point outward; the left heel is slightly raised. The figure holds a spear with the right arm and supports a shield on the other side.

The central part of the headdress contains a bunch of trimmed feathers(?) and two ropes. The rear part is almost completely missing but seems to have been similar to the headdress on the southeast and southwest jambs composed of concentric rolls with hanging ringlets. The costume—loincloth, wristlets, gaiters, a belt with tinklers and jaguar claws—is similar to the one on the northwest jamb. But on this jamb the feet are better preserved, and the open-heeled sandals (Proskouriakoff's type XII-C5) are visible. A wide ribbon pierces the earlobe, from which hang beads that form a trefoil. Special emphasis is given to the ropes: besides the ones already mentioned around the head, there are four more that make up a complex design of knots, loops, and braids on the man's chest; the ropes' ends swing to the side at thigh level.

The figure carried at least two trophy-heads, as demonstrated by the preserved long falling hair; one was in the middle of the chest, the other one on the belt's right side. The binding of the spearpoint is made with a plaited material. The wheel-shaped shield has a ribbon hanging from its center.

The Southwest Jamb (fig. 96a): The inner doorjambs are lower (129 cm) than those of the outer door, because of the bench, and they also are slightly narrower (90 cm instead of 115). On both inner doorjambs the figure and the hieroglyphic text are enclosed within a rectangular frame, and the figure's body is seen in profile and looks outward. The inscription includes an upper row and three columns, one at head level, the other two flanking the legs. Seventy percent of the jamb has been reconstructed: the headdress, the head, and the legs are in a nearly pristine state, but not much remains of the upper part of the body.

The man stands on a profile earth monster mask inside a T-shaped frame. It bears the *cauac* elements on the forehead and in the eye. Another *cauac* element may be seen on both sides, above a water lily blossom. The figure's right foot is placed in front of the slightly raised and partly hidden left. The

right hand holds a spear; a shield was probably fastened on the left arm. The headdress is complete and includes a strap decorated with Ts and a thick rounded fur(?) hat. Four bands, possibly of the same material, with tassels on the end, spring out of it. Concentric rolls adorned with small rings are at the rear. The gaiters bear the same crosses as those on the outer door's jambs, but they are cross-hatched here.

The ribbon that pierces the earlobe is of the same material as the hat. The figure carries a diminutive (a depreciating feature) captive on his back; the latter squats with his hands tied up in front of him. He has the characteristic headdress of captives and probably had ropes around his neck. He is seen against a background of the same material (fur?) used in the main figure's hat. Remains of trophy-heads are at waist level. The spear is adorned with a round element and two tassels. The shield has a long feather fringe.

The Southeast Jamb (fig. 96b): Although seventy percent of the jamb was reconstructed, it seems less complete than the others because the area between the upper part of the headdress and the lower limit of the chest is missing. The remains of the text are in the upper north corner and in front of the figure's legs.

The pedestal consists of a cruciform medallion flanked by two pairs of water lily blossoms. *Cauac* elements are in the two side lobes and in the center is an incomplete *imix*: the upper semicircle is not cross-hatched, and the short vertical lines at the base are missing. However, it certainly is an *imix* glyph, as on Machaquilá Stelae 4, 7, and 8 (Graham 1967: figs. 51, 57, 59). The three bases of these monuments are similar; but while the *imix* glyph is complete on Stelae 4 and 7, on Stela 8 it is reduced to the upper semicircle. It is obvious that in all cases the same symbol of the earth is meant.

The standing man holds a spear in the right hand, while the left carries a shield. The mask of the lancet and the Year Sign crown the headdress, whose rear portion consists of concentric rolls with pendant ringlets. The feathers that spring out from behind the headdress extend beyond the jamb's frame. The loincloth is clearly shown in front (with a knot in the middle) and back; the leggings, and the belt (or a skirt?) are decorated with cross-hatched Ts. The fringe of claws (but no tinklers) is visible under the belt. As on the southwest jamb, the warrior carried something on his back, of which only a relief under the headdress and ribbons hanging at thigh level remain. A human skull with a cord passing through its nose is displayed just above the belt. An inverted severed head is nearby. The spear's tassel is visible. The circular shield bears a solar face with a cruller below and between the eyes, a rhomboidal mouth, T-filed incisors, and a whistongue divided into two parts by a vertical strap.

Summary of Iconography and Inscriptions of the Four Jambs: The doubts raised by the fragmented state of the texts are partially compensated by the repetition of information contained in them. The reading sequence of the sections of each jamb is indicated by their known content and thus is firmly established.

All four texts ... begin with a short thematic expression of three glyphs. The first two are identical or equivalent glyphs and the expressions vary only by changes in the third glyph. Invariably the nominal clause of Rising-Sun follows in the other sections.... Given that each doorway contains only one person in its iconography and only Rising-Sun is mentioned in the accompanying inscriptions, we can conclude that we have four images of this same ruler. (Baudez and Riese 1990: vol. 2, p. 488)

On all four jambs the picture is that of the ruler Rising-Sun. He is shown alive, standing on the image of the earth surrounded by signs of fertility and water. Rising-Sun appears as a warrior, either brandishing a spear and shield or raising a scepter with the head of the roaring jaguar. He is a triumphant warrior, as shown by the lavish display of trophy-heads, skull ornaments, and the full-figure diminutive captive attached to his dress.

THE T-SHAPED NICHES

Two T-shaped niches were found *in situ* in the first room, one to the east, the other to the west. The better-preserved east niche was surrounded by a band inscribed with eighteen glyph blocks: six along the base, two on each side of the T's stem, and four along its arms. No glyphs were found *in situ* above the niche,

The sandals are topped with leggings that fasten with a large knot under the knee; the fabric is decorated with interlocking crosses. A band of the same fabric is rolled up around the wrist. At waist level hooked elements, probably jaguar claws, are visible below the tinklers.

A ribbon pierces the earlobe; this sacrificial emblem is emphasized by the attached knotted bands. Four beads forming a cross hang from the ear. Ropes that hang down from the headdress wrap around the neck and then reappear from under the belt. Others are also above and below the right arm. The pectoral is composed of seven horizontal tubes with a tassel at both ends. The man carries five small inverted severed heads. Three face the observer at chest, belt, and knee level; the two that are fastened to the belt are seen in profile. They are open-mouthed and have long falling hair and ears adorned with small round flares or, in one instance, with what looks like a paper flower. The left hand is missing, but it is obvious that there was no room for a spear or other weapon. Beneath the place that the hand occupied are incomplete motifs: a pair of ribbons, a skeletal lower jaw, and a tassel. I imagine that they formed a trophy, perhaps like those displayed on the southeast jamb (a human skull at the end of a cord). The right hand holds a scepter topped with an incomplete grotesque profile head, probably a jaguar. The feathers behind the scepter probably come from its top. Although a round shield is shown in profile, behind the figure's right arm, there is no evidence that it was fastened to him.

The Northeast Jamb (fig. 95b): 250 cm high and 115 cm wide, this also depicts a human figure standing on a mask. The inscription is composed of a row near the top and two columns on both sides of the legs. This jamb is the least complete of the four; after reconstruction forty percent of the carved blocks were still missing. There is almost no trace of the headdress, the stomach, and the thighs.

The pedestal is a reptilian head between two pairs of plant scrolls. The mandible looks skeletal. The T on the forehead is surrounded with *cauac* elements. The man's body is seen in frontal view, but the face is in profile and looks toward the right and outside. The feet are placed apart and point outward; the left heel is slightly raised. The figure holds a spear with the right arm and supports a shield on the other side.

The central part of the headdress contains a bunch of trimmed feathers(?) and two ropes. The rear part is almost completely missing but seems to have been similar to the headdress on the southeast and southwest jambs composed of concentric rolls with hanging ringlets. The costume—loincloth, wristlets, gaiters, a belt with tinklers and jaguar claws—is similar to the one on the northwest jamb. But on this jamb the feet are better preserved, and the open-heeled sandals (Proskouriakoff's type XII-C5) are visible. A wide ribbon pierces the earlobe, from which hang beads that form a trefoil. Special emphasis is given to the ropes: besides the ones already mentioned around the head, there are four more that make up a complex design of knots, loops, and braids on the man's chest; the ropes' ends swing to the side at thigh level.

The figure carried at least two trophy-heads, as demonstrated by the preserved long falling hair; one was in the middle of the chest, the other one on the belt's right side. The binding of the spearpoint is made with a plaited material. The wheel-shaped shield has a ribbon hanging from its center.

The Southwest Jamb (fig. 96a): The inner doorjambs are lower (129 cm) than those of the outer door, because of the bench, and they also are slightly narrower (90 cm instead of 115). On both inner doorjambs the figure and the hieroglyphic text are enclosed within a rectangular frame, and the figure's body is seen in profile and looks outward. The inscription includes an upper row and three columns, one at head level, the other two flanking the legs. Seventy percent of the jamb has been reconstructed: the headdress, the head, and the legs are in a nearly pristine state, but not much remains of the upper part of the body.

The man stands on a profile earth monster mask inside a T-shaped frame. It bears the *cauac* elements on the forehead and in the eye. Another *cauac* element may be seen on both sides, above a water lily blossom. The figure's right foot is placed in front of the slightly raised and partly hidden left. The

right hand holds a spear; a shield was probably fastened on the left arm. The headdress is complete and includes a strap decorated with Ts and a thick rounded fur(?) hat. Four bands, possibly of the same material, with tassels on the end, spring out of it. Concentric rolls adorned with small rings are at the rear. The gaiters bear the same crosses as those on the outer door's jambs, but they are cross-hatched here.

The ribbon that pierces the earlobe is of the same material as the hat. The figure carries a diminutive (a depreciating feature) captive on his back; the latter squats with his hands tied up in front of him. He has the characteristic headdress of captives and probably had ropes around his neck. He is seen against a background of the same material (fur?) used in the main figure's hat. Remains of trophy-heads are at waist level. The spear is adorned with a round element and two tassels. The shield has a long feather fringe.

The Southeast Jamb (fig. 96b): Although seventy percent of the jamb was reconstructed, it seems less complete than the others because the area between the upper part of the headdress and the lower limit of the chest is missing. The remains of the text are in the upper north corner and in front of the figure's legs.

The pedestal consists of a cruciform medallion flanked by two pairs of water lily blossoms. *Cauac* elements are in the two side lobes and in the center is an incomplete *imix*: the upper semicircle is not cross-hatched, and the short vertical lines at the base are missing. However, it certainly is an *imix* glyph, as on Machaquilá Stelae 4, 7, and 8 (Graham 1967: figs. 51, 57, 59). The three bases of these monuments are similar; but while the *imix* glyph is complete on Stelae 4 and 7, on Stela 8 it is reduced to the upper semicircle. It is obvious that in all cases the same symbol of the earth is meant.

The standing man holds a spear in the right hand, while the left carries a shield. The mask of the lancet and the Year Sign crown the headdress, whose rear portion consists of concentric rolls with pendant ringlets. The feathers that spring out from behind the headdress extend beyond the jamb's frame. The loincloth is clearly shown in front (with a knot in the middle) and back; the leggings, and the belt (or a skirt?) are decorated with cross-hatched Ts. The fringe of claws (but no tinklers) is visible under the belt. As on the southwest jamb, the warrior carried something on his back, of which only a relief under the headdress and ribbons hanging at thigh level remain. A human skull with a cord passing through its nose is displayed just above the belt. An inverted severed head is nearby. The spear's tassel is visible. The circular shield bears a solar face with a cruller below and between the eyes, a rhomboidal mouth, T-filed incisors, and a whistongue divided into two parts by a vertical strap.

Summary of Iconography and Inscriptions of the Four Jambs: The doubts raised by the fragmented state of the texts are partially compensated by the repetition of information contained in them. The reading sequence of the sections of each jamb is indicated by their known content and thus is firmly established.

All four texts . . . begin with a short thematic expression of three glyphs. The first two are identical or equivalent glyphs and the expressions vary only by changes in the third glyph. Invariably the nominal clause of Rising-Sun follows in the other sections Given that each doorway contains only one person in its iconography and only Rising-Sun is mentioned in the accompanying inscriptions, we can conclude that we have four images of this same ruler. (Baudez and Riese 1990: vol. 2, p. 488)

On all four jambs the picture is that of the ruler Rising-Sun. He is shown alive, standing on the image of the earth surrounded by signs of fertility and water. Rising-Sun appears as a warrior, either brandishing a spear and shield or raising a scepter with the head of the roaring jaguar. He is a triumphant warrior, as shown by the lavish display of trophy-heads, skull ornaments, and the full-figure diminutive captive attached to his dress.

THE T-SHAPED NICHES

Two T-shaped niches were found *in situ* in the first room, one to the east, the other to the west. The better-preserved east niche was surrounded by a band inscribed with eighteen glyph blocks: six along the base, two on each side of the T's stem, and four along its arms. No glyphs were found *in situ* above the niche,

and it is uncertain if the band enclosed the niche completely.

The T-shape is a symbol of the earth; we already saw it in the forehead of the earth monster on the northeast and northwest jambs and framing a *cauac* monster on the southwest jamb. It is the upper part of the cruciform medallion and is used to indicate the earth. The niches' content may have been either an image of the earth (as on the pedestal of the southwest jamb) or earthly/underworld creatures.

The inscription framing the west niche is an Initial Series that can be reconstructed as follows: [ISIG] 9.18.[10].17.18 4 [Edznab 1 Zac] (Baudez and Riese 1990).

THE RECTANGULAR NICHES

Two rectangular niches were in the south wall of the first room on both sides of the inner door; more were probably in the back room and even outside. The outset niches project 19 cm beyond the wall. They are closed on top by two bunches of feathers starting 20 cm apart. On the sides the niche is flanked by the braid-and-tassel. The inner niche, being 34 cm wide, 57 cm high, and 30 cm deep, could only contain a small sculpture.

THE INTERIOR STEP (OR BENCH)
(fig. 97):

The back room is 60 cm higher than the front room; the step that makes up that difference extends on the south side of the first to produce a bench. Its front carries eight carved masks. Each is composed of two rows of two stones each. The lower row is outset, below and on the sides, against a plain background. The upper row is on the same plane: blocks with *cauac* elements fill the space between two masks. These average 56 by 40 cm.

The upper row, where the bunch of grape and the three rings element alternate, represents the earth supported by eight masks. The even ones (2, 4, 6, 8) are those of the *cauac* monster: *cauac* elements are scattered on the forehead, the eyes, and the cheeks of the saurian face. The odd masks have a jaguar mouth, squint eyes, filed incisors, and T616b on the forehead and are images of the Jaguar Sun. Thus, for every cardinal direction two masks express the basic duality of the earth: the nourishing earth on one side, the abode of the dead on the other. This same opposition is translated in comparable terms on the bench of Structure 9M-146, which is supported by four pairs of two contrasting figures: *bacab* and death.

THE TOMB

The tomb located under the second room of Temple 18, has been described in detail by Becker et al. (1983). It consists of an antechamber with a crypt dug into it. It is a vaulted and almost squared space. Five niches were in the chamber: two in the west wall and one on every other side. Three more were in the crypt: to the west, north, and south. All these niches have the form of an inverted T. Since the tomb is the place of the dead and part of the underworld, its niches are the mirror images of those built in the temple above at surface level.

Associated Monuments

CPN 31 (ALTAR R)
(Maudslay 1889–1902: vol. I, pl. 94a).

On this prismatic monolith (100 cm by 80 cm by 33 cm) one vertical side is sculpted as a death head. The other three vertical sides are sculpted with hieroglyphic inscriptions. The top is plain. CPN 31 was found on Structure 17, 1 or 2 m to the north of the first step of the stairway that rises to Structure 18, according to Maudslay's map. It was brought to London and is currently in the holdings of the British Museum. According to its location, CPN 31 may have been associated with Structures 17, 18, or 19. The former predates Structure 18 and is probably coeval with Structure 16, dated at 9.17.5.3.4 by CPN 30. Assuming that the Calendar Round date on CPN 31, 7 Ahau 3 Zip, corresponds to the Long Count date 9.18.2.8.0, this monument postdates the inauguration of Structures 16 and 17. Structure 19 was built after Structure 18. The latter bears the date 9.18.5.16.18, that is 3 tuns, 8 uinals, and 18 kins after the date on CPN 31. The most probable association of this monument is thus with Structure 18.

The skeletal head looks human and is provided with a lower jaw. The eyes are death eyes. The entire face wears the diagnostic signs for bone: wavy lines, crescents, and circlets. The human ears are adorned with a death eye on top and a nonidentified tripar-

tite element below. Two large T58 signs flank the head.

CPN 60 (STELA 11)
(fig. 98)

This is a column with an almost circular perimeter. It is 108 cm high (including a plain butt of 33 cm) and measures 33 to 42 cm in diameter. It was found in two separate parts that fit neatly together. The entire periphery is carved in low relief. Two-thirds of it are occupied by a standing figure, while the remaining third carries a hieroglyphic inscription. The upper, larger part of this monument was discovered by the Peabody Museum expedition lying in the corridor between Structures 16 and 17. On the published map (Gordon 1896), it is located near the base of the central stairway of Structure 17. In 1979 the PAC unearthed the lower and smaller fragment in the loose rubble on the southwest corner of Structure 18, just south of the viaduct that connects it with Structure 16. This fragment was identified as part of CPN 60 by Riese, and, upon his suggestion, both were fitted together and placed in the local Museum at Copán Ruinas, where the upper part already was located. Judging from the locations where both fragments of CPN 60 were found, it is almost certain that it originally stood somewhere on Structure 18. Its reduced size and unusual columnar form also suggest that CPN 60 was not an independent and outdoor monument, but probably stood inside the building. The south room of Structure 18, above the royal(?) tomb, is its most likely original location, suggested by the death-related iconography of its human representation. The placement of a stela inside a temple is quite uncommon, but occurs at least once with Stela 63 (Fash 1991: 81). At Toniná the base of a prismatic stela (M. 74) was found set into the floor of the back room of Temple D5-1, and similar settings are reported from Tikal (Stela 31) and Yaxchilán (Stela 32).

Description: A human figure stands on a large shell while two other shells flank his legs up to the waist. This enclosure, symbol of the underworld, indicates that the man is dead. The man is bald but has whiskers and a false beard. He is flanked by two braid-and-tassel (T58) motifs, an arrangement very similar to that of the temple's rectangular niches. The figures presses a bar against his chest; it is not the usual serpent bar, but rather looks like a pectoral with tripartite ends. The ax-and-smoke motif protrudes from his forehead. It is exclusive to supernaturals and dead humans, such as the prone figures on the Hieroglyphic Stairway of Structure 26. Plants and feathers spring from the skull. The belt is adorned with crossed-bands and fringed by tinklers and two pendant tassels. Tubular beads continue the loincloth. The wristlets, anklets, and the collar are made of jade beads.

If the relief indeed represents a dead ruler and the monument comes from Structure 18, then there must be a close relationship between the tomb and this column. I have already noted that its small size and its location when found suggest an interior location, possibly in the room above the tomb. Together with CPN 31, CPN 60 may have formed a stela-altar ensemble in the temple's backroom. According to Riese, "The syntax, and therefore the overall meaning of this text, are still obscure. Possibly two or three persons are named, somehow linked and associated with an uncertain date. CPN 60 very likely represents the late ruler Rising-Sun, since the text names him, gives his age, and information about his predecessors; and this is iconographically explained as reference to a dead person" (Baudez and Riese 1990: vol. 2, p. 500).

GENERAL SUMMARY OF STRUCTURE 18

According to the information contained in the doorjambs, this building and its associated sculptures are dedicated to the Copán king Rising-Sun. The Initial Series 9.18.10.17.18 dates the temple at A.D. 800, the latest date associated with a building in Copán. Properly understood, this does not suggest that there could have been no further architectural activities before the general collapse; it simply indicates that Temple 18 was one of the last important constructions in the city. The absence of glyphs G and F and the Lunar Series may indicate that by this period the intellectual level had already decreased considerably from twenty years prior, when Temple 11 was erected with its extensive information about astronomical and divine cycles.

and it is uncertain if the band enclosed the niche completely.

The T-shape is a symbol of the earth; we already saw it in the forehead of the earth monster on the northeast and northwest jambs and framing a *cauac* monster on the southwest jamb. It is the upper part of the cruciform medallion and is used to indicate the earth. The niches' content may have been either an image of the earth (as on the pedestal of the southwest jamb) or earthly/underworld creatures.

The inscription framing the west niche is an Initial Series that can be reconstructed as follows: [ISIG] 9.18.[10].17.18 4 [Edznab 1 Zac] (Baudez and Riese 1990).

THE RECTANGULAR NICHES

Two rectangular niches were in the south wall of the first room on both sides of the inner door; more were probably in the back room and even outside. The outset niches project 19 cm beyond the wall. They are closed on top by two bunches of feathers starting 20 cm apart. On the sides the niche is flanked by the braid-and-tassel. The inner niche, being 34 cm wide, 57 cm high, and 30 cm deep, could only contain a small sculpture.

THE INTERIOR STEP (OR BENCH)
(fig. 97):

The back room is 60 cm higher than the front room; the step that makes up that difference extends on the south side of the first to produce a bench. Its front carries eight carved masks. Each is composed of two rows of two stones each. The lower row is outset, below and on the sides, against a plain background. The upper row is on the same plane: blocks with *cauac* elements fill the space between two masks. These average 56 by 40 cm.

The upper row, where the bunch of grape and the three rings element alternate, represents the earth supported by eight masks. The even ones (2, 4, 6, 8) are those of the *cauac* monster: *cauac* elements are scattered on the forehead, the eyes, and the cheeks of the saurian face. The odd masks have a jaguar mouth, squint eyes, filed incisors, and T616b on the forehead and are images of the Jaguar Sun. Thus, for every cardinal direction two masks express the basic duality of the earth: the nourishing earth on one side, the abode of the dead on the other. This same opposition is translated in comparable terms on the bench of Structure 9M-146, which is supported by four pairs of two contrasting figures: *bacab* and death.

THE TOMB

The tomb located under the second room of Temple 18, has been described in detail by Becker et al. (1983). It consists of an antechamber with a crypt dug into it. It is a vaulted and almost squared space. Five niches were in the chamber: two in the west wall and one on every other side. Three more were in the crypt: to the west, north, and south. All these niches have the form of an inverted T. Since the tomb is the place of the dead and part of the underworld, its niches are the mirror images of those built in the temple above at surface level.

Associated Monuments

CPN 31 (ALTAR R)
(Maudslay 1889–1902: vol. I, pl. 94a).

On this prismatic monolith (100 cm by 80 cm by 33 cm) one vertical side is sculpted as a death head. The other three vertical sides are sculpted with hieroglyphic inscriptions. The top is plain. CPN 31 was found on Structure 17, 1 or 2 m to the north of the first step of the stairway that rises to Structure 18, according to Maudslay's map. It was brought to London and is currently in the holdings of the British Museum. According to its location, CPN 31 may have been associated with Structures 17, 18, or 19. The former predates Structure 18 and is probably coeval with Structure 16, dated at 9.17.5.3.4 by CPN 30. Assuming that the Calendar Round date on CPN 31, 7 Ahau 3 Zip, corresponds to the Long Count date 9.18.2.8.0, this monument postdates the inauguration of Structures 16 and 17. Structure 19 was built after Structure 18. The latter bears the date 9.18.5.16.18, that is 3 tuns, 8 uinals, and 18 kins after the date on CPN 31. The most probable association of this monument is thus with Structure 18.

The skeletal head looks human and is provided with a lower jaw. The eyes are death eyes. The entire face wears the diagnostic signs for bone: wavy lines, crescents, and circlets. The human ears are adorned with a death eye on top and a nonidentified tripar-

tite element below. Two large T58 signs flank the head.

CPN 60 (STELA 11)
(fig. 98)

This is a column with an almost circular perimeter. It is 108 cm high (including a plain butt of 33 cm) and measures 33 to 42 cm in diameter. It was found in two separate parts that fit neatly together. The entire periphery is carved in low relief. Two-thirds of it are occupied by a standing figure, while the remaining third carries a hieroglyphic inscription. The upper, larger part of this monument was discovered by the Peabody Museum expedition lying in the corridor between Structures 16 and 17. On the published map (Gordon 1896), it is located near the base of the central stairway of Structure 17. In 1979 the PAC unearthed the lower and smaller fragment in the loose rubble on the southwest corner of Structure 18, just south of the viaduct that connects it with Structure 16. This fragment was identified as part of CPN 60 by Riese, and, upon his suggestion, both were fitted together and placed in the local Museum at Copán Ruinas, where the upper part already was located. Judging from the locations where both fragments of CPN 60 were found, it is almost certain that it originally stood somewhere on Structure 18. Its reduced size and unusual columnar form also suggest that CPN 60 was not an independent and outdoor monument, but probably stood inside the building. The south room of Structure 18, above the royal(?) tomb, is its most likely original location, suggested by the death-related iconography of its human representation. The placement of a stela inside a temple is quite uncommon, but occurs at least once with Stela 63 (Fash 1991: 81). At Toniná the base of a prismatic stela (M. 74) was found set into the floor of the back room of Temple D5-1, and similar settings are reported from Tikal (Stela 31) and Yaxchilán (Stela 32).

Description: A human figure stands on a large shell while two other shells flank his legs up to the waist. This enclosure, symbol of the underworld, indicates that the man is dead. The man is bald but has whiskers and a false beard. He is flanked by two braid-and-tassel (T58) motifs, an arrangement very similar to that of the temple's rectangular niches. The figures presses a bar against his chest; it is not the usual serpent bar, but rather looks like a pectoral with tripartite ends. The ax-and-smoke motif protrudes from his forehead. It is exclusive to supernaturals and dead humans, such as the prone figures on the Hieroglyphic Stairway of Structure 26. Plants and feathers spring from the skull. The belt is adorned with crossed-bands and fringed by tinklers and two pendant tassels. Tubular beads continue the loincloth. The wristlets, anklets, and the collar are made of jade beads.

If the relief indeed represents a dead ruler and the monument comes from Structure 18, then there must be a close relationship between the tomb and this column. I have already noted that its small size and its location when found suggest an interior location, possibly in the room above the tomb. Together with CPN 31, CPN 60 may have formed a stela-altar ensemble in the temple's backroom. According to Riese, "The syntax, and therefore the overall meaning of this text, are still obscure. Possibly two or three persons are named, somehow linked and associated with an uncertain date. CPN 60 very likely represents the late ruler Rising-Sun, since the text names him, gives his age, and information about his predecessors; and this is iconographically explained as reference to a dead person" (Baudez and Riese 1990: vol. 2, p. 500).

GENERAL SUMMARY OF STRUCTURE 18

According to the information contained in the doorjambs, this building and its associated sculptures are dedicated to the Copán king Rising-Sun. The Initial Series 9.18.10.17.18 dates the temple at A.D. 800, the latest date associated with a building in Copán. Properly understood, this does not suggest that there could have been no further architectural activities before the general collapse; it simply indicates that Temple 18 was one of the last important constructions in the city. The absence of glyphs G and F and the Lunar Series may indicate that by this period the intellectual level had already decreased considerably from twenty years prior, when Temple 11 was erected with its extensive information about astronomical and divine cycles.

and it is uncertain if the band enclosed the niche completely.

The T-shape is a symbol of the earth; we already saw it in the forehead of the earth monster on the northeast and northwest jambs and framing a *cauac* monster on the southwest jamb. It is the upper part of the cruciform medallion and is used to indicate the earth. The niches' content may have been either an image of the earth (as on the pedestal of the southwest jamb) or earthly/underworld creatures.

The inscription framing the west niche is an Initial Series that can be reconstructed as follows: [ISIG] 9.18.[10].17.18 4 [Edznab 1 Zac] (Baudez and Riese 1990).

THE RECTANGULAR NICHES

Two rectangular niches were in the south wall of the first room on both sides of the inner door; more were probably in the back room and even outside. The outset niches project 19 cm beyond the wall. They are closed on top by two bunches of feathers starting 20 cm apart. On the sides the niche is flanked by the braid-and-tassel. The inner niche, being 34 cm wide, 57 cm high, and 30 cm deep, could only contain a small sculpture.

THE INTERIOR STEP (OR BENCH)
(fig. 97):

The back room is 60 cm higher than the front room; the step that makes up that difference extends on the south side of the first to produce a bench. Its front carries eight carved masks. Each is composed of two rows of two stones each. The lower row is outset, below and on the sides, against a plain background. The upper row is on the same plane: blocks with *cauac* elements fill the space between two masks. These average 56 by 40 cm.

The upper row, where the bunch of grape and the three rings element alternate, represents the earth supported by eight masks. The even ones (2, 4, 6, 8) are those of the *cauac* monster: *cauac* elements are scattered on the forehead, the eyes, and the cheeks of the saurian face. The odd masks have a jaguar mouth, squint eyes, filed incisors, and T616b on the forehead and are images of the Jaguar Sun. Thus, for every cardinal direction two masks express the basic duality of the earth: the nourishing earth on one side, the abode of the dead on the other. This same opposition is translated in comparable terms on the bench of Structure 9M-146, which is supported by four pairs of two contrasting figures: *bacab* and death.

THE TOMB

The tomb located under the second room of Temple 18, has been described in detail by Becker et al. (1983). It consists of an antechamber with a crypt dug into it. It is a vaulted and almost squared space. Five niches were in the chamber: two in the west wall and one on every other side. Three more were in the crypt: to the west, north, and south. All these niches have the form of an inverted T. Since the tomb is the place of the dead and part of the underworld, its niches are the mirror images of those built in the temple above at surface level.

ASSOCIATED MONUMENTS

CPN 31 (ALTAR R)
(Maudslay 1889–1902: vol. I, pl. 94a).
On this prismatic monolith (100 cm by 80 cm by 33 cm) one vertical side is sculpted as a death head. The other three vertical sides are sculpted with hieroglyphic inscriptions. The top is plain. CPN 31 was found on Structure 17, 1 or 2 m to the north of the first step of the stairway that rises to Structure 18, according to Maudslay's map. It was brought to London and is currently in the holdings of the British Museum. According to its location, CPN 31 may have been associated with Structures 17, 18, or 19. The former predates Structure 18 and is probably coeval with Structure 16, dated at 9.17.5.3.4 by CPN 30. Assuming that the Calendar Round date on CPN 31, 7 Ahau 3 Zip, corresponds to the Long Count date 9.18.2.8.0, this monument postdates the inauguration of Structures 16 and 17. Structure 19 was built after Structure 18. The latter bears the date 9.18.5.16.18, that is 3 tuns, 8 uinals, and 18 kins after the date on CPN 31. The most probable association of this monument is thus with Structure 18.

The skeletal head looks human and is provided with a lower jaw. The eyes are death eyes. The entire face wears the diagnostic signs for bone: wavy lines, crescents, and circlets. The human ears are adorned with a death eye on top and a nonidentified tripar-

tite element below. Two large T58 signs flank the head.

CPN 60 (STELA 11)
(fig. 98)

This is a column with an almost circular perimeter. It is 108 cm high (including a plain butt of 33 cm) and measures 33 to 42 cm in diameter. It was found in two separate parts that fit neatly together. The entire periphery is carved in low relief. Two-thirds of it are occupied by a standing figure, while the remaining third carries a hieroglyphic inscription. The upper, larger part of this monument was discovered by the Peabody Museum expedition lying in the corridor between Structures 16 and 17. On the published map (Gordon 1896), it is located near the base of the central stairway of Structure 17. In 1979 the PAC unearthed the lower and smaller fragment in the loose rubble on the southwest corner of Structure 18, just south of the viaduct that connects it with Structure 16. This fragment was identified as part of CPN 60 by Riese, and, upon his suggestion, both were fitted together and placed in the local Museum at Copán Ruinas, where the upper part already was located. Judging from the locations where both fragments of CPN 60 were found, it is almost certain that it originally stood somewhere on Structure 18. Its reduced size and unusual columnar form also suggest that CPN 60 was not an independent and outdoor monument, but probably stood inside the building. The south room of Structure 18, above the royal(?) tomb, is its most likely original location, suggested by the death-related iconography of its human representation. The placement of a stela inside a temple is quite uncommon, but occurs at least once with Stela 63 (Fash 1991: 81). At Toniná the base of a prismatic stela (M. 74) was found set into the floor of the back room of Temple D5-1, and similar settings are reported from Tikal (Stela 31) and Yaxchilán (Stela 32).

Description: A human figure stands on a large shell while two other shells flank his legs up to the waist. This enclosure, symbol of the underworld, indicates that the man is dead. The man is bald but has whiskers and a false beard. He is flanked by two braid-and-tassel (T58) motifs, an arrangement very similar to that of the temple's rectangular niches. The figures presses a bar against his chest; it is not the usual serpent bar, but rather looks like a pectoral with tripartite ends. The ax-and-smoke motif protrudes from his forehead. It is exclusive to supernaturals and dead humans, such as the prone figures on the Hieroglyphic Stairway of Structure 26. Plants and feathers spring from the skull. The belt is adorned with crossed-bands and fringed by tinklers and two pendant tassels. Tubular beads continue the loincloth. The wristlets, anklets, and the collar are made of jade beads.

If the relief indeed represents a dead ruler and the monument comes from Structure 18, then there must be a close relationship between the tomb and this column. I have already noted that its small size and its location when found suggest an interior location, possibly in the room above the tomb. Together with CPN 31, CPN 60 may have formed a stela-altar ensemble in the temple's backroom. According to Riese, "The syntax, and therefore the overall meaning of this text, are still obscure. Possibly two or three persons are named, somehow linked and associated with an uncertain date. CPN 60 very likely represents the late ruler Rising-Sun, since the text names him, gives his age, and information about his predecessors; and this is iconographically explained as reference to a dead person" (Baudez and Riese 1990: vol. 2, p. 500).

GENERAL SUMMARY OF STRUCTURE 18

According to the information contained in the doorjambs, this building and its associated sculptures are dedicated to the Copán king Rising-Sun. The Initial Series 9.18.10.17.18 dates the temple at A.D. 800, the latest date associated with a building in Copán. Properly understood, this does not suggest that there could have been no further architectural activities before the general collapse; it simply indicates that Temple 18 was one of the last important constructions in the city. The absence of glyphs G and F and the Lunar Series may indicate that by this period the intellectual level had already decreased considerably from twenty years prior, when Temple 11 was erected with its extensive information about astronomical and divine cycles.

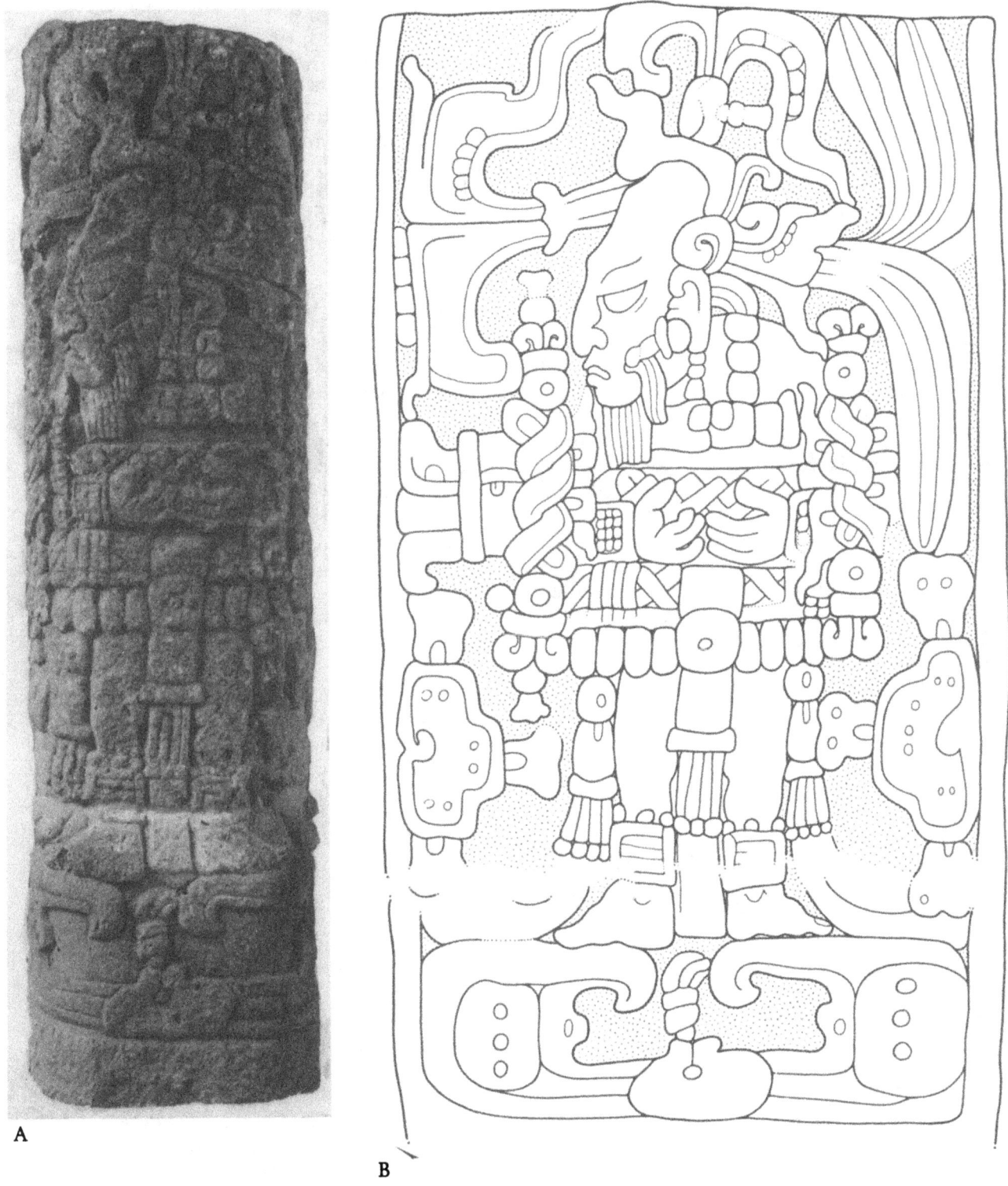

FIG. 98 CPN 60. Photo by J.-P. Courau; drawing by B. Fash.

Although burials have been found in other structures, and isolated Late Classic tombs have been excavated, Structure 18 is the first funerary temple discovered in Copán with associated sculptures that refer explicitly to an identified ruler. The iconography of this temple deals mainly with the nourishing earth theme. The ruler is depicted on the doorjambs and on CPN 60.

The Long Count date from the outer room of the temple is assumed to date the dedication of the structure and not the death of the tomb's occupant. Some of my colleagues cannot accept the hypothesis that Rising Sun was buried there, mainly because the temple is too modest an affair for such a great king. I still think that Structure 18 is Rising Sun's funerary temple for the following reasons. The king is the only person depicted and named on the temple's doorjambs. CPN 60, which shows the dead king, was not found *in situ* (as Schele and Freidel seem to imply—1990: 493, note 76) but has very probably fallen from the inner room of the temple. The funerary temple was connected to Structure 16, the temple-pyramid dedicated to the founder of the dynasty, through a small viaduct. This passage, more symbolic than functional, also served as a gateway to the East Court.

STRUCTURE 22
(figs. 99–103)

This structure has a remarkable position on the Acropolis, comparable only to Structures 16 and 11. It occupies most of the width of the East Court with its front. With its rear oriented toward the north, it overlooks the east sector of the Main Plaza. Its platform, exceptionally high (over 3 m), is E-shaped, with two salients at the southeast and southwest and a projecting stairway in the middle. To the east and west it is flanked by two smaller buildings whose walls lean against its building platform. Trik (1939: 88) concluded that these were later additions, since they were both built secondarily to the platform of the latter. This constructional sequence does not necessarily have far-reaching chronological implications; inasmuch as these secondary buildings look like annexes to Structure 22, they could have been built at the same time as the main structure. According to this hypothesis, the building-platform was built first; this was required in order to present the superstructure on a high pedestal to correspond to its importance; the main building and the two annexes leaning against the platform were then erected.

In 1885 Maudslay explored most of Structure 22. He noticed the sculpted decoration on the outer door of the building and the masks at its corners. He discovered and cleared the relief decoration framing the inner central door. Unfortunately, Maudslay did not consolidate the excavated parts and left the structure exposed. Therefore, during the earthquake of 1934, the entire structure collapsed. From December 1935 to June 1937 the Carnegie Institution, under Trik's direction, reexcavated and consolidated the entire building.

Until recently, it was generally assumed that Structure 22, like its immediate neighbors 21a and 22a and Structures 11, 12, 16, and so forth, was built during the reign of Rising Sun. David Stuart's (1989) interpretation of the temple's inscription has led him to attribute this building to Eighteen-Rabbit. The text begins with a clause stating that on 5 Lamat a katun was completed; Stuart thinks it is the date 9.14.3.6.8 5 Lamat 1 Zip, which falls one katun after the day of the accession of Eighteen-Rabbit, 9.13.3.6.8 7 Lamat 1 Mol. This is no more than a possibility.

ARCHITECTURAL DESCRIPTION
(fig. 99)

The ground plan is rectangular. Two long, narrow rooms oriented east-west are linked by a short corridor; the latter and the back room are higher by half a meter than the front room. To this H-shaped plan were added two other rectangular rooms in a north-south direction. At the far end of the west room are a bench and a niche, to which Hohmann and Vogrin (1982) add a loophole. Another niche is in the west wall, its back pierced with a loopholelike window, 20 cm wide and 80 cm, then 65 cm, high, which opens to less than 1 m from the walls of Structure 22A. Under the niche the traces of a passage (80 cm wide) to the outside were found; subsequently it had been partly filled up and its top kept open as a window for ventilation. The east room, which might have had a niche and window too, has a more complex history. The

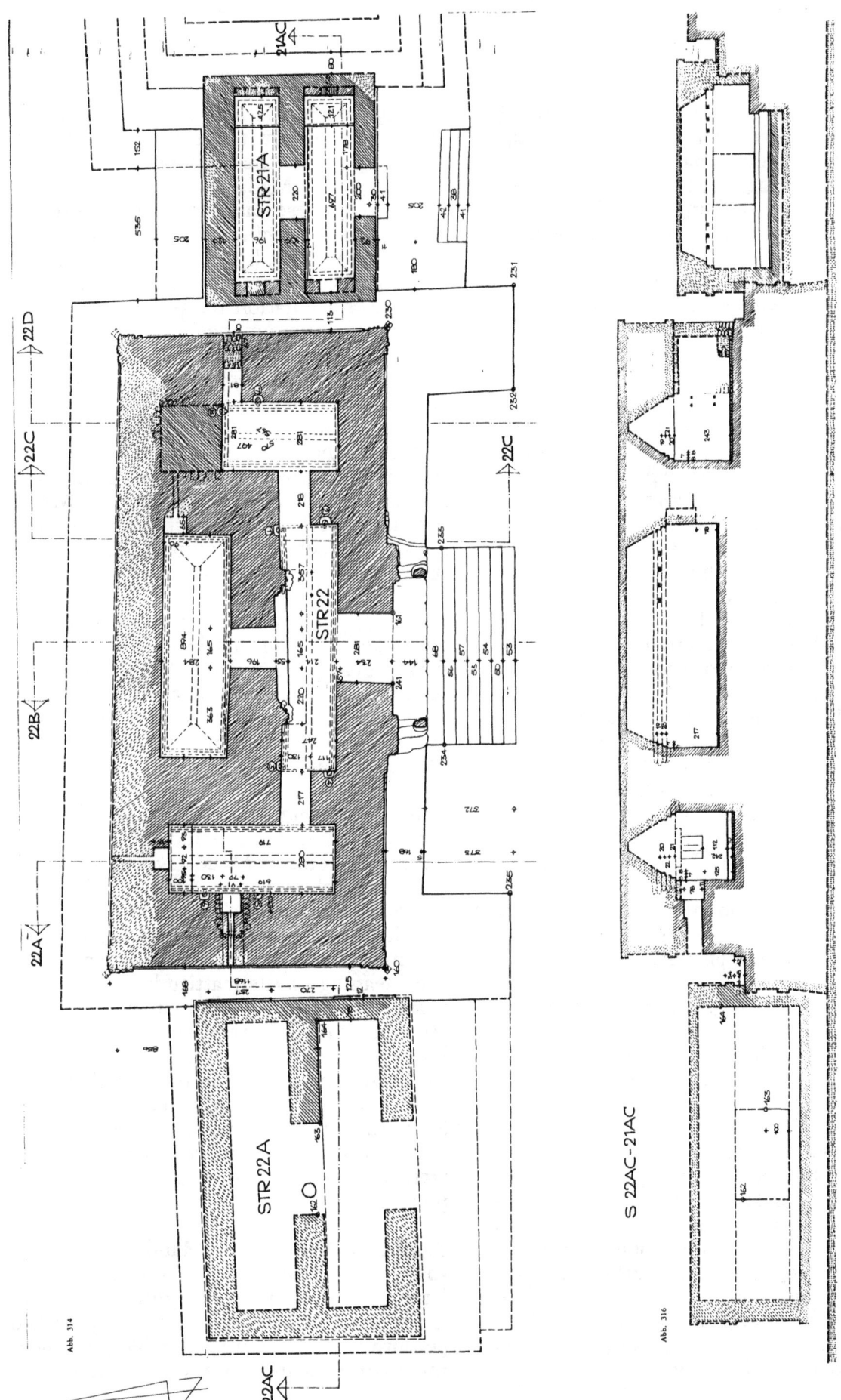

FIG. 99 Structures 22A, 22, and 21A: plan and section. After H. Hohmann and A. Vogrin, from *Architektur von Copán (Honduras)*. Copyright © 1982 by Akademische Druck- und Verlagsanstalt.

northern third of the room was obstructed, the passage outward first open, then filled up. The reasons for these changes are not apparent; Trik (1939) suggested that they were necessitated by the building of Structure 21a. This however, is hypothetical. I have elsewhere (Baudez 1987) voiced my skepticism about the hypothesis that the west window was used for astronomical sightings; not only because of the architectural history of the window, but also because the view was obstructed by Structure 22A.

The Entrance: This was framed by a representation of a reptilian lower jaw in which the front teeth made up the horizontal lower part, while the jaw's sides appear vertically. The teeth on the riser of the last stair's step are preceded by a line of beads shown as disks within medallions. The jaw's sides—or at least what remains of them—are divided into ovals including three disks, either plain or marked with the three circles of the cauac element. The same motif identifies the profile *cauac* heads which jut out of the jaws (fig. 100b, c); they represent molars, as on the east side of CPN 4. This has double meaning: the teeth are, like knives, made of stone; besides, they belong to the (cauac) earth monster. The fangs are more realistic: two large monolithic hooks that rest in specially designed channels on the last step. Grooved bands decorated with circles and with an undulating and pointed end hang from behind the jaws; they probably represent the plants that jut out of the ears of cosmic monsters.

The Four Corners (fig. 100a): Every corner was adorned with two superimposed *cauac* monster masks of monumental size (1.15 m high). According to Trik (1939), the two masks that composed the mosaic were made of nineteen carved stones each. The masks have a forehead adorned with two large scrolls, eyes half closed by a long-lashed lid, and are underlined by T23. The upper jaw has two molars and a scroll on each side; there is no lower jaw. The very large snout is a wide, wavy, projecting strip. The earthly nature of the monster is made clear by three circles placed on the forehead and on the snout. The square earplug has a scroll and plant forms above, and a bone below it.

The Upper Façade: To reconstruct the upper façade we must use the meager information given by the fragments found in the excavations by Maudslay and Trik. Extrapolating from these data may produce very different results, judging by the reconstructions published by Trik (1939: frontispiece) and by Proskouriakoff (1946: 45). While the former presents a decoration made of mosaic *cauac* masks, the latter emphasizes the importance of the "maize god" and his attendants. Since the sculpture fragments gathered in the East Court have been moved several times and since they may come from Structures 20, 21, 21A, and others as well as from Structure 22, not much can be expected from their study. However, the documents published by Maudslay and by Trik demonstrate that the upper façade was certainly complex and included many different elements.

Earth Monster Masks: Trik was able to reconstruct ten *cauac* masks in three parts that very probably come from the south façade. As a whole, they make up an area 11 m long, thus demonstrating the relative importance of this motif on the façade and the other sides of the building.

Maize Impersonator Statues (fig. 101): Statues with one hand lowered and the other raised were interpreted by Maudslay (1889–1902, vol. I, pl. 17a, b) as young girls clapping their hands while singing. According to Proskouriakoff (1946: 44), these statues are male and impersonate maize. We still do not know the meaning of their attitude, which has a variant: one raised hand at the end of a straight arm, the other one resting on the body (Núñez Chinchilla 1962: 95). Maudslay mentions that three of his "singing girls" were found in the narrow passage between Structures 22A and 22. In his excavations, Trik (1939) picked up fragments of these statues but could not reassemble any complete figure.

Statues of Dignitaries: Maudslay found torsos wearing a pectoral and a bead cape. The latter is worn neither by grotesques nor by maize impersonators, but only by anthropomorphs such as rulers, nobles, or ancestors. Unfortunately, we do not know the

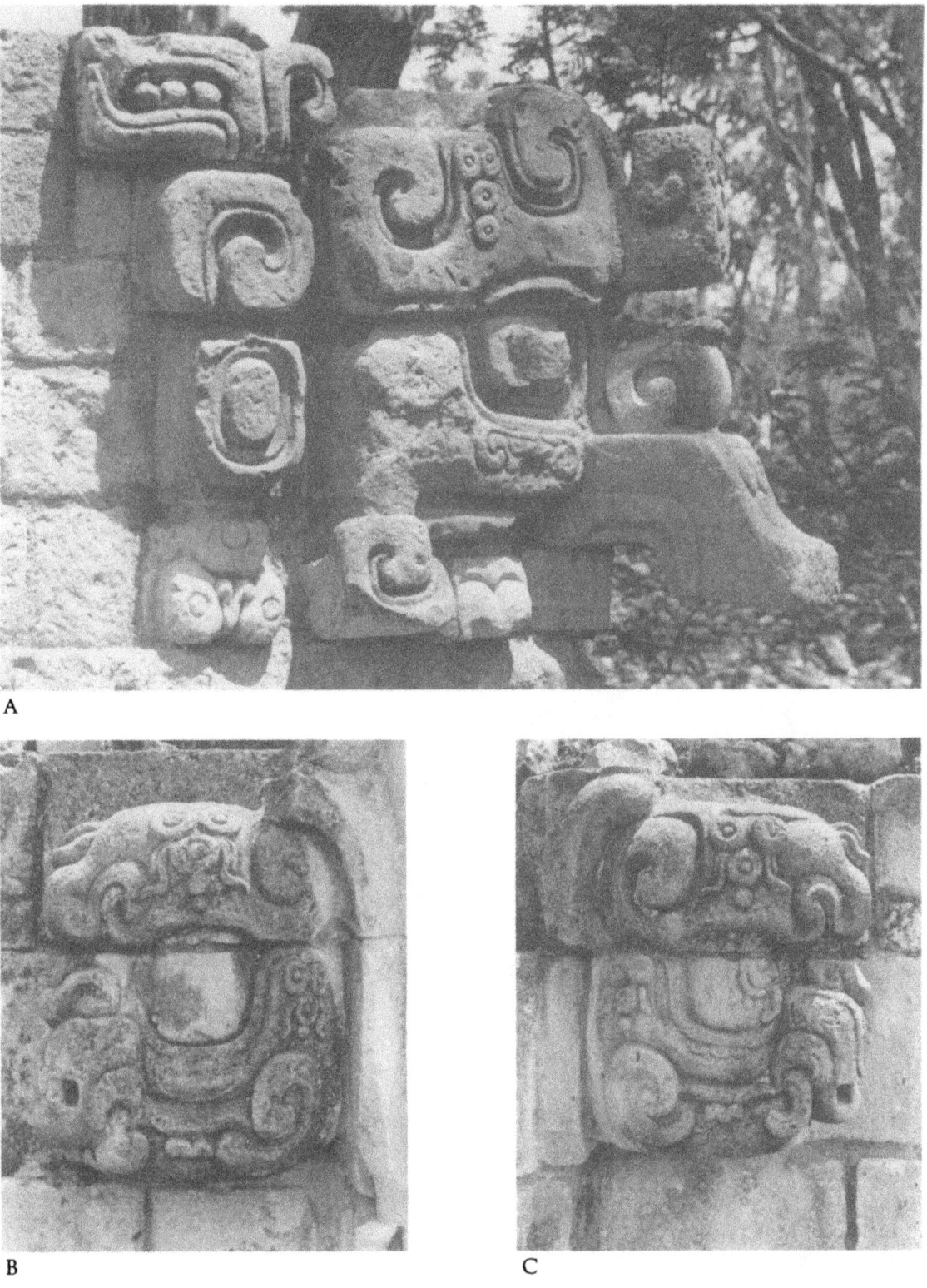

FIG. 100 *Cauac* masks from Structure 22: (a) corner mask; (b,c) masks at entrance. Photos by J.-P. Courau.

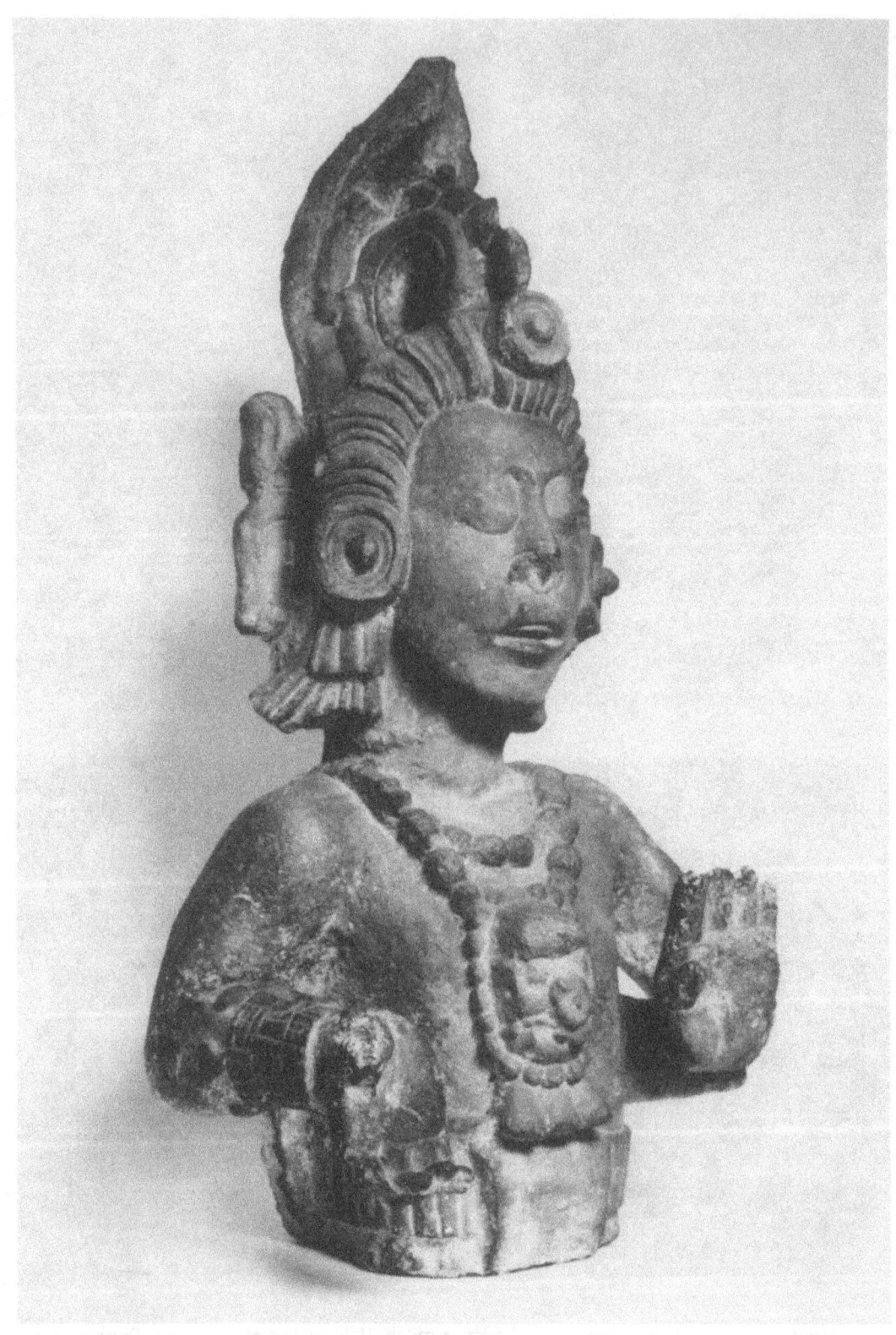

FIG. 101 Structure 22: statue impersonating maize from façade. Photo courtesy of the Museum of Mankind, by permission of the Trustees of the British Museum.

respective proportion of these two classes (grotesques vs. anthropomorphs), not separated by the investigators. On the court's side, Maudslay found "a number of headless busts and other fragments." Trik reports that fragments of hands, arms and legs were found near the building and in the East Court. There were also human heads with headdresses analogous to the ones worn on stelae (Maudslay 1889–1902, vol. I, pl. 19c).

Statues of Grotesque Creatures: Trik (1939) mentions numerous grotesque heads. One may be seen on Maudslay's plate 19c.

Miscellaneous Sculpture: Among the miscellaneous sculpture fragments found with Temple 22 were six fragments from a featherwork background such as the one decorating the outer walls of Structure 18; a knotted water lily headdress usually associated with *bacab*s; and a hand holding an upside-down lancet, such as the one presented on the jambs of the Temple of the Cross at Palenque.

Interpretation of the Facade Decoration: Assuming that the outer door represents the mouth of a *cauac* monster and that the masks of the same creature adorn the building's corners, we may propose that the structure as a whole represents the earth (and not a "mountain"; see the discussion of *cauac* masks in chapter 4). The north wall is destroyed and we do not know whether it supported another monster head, which then would be the second head of a bicephalic creature. Be that as it may, the south door represents its head (unique or front) and its sides are figured by the building's walls wearing the same masks. We must remind ourselves that several *cauac* masks often indicate the body of the earth monster (CPN 3, CPN 25, etc.). The same function is here taken by the corner masks. They have often been compared to the superimposed masks that "adorn" the Chenes buildings; in both cases, they are provided with a large undulating snout. The masks used in Yucatán architecture are almost always attributed to the god Chac; Copán Structure 22 indicates that at least some of them could represent the cosmic monster, especially in its earthly form.

The decoration of the upper façade was very varied. Much space was given to the earth through the *cauac* masks, which perhaps had no other function than to confirm the message expressed by the corner masks. Personified maize had a nonnegligible but less important role than formerly thought, as some of these statues actually represent kings. He was surrounded by fertility symbols. Supernaturals—in the grotesque category—assisted him.

Interior Decoration (figs. 102 and 103): The high step and the entrance to the back room are sculpted to represent a tripartite universe: the bench is the underworld; the bicephalic monster figures the sky; and the middle, terrestrial level, is represented by the two *bacab*s who support the sky monster above the door. On the latter, seven grotesque figures who cling to S-shaped objects replace the monster's body.

The Step-Bench: Except for two high-relief skulls at the ends, the riser is divided into two registers. The upper one is plain except for oblique grooves, at intervals of 42 cm, and groups of holes placed near the lower edge of this band. The distance between holes within the same group varies from 40 to 50 cm and that separating two groups is about 80 cm. The holes themselves (2.5 cm in diameter and 6 to 8 cm deep) almost certainly held tenons of movable ornaments.

The lower half of the riser consists of a double-columned row of glyph blocks. Three skulls divide the text into four sections. The death heads at the ends have circlets engraved on their skulls, death eyes with a crescent-shaped pupil, and a large circle on the temple. The rectangular earplug has a death eye above and a supple trifid band below it. The outside of each head has a rectangular design made of two fitted elements. The one to the left is plain except for three circles on the upper part. To the right, to the sides and below, are a blackened zone and two twisted strips.

The Bacabs: The *bacab*s just above the death heads face the center of the door. They are half-squatting with one foot on the ground while the other leg is bent under the body. The outer hand holds up one of the

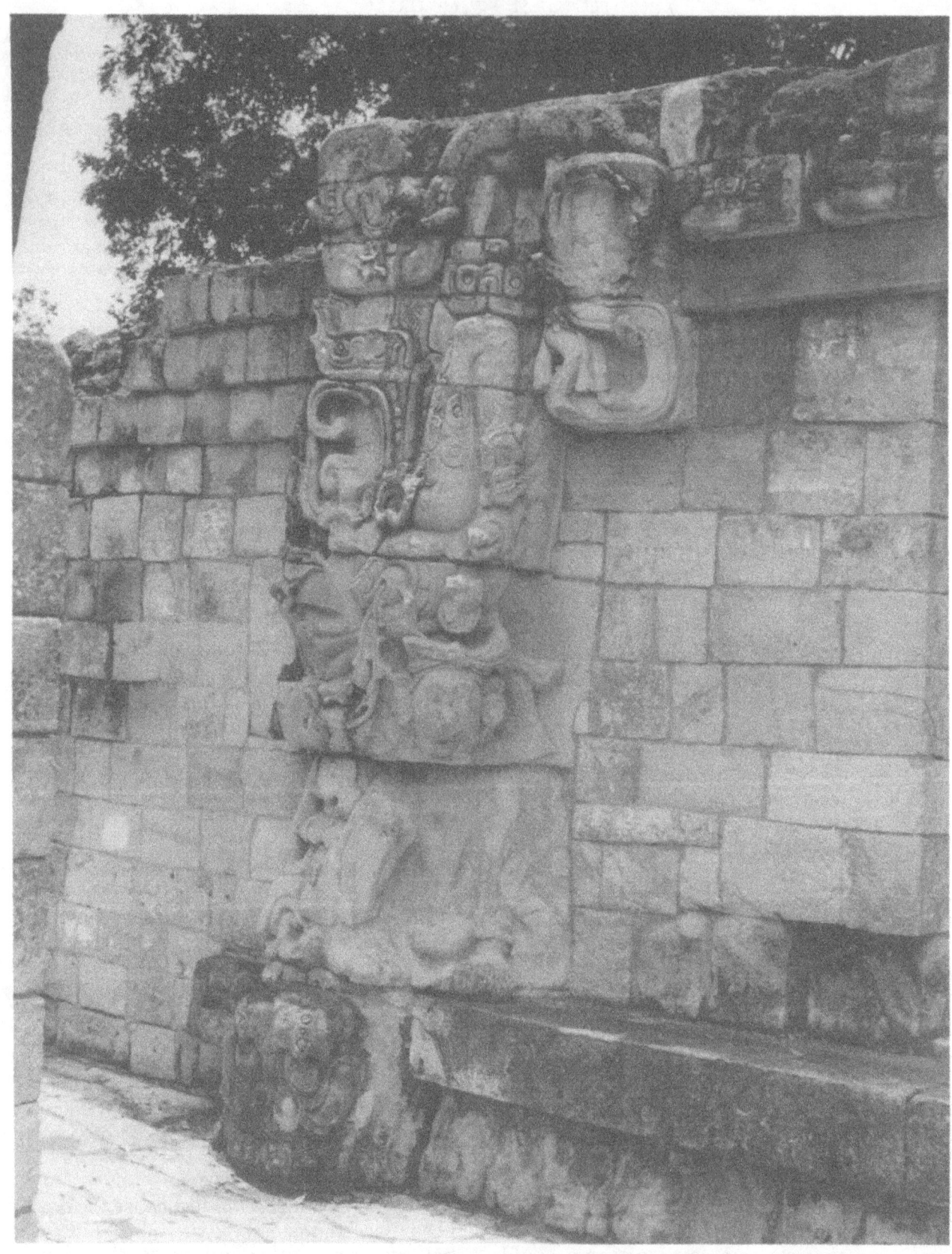

FIG. 102 Structure 22: inner door, western section. Photo by J.-P. Courau.

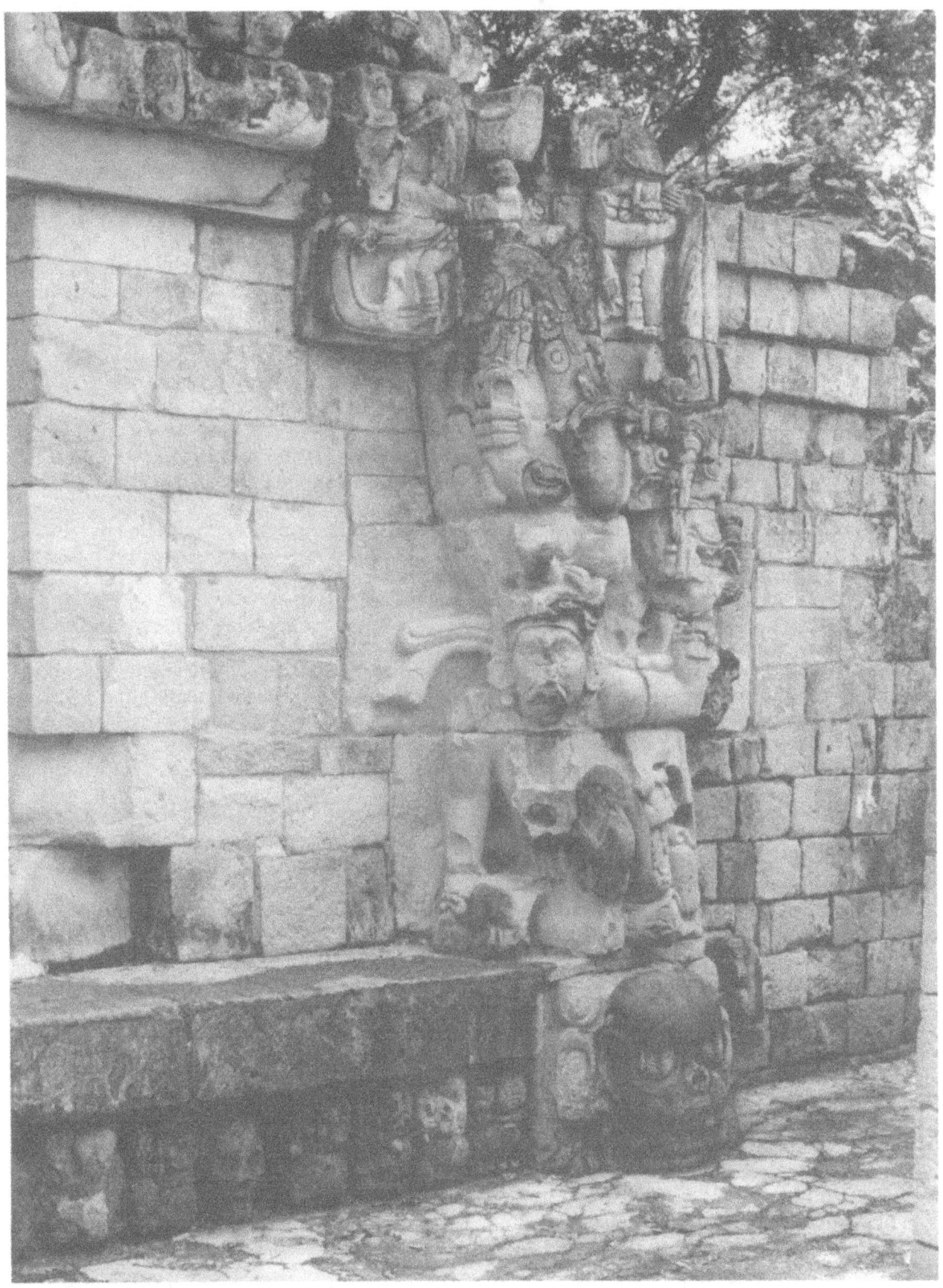

FIG. 103 Structure 22: inner door, eastern section. Photo by J.-P. Courau.

heads of the sky monster and the other hand holds of the ground. A large profile mask that faces outward, very similar to the ones stacked on the sides of CPN 3, is carved on their side. The mask is identified as *cauac* by the three high-relief circles on the forehead and by the concentric semicircles edged with dots in the eye. This mask recalls the carving *cauac* masks on the body of terrestrial beings, generally on the *cauac* monster itself, and stresses the earthly nature of the *bacab*s. The eastern *bacab*'s back is adorned with a tassel composed of a shell, beads, and a *kan* cross in a cartouche flanked with bones. A series of low-relief rectangles and circles is carved on the back of his companion. A shell hangs from a collar of round beads. Another distinctive trait of *bacab*s is the round ear ornament with three circlets; here it is crowned with a scroll (plant form?). Water lilies—not a net or blackened ribbons—are tied on the forehead. A loop and a blackened end jut out from behind the head. The hair is gathered in one tress tied with a strap that falls forward. Wristlets of the ribbon-on-band type are still visible on the eastern *bacab*. The straight body of a serpent is on the shoulder and behind the forearm of this same *bacab*: it seems to be bicephalic with a realistic head to the right and a conventional one on the other side.

The Sky Monster: To the west (left) a *bacab* supports the snout of the half-broken monster head with open mouth. A crown of hair frames the forehead while a tress falls forward. A large scroll whose base is tied with a water lily rises above the brow. The forehead is marked with a deep comma-like wrinkle and the eye has a scroll pupil. A double scroll whose wavy branch is marked with T2 and topped with T511 juts out from the shell and replaces the ear. The fangs at the snout's ends seem skeletal; but the lower jaw is alive. A long scroll with attached beads, a half-shell, and a bone are in front of the upper jaw. The thick upper lip curls over protruding, perhaps filed, incisors. A scroll juts out of the mouth. There is no lower jaw.

The head to the east seems to be alive, but the lower jaw is skeletal and marked with a wavy line. The hair is pulled back above the forehead and falls along the sides. The eye is scroll-pupiled, and the ear is human, with a scroll above and a bead below. Plant forms, probably maize, grow from the ear, and a tassel hangs from behind the head. The latter consists of a medallion marked with *cimi*, a long bead, a tripartite element, and feathers. *Kin* is stamped on the forehead and a large spine is on the skull. A shell is to its left and crossed-bands are to its right, near the monster's thigh. A large double scroll emanates from the mouth with a shell with attached upside-down grotesques; the shoulder, neck with collar and pectoral, and one hand of the latter are identifiable. Another hand is on the upper rim of the shell, but it is unclear if this belongs to the same creature. The grotesque has T616b on the forehead; a long lock of hair is pulled back and a quiff tied on top of the head. The human ears have pendant beads; a shell or a jaguar ear tops the ear. The eye sockets look empty; the thick lips have wrinkles framing the corner of the mouth. A partially broken lolling tongue hangs from the agnathic mouth.

The monster has a leg bent over and behind each head, which bear the signs that traditionally represent the belly and back scales of a serpent. The inverted personified lancet is tied to its ankle; the leg is of a deer. Above both knees is T2 (star or Venus) topped with *ahau* (T533), which signifies "lord star" or "lord Venus."

We would expect to see either the monster's body above the door or a sky band. Instead, we find a series of S-shapes with a grotesque figure associated with each one. From west to east we see the following:

1. A figure who originally passed his now-missing head through the first loop of a horizontal S wears a collar made of radiating tubes with a pendant tassel made of a bead, crossed-bands, and a tripartite element.
2. In a vertical S a creature who still had a head in Maudslay's times is visible on the photo. He has a death head with foliage growing from behind the ears. *Ahau* and two feathers or ribbons are atop his headdress. The wristlets and anklets consist of a band with three tubular beads. The ends of the loincloth are blackened and T616b marks the thigh. The right foot is human; the left foot—today broken—seems to have been replaced by a serpent head.
3. A very eroded figure lies in a horizontal S, with

the head facing westward. A large round bead with radiating tubes on the sides hangs on the chest. The loincloth is adorned with a tassel. The anklets are made of horizontal tubular beads fixed by other vertical tubes.

4. This very eroded headless figure is in the same pose as the preceding one. He wears the same wristlets and anklets.

5. The very eroded head of this creature faces east. A braid-and-tassel adorns the loincloth. The wristlets and anklets are made of tubular beads.

6. This figure stands in a vertical S. Although he is decapitated, there are still traces of a whistongue on the lower part of the face. The ear wears a bead below and a jaguar ear on top of it. From behind the headdress—completely broken off today—a long feather or a spine juts out. The belt is ostensibly knotted on the side. The end of the loincloth is blackened. Superimposed semicircles are drawn on the leg above the ribbon-on-band anklet.

7. The last figure has also lost his head; he stands in a vertical S, above the east jamb of the door, with one leg straight and the other bent. A square medallion marked with *cimi* and continued by T255 hangs from a ruff around his neck. In the photos taken by Maudslay we see his right hand holding the inverted spine-lancet. The blackended loincloth is covered by the braid-and-tassel. The anklets are made of horizontal tubular beads held together by vertical tubes.

INTERPRETATION

The inner door's frame is a three-level cosmological composition. The bench—with the large death heads to the sides and the smaller skulls mixed with the glyphs—represents the underworld. Two figures squatting on two large skulls hold up a bicephalic monster; we may wonder whether they are *bacab*s or *pawahtun*s or whether they hold up the sky or the earth. Through comparison with similar compositions (notably from Piedras Negras) we may reach the conclusion that the cosmic monster in archform represents the sky, and this is confirmed by the total absence of *cauac* signs. The *cauac* masks on the Atlantean figures, however, indicate that they are earthly and that they are supporting the sky. Their nature is defined through a series of attributes exclusive to the *bacab*s and other earthly creatures: water lilies tied around the head, ear disks with three circlets, a shell pectoral, and so forth.

These sky-bearers are sometimes called *pawahtun*s in the literature. Michael Coe (1973: 14–15) has proposed to read as *pawahtun* the name of God N in the codices; this is written with a Roman numeral III, IV, or V, followed by T548 (*tun*) or 528 (*cauac*) underneath the suffix 63 or 64, which Coe describes as "two netted elements separated by an eye-like element." Taking these two netted elements into account, he suggests that T63 or T64 must be read *pawo* or *pawah*, which designates a net bag (*talega de red*) in Yucatec. T548 or 528 has the phonetic equivalent *tun* so one obtains the compound *pawahtun*, which designates four gods of rain and wind assigned to specific directions in Postclassic Yucatan. This interpretation has several pitfalls: *pawo* is not *pawah*; the two lateral elements of T63 are not always crosshatched; and Coe's phonetic reading does not take into account the numerals III, IV, and V that precede 63:548.

I think, rather, that the name of God N is written with logographs: T63 or 64 represents the knotted water lily stem that *bacab*s wear on their foreheads (figs. 83a, 102, 103, 111, 112a), whose ends are sometimes blackened. T548 or 528 alludes to the number 5 (*tun*) whose patron is God N. The logographic hypothesis is reinforced by the last variant quoted by Coe (T63:210), where 210 is the gastropod shell with which God N is frequently associated. This hypothesis would confirm that the God N from the codices and the *bacab*s are closely related if not interchangeable.

Coe's interpretation has been extended to the iconography. Thus, Schele and Miller (1986: 54) designate as *pawahtun* creatures with cross-hatched headdresses resembling a net (*pawo*) and *cauac* elements on their bodies. The examples they provide lack coherence: two of the sky- or earth-bearers on the bench of Structure 9N-82 are shown in their illustration. 47a, which wears a napkin headdress and has no body markings, is named "God N without a shell." Another bearer (47c) with *cauac* markings on his body and a water lily knotted around his head (without net) is called *pawahtun*. The last example is on a support from the Del Río throne at Palenque; he has no body markings and his head is encircled with the knotted water lily: he is then called *bacab* although he has the same function as the preceding examples, sometimes

designated God N, other times *pawahtun*. Fash (1989: 55) gives the name "*Pauah Tun*"/Scribe to the in-the-round sculpture found in association with Structure 9N-82-2nd: his napkin headdress is cross-hatched and his shoulders are marked with the "grape" of the *cauac* glyph: but what then is the link between wind and rain deities and scribes?

Copán's iconography presents many examples of creatures with *cauac* markings on their bodies; I would stress that these signs have no phonetic value, but are logographic; proof resides in the fact that these signs are sometimes replaced by the head or the mask of the *cauac* monster: for instance, on the *bacab*s of the inner door of Structure 22, on the earth monsters at the foot of CPN 26, on the body of CPN 3 or CPN 25, and so forth. Furthermore, the cross-hatching refers more to the water lily pad, indicated as such in the iconography, than to the net headdress.

The sky monster has two contrasted heads; the one to the observer's left (westward) is alive, including the lower jaw and the nose with its tubes. As on CPN 13, the ear is replaced by a shell from which a water lily grows. It is here marked with T2 (*ek'*, "star" or "Venus"), while on CPN 13 this sign marks the eyelid of the live head. On CPN 25, an earth monster with contrasted heads, T2 is again on the live side. The head to the observer's right and to the east wears death and underworld signs. The lower jaw is skeletal, a braid-and-tassel tied to the headdress is marked with *cimi*, and the head is crowned with the three-part emblem above *kin*. Stuart (1988) designates it as head of the "Quadripartite God" and explains that it is generally attached to the rear of the sky monster, which then is monocephalic. It is quite unusual—he claims—that the head appears as that of a bicephalic monster.

The rear head is perceived as attached to a body because it is most often upside-down and not connected anatomically. I actually think that bicephality is a constant feature of the cosmic monster, whether celestial or terrestrial. When the monster's body has legs, both pairs may be oriented in the direction of the live head (CPN 25) or they may be facing opposite directions (CPN 13-28). The rear head is upside-down because this position has a negative meaning, tied to death and the underworld. This is because the netherworld is perceived as the mirror image or upside-down image of the earth. It seems to me more correct to refer to one aspect of the sun rather than to a quadripartite god; the three-part emblem composed of the spine, the shell, and the crossed-bands (a reference to the underworld, death, and sacrifice) when associated with *kin*, designates the sun of the night and the underworld, dead but ready to be born again thanks to the sacrificial blood.

We would expect to find the skeletal head wearing the symbol of the night sun to the west instead of the east. Actually, on the sculptures showing the ruler framed by the sky monster, the live head is always to the right of the king and the skeletal one to his left. It is exactly what would occur if a figure were standing on the bench. Thus, the location of the heads with respect to the king is more important than conformity to the cardinal directions.

The motifs emerging from the monster's mouth are partly hidden and have rarely been noticed by scholars. Simple or double scrolls in front of the mouths are interpreted as "emanations"; other motifs, heavier, are shown falling. I am reminded of the elongated forms, often edged with beads, that fall from the heads of some sky monsters (House E of the Palace at Palenque, Piedras Negras Stelae 6 and 11). David Stuart (1988) takes advantage of their similarity to the forms that go with the autosacrificial scenes of the Yaxchilán lintels to interpret them as streams of blood. This interpretation is surprising: we would expect to see water and not blood falling from the sky. The blue liquid edged with dots (beads) that flows from the mouth of the sky monster in the Dresden Codex (74) is the same as the one flowing from the jar held by the old goddess Ixchel in the neighboring picture. It is water in both cases. Besides, assuming that Coggins (1983: fig. 40) is right when she sees in the Río Hondo bowl a "water frieze" carrying along shells from which dead heads jut out, the monster from Structure 22 that vomits analogous motifs must vomit water.

In spite of all these arguments, we cannot discard Stuart's interpretation: first, because the upper part of the decoration displays more evidence of sacrifice; second, because the two creatures that fall together with the shells

from the monster's mouths are the same grotesque beings with solar features who belong to the iconography of death and sacrifice. Our hesitation to choose between water and blood may be precisely due to the fact that for us both are clearly different, while for the Maya they were much alike.

Because of the presence on this composition of the T2 sign (*ek'*, read "star" by some, "Venus" by others), Structure 22 has sometimes been called the Temple of Venus. In a recent article, Closs, Aveni, and Crowley (1984) interpreted the sky monster as composed of a western, Venusian side (corresponding to the famous "window" through which one would have sighted the movements of Venus around its great northerly extremes) and a solar side. In fact, they describe it as "a bicephalic monster with infixed Venus sign on the west head and the *kin* sign on the east head." *Kin* is actually determined by the three-part emblem as sun of the night and then of the west. Besides, T2, which here marks not the monster's head but the water lily from its ear, is often stamped on the live head of cosmic monsters, whether terrestrial or celestial (CPN 13, 25). Consequently, this sign is an attribute of the monster and not of the building where the monster is pictured. The hypothesis of a Venus/sun opposition is even less acceptable considering that T2 is also prefixed by *ahau* above both knees of the monster. The importance of T2 as Venus in the structure's iconography is dubious as soon as we realize that the west room window cannot have been used for astronomical sighting because of Structure 22A, which obstructed the view (Baudez 1987).

David Stuart (1988) thinks that the S-forms that make up the top of the door represent a blood serpent, such as on the Ucanal, Jimbal, and Ixlú stelae, and that the figures that go with each one are ancestral deities. In fact, even if it is hard to know what these Ss exactly mean (the same serpent body in seven pieces, or seven serpents, blood emanations, clouds, etc.) there is no doubt that this design is concerned with blood inasmuch as all the creatures there appear as patrons of sacrifice. Their features are skeletal; their jewels are marked with the crossed-bands or *cimi*; they wear a whistongue or hold the lancet.

These grotesques may be compared to those that cling to the body of the sky serpents that frame the ruler on stelae, especially CPN 7 and CPN 11. The sky serpent framing the ruler is a very common theme at Copán and elsewhere (Piedras Negras Stelae 6, 11, 14, 25; Quiriguá Monument 9; Yaxchilán Stelae 1, 4, 6, 11; Tikal Lintel 3 of Structure 5C-4), and we may compare the decoration on the door to the one on the stelae.

In other words, the inner door of Structure 22 looks like a stela with the main figure taken out. We may then conclude that this door was used as a frame for the live king, either to appear to his subjects in majesty or—more restrictedly—to perform sacrificial rites. Structure 22 appears to be a royal palace in the largest sense. The stone "censers" found by Maudslay in the central back room indicate that at least some cult activities took place there. The lateral chambers closed by curtains may have been used for domestic purposes (bench-bed at the far end of the west room?); this function, however, may have been exclusive of Structure 22A. Although it appears to be a very simple building, it is marked by the royal seal as a braid with mat pattern formed by a mosaic set on the upper frieze.

STRUCTURE 24
(THE JAGUARS' STAIRWAY)
(figs. 104–106)

The stair that links platform 25 and the East Court is composed of three flights (fig. 104): The upper, very narrow (6.5 m) flight of five steps is divided into two separated stairs by a central rectangular block, which is level with the platform's edge. A high-relief head in serpent jaws is tenoned into the front of this block. The second flight, also with five steps, extends along almost the entire length of the court.

After a 2-m-wide landing, the stairs narrow considerably; the lower flight, which includes seven steps, is only 16.5 m wide. Two standing jaguars flank it; they are stuck against the sloping wall of the structure's first terrace. A death head is carved on both ends of the fourth step's riser, at a level approximately corresponding to the "ground" on which the jaguars stand.

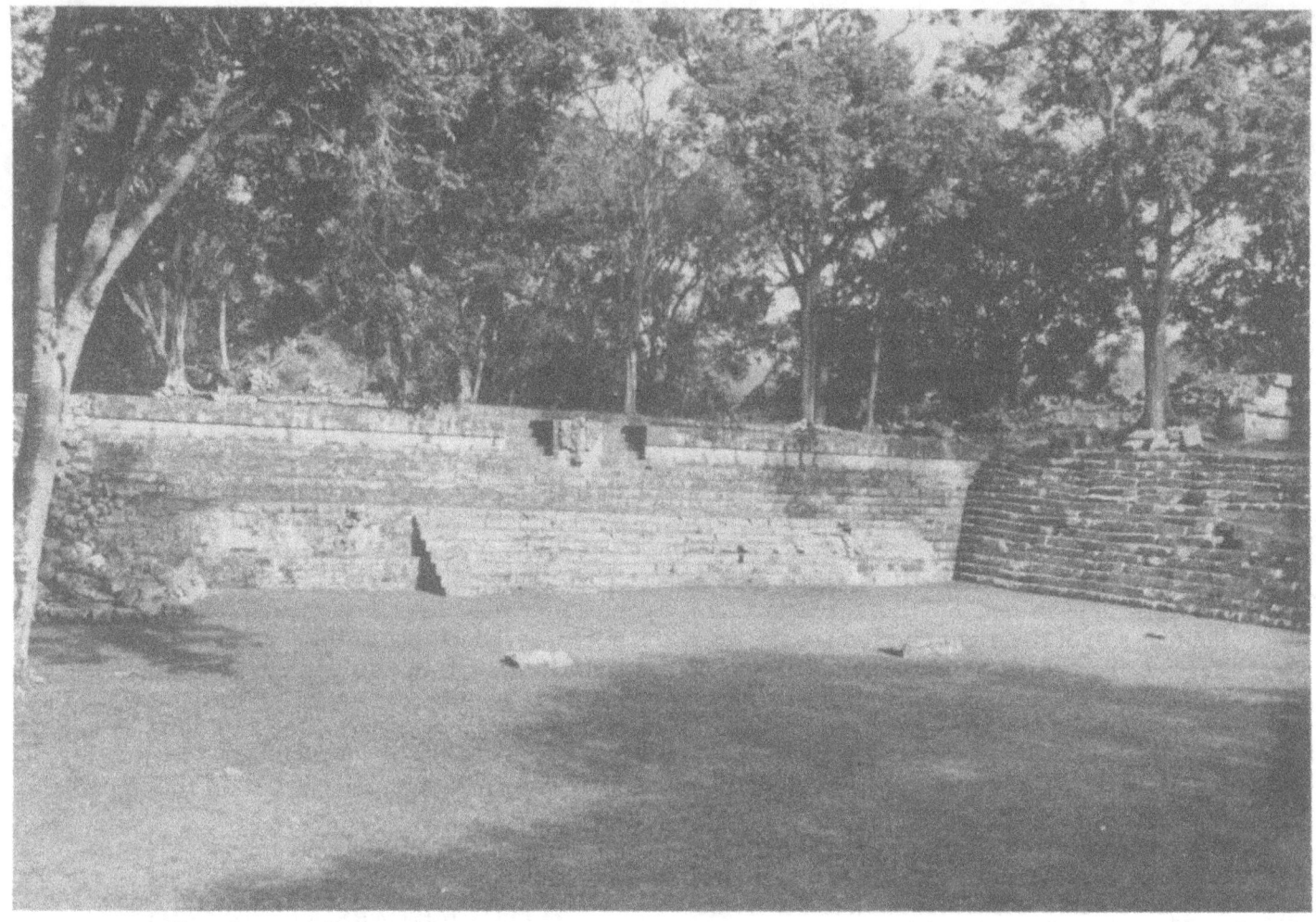
FIG. 104 East Court with Structure 24. Photo by C. F. Baudez.

The three rectangular slabs in the court's floor belong to the sculptural ensemble of Structure 24. They are in line with the two jaguars and with the central block of the stairs, respectively.

DISCOVERY AND LOCATION

Stephens (1854: 87–88) identified the sculpture on the stair block ("a gigantic head") but not the jaguars ("other fragments of sculpture of colossal dimensions") and confused the court slabs with two fallen and half-buried large heads. Maudslay was the first to describe the jaguars. Carnegie archaeologists reexcavated and restored Structure 24.

Solar Head Within the Jaws of a Serpent (fig. 105a): The serpent head is flanked by two large *ek* (close to both T1 and T2) signs; less prominently, they appear as a background against which the central motif stands out. The latter is composed of three blocks: the serpent head and the top of the solar head are sculpted on the upper block; the face is carved on the middle one; the serpent's lower jaw, teeth, and tongue take up the lower block.

The several blocks that make up this sculpture (170 cm high) in high relief have been reset and cemented together. The thickest reliefs are clear, but the shallow details are very eroded.

The forehead of the serpent appears as a mass flanked by two thick scrolls. The tip of the snout is skeletal, the pupils are erased, the incisors are broken, but a few hooks, representing teeth, remain. The large lower jaw is skeletal (there is a crescent on the lower side) and supports four teeth shown as thick cylinders. They are in part covered by a tongue with serrated edges. Its upper part, wide and rounded, bears the three circles from *cauac*;

then the tongue narrows and tapers to a point. Thus, the dead serpent is provided with a knife-tongue, made of stone (*cauac*) and with cutting (serrated) edges.

The head contained in the jaws is of the old sun. His hair is pulled back, then arranged in a loop that falls forward. The oval earplugs are topped with a large ear, black-spotted and adorned with circlets; the notch on its upper inner edge is reminiscent of knives and eccentrics. The large oval eyes, overhung by thick brows, have a scroll pupil.

The very regular nose is adorned with the cruller made of two strips twisted up onto the center of the forehead several times; after edging the eyes, they end up close to the ears. The upper lip, framed by a deep wrinkle, curls up, leaving bare filed incisors. The whiskers are depicted in the conventional manner, as a plaque with a black center, which follows the cheeks and the lower jaw; when one faces the sculpture, the tongue seems to continue the whiskers, thus making a whistongue, very similar to the one worn by the king on CPN 3.

The portrait of the old/setting sun is swallowed by the earth, presented as a skeletal serpent. The central motif may be seen either flanked by two *ek* signs or placed in the middle of T510, which amounts to the same thing, considering that the former is no more than half the second. We have yet to discover the meaning of *ek*/T510. It is certain that, preceded by T109, it designates Venus. In the tables that refer to this planet in the Dresden Codex, the abbreviated form—without T109— sometimes replaces the whole form and scholars agree to give it the same value. There is more argument when the *ek* sign or T510 is used alone and out of context: is it the Star (Venus) or a star? The advocates of the first interpretation may see in the sculpture an image of the planet's heliacal rise or synodic period. For Mary Ellen Miller (1988) it is a glyphic compound denoting "war" here; thus, Structure 24 would represent the same concept as the Bonampak stairs, where sacrificial victims crawl. In the texts the war expression actually is a complex of several glyphic elements, such as 2:325.575.325:126, and T2 alone is powerless to convey the concept of war. Even if *ek*/T510 may refer to Venus in some cases, these signs do not always have this value and express—at least sometimes—the generic term "star."

The stair block sculpture shows the old sun sinking into the jaws of the earth monster. When the sun vanishes, the stars appear, and this is precisely what is shown, with the image of the earth swallowing the dying sun on a starry background. Mixtec and Aztec art uses the same convention of painting stars to indicate the night.

The Two Standing Jaguars (fig. 105b): The two felines (158 cm high) stand, with their bodies presented in three-quarter view and the heads in front view, in a very dynamic pose. One of their forelimbs rests on the hip, the other reaches out toward the stair. Their hind limbs are spread out as if they were walking. The head is as realistic as possible, and vertical strips (or ribbons) hang from their ears. Round hollows—probably made to hold obsidian inlays to represent the jaguar spots— are scattered on the whole body. The paws have claws; a bead tassel and a double scroll continue the two-segment tail. The collar is made of several concentric bands. The two jaguars wear loincloths. An unidentified round shape—perhaps another piece of garment—may be seen behind the right arm of the south jaguar.

The Two Death Heads (fig. 106a, b): Both death heads are eroded, but the one to the south is the best preserved of the two. They are found at the ends of the fourth step's riser. The sketchy heads, carved in the Egyptian way (in relief in a hollow) are in front view. The forehead is narrow, the round eyes are bulging, the nose U-shaped; they have long teeth and a rounded jawbone; they wear three-part ear ornaments, today eroded.

The Three Floor Slabs (fig. 106c): The three floor slabs are rectangular (north slab 144 cm by 73 cm, middle slab 203 cm by 93 cm, south slab 128 cm by 77 cm) and aligned north-south. They are so damaged that most visitors are not aware that they are carved monuments. Stephens thought they were half-buried colossal heads; even in Maudslay's time not much relief could be made out ("they bore traces of sculpture on the upper surface": 1889–1902, vol. 5, p. 29).

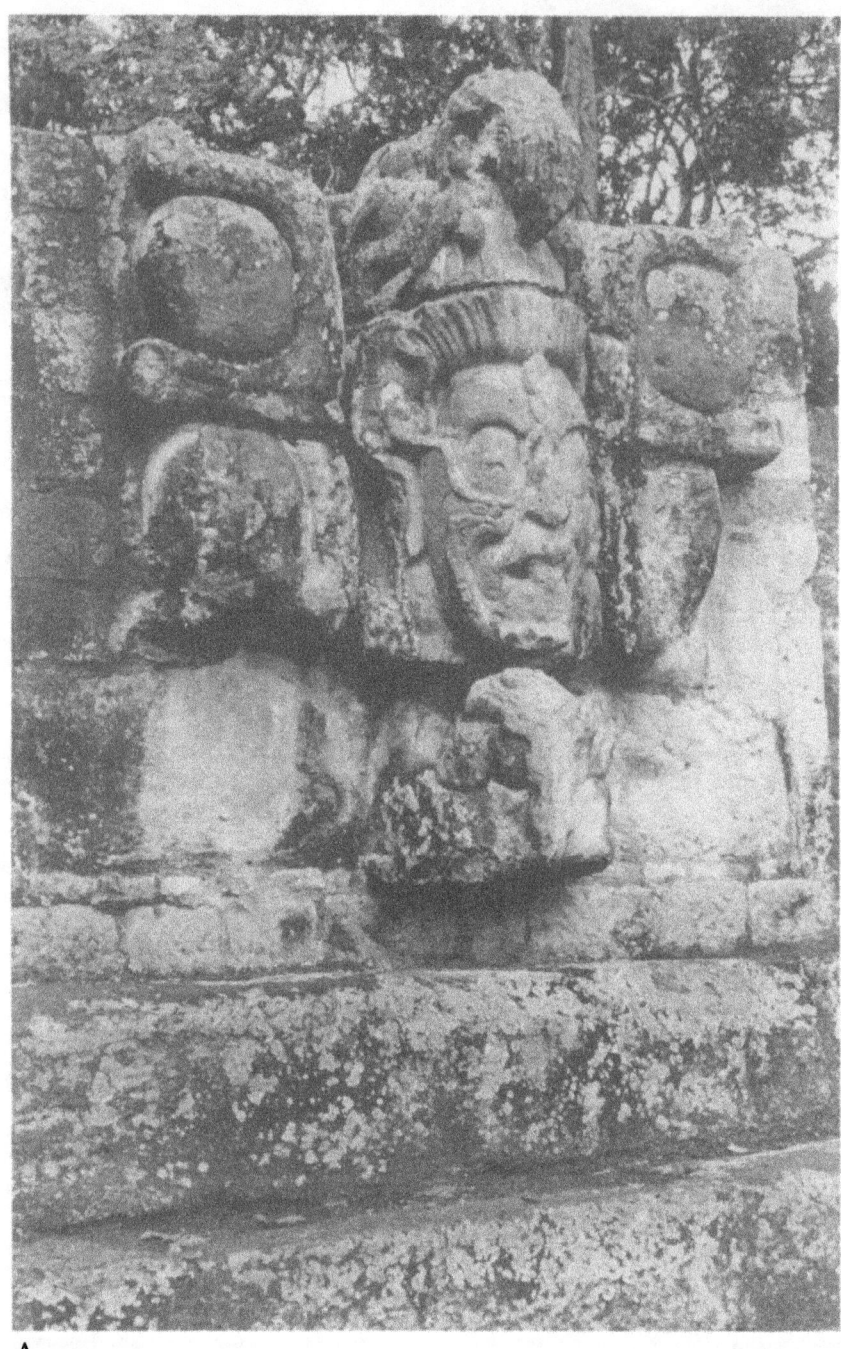

A

FIG. 105 Structure 24: (a) representation of the setting sun. Photo by C. F. Baudez. (b) Standing jaguar. Photo by J.-P. Courau.

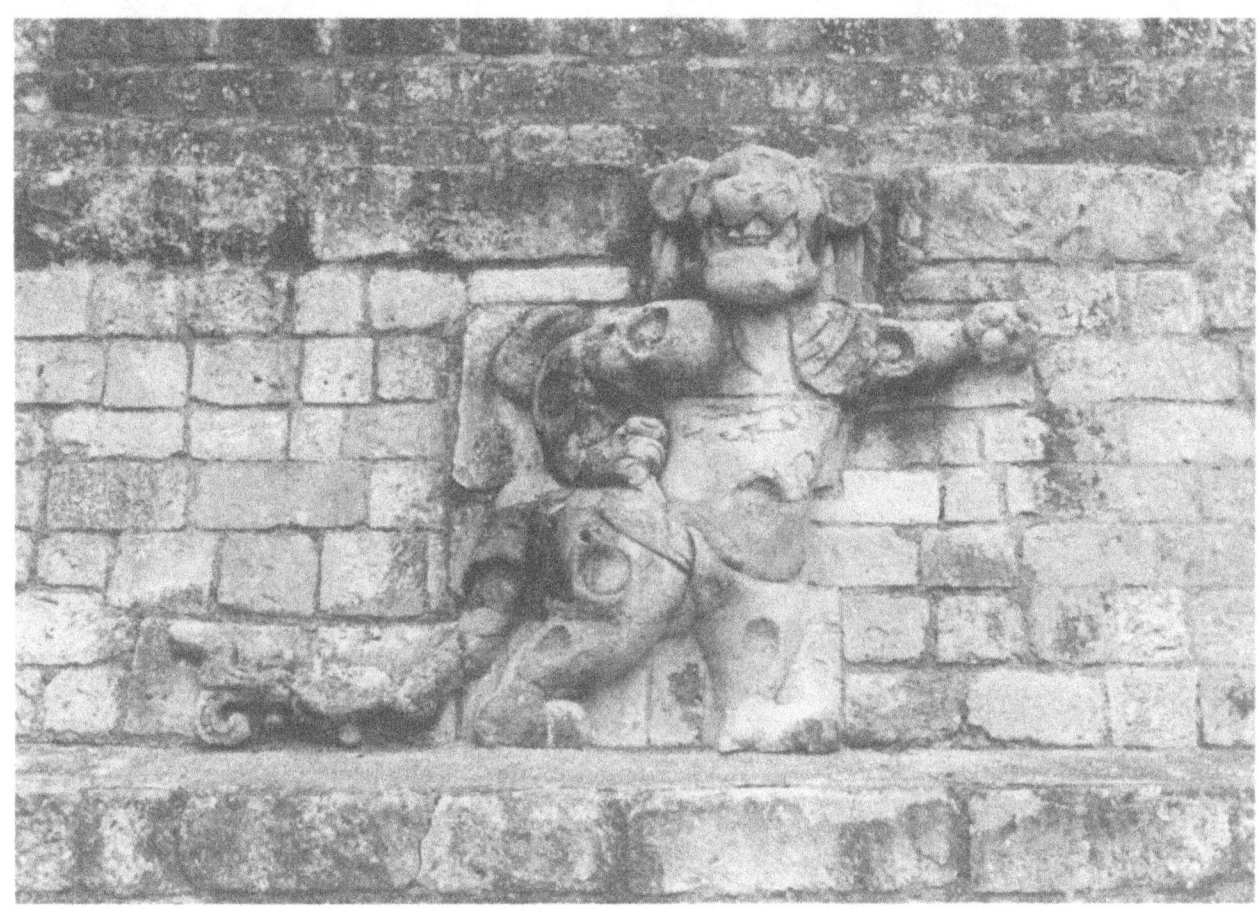
B

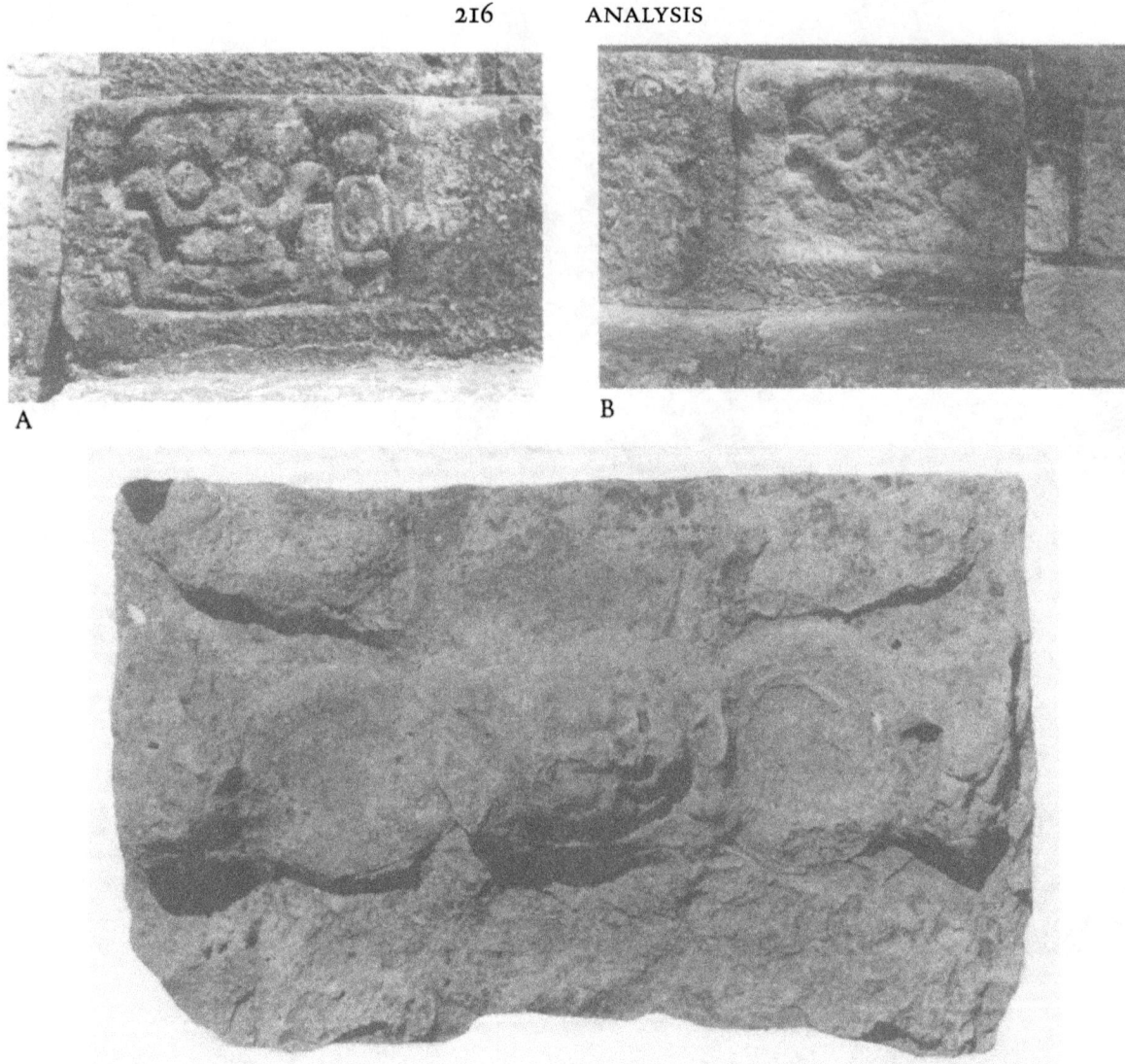

FIG. 106 Structure 24: (a,b) death heads at both ends of step; (c) East Court, south carved slab. Photos by J.-P. Courau.

Today the less destroyed one is to the south. In the center is the head of a roaring jaguar in high relief; it is flanked by two very eroded circular motifs with a regular frame: they must be shields. The slab's remaining space is completely eroded. As far as we can judge, the other slabs were similar to this one since they have traces of a jaguar head and of two round shields.

INTERPRETATION OF THE WHOLE

Proskouriakoff (1963–64: 47) noted the striking similarities between Structures 12 and 24. In both cases, there is a stairway with a sculpture placed high in the middle, two other subjects on the sides with one arm reaching out toward the stair, and three slabs on the court floor, in line with these sculptures. As Proskouriakoff said, "We can scarcely avoid the conclusion that both had more than a merely decorative function and were probably adapted to the requirements of some prescribed formal procedure or ceremony."

I think that Structure 24, like Structure 12,

is a stage for a ritual perambulation, following a prescribed course, and that Structure 24 is the stage of the symbolic descent into the underworld. The entrance, so narrow that no more than two persons can pass through it at the same time, is from Structure 25. Assuming that there was an audience to the rite, it was in the East Court, where it could see the performance to the west, where the sun sets. The entrance is level with the surface of the earth, into which the old sun sinks; the stars are close by, ready to replace it in the sky. After descending the first five steps, one is on top of a first flight, followed by another, much narrower flight. The stair of decreasing width generally indicates a privileged direction. The path to the sacred gets narrower as one gets closer to it. For instance, the stairs of Structures 11 and 16, wide at the base, become narrower uphill as one gets closer to the temple; conversely, on Structure 24, the steps are wide upstairs and narrow downstairs, which indicates that the stair direction is downward—the stair must be used for descent.

As soon as one has left the wide stair for the narrow flight, one is flanked by the two jaguars, which convey a rather threatening attitude. They guard the door to the underworld, abode of the night sun but also of the dead, as one is reminded by the two skulls carved on the fourth step. The court's floor constitutes the lower stage of the underworld. It is indicated by three slabs sculpted with a roaring jaguar flanked by shields. They are a reminder that it is through war and sacrifice that the sun finds the new strength he needs to be born again. This perambulation could be performed in the ritual by one or several officiants who impersonated the sun or the dead.

Structure 24 is an incomplete cosmogram, limited to the lower levels of the universe: from the horizon (below which the sun sets) down to the bottom of the underworld. It is, however, possible that a perishable structure represented the upper levels of the cosmos; permanent or temporary (built only for the rite performance), it would have been erected on the low platform 25, on which there are no traces of stone construction. This reconstruction is suggested by Structure 11, where two parallel stairs linked the sky and the earth levels; in Structure 24 it is also via two stairs, on both sides of the image of the setting sun, that one begins the descent into the underworld.

STRUCTURE 26
(THE HIEROGLYPHIC STAIRWAY)
(fig. 107)

CIRCUMSTANCES OF DISCOVERY

As observed by Gordon (1902: 6), Maudslay was the first in 1885 to notice steps carved with glyphs on the west side of Structure 26 and to call the stairway "hieroglyphic." He thought at the time that the fifteen steps, which had moved together with the same landslide, were *in situ*; digging just above them, he discovered several terraces of the pyramid on which the stairs leaned. In December 1892 and January 1893 Owens cleared the landslide steps. Death interrupted his work, which was pursued by Gordon between 1895 and 1899. In the 1940s the Carnegie reconstructed the stairway following the analyses of Morley and Tozzer.

The Peabody excavations indicated that of the original sixty-two to sixty-three steps (according to Baudez and Riese 1990) only the first ten were found at once complete and *in situ*; the following five were incomplete. In addition, fifteen steps from the stair's upper portion had slid together but had kept their relative position, although "few of these steps are complete, blocks are missing . . . and the carvings . . . are much damaged" (Gordon 1902: 9).

The sculpted block at the center of the stair foot, whose top is level with the fourth step, was quite deteriorated on its sides as well as on its top. Five steps above the block, a seated statue was found *in situ* and nearly complete. The human figure had a shield on his left arm and the "right arm extended outward and forward and the hand formerly held some object which has been broken away." Gordon correctly discovered that a pair of intertwined serpents framed the statue's head (1902: fig. 8). In 1893 fragments from another statue were found behind the landslide steps, along the stair's axis. The sculpture, presently reconstructed in the Peabody Museum, was probably the

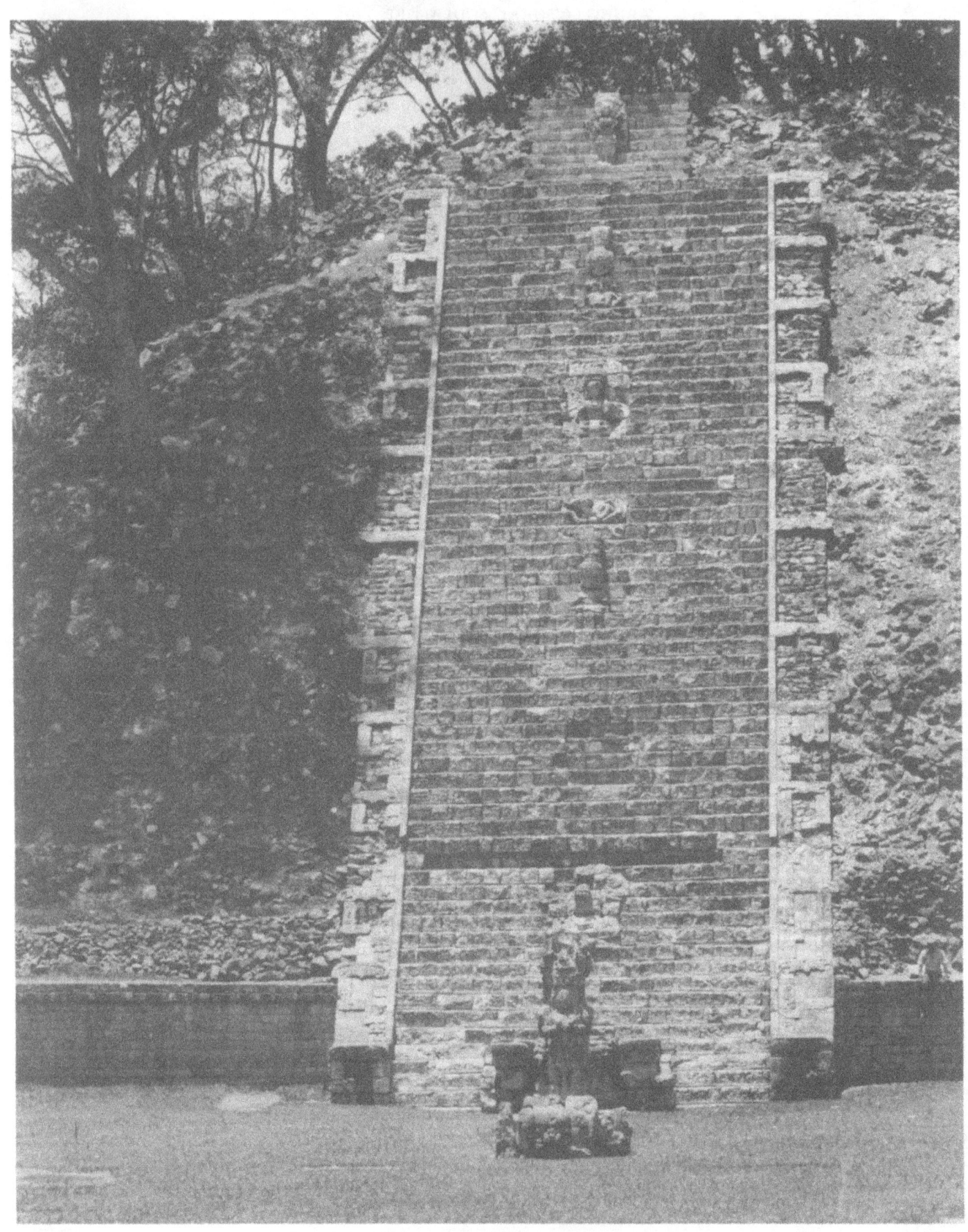

FIG. 107 Structure 26: the Hieroglyphic Stairway. Photo by J.-P. Courau.

second one from the stair base. Gordon describes the throne of another similar figure in the middle of one of the landslide lower steps (1902: 11); of the figure "few small fragments of the upper portion . . . were found among the debris." Fragments from two other statues were also found. Thus, the stair included at least five seated statues, which corresponds to the reconstruction by the Carnegie. Only the first and the second one are absolutely reliable; doubts remain about the relative location and the reconstruction of the other three.

The prone figures carved on some of the steps' risers sometimes were centered and sometimes had other locations (Gordon 1902: 14). Among the *in situ* steps, the figure of the fifth (pl. VI, H, 9–12) is in the middle; among the landslide steps, some are in the middle (pl. V, F, 8–10; G, 8–10), while others are not (D, 4–6; J, 12–15). Data are lacking about the original location of the other two, which apparently were randomly replaced.

The temple of Structure 26 contained one of the largest and finest full-figure inscriptions at Copán. The outer decoration included macaws, as shown by the three horizontally tenoned heads and the fragments of claws found in the stair rubble (Gordon 1902: 18). The decoration also used the serpent bar motif; Gordon described and illustrated four reptilian heads holding a long-nosed head within their jaws (1902: 18 and fig. 9).

The only remaining images of the repeating motif on the stair's ramps were a stylized water lily and a frontal bird head above a profile *cauac* monster head, which Gordon calls a "serpent" (1902: pl. 13, W). He used only these elements for his reconstruction drawing. In the material reconstruction Carnegie archaeologists completed the motif with two other elements found elsewhere: a stylized wing and a claw. The latter reconstruction seems convincing because of the shape and dimensions of the carved blocks as well as the images they bear.

The Hieroglyphic Stairway is conceived as a meaningful iconographic complex, composed of the following parts: central block, ramps, superstructure, statues, and prone figures.

THE CENTRAL BLOCK AT THE BASE OF THE HIEROGLYPHIC STAIRWAY

This is 155 cm high, has a maximum width of 330 cm at the top, and is 221 cm deep. It was damaged by the rubble that fell from the temple and upper levels of the stairs. Its low-relief carved top is "so worn that I am unable to make much out of it" wrote Gordon (1902: 10). The same is true of its sides. In addition, the block has been vandalized: the two human heads that are visible on the Peabody photos have since disappeared.

This composite sculpture leans against the four lower steps of the stair. It is composed of three main parts; the central and most important one is prominent in relation to the lateral blocks. The top is only visible from the stair and displays a four-figure scene in low relief contained within a serpent's jaws. The sides of the block, which can be seen from the Plaza, show a monster head carved in the round with serpents running through it. In addition to the Hieroglyphic Stairway, the altar is spatially associated with CPN 24 and its altar. A cache with jade, shells, and eccentrics was discovered in 1986 under the altar.

The Top: A large serpent mouth occupies the sides and bottom of the composition. It is the representation of a lower jaw, composed of two vertical sides connected by the jaw's front. In this way the scene appears completely enclosed within the jaw. The head looks alive and bears no markings associated with either bones or death. The head's content occupies the block's central section: a network of ropes, sometimes twisted, frames every one of the four figures and links one to another; it gives a sacrificial overtone to the whole. The two lower figures kneel with an arm raised in the same position as the victim on the eastern ramp of Temple XXI at Palenque. Their posture suggests that they are sacrificial victims, captives, or kings immolating themselves, as proposed by Schele (1984). The two upper figures are cast as dignitaries by their bulkier headdress. All figures sit cross-legged in profile and seem to be holding objects; one such object on the left seems to be resting on a base or protruding from a vessel. A short, now-eroded hieroglyphic caption accompanies each figure.

The Sides: From the Plaza the block appears as a three-dimensional head or mask. The location of the eyes is puzzling: either close together on the central block (presently almost completely defaced) or set apart on the sides. In the first hypothesis the lateral blocks would constitute the earflares, but obviously this is not the case. We must then accept the second hypothesis as more likely and note the absence of ear ornaments.

Two crescent signs that indicate bone and V-shaped traces of a "nose" are visible on the upper register of the central block. The snout begins at the bottom center of the mask; it is a long, narrow stone band that rests on the Plaza floor. The upturned end is broken, but probably undulated, judging from the long-nosed masks at the site. A band representing the lip or the upper jaw bears the same motifs on both sides of the snout: an inverted Year Sign with pendant ropes and hair next to a scroll, then a human skull with a death eye and a rectangular earflare with a death eye above and T122 below it. A row of skulls replaces the teeth.

Several serpent bodies seem to bring the mask to life:

1. One of them, with cartouches containing a stylized serpent head, undulates on the protruding forehead.
2. On the lateral blocks two others form the eyebrows then travel down along the eye's inner rim. They bear a cartouche framing an inverted bird head with eyes half closed on an upturned pupil. The stylized wings are marked with a *kan* cross.
3. Below each globular eye of the mask is a large scroll oriented inward that forms a serpent tail whose body seems to vanish into the stair. A large skull with ringed eyes, nostrils with tubes, and without a lower jaw is located at the mask's corner. The tongue hangs out between two angular scrolls. It is wide and rectangular and is marked with a serpent tail in a medallion before it tapers to a point. The folds of the large scrolls also contain imagery (see Peabody photo N28282). On the north is a helmeted human head; on the south the head of an old man, perhaps a *bacab*.

The iconography on this mask illustrates the themes of death and sacrifice. The mask itself is a skull surrounded by skulls, inverted Year Signs, ropes, hair (of the captives held by the victor?), pseudo-Tlalocs, and variants of the Pax jaguar, an agnathic skull with ringed eyes and a knife-tongue flanked by scrolls. The serpents who "live" in this skull emphasize its morbidity through their chthonian nature. They are marked either with a serpent sign or by the death bird.

The Ramps: The repeating motif is composed of five very stylized elements:

1. A frontal bird head is carved on a long horizontal stone that slightly cantilevers the outer edge of the ramp.
2. A wing with a serpent head in a cartouche (serpent wing) is below and outward.
3. A claw is below the latter.
4. A profile *cauac* monster head is below the bird head, but inward.
5. A water lily blossom is the lowermost element.

Most of the bird masks are alike; those that adorn the blocks at the foot of the ramps, however, have round crossed eyes with a blackened pupil and a scroll with a tripartite element on the side in place of the ear. A serpent head in a cartouche is below this on the block. The ramp masks have oval-ringed, half-closed eyes with a central pupil, a nose with two bones, a scroll, and water lilies on the sides. In both cases it is the same bird: neither the macaw nor the quetzal nor the *katun* bird, but a kind of owl (*muan*?) with round ringed eyes and a short, hooked beak. If the birds in the lower part of the ramp differ slightly but significantly from the others, it is because they are at the central block's level, the level of the underworld.

The *cauac* monster is identified by the three circles flanked by two streamers on its forehead. It has scrolled eyebrows, a large rectangular scroll-eye, and another scroll on the nose. The jaws look skeletal. A stylized water lily similar to motifs on CPN 13, CPN 28, and CPN 33 emerges from the *cauac* head.

In Copán iconography there are several examples of bird/earth monster pairs, in which the former occupies a dominating position. On the back of CPN 16 the quetzal at the top of the cosmological composition represents the day sun, as on the panels in the Temples of the Cross and Foliated Cross at Palenque. When the triumphant king is compared to the sun, the quetzal or the macaw dominating the earth monster becomes the symbol of royal power (quetzal mask on the earth croco-

dile on CPN 4 east; macaw heads on top of the cauac monster on CPN 3 east). On the ramps of the Hieroglyphic Stairway we again find the bird dominating the earth, but here it is another bird. This owl is part of the sacrificial complex illustrated on the sides of the central block and—as we shall see—on the seated statues; it includes pseudo-Tlalocs, Year Signs, down balls, ropes, and so forth. The motif on the ramps would thus symbolize the domination or triumph of death and sacrifice over the earth. We may even suggest that here too the bird represents the king: he dominates the earth, not as the triumphant star that no one can look at, but as the great sacrificer.

The sculpture on the ramp has a different function. The assemblage of the five aforementioned elements (stylized to the limits of identification) reproduces a kind of fret that, when repeated, forms the dynamic image of the crawling serpent. The stair is thus conceived of as a serpent body and the scroll-shaped bases of the ramps might represent the reptile's tail.

Seated Statues

Statue No. 1 (fig. 108a): Located on the ninth step, this statue is 220 cm high. It was already quite deteriorated when discovered and has suffered a great deal since, due to microorganisms and water. Some reliefs are chipped off and effaced. For instance, the two serpents knotted on the stomach, which are clearly visible in early photos, can no longer be distinguished. In addition, the right hand has been broken, probably by vandals. The figure, in frontal view and three-dimensional, is seated on a bench that is level with the tenth step up from the Plaza floor. The left arm is hidden by a shield; the right, straight one held an object, probably a spear. In her reconstruction Tatiana Proskouriakoff (1963–64: 35) put a manikin-scepter in its hand. Besides the fact that the latter object is unknown at Copán, I prefer to envision the figure holding a spear due to the statue's martial attitude and the associated sacrificial iconography. Two intertwined serpents formed an arch above the helmeted head of the statue.

The throne's framework is made of crossed strips and the seat is covered with a cloth, edged with a beaded, fringed braid. A youth mask, topped with a black-spotted T60, is at both ends of the bench as on the belts worn by the stelae figures. Tinklers marked with an effaced sign hang from these heads. The main figure is half enclosed in the jaws of a fantastic creature with prominent eyebrows, a round muzzle, a double-scrolled nose, skeletal jaws with large teeth, oval eyes, and shells in place of the ears. Eroded reliefs on top of its skull and on the lower jaw have not been identified.

The main figure's face is eroded. But a bead that hangs from his oval earflares is visible. The pectoral is a youth mask surrounded by beads. The costume includes a cape, a fringed skirt, and a loincloth whose ends are embroidered with T-shaped motifs. Two intertwined serpents are between the helmet's lower jaw and the belt. The latter is edged with blackened shells and supports a human skull on the right side. The belt's central mask, which is flanked by two bones, is an agnathic skull, with ringed sockets, two holes instead of the nose, and prominent incisors. A double-scroll and a stylized water lily blossom (like element no. 3 on the ramp) replace the ear. The wristlets were apparently made of beads. The sandals are tied around the ankle. The fringed square shield bears a bird head with round eyes; from its open beak emerges a serpentine element that ends in a loop under the earplug. Two profile serpents frame the helmet as a celestial arch; their head is close to the shell-ear of the helmet; they lack lower jaws, but have saber teeth. The serpent bodies rise and turn inward to form a loop with the other serpent, then turn in the opposite direction and end with a four-rattled tail, continued with T122. These serpents are seen against a background of feathers; some are plain, while others show stems and black spots.

Statue No. 2: A gap was left on the twentieth step by Carnegie archaeologists during restoration to provide space for the second statue, which is housed in the Peabody Museum. The arms, shield, part of the cape, and the sides of the waist are missing. The reliefs are generally sharper than on the preceding statue; their superior condition is in part due to the protection afforded by the Peabody Museum for a century. It is certain that the

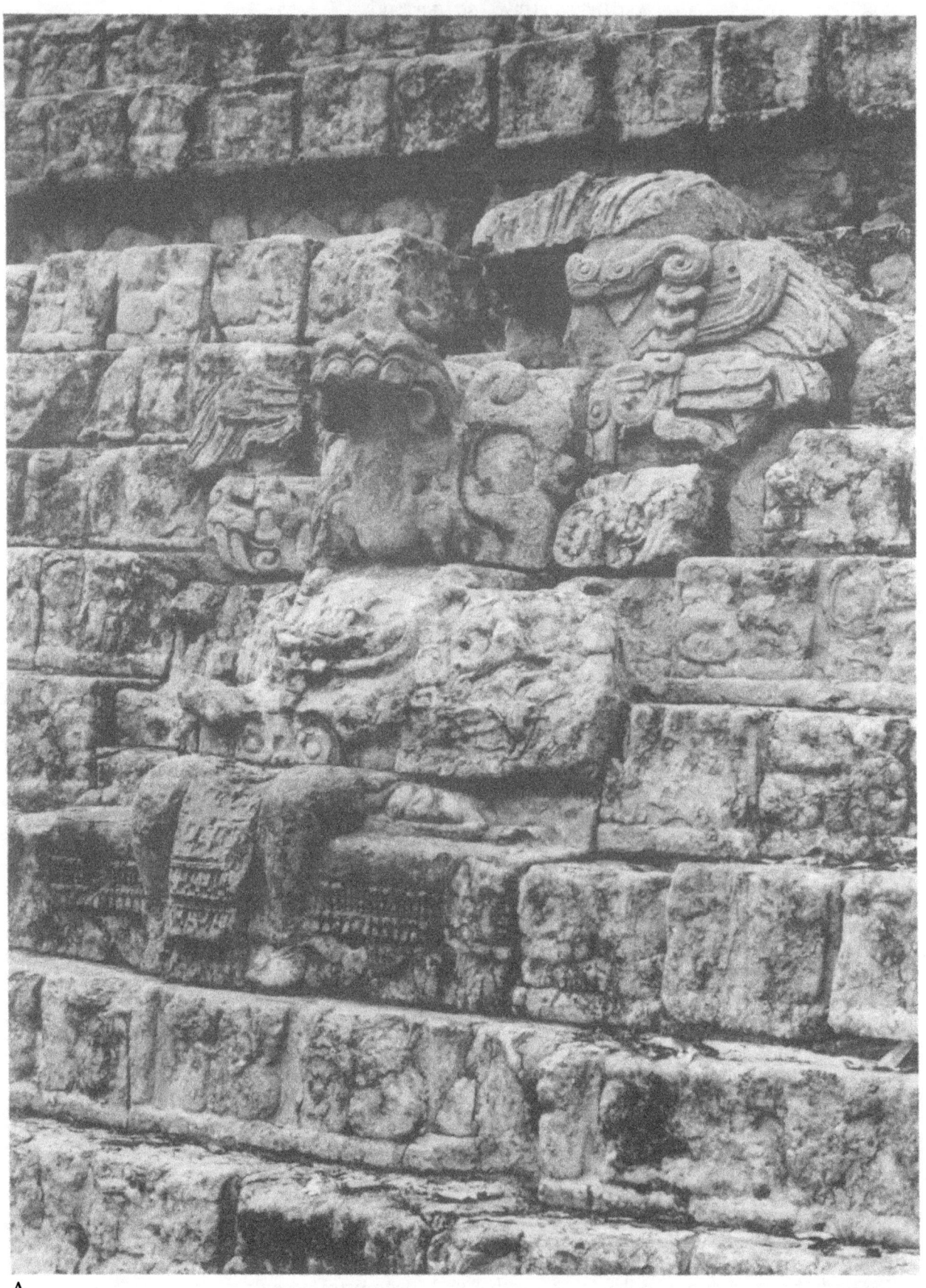
A

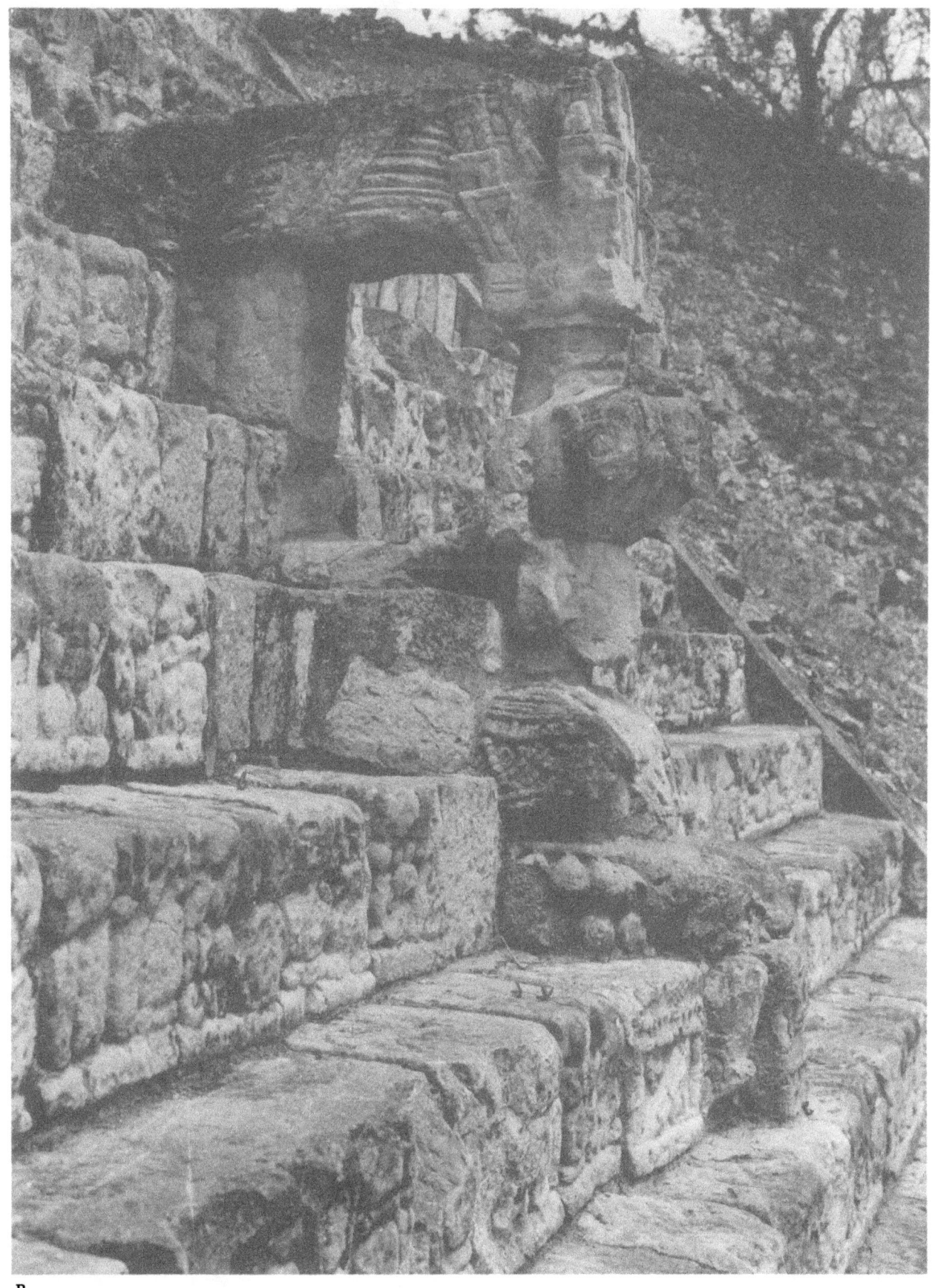

B

FIG. 108 Structure 26: (a) statue 1; (b) statue 3. Photos by J.-P. Courau.

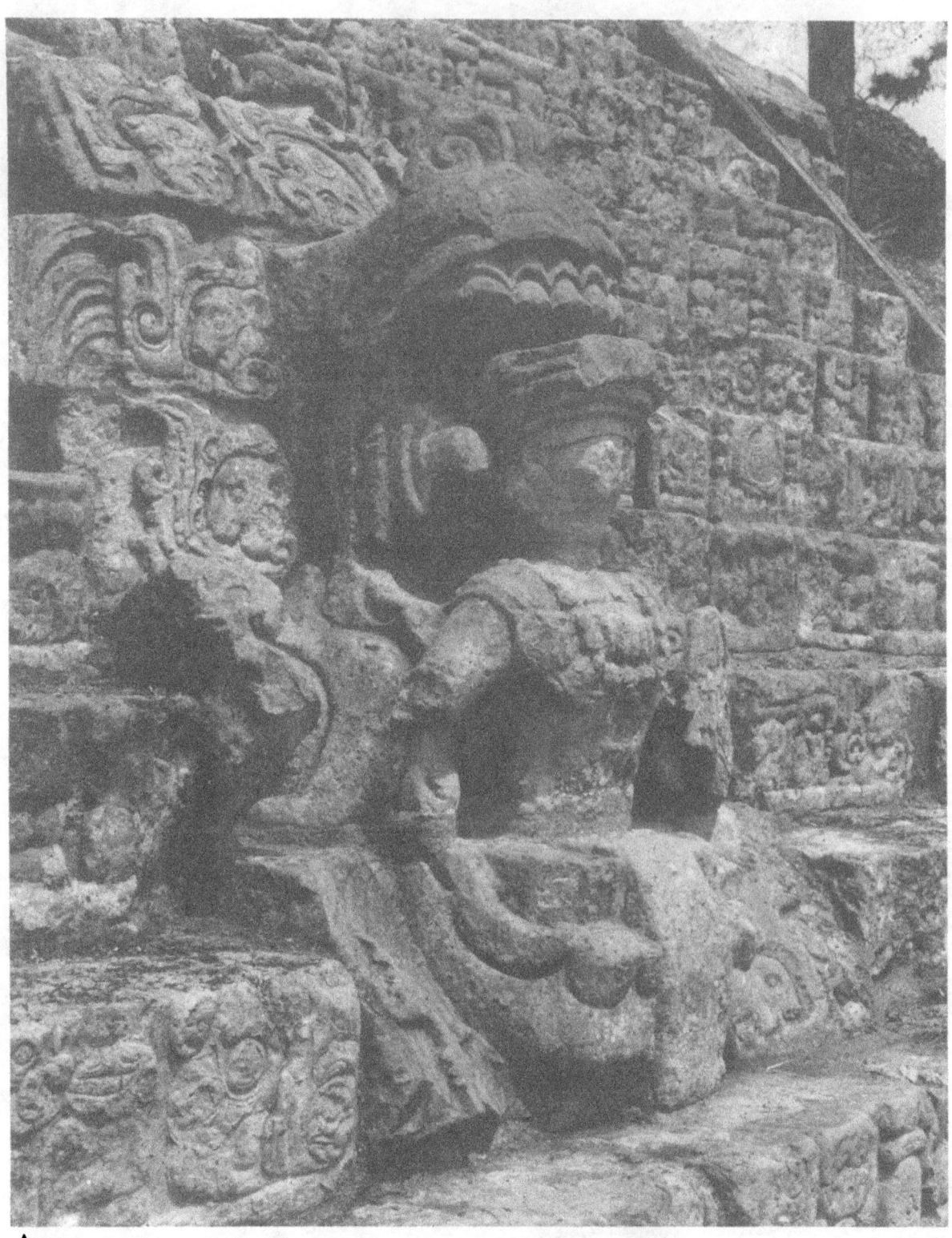
A

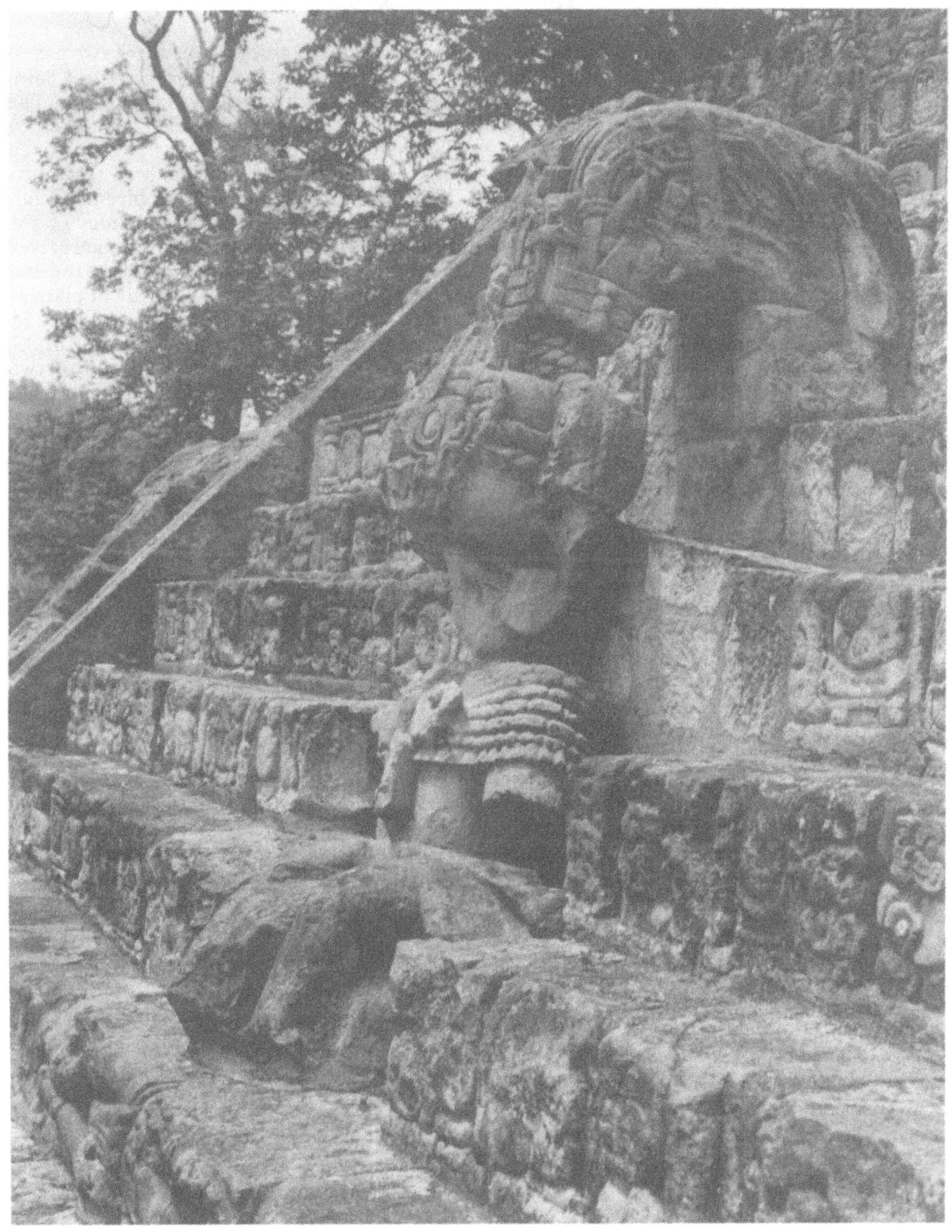

B

FIG. 109 Structure 26: (a) statue 4; (b) statue 5. Photos by J.-P. Courau.

figure (about 220 cm high) had the same posture as the other statues on the stairs and held a spear on one side while wearing a shield on the other. At least two shields were gathered in the rubble (Gordon 1902: pl. XV).

The bench is similar to the one previously described, except for the masks at both ends of the seat. Here they depict an old solar cross-eyed creature with T-shaped teeth and a knotted band (T60) on top of his head. The helmet is similar to the first statue but with black eyes. It is crowned by a panache of trimmed feathers continued by three long spotted feathers. The figure wears circular earflares with a top scroll, a collar of round beads, and a rectangular pectoral with a skull laying on its side in the fashion of Naranjo (Stelae 2, 7, 14) or Piedras Negras (Stela 7). A short cape covers the shoulders and the chest; its decoration is reminiscent of the crossed strips that adorn the bench. The belt, from which hangs an inverted Year Sign, is made of unidentified oval elements between two skeletal serpent bodies. On the left a skull or a bone head is attached to the belt. Two ropes come down the loincloth, which is marked with crossed-bands and a large black spot; their ends meet other ropes placed horizontally above an inverted Year Sign. The leggings are made of ribbons with three pendant trapezoids. The sandals are the same as those worn by statue no. 1. A ring-eyed skull that sticks out a long tongue flanked by double scrolls lies on the bench, close to the main figure's left leg. It has serrated edges, is pointed, and reproduces a feather of the *muan* bird with stem and black spots. The motif on the right is broken but looks like *Oliva* shells.

STATUES NO. 3 TO 5

The statues that occupy the third, fourth, and fifth ranks on the stairway are reconstructions made by the Carnegie archaeologists out of fragments gathered in the rubble. We may cast doubts on the genuineness of each assembling and on its location. In any case, the iconography of these sculptures, as a whole, maintains its full value.

Statue No. 3 (fig. 108b): This was placed on the thirty-first step by Carnegie archaeologists during restoration. The throne and feet are part of Step M from the landslide (Gordon 1902: pl. V). The throne consists of two panels framed by knotted bands that contain a Saint Andrew's cross made of two other bands. The figure wears a globular headdress flanked by two knotted bands; a bird mask with an open beak, as on the shield of statue no. 1, is on its front; what looks like another bird head, but this time in profile, is on the sides of the headdress. Two superimposed bands are carved above the ball; each with a knotted band and a Year Sign crowned by a panache of plain or black-spotted feathers. Two ropes covered by two crossed bands (Gordon 1902: pl. XIII, G) are atop this. The cape is made up of two parts, one a beaded network. The pectoral is a large horizontal rectangle, which is now eroded. Two rows of shell tinklers hang from the belt. The loincloth has a T-shaped cutout in which a braid stands against a bead background. The sandals are the same as on the other statues.

Statue No. 4 (fig. 109a): This was placed on the forty-third step by Carnegie archaeologists during restoration. The human figure's torso emerges from the jaws of a monster, who is very similar to the one with statues no. 1 and no. 2. The man wears a turban and a bead necklace. The pectoral consists of several strips bent into a loop and attached by a band. On the left he holds a rectangular shield decorated with a profile serpent head and fringed with feathers on three sides. Eight rabbit heads with ringed eyes (Gordon 1902: pl. XIII: K, L, V) surround the monster against a feathered background. Elaborate images, probably plant forms, surround and connect the rabbit heads.

Statue No. 5 (fig. 109b): Placed on the fifty-third step, this statue is incomplete and without any visible throne. It is coiffed by a spherical headdress adorned with three bird masks linked with ropes. Serpentine forms emerge from their open mouths. Their eyes are ringed. A scroll and a water lily blossom replace the ear. A pack of ropes in a cylindrical shape on which the top of the headdress rests is above the spherical piece; it includes the three knotted bands and the Year Sign repeated three times and continued by a panache made of feathers and cords. The figure is dressed in a bead cape and wears a shell pectoral.

Statue No. 6 (fig. 110a): Set on the sixty-sixth step, this statue does not belong to the stairway proper; it leans against the vertical block placed on the steps that ascend the building platform. But the statue is in line with the seated figures and as such forms an element of the same composition. Although the arms are broken, they could have held a spear and shield. The man's youthful and round face is enclosed in a jaguar helmet surrounded with feathers. A T-shaped motif with beads frames the lower part of the helmet. A tube with radiating beads at both ends hangs on the chest. Two large rings on both sides of a vertical band above the belt are reminiscent of pseudo-Tlalocs or of ring-eyed skulls. Tubular beads and blackened shells as tinklers hang from the belt. The loincloth, framed with beads, bears the usual jaguar mask with T616b on the forehead, crossed eyes, and filed incisors.

This figure differs from the others mainly because of its standing position at the foot of the temple but also in the youthful air, jaguar helmet, and the same animal's mask on his loincloth. This figure is thus closer to the main figures depicted on the stelae.

Additional carved fragments, which the Carnegie apparently did not use, may be added to their reconstruction. The fragments, such as some illustrated by Gordon (1902) in his plate XV probably come from the stairway. These include a rectangular and a circular shield, each with a solar head; a torso that displays the same pectoral with a skull on the side as worn by statue no. 2; and another torso, with the same pectoral without a skull.

INTERPRETATION

The iconography of the seated figures of the stairway appears to be very homogeneous. All probably had the same posture. Three of them wear a helmet, which is particularly large in two cases. Statues 1 and 4 seem to emerge from or sink into the mouth of a monster. The latter certainly is neither a jaguar nor a bird; although it does not look like a serpent, having no ophidian characteristics, it could be a crocodile. If this hypothesis is correct, then figures 1 and 4 would be either emerging from or sinking into the earth. The other two figures wear a spherical hat supporting bird heads and surrounded by ropes, *muan* bird feathers, Year Signs, knotted bands—in short, elements related to sacrifice and autosacrifice.

Linda Schele (1984: 30–33) has shown the relationship between the Year Sign, globular hat, and pseudo-Tlaloc at Yaxchilán, Aguateca, and Dos Pilas. At the former site these symbols are found in an autosacrificial context, while at Dos Pilas the context is war and the sacrifice of captives. On Yaxchilán Lintel 25 the jaguar skin hat seems to be a copy of the headdresses depicted on Aguateca Stela 2, Dos Pilas Stela 16, and Piedras Negras Stela 3. In these three examples the headdress is perfectly spherical and probably represents a down ball, analogous to the Aztec sacrificial symbol. Avian images are associated with the down ball. At Copán bird masks are directly attached to the ball; on Piedras Negras Stela 3 the mask crowns the spherical headdress; on the examples from Aguateca and Dos Pilas mentioned above the king wears a bird on the chest. Finally, the pectoral with the skull lying on the side is another motif shared with Dos Pilas Stela 16.

On the Hieroglyphic Stairway the individuals who wear the crocodile "helmet" are surrounded by the same motifs as those wearing the spherical headdress: realistic human skulls, ring-eyed skulls with a protruding tongue, ropes, *muan* feathers, Year Signs, and so forth. The warlike posture of those individuals who display both shield and spear relates this symbolic system to sacrifice rather than to autosacrifice. The exceptional location on the stair, the costumes, and the jewels of these great warriors and sacrificers designate them as kings.

If we compare the stairway to CPN 30, where the predecessors of Rising-Sun form a line behind him, it is easy to imagine that seated behind the portrait of Smoking-Squirrel on CPN 24 are the kings who preceded him. Following this hypothesis, the first figure would be the fourteenth king (who ruled briefly after Eighteen-Rabbit's death) and the second figure would be Eighteen-Rabbit himself. There is no way of testing this hypothesis. Yet Statue no. 4 is surrounded by rabbit heads: is this an allusion to the name of the thirteenth king? If so, then we would expect to see this motif associated with the second figure instead of the fourth. An alternative

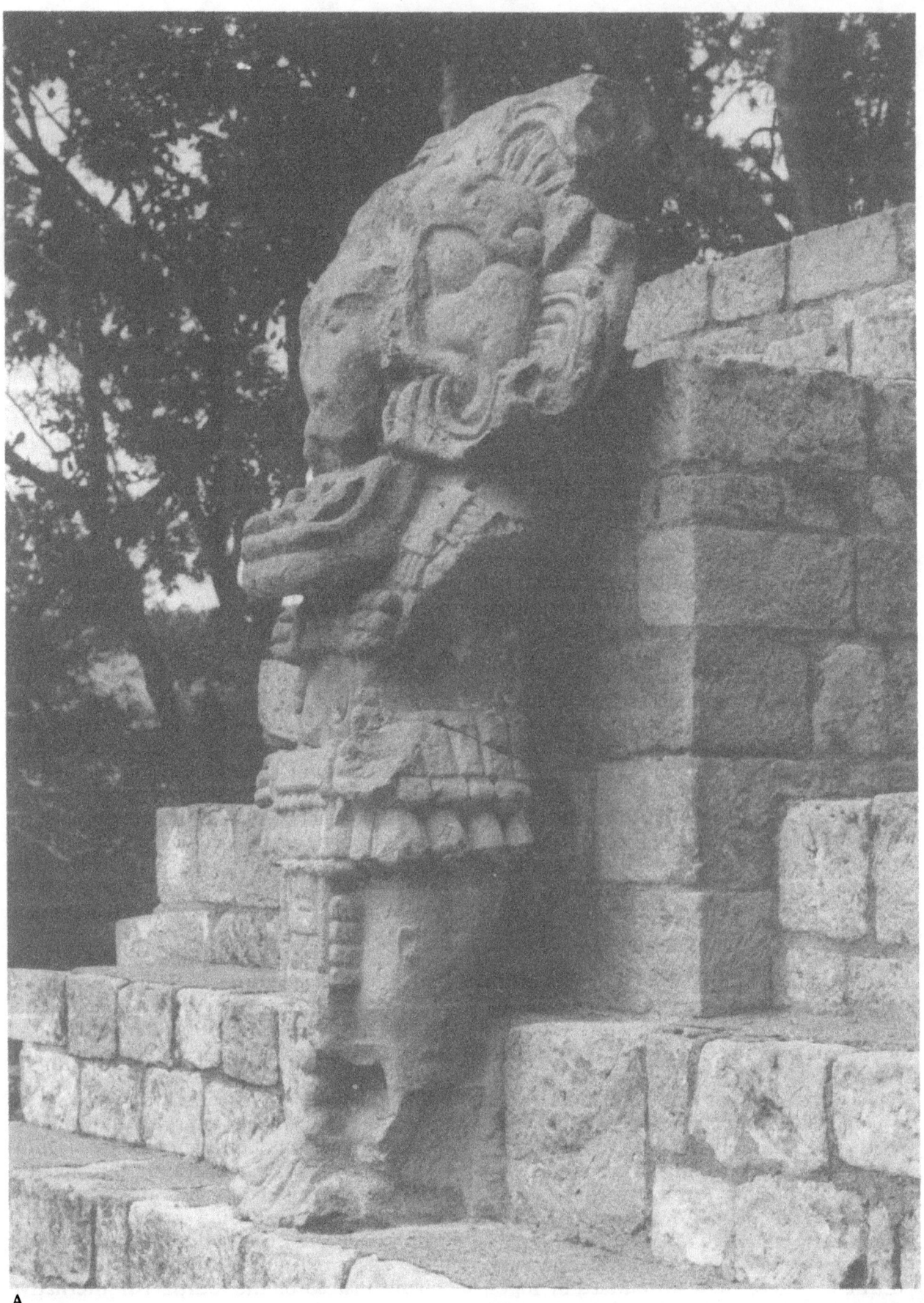
A

B

FIG. 110 Structure 26: (a) statue 6. Photo by J.-P. Courau. (b) "King-Grasping-Fish." Photo by C. F. Baudez.

would be that the rabbit heads refer not to an individual but to his dynasty. They also flank the pectoral of the two protagonists on CPN 23. Similarly, on the central marker of Ball Court A-IIb, the head of the same rodent is held by the lord of the underworld. Is he the one Eighteen-Rabbit comes to avenge?

Here again, the iconography does not individualize the kings. As on CPN 30, variations in costume, ornaments, objects, and associated symbolic creatures do not differentiate one individual from the other. With the exception of the rabbit heads, the attributes of each one fit the others and belong to the same theme, part of the war/sacrifice complex. The kings are named in the text, but not in the representations, and so the latter seem to express dynastic continuity.

However, the young man standing at the foot of the temple (statue no. 6) differs enough from the seated figures to have had a special status. The iconography of the Hieroglyphic Stairway is very close to that of CPN 52, dated 9.12.10.0.0. We do not understand why motifs such as the Year Sign and the pseudo-Tlaloc do not appear in the intervening period, especially during the reign of Eighteen-Rabbit.

The five seated and one standing figures in warrior attire distributed along the axis of the stairway have been identified mainly for iconographic reasons as six rulers of Copán. If we include CPN 24 at the base of the stairway as a seventh ruler representation, we have a complete match between warrior figures and accession reports. For epigraphic reasons it is therefore plausible to identify these figures as representing the ruling king Smoking-Squirrel and his six predecessors, since they are identified as such in the hieroglyphic text. Since Smoking-Squirrel is depicted on the stela at the bottom, the sequence of figural representations should be ascending until the oldest is reached at the

top. This again is in exact agreement with the chronological reading sequence established independently (Baudez and Riese 1990).

Prone Figures

Prone Figure No. 1 (Gordon 1902: pl. VI: H): This figure is *in situ* and occupies the central block of the fifth step, four steps away from statue no. 1. Although it is very eroded, we can still observe the overall form of the figure and a few details. He is lying on his right side, with his head to the north; his right arm is bent under the head, which faces the ground; the legs are crossed. The hair is long and knotted. A loincloth and a bracelet are also visible.

Prone Figure No. 2 (Gordon 1902: pl. V: J): This was part of one of the landslide steps, presently step 34. The sculpture is shifted from the axis to the south and is very eroded. He has the same posture as prone figure no. 1, except for an upward hand. The left arm along the body is in line with the upper edge of the step. The man has a deformed skull and his hair is knotted on top. The smoking-ax motif is above the forehead. The pectoral is a circular medallion with an eroded sign in the middle. Another medallion containing the crossed-bands with a tripartite pendant dangles from the loincloth.

Prone Figure No. 3 (Gordon 1902: pl. V: G): This figure also belonged to the landslide steps. He is now in the middle of the thirty-seventh step, below the king-grasping-fish. He is very eroded and has the same position as the preceding figure. There are traces of a wristlet and an anklet. The edge of the skirt is above the right knee.

Prone Figure No. 4 (Gordon 1902: pl. V): This figure is also from the landslide steps. He is presently part of the fortieth step. The relief is better preserved than on the preceding figure. The individual is also lying on his right side with his head slightly up and to the north. The legs are crossed; one is straight and the other bent. Both hands join near the loincloth, whose ends have black spots below the *cimi* sign. The smoking ax is implanted in his forehead. A collar attached with a rope is adorned with a row of black semicircles and another row of death eyes; a wide band with the crossed bands motif hangs from the collar. The anklets are made of beads.

Prone Figure No. 5 (Gordon 1902: pl. XII: O): On a block of unknown provenience, this figure is presently part of the fiftieth step and is very eroded. It depicts an individual lying on his stomach with the right arm bent on the chest and the face toward the ground. Both legs are stretched out. The figure has a beard and oval earrings and a bracelet. He wears a belt and a loincloth. An unidentified serrated element is above the legs.

Prone Figure No. 6 (Gordon 1902: pl. XII: N): Of unknown provenience, this figure is presently on step 53. He is very eroded and is in the same position as figure no. 5, except that the feet point outward. He wears an irregular earplug and possibly a beard. The figure also has a fringed and tasseled pectoral, a loincloth, and a beaded anklet.

Prone Figure No. 7 (Gordon 1902: pl. XII: E): Also of unknown provenience, this figure is presently on step 60. He is the best preserved of the prone figures. He lies on the right side with the arm stretched out on the ground and the hand upward. The left arm is folded on the chest, and the legs are crossed. The smoking ax is implanted in his forehead. The figure wears a beard and an oval earring; a tubular bead hangs from a bead collar. The wristlets, anklets, and belt are also made of beads. The cross appearing twice on the loincloth contains two twisted strips; its lower edge is stepped.

Summary and Interpretation

Analysis is difficult because of the poor condition of four of the seven prone figures. In all cases the bodies are contained within the space of the step's riser and the head is to the north. The rest of the position does not vary much: the right arm is bent under the head or stretched out on the ground with an upturned hand. Only in one case is the right hand near the belt. The legs are almost always crossed like those of the captives on the steps at Tamarindito. The figures wear jewels (collar and/or pectoral, bracelets, anklets) belt, and loincloth. Three have a smoking ax implanted in the forehead, an attribute exclu-

sive to other unworldly creatures (supernaturals and dead humans). They wear symbols of sacrifice and death: knotted long hair (nos. 2 and 3), a rope (no. 4), crossed-bands (nos. 2 and 4), black spots (no. 4), death eyes (no. 4), a *cimi* sign and a cross with two twisted strips (no. 7), as on Yaxchilán Lintels 24 and 25. They do not wear, however, symbols usually worn by captives such as ropes tying limbs or worn as arm bands, ribbons piercing earlobes, and so forth.

Whom do these figures represent? They do not seem to be supernaturals because their faces are not grotesque and their costumes are of the kind worn by dignitaries. If they are alive, why do they lie in the posture of the dead, specifically of sacrificed captives, as on the stairs at Dos Pilas and Tamarindito? Even if rulers disguised themselves as captives to practice autosacrifice (as Schele 1984 claims), they were not humble enough to have their images carved on the steps and consequently trampled. Thus, while the prone figures do not bear the expected diagnostic signs of sacrificial victims, I still think that they represent dead enemies, either sacrificed or killed in battle.

The King-Grasping-Fish Figure (fig. 110b; see also Gordon 1902: fig. 7, 14): Autosacrifice is illustrated on the stairway by a very deteriorated sculpture on the central block of one of the landslide steps, just above prone figure no. 3. This high-relief figure occupies about two steps. It is seated cross-legged and leans strongly to the north. He holds the tail of a fish that swallows a water lily stem. Other parts of the plant (among them a blossom drawn like an *imix*) may be seen above the figure's left knee. Although his features and jewels are eroded, he probably represents a Copán king, because he wears the proper turban.

The composition is cyclical: from the king's hand one moves to the fish, then to the stem, then to the water lily above the king's leg, then back to the fish, and so on. This sculpture must be seen as a full-figure image of the hand-grasping-fish glyph (T714), which refers to an autosacrificial rite (Proskouriakoff 1973). It probably means that the sacrifice of the king (hand-grasping-fish) ensures fertility (fish feeding water lily). Its function reminds one of the basic role performed by autosacrifice, as well as war and the sacrifice of enemies, which are celebrated on the stairs.

STRUCTURE 26: SUMMARY AND CONCLUSIONS

Structure 26 is a cosmological composition on three levels: the monster's skull inhabited by serpents represents the underworld and the superstructure represents the sky as the abode of the sun at zenith. The stairway presented as a head-first (split on the block's top) serpent links the lower and the upper worlds. It is, as its ramps demonstrate, under the curse of the death bird, which spreads its shadow on the earth. It has the same function as the serpent-shaped columns of Tula or Chichén Itzá, which support the temple's roof, envisioned as the sky. This transition is represented on the ball court by the sloping wall or on the Palenque panels by the cosmic tree. Another possible hypothesis is more difficult to argue: the stairway could be a monster's body whose two heads join together on the central block.

Structure 26 in its final construction phase is a monument erected by Smoking-Squirrel to the glory of his dynasty. The association with this ruler makes it especially important, since it seems to be the only large architectural complex of the Main Group that was not rebuilt by the later ruler Rising-Sun. The temple is the abode of triumphant kingship; on the stairway are seated the immediate five predecessors of Smoking-Squirrel, shown as great warriors and great sacrificers; a sixth stands in front of the crowning temple. These kings hold weapons and wear sacrificial symbols such as human skulls, skulls with ringed eyes, Year Signs, ropes, and globular headdresses made of down. Scattered here and there, the corpses of hostile princes are the witnesses of the royal feats. The image of the king grasping the fish elegantly reminds one of the importance of royal autosacrifice, in addition to the sacrifice of captives. Structure 26 also is a monument to kingship and to its paramount role in the cosmos: to perpetuate the universe repeated blood offerings are crucial. Smoking-Squirrel's ancestors are there as witnesses to dynastic and ritual continuity.

The hieroglyphic text on the steps of the stairway is the longest classic Maya text ex-

tant. It was intended as a history book covering 200 years of Copán dynastic history in unusual detail and precision.

THE DECORATED BENCHES
(figs. 111–112)

This chapter on architectural sculpture ends with the analysis of several examples of carved benches (whole or fragmented, with or without known context) from Copán. One of the best preserved and most spectacular ones was found by the PAC 2nd phase in 1981 and comes from Room 1 of "The House of the Bacabs" (fig. 111). This structure (9N-82) has been published in detail and I refer the reader to it for the analysis of its decorated bench (Baudez in Webster 1989).

STRUCTURE 9M-146

Excavated in 1977 by the Harvard Project (Willey, Leventhal, and Fash 1978), this is the most important structure of the group 9M-18. Like Structure 9N-82, it faces north and closes the south side of the group's plaza. An outset stair permits climbing to the platform of one of these building elements and gives access to a three-room edifice. The room in the center opens to the north, while the side rooms open to the west and the east, respectively. The three rooms have a 60-cm-high bench on the back wall: only the one in the center room is sculptured.

DEDICATORY DATE

9.17.17.2.0 11 Ahau 13 Pax (Baudez and Riese 1990). Linda Schele (1989a) reads the dedicatory date as 9.17.10.0.0 12 Ahau 8 Pax and proposes 9.16.10.13.10 11 Oc 13 Pax for the opening Calendar Round date.

The Bench (fig. 112a): The front face is entirely occupied by an inscription almost 4 m long composed of thirteen full-figure glyph-blocks. The bench is supported by four pairs of small columns carved into a sitting Atlantean figure, his arms raised. Each pair includes an image of death and a *bacab*. According to Willey et al., on each pair the *bacab* was on the left and death on the right, but this is not the case on B. Fash's drawing (fig. 112a).

The *bacab* issues from a single-valve shell and has a knotted water lily on the forehead; on one end we can distinguish the pad in the form of a notched circle with a hatched spot in the center. The wrinkled face of the *bacab* is framed by circular ear ornaments decorated with three little circles. He has a bead necklace around his neck with a section of shell as an ornament (pendant?). The second Atlantean figure of each pair has a death head, with no mandible and with half of a *kan* cross on the forehead. A forked tongue or emanation hangs from the upper jaw. The ear ornament is a death eye continuing into an asymmetrical double scroll.

COMPARISONS

It is noteworthy that the alternation of four deaths and four *bacabs* corresponds structurally and semantically to the alternation of the four sun jaguars and the four *cauac* monsters on the bench of Structure 10L-18.

CPN 489: BENCH SUPPORT
(Baudez 1989: fig. 73).

In the storage room of the Copán Museum was found a rectangular sculptured block (slab) with a figure seated on the head of a crocodile. He is portrayed in front view, except for the head, which is in left profile; the hand on this side is on his belly, while the right one is raised toward the front; above this hand, whose exact position is difficult to establish, is an effaced relief that could have been an object held by it. The figure is clothed with a loincloth; he wears a necklace, ear ornaments (unidentifiable) and an element under the chin, perhaps a beard. His seat is a crocodile head, in left profile, with *imix* on the forehead; it is accompanied by a water lily pad. Vestiges of two glyph-blocks are visible in front of the knees of the figure: we can recognize above the emblem-glyph of Copán and below the glyphic composition *ba-ca-b(a)* that generally terminates inscriptions.

COMPARISONS

The identification of this piece as a bench support is the result of comparison with the feet of the Del Río throne at Palenque (Schele 1978: fig. 12). In both cases the seated figure most likely represents a *bacab*.

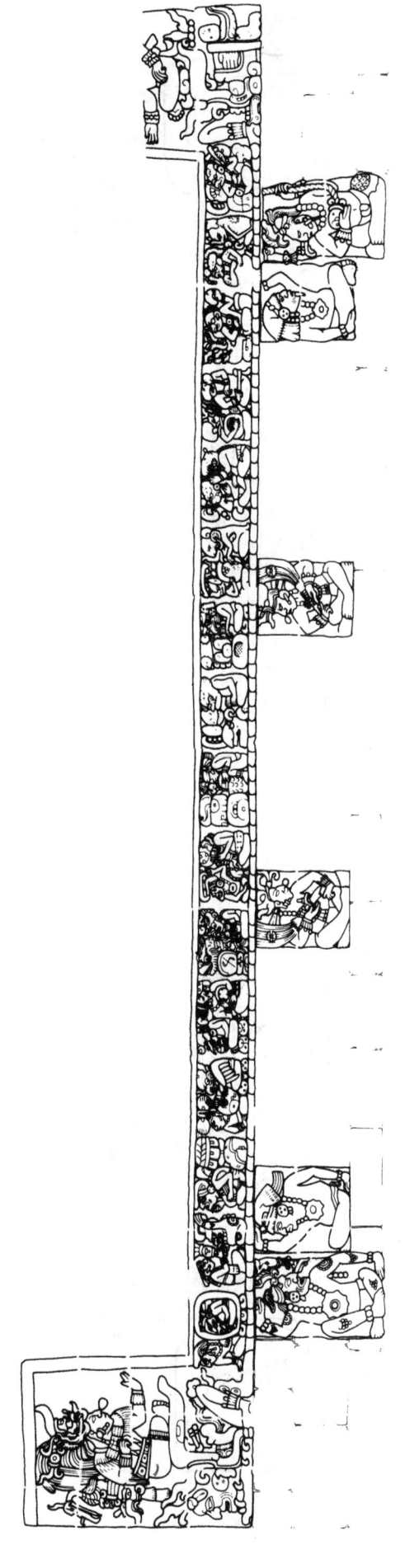

FIG. III Structure 9N-82: carved bench. Drawing by A. Dowd.

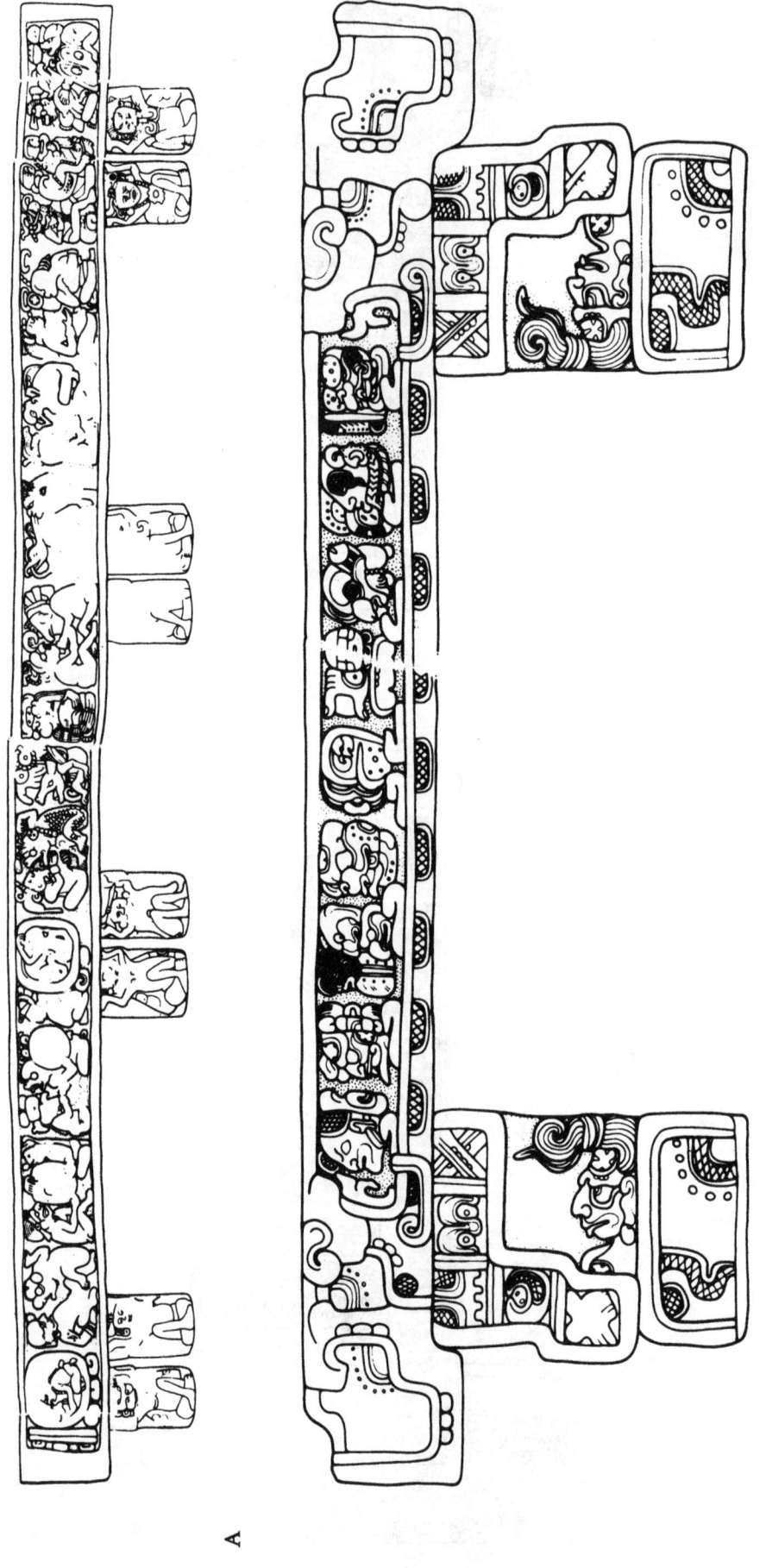

FIG. 112 (a) Carved bench from Structure 9M-146; (b) carved bench from group 10K (CPN 999). Drawings by B. Fash

CPN 999: Sculptured Bench

CIRCUMSTANCES OF DISCOVERY

This bench comes from one of the low mounds situated in front of the old entrance to the Archaeological Park, several meters to the west of the road. The structure, one of the mounds of group 10K-4 (Structures 10K-11 to 14), was originally explored by looters; afterward it was the object of "salvage" archaeology by Arturo Sandoval, with instructions from the IHAH, in the 1960s. The bench that faced west was dismounted and transported to Tegucigalpa. In 1980 it was in the Museum of Anthropology there; the way in which it was remounted does not conform to the description A. Sandoval gave me, which I will follow here.

The bench, whose face is sculptured, is sustained at both ends by two similar supports each made from two blocks that form the glyphic composition "Sun at the Horizon" (fig. 112b). One discerns a compound of *caban* and *cauac* elements indicating the earth and placed under the *kin* solar head; this in turn is surmounted by an arched celestial band portraying the sky. Although these two supports lack the prefix *yax* forming "New Sun at the Horizon" or "Rising-Sun," they undoubtedly mention twice the name of the sixteenth king of Copán. He therefore appears as a *bacab* holding up the earth monster that composes the main part of the bench. According to Sandoval, there was a third central support formed of two blocks, each bearing three vertically aligned rings. We do not know what this support represented; perhaps it depicted the body of the *cauac* monster, the rings then being the reptile's markings.

The front face of the bench is the split representation of a head of the *cauac* monster, whose jaws contain an inscription composed of nine glyphs. The two halves of the monster's head are lying on either end of the bench; from inside to outside, we can discern the scroll at the mouth's edge, a tooth, the snout and the nose, the eye (with the *cauac* element as pupil) and half of the T sign with a central cleft that adorns the forehead of the earth monster. The mandible, which reunites the two halves of the head, is carved on the lower edge, as is a band covered with black reptilian spots. The inscription must be related in some way to the underworld, because it is presented *within* the jaws of the earth monster.

PART II SYNTHESIS

CHAPTER 3

The History of Monumental Art at Copán

Plotting attributes of form and content on a chronological chart reveals that, although many of them are not significant (they are too scarce or too common or too evenly distributed), a number of traits may be used to divide the continuum of the history of monumental art into several major periods.

MAJOR PERIODS

Formal attributes are especially relevant. Spinden (1913) noticed meaningful characteristics such as the depth of relief, the relative proportions of the human head and body, the position of the arms on the chest, the place of the feet, and so forth. To this list may be added other features related to the iconographic composition of stelae and altars. Details in dress also change through time, either in terms of absence and presence (for instance, the chin mask vanishes after 9.13.0.0.0) or in the form of garments and jewels (such as earplugs). Symbolic objects and other accessories (such as the serpent bar or sacrificial instruments or symbols) are equally time-sensitive, as shown by Proskouriakoff (1950). However, the chronological distribution of icons of animated beings (cosmological images, ancestors, supernaturals) must be interpreted with caution. New representations do not necessarily correspond to new concepts or new chapters of mythology. Their former absence may be due to a lack of space on the early monuments and to our lack of knowledge of the early architectural sculpture. In this domain we cannot demonstrate any replacements from one period to the other; we merely observe the broadening of the repertory, where new forms are added to earlier ones and complement them. It is obvious that the main cosmological themes of the Maya of Copán were already part of their thought and ritual, at the very beginning of the sequence, at least from 9.9.0.0.0.

All chronologically significant traits appear on chart 2; their manifestations on the monuments are plotted relative to a time scale expressed in Long Count dates. The distribution reveals three major groupings. In Period A are traits in use before 9.14.0.0.0, a date that corresponds to the beginning of the reign of Eighteen-Rabbit. A transitional period covers a time span between 9.11.15.0.0 and 9.13.0.0.0. On CPN 47 and CPN 18, which mark this interval, many attributes may be seen for the last time together with new traits. In Period B are traits that appear with Eighteen-Rabbit and for the most part, continue until the fall of the city. An unaccounted-for gap of one katun in the monumental sequence (there is no stela celebrating the 14th katun) separates CPN 20 from CPN 11, but in twenty years the changes are spectacular. Traits that appear after the reign of Eighteen-Rabbit and an apparent silence of one katun (between CPN 7 and CPN 24) constitute the third group, in Period C. Many of these innovations seem to correspond to the reign of Rising-Sun, but may be earlier since the works of his predecessors are very poorly known.

FORMAL PROPERTIES

From A to B: Spinden noticed the difference in relief of the stelae before and after 9.15.0.0.0.

CHART 2. Distribution of selected time-sensitive iconographic elements on monuments and architectural sculpture (see legend on p. 246).

Time (h m s)	Values
9 14 10	
9 14 5	
9 14 0	
9 13 15	18
9 13 10	
9 13 5	
9 13 0	18, 18, 18
9 12 15	
9 12 10	52, 52, 52
9 12 5	
9 12 0	38, 38
9 11 15	47, 47, 47, 47, 47, 47, 47, 47, 9
9 11 10	9, 9, 9, 9, 9, 9, 9
9 11 5	40, 57, 61; 40, 40, 41, 40, 41, 41, 41, 41, 41, 40
9 11 0	19, 50, 87, 22; 39, 49, 10; 70, 63; 105; 40, 41, 41, 41, 41, 41, 41, 40
9 10 15	53, 86
9 10 10	
9 10 5	
9 10 0	
9 15	
9 9 10	29, 29, 29, 29, 29, 29, 29, 29
9 9 5	
9 9 0	54, 54, 54, 54, 54, 54, 54, 54
9 8 15	48
9 8 10	
9 8 5	
9 8 0	
9 7 15	

(continued)

Category	Feature	9.18.15	9.18.10	9.18.5	9.18.0	9.17.15	9.17.10	9.17.5	9.17.0	9.16.15	9.16.10	9.16.5	9.16.0	9.15.15	9.15.10	9.15.5	9.15.0	9.14.15
Costume	Tinklers: Oliva shells					4					26	24	26		7	3	1	43
Costume	Jade plaques: marked with T616b					4					26				7	3	1	
Costume	Pectoral: long tubes		18			33		30	11		26					3	16	43
Costume	Earflare with serrated central element										26				7	3	16	43
Costume	Hair: pulled back with strands framing the face										26	24			7	1	16	43
Costume	Wristlets & Anklets: ribbon-on-band							30	11		26					3	1	16
Costume	Wristlets & Anklets: knotted bands					4		30 22	11		26	24				3		
Costume	Wristlets & Anklets: lancet heads					4					26	24			7	3	1	43
Altars	Sandals: type C5														7	3	1	
Altars	Altar: monolithic, non geometric										27				8	17		
Stela Composition	Altar: composite					5						25						
Stela Composition	Three figures at top					4					26	24	26			43		
Stela Composition	Central figure at top holding two serpents					4									7			
Stela Composition	Main figure framed by cosmic serpents from top					4					26	24			7		16	43
Knot-rope complex	Main figure extends all over the monument											24			7		16	43
Knot-rope complex	Loop serpent																	
Knot-rope complex	Serpent tying a sandal																	
Knot-rope complex	Knotted bundle																	
Knot-rope complex	Serpent as rope																	
Knot-rope complex	Braid-and-tassel: framing ear flares																	
Knot-rope complex	Braid-and-tassel: underlining belt masks																	
Knot-rope complex	Braid-and-tassel: falling from monster's mouth																16	
Serpent-bar	Circular shield, flanking legs of main figure																1	
Serpent-bar	Body: flaccid, skeletal																	
Serpent-bar	Body: flaccid, live																	

Time (h m s)																
9 14 10	11								11	12	11	11	11	11	47	11
9 14 5																
9 14 0																
9 13 15																
9 13 10																
9 13 5																
9 13 0				18												
9 12 15			18	18												
9 12 10		52									21					
9 12 5			18	18	18											
9 12 0			18	18	18	18									38 47	
9 11 15		38 9	47	47	47	47									47 9	
9 11 10					9	9									9	
9 11 5		41 40													41 40	
9 11 0		40	40	40	41	41									62	
9 10 15																
9 10 10		29			29											
9 10 5			54	29	29											
9 10 0		54		54	54											
9 9 15															48	
9 9 10		29														
9 9 5																
9 9 0		54													54	
9 8 15																
9 8 10																
9 8 5																
9 8 0																
9 7 15																

(continued)

Date	Serpent-bar: Body rigid with mat pattern	Serpent-bar: Serpent heads terminal fangs exaggerated	Serpent-bar: Content grotesque with eccentric as skull	Sacrificial: Scepter jaguar paw	Sacrificial: Staff composite	Sacrificial: Eccentric knife as skull	Sacrificial: Lancer double scrolled base	Sacrificial: Lancer serpent head	Sacrificial: Head lancet on ribbon	Sacrificial: Whistongue	Maize: Anthropomorphic head alone	Maize: Anthropomorphic whole figure	Grotesques: Long-nosed figure with no smoking axe	Grotesques: Long-nosed figure with smoking axe	Grotesques: Bicephalic monster with contrasting heads	Grotesques: Bicephalic monster with non contrasting heads	Grotesques: Cauac monster with contrasting heads	Grotesques: Cauac monster with non contrasting heads	Grotesques: Cauac masks on monster's body	Earth forms: Other earth forms	Earth forms: 7 Head/9 Head	Earth forms: T-shaped opening	Earth forms: Altar carved, prismatic, high	Earth forms: "Split head" representation	Earth forms: Grotesque heads on scrolls & serpents
9 18 15						13				18					13					18		18			13
9 18 10										13															
9 18 5																14							34		
9 18 0								82							82						33		31	82	33
9 17 15								4	4		4		4	101	5		101	4	101				33		4
9 17 10								22				22			22	15	82		22				30	16	
9 17 5				30				22		22					82								23	22	
9 17 0				11								11		11		11						37		11	
9 16 15						24																	37		
9 16 10					24	24	22		24	26			26	26					26						
9 16 5														24	25		25		25						
9 16 0																								26	
9 15 15																									
9 15 10	7	7	3					7	7		7		7	7											
9 15 5	1	3	3			3			3	3	3		3	3	8	3	8	3	3		7				
9 15 0	16	1	1			1		16	1			16		16					3						
9 14 15	43	16	16			16			43					43											

Time								
9 14 10								
9 14 5	11							
9 14 0								
9 13 15								
9 13 10							20	
9 13 5						20		
9 13 0								
9 12 15								
9 12 10								
9 12 5								
9 12 0								
9 11 15	11							
9 11 10								
9 11 5								
9 11 0								
9 10 15				47				
9 10 10		11						
9 10 5		11						
9 10 0		11	47					
9 9 15								
9 9 10								
9 9 5								
9 9 0								
9 8 15								
9 8 10								
9 8 5	11							
9 8 0								
9 7 15								

(continued)

CHART 2 Distribution of selected time-sensitive iconographic elements on monuments and architectural sculpture (indicated by CPN number; numbers of architectural sculptures are in italic face). Some monuments that are not discussed in text for lack of iconography are included in this chart because of their chronological significance in the fields of stela and altar composition or form. They are CPN 22 (Altar K), 49 (East Altar of Stela 5), 50 (West Altar of Stela 5), 57 (Stela 10), 61 (Stela 12), 62 (Stela 13), 63 (Altar of Stela 13), and 86 (Altar H'). The chronological placement of these monuments is according to Riese (in Baudez and Riese 1990).

Date	Costume												Earth forms				
	Biconical turban	Earplugs: circular with tube	Pectoral: T & tubes	Pectoral: T & jaguar mask	Shield: square or rectangular	Skull(s) indicating the Underworld	Braid-and-tassel: used alone	Scepter: bundle	Ancestor facing ruler	Ancestors in a row	Bacabs emerging	Bacabs as atlantes	Feathered serpent	Turtle	Toad	Crocodile	Waterlily
9 18 15													13				13
9 18 10							18				13		14				18 14
9 18 5													15				15
9 18 0						31			82		82	82					82
9 17 15	33	33					55	33									
9 17 10							4	33	33	33				5	33	33	33
9 17 5	30	30	30	30	30	24		30	30	30		146			101		101
9 17 0	23	23		23		22		23	23			22			82		22 12
9 16 15	11	11	11	11				11	11	11					11		11
9 16 10			26			26				26					26	26	26 26
9 16 5					26						25						24
9 16 0																	
9 15 15																	
9 15 10																	
9 15 5																	
9 15 0																	
9 14 15																	

He postulated a progressive increase in relief and thus assigned to CPN 11 and CPN 43 an age inferior to the one inferred from their dedicatory date. Proskouriakoff (1950: 143) rightly criticized this position.

In Period A the figure and its environment may extend beyond the main side, but without taking more than half the depth of the monument; conversely, on the first sculptures of Period B the image of the king and the surrounding frame occupy three sides. The artist now has more room for obliquely placing the feet of the figures and for lowering their arms; these creatures look more slender. What is more important, the three dimensions allow for a considerable increase of the decorative field, and thus the iconographic message can be much longer.

The composition also changes. The top of the Period A stelae is occupied by several small masks (one of them illustrating the skull-and-vegetation motif); the sky serpents that frame the ruler are only visible from the waist down, and creatures emerge from the serpent jaws at the level of the king's helmet. During the following period they are absent, as well as the masks at the top; furthermore, the king is completely surrounded by the sky serpents and placed under the protection of his ancestors. The cylindrical or prismatic altars, sometimes shown as bundles, are exchanged for nongeometric, monolithic, or composite altars.

From B to C: After katun 17 the major change consists in the almost complete disappearance of the stelae in favor of high prismatic altars and architectural sculpture. The decoration of grotesque heads on scrolls and serpents (Proskouriakoff's trait Ke) as well as the split representation appear in the same period.

Costume

From A to B: Wristlets and anklets that combined a serpent-head with the crossed-bands or the quincunx give way to the serpent-head lancet, the knotted bands, and the ribbon-on-band type. The references to sacrifice are more explicit in these ornaments. The rectangular earflares become rounded. Strands of hair now replace the beaded band framing the forehead. The skirt's edge no longer has beads or fringe. The chin mask is gone. The *Oliva* shells used as tinklers appear below the belt. On the jade plaques hanging from the belt masks or the skirt the glyphic signs change: T24 and T103 are replaced by T616b and T528.

From B to C: The king's turban becomes more elaborate, including more accessories; pectorals also get larger and more sophisticated: composite jaguar masks, tubular beads, Ts, and so forth. The ear ornament is now frequently shown as a flare and tube.

Accessories and Symbolic Objects

From A to B: The bicephalic sky serpent, symbol of royal rulership, first shown with a flaccid body, becomes a serpent bar with a conventional, rigid body marked with the mat or the celestial crossed-bands. On the monuments of Eighteen-Rabbit the serpent heads have exaggerated terminal fangs. On the sculptures of Period A they enclose solar creatures or anthropomorphs. With Period B new beings appear: they evoke sacrificial rites more explicitly than in the past. The bloodletting instruments are now displayed in realistic or symbolic form: the double-scrolled lancet, the serpent-head lancet, the whistongue. Among the more abstract expressions of sacrifice, some become obsolete—the bundle, the loop serpent, the rope serpent—in favor of the three-knotted bands symbol, which is used more frequently.

From B to C: The serpent bar is treated in a more conventional, more geometric, also more flamboyant style; the Thunderer is often found within the jaws of the serpents at its ends. No longer is the serpent bar the only scepter that the king holds. Near the circular shield are square or rectangular forms. In the cosmograms the underworld is more often referred to by a skull than by a solar head. The braid-and-tassel becomes autonomous and is sometimes used alone.

Animated Beings

From A to B: From the beginning the ancestors accompany the king on the stelae. Among the supernaturals, there is still much variety among the felines (for instance, the opposition of the Uo and Pax jaguars) as well as in

the solar and sacrificial forms; however, there are no zoomorphs, with the exception of the jaguar and the serpent. With Eighteen-Rabbit's reign, and more available space on the stelae, new creatures appear: grotesque figures with a human body and the head of a polymorph; long-nosed creatures, some of them provided with the smoking ax; anthropomorphic representations of maize (the head alone or the whole figure) with the skull topped with foliage; the bicephalic monster and/or the earth monster.

From B to C: With Smoking-Squirrel the *bacab*s and other earthly manifestations such as the water lily, the toad, and the crocodile are illustrated for the first time at Copán. Dynastic continuity is illustrated by the line of kings seated on the Hieroglyphic Stairway; in Rising-Sun's era this theme is expanded by a new expression of legitimacy: the ancestors facing the ruler. The turtle (CPN 5) is a new form for the earth. The feathered serpent is a late introduction.

Summary

The history of Copán art is divided into three great periods by two major breaks: the first break precedes the beginning of Eighteen-Rabbit's reign; the second occurs during the reign of Smoking-Squirrel and the beginning of Rising-Sun's rule (about 9.16.5.0.0 to 9.16.10.0.0). In both cases, these periods of major change are preceded by a hiatus of fifteen to twenty years. If these changes seem abrupt, it may be because some of the links of the evolutionary chain are missing; however, assuming the changes were actually sudden, the gaps would be the expressions of troubled times, during which new forms had to evolve. Be that as it may, it will be shown below that the history of Copán art is more accurately related when using finer divisions. These take into account not only the stylistic and iconographic changes, but also dynastic history.

FINER DIVISIONS

Before 9.9.0.0.0: Insofar as CPN 46 and CPN 51 are preclassic, pre-Maya sculptures related to the art of the Pacific coast and the highlands of Guatemala, the earliest Maya monument at Copán is CPN 188. This double-figure stela is very close to the Early Classic monuments of the Central Petén. Stylistically it is dated from the end of the 8th or the beginning of the 9th baktun. The archaisms displayed by this sculpture and by those that follow it (such as the flaccid serpent, already absent on the baktun 8 stelae at Tikal) seem to indicate that Copán was Maya well before 9.0.0.0.0. Strangely enough, all monuments after CPN 188 until 9.9.0.0.0 lack images and bear texts only.

From 9.9.0.0.0 to 9.11.15.0.0: CPN 54 is the first dated (9.9.0.0.0), iconic, whole (although not complete) stela. A prismatic block progressively widening toward the top is carved in low relief: the iconography occupies one side and a text is spread on the other three. The main figure, slender, stands in front view; his arms, almost vertically placed, hold the bicephalic serpent against the chest. The upper part of the figure with serpent and headdress occupies the whole width of this narrow monument; there is no room for the cosmic serpents that would normally frame the king; they are indicated on both sides of the king's legs, where the body is narrower and leaves room for these serpents and shields. The king appears under the sign of the jaguar (helmet) and of the Jaguar Paddler (ends of bicephalic serpent). Above the king the skull-and-vegetation motif expresses one of the major themes of Maya thought.

CPN 9 is stylistically closer to CPN 54 than to the katun 11 stelae, although Riese dates it on 9.11.13.5.0. Ancestors are seen in their preferred place (i.e., at the top, as if to protect the ruler). They hold up the ax of war and sacrifice. Variants of the Pax jaguar may be seen at the ends of the bicephalic serpent; the same creature is identified on the sides of the belt.

CPN 29 and 40 are thirty tuns apart but are almost identical; the only important difference concerns the king's helmet: on CPN 40 it is a jaguar, while it is a serpent or crocodile on CPN 29. The composition reproduces that of CPN 54: cosmic serpents and shields frame the ruler's legs; what will become the ceremonial bar is a two-headed flaccid serpent with solar creatures in its jaws; the belt bears youth masks; and a braid-and-tassel adorns the loincloth. On the top of the stelae are sacrificial

creatures and the skull-and-vegetation motif against a jaguar skin background. Such a similarity between two monuments is unique at Copán and cannot be accidental; it seems that the same artist purposely made them similar. They were later displaced and lost their altar, if they ever had one. Originally they may have formed a pair in which the king appeared under the two main aspects of the earth/sun duality: crocodile versus jaguar. Unfortunately, the texts do not express any specific relationship between the two monuments.

Besides CPN 40, four Copán monuments have 9.11.0.0.0 as dedicatory date: CPN 57, CPN 61, CPN 62, and CPN 75. To this list may be added CPN 69 and CPN 41, whose Initial Series date is respectively 5 and 13 uinals before the katun ending. With the exception of CPN 40 and CPN 41, these monuments were not erected in the Main Group but in the valley. Smoke-Jaguar wished to celebrate the end of katun 11 with the erection of seven stelae, out of which five are at the limits of his territory; they only bear texts, except for the cribbing frame of CPN 62, which is sculpted with sacrificial symbols: the bundle and the knotted serpent. The two stelae in the Main Group, however, are iconic: CPN 40 (a copy of CPN 29, thirty years older?) and the double-figure CPN 41. Like the other double-figure stelae, it is a succession monument, on which the king presents his successor. Here as on CPN 47, another succession stela, ancestors emerge from the jaws of a monster. CPN 41 is also replete with sacrificial images, capture and death symbols, God Q faces, and primitive forms of the personified lancet (animal heads with a knife-tongue). Its base was surrounded by a monolithic frame carved with fertility and sacrifice images.

CPN 47 celebrates the succession of Smoke-Jaguar to his predecessor; the latter, being dead, wears a jaguar mask and helmet, which likens him to the nocturnal sun. For the art historian, CPN 47 is a transitional monument: at the same time it exhibits traits diagnostic of the early monuments and new elements that will be part of the iconographic repertory in the future: the serpent-head lancet for wristlets and anklets, the ribbon-on-band wristlets, the shell tinklers, the whistongue, and so forth.

From 9.11.15.14.0 to 9.12.10.0.0: The two strangest monuments at Copán, CPN 38 and CPN 52, were erected within ten years. According to Proskouriakoff (1950: 116), "the most significant contribution of Stela 1 [i.e., CPN 38] to the art of Copán was an increased emphasis on the conception of the design as an arrangement of masses or three dimensional forms, expressed in the composition of receding and projecting surfaces. Oblique masses, however, are not yet introduced, and the figure can still be adequately envisaged on perpendicular planes, in spite of its rounded contours." On the preceding stelae the relief of the main figure never occupied more than one-third of the monument's thickness. With CPN 38 the king takes almost half of the stela volume. Proskouriakoff wondered whether a work that violates the tradition to that extent could have been locally created without inspiration from the outside. In fact, it has no known antecedents anywhere. It is remarkably simple: the king is not framed by sky serpents; neither is he topped or flanked by masks. He is presented alone, and he strongly claims the citizenship of Copán by wearing the large turban for the first time and displaying turbaned ancestors emerging from the heads of his serpent bar. According to Proskouriakoff, the wide, thick, undecorated style, except for the draping belt, would be reminiscent of the Usumacinta style. As for the wristlets and the earplugs, they are new at Copán.

CPN 52 is very close to the latter because of its relief, the absence of a cosmic frame, the small size, and the turban. The main figure is in the guise of a penitent and wears elements of the pseudo-Tlaloc/Year Sign complex. The pseudo-Tlaloc may be found in the headdress and in the jaws of the bicephalic serpent (whose body is flaccid, in the Copanec tradition). The king also wears the heart-and-dripping blood motif, knee ornaments made of bands and rhomboids, a belt made of ropes, and a skirt made of sacrificial ribbons. In the Maya area this monument is the earliest to display the pseudo-Tlaloc complex in the Late Classic; this complex must be distinguished from the Teotihuacanoid set of the Central Petén, which is 200 years earlier. Following Copán, the complex will be later illustrated in the Usumacinta drainage, at

Piedras Negras, Aguateca, Dos Pilas, and Yaxchilán. Following CPN 52, the first monument using this iconography is Piedras Negras Stela 7; it is dated 9.14.10.0.0 (i.e., two katuns later than CPN 52). We can only guess about the direct origin of this complex; if its first and remote source certainly is central Mexico, there must exist intermediate forms between the Mexican illustrations and CPN 52, either inside or outside the Maya area. Once discovered, these missing links would throw light on the origin of the high-relief sculpture at Copán if we assume that CPN 38 and CPN 52 are related and share the same origin.

It has been suggested (Baudez 1986) that these stelae represent a usurper. This hypothesis rested on the following observations: the two stelae (CPN 38 and 52) are at the same time very close to each other and very far from the preceding monument (CPN 47, re-erected five years before CPN 38); their style and iconography are alien to Copán; they seem to depict the same individual, who wears the turban in both cases; and the two stelae that follow (CPN 18 and 20) return to the style of the 11th katun and earlier monuments. It is of course possible to explain the originality of these two monuments by a whim of the king to call on foreign artists; in this unlikely hypothesis, local or Copanized carvers later would have been reemployed.

From 9.13.0.0.0 to 9.13.10.0.0: The proportions of the rounder relief of CPN 18 may have been inspired by those of CPN 38 and CPN 52. But its iconography is closer to that of CPN 41 and CPN 47. CPN 18 and CPN 20 are respectively interpreted as a funerary monument and as an accession stela. On the former the king Smoke-Jaguar (with his name in figurative form enclosed within the jaws of the skeletal bicephalic serpent) is likened to the nocturnal sun, because he is the sun and because he is dead (to be born again). He is the equivalent of the figure on CPN 47 west. He wears the mask of GI, an aspect of the night sun, and a jaguar helmet, whose infernal connections are indicated by the four-part emblem. The cosmic frame (serpents and shields) around the king is only visible from the belt down. Turbaned ancestors watch over the king.

On the west side of CPN 20 the earth is shown as a large *cauac* monster mask (its first appearance at Copán) with a few solar traits. On the east side a long text is patterned as a mat, symbol of rulership. There are two alternative interpretations:

1. Like CPN 18, the monument is a funerary stela that commemorates the death of the king. In this hypothesis, the king (the mat) is shown inside the earth (the sun is seen through the earth).
2. Or, more likely, it is an accession presented as an emergence, a foreshortened image of CPN 3, on which the mat would represent the king (emerging from an implicit front head), with the *cauac* mask representing the rear head of the earth monster. This stela, different from all other Copán monuments (except in its construction, which reminds us of CPN 3) is in very shallow relief and owes nothing to the innovations discussed above. The strange sculpture associated with it, which may have been an altar, is also unique: it consists of a jaguar head on top of a truncated pyramid (a symbol of rulership?).

Prior to the great period marked by the Eighteen-Rabbit stelae, a new gap of twenty years occurs in the monument sequence. It is very strange that no stela celebrating the end of the 14th katun has ever been found. Did the new king experience hardships at the beginning of his reign?

Except for CPN 21, all altars from periods I-IV are geometric, plain cylindrical (CPN 53), or carved with an inscription on the side (CPN 10, 39, 49, 50) and sometimes tied as a bundle (CPN 19). They may also be prismatic, low, with a text on the side, shown as a bundle (CPN 79) or not (CPN 22, 86, 87). To the pre-Eighteen-Rabbit period also belong the altars CPN 48 and CPN 44 reused in the foundations of CPN 47 and CPN 43; they once formed a pair expressing the sun/earth duality. Because of their shape and style, the square blocks (CPN 109 to 111), with the aquatic frieze on their four sides, are placed before the reign of Eighteen-Rabbit. They indicate that sculpture was also used to illustrate the major cosmological themes.

From 9.14.10.0.0 to 9.15.5.0.0: As Proskouriakoff (1950: 129) observed, there is a difference in nature and not in degree between the Eighteen-Rabbit stelae and the earlier monuments: the latter, including CPN 38 and CPN

52, "are conceived and designed on perpendicular planes. The masses have different degrees of projection, but are never oblique to the face of the monument."

Conversely, the new stelae present "three-dimensional forms arranged obliquely in space" (Proskouriakoff 1950: 129). On CPN 11 the main figure and its surrounding decoration occupy, without discontinuity, three of its four sides. The king appears as a penitent or as a victim of self-sacrifice, framed with celestial serpents from top to bottom. These serpents are bicephalic with contrasted heads, and their body—in accordance with the sacrificial theme—is replaced by a rope. Grotesque figures, with a human body and a polymorphous head, cling to these ropes; these supernaturals, patrons of sacrifice, display lancets and knotted bands. The king wears the whistongue on his face and a large serpent-head lancet adorns his belt. He is placed under the protection of three ancestors, who like himself are shown as penitents. The text is divided into several parts framed by ropes. The altar associated with the stela is composite: several blocks arranged in a cross combine two Pax jaguar masks with two realistic jaguars, head-first and with a sacrificial scarf around the neck. Here the altar's iconography completes the stela's message; from now on, altar and stela will constitute an indivisible whole.

CPN 43, dated 9.15.0.0.0 (Riese 1988a) or 9.14.15.0.0 (Stuart 1986a), again depicts the king as a penitent. He is surrounded by a strange creature, repeated six times, which has a knotted serpent body and a long-nosed head with a smoking ax implanted in the forehead. Assuming that the Thunderer represents the king's power, this creature could be an image of the sacrificed ruler. The altar is a flattened sphere encircled with a rope; its top is carved out to form a cup, from which radiate four channels. The altar is obviously sacrificial, as all Copán altars probably are.

In the foundations of CPN 43 and CPN 47 were found two archaic sculptures (CPN 46 and 51) and two early altars (CPN 44 and 48). Such identical deposits cannot be fortuitous. They imply that CPN 43 and CPN 47 were erected at the same time after the deposit of an archaic statue and a rectangular altar, in the foundation of each. This took place at the date of the later monument (i.e., CPN 43). This implies that CPN 47 was reerected three katuns after its dedication. This displacement may express a special relationship between CPN 47 and CPN 43 (a three-katun anniversary?). These deposits are not new at Copán. Under CPN 54 was found CPN 76. Sculpture fragments were often purposely deposited in buildings, in substructure fills or stairs (Riese in Baudez 1983: vol. 2, pp. 182–84). It seems that in depositing early sculptures the Copanecs preserved and reused power for the erection of a stela or of a building. Until the reign of Eighteen-Rabbit these deposits are the only known expressions of respect for the monuments of the past. Their destruction could have occurred at once in a war or a revolution or step by step, each new ruler destroying the images of his predecessor. The monuments of Smoke-Jaguar and a few of his predecessors were the first to be preserved; thus, Eighteen-Rabbit is the one who systematically watched over their conservation. Sometimes the original location of the monument has been preserved (CPN 18), but most often it has not (CPN 9, CPN 40). This new attitude, apparently followed by the rulers succeeding Eighteen-Rabbit, is probably political. In fact, after 9.11.0.0.0, the irregular rhythm of stela erection and the stylistic changes are witnesses to a politically unstable period. Fifteen years after the great showing of the 11th katun ending, two very exotic monuments make their appearance; those that follow come back to past modes. Then the great production of Eighteen-Rabbit begins in 9.14.10.0.0, after a twenty-year gap. It seems that the latter king succeeded in reestablishing his power after troubled times; he claimed his succession to Smoke-Jaguar with the conservation and exhibition of his monuments.

The end of the 15th katun was brilliantly celebrated with the construction of Structure 4, a four-stair pyramid that reproduces—like the Tikal Twin Pyramids—the sign for completion (Baudez 1991); on the same occasion three stelae and their respective altars were also erected. CPN 1 and CPN 16 constitute a pair and represent Eighteen-Rabbit and perhaps his wife Lady Turtle. This monument bears the date 9.14.19.5.0 (repeated on CPN 1), that is, one tzolkin before the katun ending;

the same interval separates the date of CPN 41 from the end of the 11th katun. On CPN 1 the king appears in the full strength of a young warrior. Composite staffs and shields flank his legs, as on the early stelae. Another archaism is the skull-and-vegetation motif above the ruler's head. This motif is strengthened by the presence of skeletal serpents, which open their jaws on an earth symbol. The iconography consists in a well-balanced mixture of sacrificial creatures and symbols, with elements associated with the earth, vegetation, and maize.

CPN 3, with an exact katun ending date, commemorates the king's accession. The ruler is shown standing, coming out of the front head of the *cauac* monster, like the rising sun that leaves the jaws of the earth. Two macaws, symbols of the diurnal sun, are perched on the monster's head, the whole image illustrating the earth/sun duality. The earth body is indicated on the sides of the monument by piled up *cauac* masks. The rear head is seen as a large mask reminding one of CPN 20; an ancestor, elaborately costumed, sits on top of it. He probably is the great ancestor Yax K'uk' Mo'o, founder of the Copán dynasty. On the other side Eighteen-Rabbit wears the whistongue on his face and another one is placed upside down on his turban; close to it are maize heads. The creatures emerging from the serpent bar are patrons of sacrifice. The king is surrounded by turbaned ancestors who wear bloodstained ribbons or paper strips, which constantly remind us of the essential role of the king in the world of sacrifice.

CPN 7 was erected five years later. The main figure, masked, is seen behind the skeletal head of the bicephalic monster (CPN 8). The comparison with other monuments would lead to the conclusion that CPN 7 shows Eighteen-Rabbit sinking into the underworld; if this is so, the stela is antedated by more than a year: Eighteen-Rabbit's capture by Quiriguá occurred on 9.15.6.14.6. Be that as it may, sacrifice and fertility are, as usual, two related themes developed on this monument. Sacrifice is first illustrated in the king's costume by the serpent-head lancet on the loincloth and the headdress. Around the ruler grotesques cling to the cosmic serpents; holding either a severed head or a lancet, they incite bloodletting. Images of the Thunderer holding plants and fruits emerge from the jaws of cosmic serpents on the sides of the monument. Two earth images, 7-Head and 9-Head, variants of the skull-and-vegetation motif, are drawn at the foot of the stela; the severed head of maize may be seen on the former. On the stela's back is a full-figure text, the earliest such text known from Copán. CPN 8 is a bicephalic monster that represents the earth: the live head (*cauac*) is connected to the dead one (solar) by skeletal legs placed at the corners of the monument.

Of the excavated buildings attributed to Eighteen-Rabbit, only Ball Court A (phases II and III) is decorated with sculpture. The court is a three-level microcosm: the alley markers that present the underworld scenes mark the lowest level; the top of the lateral structures where macaws (the diurnal or zenithal sun) are perched corresponds to the sky; the bench and the sloping wall allow the passage between these two extremes. This is not for human circulation but for the movements of the sun-ball during the game.

The markers of Phase IIb represent three acts of a cosmic drama:

1. North marker: prologue, before the game.
2. Central marker: action. Eighteen-Rabbit identifying with the *Popol Vuh* twins, triumphs over the lords of Xibalba, avenges his ancestors, and allows the sun and the life forces to overcome.
3. South: outcome. After victory the sun will leave the underworld and shine in the sky; the earth will bear fruit, particularly maize. This scenario throws light upon the essential role of the king in the mythico-ritual agrarian complex, as well as upon the function of the game.

From 9.16.5.0.0 to 9.16.15.0.0: The monument sequence is again interrupted for twenty years following the death of Eighteen-Rabbit. No sculptures are known that may be attributed to the short reign of the fourteenth king. His successor, Smoking-Squirrel, constructed the Hieroglyphic Stairway. The architectural complex represents the cosmos and its three levels: the underworld (the skeletal head) and the sky (the temple) are connected by a head-first serpent (the stair). Five kings, armed with spear and shield, are seated on its body. The iconography reminds us that war is, above all, a preliminary stage to human sacrifice;

the creatures and the symbols of the pseudo-Tlaloc complex, first seen on CPN 52, surround the rulers. The sacrifice of others must not be dissociated from the sacrifice of self; this is taught by a full-figure image of the hand-grasping-fish glyph (T714). Structure 26 is at the same time a cosmogram, a glorification of kingship, a demonstration of its cosmic role through the rites, and a lesson of history with the texts inscribed on its steps.

At the stair's foot are CPN 24 and its altar (CPN 25), an elaborate representation of the *cauac* monster. The two monuments may form a composition in which the king emerges from or sinks into the earth, a situation already analyzed for CPN 4 and CPN 7. The earth monster is here presented with a host of details: its front, serpentlike head vomits a *bacab*; its rear, skeletal head is topped with the four-part emblem (the dead sun). On the stela the king is surrounded by the cosmic frame, to which grotesque sacrificial creatures cling.

CPN 26 was erected at the foot of the stair that leads to Structure 11. We would expect that the two back-to-back figures express the succession of Rising-Sun to Smoking-Squirrel; however, the figures are not contrasted, as on CPN 47, and we may wonder whether they may represent two different individuals. Actually, it is the king in both instances, and here the personage matters more than the individual. Succession is clearly illustrated on the sides of the monument by pairs of royal figures placed above the gaping jaws of the earth monster, which now vomits, now swallows them. The main figure of the stela wears earth and fertility symbols; here the rulers are likened to the *bacab*s. This does not exclude the presence of infernal creatures and protecting ancestors. The world of sacrifice is better illustrated by the monolithic, cross-shaped altar associated with the stela. Two jaguar masks, a bat, and a skull-and-vegetation motif probably represent the four directions of the underworld.

From 9.17.0.0.0 to 9.18.10.0.0: With Rising-Sun, the architectural sculpture acquires tremendous importance. More than his predecessors, he used architecture as a medium of political expression. In the Main Group the excavated buildings that have been identified by way of the associated sculpture are of several kinds. Structure 22 and its annexes 22A and 21A make up the closest equivalent to a royal palace. Structure 22 represents the earth monster; the monumental door is its mouth and its walls wear the masks marking its body. The sculpture framing the inner door gave cosmic dimensions to the king when he stood on the bench; there he probably appeared to his subjects when performing bloodletting, the most important rite according to iconography. The other rooms as well as Structure 22A, adorned with the mat, were certainly reserved for the king, for administrative functions or private activities.

Structure 16, the highest at Copán, is interpreted as the monument erected by Rising-Sun to the glory of his dynasty and of the dynasty's founder, whose statue could be seen in one of the rooms of the temple. He emerged from serpent jaws, as the great sacrificer. The skulls adorning the pyramid's stair once again recall the warlike role of kingship. CPN 30, the altar at its foot, tells in images the dynastic history of Copán; Rising-Sun is depicted on accession day, receiving the insignia of rulership from the founder ancestor and surrounded by the other fourteen kings who preceded him. Structure 16 is to Rising-Sun what Structure 26 was to Smoking-Squirrel, the only difference being that here the dynastic succession is depicted on the altar instead of being illustrated on a stair.

Structures 11, 12, and 24 were intended to be stages for ritual perambulations. The former was another image of the cosmos; the ground floor—the only one preserved—represented the earth and the underworld. On period endings or at other important time periods, officiants followed courses involving the four directions and the center of the universe.

Structure 12 was the stage for agrarian rites; impersonators reenacted the emergence of the spirits of vegetation from the underworld waters. On these two buildings (11 and 12), whose ritual function is demonstrated by their sculptures, politics are not ignored. At the four entrances of Temple 11 and on the main step of Structure 12 inscriptions state the accession of the king, claim his legitimacy, and give his titles.

The descent into hell of the setting sun and of the dying king was performed on the steps

of Structure 24, on the west side of the East Court of the Acropolis.

Rising-Sun's funerary temple, Structure 18, is the latest building known at Copán. The exterior decoration deals with life and fertility; inside, after stepping across a bench where sun and earth alternate, we may see, carved in low relief on the jambs, the king as a warrior and a sacrificer. This temple also contained the funerary monument of the king (CPN 60). The king is in the realms of the dead, surrounded with shells and with a smoking ax implanted in the forehead. CPN 31, which represents a skull, was probably part of the Structure 18 imagery.

Besides the Main Group, we know of two buildings belonging to this period. Structure 9M-146 is probably an administrative building; the bench on which the high-ranking administrator(s) sat is also a cosmological image and bears the name of the king. The same may be found on the very elaborate bench of Structure 9N-82. The importance of the building as well as the whole group points to the *bacab* who inhabited it as an eminent figure, probably from the close entourage of the king. Outside the sculpture mentions the king's patronage and indicates the function of the building and the personage who lives there. Inside he sat on a bench representing the earth monster supported by four *bacabs*. The text provides information on the house's inhabitant, gives the dedicatory date of the building, and, of course, mentions Rising-Sun.

Few stelae are attributable to his reign; it seems that in part they were replaced by altars, which, while getting taller, became self-sufficient monuments. After CPN 26 stelae are rare and not very impressive: on CPN 55 the iconography is reduced to the braid-and-tassel; CPN 60 is actually a small indoor funerary monument and not a stela at all.

CPN 4 is exceptional for its size and its wealth of iconographic details. This double-figure stela is the tallest at Copán; provided with two altars, one plain, the other naturalistic, it was erected by Rising-Sun among the statues of Eighteen-Rabbit and very near to CPN 3, which depicts the latter's accession. This is precisely because this monument celebrates the anniversary of the succession of Eighteen-Rabbit to Smoke-Jaguar. On the east side the young ruler emerges from the jaws of the earth monster, half-*cauac*, half-crocodile; on the west one can see the aged, late king sinking behind the bicephalic turtle that represents the earth. It is then a particular homage paid by Rising-Sun to Eighteen-Rabbit.

In general, we do not know the context of the large rectangular altars characteristic of this period. CPN 33 represents the earth in a crocodilian form, below or within which are gathered personages and creatures from the underworld. CPN 34 shows *k'inich ahau* in the earth, flanked by two skeletal serpents. CPN 37 is also a solar image swallowed by a terrestrial symbol. In every instance, the accession date of Rising-Sun is given.

CHAPTER 4

Religion and Politics at Copán

BELIEFS

COSMOLOGY

THE BICEPHALIC MONSTER
This is particularly well represented at Copán in multiple forms and diverse contexts. The quantity and variety of examples is a great advantage in defining its symbolism. It is present as the serpent bar held by the king; the latter is most often framed on either side of the stela by other two-headed serpents. A similar monster slithers around the inner door of the royal palace. He haunts altars and benches. Entire buildings or parts of edifices (sanctuary of Structure 11) are constructed in his image. His body, usually serpentiform, has clawed feet or deer hooves and might carry a trilobal shell above his knees. His reptilian heads are either similar or contrasting; when similar, they are portrayed as "living" or "skeletal." When the monster has contrasting heads, the front head is living and oriented normally (from an anatomical point of view); the rear head is skeletal and often placed in an abnormal position.

The opposition front/rear is only possible when the four feet are oriented in the same direction (for example, on CPN 25). Nonetheless it is common to find two pairs of feet with different orientations: each head is accompanied by a pair of front feet (for example, on CPN 13). The dead/living opposition is expressed to a great extent by the mandible, either covered with flesh or skeletal. Certain features, accessory on living heads, are excluded from dead heads: the tongue, the nose plugs, the spirals issuing from the jaws (breath?), and the beard. When the living head is oriented normally, the dead head is placed in an abnormal position: pointing either inward or upward (these two positions can be combined, as shown on the bench of Structure 82) or upside-down as on the sides of CPN 7. It has been assumed that because of its irregular orientation the back head is only a mask attached to the monster's tail, which is therefore not bicephalic. This is in fact one way to present it (CPN 7). At Copán, however, symmetry of front and rear heads is more frequent than irregular orientation, whether the feet have different or similar orientations (CPN 8, CPN 25, CPN 82, CPN 13). Abnormal orientation is thus accessory and should not be treated literally. It bears the negative symbolic value of "opposite" in Maya iconography because it refers to the realm of the dead. In addition, two-headedness is frequently expressed, whether or not the heads are similar or contrasting.

The dead head wears the quadripartite emblem, composed of the *kin* sign, with three common motifs underneath: the crossed-bands, which here mean death and are sometimes replaced by T509 (*cimi*); the shell, symbol of the underworld; and the spine, an instrument of autosacrifice. These three objects symbolize the underworld and, when associated with the sun sign, define it as the nocturnal sun. The rear head is here therefore the side of the "dead" sun during the night, which will be revived only through blood sacrifice. This interpretation is confirmed by examples of bicephalic monsters whose rear head, lacking the quadripartite emblem, depicts the dead sun (on CPN 8, the rear head is a skull with *kin* in its eyes). For this reason it is unnecessary to postulate the existence of a "quadripartite god": this is only one of the representations of the dead sun. The ornament behind the ear or above the eye of living

heads often includes a shell, joined by T2 plus a stylized serpent jaw or a water lily. The shell is not associated with the dead head, except in the quadripartite emblem; T2 is specific to living heads, where it adorns the eyes.

The Bicephalic Celestial Monster: In Maya iconography one often encounters a two-headed monster whose body is composed of a celestial band that forms a frame above and on the sides of the ruler ("royal canopy"). The king is seated in a niche (Piedras Negras Stelae 6, 11, 14, and 25; Quiriguá Stela I) or standing on a throne (Tikal, Structure 5C-4: Lintel 3). At Copán a bicephalic monster supported by two *bacab*s (terrestrial) who stand above the underworld, represented by skulls, frames the inner door of Structure 22. At Palenque two doors of the Palace's Structure E are framed by a bicephalic monster. On Yaxchilán Stelae 1, 4, 6, and 11 the monster forms a vault above the ruler without actually framing him. In almost all cases, a bird is perched above the vault or the arch. Clearly the monster, with his superior position, his arched form, and the celestial band sometimes used for his body, represents the celestial vault. His two heads are almost always long-nosed, reptilian, and borrow more features from the serpent than from any other animal. Issuing from them are liquids (which I believe to be at once water and blood) and sometimes solar creatures (Copán Structure 22; Yaxchilán Stelae 1, 4, 11). Serpents that frame the king on Copán stelae (first from the belt down, then the whole body length) are also representations of the sky. Several of them play the same role as those at Piedras Negras. The serpent bar (as well as its earlier figurative forms) represents the sky. Although their extremities are generally identical and the creatures emerging from them are not always solar, these objects also represent the sky: they are often adorned with a celestial band or with crossed bands.

The Bicephalic Terrestrial Monster: At Copán and Quiriguá there are monsters with contrasting heads, different from the preceding in that they are marked with elements of the glyph T528 or because they have on their bodies the masks of the *cauac* monster with crocodilian features: half-closed eye and pendulous nose. These marks and masks are never found on monsters whose position otherwise would indicate that they represent the sky; we find them on monocephalic monsters or masks, either because they represent the lower level of the cosmograms or because they serve as pedestals for the king (Panel of the Foliated Cross at Palenque; Copán, Structure 18; Bonampak, Stela 1; Quiriguá Stelae E, H, I; Naranjo Stela 31, etc.). These terrestrial monsters also named *cauac* monsters may have two different contrasting heads as on CPN 25 or different but noncontrasting heads (CPN 4 east, front *cauac* head, rear crocodile head) or identical heads (CPN 3). In the last two examples the king emerges from one of the monster's jaws. When the two heads contrast, it is from the living head that the king (CPN 82, Quiriguá Zoomorph P) or a *bacab* (CPN 25; Bench of Structure 9N-82) emerges. On CPN 101 is a monster with its body marked with a *cauac* mask, but headless: in place of the heads there is a toad on the left and on the right, a long-nosed skeletal head with the smoking ax implanted in the forehead. We observe this same opposition on vases (see Robicsek and Hales 1981: figs. 57, 58b). The toad and the *bacab* are related; both have the same ear ornament and a water lily is often knotted on their forehead. CPN 13 depicts a bicephalic monster with contrasting heads, but without *cauac* signs; it is probably terrestrial: a *bacab* emerges from its living head and a solar creature from its dead head. In sum, the living terrestrial (*cauac*) head gives birth to the king, to the *bacab*, to the toad; the dead head most often is empty, with some exceptions: a solar creature or a skeletal Thunderer.

Bicephalic monsters, whether they embody the earth or the celestial vault, mainly offer two terms of the opposition: earth-life/sun-death. This said, it would be absurd to seek a precise cosmological meaning for every creature found in the serpent's mouth, which is omnipresent in Mesoamerican art. Quite often we are in the presence of a simple stylistic clause of epiphanous function that emphasizes the appearance or manifestation on earth of a creature belonging to other worlds. In Western art, it would appear coming out of a cloud. One might, in many cases, interpret

this emergence as "see what appears," or even "behold!"

Schele and Miller (1986: 46–47) believe that the figures emerging from the mouth of serpents represent visions induced by self-sacrifice and give the name "vision serpent" to the often two-headed creature that contains the figures. They analyze as a causal relationship the juxtaposition on Yaxchilán lintels (especially Lintel 25) of an autosacrificial offering and a serpent with a mouth gaping onto a human or grotesque figure; in this case, the bloodletting would be the direct cause of the apparition or vision. Furst (1976) has in fact suggested, drawing from examples provided by Plains Indians (steam baths, Sun dance, etc.) that the excruciating pain induced by self-sacrifice did produce visions, which were the very aim of this ritual. If this demonstration holds for the Plains Indians, it is less likely in the case of Mesoamerican societies. Among the Aztecs, self-sacrifice, which was a very common and sometimes very painful practice, does not seem to have had visions as a goal, according to the plentiful information we have on the subject. In central Mexico there was no semantic difference between self-inflicted sacrifice and human sacrifice in general, and this was the case with the Maya, as Schele (1984) has convincingly demonstrated. Bloodletting was primarily considered a "payment" to settle human debts to cosmic forces or gods. On Lintel 25 at Yaxchilán self-sacrifice and a cosmic monster out of which an ancestor or a supernatural creature appears are indeed associated, but with no cause-and-effect relationship. When emerging from the mouth of the cosmic serpent, the ancestor shows that he belongs to another world and attends the ritual, which he efficiently sponsors. This is also the case for the ancestors emerging from gaping cosmic serpents' mouths on CPN 47, 41, or 4, who carry sacrificial symbols or instruments. There are no "visions" there.

OTHER REPRESENTATIONS OF THE EARTH: *CAUAC*

The *cauac* mask may appear dead or in hybrid form. When the earth was represented by only one mask or one head, the artist chose from one of three varieties: (1) To emphasize the fertile, creative aspect of the earth, he depicted it as the living head of the bicephalic monster, *cauac* monster, or crocodile serpent, toad, and so forth. (2) If more interested in the earth as the land of the dead and the nocturnal sun, he showed it as a dead solar head. (3) Or if he wanted to show the two opposite aspects of the earth, he combined features borrowed from the monster's two heads on the same mask. On CPN 20, for example, the *cauac* borrows the traits of the old sun: incisors filed into Ts, squint eyes; the crocodile heads (terrestrial animals) on the north face of CPN 26, at helmet level, are filled with solar attributes: jaguar ear, cruller, whistongue. Even the least ambiguous images may often present elements of the opposite realm; at Palenque the skeletal solar head at the base of the cosmogram on the Temple of the Cross panel has hook pupils and vegetation above the ears. The *cauac* head of the Temple of the Foliated Cross is squinting. At Copán Structure 10 of Ballcourt A-III the recently reconstructed macaw, which represents the diurnal sun, also displays symbols of death (bones) and darkness (*akbal*) (Fash 1991: fig. 80).

Let us remember that the *cauac* mask is used to give an earthly character to mono- or bicephalic creatures (CPN 3), *bacab*s (door of Structure 22), or edifices (corners of Structure 22). The *cauac* mask or other reptilian head serves often as a seat or a pedestal; on the north and northwest doorjambs of Structure 18 the king stands on a serpentlike head in profile accompanied by *cauac* and vegetal elements. The monsters often have a T- or funnel-shaped element, sometimes adorned with scrolls, which represents an opening (probably a cave), an entrance to the underworld. We have seen this on the forehead of the cauac mask of CPN 20. Other examples may be seen at Bonampak (Stela 1), Palenque (Foliated Cross), Quiriguá (Stela H), and so forth.

David Stuart (1987) has read the glyphic compound T117:507 or T277:507 as *wits(i)*, meaning hill or mountain in Yucatec. In this reading T117 or T227 has the phonetic value *wi* and T507, *tsi*. The origin of his demonstration is a passage from the Dresden Codex (66c) where the image is the god Chac sitting on the head of a toothless old man, with a pointed nose and the same eye outlining as

the deity sitting on him. The latter, however, has on his cheek the "grape" element of the *cauac* glyph, used at Copán either to indicate "stone" or as a reference to the earth.

In the text accompanying the image the glyphic compound before the deity's name is T117:507 preceded by the locative *ti*. Stuart translates this as "Chac on the mountain." On the panel of the Temple of the Foliated Cross at Palenque this same compound together with suffixes read as *nal* (vegetation) reappears in the left eye of the *cauac* monster upon which Pacal is standing. According to Stuart, this glyph means that the monster is not an earth figure, but a mountain. The same author recognizes a logographic equivalent of the phonetic compound: variants T529 and T531 of the *cauac* glyph (T528), sometimes called "eccentric *cauac*." Their characteristic features are an irregular contour with a deep furrow at the top extended on one side by a scroll that reminds us of the *cauac* monster from the Temple of the Foliated Cross, where scroll-like vegetal elements sprout from a cleft.

The iconographic implication of Stuart's reading is that the *cauac* monster, "distinguished from the *cauac* zoomorph meaning stone by the presence of eyelids and a stepped indention in the forehead" (Schele and Freidel 1990: 427, note 16), is the illustration of a mountain. Therefore, the masks called *wits* piled up at the four corners of Structure 22 at Copán indicate, for these authors, that this edifice represents a "sacred mountain." Fash (1991: 123) goes even further when he interprets the *cauac* elements on the masks as *tun* ("stone") and then translates the whole as *tun wits*, meaning "stone mountain."

To call a temple on the top of the Copán Acropolis a mountain or stone mountain is not absurd in itself; however, to call a "mountain" such monuments as the Altar of Stela M (CPN 25) or Stela B (CPN 3) or Stela J (CPN 20) just does not make sense. How far can this interpretation be extended? Grube and Schele (1987: 1) state that "the Altar L pectorals bear *cauac* markings identifying the zoomorphic heads as personified 'mountains.'" Besides, do the other *cauac* monsters, like the two-headed creature on CPN 82, represent mountains or stones?

From my point of view, T117(or 277):T507 is not a phonetic compound but a logograph. T507 is a variant of the *kan* sign called dotted-*kan* or spotted-*kan*, on account of the rows of dots added to the traditional form of the glyph. Even if *kan* in Maya languages means "yellow" or "rope" and does not refer directly to maize, it is highly likely (see Thompson 1950: 75) that the sign for the day name *kan* represents the maize kernel. T117 is a corn-husk image often seen in iconography: two open leaves (one long, the other short) and a row of kernels. The group T117:507 thus would assumedly be an image of germination, of fertility, equivalent to the "eccentric" *cauac* (T529 to 531), which stresses the fertile and nourishing aspects of the earth with the husks sprouting from the cleft. Stuart in his demonstration discusses the emblem-glyph from Ucanal that employs T529 as its main sign. It is noteworthy that a *kan* cross is infixed in it, precisely to emphasize this very idea of fertility (Stuart 1987: fig. 31).

THE CROCODILE

According to Lizana (1893), the crocodile represented earth and was worshiped. It is probable that this animal is the origin of the *cauac* monster and particularly of its pendulous nose. It is often present at Copán and it is easy to demonstrate that it represents the earth. A crocodile with human body marked with *cauac* signs is seated on the sides of CPN 26, near its base. The raised, wide-open jaws devour the dead king and vomit his successor. On the east side of CPN 4 the king emerges from the *cauac* mouth of a bicephalic monster whose other head is crocodilian. Here the heads do not contrast, but are similar, as *cauac*/crocodile = earth. The top of CPN 33 is a crocodile pelt below which ancestors and infernal creatures are gathered: one has a human body, a bird's wing, and a crocodile head. Another head of the same animal serves as the seat for one of the major human figures of the scene (fig. 113a). A crocodile is one of the main characters of the aquatic frieze depicted on CPN 44. The tortoise with crocodile heads which forms the Altar of CPN 4 seems to float in a circular basin dug into the Main Plaza.

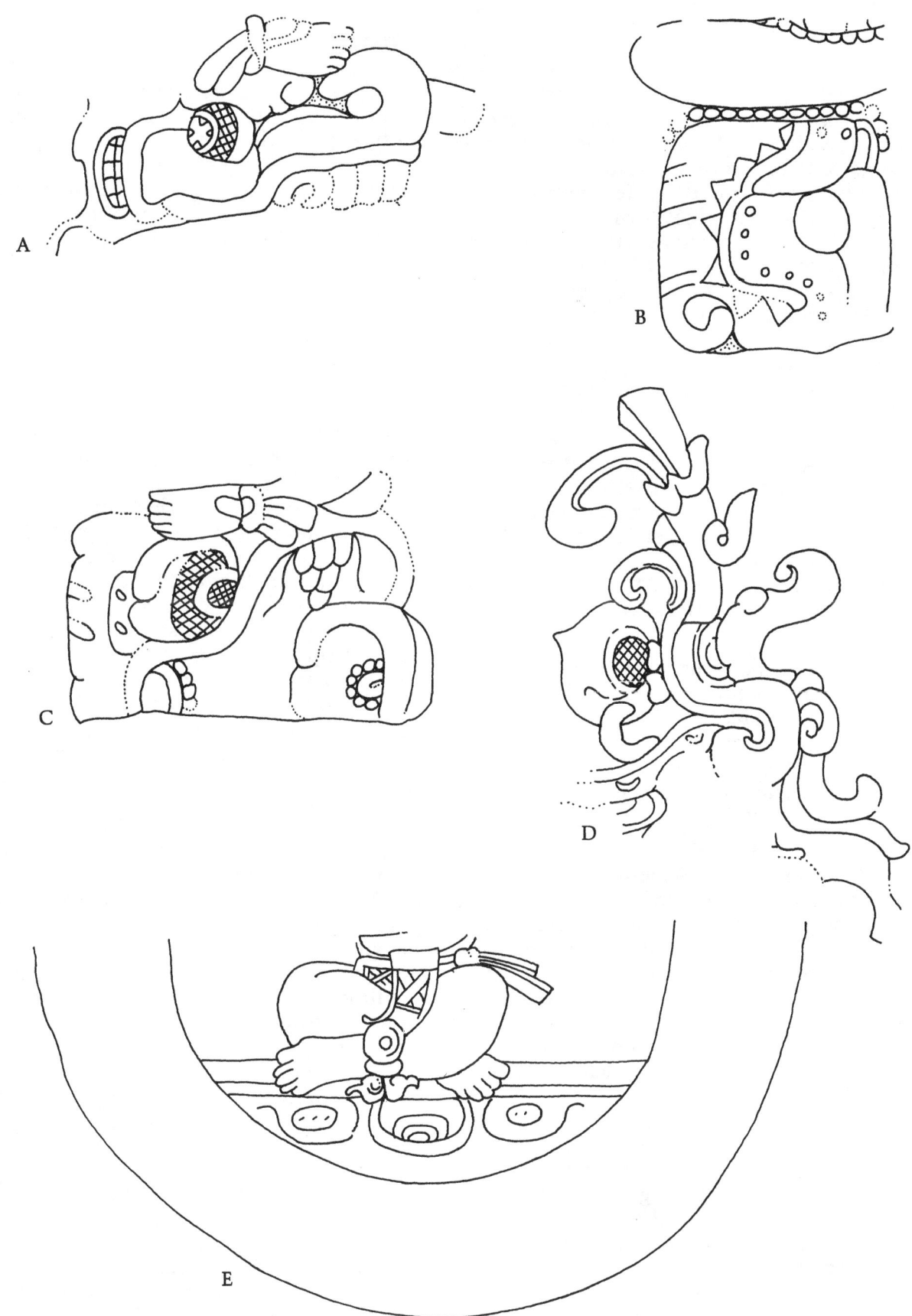

FIG. 113 Emblematic and glyphic forms of the earth: (a) crocodile from CPN 33; (b) upended frog from CPN 33; (c) *cauac* from CPN 33. Drawings by S. Matta. (d) *Caban* infixed within a water lily blossom from CPN 1. Drawing by A. Dowd. (e) Earth monster with T616b and *caban* markings from Toniná, Monument 69. After I. Graham.

THE TOAD

The Toad, as we have seen, is a terrestrial creature akin to the *bacab*, who sometimes comes out of the living head (*cauac*) of the bicephalic earth monster. He contrasts to the skeletal Thunderer (CPN 101) and to the jaguar (CPN 82). A creature with a toad's head and a human body inscribed with a *cauac* mask is sitting next to the foot of CPN 26. A ruler emerges from his wide-open jaws; thus, the toad is more than just a terrestrial creature—he can himself signify earth. The toad head pointing upward (upended frog, T740) that is the seat for one of the actors on CPN 33 represents earth, as do all the other seats of this monument (fig. 113b). It is not surprising that a birth meaning has been attached to this glyph; it is in fact an image of the earth that gives birth by its very position, as on CPN 26. The toad no doubt evokes rain: he is often represented diving on CPN 28, CPN 82, and Structure 11 (under the south door).

THE SERPENT

The head of the serpent serves as a pedestal on the jambs of Structure 18 (fig. 114d below). On the central block of Structure 24 the serpent swallows the setting sun. On the frame surrounding the foot of CPN 41 two serpents interlaced and knotted must represent the earth, as on CPN 634.

GROTESQUE FIGURES

Polymorphic or grotesque features are combined and borrowed from creatures so diverse that any comparison with real animals seems arbitrary. The *cauac* mask is such an example. There are serpentlike heads; also creatures with long noses who in aquatic friezes evoke the nourishing aspects of earth. These skeletal heads float between the primordial waters of the underworld, which Lizana (1893) has described; surrounded by aquatic symbols, they give birth to vegetal forms, specifically water lilies (CPN 109–111). The floor slabs in the West Court show the earth personified in the form of a grotesque character with a long nose and a human body; he bears an offering toward the west and from his body vegetal forms radiate in four directions. Vegetation, especially the water lily, at once aquatic and terrestrial, is omnipresent where earthly fertility is evoked. The water lily is knotted around the forehead of *bacab*s, the toad, and skeletal heads (step of Structure 11); on the rulers from CPN 26 the entire plant is a headdress: the stem is knotted around the pad and a fish nibbles at the flower. It also grows from behind the head of bicephalic monsters as well as on the deer's skull of CPN 26, and so forth.

THE QUADRILOBAL MEDALLION

The cruciform medallion that represents earth must have originally portrayed the earth monster with its jaws open and seen from above (as the mouth of the jaguar on Monument 9 of Chalcatzingo). On the southeast jamb of Structure 18 *cauac* elements and an *imix* glyph (incomplete) are inscribed in a quadrilobal medallion (fig. 114a); water lilies come out from under the four corners. The pedestal of Stela 10 at Machaquilá has the same form, there enclosing a head (terrestrial) turned upward (fig. 114b). Taylor (1978: fig. 4) has published a fine example of the quadrilobal medallion that serves as the seat of a grotesque figure painted on a Tepeu vase. When a scene is framed by the cruciform medallion, we may suppose that it takes place in the underworld, such as the figures carved on the markers of Ball Court AII-b and CPN 131.

The pedestal on Machaquilá Stela 4 is the top half of one of these medallions, which has but three lobes. As on the above example of Copán Structure 18, it combines *imix* and *cauac* (fig. 114c). The top of CPN 37 is identical to the preceding but is treated in a more angular fashion.

Sometimes it is the lower half of the medallion that is depicted. Thus, the platform of the southwest jamb of Structure 18 is composed of a T surrounded by a *cauac* and water lily element; the *cauac* monster's head seems framed there, as behind a window (fig. 114e). On the altars of Zoomorph O and P at Quiriguá the dead king sinks into the earth, portrayed as a giant T (fig. 114f). Monument 135 at Toniná shows the king sitting on a T with *cauac* elements and water lily blossoms in the corners (fig. 114g).

Schele and Grube (1990) have argued that the quatrefoil medallion with the *imix* sign and water lilies with a reading of *nab* refer to a plaza or court. I disagree with this interpretation. While it is true that the plazas are

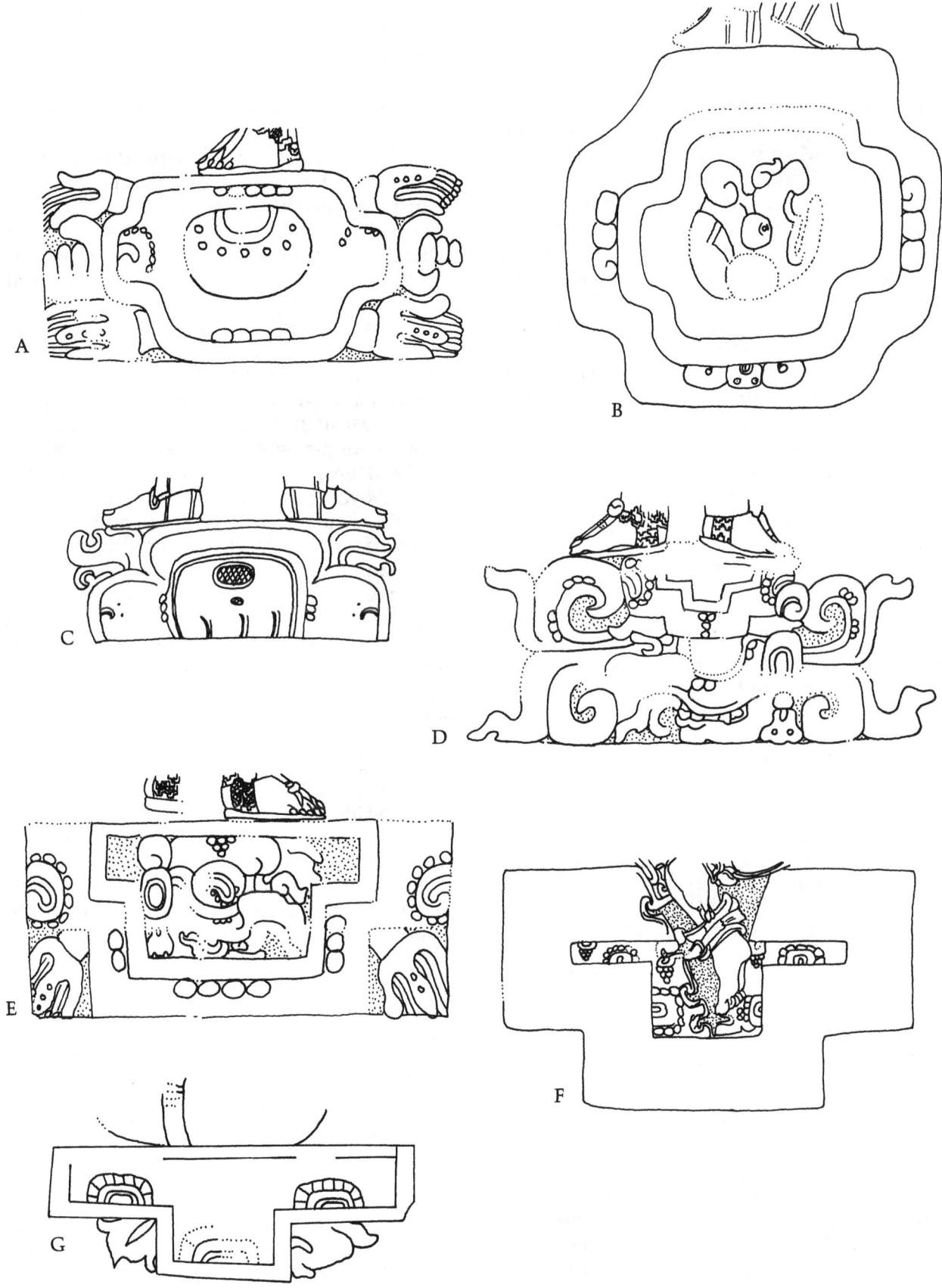

FIG. 114 Cruciform medallions and Ts as conventional representations of the earth: (a) Copán Temple 18, southeast jamb. Drawing by A. Dowd. (b) Machaquilá Stela 10. After I. Graham. (c) Machaquilá Stela 4. After I. Graham. (d) Copán Temple 18, northeast jamb. Drawing by A. Dowd. (e) Copán Temple 18, southwest jamb. Drawing by A. Dowd. (f) Quiriguá, Monument 2 (Altar of Zoomorph P). After W. R. Coe. (g) Toniná, Monument 135. After P. Mathews.

oriented to the cardinal directions and may be seen as reproducing the cross pattern favored by the Maya when referring to the earth, the quatrefoil has a much broader meaning than plaza. At least as early as Olmec times, this sign most often comes with water lilies at its corners and *imix* (another form of water lily) at its center, when it represents the earth in its wet and fertile aspect. If the water lilies are taken out, the quatrefoil frames a scene occurring in the underworld as on the markers of Ball court II-b. It may represent a cave or an opening to the earth, such as the base of the southwest jamb of Temple 18, where behind the T-shaped window one can see the *cauac* monster. The opposition between a *witz* monster (on the northern jambs of the same structure), which would represent a mountain temple on which the king would stand or dance, and a *nab*/court (on the southwest jamb) is untenable (Schele and Grube 1990). To the north is a monster with *cauac* signs and a T on the forehead; the same T plus *cauac* and water lily signs occur on the southwest jamb and through the T window can be seen another *cauac* monster. The two *cauac* monsters are no more than two variants of the same representation.

GLYPHIC FORMS

The *cauac* glyph is sometimes used in lieu of the *cauac* monster (fig. 113c). Thompson (1950) correctly demonstrated that *imix* (T501) is a simplified representation of the water lily blossom and we are not surprised to find it often associated with *cauac*. Like T528, it serves as the seat for one of the figures on CPN 33. Strangely, *caban* (T526) is little used in iconography representing the earth. However, on both lower sides of CPN 7 an angular strip with the *caban* sign infixed represents the earth. On CPN 1 skeletal serpents vomit flowers stamped with the main element of *caban* (fig. 113d); and one of the skeletal heads of the two-headed monster of one step of Structure 11 is also stamped with the same glyph. On the middle step of the three sculpted steps of the same structure figures present offerings to glyph T526, repeated several times. At Toniná the ruler on Monument 69 sits on a platform marked with T616b framed by two *caban* elements (fig. 113e).

EMBLEMATIC FORMS
(fig. 115)

Two figures more emblematic than glyphic and preceded by a numeral are aspects of the nourishing earth. These are 7-Head and 9-Head, which I have discussed in detail elsewhere (Baudez 1984: 144–46). These emblems are found either alone—the former as a seat for one of the figures on CPN 33 (fig. 115f), 9-Head on the four sides of CPN 98 (fig. 115b) and 999—or in pairs. The best example is given by the sides of CPN 7, where on a terrestrial band 9-Head appears on the west side, while 7-Head is to the east (fig. 115c). The latter is long-nosed with a *kan* cross on the forehead and an anthropomorphized maize head above. The head preceded by the numeral 9 is surmounted by T629 and T34. We find variants of these two emblems on the north and south markers of Ball Court A-IIb (fig. 115d, e). Accompanied by water lilies, a long-nosed mask with *imix* on the forehead and preceded by number 7 is repeated several times on the exterior of Structure 18 (fig. 115a); at the corners of the temple we find it associated with 6 Ahau (another terrestrial expression?). I have shown (1984: 144–46) that if 9-Head appears identical to the main element of the aquatic frieze (skull and vegetation), 7-Head expresses more than a simple promise of replenishment; T629, the skeletal head, is here replaced by *kan*, an allusion to ripe maize. The two emblems thus refer to two moments or two different aspects of the nourishing earth. Apart from Copán these paired emblems are found on either side of the ruler (on Tikal Stela 2; Stelae 2, 3, and 4 at Yaxhá) and on the solar shield (Palenque, Temple of the Sun), as if the main character or central symbol established a mediation between two different states. In the same vein the action described on the central marker of Ball Court A-IIb at Copán permits the passage from the state 9-Head to 7-Head. Alone they serve as pedestals or seats (9-Head on Monument 114 at Toniná [Becquelin and Baudez 1979–82: vol. 3, fig. 143a] and on the panel of the Temple of the Cross at Palenque; 7-Head on CPN 33) or are presented as offerings (on an alabaster bowl at Dumbarton Oaks; Kubler 1977).

In summary, the earth may take on various forms that are partly determined by the as

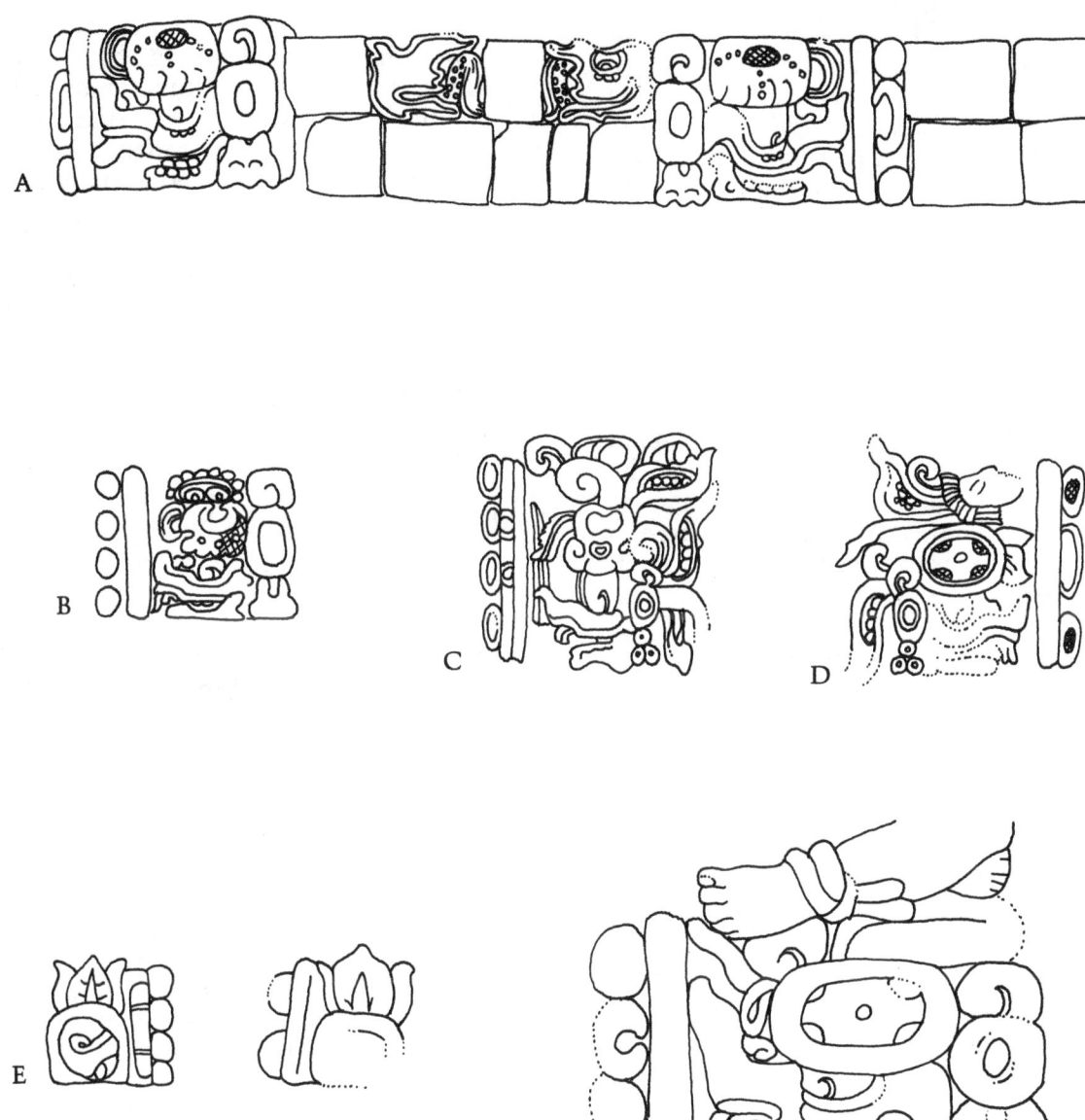

FIG. 115 7-Head and 9-Head as emblematic representations of the earth: (a) structure 18, façade. Drawing by A. Dowd. (b) CPN 98. Drawing by J. Espinoza. (c) CPN 7, west and east. After A. Dowd. (d) Ball Court A-IIb, north marker. Drawing by B. Fash. (e) Ball Court A-IIb, south marker. Drawing by B. Fash. (f) CPN 33. Drawing by S. Matta.

pect the artist desired to emphasize: either the bicephalic monster with similar or contrasting heads (living/dead) or with a single head. Animal forms, more or less naturalistic, were borrowed from reptiles and batracians. On another level of abstraction the earth may be represented by a cruciform medallion that evokes its gaping jaws or by half of it; or further by emblems combining iconographic and glyphic elements; finally by glyphs alone (T501, T528, T529, T526).

THE EARTH: CONTEXT AND FUNCTIONS

A form inventory is not enough to summarize the role and functions of the earth in Maya cosmology. It must be completed by the study of the contexts to which these forms belong. At Copán as at Quiriguá the king is likened to the sun; in this way his accession is portrayed as a rising above the jaws of the earth monster; for his setting or his death we see him sinking into the earth. To show this relative movement the entire stela can represent the two-headed monster: we see the king coming out of one of his mouths (CPN 3); we can also interpret the entire scene on a single level, as on the east face of CPN 4 or reduce it to an image that occupies only a small part of CPN 26. A more refined process in which the king is shown sinking into the earth is to place a sculpted representation of the earth in three dimensions before his feet (CPN 4 west, CPN 7, and CPN 26). We have the impression that the king is moving in relation to the altar, which hides his legs; the direction of the motion is given by signs coming from other sources (e.g., signs of old-age, mask).

In the three cases cited above, has the altar no other function than to combine with the stela to form another image? The iconography of Copán altars suggests that they were sacrificial stones; ropes bind the oldest of these; CPN 12 and CPN 27 depict creatures associated with sacrifice, and CPN 45 is surrounded by a rope and specially arranged for the flow of precious liquids. Besides this, why do earth representations appear in sacrificial iconography? They are specifically found there insofar as the earth monster, generally his head alone, serves as an altar for the sacrifice of the jaguar god on vases that treat this theme (Robicsek and Hales 1981: vases 19, 23, 25–28). The reason for the use of the earth monster as a sacrificial stone perhaps resides in the phonetic value of *tun*, "stone," which belongs to the *cauac* glyph. But without a doubt this pun was chosen for its symbolic value. Earth is the optimal altar: sacrifices were made on it, and through it the blood of the sacrifices passes and arrives to those who must benefit from them: the sun and the spirits of vegetation, to mention only two. Be that as it may, the terrestrial altars of Copán do not contradict but to the contrary enhance the sacrificial role of these monuments.

It has been suggested (Clancy 1976) that altars were in fact pedestals or thrones; it is possible that in certain circumstances this function was valid: Monument 102 at Toniná, a statue, was placed on a rectangular pedestal representing a *cauac* mask, and many dignitaries on stelae stand on terrestrial masks. This does not imply that in reality the king stood or sat on a pedestal or a seat in earth-form. To the contrary, palace scenes show him rather sitting on thrones or benches in bicephalic jaguar form (there are examples of these thrones in Copán). To stand on an earth image is a conventional composition whose meaning escapes us: we could certainly say of the king standing on the earth monster that he dominates the planet; but how do we explain the humans of different ranks and underworld creatures who all sit on earth images on CPN 33?

The idea of earth's domination can be retained as a hypothesis to explain coupled images of a bird and an earth monster. On top of CPN 3 two macaw heads are perched on a *cauac* head from which the king emerges. On the eastern face of CPN 4 another figuration of accession, a bird mask (quetzal) is placed on the crocodile head, the monster's rear head. I have proposed that these images signify the triumph of the sun and by extension the king on earth. The ramps of the Hieroglyphic Stairway offer a similar image, repeated indefinitely, that of the bird-on-earth, but here it is the owl, a death bird, who dominates the earth in the same way as warrior kings and sacrificers.

THE COSMOS: SKY AND EARTH

Thompson (1970: 224) stressed the confusion of the sky and earth in Maya thought: "Celestial and terrestrial elements of Itzam Na are intermingled precisely because they are parts of one undivided body or edifice." In the preceding pages I have shown that if earth and sky could both appear as two-headed monsters, there were also means to be specific—when this was necessary—about whether one or the other was represented: by the context (the elevated and arched position of the sky, the inferior position, as seat or pedestal, of the

earth), by *cauac* marks (diagnostic elements of the glyph and of masks), and by their functions (e.g., earth alone gives birth to plants). Nonetheless, Thompson's (1970: 214) hypothetical reconstitution that "the Maya conceived the world to be set within a house, the roof and walls of which were formed by four giant iguanas, upright but with their heads downward, each with his own direction and color" permits the explanation of a great number of elements; for example, the upsidedown serpent-shaped columns at Tula and Chichén Itzá, the Hieroglyphic Stairway at Copán, and the bottom of the panel of the Temple of the Cross at Palenque, where the profile of two celestial serpents forms the skeletal head of the earth monster. This said, certain points defended by Thompson seem more questionable: although we perceive in polymorphic monsters certain features borrowed from the serpent, the crocodile, or the toad, we see no element that has the iguana as origin (the characteristic crest is missing, for example). In addition, Itzam Na seems to be more a cosmological principle than a specific god of monotheistic pretensions.

THE COSMOS: THE SUN

There are two suns. The nocturnal sun is "dead" in the underworld and can only be reborn through blood sacrifice. Its images are multiple and surrounding them are a multiplicity of fabulous half-human, half-feline creatures often laden with sacrificial symbols. This world will be described in the section on sacrifice. The other sun, diurnal, has less importance and, with exceptions, is visible only in cosmograms, where it is not always present (inner door of Structure 22). At Copán one of the favorite forms of the diurnal sun is the brilliantly colored macaw. Lizana (1893) tells us this bird personifies the sun at noon; this is confirmed by the name of the Yucatec god k'inich k'ak' mo'o (sun eye or face, fire macaw) and by pictures of macaws with solar attributes in the Dresden (40b) and Madrid (89a) codices. The macaw appears on the upper register of cosmograms that Ball Court A and Structure 26 reproduce.

The bird on the top of the cosmogram depicted on the back of CPN 16 is identical to the mask on the crocodile head of CPN 4 (east). If compared to the birds seen in profile on the panels of the Palenque temples, it is without a doubt a quetzal. He must represent the sun on account of his supreme position in the cosmogram. Macaw and quetzal are thus the two aspects of the diurnal sun. The opposition macaw or quetzal and jaguar (diurnal sun/nocturnal sun) among the Maya is the equivalent of the opposition eagle/jaguar of central Mexico.

COSMOGRAMS

These schematic representations of the universe are either horizontal (as on a plane, like the calendar of the Madrid Codex, pp. 75–76), or vertical (an elevation), or else treated in volume with three dimensions (architectural cosmograms). At Copán it seems that all monumental architecture is microcosmic. Thus, Structure 4 reproduces in three dimensions a calendrical cross, analogous to the one in the Madrid Codex; perambulation could proceed from left to right, from front to back, and also from bottom to top. The ball court's alley represents earth and the underworld: the top of the lateral structures corresponds to the home of the diurnal sun; the sloping benches link the two worlds. During the game the ball's movements reproduce those of the sun.

Structure 26 is symmetrical to the ball court; the skull inhabited by serpents at the foot of the stair corresponds to the alley; the superstructure adorned with macaw heads finds its twin at the top of the lateral structures. The stairway that unites them is another slope. Only the lower level of Superstructure 11 remains, which represented the earth with its four directions and its center. This plan is the same as the cache under the stelae; the pair formed by the monument and its cache could have been conceived as a cosmic image. The inner stairs of Structure 11 and the presence of colossal *bacab*s suggest that this was a volumetric representation of the upper level of the cosmogram. The ritual perambulations were thus executed in three dimensions. Structures 22 and 24 are parts of cosmograms where only the lower levels are included.

Inasmuch as Structure's 22 represents the earth, each time the king comes from it, he is in an emergent situation (i.e., is rising like the sun); when he goes in, he "sets." In this way the architectural metaphor (house =

earth) reinforces the assimilation of king to sun. In addition the monster's jaws that frame the king have, as we have seen, an epiphanous function: "Behold, the king!" The statue of the great ancestor against the wall at the back of the west room of Structure 16 was framed in the same manner.

The vertical cosmogram of the inner door of Structure 22 has been recognized as such by numerous researchers. The underworld is illustrated by a row of skulls; the earth's surface is that of the bench where two *bacabs* kneel, whose thighs are stamped with a *cauac* mask. They support with one hand a head of the bicephalic celestial serpent. Above the door, where the serpent's body or a celestial band should have been, we observe a series of S-forms to which cling grotesque figures who belong to the world of death and sacrifice. This decor speaks of blood spilled and offered; what spews from the monster's jaws in return is a rain of water rather than blood.

On the back rack of CPN 16 may be seen, successively: the earth and the underworld, as home of the nocturnal sun, which appears as a skull crowned with the quadripartite emblem (the black head of the two-headed monster); above is the sky in the form of a serpent-bar, but whose two ends are heads of the *katun* bird; the quetzal bird with its serpent-wings extended is perched on the bar and represents, of course, the diurnal sun.

This cosmogram has been compared to those on the Tablets of the Cross and the Foliated Cross at Palenque, which are different only in that they also portray the cosmic tree linking earth to sky. On CPN 16 the skeletal terrestrial head has the braid-and-tassel (as the belt-mask usually have) and continues lower into a loincloth flanked with stylized serpent jaws, half hidden by a small, very eroded anthropomorph.

In this way the skull is placed in the same situation as would be a belt's central mask. To push the analogy even further, we discover that the sky serpent bar is in the same place as the serpent bar held by the main figure on the stelae, and that the quetzal corresponds with the feathered headdress of the king. This analogy is even more striking on the front of CPN 16, where the main figure wears a bird helmet with spread wings. It seems that the sculptor tried to convey the fact that the upper half of the body is a cosmogram. This same idea is expressed on the back of Stela I at Quiriguá: the king is seated in a niche and framed by a celestial band with birds' heads at the ends. Another bird is perched high in the sky. The living *cauac* mask upon which the ruler is seated is treated in the same fashion as a belt mask and continues into a loincloth.

SUPERNATURAL BEINGS

From my very first attempt to classify the representations of animated beings that haunt Copán sculpture I was able to distinguish certain idealized anthropomorphs. Their heads and bodies are perfectly human and their faces, ideal reproductions of Maya beauty, are young (without wrinkles) and inexpressive. Because the headgear in these figures (usually a turban) is similar to that of the main figure on stelae and because grotesque figures do not wear it, I hypothesize that perfect anthropomorphs represented royal ancestors. They could not, in fact, be king's contemporaries: we encounter them in the sky or in hell but never on earth in the company of the ruler. The other anthropomorphs have grotesque faces, with the following exceptions: (1) creatures representing maize have young idealized faces, but differ from humans in that they have maize husks in the place of the hair; (2) the prone figures on the steps of the Hieroglyphic Stairway cannot be ancestors because of their humiliating position—their postures and certain signs designate them as enemies killed on the battlefield or sacrificed on altars; (3) *bacabs* have the marked, wrinkled faces of old men and are otherwise identified by diverse signs: headdress, ear ornaments, pectorals, and so forth.

The remaining corpus of forms is composed entirely of animals (uni- or polymorphous) and creatures with human bodies and monstrous heads. Some of these beings have been identified with the aid of their contexts as images of great cosmic personae, such as the sky, the earth, and the sun. The numerous others may be classified in two categories: (1) short-nosed ones with solar, feline, or death attributes; (2) long-nosed ones with terrestrial, reptilian, and life-bearing characteristics. In other words, this body of figures reflects the fundamental duality earth/nocturnal sun or

life/death. In the mythical universe of the Maya, there were most certainly a greater number of subdivisions in these two larger categories. But we cannot define them for the moment. Natural forces such as the wind, the rain, and fire are certainly present before our eyes, which are incapable of seeing them. In this busy world all the creatures are different, and the short-nosed are the most varied. The only being that is always the same on diverse monuments and has a quite recognizable personality is the grotesque figure with a long nose and a smoking ax in the forehead elsewhere called God K or K'awil (Stuart 1987: 15), which I prefer to call the Thunderer (Baudez 1992). Notwithstanding, how are we to identify the creature that has exactly the same face but lacks the smoking ax? Is this another being or is the smoking ax only a facultative accessory? This general absence of personality in the creatures we call supernaturals leads us to avoid the term "pantheon of gods." In Classic Copán the situation seems different from the mythical world of the Postclassic, as we see it in the codices. Here, to the contrary, the diversity of grotesque figures seems to obey the same rules we have seen in cosmological representations. For example, there is not one image of the earth, but an infinite number of them; forms vary with the semantic and formal context and also with the contents the artist intends to transmit through the terrestrial image. The earth is represented, but which earth? Of all its aspects and functions, which are illustrated? When several things are to be communicated at the same time, which ones take precedence? In conclusion, I do not definitely discard the notion of the existence of gods at Copán, but I do say that the data at hand do not establish this with certainty and that the creatures we encounter here and there seem to be spirits, aspects, or emanations of the natural forces rather than gods.

I daresay that more often than not my colleagues have confused signifiers and signifieds, images and their representations. Five images do not necessarily represent five divinities; they can express five aspects of the same thing or being or five creatures from the same realm, which were meant to be different to show the plurality of their nature (such as spirits of vegetation or rain). I do not believe that the Maya ever had a "quadripartite god" characterized by the *kin* sign and the tripartite emblem. If there exists a personified form of the lancet, there is no reason to call it the "Perforator God"; equally, the young anthropomorphs who represent maize are probably not representations of the "maize god." How do we know that the sun was a "sun god"? Inversely, a concept such as the "Principal Bird Deity" (Bardawil 1976) seems exaggeratedly reductive. Insofar as Copán is concerned, one can definitely distinguish the macaw and the quetzal, plus hybrid forms of these two species (whose glyphic form is read as *k'uk' mo'o*), as well as different forms of birds of prey like the *katun* bird or the owl-like one depicted on the ramp of the Hieroglyphic Stairway. In the same way, the earth monsters, all different, are the product of a fine blending of crocodile, serpent, and iguana(?) with life and death symbols; birds are the result of several species with distinct symbols and almost always borrow the serpent's skeletal upper jaw to arm their wings and sometimes their beaks. In exchange and at a later date, they will lend the serpent their feathers (CPN 82). Under these terms, where is the "principal deity"?

Bipolar Thought

In their iconography the Maya at Copán have constantly exploited the concept of opposite poles, however complementary and indivisible, of life and death. This principle is illustrated essentially by two opposed pairs: the first contrasts skull and vegetation; the second, earth in its fertile aspect and the nocturnal sun.

SKULL AND VEGETATION

One finds this motif most often on top of stelae: vegetal forms grow on a human skull (CPN 1), on an ophidian skeletal head (CPN 29), or on a short-nosed head (CPN 47 west and east). The head and water lily are sometimes merged into a sole image of a head with a pointed skull that reproduces the form of the aquatic plant's blossom (CPN 54, CPN 40). The pair skull/vegetation is the essential element of the aquatic frieze, assuming the form of a skeletal ophidian head (CPN 109–111). This same form appears in the emblems 7-Head and 9-Head on the sides of CPN 7, and

the human skull with foliage is one of the aspects of the quadripartite altar of CPN 26. This theme is again illustrated by one of the grotesque figures with human body on CPN 4 (east).

These images of the nourishing earth also express the principle that life can only be born of death. The ornaments convey this same opposition; the most common ear ornament in the Maya area is a disk surmounted by a scroll (vegetal form) and finished on the bottom with a bone end. The tubes represented in the nostrils of different cosmic monsters should not be considered real objects, so-called stoppers that, in that they exclude breathing, would denote that the creature wearing them is dead. It is more reasonable to consider these elements images of breath emanating from the nostrils of these monsters: the jade tube that symbolizes life terminates in a bone end to indicate death.

EARTH AND SUN

The contrasting heads on the bicephalic monster express this opposition; for instance, on one side of CPN 8 we find a *cauac* head, reptilian and living, while on the other side is a feline skeletal *kin* head. On CPN 82 the opposition is expressed in a slightly different fashion: a diving toad has a jaguar mask on its back facing the opposite direction. On the bench of Structure 18 the mask of the nocturnal sun and that of the *cauac* monster alternate four times. If we accept the idea that CPN 44 and CPN 48 form a pair, one of them displays solar creatures forming the sacrificial knot, while an aquatic frieze is sculpted on the other.

RITUAL

SACRIFICE

In contrast to the Aztecs and other Mesoamerican cultures, the Maya only rarely represented scenes of human sacrifice in their sculpture. Those of Piedras Negras (Stelae 11 and 14) are famous exceptions. It was thought for some time that blood rituals played only a minor role in Maya religion. The analysis of the Huehuetenango vase by Thompson (1961) was the first in a series of studies (Joralemon 1974; Schele 1984; Baudez 1985a; Stuart 1988) demonstrating that, while direct representation of sacrifice was rare, indirect evidence of sacrificial victims and autosacrifice was abundant. This is particularly well illustrated at Copán, where sacrifice is manifest in instruments (which are not directly identifiable because of their lack of realism) and symbols, while immolation scenes are unknown, and the portrayal of victims and captives is quite rare.

SACRIFICIAL INSTRUMENTS

The Lancet: At Copán the least ambiguous manner of mentioning sacrifice is to show its instruments. There are two main types of lancets for autosacrifice; the first is visible in the center of the tripartite emblem: a point, usually barbed, whose base flares into two scrolls (fig. 116a). The same implement is illustrated elsewhere, such as at Yaxchilán (fig. 116c). This is usually identified as a stingray spine, because it is seen on the tail of this fish on Structure 1-sub at Dzibilchaltún.

At Copán the lancet with double scrolled base is rarely shown as a simple instrument; on the east face of CPN 47 at least, two ancestors have it in their hands (fig. 116b); this applies to the seventh grotesque figure (counting from west to east) on the upper part of the inner door of Structure 22. CPN 540, a piece of unknown origin preserved in the Copán Museum, is a large spine nearly 40 cm high, sculpted in the round. It seems that it was originally part of a composition, probably a tripartite emblem. Its edges are barbed, and a deep channel runs the full length. Three knotted bands adorn the base; above this we observe two miniature spines that resemble the bigger one and, like it, are surrounded with three bands. This type of lancet can assume a personified form as on the west face of CPN 4, on the right of the king's helmet: a grotesque head whose skull is formed by a point with a double scrolled base.

The most common form of the personified lancet is the one illustrated on the Huehuetenango vase (fig. 116d; Thompson 1961) and studied in detail by Joralemon (1974). A serpent head with no mandible but with a protruding and pointed tongue represents the active part of the instrument. The symbol of the three knotted bands and a feather panache crown its head. Appearing at Copán on the first stelae of Eighteen-Rabbit, it was quite popular until the fall of the city. It is

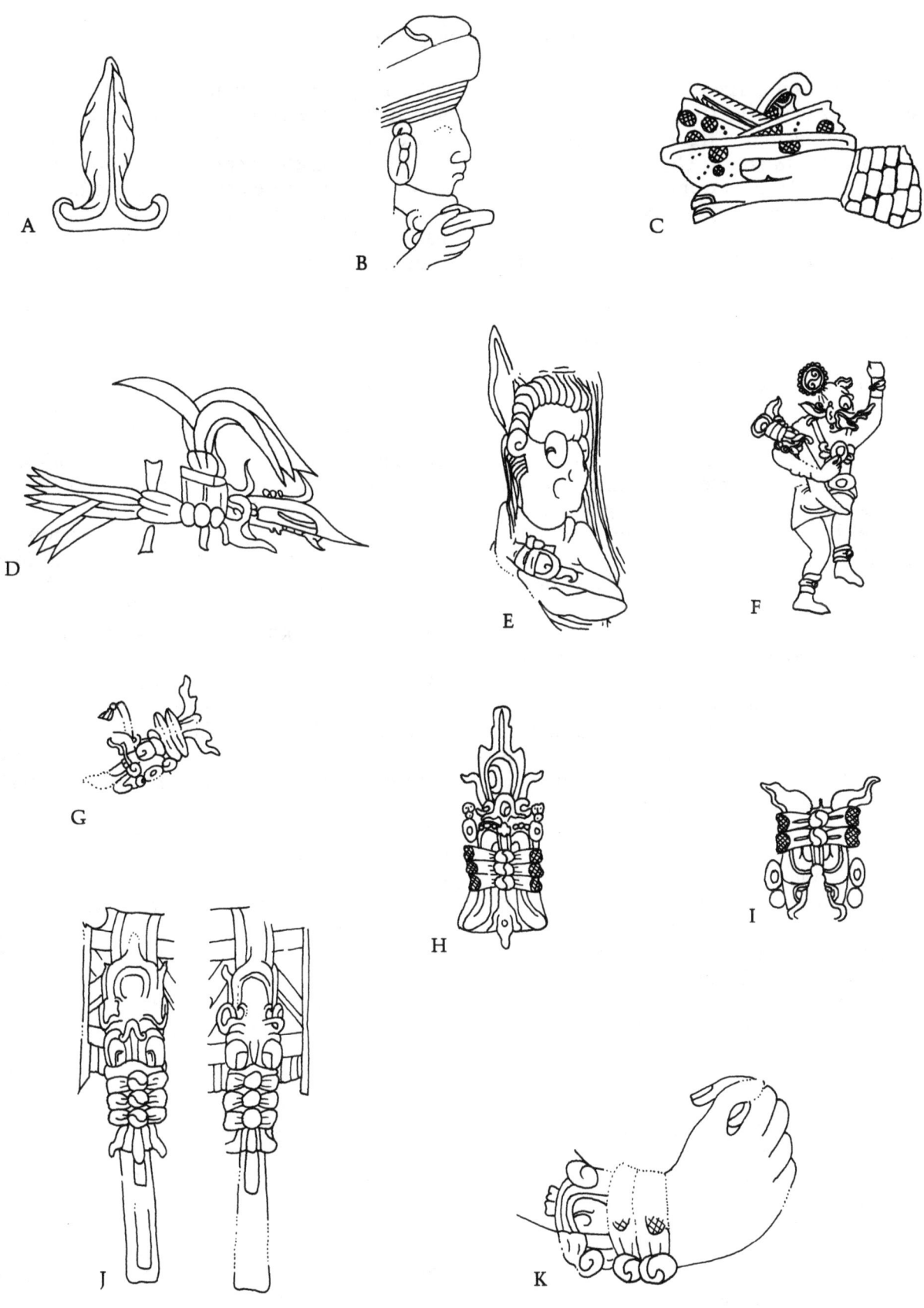

FIG. 116 Iconography of sacrifice. The double-scroll lancet form: (a) CPN 16, east. Drawing by B. Fash. (b) CPN 47, east. Drawing by B. Fash. (c) Yaxchilán, Lintel 25. After I. Graham. The head-lancet form: (d) Huehuetenango vase. After D. Joralemon; (e) CPN 11, south; (f) CPN 7, west; (g) Temple 18, southeast jamb; (h, i) CPN 7, south; (j) CPN 3; (k) CPN 7. Drawings by A. Dowd.

held by grotesque figures on CPN 11 (fig. 116e), CPN 7 west (fig. 116f), and CPN 4 west; the personified maize figure wears it on its wrist on CPN 16 south. Under the bench of Structure 9N-82 ancestors present it with ostentation. It was held by one of the figures on the façade of Structure 22 and is attached to the headdress of Rising-Sun on the southeast jamb of Structure 18 (fig. 116g). The lancet appears more often again in metaphoric form: it is not the instrument itself but its image. The belt mask of Eighteen-Rabbit on CPN 11 is an upside-down lancet; on CPN 7 it is right-side-up on the headdress of the main figure and upside-down on the loincloth (fig. 116h, i). It is most often portrayed laid flat, painted, or embroidered: upside-down on ribbons hanging from the belt on either side of the loincloth (fig. 116j); upside-down or right-side up, it constitutes the knee, wrist, and ankle ornaments of the ruler (fig. 116k).

The lancet may assume other forms. The wide-handled point (blade) stamped with T528 held by the grotesque figure with a bat's head on CPN 7 (west) has been interpreted as an instrument of autosacrifice. In the same way the curved point with a "hilt" surrounded by little cords and terminating in feathers is planted in the headdress of the ancestor on the west face of CPN 3.

The Knife: We identify as knives oblong objects pointed on both ends, often with serrated edges and with semicircular notches; they may be symmetrical or asymmetrical, that is, "eccentric." They almost always have marks signifying that they are made of stone; these are elements of the *cauac* glyph, more or less deformed (T528): concentric lines, straight or wavy, edged with dots; circles or concentric circles in triangular arrangement or T635; and variants of T518. At Copán the eccentric knives are not shown as independent objects. They are never in the hand of a figure, whether the king, an ancestor, or a supernatural creature. Most often they are personified and the knife itself constitutes the skull of a grotesque head (fig. 117a) as on Altar 7 at Tikal. At the top of CPN 24 we can see a composite shafted lance with a serpent head at either end; these allow room for two grinning skeletal heads with knife blade skulls (fig. 117b). These creatures are definitely personified knives, because they take up the place generally occupied by knives coming out of a serpent's jaw on a lance end (fig. 117c). A personified knife constitutes the helmet of the grotesque head on the ends of the serpent bar on CPN 3. Other grotesque heads with their blade-shaped or eccentric skulls (often exaggeratedly elongated into a hook as on CPN 1 and CPN 11) emerge from the ends of the serpent bar on CPN 1 (fig. 117a), CPN 11, and CPN 16. On CPN 11, in addition, personified eccentrics issue from the jaws of cosmic serpents at the foot of the main figure. The dead head of the bicephalic serpent (on the present-day north face) of CPN 13 is followed by a grotesque head with a stone skull (T616b) and wearing the whistongue.

The substitution of a knife for the tongue of cosmic creatures would express the idea that the natural forces are thirsty for blood. This image is often found on the ends of serpent bars; the knife-tongue is then marked with T528 (CPN 4, CPN 47, CPN 9) or with *akbal* (CPN 41 north). The skeletal heads at the ends of the loop serpents of CPN 41 have long knives hanging from their mouths. At the top of the stairs of Structure 24 the ophidian head of the earth monster that is swallowing the nocturnal sun sticks his tongue far out; the edges are serrated and three rings (*cauac*) confirm that we are dealing with stone.

Through their pointed forms the lancets seem reserved for autosacrifice, while the symmetrical knives with sharpened edges are more directed toward taking the lives of human victims; eccentric knives can be instruments of torture for others, as well as for oneself, unless they are symbolic objects such as the whistongue. In a preceding study (Baudez 1985a) I coined this neologism to designate the Y-shaped form placed on the face of Eighteen-Rabbit on CPN 11 and 3 (fig. 117d). I have suggested that it was composed of the whiskers and tongue of the jaguar and that it was a symbol if not an instrument of sacrifice. It is possible in fact that such an object (undoubtedly a stone eccentric) was used in bloodletting rites. It is found upside down on king's headdresses (CPN 3, CPN 26, CPN 30), but also on the face of grotesque figures (CPN 3 east, end of the serpent-bar;

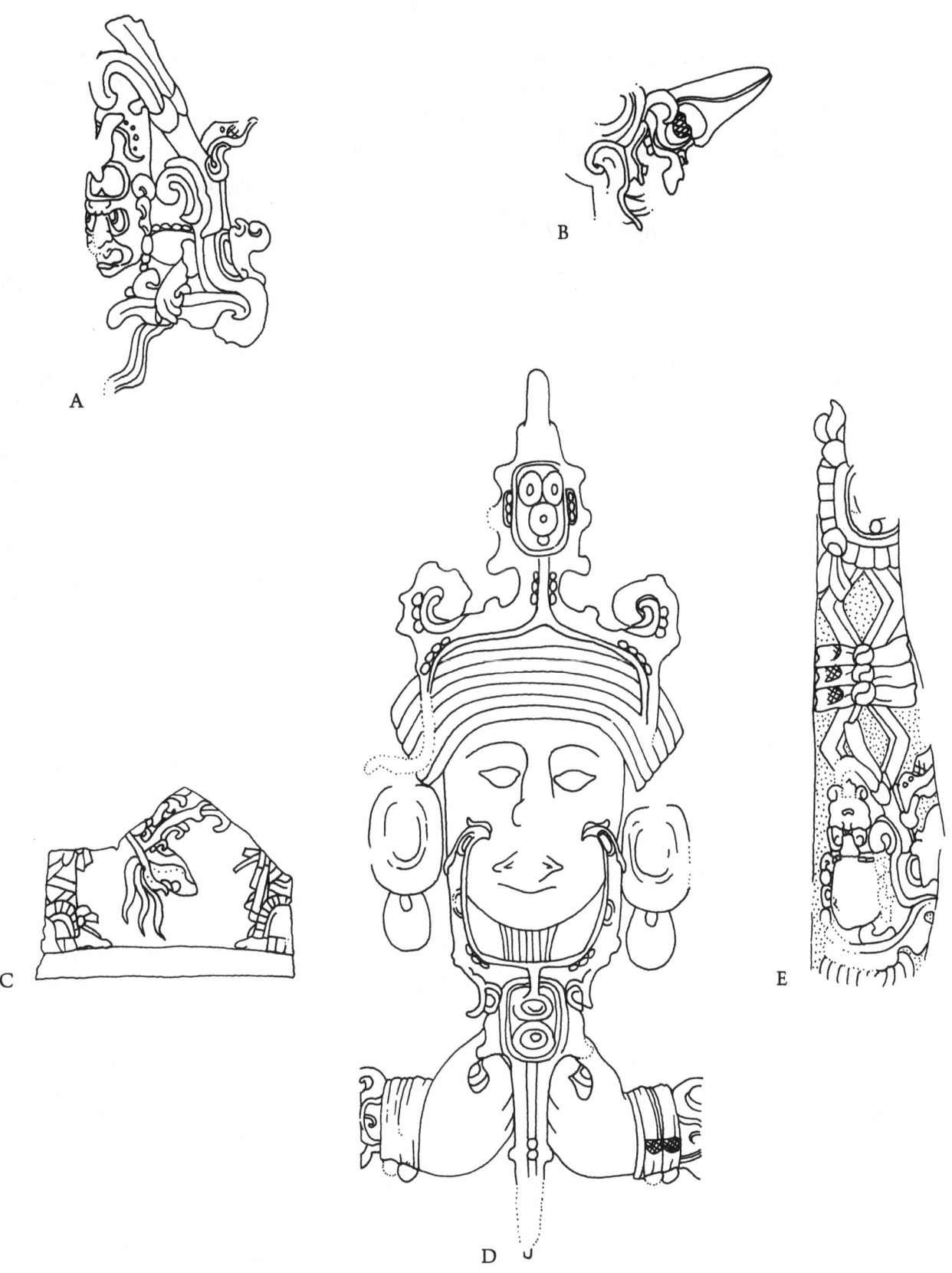

FIG. 117 Iconography of sacrifice: (a,b) personified knife (CPN 1 and CPN 24); (c) knife-tongue (alabaster sherd from tomb-fill of Structure 18); (d) whistongue (CPN 3); (e) composite staff (CPN 1). After A. Dowd.

pent or a crocodile (CPN 47 east; CPN 26 north), and on a solar mask on a shield (Structure 18, southeast jamb).

It has been noted (Schele 1984; Baudez 1985a) that the Maya did not attempt to contrast the sacrifice of others to the sacrifice of self in their imagery. The following example serves as an illustration: on Tamarindito Stela 3, a serpent-head lancet appears at several points at intervals on the lance shaft held by the main figure. The ambiguity between these two forms of sacrifice is intentional. In the same way the voluntary confusion of war and sacrifice shows that the former has the latter as a goal. Accordingly, arms can be considered as instruments of sacrifice in the broad sense and here are treated with this in mind.

The composite shafted lance includes two broken lines on either side of a straight line. Very common at certain sites (mainly in the Petén, as at Tikal and Naranjo) this appears at Copán only in two examples. At one or another extremity a serpent opens its jaws onto a knife-tongue. I have already cited the lance on the top of CPN 24. Two similar objects—but without the central straight shaft—accompanied by shields frame Eighteen-Rabbit on CPN 1 (fig. 117e). The lower part (the only visible one) ends in a serpent head whose jaws open onto a grotesque head. The shaft is completed by groups of three bands knotted at regular intervals, accentuating the sacrificial character of the instrument.

According to their postures, the rulers on the Hieroglyphic Stairway held lances, undoubtedly wooden ones, in their extended right arms, and a shield partly hides their left arm. The lance and shield are also held by Rising-Sun on the jambs of Structure 18. Often these shields carry the image of a creature with sacrificial implications: pseudo-Tlaloc (on the shields that adorn the dead king's loincloth on CPN 47), owl (Hieroglyphic Stairway, first seated figure), solar head (Structure 18, southeast jamb), Pax jaguar (CPN 40). There are also three white or black circles that could allude to the jaguar (T524 = *ix*, "jaguar"). The circles—not to be confused with the three *cauac* rings—are found on the tongue of the serpent (CPN 18) or that of the bird (CPN 16). The shields are also decorated with a motif repeated in a diagonal pattern: feather (CPN 40) or death eye (CPN 18, CPN 54, CPN 47 west). On the blocks of the East Court that mark the level of the underworld shields accompany the growling jaguar. In this way the shield is the emblem of the jaguar/nocturnal sun, principal patron (and beneficiary) of human sacrifice.

SYMBOLS

The Knot-Rope Complex: This symbolic ensemble uses the emblems of captivity, the rope, and especially the knot. The most common of all is the band knotted in a bow, which is found most often in groups of three. The knotted bands are used in iconography either as "substantives" (nouns) or as "adjectives." In the first case the motif alone symbolizes sacrifice: for example, as when a grotesque figure presents three knotted bands in an offering bowl, either alone (CPN 4 west) or accompanied by ribbons or feathers (CPN 11 north and south); or when a wide knot forms the contents of a serpent's jaws at the end of a bar held by an ancestor (CPN 4 east; in this last case the ophidian head at the other end of the bar contains a knife, another obvious symbol of sacrifice).

Most often, however, the knotted bands are added to other symbols whose sacrificial nature they confirm and reinforce. We have observed that they compose the "headdress" of the serpent-head lancet whether it is presented as an instrument by a figure, or as an image on ribbons, or as a mask, as on ankle or wrist ornaments. The three bands knotted around the forehead of the two jaguars of CPN 12 confirm that they are patrons of sacrifice; those that crown the pseudo-Tlaloc of the loincloth and the skulls on the belt of CPN 47 (west) are similar, as well as those who bind the hairpiece of the grotesque figure on CPN 11 (north). When this motif appears in the king's headdress or his ancestors' (CPN 30), there is no doubt that it is intended to remind one of the role of the ruler as a "great sacrificer." The three bands are repeated several times on the composite shaft of the lance on CPN 1 and adorn the bar, as much an arm as a scepter, judging from the knives in the serpent's jaws carried by ancestors on top of CPN 41. The jaguar paw scepter with its claws flexed is perhaps itself an instrument of sacrifice, as implied by the three

bands wrapped around it (CPN 3 west). Three bands attached by a bow are always found at the base of the loop serpent (fig. 118b, c below), with only one exception.

The rope has the same function and value as the knot. The cosmic serpent's body that frames rulers on stelae is sometimes replaced by a cord; this is to emphasize the sacrificial role of the king (CPN 11, CPN 41 north and south, CPN 47 east, CPN 9). With a similar intention the two rulers represented on CPN 4 are framed by two cords coming from the serpent bar carried by the ancestor. It is also possible to place an entire scene (top of the altar of Hieroglyphic Stairway) or an inscription (CPN 11 east) under the sign of sacrifice by encircling it with a rope. But the rope is used mainly as a costume element: it is found in the headdress (northwest and northeast jambs of Structure 18, head in-the-round of Structure 16) or replacing the necklace (CPN 3 east and west; Structure 26, reclining figure no. 4). Twisted several times around the waist, it replaces the belt on CPN 52, on CPN 11, and on the statue of Structure 16. It is present on the ankles of Eighteen-Rabbit on CPN 11 and CPN 43, and on these same monuments it covers the loincloth or hangs from it. In these contexts the rope may indicate either autosacrifice (the king as penitent weighted with ropes) or the sacrifice of others; in this way on the northeast jamb of Structure 18 Rising-Sun, brandishing his lance, bears a bundle of ropes on his chest: is this a mere symbol or bonds to tie captives taken in combat?

The bundle is another expression of the knot-rope complex. To underline its connection with the sacrificial universe, the altar or cribbing is wrapped with a rope (CPN 45) or several ropes, generally three, crossed and knotted (CPN 44, CPN 48, reutilized altar in the Hieroglyphic Stairway; cribbing frame of CPN 62, CPN 9, CPN 18). Thompson viewed this image as an equivalent to a period ending comparable to *xiuhmolpilli*, the binding of the years of the Aztecs. Because of the three bands that attach these bindings, I prefer to interpret them as symbols of sacrifice.

We have seen above serpents whose bodies were replaced by a rope. If we allow rope and knot to have the same value, we may replace rope serpent by knotted serpent or loop serpent. On CPN 43 the ruler is framed by six creatures with the Thunderer's head and knotted serpent bodies (fig. 118a). We find knotted serpents on the cribbing frame of CPN 62 (CPN 62A), and others bind the sandals of the ruler on CPN 9 and CPN 18. On the loop serpent, a variety of knotted serpent, the reptile's body forms a loop attached at the base by three knotted bands (fig. 118b, c; CPN 41, CPN 47, CPN 9, CPN 40, CPN 38) or in one exceptional case by a trilobal shell (CPN 54).

On polychrome vases representing scenes of sacrifice in the underworld the jaguar who is one of the main personae sometimes wears a scarf knotted around his neck. This same symbol is visible on both jaguars that form CPN 12.

The Pseudo-Tlaloc Complex: Linda Schele (1984) has competently demonstrated that the pseudo-Tlaloc mask, the Year Sign (two overlapping triangles forming a half Star of David), and the globular headdress (which she interprets as being made of jaguar fur), often associated, refer directly to sacrifice. In the Late Classic period this complex is illustrated— for the first time in the central Maya zone— on CPN 52. Pseudo-Tlaloc masks and Year Signs adorn the headdress, surmounted with a crown of clipped feathers (fig. 118d). The same Tlalocs at the end of serpent bars have lolling knife-tongues (fig. 118e). Another, crowned with three bands, appears on a shield on the loincloth of the east face on CPN 47. Oddly, this iconographic complex is no longer used on monuments associated with Eighteen-Rabbit. The pseudo-Tlalocs do not reappear until Smoking-Squirrel, and then profusely, on the Hieroglyphic Stairway, first on the altar at its foot: inverted Year Signs with ropes and hanging hair and monstrous pseudo-Tlalocs with an oversized tongue flanked by two hooks hanging out of the skeletal jaws. Finally, almost all the royal statues set on the stairway have these insignia in their headdresses or at their sides. This complex was utilized later by Rising-Sun in the iconography of Structure 16 (heads of the west room); most likely we must attribute to this period the pseudo-Tlaloc heads of the architectural ensemble of the Cementerio immediately to the south of the Acropolis.

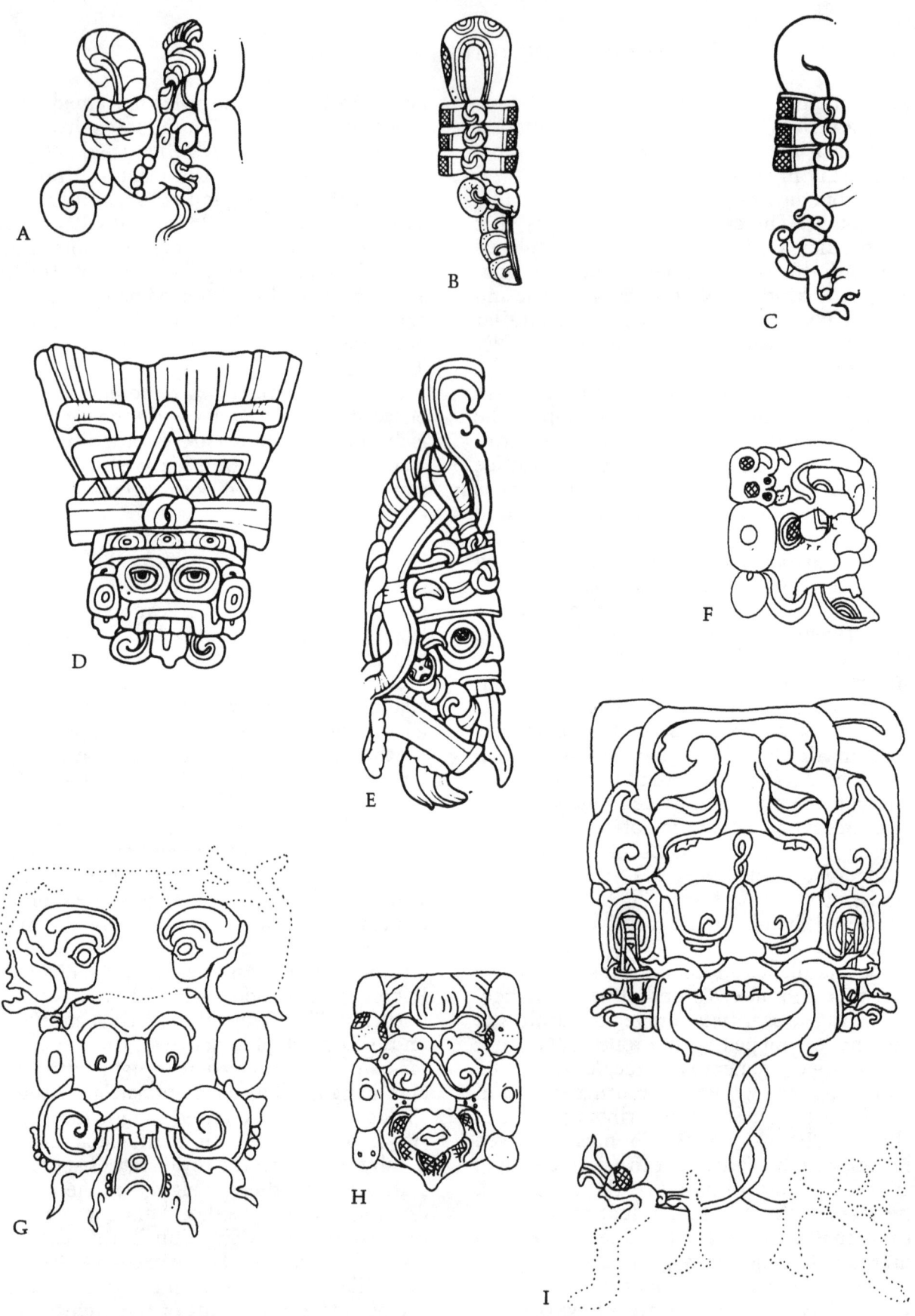

FIG. 118 Iconography of sacrifice. The knotted serpent: (a) CPN 43. The loop serpent: (b) CPN 41; (c) CPN 9. Pseudo-Tlaloc: (d,e) CPN 52. The jaguar, patron of Pax: (f) CPN 18; (g) CPN 4, west. The jaguar, patron of Uo:(h) CPN 18; (i) CPN 4, west. After B. Fash.

Another mark of sacrifice is an element of the pseudo-Tlaloc and perhaps its most characteristic element: the rings around the eyes. This distinctive sign is worn by Pax jaguar (belt masks of CPN 47, CPN 9) and other grotesque figures (CPN 4 west), by skulls (Hieroglyphic Stairway figure no. 1, CPN 47 west), by owls (ramps of the Hieroglyphic Stairway), or even by rabbits such as those around the head of Hieroglyphic Stairway figure no. 4. They are also the distinctive features of the Founding Father who faces Rising-Sun on CPN 30 and the human and grotesque heads of Temple 16.

VICTIMS

Copán has no representation of human sacrifice and, with few exceptions (southwest jamb of Structure 18), few images of captives. Even so, we have found numerous clues testifying to the existence and importance of the sacrifice of human victims. The kings on the Hieroglyphic Stairway, for instance, are presented at once as warriors armed with lance and shield whose enemies lie fallen at their feet and also as sacrificers loaded with such sacrificial symbols as pseudo-Tlalocs, Year Signs, ropes, and death heads.

Instruments of sacrifice, as we have seen, may be divided into two large families; while points and lancets are used for autosacrifice, blades and knives (symmetrical or asymmetrical [i.e., eccentric]) are more adapted and probably reserved for the sacrifice of others. These are the same knives we find at the end of the two-headed lances with simple or composite shafts. I believe that this indirect evidence is sufficient at Copán to demonstrate the existence of the sacrifice of victims as well as automutilation. There is room to believe that, as in the proto-historic period, enemy captives were the great majority of human sacrificial victims, which seems to be the case in other Classic sites, such as Yaxchilán, Bonampak, or Piedras Negras.

The iconography does not indicate who practices autosacrifice or when. Most certainly the king does, while his ancestors around him seem to encourage him to continue this tradition. Being the most important of all humans, his blood and pain are the greatest gift for the powers who are to receive his offering. The ruler is the autosacrificer *par excellence*, the man who incarnates the entire community. According to historical sources, the Yucatecs of the sixteenth century all practiced autosacrifice, but with variable frequency and intensity, according to their rank. The more responsibility one had, the more one accomplished the rite of self-sacrifice. Eighth-century Copán must have observed the same standards, and occasions for celebrating these blood rites must have been frequent. The blood spilled was collected on ribbons or paper strips gathered as offerings in a bowl or a basket.

BENEFICIARIES AND PATRONS OF SACRIFICE

Conventional animals or polymorphs, grotesque figures with human bodies and imaginary heads, others with death heads, turbaned ancestors, and the like belong to the world of sacrifice either because they display a torture instrument or its result (bloodstained paper strips) or because their very features evoke sacrifice (e.g., knife-blade for head) or death (skull, skeletal mandible or absence of jaw). Among these creatures some represent instruments of torture and others are associated with sacrifice as its beneficiaries or patrons. The importance of sacrifice in belief as in ritual was so great that it is probable that certain spirits were exclusively attached to it; their role may have been to watch over and see that the rite was accomplished according to the rules and also to ensure the transmission of the offering to its beneficiaries, in the role of messengers between humans and the other worlds.

Although certain attributions may be arbitrary, we may consider those representations that exist outside of the sacrificial context as beneficiaries of these rites. The *cauac* monster, for example, is an image of earth, which may receive sacrifices (serving as altar, for example), but which has many other roles to play besides this. Conversely, the pseudo-Tlaloc and Pax jaguar only exist within the sacrificial context and are thus considered to be patrons of sacrifice (fig. 118d, e; f, g).

The entire cosmos, it would seem, laid claim to human blood, indispensable to the dynamics of the universe. First, the sun; dead or nocturnal, it is characterized on the rear head of the bicephalic monster by a tripartite emblem with shell, crossed-bands, and sacrifi-

cial instrument. The jaguar, which represents the sun during its underground sojourn, is frequently associated with creatures or symbols of the sacrificial domain. Solar creatures with *kin* engraved on the forehead often have blade skulls (CPN 1). The monkey, a solar animal (*kin*), holds a severed head on CPN 4 west. The whistongue may be found—except on the king—particularly on solar creatures (fig. 118h, i; and Structure 24 stairway central block) or felines. If we suppose that all short-nosed creatures are from the solar realm, most of them have sacrifice emblems even when they are not specifically qualified as being solar.

To a lesser degree and in a less urgent way, the earth also is bloodthirsty. This is indicated by the altars that represent it (*cauac* monster), on which victims are sacrificed (MNA vase and CPN 25). As a glyph, *cauac* may have the phonetic value *tun*. It alone could designate the sacrificial stone; but when *cauac* appears in its monstrous form, it designates at once stone and earth. The sacrifice demanded in exchange for good harvests is indicated by the images of the severed head of maize in human form (CPN 7) or that of the same figure with a lancet hanging from his wrist (CPN 16). On this same monument the headdress of the main figure is a mixture of maize and bone. The skull-and-vegetation theme not only states that death promises life; it also has a normative value: blood must flow to obtain life from the universe. The iconography of the inner door of Structure 22 has shown us that the celestial monster has a liquid issuing from his mouth that is at once water and blood. This ambiguity, this intentional confusion, underlines the indissoluble bond between blood and rain.

The patrons of sacrifice are first of all the grotesque figures with death heads. To their skulls are sometimes added rings around the eyes (CPN 47 west) or a hand in place of the mandible (CPN 4 east), as well as a hairpiece, a collar, and a double pectoral (CPN 16 south, north, and east). The creature that has been identified as the ancestral form of God Q on CPN 41 has an eye split by a vertical line. Its association with death and sacrifice is otherwise indicated by a group of signs: *cimi*, the three knotted bands, and the hand covering the mouth. In the Madrid/Dresden Codex God Q presides over sacrifice; in the Dresden Codex (6b) his ear is traversed by a bone and his headdress has death eyes and three knots.

The bat, or rather the vampire, is the animal most suitable for representing sacrifice. He lives in caves, is active at night, and lives from fresh blood. He is treated in a realistic manner on the east side of CPN 27, from which he emerges halfway. Taking the form of a grotesque figure with a vampire's head, he holds a lancet on CPN 7; he is one of the infernal creatures of CPN 33 and the grotesque figures of CPN 4 (east). On CPN 4 we can see two bat heads on the east, accompanied by knotted bands on the ropes that encircle the main figure; on the west these two heads are carved on two large disks, undoubtedly shields. The vampire, finally, composed the headdress of Pax jaguar on the left side of the belt of the late ruler.

Another nocturnal animal bearing the death message is the owl, who at Copán is only visible on the Hieroglyphic Stairway; with his ringed eyes, he marks the serpent bodies (in an upside-down cartouche) that inhabit the skull representing the underworld; he presides over the *cauac* monster on the ramp and adorns the bulbous down headdress of two royal statues (nos. 3 and 5). This bird is in addition represented by his feathers; thus, on CPN 11 the loincloth has the blackened ends and small spots that characterize the feathers of the *muan* bird.

Ancestors also play a role in sacrificial iconography. Like supernaturals, they are often portrayed accompanying the ruler, loaded with ritual insignia; a lancet (CPN 3 west, CPN 47 east), ribbons (CPN 3), or an ax (CPN 9). They are often shown like the king, as penitents with the rope around the neck. If the scepters(?) borne by ancestors on CPN 30 and the step of Structure 11 are truly lancets, the role they play in the sacrificial world is even greater.

Sacrifice is the most important theme in Copanec iconography. Once we have recognized its instruments, identified its symbols, and discovered its actors, it is ubiquitous—in the ruler's costume, in the hands of his ancestors, with the spirits of the natural forces to which it is dedicated. The great sacrificer is the king, who, in the name of all, lets flow the blood of his victims, as well as his own.

Both are demanded by the frightful creatures such as the Pax jaguar and pseudo-Tlaloc, for the benefit of the moribund nocturnal sun and the dry earth. Quenched with human blood, the sun, after having transversed nocturnal shadows, appears in the eastern sky for a new day; earth, having received the precious water (as the Aztecs expressed it), lets the spirits of rain and vegetation come out of the subterranean waters. The good harvests that result from this will permit the people to live, and again they must give, in order to receive.

Perambulations

It has been shown that a certain number of monumental edifices at Copán were microcosms, portraying the cosmos as a whole or perhaps only in part. These constructions were three-dimensional stages for rituals that required movement of the officiants.

Structures 12 and 24, as well as Ball Court A (Structures 9 and 10) have three levels:

1. The alley of the ball court, which has images of the underworld on its markers, is linked to the sky (symbolized by the macaws) by the sloping bench. The player's movements reproduce the struggle between life and infernal forces in the manner of the game related in the *Popol Vuh*. The sun's visible movements are imitated by the ball.
2. Structure 12 represents the aquatic underworld at whose bottom (that is, on the courtyard) we can see fertile earth images, in the shape of long-nosed grotesque figures who give birth to vegetation in four directions. Earth spirits, responsible for fertility, surge from the underground water levels here marked by the layer of conch shells. The actors of the agrarian rite go up the stairs to mime the mysteries of germination. They could also accomplish lateral movements, in relation to the three north-south axes marked by the alignments conch-statue-slab.
3. Another aspect of the underworld, the home of the dead and the nocturnal sun, was illustrated by Structure 24. The most important movement of the protagonists illustrated the descent to hell, whose bottom was attained by reaching the court floor. The upper level corresponded to the horizon behind which, to the west, the sun sets. As for the preceding structure, the triple alignment slab-sculpture must have had a specific function in the perambulation or in the number of participants.

Other rituals included a perambulation in which the four cardinal directions played an essential role. The cross-plan of the lower level of Temple 11 represents the earth with its four directions and center. Either the passages used only the four cardinal points, marked by the four doors, and the central sanctuary, or they included the four angles of the edifice, which then represented the solstice points at rising and setting sun, reproducing in this way the graffito found by Strömsvik in Structure 26. It must be noted, however, that circulation was greatly hindered on the south side, which had no stair.

In the center of the Main Plaza Structure 4 was equipped with four stairways and an altar to celebrate the 15th katun. I think, as does Coggins (1980, 1983; see also Jones 1969), that radial pyramids, oriented in the cardinal directions with no funerary function and no temple at the top, were specifically utilized—as were the twin pyramid complexes at Tikal—for period-ending rites.

Other than perambulations that covered the "space of time," there were also sacrificial, divinatory, and propitiatory rites. The ritual courses were in three dimensions and used only the stairs and the corners of the edifice.

Perambulations probably were accomplished in the center of the site, also a cruciform microcosm (Baudez 1991); it was composed in the center by Structure 4, on the north and south by the Main Plaza, on the east by the *sacbe* joining Structure 10L-3 to 10M-1, and on the west by the *sacbe* found by Gordon (1896: 25) "3 or 4 hundred yards" from Structure 10L-54 leading to a group of edifices, of which nothing remains presently (if not Structure 10K-16) because of public works in the twentieth century: a road and two airstrips.

The Ancestor Cult

The frequent presence of ancestors on stelae is enough to demonstrate their importance in legitimizing the power of the reigning king. Monuments such as Structure 26 or CPN 30 were erected to the glory of the dynasty. The existence of a true cult is shown only in Structure 16. There, at the back of a room open on the west of the highest temple at Copán and occupying a central position on

the Acropolis, is presented as an apparition (i.e., emerging from the jaws of a cosmic serpent) what we believe to be the representation of the great ancestor, founder of the dynasty. His statue, surrounded by spirits or patrons of sacrifice, held a severed head in his hand. An incense burner or an offering receptacle in the shape of a *cauac* monster stood nearby.

Structure 16, the work of Rising-Sun, dedicated at least in part to the Founding Father, is linked by a sort of bridge to Structure 18, the funeral temple (temporary or permanent?) of this king. This bridge establishes a symbolic connection between Rising-Sun and the first king of the dynasty.

KINGSHIP

At Copán, as at Quiriguá, no members of the king's entourage (e.g., courtesans, servants, women, priests, dwarfs, and captives) are depicted in the sculpture. Exceptions to this rule are rare (CPN 33, CPN 16). Besides the main figure of the stelae, the reigning king, anthropomorphs representing his ancestors are presented as inhabiting "other worlds": the sky or hell. This concentration of kingly images on anthropomorphic sculpture is an extraordinary panorama of the rulers of Copán.

THE KING ON STELAE

The king is portrayed as either dead or living. The dead king identifies himself with the nocturnal sun by hiding his face behind a jaguar mask or sinks into the earth represented by an altar (standing) before his feet. The living king sometimes is seen as acceding to his supreme duty; he comes out, like the rising sun, from the jaws of the earth monster. Always he is standing in a hieratic, very rigid posture; this rigidity is intentional, translating his will to be likened to the cosmic tree. He has his feet on the ground, the diurnal sun on his head (the bird represented by his feathered headdress), and the sky in his arms.

His headdress is often a jaguar, a crocodile, or a serpent helmet. In the first case he appears under the patronage of the nocturnal sun and in his role as a warrior and sacrificer. In the two other cases he manifests himself as a *bacab* and as guarantor of fertility. After CPN 38 the turban is sometimes worn by the main figure but more frequently by his ancestors, who thus are identified as being from Copán. This turban therefore appears to be an emblem of the city. Sometimes it serves as a background for accessories: instruments of sacrifice, symbolic animals, and such. In general—if we are to judge by the great diversity of headgear—the headdress is the costume element in which liberty of expression is most evident. For example, on CPN 1 the king wears a cylindrical hat made of three braids, the symbol of power, and the great ancestor on the west face of CPN 3 wears a spherical headdress wrapped with a cord (a miniature of CPN 45?).

The ear ornaments and the bead necklaces express life and fertility in that they are composed of jade. Their forms are quite varied, as are the pectoral ornaments, which sometimes are reminders of the theme expressed in the headdress. Bracelets and anklets, usually identical on the same figure, express sacrifice. More ancient forms are composed of a serpent-head completed by crossed-bands or a quincunx design (probable symbols of death); from Eighteen-Rabbit on, this is almost always with the serpent-head lancet in the usual form.

The belt is most frequently adorned with a row of Saint Andrew's crosses (here being more celestial signs than death emblems) or a sky band. Often these signs are replaced by symbols of power: braid or twisted strands. Three masks usually are attached at the belt; when they resemble one another, they are almost always youth heads (*ahau*?) or skulls. The central mask may be found to differ from the lateral masks; in this case we have the following pairs: Pax jaguar/Uo jaguar (CPN 18 and CPN 4; fig. 118 f, h; g, i); lancet/youth mask (CPN 11 and CPN 7); *xoc* fish/solar head (CPN 16); and so on. Three jade plaques that may be marked T616b (or sometimes T528, T24, or T103) hang from the belt masks. These plaques may also be made of tortoise shell (CPN 40). Other tinklers, made from *Oliva* shells, were attached to the belt.

When the main figure wears a skirt, it generally is made of jaguar skin edged with a row of beads and tinklers. The loincloth is adorned with a feline mask (e.g., CPN 3 east, CPN 26, and CPN 24) or two (CPN 4 west) or with owl feathers (CPN 11, CPN 41, CPN 47), a lancet

(CPN 7), or a shield with a pseudo-Tlaloc effigy (CPN 47 west). Briefly, all these images are from the domain of the underworld and its associated rituals. The loincloth itself is covered with, or continues into, a braid-and-tassel (sometimes replaced by a rope, as on CPN 43) and flanked with a stylized serpent jaw (the cosmic serpents?).

It seems that there is a contrast between the upper body of the king, with his belt representing the sky, and the lower body, depicting the earth and the underworld. The serpent bar was, in origin and until CPN 47, a bicephalic serpent with a living or skeletal body. This is certainly the celestial monster, as shown in the cosmogram on the back of CPN 16, which is confirmed by the bar itself; in fact, when it does not have the mat (royal), it bears Saint Andrew's crosses (CPN 26, CPN 43) or the celestial band (CPN 3), as do the belts. The ends of the bars are identical serpent heads, mostly skeletal, sometimes living, or mixed. Their content in most cases refers to sacrifice and to solar creatures: instruments or symbols of torture (CPN 47, CPN 4 east), patrons of sacrifice in the form of grotesque figures with symmetrical or eccentric blade heads (CPN 1, CPN 3, CPN 11, CPN 16), solar creatures such as the old sun (CPN 47 west, CPN 3, CPN 29, CPN 40, CPN 54), Smoke-Jaguar (CPN 18), the Blind Jaguar (CPN 9), the pseudo-Tlaloc (CPN 52), and a turbaned monkey bearing a severed head (CPN 4 west).

In addition, an anthropomorph is coiffed with a solar helmet in two examples. In two cases the emergent creature belongs neither to the "solar reign" nor to sacrifice; it is then the Thunderer (CPN 7, CPN 24, CPN 26) or a turbaned ancestor (CPN 38, CPN 47 east).

The serpent bars are essentially qualified and personalized by their contents. Mostly the ruler calls upon patrons of sacrifice in his essential role as sacrificer and victim, and in these instances the iconography of the stela has sacrifice as its essential theme. Sometimes, however, he invokes long-nosed creatures that I believe are spirits of Mother Earth; the iconography of CPN 7 and CPN 26 (and perhaps of CPN 24, unfortunately quite damaged) occupies an important place in the fertility theme. CPN 38, abnormally simple if not to say bare, has as its first concern legitimizing the power of the main figure, referring to a token ancestor (that is, one with a turban).

OTHER PORTRAITS OF THE RULER

On stelae the ruler assumes an essentially cosmic role and looks impersonal and stiff; on other sculptures, however, the poses are less hieratic, more dynamic, the ruler emphasizing his role in the cosmos and among humans.

On the Hieroglyphic Stairway and on the jambs of Structure 18 he appears mainly as a formidable warrior. He may be armed with the spear and the shield, surrounded by death and sacrifice images on the stairway, and overloaded with ropes and trophy heads on the funerary temple.

We also observe the ruler facing an ancestor (CPN 23) or all the elders of his lineage (CPN 30, step of Structure 11), who celebrate with him the anniversary of his accession. He also intervenes in the mythic world; we see Eighteen-Rabbit on the central marker of Ball Court AII-b, facing the lord of hell in a ball game, winning, and thus permitting the triumph of life over death. Doubtless we are witnesses to a mythic episode with kings as actors again on CPN 33: in hell the rulers are found in the company of fantastic creatures.

On all these monuments the king and his ancestors hold in their hands what has been interpreted as an insignia of power in the shape of a tube continued with feathers: it could be, as Benson (1982) has suggested, a lancet in its sheath, but this remains to be demonstrated. Rulers may brandish a scepter with a jaguar head (Structure 18, northwest jamb) or a water lily blossom (step of Structure 11) or a jaguar's paw (CPN 30). Headdresses and jewels show great variety, but they do not allow us to identify or characterize the figures.

In sum, the king becomes king by virtue of his ancestors and his connection with the dynasty. Assimilated into the sun, he sinks into the earth at his death and emerges at his accession: the dynastic cycle is assimilated into the solar cycle, and the king is only one sun among many, one link in the dynastic chain.

The king has a fundamental religious role,

which is to nourish the forces of the universe with human blood. He is at once torturer, sacrificer of enemies captured on the battlefield, and victim (because he frequently must offer his own blood and endure pain). But like all, he gives because he receives. He is responsible for the smooth operation of the universe, whether sunrise or rainfall or the growth of plants.

ANCESTORS

On stelae the primary role of ancestors is to assist the king, stressing continuity and the necessity for the rite of sacrifice. I identify ancestors—those completely anthropomorphic creatures shown by the context and sometimes also by certain features (e.g., the shell replaces the ear, sign of an underworld connection)—as having a cosmic dimension, not earth-bound. They may be found enthroned on the very top of a monument, above cosmic serpents, or lower on the sides, gripping their body. Sometimes they come out of the ends of serpent bars or emerge from or sink into serpents' jaws. At other times they simply appear within the serpent's jaws. Anonymous ancestors, if they are not former kings, are nonetheless part of the royal lineage. Most often their headdress is a turban or another royal hat: for example, we see the headdress worn by ancestors on CPN 47 east and by Eighteen-Rabbit as the main figure of CPN 1, and ancestors on CPN 41 north and south wear a serpent helmet and the exclusive serpent bar. Sometimes a human head is coiffed with a "solar" helmet. Here again we know we are dealing with a royal ancestor because he appears in the mouth of the bar ends or at the end of cosmic serpents (CPN 4 east, CPN 41 north, CPN 47 east). On the sides of CPN 26 the ancestors illustrate dynastic succession: they are represented either coming out of or sinking into the mouth of the earth monster. Elsewhere, when they surge vertically from jaws, we can suppose that they are emerging from the earth monster (CPN 41 north and south, CPN 47 east); this is more difficult to discern when the monster's head is horizontal; it could be an emergence or a simple "apparition" (CPN 4, CPN 47).

On many stelae (coeval with and later than Eighteen-Rabbit: CPN 11, CPN 43, CPN 24, CPN 26, CPN 4 east) the top is occupied by ancestor figures, most often three in number (one in front view and two in profile), who dominate the entire scene and sometimes hold the cosmic serpents that frame it. Is this not a true gesture of power, that of the bearers of the serpent bar, to hold or carry the sky symbol?

Ancestors sometimes manifest their patronage only in that they are present; more often they demonstrate their association with sacrifice, in the role either of executioner (brandishing an ax on CPN 9) or of victim (as penitents on CPN 11). We see them with lancets (CPN 47 in serpent bar) or carrying a patron of sacrifice (the head of the serpent, patron of Ceh on CPN 3) or blood-stained strips (CPN 3). Occasionally ancestors offer, it seems, something other than blood; on CPN 47, at least, there seems to be an incense offering.

Ancestors underlining the role and duty of the king are present on monuments other than stelae. We have seen that all the statues on the Hieroglyphic Stairway are images of great sacrificers: a number of Rising-Sun's ancestors have sacrificial features on their headdress, and the founder of the dynasty (if this is he) holds a severed head in his hand. On all these monuments and edifices ancestors also are present, especially to legitimize their successor (e.g., on CPN 30, CPN 23, the step of Structure 11, giving him a scepter). Other figures, representing his lineage, sit on a throne (Hieroglyphic Stairway) or on a glyph that names them (CPN 30) or is part of a sentence (step of Structure 11). In all these examples the emphasis is on continuity; that of ritual should be assured to permit the movement of the universe; dynastic continuity is expressed by the solar cycle (i.e., dawn always follows the setting sun) and by the parade of dead kings. Surely these two continuities go hand in hand: if dynastic succession is interrupted, ritual is as well, with all the catastrophic consequences that ensue.

Conclusion

The purpose of this study of the sculpture of Copán was first to analyze images in order to reveal their meaning in a well-defined historical and sociocultural unit. Emphasis was on content rather than on style and aesthetics. Monumental sculpture constitutes a homogeneous corpus: since it is unmovable, its provenience is controlled to a great extent; and, since many monuments are dated, most productions can be approximately anchored in time. It is also a homogeneous set, as far as function and destination are concerned, a public, official, and propaganda art. Combined with architecture, it acquires an additional dimension, revealing new meanings.

On Copán monuments text and image usually occupy separate spaces, and this reflects independence in content of both media of communication. Both focus on royalty, legitimacy of the ruler, and his duties as sacrificer. But in the more specific levels of content they are quite distinct and overlap little.

The first step of the analysis was to find out what the images represent. It is paramount correctly to identify and recognize the elements that compose the images and the way they are combined. Maya art is not an easy matter for the Western eye, and wrong identifications inevitably give way to wrong interpretations. In order to avoid these pitfalls and to let the reader know exactly what we see and do not see, I have described each image at length. Tedious as they may appear, these descriptions are as necessary a basis of further interpretation as hieroglyphic transcriptions for the epigrapher.

An important finding of this study is that with time monumental sculpture at Copán changes not only its technical and stylistic properties but also its message. While I have been able to point out significant changes in the use of symbols and signs, I have failed to reveal a correlation of these changes with political history. And this lack of correlation also applies to the introduction of new styles and forms of monumental sculpture. More research at Copán and in other Maya sites is required to further this approach.

Architecture, altars, and stelae have been very informative on the beliefs shared by the Maya of Copán during the late Classic period. Architecture and sculpture express cosmology through vertical and horizontal cosmograms. Cosmic serpents, most of the time provided with two heads, were used to define the sky and earth, as well as the sides of the universe. Emphasis was put on the earth and underworld, designated by a rich repertory of forms. The Maya of Copán participated in the Mesoamerican conception of the nocturnal journey of the sun through the underworld and of its rebirth at dawn, which required constant offerings of human blood.

Cosmology and the supernatural world are organized in accordance to a basic dualistic pattern, best exemplified by the cosmic monster with contrasting heads. The basic opposition is between life and death, at the same time opposed and complementary. The vegetative and nourishing earth, taking reptilian forms, is on the life side; on the death side is the nocturnal sun depicted as a feline. The supernaturals that seem to belong more to the category of spirits than of gods are composite creatures that can be divided into two sets: one reptilian, the other feline.

Creatures from both sets frequently appear associated with sacrificial implements or symbols. The importance of sacrifice is deduced from its ubiquity in the form of instru-

ments, symbols such as the knot, the rope, or the elements of the pseudo-Tlaloc complex, and as supernaturals acting as beneficiaries or patrons.

Some of the architectural configurations are not only cosmograms, but also stages used for the performance of ritual three-dimensional perambulations. They were performed to celebrate period-endings or more specialized rites of agrarian or ancestor cults.

A large portion of the iconography deals with the representations of the royal figure. Several aspects of the nature and function of kingship are revealed by the costume and the paraphernalia worn by the king as well as by the context that surrounds him. The king has a cosmic dimension, either when he identifies himself to a cosmic tree supporting the sky or when he is likened to the sun. He plays an important role in religion as great sacrificer and autosacrificer. It seems that his own blood and the blood of the victims he captured in war had a special sacred value. The king is also responsible for plant growth and agricultural wealth, according to his frequent disguise as a *bacab*, an old earthly creature. The ruler is rarely presented alone without the company of his ancestors. Their patronage strengthens his legitimacy; at the same time, the ancestors underline the royal functions and duties, especially in the realm of sacrificial rites.

In many instances, I have noted the high degree of inventiveness of the Copanec carver. No two monuments are alike, and many different forms can be used to convey the same meaning. As soon as he had the opportunity to do so, the artist created a new expression. He could not much develop his creative mind in certain domains rigidly defined by custom and etiquette such as the royal costume. He had much more freedom when dealing with cosmological matters. A concept such as earth could be rendered in many different ways, on varied levels of abstraction: from naturalistic forms to pure abstractions such as glyphs. The iconographic system of the Copanecs was highly flexible and able to express symbols in all their complexity. To represent the earth, the artist used different attributes according to how much he wanted to emphasize its positive or negative aspects. Motifs like the skull and vegetation expressed contradiction and complementarity; through visual means, emphasis on the skull or on the plants growing out of it reinforced the death or the life aspect of this image.

The Maya of Copán have developed the capacities of iconographic language to an extraordinary degree that expresses much better than writing the contradictions, complementarities, and ambiguities of human life; taking advantage of the extra space that their high-relief sculptural technique provided, they have left us a rich and varied iconic discourse that we have hardly begun to decipher.

APPENDIX I

Dedicatory Dates of Monuments Analyzed in This Study

	Riese's Datings		*Other Datings*
CPN 23			9.19.11.14.5 3 Chicchan 3 Uo (Grube and Schele 1987)
CPN 13	9.18.10.0.0	10 Ahau 8 Zac	
CPN 34	9.18.5.0.0	4 Ahau 13 Ceh	
CPN 14	9.18.5.0.0	4 Ahau 13 Ceh	
CPN 30	9.17.5.3.4	5 Kan 12 Uo	
CPN 33	9.17.12.5.17	4 Caban 10 Zip	
CPN 55	9.17.12.6.2	9 Ik 15 Zip	
CPN 4	9.17.12.0.0	4 Ahau 18 Muan	
CPN 101	9.17.5.9.4	8 Kan 12 Mol	
CPN 82	9.17.0.0.0	13 Ahau 18 Cumku	
CPN 37	9.17.0.0.0	13 Ahau 18 Cumku	
CPN 15	9.17.0.0.0	13 Ahau 18 Cumku	9.16.15.0.0 (Schele and Freidel 1990)
CPN 26	9.16.10.0.0	1 Ahau 3 Zip	
CPN 24	9.16.5.0.0	8 Ahau 8 Zodz	
CPN 7	9.15.5.0.0	10 Ahau 8 Ch'en	
CPN 1	9.15.0.3.0	12 Ahau 13 Mac	
CPN 43	9.15.0.0.0	4 Ahau 13 Yax	9.14.15.0.0 11 Ahau 13 Zac (Stuart 1986a)
CPN 3	9.15.0.0.0	4 Ahau 13 Yax	
CPN 16	9.14.19.5.0	4 Ahau 18 Muan	
CPN 11	9.14.10.0.0	5 Ahau 3 Mac	
CPN 20	9.13.10.0.0	7 Ahau 3 Cumku	
CPN 18	9.13.0.0.0	8 Ahau 8 Uo	9.12.5.0.0.0 3 Ahau 3 Xul (Schele 1987c)
CPN 52	9.12.10.0.0	9 Ahau 18 Zodz	
CPN 47	9.11.15.0.0	4 Ahau 13 Mol	
CPN 38	9.11.15.0.0	4 Ahau 13 Mol	
CPN 9	9.11.13.5.0	13 Ahau 18 Zec	9.5.0.0.0 11 Ahau 18 Zec (Schele 1987b)
CPN 40	9.11.0.0.0	12 Ahau 8 Ceh	
CPN 41	9.11.0.0.0	12 Ahau 8 Ceh	
CPN 62	9.11.0.0.0	12 Ahau 8 Ceh	
CPN 29	9.9.10.0.0	2 Ahau 13 Pop	
CPN 54	9.9.0.0.0	3 Ahau 3 Zodz	
CPN 48	9.8.12.7.18	11 Edznab 1 Kankin	
CPN 44	9.7.1.7.6	6 Cimi 19 Uo	9.6.9.4.6 7 Cimi 19 Uo (Schele and Grube 1987)

APPENDIX 2

Glyphic Elements in Copán Iconography

T2 (*ek*, star)
 On eyelid of live head of bicephalic monster
 CPN 13, Str. 9N-82 bench
 On both sides of front head of bicephalic monster
 CPN 25
 Above knees of sky monster
 Str. 22 inner door
 On scroll from ear of live head of sky monster
 Str. 22 inner door
 On waving element from ear of grotesque figure
 CPN 26 E
 On both handles of *tunkul*
 CPN 155
 On both sides of earth monster swallowing sun
 Str. 24 central block

T19
 Above head of jaguar
 CPN 33

T23
 Below eyes of *cauac* monsters
 CPN 3 N & S, CPN 4, CPN 8, CPN 25, Str. 22 corners
 Below eyes of jaguar mask
 CPN 34, CPN 18 (loincloth)
 Below "scribe-in-serpent-mouth" motif
 Str. 9N-82 façade
 On tinklers
 CPN 18
 Above wristlets
 CPN 54
 Inverted, as element of water frieze
 CPN 109, CPN 44

T24
 On tinklers below three belt masks
 CPN 3 W, CPN 4 W, CPN 9, CPN 29
 On tinklers below belt central mask
 CPN 40, CPN 47 E, CPN 54
 On belt side masks
 CPN 9, CPN 18, CPN 38
 On loincloth mask
 CPN 18
 On body of serpent used as ceremonial bar
 CPN 29, CPN 40
 On body of grotesque figures
 CPN 44, CPN 48
 On helmet sides
 CPN 47 E
 Above leaves sprouting from 9-Head emblem
 CPN 7 W

T27
 On body of serpent used as ceremonial bar
 CPN 40

T42 or T122
 On earplug
 CPN 8 S
 In eyes of serpents from bar and from wristlets
 CPN 26 N
 Variant in eyes of central and right headdress masks
 CPN 4 W
 In mouth of serpents
 CPN 28 E & W
 Presented as offering
 CPN 33 top
 As pectoral
 CPN 11 N
 Inverted, as lower element of earrings
 Str. 26 altar, CPN 8 S

T44
 Element of water frieze
 CPN 109 N, CPN 44

T58 (*zac*)
 At end of loincloth
 CPN 1, CPN 58
 At end of mat
 CPN 4 E
 At tip of upper jaw of serpent
 CPN 16 N & S, CPN 34
 Formed by intertwined serpents
 CPN 16 N & S
 Repeated on strip as lower jaw of serpents
 CPN 40
 As earring
 Ballcourt AII-b central marker
 On both sides of skull
 CPN 31
 Countless examples of braid-and-tassel motif (braid with T58 at both ends)
 CPN 9, CPN 18, CPN 29, etc.

T60 (knot)
 Crowning belt masks
 CPN 1 E, CPN 4 E, CPN 7 S, CPN 11, CPN 24, CPN 26 N & S, CPN 43, CPN 54
 Crowning belt central mask
 CPN 47 W
 Crowning jaguar Pax heads (top of stela)
 CPN 47 W
 Crowning head of diving jaguars
 CPN 12
 Crowning throne masks
 Str. 26, statues 1 & 2

T103
 On helmet sides
 CPN 18, CPN 41 N, CPN 47 W
 On strap circling helmet forehead
 CPN 18
 On tinklers
 CPN 41 N & S

T118
 In front of mouth of figures at ends of bar
 CPN 47 E
 In front of mouth of *bacabs*
 Str. 9N-82 bench

T122 (see T42)

T173 (zero)
 Hanging from serpent tails at level of ruler's head
 CPN 18
 On outer edge of branches, at top of stela
 CPN 40 S
 On jaguar skin skirt of ruler
 CPN 41 N & S
 In mouth of serpent from bar
 CPN 54

T188 (*le*)
 Part of water frieze
 CPN 110
 Accompanying undulating body of two-headed serpent
 Str. 11 upper step

T255 and other three-part vegetal motifs (e.g., T24, T124, T125, T241, T340)
 Generally associated with braid-and-tassel motif
 Underlines belt masks
 CPN 1, CPN 16 W, CPN 18,
 Underlines earrings
 CPN 9, CPN 18, CPN 40, CPN 41 N & S, CPN 47 E & W,
 Frames anklets
 CPN 9
 Below mask and false apron
 CPN 16 E
 Below crossed bands, part of chin mask
 CPN 29
 At end of serpent bar held by ancestors
 CPN 47 E
 With *cimi* pectoral on figure no. 7
 Str. 22 inner door

T281 (*kan* cross)
 On eyelid of bicephalic serpent
 CPN 4 W
 On serpent body
 CPN 24 S
 On 7-Head emblem
 CPN 7 E
 As an offering
 CPN 33 top
 On ear ornament of left pseudo-Tlaloc in serpent bar
 CPN 52
 On ball, suffixed by T116, associated with T528
 Ball Court AII-b central marker
 On bird wings
 Str. 26 altar
 Part of façade decoration, alternating with skulls
 Str. 16
 Part of tassel on back of *bacab*
 Str. 22 inner door

Half *kan*-cross on forehead of death Atlantean figures
 Str. 9 M-146
In headdress
 Ball Court AII-b south marker

T501 (*imix*)
On forehead of mask or helmet
 CPN 1, CPN 38, CPN 47 E
On forehead of 7-Head
 Str. 18 corners
Crowning headdress
 CPN 33
On T-shaped teeth of *cauac* mask
 CPN 20 W
On forehead of mask
 CPN 37
On knotted-serpent
 CPN 41 S
In eyes of serpents from which ancestors emerge
 CPN 47 E
On pectoral of figures presenting offerings
 Str. 11 fallen step
As pedestal under ruler's feet
 Str. 18, SE jamb
On forehead of crocodile used as seat
 CPN 489 bench support

T503 (*ik*)
T-shaped platform on which monuments stand
 CPN 7–8
T-shaped central block of stairway
 Str. 16
T-shaped niches in front room
 Str. 18
Inverted T-shaped niches in funerary chamber
 Str. 18
Infixed in T58, at tip of serpents' upper jaws
 CPN 16 N & S, CPN 34
On rattles held by lateral figures on stairs
 Str. 12
Repeated on turban and on fringe of cape in figure 2b
 CPN 33

T504 (*akbal*)
On leg wrapping of bicephalic monster
 CPN 8 N
On knife-tongue of serpent
 CPN 41 N

T509 (*cimi*)
On ear ornaments of belt masks
 CPN 41 S, CPN 47 W

In headdress of rear head of sky monster
 Str. 22 inner door
On pectoral (with 255) of grotesque no. 7
 Str. 22 inner door
On loincloth of reclining figure no. 4
 Str. 26 stairway
Part of tripartite emblem on rear head of monster
 Str. 9N-82 bench

T511 (*muluc*)
On pectoral
 CPN 7 E & W, CPN 11 S, CPN 16 S
Associated with T2 on scroll from ear of live head of monster
 Str. 22 inner door

T517
On forehead of loincloth mask
 CPN 41 N

T524 (*ix*)
Three circlets on shields
 CPN 1 E, CPN 54
Three black dots on shields
 CPN 18
Three circlets on bird tongue
 CPN 16 E, CPN 18

T526 (*caban*)
In angular strips at base of stela
 CPN 7 E & W
On water lily blossom
 CPN 1, CPN 41
Repeated several times
 Str. 11 med. step
On one of heads of bicephalic monster
 Str. 11 step door N
Associated with *cauac* element (grape)
 CPN 64
In full-figure forms presenting offerings
 CPN 33

T527 (*edznab*)
On tinklers
 CPN 18

T528 (*cauac*)
As tooth of cauac monster
 CPN 4 E, Str. 22 ext. door
As seat of figure 2a
 CPN 33
On ball, together with T281
 Ball Court AII-b central marker

T528 Elements
1. Curves edged with dots
 a. To indicate *cauac* monster
 On reptilian monsters
 CPN 25, Str. 18 bench, CPN 101

On eyes of live head of bicephalic monster
CPN 8 N
b. To indicate stone
On eccentric heads from bar
CPN 1, CPN 11, CPN 16, CPN 18
On heads from bar
CPN 18, CPN 9
On belt masks
CPN 18
On tinklers
CPN 9, CPN 24
On Thunderer's forehead
CPN 24
On tongues
CPN 41, CPN 47 E, CPN 52
On forehead of masks or helmets
CPN 40, CPN 34, CPN 38, CPN 47 W, CPN 41 S
2. "Grape"
a. To indicate *cauac* monster or earthly origin
On reptilian monsters' face and body
CPN 3 E, N, S, W, CPN 25, CPN 20 W, CPN 8 N, CPN 26 E & W, Str. 18 bench, CPN 82, CPN 101, Str. 26 ramps
On bat or jaguar figures
CPN 27
Associated with *caban*
CPN 64
b. To indicate stone
On the forehead of masks
CPN 40, CPN 9
On tongue or whistongue
CPN 3 E, Str. 24 stair block

T533 (*ahau*)
In the eyes of the jaguar
CPN 34
On top of human mask, at top of stela
CPN 41 S
With T2 above knees of sky monster
Str. 22 inner door

T535 (decorated *ahau*)
At tip of tail of diving jaguars
CPN 12
At tip of tail of serpents
CPN 28
At end of rope held by young *bacab*
Str. 9N-82 bench
Above crocodile heads
CPN 26 N

T544 (*kin*)
a. Associated with three-part emblem (shell /crossed bands/spine)
CPN 16 E, CPN 25, CPN 18, Str. 22

inner door, CPN 47 W, Ballcourt AII-b markers, Str. 9N-82 bench, CPN 82
b. Alone
On eyes of dead head of bicephalic monster
CPN 8 S
On eyes of jaguar mask with *ahau*
CPN 34
In eye of crocodile below right-profile figure no. 1
CPN 33
On heads from serpent bar and from ends of staff
CPN 1
On forehead and temples of jaguar helmet
CPN 47
At center of composition
CPN 48
On small sides of *tunkul*
CPN 155

T552 (crossed-bands)
On belt
CPN 18, CPN 24, CPN 26 N, CPN 47 W, CPN 41 N & S, CPN 60
On wristlets and anklets
CPN 18, CPN 9, CPN 41 N
On loincloth
CPN 34, Str. 26 prone fig. no. 2
On tongue
CPN 4 W, CPN 4 E, CPN 26 N (whistongue)
On forehead of bird mask forming wristlets of crocodile
CPN 4 E
Replacing lower jaw of serpent
CPN 18, CPN 26 S, CPN 29
On back of jaguar's headdress
CPN 21
On eye of earth monster or front head of bicephalic monsters
CPN 26 S, CPN 82, CPN 33
On pectoral
Str. 26 prone figure no. 4
On serpent wing of figure no. 4b
CPN 33

T561 (sky)
On tinklers under belt side masks
CPN 4 W

T611
Presented as offering by Thunderer
Str. 11 fallen step

T614a
 Façade
 Str. 18
 Headdress of scribe statue
 Str. 9N-82

T615
 On belt
 CPN 11, CPN 43
 On pectoral
 CPN 41 S

T616b
 On tinklers
 CPN 1, CPN 3 E, CPN 4 E, CPN 7, CPN 26, CPN 47 E
 On forehead of jaguar mask or helmet
 CPN 4 E, CPN 82, Str. 18 bench, Str. 26 statue no. 6
 On forehead of bird mask or helmet
 CPN 4 E, CPN 16 W & E
 On forehead of belt masks
 CPN 16 W
 On forehead of medallions type B
 Str. 18 roof
 Inverted and blackened on forehead of skeletal head
 CPN 8 S
 On forehead of mask covering face of ruler
 CPN 7
 On forehead or thighs of grotesque figure
 CPN 13 N, CPN 34, Str. 22 inner door
 On forehead or leg of Thunderer
 CPN 16 N, CPN 101
 On leg of toad
 CPN 101
 On serpent bar held by ancestors
 CPN 4 W top

T617a
 On forehead of jaguar masks or heads
 CPN 47 W, CPN 12, CPN 18, CPN 41 S & N, CPN 43, Ball Court AII-b north marker
 On forehead of creature in skeletal head of monster
 CPN 13
 On forehead of Thunderer
 CPN 43
 On helmet of human from serpent bar
 CPN 47 W
 On tongue of jaguar mask on belt
 CPN 18
 On tongue of inverted lancet on ruler's loincloth
 CPN 7 S
 On lancet held by grotesque with bat head
 CPN 7 E
 On eyelid of serpent
 CPN 41 N
 On tinklers
 CPN 24, CPN 26 N & S

T628
 As skeletal lower jaw of serpent
 CPN 24, CPN 26, CPN 34
 On whistongue, on both sides of top
 CPN 47 E

T629
 On forehead of 9-Head emblem
 CPN 7 W

T632 (S design)
 In medallion atop head of grotesque figure
 CPN 7 W

T635 (2 circles)
 On eccentric heads
 CPN 1, CPN 11 N & S
 On head of *kin* figure
 CPN 7 N
 On tongue of belt mask
 CPN 4 W
 On whistongue
 CPN 3 E
 On loincloth
 CPN 1

T696
 1. Alone
 On crocodile head, above nose
 CPN 4 E
 2. With T526 infixed
 In mouth of serpent
 CPN 1, CPN 41 N, Str. 18 up. façade

T713a (hand)
 As lower jaw of grotesque figure
 CPN 4 E, CPN 41 S, Ball Court AII-b central marker
 Replaces *kin* on rear head of bicephalic monster
 Str. 9N-82 bench

T741
 As helmet of belt side masks
 CPN 41 N

T824
 On points radiating from shields
 CPN 29
 On feathers(?) in headdress of human or grotesque
 CPN 34

T1011
 Mask worn by main figure
 CPN 18

T1013
 Heads from ceremonial bar
 CPN 9

References

Andrews, E. Wyllys, IV, and E. Wyllys Andrews V
 1980 *Excavations at Dzibilchaltun, Yucatan, Mexico.* Middle American Research Institute Publication 48. New Orleans: Tulane University.

Aveni, Anthony F.
 1990 Rejoinder to Baudez. Manuscript in possession of the author.

Bardawil, Lawrence W.
 1976 The Principal Bird Deity in Maya Art: An Iconographic Study of Form and Meaning. In *The Art, Iconography and Dynastic History of Palenque: The Proceedings of the Segunda Mesa Redonda de Palenque,* edited by Merle Greene Robertson, pp. 195–209. Pebble Beach, Calif.: Robert Louis Stevenson School.

Barrera Vasquez, Alfredo
 1980 *Diccionario Maya-Cordemex.* Mérida, Mexico: Ediciones Cordemex.

Baudez, Claude-François
 1984 Le roi, la balle et le maïs. Images du jeu de balle Maya. *Journal de la Société des Américanistes* 70:139–51.
 1985a The Knife and the Lancet: The Iconography of Sacrifice at Copán. In *Fourth Palenque Round Table, 1980,* edited by Elizabeth Benson, pp. 203–10. San Francisco: Pre-Columbian Art Reserach Institute.
 1985b The Sun Kings at Copan and Quirigua. *Fifth Palenque Round Table, 1983,* edited by Virginia M. Fields, pp. 29–38. San Francisco: Pre-Columbian Art Research Institute.
 1986 Iconography and History at Copan. In *The Southeast Maya Periphery,* edited by Patricia A. Urban and Edward M. Shortman, pp. 17–26. Austin: University of Texas Press.
 1987 Archaeoastronomy at Copan: An Appraisal. *Indiana* 11:63–72.
 1988 Solar Cycle and Dynastic Succession in the Southeast Maya Zone. In *The Southeast Classic Maya Zone,* edited by Elizabeth H. Boone and Gordon R. Willey, pp. 125–48. Washington, D.C.: Dumbarton Oaks.
 1989 The House of the Bacabs: An Iconographic Analysis. In *The House of the Bacabs, Copan, Honduras,* edited by David Webster, pp. 73–81. Studies in Pre-Columbian Art and Archaeology no. 29. Washington, D.C.: Dumbarton Oaks.
 1991 The Cross Pattern at Copan: Forms, Rituals and Meanings. *Sixth Palenque Round Table, 1986,* edited by Merle Greene Robertson, pp. 81–88. Norman: University of Oklahoma Press.
 1992 The Maya Snake Dance: Ritual and Cosmology. *Res* 21:37–52.

Baudez, Claude-François, ed.
 1983 *Introducción a la arqueología de Copán.* 3 vols. Tegucigalpa: Secretaría de Estado en el Despacho de Cultura y Turismo.

Baudez, Claude-François, and Anne Dowd
 1983 La decoración del templo [10L-18]. In *Introducción a la arqueología de Copán,* edited by Claude-François Baudez, vol. 2, pp. 447–73. Tegucigalpa: Secretaría de Estado en el Despacho de Cultura y Turismo.

Baudez, Claude-François, and Berthold Riese
 1990 The sculpture from Copán. Microfilm Collection of Manuscripts on Cultural

Anthropology no. 381, series 73. Chicago: University of Chicago Library.

Becker, Marshall Joseph, Charles D. Cheek, Claude-François Baudez, Anne S. Dowd, and Berthold Riese
1983 La estructura 10L-18. In *Introducción a la arqueología de Copán*, edited by Claude-François Baudez, vol. 2, pp. 381–500. Tegucigalpa: Secretaría de Estado en el Despacho de Cultura y Turismo.

Becquelin, Pierre, and Claude-François Baudez
1979– *Tonina, une cité maya du Chiapas*. 4
82 vols. Collection Etudes Mésoaméricaines no. 6:3. Editions Recherche sur les Civilisations. Paris and Mexico City: Mission-Archéologique et Ethnologique Française au Mexique.

Beetz, Carl, and Linton Satterthwaite, Jr.
1981 *The Monuments and Inscriptions of Caracol, Belize*. University Museum Monographs no. 45. Philadelphia: University Museum, University of Pennsylvania.

Benson, Elizabeth P.
1978 Observations on Certain Visual Elements in Late Classic Maya Sculpture. In *Tercera Mesa Redonda de Palenque*, edited by Merle Greene Robertson and Donnan C. Jeffers, pp. 91–97. Monterey: Pre-Columbian Art Research Center.
1982 Symbolic Objects in Maya Art. *Mexicon* 4(3):45–47.

Berlo, Janet C.
1989 Early Writing in Central Mexico: *In Tlilli, In Tlapalli* before A.D. 1000. In *Mesoamerica after the Decline of Teotihuacan A.D. 700–900*, edited by Richard Diehl and Janet C. Berlo, pp. 19–47. Washington, D.C.: Dumbarton Oaks.

Brinton, D. G.
1882 *American Hero Myths: A Study in the Native Religions of the Western Continent*. Philadelphia.
1895 *A Primer of Mayan Hieroglyphics*. University of Pennsylvania Series in Philology, Literature and Archaeology 3, no. 2. Philadelphia.

Catherwood, Frederick
1844 *Views of Ancient Monuments in Central America, Chiapas and Yucatan*. London. Reprint: Barre, Mass., 1966.

Cheek, Charles D.
1983a Introducción a las operaciones en la plaza principal. In *Introducción a la Arqueología de Copán*, edited by Claude-François Baudez, vol. 2, pp. 11–24. Tegucigalpa: Secretaría de Estado en el Despacho de Cultura y Turismo.
1983b Excavaciones en la plaza principal. In *Introducción a la arqueología de Copán*, edited by Claude-François Baudez, vol. 2, pp. 191–290. Tegucigalpa: Secretaría de Estado en el Despacho de Cultura y Turismo.
1983c Las excavaciones en la plaza principal, resumen y conclusiones. In *Introducción a la arqueología de Copán*, edited by Claude-François Baudez, vol. 2, pp. 319–48. Tegucigalpa: Secretaría de Estado en el Despacho de Cultura y Turismo.

Cheek, Charles D., and Verónica Kennedy Embree
1983 La estructura 10L-2. In *Introducción a la arqueología de Copán*, edited by Claude-François Baudez, vol. 2, pp. 93–142. Tegucigalpa: Secretaría de Estado en el Despacho de Cultura y Turismo.

Cheek, Charles D., and Daniel Milla Villeda
1983 La estructura 10L-4. In *Introducción a la arqueología de Copán*, edited by Claude-François Baudez, vol. 2, pp. 37–92. Tegucigalpa: Secretaría de Estado en el Despacho de Cultura y Turismo.

Clancy, Flora
1976 Maya Pedestal Stones. *New Mexico Studies in the Fine Arts I* 1:10–19. Albuquerque: University of New Mexico Press.

Closs, Michael P., Anthony F. Aveni, and Bruce Crowley
1984 The Planet Venus and Temple 22 at Copán. *Indiana* 9:221–48.

Coe, Michael D.
1973 *The Maya Scribe and His world*. New York: Grolier Club.
1978 *Lords of the Underworld*. Princeton, N.J.: Princeton University Press.

Coggins, Clemency
1980 The Shape of Time: Some Political Implications of a Four-Part Figure. *American Antiquity* 45:727–39.
1983 *The Stucco Decoration and Architectural Assemblage of Structure 1-sub, Dzibilchaltun, Yucatan, Mexico*. Mid-

dle American Research Institute Publication no. 49. New Orleans: Tulane University.

Davoust, Michel
- 1976 *Etude épigraphique 1: Les chefs mayas de Copán, Palenque et un ancien glyphe emblème.* Angers. Mimeo.
- 1978 *Etude épigraphique 3: Les glyphes nominaux individuels et titres des chefs Mayas.* Angers. Mimeo.
- 1979 Glyphes nominaux des chefs mayas de Copan. *42è Congrès International des Américanistes* 7:221–37.

Dieseldorff, Erwin Paul
- 1930 Kunst und Religion der Mayavölker im alten und heutigen Mittelamerika II. Die Copaner Denkmäler. *Zeitschrift für Ethnologie* 62:1–44.

Fash, William L.
- 1989 The Sculptural Façade of Structure 9N-82: Content, Form and Significance. In *The House of the Bacabs, Copan, Honduras*, edited by David Webster. Studies in Pre-Columbian Art and Archaeology no. 29. Washington, D.C.: Dumbarton Oaks.
- 1991 *Scribes, Warriors and Kings: The City of Copán and the Ancient Maya.* London: Thames and Hudson.

Fuentes y Guzmán, Francisco Antonio de
- 1882 *Recordación florida: Discurso historial y demostración natural, material, militar y política del reyno de Guatemala.* Guatemala: Biblioteca "Goathemala."

Furst, Peter T.
- 1976 Fertility, Vision Quest and Auto-Sacrifice: Some Thoughts on Ritual Blood-Letting among the Maya. *The Art, Iconography and Dynastic History of Palenque: Segunda Mesa Redonda de Palenque*, edited by Merle Greene Robertson, pp. 18–93. Pebble Beach, Calif.: Robert Louis Stevenson School.

Galindo, Juan
- 1920 A Description of the Ruins of Copan by Juan Galindo in 1834. In *The Inscriptions at Copan*, Publication no. 219, edited by Sylvanus Griswold Morley, pp. 593–603. Washington, D.C.: Carnegie Institution of Washington.

García de Palacio, Diego
- 1840 A Description of the Ruins of Copan. In *The Inscriptions at Copan*, Publication no. 219, edited by Sylvanus Griswold Morley. Washington, D.C.: Carnegie Institution of Washington.

Gordon, George Byron
- 1896 *Prehistoric Ruins of Copan, Honduras. A Preliminary Report of the Explorations by the Museum 1891–1895.* Memoirs of the Peabody Museum of American Archaeology and Ethnology 1, no. 1. Cambridge, Mass.: Harvard University.
- 1898 *Caverns of Copan.* Memoirs of the Peabody Museum of American Archaeology and Ethnology 1, no. 5. Cambridge, Mass.: Harvard University.
- 1902 *The Hieroglyphic Stairway, Ruins of Copan. Report on Explorations by the Museum.* Memoirs of the Peabody Museum of American Archaeology and Ethnology 1, no. 6. Cambridge, Mass.: Harvard University.

Graham, Ian
- 1967 *Archaeological Explorations in El Peten, Guatemala.* Middle American Research Institute Publication 33. New Orleans: Tulane University.
- 1975 *Corpus of Maya Hieroglyphic Inscriptions. Vol. 1: Introduction to the Corpus.* Cambridge, Mass.: Peabody Museum of Archaeology and Ethnology, Harvard Unversity.

Greene Robertson, Merle
- 1974 The Quadripartite Badge—a Badge of Rulership.In *Primera Mesa Redonda de Palenque, Part 1*, edited by Merle Greene Robertson, pp. 77–93. Pebble Beach, Calif.: Robert Louis Stevenson School.

Grube, Nikolai, and Linda Schele
- 1987 *U Cit Tok, the Last King of Copán.* Copán Note 21. Copán, Honduras: Copán Mosaics Project and the Instituto Hondureño de Antropología e Historia.

Grube, Nikolai, Linda Schele, David Stuart, and William Fash
- 1989 *The Date of Dedication of Ballcourt III at Copán.* Copán Note 59. Copán, Honduras: Copán Mosaics Project and the Instituto Hondureño de Antropología e Historia.

Hellmuth, Nicholas M.
- 1987 *Monster und Menschen in der Maya-Kunst. Eine Ikonographie der alten*

Religionen Mexikos und Guatemalas. Graz: Akademische Druck-und Verlagsanstalt.

Hohmann, Hasso, and Annegrete Vogrin
1982 *Die Architektur von Copan (Honduras).* 2 vols. Graz: Akademische Druck- und Verlagsanstalt.

Jones, Christopher
1969 *The Twin-Pyramid Group Pattern: A Classic Maya Architectural Assemblage at Tikal, Guatemala.* Ph.D. dissertation, University of Pennsylvania, Philadelphia. University Microfilms no. 69-21,375, Ann Arbor.

Jones, Christopher, and Linton Satterthwaite, Jr.
1982 *The Monuments and Inscriptions of Tikal: The Carved Monuments.* Tikal Reports no. 33A/University Museum Monographs no. 44. Philadelphia: University Museum, University of Pennsylvania.

Joralemon, David
1974 Ritual Blood-Sacrifice among the Ancient Maya: Part I. In *Primera Mesa Redonda de Palenque, Part 2*, edited by Merle Greene Robertson, pp. 59–75. Pebble Beach, Calif.: Robert Louis Stevenson School.

Justeson, John S., and Mathews, Peter
1983 The Seating of the Tun: Further Evidence Concerning a Late Preclassic Lowland Maya Stela Cult. *American Antiquity* 48(3): 586–93.

Kelley, David Humiston
1962 Glyphic Evidence for a Dynastic Sequence at Quirigua, Guatemala. *American Antiquity* 27(3): 323–35.
1976 *Deciphering the Maya Script.* Austin: University of Texas Press.

Knorosov, Yuri V.
1952 Drevniaia pis'mennost' Tsentral'noi Ameriki. *Sovietskaya Etnografiya* 3(2): 100–18.

Kubler, George
1969 *Studies in Classic Maya Iconography.* Memoir no. 17. New Haven: Connecticut Academy of Arts and Sciences.
1977 *Aspects of Classic Maya Rulership on Two Inscribed Vessels.* Studies in Pre-Columbian Art and Archaeology 18. Washington, D.C.: Dumbarton Oaks.

Lizana, Bernardo de
1893 *Historia de Yucatán. Devocionario de Nuestra Señora de Izamal y Conquista Espiritual.* México.

Longyear, John Munro, III
1952 *Copan Ceramics: A Study of Southeastern Maya Pottery.* Publication no. 597. Washington, D.C.: Carnegie Institution of Washington.

Lounsbury, Floyd
1973 On the derivation and reading of the "ben-ich" prefix. In *Mesoamerican Writing Systems*, edited by Elizabeth Benson, pp. 99–143. Washington, D.C.: Dumbarton Oaks.

Maler, Teobert
1901–03 *Researches in the Central Portion of the Usumatsintla Valley.* Memoirs of the Peabody Museum of American Archaeology and Ethnology 2, nos. 1,2. Cambridge, Mass.: Harvard University
1908 *Explorations of the Upper Usumatsintla, and Adjacent Region.* Memoirs of the Peabody Museum of American Archaeology and Ethnology 4, no. 1. Cambridge, Mass.: Harvard University.

Maudslay, Alfred Percival
1889–1902 Archaeology. In *Biologia Centrali-Americana.* 4 vols. London: Porter and Dulau.

Miller, Jeffrey
1974 Notes on a Stela Pair, Probably from Calakmul, Campeche, Mexico. In *Primera Mesa Redonda de Palenque, Part 1*, edited by Merle Greene Robertson, pp. 149–61. Pebble Beach, Calif.: Robert Louis Stevenson School.

Miller, Mary Ellen
1986 *The Murals of Bonampak.* Princeton, N.J.: Princeton University Press.
1988 The Meaning and Function of the Main Acropolis, Copan. In *The Southeast Classic Maya Zone*, edited by Elizabeth Boone and Gordon Willey. Washington, D.C.: Dumbarton Oaks.

Morley, Sylvanus Griswold
1920 *The Inscriptions at Copan.* Publication no. 219. Washington, D.C.: Carnegie Institution of Washington.

Núñez Chinchilla, Jesús
1962 *Las ruinas de Copán: Guía completa de la gran ciudad Maya.* Tegucigalpa: Banco Central de Honduras.

Parsons, Lee Allen
1981 Post-Olmec Stone Sculpture: The

Olmec-Izapan Transition on the Southern Pacific Coast and Highlands. In *The Olmec and Their Neighbors: Essays in Memory of Mathew W. Stirling*, edited by Michael D. Coe, David Grove, and Elizabeth P. Benson, pp. 257–88. Washington, D.C.: Dumbarton Oaks.

1986 *The Origins of Maya Art: Monumental Stone Sculpture of Kaminaljuyu, Guatemala, and The Southern Pacific Coast*. Studies in Pre-Columbian Art and Archaeology no. 28. Washington, D.C.: Dumbarton Oaks.

Pasztory, Esther

1974 *The Iconography of the Teotihuacan Tlaloc*. Studies in Pre-Columbian Art and Architecture no. 15. Washington, D.C.: Dumbarton Oaks.

Proskouriakoff, Tatiana

1946 *An Album of Maya Architecture*. Publication no. 558. Washington, D.C.: Carnegie Institution of Washington.

1950 *A Study of Classic Maya Sculpture*. Publication no. 593. Washington, D.C.: Carnegie Institution of Washington.

1960 Historical Implications of a Pattern of Dates at Piedras Negras, Guatemala. *American Antiquity* 25(4): 454–75.

1961 Portraits of Women in Maya Art. In *Essays in Pre-Columbian Art and Archaeology*, edited by Samuel K. Lothrop et al., pp. 81–99. Cambridge, Mass.

1963– Historical Data in the Inscriptions of
64 Yaxchilan. Part 1. *Estudios de Cultura Maya* 3:149–67. Part 2. *Estudios de Cultura Maya* 4:177–201. Mexico City: Universidad Nacional Autónoma de México.

1965 Sculpture and Major Arts of the Maya Lowlands. In *Handbook of Middle American Indians*, vol. 2, pp. 469–97. Austin: University of Texas Press.

1971 Early Architecture and Sculpture in Mesoamerica. In *Observations on the Emergence of Civilization in Mesoamerica*, edited by Robert F. Heizer and John A. Graham with the assistance of C. W. Clewlow, pp. 141–56. University of California Archaeological Research Facility no. 11. Berkeley: University of California Press.

1973 The Hand-Grasping-Fish and Associated Glyphs on Classic Maya Monuments. In *Mesoamerican Writing Systems*, edited by Elizabeth Benson, pp. 165–78. Washington, D.C.: Dumbarton Oaks.

Rands, Robert

1955 *Some Manifestations of Water in Mesoamerican Art*. Bureau of American Ethnology Bulletin 157: 265–393. Washington, D.C.: Smithsonian Institution.

Reents-Budet, Dorie

1991 The "Holmul Dancer" Theme in Maya Art. In *Sixth Palenque Round Table, 1986*, edited by Merle Greene Robertson, pp. 217–22. Norman: University of Oklahoma Press.

Richardson, Francis B.

1940 Non-Maya Monumental Sculpture of Central America. In *The Maya and Their Neighbors*, pp. 395–416. New York: Appleton-Century.

Riese, Berthold

1984 Relaciones clásico-tardías entre Copán y Quiriguá. Algunas evidencias epigráficas. *Yaxkin* 7(1): 23–30. English translation in *The Southeast Maya Periphery*, edited by Patricia Urban and Edward M. Shortman, pp. 94–101. Austin: University of Texas Press, 1986.

1988 Epigraphy of the Southeast Zone in Relation to Other Parts of the Maya Realm. In *The Southeast Classic Maya Zone*, edited by Elizabeth Hill Boone and Gordon R. Willey, pp. 67–94. Washington, D.C.: Dumbarton Oaks.

Riese, Berthold, and Claude-François Baudez

1983 Esculturas de las estructuras 10L-2 y 4. In *Introducción a la arqueología de Copán*, edited by Claude F. Baudez, vol. 2, pp. 143–90. Tegucigalpa: Secretaría de Estado en el Despacho de Cultura y Turismo.

Robicsek, Francis, and Donald Hales

1981 *The Maya Book of the Dead: The Ceramic Codex—the Corpus of the Codex Style Ceramics of the Late Classic Period*. Norman: University of Oklahoma Press.

Schele, Linda

1974 Observations on the Cross Motif at Palenque. In *Primera Mesa Redonda de Palenque, Part 1*, edited by Merle

	Greene Robertson, pp. 41–61. Pebble Beach, Calif.: Robert Louis Stevenson School.
1978	Genealogical Documentation on the Tri-Figure Panels at Palenque. In *Tercera Mesa Redonda de Palenque*, edited by Merle Greene Robertson, pp. 41–70. Monterey: Pre-Columbian Art Research Center.
1984	Human Sacrifice among the Classic Maya. In *Ritual Human Sacrifice in Mesoamerica: A Conference at Dumbarton Oaks*, edited by Elizabeth Benson, pp. 6–48. Washington, D.C.: Dumbarton Oaks.
1985	*The Inscription on Stela 5 and Its Altar*. Copán Note 31. Copán, Honduras: Copán Mosaics Project and the Instituto Hondureño de Antropología e Historia.
1986a	*The Founders of Lineages at Copán and Other Maya Sites*. Copán Note 8. Copán, Honduras: Copán Mosaics Project and the Instituto Hondureño de Antropología e Historia.
1986b	*The Figures on the Central Ballcourt Marker of Ballcourt IIa at Copán*. Copán Note 13. Copán, Honduras: Copán Mosaics Project and the Instituto Hondureño de Antropología e Historia.
1987a	*The Protagonist and Dating of Stela E*. Copán Note 25. Copán, Honduras: Copán Mosaics Project and the Instituto Hondureño de Antropología e Historia.
1987b	*New Data on the Paddlers from Butz'-Chaan of Copán*. Copán Note 29. Copán, Honduras: Copán Mosaics Project and the Instituto Hondureño de Antropología e Historia.
1987c	*Stela I and the Founding of the City of Copán*. Copán Note 30. Copán, Honduras: Copán Mosaics Project and the Instituto Hondureño de Antropología e Historia.
1987d	*The Reviewing Stand of Temple 11*. Copán Note 32. Copán, Honduras: Copán Mosaics Project and the Instituto Hondureño de Antropología e Historia.
1987e	*Two Altar Names at Copán*. Copán Note 36. Copán, Honduras: Copán Mosaics Project and the Instituto Hondureño de Antropología e Historia.
1988	*Revisions to the Dynastic Chronology of Copán*. Copán Note 45. Copán, Honduras: Copán Mosaics Project and the Instituto Hondureño de Antropología e Historia.
1989a	*A House Dedication on the Harvard Bench at Copán*. Copán Note 51. Copán, Honduras: Copán Mosaics Project and the Instituto Hondureño de Antropología e Historia.
1989b	*A Brief Commentary on the Top of Altar Q*. Copán Note 66. Copán, Honduras: Copán Mosaics Project and the Instituto Hondureño de Antropología e Historia.

Schele, Linda, and David Freidel
1990	*A Forest of Kings: The Untold Story of the Ancient Maya*. New York: William Morrow.

Schele, Linda, and Nikolai Grube
1987	*The Birth Monument of Butz'-Chaan*. Copán Note 22. Copán, Honduras: Copán Mosaics Project and the Instituto Hondureño de Antropología e Historia.
1988	*The Father of Smoke-Shell*. Copán Note 39. Copán, Honduras: Copán Mosaics Project and the Instituto Hondureño de Antropología e Historia.
1990	*The Glyph for Plaza or Court*. Copán Note 86. Copán, Honduras: Copán Mosaics Project and the Instituto Hondureño de Antropología e Historia.

Schele, Linda, and Jeffrey H. Miller
1983	*The Mirror, the Rabbit and the Bundle: "Accession" Expressions from the Classic Maya Inscriptions*. Studies in Pre-Columbian Art and Archaeology no. 25. Washington, D.C.: Dumbarton Oaks.

Schele, Linda, and Mary Ellen Miller
1986	*The Blood of Kings: Dynasty and Ritual in Maya Art*. Fort Worth: Kimbell Art Museum.

Schele, Linda, David Stuart, and Nikolai Grube
1989	*A Commentary on the Restoration and Reading of the Glyphic Panels from Temple 11*. Copán Note 64. Copán, Honduras: Copán Mosaics Project and the Instituto Hondureño de Antropología e Historia.

1991 *A Commentary on the Inscriptions of Structure 10L-22A at Copán.* Copán Note 98. Copán, Honduras: Copán Mosaics Project and the Instituto Hondureño de Antropología e Historia.

Schellhas, Paul
1903 *Die Göttergestalten der Mayahandschriften.* Berlin.

Seler, Edward
1902–23 *Gesammelte Abhandlungen zur amerikanischen Sprach-und Alterthumskunde.* 6 vols. Berlin.
1904–09 *Codex Borgia, eine altmexikanische Bildershrift der Bibliothek der Congregatio de Propaganda Fide.* 3 vols. Berlin: Loubat/Unger.

Spinden, Herbert Joseph
1913 *A Study of Maya Art, Its Subject Matter and Historical Development.* Memoirs of the Peabody Museum of American Archaeology and Ethnology no. 6. Cambridge, Mass.: Harvard University.
1924 *The Reduction of Mayan Dates.* Papers of the Peabody Museum of Archaeology and Ethnology 6, no. 4. Cambridge, Mass.: Harvard University.

Stephens, John Lloyd
1854 *Incidents of Travel in Central America, Chiapas and Yucatan.* 2 vols. London: Arthur Hall, Virtue and Co.

Stone, Andrea
1989 Disconnection, Foreign Insignia, and Political Expansion: Teotihuacan and the Warrior Stelae of Piedras Negras. In *Mesoamerica after the Decline of Teotihuacan A.D. 700–900,* edited by Richard Diehl and Janet C. Berlo, pp. 153–72. Washington D.C.: Dumbarton Oaks.

Strömsvik, Gustav
1941 *Substela Caches and Stela Foundations at Copan and Quirigua.* Contribution to American Anthropology and History no. 37/Publication 528. Washington, D.C.: Carnegie Institution of Washington.
1947 *Guide Book to the Ruins of Copan.* Publication 577. Washington, D.C.: Carnegie Institution of Washington.
1952 *The Ball Courts at Copan, with Notes on Courts at La Unión, Quirigua, San Pedro Pinula and Asunción Mita.* Contribution to American Anthropology and History no. 55/Publication 596, pp. 183–214. Washington, D.C.: Carnegie Institution of Washington.

Stuart, David
1986a *The Hieroglyphic Name of Altar U.* Copán Note 4. Copán, Honduras: Copán Mosaics Project and the Instituto Hondureño de Antropología e Historia.
1986b *The Chronology of Stela 4 at Copán.* Copán Note 12. Copán, Honduras: Copán Mosaics Project and the Instituto Hondureño de Antropología e Historia.
1987 Ten Phonetic Syllables. In *Research Reports on Ancient Maya Writing 14.* Washington, D.C.: Center for Maya Research.
1988 Blood Symbolism in Maya Iconography. In *Maya Iconography,* edited by Elizabeth Benson and Gillett Griffin, pp. 175–221. Princeton, N.J.: Princeton University Press.
1989 *Comments on the Temple 22 Inscription.* Copán Note 63. Copán, Honduras: Copán Mosaics Project and the Instituto Hondureño de Antropología e Historia.

Taylor, Dicey
1978 The Cauac Monster. In *Tercera Mesa Redonda de Palenque,* edited by Merle Greene Robertson, pp. 79–89. Monterey: Pre-Columbian Art Research Center.

Tedlock, Dennis
1985 *Popol Vuh: The Mayan Book of the Dawn of Life.* New York: Simon and Schuster.

Teeple, John Edgar
1930 *Maya Astronomy.* Contributions to American Anthropology and History no. 2/Publication 403, pp. 29–115. Washington, D.C.: Carnegie Institution of Washington.

Thompson, John Eric Sidney
1950 *Maya Hieroglyphic Writing: An Introduction.* Publication 589. Washington, D.C: Carnegie Institution of Washington.
1961 A Blood-Drawing Ceremony Painted on a Maya Vase. *Estudios de Cultura Maya* 1:13–20.
1962 *A Catalog of Maya Hieroglyphs.* Norman: University of Oklahoma Press.

1970 *Maya History and Religion.* Norman: University of Oklahoma Press.

1972 *A Commentary on the Dresden Codex.* Memoirs of the American Philosophical Society no. 93. Philadelphia: American Philosophical Society.

Tozzer, Alfred Marston, and George Allen

1910 *Animal Figures in the Maya Codices.* Papers of the Peabody Museum of American Archaeology and Ethnology 4, no. 3. Cambridge, Mass.: Harvard University.

Trik, Aubrey S.

1939 *Temple XXII at Copan.* Contributions to American Anthropology and History no. 27/Publication 509. Washington, D.C.: Carnegie Institution of Washington.

Villacorta, C. Juan Antonio, and Carlos A. Villacorta

1977 *Codices Mayas.* 2d ed. Guatemala.

Watanabe, John M.

1983 In the World of the Sun: A Cognitive Model of Mayan Cosmology. *Man* 14(4): 710–28.

Webster, David, ed.

1989 *The House of the Bacabs, Copan, Honduras.* Studies of Pre-Columbian Art and Archaeology no. 29. Washington, D.C.: Dumbarton Oaks.

Willey, Gordon R., Richard M. Leventhal, and William L. Fash, Jr.

1978 Maya Settlement in the Copan Valley. *Archaeology* 31:32–43.

Index

Aguateca (Guatemala): pseudo-Tlaloc complex at, 250; Stela 2, 136, 227
Ancestors, 26, 28, 33, 35, 48, 52, 68, 84, 86, 109, 115, 117, 121, 130, 132, 188, 247–49, 252, 266, 276–78, 280
Aquatic frieze. *See* Water frieze
Autosacrifice, 4, 19, 23, 28, 35, 52, 62, 115, 125, 136, 231, 257, 270

Bacab, 58, 76, 80, 84, 86, 101–104, 147, 170, 181, 197, 205, 209–10, 220, 232, 235, 248, 251, 253–54, 256, 260, 265–66, 275, 278
Back rack, 63, 266
Bird-upon-earth motif, 28, 32, 35–36, 220–21, 252, 264
Bloodletting. *See* Autosacrifice
Bonampak (Mexico): captives at, 275; dynastic history of, 12; murals, 61, 183, 213; Stela 1, 256–57
Butz' Chan (eleventh ruler of the Copán dynasty), 9. *See also* Smoking-Heavens

Cacaxtla (Mexico), 136, 188
Calakmul (Mexico): Stela 9, 61; Stela 28, 62; Stela 29, 62
Cancuén (Guatemala): Monument N.N., 70
Caracol (Belize): dynastic history of, 12
Cauac-Sky (ruler of Quiriguá), 10
Ceh: patron of month, 26, 28, 280
Chac, 94, 174, 205, 257–58
Chalcatzingo (Mexico): Monument 9, 260
Chan Bahlum (ruler of Palenque), 63
Chenes (style of architecture), 10, 205
Chichen Itza (Mexico), 231, 265
Cleft-Moon Leaf-Jaguar (tenth ruler of the Copán dynasty), 9, 109. *See also* Moon Jaguar
Composite staff, 20–21, 136, 252, 272
Copán (Honduras): Acropolis, 5–6, 10–11, 92–94, 158, 165–66, 177, 200, 254, 258, 278; Acropolis East Court, 5, 200, 202, 205, 211, 217, 254, 272; Acropolis West Court, 92, 95, 168, 170, 179–80, 183, 260; Bosque, 151; Cementerio, 275; CPN 1 (Stela A), 10, 19–23, 26, 36, 59, 61, 118, 121, 130, 190, 251–52, 262, 267, 270–72, 276, 278–80, 283; CPN 2 (Altar of Stela A), 19; CPN 3 (Stela B), 10, 23–28, 32, 34, 36, 43, 48, 70, 86, 97, 118, 121, 141, 205, 208, 210, 213, 221, 250, 252, 254, 256–58, 264, 270–73, 276, 278–80, 283; CPN 4 (Stela C), 10, 13, 27–36, 38, 46, 64, 80, 86, 101, 116, 221, 253–54, 256–58, 264–65, 268, 270–73, 275–76, 278–80, 283; CPN 5 (West altar of Stela C), 32, 36–38, 248, 258; CPN 6 (Plain altar of Stela C), 32; CPN 7 (Stela D), 34, 38–43, 46, 80, 211, 239, 252–53, 255, 262, 264, 268, 270, 276, 278–79, 283; CPN 8 (Altar of Stela D), 38, 42–46, 104, 252, 255, 268; CPN 9 (Stela E), 8, 10, 46–48, 121, 248, 251, 270, 273, 275–76, 279–80, 283; CPN 10 (Altar of Stela E), 46, 250; CPN 11 (Stela F), 11, 23, 48–53, 55, 59, 121–22, 136, 188, 211, 239, 247, 251, 270–73, 276, 278–80, 283; CPN 12 (Altar of Stela F), 48, 53–55, 66, 90, 264, 272–73; CPN 13 (Altar G1), 11, 14, 36, 55–58, 92, 101, 210, 220, 255–56, 270–72, 283; CPN 14 (Altar G2), 14, 36, 55, 58, 283; CPN 15 (Altar G3), 14, 36, 55, 58, 189, 283; CPN 16 (Stela H), 5, 10, 36, 42, 48, 55, 59–64, 121, 220, 251, 265–66, 270–72, 276, 278–79, 283; CPN 17 (Altar of Stela H), 59, 64–66, 90; CPN 18 (Stela I), 8, 10, 36, 44, 66–69, 136, 239, 250–51, 272–73, 278–79, 283; CPN 19 (Altar of Stela I), 10, 66, 69, 250; CPN 20 (Stela J), 69–70, 72, 136, 239, 250, 252, 257, 283; CPN 21 (Altar of Stela J), 69–72, 250; CPN 22 (Altar K), 250; CPN 23 (Altar L), 8, 11, 72–74, 97, 104, 111, 164, 229, 279–80, 283; CPN 24 (Stela M), 10, 74–76, 80, 84, 219, 227, 229, 239, 253, 270–72, 279–80, 283; CPN 25 (Altar of Stela M), 28, 55, 74, 76–80, 86, 205, 210, 253, 255–56, 258, 276, 280; CPN 26 (Stela N), 5, 10, 36, 76, 80–87, 90, 117, 189, 253–54, 257–58, 260, 264, 268, 272, 279, 283; CPN 27 (Altar of Stela N), 64, 66, 83, 87–90, 264, 276; CPN 28 (Altar O), 14, 36, 90–92, 101, 189, 210, 220, 260; CPN 29 (Stela P), 10, 48, 92–95, 112, 248–49, 267, 279, 283; CPN 30 (Altar Q), 8, 11, 28, 73, 86–87, 95–97, 104, 176, 188, 197, 227, 229, 253, 272, 275–77, 279–80, 283; CPN 31 (Altar R), 197–98, 254; CPN 32 (Altar S), 147; CPN 33 (Altar T), 11, 36, 97–104, 189, 220, 254, 258, 260–62, 264, 276, 278–79, 283; CPN 34 (Altar U), 11, 64, 101, 104–107, 254, 283; CPN 37 (Altar Z), 107, 254, 260, 283; CPN 38 (Stela 1), 9–11, 107–109, 136, 249–50, 273, 278–79, 283; CPN 39 (Altar of Stela 1), 109, 250; CPN 40 (Stela 2), 10, 48, 72, 109–112, 248–49, 251, 267, 272–73, 278–79, 283; CPN 41 (Stela 3), 36, 64, 112–18, 121, 130–31, 249–50, 252, 257, 260, 270, 273, 276, 279–80, 283; CPN 41A (Cribbing frame of Stela 3), 112, 117; CPN 42A (Prismatic sculpture),

118; CPN 42B (Prismatic sculpture), 118; CPN 43 (Stela 4), 10–11, 52, 55, 118–22, 125, 127, 247, 250–51, 273, 279–80, 283; CPN 44 (Altar Y), 118, 122, 125, 250–51, 258, 268, 273, 283; CPN 45 (Globular altar of Stela 4), 121, 125, 264, 273, 278; CPN 46 (Archaic sculpture), 8, 118, 122, 127, 133, 248, 251; CPN 47 (Stela 5), 9–10, 13, 23, 36, 64, 69, 94, 116, 121–22, 127–33, 136, 239, 249–51, 253, 257, 267–68, 270–73, 275–76, 279–80, 283; CPN 48 (Altar X), 122, 125, 127, 132, 250–51, 268, 273, 283; CPN 49 (East altar of Stela 5), 127, 250; CPN 50 (West altar of Stela 5), 127, 250; CPN 51 (Archaic sculpture), 8, 122, 127, 132–33, 248, 251; CPN 52 (Stela 6), 9–10, 109, 116, 133–37, 188, 229, 249–50, 253, 273, 279, 283; CPN 53 (Altar of Stela 6), 125, 133, 250; CPN 54 (Stela 7), 8, 137–39, 248, 251, 267, 272–73, 279, 283; CPN 55 (Stela 8), 139, 254, 283; CPN 56 (Stela 9), 139; CPN 57 (Stela 10), 249; CPN 60 (Stela 11), 11, 101, 198, 254; CPN 61 (Stela 12), 249; CPN 62 (Stela 13), 139–40, 249, 283; CPN 62A (Cribbing frame of Stela 13), 139–40, 273; CPN 64 (Altar 14), 140–41; CPN 69 (Stela 19), 249; CPN 75 (Stela 23), 249; CPN 76 (Stela 24), 251; CPN 79 (Altar A'), 125, 250; CPN 82 (Altar D', Oblong altar, Altar 41), 141, 189, 255–56, 258, 260, 267–68, 283; CPN 86 (Altar H'), 250; CPN 87 (Altar I'), 250; CPN 98 (Altar T'), 144, 147, 262; CPN 99 (Altar U'), 147; CPN 101 (Altar W'), 147, 151, 170, 256, 260, 283; CPN 109, 122, 125, 147–51, 183, 250, 260, 268; CPN 110, 122, 125, 147–51, 183, 250, 260, 268; CPN 111, 122, 125, 147–51, 183, 250, 260, 268; CPN 131 (Four-lobed disk), 151, 260; CPN 155 (Tunkul), 151–54; CPN 188 (Stela 35), 11, 155–56, 248; CPN 489, 14, 232; CPN 540, 268; CPN 634, 118, 156, 260; CPN 999, 6, 235, 262; Las Sepulturas, 6, 147; Peccary Skull, 8; settlement pattern study at, 6; Stela 63, 198; Structure 9M-146 and bench, 11, 197, 232, 254; Structure 9N-82 and bench, 6, 11, 72, 80, 84, 210, 232, 254–56, 270; Structure 10K-16, 277; Structure 10L-1, 46; Structure 10L-2, 6, 10, 38; Structure 10L-3, 55, 66, 69, 277; Structure 10L-4, 5–6, 10, 19, 66, 112, 156, 251, 265, 277; Structure 10L-7, 91, 141; Structure 10L-9 and 10 (Ball Court A), 5–6, 10, 28, 72, 107, 109–111, 151, 158–66, 183–84, 229, 252, 257, 260–62, 265, 277, 279; Ball Court B, 6, 184; Structure 10L-11, 5–6, 10–11, 83, 92, 107, 141, 166–77, 179, 188, 198, 200, 217, 253, 255, 260–62, 265, 276–77, 279–80; Structure 10L-12, 5–6, 10, 177–84, 200, 216, 253, 277; Structure 10L-13, 156, 183; Structure 10L-14, 153; Structure 10L-16, 5–6, 8, 11, 95, 97, 183–89, 197, 200, 217, 253, 266, 273, 275, 278; Structure 10L-16-sub (Rosalila), 8, 189; Structure 10L-17, 197–98; Structure 10L-18, 6, 8, 10–11, 23, 42, 107, 136, 139, 189–200, 205, 232, 254, 256–57, 260–62, 268, 270–73, 275, 278–79; Structure 10L-19, 197; Structure 10L-20, 5, 202; Structure 10L-21, 10–11, 202; Structure 10L-21A, 6, 200, 202, 253; Structure 10L-22, 5–6, 10–11, 170, 189, 200–211, 253, 256, 258, 265–66, 270–72, 276; Structure 10L-22A, 10–11, 200, 202, 211, 253; Structure 10L-24, 51, 53, 151, 183, 211–17, 253–54, 260, 265, 270, 276–77; Structure 10L-25, 211, 217; Structure 10L-26 and Hieroglyphic Stairway, 5–6, 10, 58, 74, 83, 91, 151, 166, 184, 210, 217–32, 252–53, 264–65, 273, 275–77; Hieroglyphic Stairway, prone figures, 101, 198, 219, 230–31, 266, 273; Hieroglyphic Stairway, statues, 136, 164, 188, 217–19, 221–30, 248, 272, 275–76, 279–80; Structure 10L-54, 277; Structure 10M-1, 277; sub-stela caches, 19, 23, 32, 38, 53, 59, 66, 69, 72, 74, 83, 94, 107, 112, 133, 137, 140

Copán Ruinas (village), 101, 104, 137, 139–140, 144, 147, 156

Cosmic serpent, 42, 52, 63, 95, 122, 205

Cosmogram, 4, 63, 165–66, 171, 174, 209, 217, 231, 247, 252–53, 265–66, 277, 281

Death-and-rebirth theme, 42–43; as bones and maize, 61, 276; as ear ornaments, 27, 268; as skeletal creatures and maize, 63; as skull topped with toad, 118; as skull-and-vegetation, 19–20, 23, 48, 90, 95, 130, 139, 163, 247–49, 252–53, 267–68, 276; as toad topped with jaguar, 141

Decorated Ahau (first ruler of the Copán dynasty), 8–9. *See also* Yax K'uk' Mo'o

Dos Pilas (Guatemala): pseudo-Tlaloc complex at, 250; stairs, 231; Stela 1, 61; Stela 16, 136, 227

Dresden Codex, 174, 210, 213, 257, 265, 276

Dzibilchaltún (Mexico), 176, 268

Earth Monster, 104; as bicephalic *cauac* monster, 4, 26–27, 32, 35, 43, 77–80, 141, 147, 168, 248, 252–53, 255–56, 260; as bicephalic turtle, 33, 35–38; as bicephalic underworld monster, 170–71, 174, 176–77; as *cauac* mask, 27, 69–70, 104, 194, 197, 202, 220, 235, 250, 257, 260; with *cauac* masks on body, 28, 77, 86, 117, 205, 208, 210, 252, 256, 260; *cauac* monster as sacrificial stone, 264, 276; censer in *cauac* form, 188; monocephalic with anthropomorphic body, 84, 86

Eighteen-Rabbit (thirteenth ruler of the Copán dynasty), 8–10, 19, 26, 32, 35–36, 43, 52, 62, 97, 107, 164–65, 184, 200, 229, 239, 247–48, 250–52, 254, 270, 273, 278–80

El Perú (Guatemala): Stela 33, 62; Stela 34, 62
Enucleation, 27

Feathered Serpent, 248; bicephalic, 55–58; monocephalic, 91, 95

Founding Father, 28, 97, 176–77, 188, 252–53, 275, 278, 280. *See also* Yax K'uk' Mo'o

Full figure inscription, 38, 43, 219

God B. *See* Chac
God K. *See* Thunderer
God L, 136
God N. *See* Bacab
God Q, 115, 249, 276
God R, 133
Graffiti (of ritual paths), 176, 277

Hauberg stela, 156
Head-on-Earth (eighth ruler of the Copán dynasty), 9
Huehuetenango vase, 268

Ixchel (goddess), 210
Ixlú (Guatemala), 211

Jaguar Sun God (seventh ruler of the Copán dynasty), 9, 109. *See also* Water Lily Jaguar
Jimbal (Guatemala), 211

Lady Turtle (wife of Eighteen-Rabbit), 251
La Florida (Guatemala): Stela 10, 70
La Florida de Copán (Honduras): archaic sculpture, 127
La Laguna (Copán area), 6
Leaf-Jaguar. *See* Cleft-Moon Leaf-Jaguar
Leyden plaque, 11, 156

Macaw, 26–28, 165, 219, 252, 257, 264–65, 267
Machaquilá (Guatemala): Stela 2, 61; Stela 4, 196, 260; Stela 7, 196; Stela 8, 196; Stela 10, 260
Madrid Codex, 131, 171, 174, 176, 265, 276
Maize: cob of, 61; impersonators of, 62, 164, 170, 202, 248, 266–67, 270; severed head of, 26, 34, 42–43, 252, 276
Microflora: at Copán, 12; at Quirigua, 12
Moon-Jaguar (tenth ruler of the Copán dynasty), 9. *See also* Cleft-Moon Leaf-Jaguar

Naranjo (Guatemala), 136; composite staffs at, 272; Stela 2, 62, 226; Stela 3, 62; Stela 7, 226; Stela 14, 226; Stela 22, 62; Stela 24, 62; Stela 28, 62; Stela 29, 62; Stela 30, 62; Stela 31, 62, 256

Ometepec (Guerrero, Mexico), 133

Pacal (ruler of Palenque), 258
"Paddlers," 94–95, 111, 139, 189, 248
Palenque (Mexico): banners, 61; cosmogram at, 63, 231; Del Rio throne, 209, 232; dynastic history of, 12; GI of the triad, 66; House D, 63–64; House E, 210, 256; Palace tablet, 64; Temple of the Cross, 63, 205, 220, 257, 262, 265–66; Temple of the Foliated Cross, 62, 220, 256–58, 266; Temple XIV, 151; Temple of the Sun, 262; Temple XXI, 219; Templo Olvidado, 53
Pawahtun. *See* Bacab
Pax jaguar, 33–35, 44, 46–47, 53–55, 68–69, 85, 90, 111, 115, 117, 131, 153–54, 220, 247–48, 251, 272, 275–76, 278
Perambulations, 174–77, 183, 217, 253, 265, 277, 282
Petapilla (Copán area), 140
Piedras Negras (Guatemala): accession stelae, 12; captives at, 275; cosmogram at, 63, 209; pseudo-Tlaloc complex at, 250; stela alignment at, 121; Stela 3, 227; Stela 4, 61; Stela 6, 63, 210–11, 256; Stela 7, 136, 226, 250; Stela 8, 136; Stela 9, 136; Stela 11, 63, 210–11, 256, 268; Stela 14, 63, 211, 256, 268; Stela 25, 63, 211, 256

Popol Vuh, 163–64, 252, 277
Pseudo-Tlaloc/Year Sign complex, 116, 130–31, 133–36, 188, 196, 220–27, 229, 249, 253, 272–75, 279

Quiriguá (Guatemala), 125, 136, 256, 278; capturing Eighteen Rabbit, 10, 43, 252; control by Copán, 8; cosmogram at, 63; Monument 5 (Stela E), 256; Monument 8 (Stela H), 70, 257; Monument 9 (Stela I), 63–64, 211, 256, 266; Monument 12 (Altar L), 9; Monument 13 (Altar M), 80; Monument 14 (Altar N), 80; Monument 15 (Zoomorph O), 28, 42, 59, 256, 260; Monument 16 (Zoomorph P), 28, 42, 59, 256, 260; Monument 23 (Altar of Zoomorph O), 28, 42, 59, 256, 260; Monument 24 (Altar of Zoomorph P), 28, 42, 59, 256, 260; Rising-Sun ritual activity at, 72; rulers of, 12

Río Hondo bowl, 210
Rising-Sun (sixteenth ruler of the Copán dynasty), 8–11, 32, 72, 87, 97, 141, 176–77, 184, 188, 196, 198–200, 231, 235, 239, 248, 253–54, 272–73, 278, 280. *See also* Yax Pac

Sacrifice, 23, 34–35, 42–43, 52, 61, 63–64, 69, 115, 125, 136, 188, 210–11, 220, 229, 231, 247, 252, 264, 266, 268–277
Sacrificial Implements: eccentrics, 33; jaguar paw, 27, 95, 273; knife-tongue, 32, 34, 76, 116, 131, 154, 213, 220, 249, 270, 273; lance point in head form, 23, 270; lancet, 27, 43, 131–32, 209, 247, 268; lancet in head form, 19, 23, 26, 28, 33–35, 38, 42–43, 47–48, 51–52, 62, 76, 121, 132, 196, 205, 208, 247, 249, 251–52, 267–68, 272, 278; skull in the form of an eccentric knife, 19, 23, 51–52, 58–59, 270; skull in the form of a knife, 26, 76, 270; stingray spine, 34, 209; whistongue, 26, 28, 51–52, 58, 84, 86, 95, 196, 209, 213, 247, 249, 251–52, 270
Santa Rita (Copán area), 140
Self-sacrifice. *See* Autosacrifice
Sky Serpent (or Sky Monster), 42, 52, 86, 92, 174, 208–11, 221, 247, 251, 256, 279
Smoke-Imix God K (twelfth ruler of the Copán dynasty), 9. *See also* Smoke-Jaguar-Imix-Monster
Smoke-Jaguar-Imix-Monster (twelfth ruler of the Copán dynasty), 9, 35, 47, 68–69, 73, 132, 249, 251, 254. *See also* Smoke-Imix God K
Smoke-Monkey (fourteenth ruler of the Copán dynasty), 9, 87. *See also* Three-Death
Smoke-Shell (fifteenth ruler of the Copán dynasty), 9. *See also* Smoking-Squirrel
Smoking-Heavens (eleventh ruler of the Copán dynasty), 9, 94, 122, 132, 137, 189. *See also* Butz' Chan
Smoking-Squirrel (fifteenth ruler of the Copán dynasty), 9, 74, 87, 184, 188, 229, 231, 248, 252–53, 273. *See also* Smoke-Shell
Structural analysis, 4–5
Sun-King theme, 227, 264, 266, 278; accession as sun-

rise, 23, 28, 35, 85, 132, 141, 252–54; death as sunset, 35, 70, 85, 132, 253–54; king as turbaned *kin*, 34

Tamarindito (Guatemala): captives on steps at, 230–31; Stela 3, 272
Teotihuacán (Mexico), 136
Tepeyollotl, 153
Three-Death (fourteenth ruler of the Copán dynasty), 9. *See also* Smoke Monkey
Thunderer, 27–28, 38, 42, 74, 83, 85–86, 121, 147, 170, 247, 251–52, 256, 260, 267, 273, 279
Tikal (Guatemala): Altar 7, 270; archaic sculpture, 127; baktun 8 stelae at, 248; bowl from Burial 160, 183; censer from Burial 10, 188; Columnar Altar 1, 136; composite staffs at, 136, 272; cosmogram at, 63; dynastic history of, 12; Lintel 3 of Structure 5C-4 (Temple I), 61, 211, 256; MT38 from Burial 116, 189; Stela 1, 11, 156; Stela 2, 11, 262; Stela 28, 156; Stela 31, 136, 198; Stela 36, 156; twin pyramid complexes, 251, 277
Tok (second ruler of the Copán dynasty), 9
Toniná (Mexico), 61, 62; Monument 22, 118; Monument 49, 176; Monument 69, 262; Monument 74, 198; Monument 102, 264; Monument 114, 262; Monument 135, 107
Triadic sign. *See* Tripartite emblem
Tripartite emblem, 4, 66, 80, 162–63, 208, 210, 255–56, 267, 276
Tula (Mexico), 231, 265

Ucanal (Guatemala), 211, 258
U-Cit-Tok (ruler of Copán?), 8–9
Uo jaguar, 34, 68–69, 247, 278
Uolantún (Guatemala): Stela 1, 156
Uotan, 153
Usumacinta (sites), 176, 249

Water frieze, 122, 125, 151, 183, 210, 250, 267
Water Lily Jaguar (seventh ruler of the Copán dynasty), 9, 47, 121. *See also* Jaguar Sun God

Xibalba, 252
Xipe Totec, 115
Xochicalco (Mexico), 136

Yaxchilán (Mexico): autosacrifice at, 210, 227; dynastic history of, 12; Lintel 8, 12; Lintel 9, 61; Lintel 15, 188; Lintel 17, 136; Lintel 24, 136, 231; Lintel 25, 136, 188, 227, 231, 257, 268; Lintel 33, 61; Lintel 48, 34; Lintel 50, 61; sacrificial victims at, 275; Stela 1, 211, 256; Stela 4, 211, 256; Stela 6, 211, 256; Stela 11, 61, 211, 256; Stela 32, 198, 227, 231, 250, 256
Yaxhá (Guatemala): Stela 2, 262; Stela 3, 262; Stela 4, 262; Stela 6, 156
Yax K'uk' Mo'o (first ruler of the Copán dynasty), 8–9, 69, 97, 177, 188, 252. *See also* Decorated Ahau; Founding Father
Yax Pac (sixteenth ruler of the Copán dynasty), 9. *See also* Rising-Sun

CPSIA information can be obtained
at www.ICGtesting.com
Printed in the USA
BVHW060935280822
645601BV00008B/395